O9-AIC-473

A17000 461522

RUBENS
AND
ITALY

Michael Jaffé

RUBENS AND ITALY

Cornell University Press

Ithaca, New York

FORBES LIBRARY
Northampton, Mass.

WAR 823 +
J18r

For
KENNETH CLARK
in gratitude & admiration

Jaffe, Andrew Michael.

128 p., [103] leaves of plates : ill. (some col.) ; 29 cm.
Bib. p. 121-123
 Includes index.

1. Rubens, Peter Paul, Sir, 1577-1640. 2. Mannerism
(Art) - Italy. 3. Art, Italian I. Title.

© 1977 by Phaidon Press Limited, Oxford

All rights reserved. Except for brief quotations in a review,
this book, or parts thereof, must not be reproduced in any
form without permission in writing from the publisher. For
information address Cornell University Press, 124 Roberts
Place, Ithaca, New York 14850

First published 1977 by Cornell University Press

International Standard Book Number 0–8014–1064–9
Library of Congress Catalog Card Number 76–20065

Filmset in Great Britain by Keyspools Limited, Golborne,
Warrington, Lancs
Printed in Italy by Amilcare Pizzi SpA, Milan

Contents

Acknowledgements

'RUBENS IN ITALY 1600–1608' was the theme approved for the dissertation which I submitted in December 1951 to the Electors to Fellowships at King's College, Cambridge. The choice of it had been stimulated in me the previous year. I had attended a series of classes held in London at the Courtauld Institute of Art by Johannes Wilde; as a feature of this we students were treated one morning to a sight of the splendid collection at 56 Prince's Gate which had been formed by Professor Wilde's former pupil from Vienna, Count Antoine Seilern. Moreover, in London, in the winter of 1950, anyone with even the glimmer of a passion for the art of Rubens could relish, beside the riches of the national collections and of the Dulwich Gallery, 'Peter Paul Rubens, Kt', a generally well chosen and instructive exhibition organized at Wildenstein's by Ludwig Burchard. For this favourable concatenation of circumstances I am lastingly grateful. On subsequent journeys and searches across North America in 1951 and 1952 I had the support of a Commonwealth Fund Fellowship; and in Europe, during the years following my return to England to take up a Research Fellowship at King's, I had further support from the College. I owe incalculably much to this sustained interest and generosity.

Increasing dissatisfaction with the limitations as a subject of 'Rubens in Italy', as well as with the insufficiencies of my initial treatment of it, led me to hope that one day, despite distractions, I might be in a position to undertake with a considerable body of fresh material the larger subject of 'Rubens and Italy'. In the period intervening between the submission of my fellowship dissertation and the preparation of this book, Rubens specialists and many others have published notable contributions relevant to this enlarged theme; and I have sought to sharpen my insight thereby. I think particularly of Benesch, of Burchard, of Longhi, of Lugt and of Stechow; and, amongst the living, of S. Alpers, F. Baudouin, P. Bjurström, J. Byam Shaw, H. Geissler, J. G. van Gelder, H. Gerson, C. van Hasselt, E. Haverkamp Begemann, J. S. Held, R.-A. d'Hulst, J. Kusnetsow, M. J. Lewine, E. McGrath, M. de Maeyer, G. Martin, J. R. Martin, O. Millar, A. Mongan, J. Müller-Hofstede, C. Norris, I. Q. van Regteren Altena, A. Seilern, C. Sterling, H. Vlieghe and M. Winner. Moreover their work has often profited by notice of our expanding comprehension of the changing artistic situations in Italy during the Cinquecento and the Seicento. Their debt in this respect is also mine, to the work of Keith Andrews, Andrea Emiliani, Sidney Freedberg, the late Walter Friedländer, John Gere, Cesare Gnudi, Denis Mahon, M. Muraro, Konrad Oberhuber, Harald Olsen, John Pope-Hennessy, Donald Posner, Philip Pouncey, D. Rosand, John Shearman, Malcolm Waddingham, Harold Wethey and the late Rudolf Wittkower.

I have received friendly help on both sides of the Atlantic and in many countries, not only from scholars and amateurs of painting and the graphic arts, but also from archivists, librarians, restorers, auctioneers, and dealers; and especially from those in charge of collections, both private and public. I ask their indulgence if I do not name here each one of so many. However, I must declare that it was the encouragement of Hans Calmann and of his son John, formerly a director of the Phaidon Press, which brought me eventually to this book; that it was the vigorous, constructive criticism of Dr. G. H. W. Rylands, and the expert editing of Dr. I. Grafe, which has made the writing easier to be read; that it was the devoted industry of Brenda Branson, and, latterly also of Judy Whitcher, which got successive revisions of the text typewritten on time; and that it was the sympathetic understanding of my wife, which saved me more than once from despair at slow progress towards a publishable form.

MICHAEL JAFFÉ

Fitzwilliam Museum
Cambridge, 1976

1. The Nature of his Decision

PETER PAUL RUBENS, by the chauvinist reckoning of very many of his latter-day compatriots, stands first and foremost as the heroically Flemish painter of his age. By them he is not unreasonably ranked alongside Jan van Eyck and Pieter Bruegel in the two centuries preceding his own: but this foreshortened sort of accounting slights the significance of the individual connections of these men with foreign patronage and foreign art. To discount patriotically the eight years which Rubens himself spent south of the Alps, in a crucially formative phase of his life, divorces from their context the magnitude and quality of his subsequent achievement in the course of the next thirty-one years in Flanders. To review his work and studies during the proportionately long period of his young manhood away from home is not only fundamental to his biography, but indispensable to the far more extended and more complex story of those relationships between Netherlandish and cisalpine art which run discernibly and almost continuously from the early fifteenth until the late seventeenth century. Indeed it is to survey from the chief point of vantage one of the most rewarding areas of the cultural geography of Western Europe, while observing the growth, the destiny and, eventually, the international reverberation of a quite prodigious artistic talent. How much did this Flemish painter absorb of Italy, and how did Italy respond to him? How deliberate, or how chancy, was the intricate process of mutual assimilation?

Bernard Berenson wrote that 'Rubens è un italiano'; by which he sought imaginatively to invoke the strong spells on a sympathetic northerner of Italian wine and Italian sunshine, as well as of the heady mixture of past and present in the Italian cities and their surrounding landscape. Rubens, expatriate in Italy, continued to be 'fiammengo', and on his return to Flanders he could not rid himself of the sense, though he might smother it with his industry and with the distractions of state affairs, that he flourished in exile from what might have remained his adopted country. Of the five languages which he came by his middle twenties to write with apparent ease, Tuscan remained his favourite for correspondence. In Antwerp the mansion on the Wapper which he built for himself at great cost, the domestic pantheon which housed there his precious assembly of antiquities, and the Italianate garden with its triumphal archway of stone and its elegant pavilion, this ensemble became for visitors one of the principal sights of the city; and from it emanated for him consoling recollections of the style of living which he had known in Mantua, Rome and Genoa. As he busied himself with his students and assistants, or relaxed with his family and friends, he did not cease to feel the force of separation from the company he had kept in the South. Those persons and places beckoned him from home: but he was too clear-sighted and too self-disciplined not to make the very best of what he gathered around him in his fully charged career.

* * *

On 9 May 1600, shortly before his twenty-third birthday, he rode southwards from Antwerp, intent on a personal exploration of Italy. According to the Latin *Life* long credited to his nephew, the desire possessed him to travel there, 'in order to study at close quarters the works of the ancient and modern masters and to improve himself by their example in painting'.[1] That account, whether or not written by Philip Rubens the younger, depends almost certainly on a word of mouth tradition within the Rubens family. It is terse, but fairly explicit. Ancient art for the seventeenth century amounted substantially to a canon of Hellenistic and late Roman sculpture with, *rarissima*, a few Greek originals. Virtually all that was considered of consequence remained either in Rome and her surroundings, or in the Veneto, or in the collections of the ruling families in Mantua and Florence. Modern art comprised whatever paintings and statues, ranking as masterpieces by cisalpine standards, had been created from the Renaissance onwards. The motives stated in the *Life* are utterly plausible. Beyond the *Life* we have no record of Peter Paul's original intention. No letters written by him to his family are known in any form; and no letter of his at all before March 1603. We feel most keenly the loss of those he must have written to his erudite brother Philip, his immediate senior and closest associate amongst his four siblings, and to Maria Rubens, their compassionate and dignified mother. So we can only speculate how long at any stage he contemplated spending on those studies which

appeared so vital to him in his profession. We can only speculate how the youngest son of a widow, whose settled property had dwindled in value during the years with her late husband in exile from their native Antwerp, may have proposed to maintain himself during his self-imposed absence abroad.

To the percipient, Rubens in 1600 must have seemed a person of singular promise. Nevertheless he was as yet without a real protector, having left the duties of a page in the household of the widowed Comtesse de Lalaing at Audenaerde in order to train as a painter with his mother's kinsman Verhaecht. From the circumstance of his having had to leave school at the age of thirteen so that a respectable dowry could be provided for his sister, Blandina, we can infer his lack of independent means. In this respect his worldly situation in Antwerp that first spring of the century contrasts with the one in which his principal assistant to be, Anthony van Dyck, found himself there twenty or so years later. Van Dyck by birth was of the same class, and he was to set out for Italy at very much the same age: but he had been indulged as the only son of rich parents; and he travelled initially with the specific approval of 'the father of *virtù* in England', who had become Rubens's admirer, the Earl of Arundel. Having no such backing, Rubens's youthful enterprise was the more remarkable. He contrived to remain beyond the Alps, unceasingly active in the exercise and improvement of his art, until, in the last week of October 1608, he was recalled in haste by news that his mother lay in an illness likely to be her last.

He galloped north from Rome, his paintings for the great new church of the Oratorian Fathers, his capital undertaking in the city, barely complete (Plates 333, 335, 336). As he strained to reach his mother's bedside in time, he must have reflected how this abrupt departure might affect his whole future. Would he be free eventually to ride back, and so follow up this first conspicuous success in what had been for a century past the artistic metropolis? Would the Spanish Archdukes, Albert and Isabella, who had seemed uncaring at his quitting the Netherlands, but who had begun a year ago to press for his early return, insist now on retaining him as their painter at Brussels? Or could he somehow make terms with Their Highnesses so as to re-establish himself at a comfortable distance from their Court, preferably at Antwerp, where he had gained his mastery ten years before, and develop there to maximum effect the wealth of visual intelligence gathered in Italy?

He reached Antwerp hotfoot in November, too late to see his mother alive. Indeed she had died before he left Rome. Family mourning and the persuasions of his brother Philip doubtless checked any immediate plans to slip away again southwards. Then, for professional as well as domestic reasons, it became out of the question for him to go; and he set up house in the Klosterstraat. Public commissions of importance were coming his way: large paintings of sacred subjects for the principal room of the City Hall and for an altar of the Dominican Fathers at St. Paul's; and a smaller altarpiece for the Grand Sodality which he had joined at the Jesuit Maison Professe (Col. Plate XIII). He confided to a friend at the Papal Court that Antwerp and her citizens would satisfy him, if only he could say farewell to Rome: but, despite hopes more than once expressed over the years, he was never again to visit Italy. On 3 October 1609 he married, obviously in a state of radiant happiness, a young woman of good Antwerp stock; Isabella, daughter of Jan Brant, a lawyer, and the niece of his brother Philip's wife. She was a proper match in good looks, warmth of heart and intelligence. That same autumn, on 23 September, having completed a fortnight previously his first official portraits of the Archdukes, he was named their painter. Simultaneously he was granted leave to reside out of Brussels; and, in virtue of being a court painter, he was privileged to be free in Antwerp of Guild restrictions on the registration of pupils. This favoured position he was well able to exploit. By his genius he became the fountainhead of what we now call the Baroque style. He made himself also, and recognizably to his own generation, the greatest *caposcuola* and *impresario* in the history of the Antwerp School, eclipsing even the renown and distinction of its founder, Quentin Matsys, and conferring on it European instead of just provincial status.

★ ★ ★

The Latin *Life* tells us that on crossing the Alps in 1600 Rubens headed – presumably by way of Verona and Padua – for Venice. Since Albrecht Dürer had been impelled twice to visit the city of Giovanni Bellini, and had failed to reach the city where Raphael worked for the Pope, Germans and Flemings had felt varying pulls towards these cultural centres. Rumour of a second Golden Age for the arts in Rome, interrupted for a few years by the shock and aftermath of the Sack, had been sustained not only by memories of the cartoons sent from Raphael's studio to the Brussels weavers, but also by the circulation beyond Italy of prints, of

1. The Artist and his Brother Philip. Detail from the *Self-Portrait with Friends at Mantua* (Plate 253). About 1602. Oils on canvas. Cologne, Wallraf-Richartz Museum

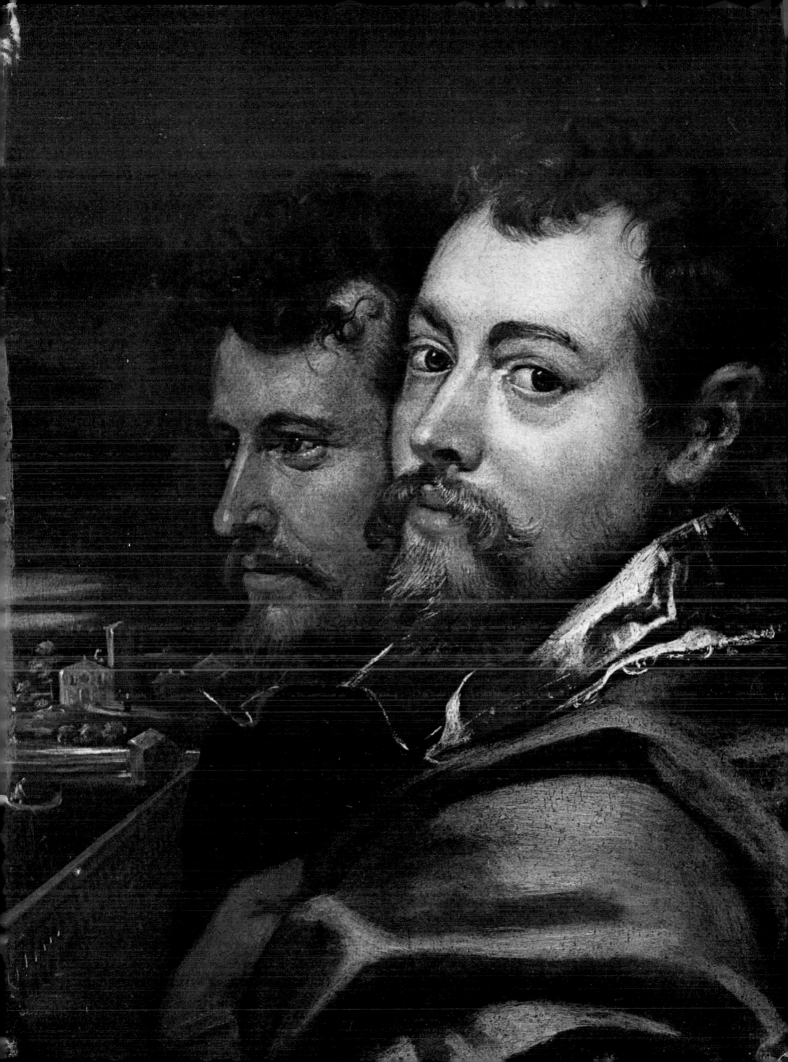

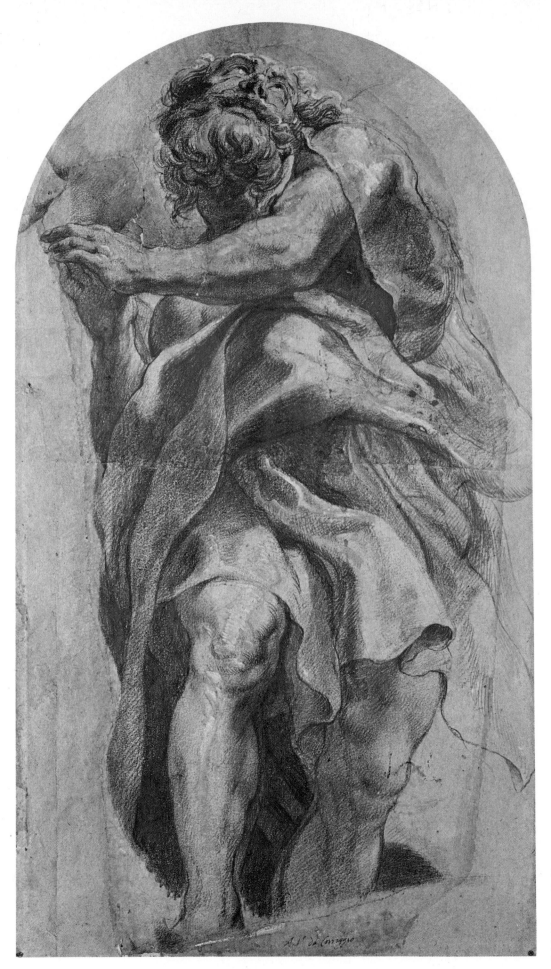

11. *An Apostle* (after Correggio). About 1604–5. Chalk, heightened in bodycolours, on paper. Paris, Louvre

sculpture in bronze reductions and of painted and drawn copies of masterpieces. Then, in the last quarter of the century, as the international fame of Jacopo Bassano was added to that of Titian, and as the reputations of Jacopo Tintoretto and Paolo Veronese in the Veneto spread afar, Venice in a significant number of cases took priority from Rome as first or even sole call for painters from the North. Of closest relevance to Rubens in this respect were three from German cities: Christoffel Schwarz (Plate 183) and Hans Rottenhammer from Munich, and Adam Elsheimer from Frankfurt. Before he left home, he would have known that Schwarz, who had worked with Titian and Tintoretto, was dead. But, when he reached Venice, he was to find that Rottenhammer (Plate 203) was well established, and still painting for the most part small-scale and exquisite renderings of Veronese's and Tintoretto's styles; and that Elsheimer (Plate 178), who had been closely associated with Rottenhammer, had moved only a few months ago to Rome. Soon after his own arrival, which could have been within four weeks of leaving Antwerp, he was fortunate enough to attract the favourable notice of a gentleman accompanying the Duke of Mantua. From other sources we know that, conveniently for Rubens, Duke Vincenzo happened to be in Venice during the third week of June for the Carnival;[2] that, in the person of the Ducal Secretary of State, Annibale Chieppio, he had the luck to find early a steadfast friend; and that, by October at latest, he had entered the Duke's service in the accepted rôle of a Flemish painter at an Italian court.[3]

Replenishing portrait galleries, making presentable copies of masterpieces, and supplying small landscapes and other decorations on command, was hardly an elevated rôle for a rising young artist in Italy: but, in the view which had been expressed, according to Francisco de Hollanda's first Dialogue, by no less an authority than Michelangelo, Flemings lacked boldness, substance and vigour, and so could not aspire to the heights of history painting. Nevertheless the offer of employment at Mantua was the most auspicious that anyone in Rubens's position could have dreamed of, however he might weary of the portrayal of court ladies for the ducal 'Gallery of Beauties', and whatever inadequacies or arrears there might prove to be in the payment of his salary. Presumably he did not hesitate. He was to serve Vincenzo I Gonzaga, a patron neither readily nor fully appreciative of his efforts and of his potentialities, faithfully for more than eight years; longer than Rogier van der Weyden or Justus van Ghent or

any other Flemish painter before him had served an Italian prince. Living in the quarters of a court painter at Mantua, even if he was never to overcome entirely the conventional disadvantage in Italy of being a Fleming, he could regard himself not only in the line of his fellow countrymen, Jan Bahuet and Frederik van Valckenborch, but as continuing the more illustrious succession of Andrea Mantegna and of Giulio Romano.

A century and a half of patronage by the Duke's forbears had filled their vast Reggia with the most extensive and varied collection in Italy outside the Vatican. The taste and wealth of these *magnifici* had secured masterpieces of all Renaissance schools; and the Duke's agents were instructed by Chieppio to pursue yet more, a Gaudenzio Ferrari in Milan, or a Raphael in Rome.[4] This patrimony – for which Rubens was at length to be entrusted with curatorial responsibilities – already included of Titian an *Entombment* and a *Supper at Emmaus* (Plates 174, 170), besides the room inset with half-lengths of eleven *Caesars*. It included portraits by Pordenone; Paolo Veronese's *Finding of Moses*; *Esther before Ahasuerus* and the *Histories of the Gonzaga* commissioned from Jacopo Tintoretto; a *Madonna and Child with an angel and St. John* by Andrea del Sarto; Correggio's *Education of Cupid* and *Jupiter and Antiope*; a *Madonna* designed by Raphael, and his *Acts of the Apostles Peter and Paul,* the second set of these tapestries to be woven in Brussels after the *editio princeps* for the Sistine Chapel; the contents of Isabella d'Este's *Grotta*; Mantegna's suite of *The Triumph of Caesar* in the Palazzo di S. Sebastiano, as well as his frescoes on the walls and vault of the Camera degli Sposi; and, in abundance, Giulio Romano's decorative work for the Sala di Troia, and outside the Palazzo Ducale, for the Palazzo del Tè, for the ducal hunting-box at Marmirolo, and for his own house in Mantua. In addition the Gonzaga kept choice antiquities: marble reliefs from sarcophagi; a magnificent cameo of *Ptolemy and Arsinoë*; and a carved onyx vase of scarcely less curiosity. Rubens was to appreciate better than anybody the artistic value of the treasures which were to be sold in 1627 by one of his Duke's sons, Duke Francesco, to the agent of Charles I of England, and he had a second, extraordinary chance to see many of them again in 1629, during his pacificatory mission to the English Court.

The small Duchy of Mantua was ideally situated as a centre for an able-bodied and energetic sightseer in North Italy. Rubens kept himself fit with horse exercise until the end of his days; and, with the

Gonzaga stables at hand, he could be excellently mounted. His zest for sights was unquenchable. Whenever he could get short leave, he had within two days' ride not only the most lively modern school of painting at Bologna, the home city of the Carracci and of Guido Reni, but also the splendours of the Emilian Cinquecento in Parma, Reggio and Modena; he could visit Brescia and Milan in Lombardy; and, in the Veneto, cities such as Treviso and Vicenza, which he may or may not have had time to see during his first unemployed weeks after crossing the Alps. The churches and *scuole* and palaces of Venice itself he must have visited repeatedly. S. Spirito in Isola, S. Maria Gloriosa dei Frari and S. Sebastiano, the Scuola Grande di S. Rocco and the Scuola Grande di S. Marco, the Doge's Palace and the palace of Federigo Contarini, these places held special fascinations for a man of his *gusto*. A beautifully coloured copy which he drew of Barocci's *Martyrdom of S. Vitalis* (Col. Plate XI), the high altarpiece of the Olivetan Church at Ravenna, is the most satisfying kind of testimony to an expedition further afield.[5] As early as 13 December 1601 Philip Rubens, who yet more recently had crossed the Alps for the first time and in late November had reached Padua, could write to his younger brother, eager to hear from him directly his impressions, not only of that celebrated university city, but of others in Italy. At most of these, during the past eighteen months, Peter Paul had already had a look. Philip's Latin tended to literary flourish: but we have no cause to discount as hyperbole his, 'Quid tibi de hac urbe videatur, ceterisque Italiae quas lustravisti jam plurimas, volupte sit ex te audire.'[6] (I long to hear your impression of this city and of those others in Italy, so very many of which you have already sampled).

On his own account Peter Paul made the most of his opportunities. He travelled also with, and for, Casa Gonzaga. Shortly after his appointment he was in the train of his Duke and Duchess to attend in Florence the marriage-by-proxy of the Duchess's younger sister to Henri IV of France; and on 5 October 1600, being present in S. Maria del Fiore for that ceremony and at the banquet following – as emerges from his correspondence twenty-two years later with his friend Peiresc in Paris – he had his first glimpses of the bride, his future patron, Maria de' Medici.[7] During ten days of festivity he would have found a way to investigate the matchless collection of Tuscan art which Princess Maria's father, the Grand Duke Cosimo, had inherited together with some notable antiquities. Manifestly he visited also on this occasion the Casa Buonarroti and the Medici Chapel at S. Lorenzo, in order to draw what had been sculpted by the man rated to be the greatest sculptor since antiquity, Michelangelo. Nine months later, Duke Vincenzo, having decided to join the Emperor for a late summer's crusading in Croatia, despatched 'Piet.º Paolo fiamingo il mio Pittore' for a few weeks to Rome, with a letter to the immensely rich nephew of Sixtus V, Cardinal Montalto.[8]

Under Montalto's wing, graciously outstretched, Rubens was to make copies and to paint such pictures as might please this august protector. The mixture of duties had the advantage that he could also pursue his own studies in other private palaces and *vigne*, in the Vatican, in the churches, and in the common streets and *piazze*; enough to whet his appetite for a more prolonged stay. In the event he was allowed to remain through the winter, at the behest of the newly appointed Flemish Resident at the Holy See, Jean Richardot, in order to finish three paintings commissioned on behalf of the Archduke Albert for the semi-subterranean Cappella di S. Elena at S. Croce in Gerusalemme (Plates 179, 182, 187).[9] He was required to return to Mantua only in time to help prepare the Easter Carnival of 1602. Then again, from the last months of 1605 until he had to hasten away at the end of October 1608, he was permitted by his remarkably compliant employers to spend almost four fifths of his time in Rome, his duties to them seeming for the most part scarcely more than incidental to his own pursuits.

In assessing his unrivalled advantages as a young Flemish painter in Italy, we need to remember also that in March 1603, evidently on the recommendation of Chieppio, he was put in sole charge of an embassy of expensive presents by which Duke Vincenzo aimed to curry favour with Philip III of Spain and his principal courtiers.[10] This first diplomatic mission provided him also with a first, all too brief introduction to the outstanding riches of the Habsburg family collection. In the Madrid palaces and in the Monastery of the Escurial were housed more than seventy works painted by Titian for Charles V and Philip II, not to speak of other fine Venetian paintings, a painting by Raphael, and monumental groups in bronze by Pompeo Leoni of the Habsburgs kneeling in worship (Plate 240). Even if Rubens had time only to make a few notes and copies, before pressing on with the mule-train to find the Spanish Court at Valladolid, the consequences of the experience far outreached the immediate outcome. These consequences did not

fully mature until, twenty-five years later, he was able to return to Madrid as the private envoy of the Archduchess Isabella to her nephew, Philip IV, and as a painter with eyes and hands ready at last to benefit fully from the incomparable array of Titians.

We need to remember also that returning from Spain to Italy early in 1604 he disembarked at Genoa, and lingered there long enough to recoup the extraordinary expenses of his mission from Nicolò Pallavicini, the Gonzaga's banker. To Genoa, and to the custom of the Genoese banking patriciate, he was to return on occasion during 1606 and 1607; once, for three weeks in July 1607, in attendance on Duke Vincenzo, who was on holiday in the splendid villa at San Pier d'Arena lent by Giambattista Grimaldi. He was to acknowledge that he spent more time in Genoa than in any Italian city save Mantua and Rome. Outside Mantua, his most important patrons during the second half of his career in Italy were Genoese. With Genoa he maintained connections for at least twenty years after he had quitted the peninsula. On 19 May 1628 he wrote from Antwerp to Pierre Dupuy in Paris, 'I have been several times in Genoa, and remain on very intimate terms with several eminent personages in that republic.'[11] In 1617 he supplied cartoons to the order of 'alcuni Gentilhuomini genovesi' for a suite of tapestry condensing into six scenes *The Life of the Consul Decius Mus*.[12] Within two years of that consignment he had despatched to the Pallavicini the *Miracle of St. Ignatius*, a variant of the altarpiece on this theme for the Jesuit Church in Antwerp, for the saint's chapel in the Jesuit Church[13] in Genoa, Nicolò Pallavicini's brother Marcello being of the Company there. Between 1609 and about 1625 Marcello Durazzo had from him three paintings illustrative of the interest in optics which, particularly since his return to Antwerp, he had developed through association with Father François Aguilon, s.j., at the Maison Professe.[14] And in 1622 he published, with a dedication to Carlo Grimaldi, the *Palazzi di Genova*, in-folio, the finest illustrated book yet devoted to extolling the architecture of any city of Italy.

In Genoa, Rubens devised a dazzling succession of full-length portraits to gratify the leading families. Some of the mythologies which he painted, there or elsewhere in Italy, may have been intended for members of that exclusive, in his view too exclusive, oligarchy. Having impressed Nicolò Pallavicini, he was commissioned in 1605 to paint *The Circumcision* (Plate 249) as the appropriate subject for the high altar of the Gesù in their city.[15]

In Rome, apart from mythologies and the smaller sort of devotional works, he had altarpieces on view, both at the medieval Basilica of S. Croce in Gerusalemme (Plates 179, 182, 187) and at S. Maria in Vallicella, the new church of the Oratorians (Plates 333, 335, 336). The first of these commissions had been paid, none too generously, by the Archduke Albert through his resident agent, Richardot. The second, for a more prominent position, was steered towards him by a sufficiently tempting offer made to the Fathers on his behalf by the Papal banker, Monsignor Jacomo Serra.[16]

In Mantua, however, he was entrusted by the Gonzaga with only one major commission in painting: three vast canvases (Plates 239, 246, 247, Col. Plate v) to be ready for the walls of the *cappella maggiore* in the Jesuit Church by Trinity Sunday 1605.[17] More than two years later, as he was to remind Chieppio, there hung, apart from portraits, no independent work of his in the Ducal Gallery. Lacking encouragement of this kind from his chief employers, he had had to trade his talents elsewhere. Yet Mantua was vital in the chain of luck by which he obtained other patronage. Happily for him, throughout his time in Italy, Duke Vincenzo listened to Chieppio in virtually all relevant affairs. It was through the Duke's introduction that he met Cardinal Montalto; and probably through Montalto he met a much younger Cardinal whose favour proved to be of especial consequence to him in Rome, Scipione Borghese. Through Chieppio's advice to the Duke he had the opportunity to meet at Valladolid, if not Philip III, then at least Philip III's *privado*, the overmighty Duque de Lerma, for whom in the autumn of 1603 he created a stupendous equestrian portrait (Col. Plate iv),[18] and, about ten years later, an *apostolado*.[19] Again it was through his discharge of the Duke's affairs that he met Nicolò Pallavicini; and it was Nicolò who would have led him to business associates of the Pallavicini, the Serra, and in particular to Monsignor Jacomo, an enthusiast for the more vigorous sort of modern painting. In papal circles, besides Scipione Borghese, Paul V's rich nephew and self-appointed protector of Flemish and German artists, and Jacomo Serra, Scipione's friend, who became Paul V's Commissary General, he came to know a layman from his own side of the Alps, Johann Faber of Bamberg, the famous botanist established in Rome as Paul V's physician. About Faber clustered a group of these Northerners. Of most concern to Rubens were two painters among them; Elsheimer, and his own countryman, Paul Brill. Only one

significant act of patronage is known to have originated outside this chain: that by his family friend Richardot, when commanded from Brussels to find a not too expensive painter for the Cappella di S. Elena in S. Croce in Gerusalemme. Although Philip Rubens served as Librarian, in effect private secretary, to Cardinal Ascanio Colonna, for the two years during which he and his brother were sharing a house in Rome, Peter Paul does not seem to have been represented in Casa Colonna by more than a small *Entombment* painted on copper (Plate 198).[20]

For all their shortcomings as employers, Rubens had reason to be grateful to the Gonzaga. To a letter written by him from Antwerp in August 1630 to Peiresc, he added a postscript: 'We have received very bad news from Italy, that on 22 July the city of Mantua was taken by the Imperial troops, with the death of the greater part of the population. This grieves me very deeply, for I served the House of Gonzaga for many years, and enjoyed delightful residence in that country in my youth. *Sic erat in fatis.*'[21]

Such Stoic acceptance of destiny was heartfelt, and proper to the younger brother of Justus Lipsius's star pupil: but at no time did Stoicism inhibit Rubens's resolute self-help. By exceptional energy and talents as well as by luck, he made a resounding success of his explorations of Italy. He observed and recorded with loving care antiquities of every sort and size, intact or broken; from Imperial coins in the collection of Fulvio Orsini to the Cameo Gonzaga; from bronze figurines on the shelves of *studioli* to monumental marble carvings in the Belvedere of the Vatican and at Villa Borghese. He was in a position to grasp the scope of Renaissance achievement in its all but undisturbed state, finding nearly every masterpiece still in its intended setting. As an indefatigable draughtsman and collector of drawings he assembled, not only for his own immediate pleasure and future reference, but ultimately for the instruction of pupils in Antwerp, an impressively wide conspectus of the historical progress of *disegno* as that was understood in sixteenth-century Florence and Rome.

He valued this resource. By his Will the drawings were to be kept in his family so long as there remained a possibility that a son or son-in-law of his might follow him as a professional painter. When, seventeen years after his death, this part of his collection was eventually sold, his heirs released a flood of visual intelligence. Many loose sheets which illuminate his experience of 'the works of the ancient and modern masters' are known. One

important group of unimpugnable provenance, and thus the key to his early studies, came to the Louvre from the Royal Collection of France, having passed through the hands of Eberhard Jabach, who bought them at the dispersal of August 1657.[22] But another body of evidence is seriously incomplete. His Pocket-Book, filled on his travels with quotations and opinions, was substantially burnt in the early hours of 30 August 1720, when fire raged through the quarters of André-Charles Boulle at the Louvre.[23] The range and interest of this book Giovanni Pietro Bellori had announced less than half a century earlier in Rome, in these terms: 'It remains to say something of his habits in art. He was not only a practical, but a learned man. A book is to be seen by his hand which contains observations on optics, symmetry, proportion, anatomy, architecture, and an investigation of the principal actions and reactions culled from the descriptions of poets and the demonstrations of painters. There are battles, shipwrecks, names, loves and other passions and events. Some verses of Virgil and others are transcribed together with corresponding passages principally from Raphael and the antique'.[24]

Of this priceless compendium only two leaves covered with drawings and quotations have been identified (Plates 39, 40, 281, 283), although it is possible that one or two smaller fragments belonged to it. A useful part of the remainder may be reconstructed by collating two late seventeenth-century transcripts, each incomplete in different ways, with the highly idiosyncratic extracts made from it by Van Dyck, as a very young man in Antwerp, for his own Sketchbook. Nevertheless the gap remains.

Rubens's graphic encounters with the art of his more or less distant predecessors strengthened him as a modern painter, alert to the diverse trends set by contemporaries and seniors: Federico Barocci, who had withdrawn from the Roman scene to his native Urbino; Lodovico Cardi, il Cigoli, in Florence; the Roman *cavalieri*, Cristofano Roncalli and Federico Zuccaro; the Bolognese active in Rome, Agostino and Annibale Carracci and Guido Reni; and Michelangelo Merisi da Caravaggio.

By the end of his stay in Italy Rubens had made astonishing advances in those studies which he chose to set himself. Though far yet from being the equal of Titian, he had mastered the art of painting as painting was understood by Seicento admirers of Tintoretto, Veronese and Bassano. He had begun to gain a Roman reputation. If, in attending to what we find held his attention, we come to enjoy his

creative way of looking, we may enlarge our smaller visions. Investigation of this sort must preface any more detailed account and analysis of the works painted by him during his Gonzaga service.

Even so, in attempting to follow his sight-lines, we may miss something essential. Italy, for a man of his upbringing, was not only the repository of past glories and the scene of present hopes of painting, but the eternal home of all the arts of civilization. So much of his pre-Italian experience contributed to this: whatever he and Philip had learned in Cologne from their exiled father, Jan, who had himself been an intellectual pilgrim in Italy, as well as a promising young lawyer, *doctor utriusque juris*; whatever further grounding he had gained through Philip from Lipsius's teaching at Louvain; and whatever, in his own training, he had imbibed from the humane culture of the last and most influential of his masters in painting, Otto van Veen – all these played their part. When he set out in May 1600, ambitious for his career and professedly seeking visual adventure, he was binding himself silently to a yet more enlightening apprenticeship in civilized sensitivity, an apprenticeship which he knew could only be served by presenting himself beyond the Alps.

2. Preparations for Italy

RUBENS'S PROFESSIONAL PREPARATION for Italy was more restricted and less sophisticated than the one which he himself could offer the young Van Dyck two decades later. We need to ponder it if we are to estimate what manner of Flemish painter he was when he entered Gonzaga service in the mid summer of 1600, and to understand the ways in which he reacted so profitably to Italian art in Italy and in Spain.

He and his brother Philip were born, not in their paternal house in Antwerp, but at Siegen in Westphalia. Since their proscribed and pathetically errant father, Jan Rubens, was confined to that remote hill town in the territory of Nassau, they were baptized there of necessity as Lutherans. Only after Jan's death in 1587 did it seem prudent for his widow to bring home to the Spanish Netherlands their four surviving children. That Peter Paul, the youngest of these, spent the first ten years of his life in exile, both from the Catholic cult and from his ancestral city, affected his outlook profoundly. We may detect this circumstance as a factor in the regularity, lifelong from boyhood, of his observance in Catholic devotion; in his advice and other service to the Archduchess, in which he united European-mindedness to impeccable patriotism; and, more tangibly, in his otherwise unexplained predilection after his return in 1608 from Italy, really a second homecoming, for painting versions of that extremely rare subject taken from St. Matthew's Gospel, *The Return from the Flight into Egypt*.[1] By his very upbringing he was prone to regard more selfconsciously than any Antwerp-born painter, Van Dyck included, the tradition of Netherlandish art from Jan van Eyck and Rogier van der Weyden as his peculiar inheritance; and to appreciate the relationship of that tradition to the graphic art of the German lands. A sheet of his drawings shows that he had accurate knowledge of figures in Rogier's Bladelin altar;[2] and the Inventory of his estate when he died in 1640 tells us that he actually owned a pair of paintings by Jan.[3]

His interest in design was aroused early by those sixteenth-century Swiss and South German publications which were enlivened by excellent small woodcuts. These his father could show him as a child, after the family's move from Siegen to an easier, city life in Cologne. Chief amongst them were the *Neue Künstliche Figuren Biblischer Historien* (Basel, 1576), illustrated by Tobias Stimmer;[4] the *Opera Josephi ... De Antiquitatibus judaicis* (Frankfort, 1580), illustrated by Jost Amman;[5] the *Von der Artzney beyder Glück* (Strasbourg, 1532), illustrated by Hans Weiditz;[6] and the *Imagines Mortis* by Hans Holbein the younger, available in several editions.[7] From this last book he copied as a mere boy every illustration, almost to scale and with astonishing increase in vitality. From each of the others he was to select those figures or groups which took his fancy and quickened his narrative sense. By a procedure which became characteristic of his assemblage of visual reference, he reassorted them on the pages of his notebook so as to order them to the pace and categorizations of his own thinking.

In 1623 he told the young German painter who was to be one of his early biographers, Joachim von Sandrart, a fellow passenger on a towboat from Utrecht to Amsterdam, how in his own youth he had been attracted to these German masters.[8] Evidently the attraction lasted. The fascination of Weiditz's work might be supposed to have faded, insofar as its charm for him may have lain largely in the picturesque extravagance of the apparel, and thus in the same department of his promptly organized mind as the miscellany, known as 'the Costume Book', which he had begun to compile before he left for Italy.[9] But in fact, his *Lansquenets carousing with peasants*, a painting assignable to the late 1630s, even the pen style of his preparatory drawings for the central group,[10] still reflects his youthful taste for this genre. His feeling for Stimmer persisted even stronger. He was to express it in the lavishly worked re-interpretation which he drew of the Baseler's own *Self-portrait* now in Baden-Baden;[11] and even more vividly in two highly finished paintings which he composed on panels about 1616, *The Dismissal of Hagar*[12] and *The Conversion of Saul* (Plate 160),[13] each owing a part of its inspiration to pages in the woodcut Bible. There are signs that his boyhood interest in Holbein broadened with the years. He enriched with pen and ink and wash and bodycolour, a favourite combination of media, the modelling and movement of a pallid offset which had been taken from Holbein's drawing for *The Road to Calvary*.[14] He fastened on Holbein's compelling veracity in portraiture. For

his own pleasure and instruction he turned about 1620, with eyes sophisticated by renewed attention to the Raphael portrait of *Baldassare Castiglione*[15] (Plates 48, 49), to copy the bust-length *Sir Thomas More*.[16] During his London mission of 1629–30, whilst preparing a magnificent portrayal of his own invention, the three-quarter-length canvas displaying *The Earl of Arundel*[17] in the flatteringly martial guise of Constable, as though he were a *capitano alla veneziana*, he found time to sublimate his own frustration as a collector by copying with deceiving fidelity one of his sitter's coveted group of Tudor personalities drawn by Holbein. Rubens's *John Fisher, Bishop of Rochester*,[18] distinguishes itself from Holbein's original neither in quality nor in scale nor really in technique, but in the idiosyncratic rhythms of the silhouettes and in the subtleties of modelling by *chiaroscuro*. Possibly later still in his career he overlaid with pen-lines, wash and brushwork a large drawing of *A young woman holding a shield*.[19] This has been penned and washed originally in the style promoted by Holbein for designing stained glass. As edited by Rubens, it appears a handsome salute to the art of his predecessor.

To these names, Holbein, Weiditz, Amman and Stimmer, we should add those of two earlier German masters of graphic design: Israhel van Meckenem and Albrecht Dürer. Rubens's copy in pen of van Meckenem's *Fashionable Young Couple*[20] is characteristically larger than the original engraving; but otherwise follows it rather closely, except for the omission of a scroll. The young woman was to reappear in a composition of his own, registered by a copyist's drawing, of monks and young women in fifteenth-century dress; and there may be the traces of her in his final draft of the Virgin for the *Visitation*[21] wing of the *Deposition* triptych in Antwerp Cathedral (Plate 93). The brio of his pen line in working up a tracing of the key group in Dürer's *Trinity* of 1511, surely among the earliest of his copies, gives a foretaste of what was immanent in the genesis of his own much later treatment of the theme.[22] With a fine pen he drew also a splendidly free rendering of another Dürer engraving, the bust portrait of *Frederick of Saxony*;[23] and the vital intensity of glance and presence in his drawing shows early how masterly was his response to a great master. To an old copy of a Dürer pen study for a *Madonna dandling the Child* he added patches of white bodycolour as well as his own pen strokes to enliven its expressive power.[24] Italy was to keep Dürer in his mind, Dürer who had been twice in Venice and who had exchanged gifts with Raphael,

Dürer who had sought to visit Mantegna at Mantua. Many years after his return from Italy, he was to base his composition of *The Marriage by proxy of Maria de' Medici* on Dürer's *Marriage of the Virgin*.[25]

Having formed early the fruitful habit of perusing prints, Rubens kept himself *à la page*. Individual plates of the superb *Passion* engraved by Hendrick Goltzius are dated 1596 and 1597, the series being published in the United Provinces; that is, in disaffected territories to the North of those remaining under Spanish control. Nevertheless impressions must have reached Antwerp with little delay. For Rubens made his excerpts[26] promptly, contemporaneously with those from Stimmer and the rest; the pen-style, the very process of ingestion, is congruent. Goltzius, like Dürer eighty years earlier, having made such brilliant use of his time in Italy, was utterly sympathetic to him. Some of Goltzius's large and elaborate records in red chalk of the most celebrated antique statues in Rome, intelligently observed from different angles, were engraved. They presage those drawn there in black chalk by the no less assiduous Rubens a generation later.

Rubens's continuing interest in the graphic work of Northerners spread wider yet. He had found narrative interest in the *Tobit* series of Jan Swart van Groningen.[27] He responded to the decorative fancy in the Italianate ornaments of Cornelis Bos.[28] He drew after drawings as well as after paintings by Pieter Bruegel the Elder; and in one case, by subtle reworking, he breathed life into a tame old drawing after Bruegel's *Dormition of the Virgin*,[29] a painting which deservedly he was one day to own himself. As a collector of drawings he was to find it worthwhile to supply of his own invention missing parts of the design in sheets drawn by Lucas van Leyden and Barent van Orley;[30] in youth he copied Lucas's *Triumph of Mordechai* with exquisite care;[31] and to Lucas, as to Stimmer, he was in the 1630s to pay the special tribute of a portrait, based in this case on Andries Stock's engraving after the artist's own *Self-portrait*, his drawing being lettered LVCAS LEYDANUS, *Sculptorum Columen, Lux, Lunaque, Solque penelli*.[32] The range of what he would copy, or repair, or re-work in the run of his life was to include also drawings by Hans von Kulmbach, Maerten van Heemskerk, J. C. Vermeyen, Niklaus Manuel Deutsch and Martin Oldenbach. His assimilative and recreative powers were so developed that he could learn from a variety of men with gifts weaker or narrower than his own. What he learned thus was more than just a diversification of knowledge in the course of his training in the Antwerp

studios, or just a makeweight to his Italian experience. It became integral to both.

In Antwerp he was apprenticed first in 1592 to his mother's cousin, Tobias Verhaecht, who painted landscape in the staling tradition of Joos de Momper. From Verhaecht, a man of modest talents, he can have derived little more than the rudiments of studio practice. He passed quickly to a more considerable master, Adam van Noort, whose reputation as a teacher was eventually to attract Jordaens also to be his pupil. Van Noort was a history painter of no mean ability; and from him Rubens would have had his first effective lessons in the management of sizeable figures. However, unlike other leading masters of the Antwerp school, such as Frans Floris de Vriendt and Maerten de Vos, Van Noort apparently made no effort to go to Italy. He followed his profession without noticeable leanings towards humanist culture. Not surprisingly Rubens transferred for the last four, the most significant years of his official apprenticeship to a more learned and ingenious man, Otto van Veen of Leyden, the pupil of Lampsonius. Van Veen had spent no less than five years south of the Alps in the study and practice of his art; and was declared by the celebrated geographer, Abraham Ortelius, to have joined the liberal arts with painting, 'primum in nostro Orbe'.

Octavio Vaenius, as he pleased to call himself, was the Court painter at Brussels and the most distinguished choice to be made amongst the Antwerp Romanists. In painting he rarely showed himself to be a strong master, and the classicizing manner into which he settled was tepid (Plates 4, 5): but from his livelier example as a draughtsman, Rubens learned to make serious play with emblems. This sleight of mind stood him in good stead when he came to devise numerous title-pages for the Plantin Press; especially when in 1613 his task was to draw a vignette for each of the six books of Aguilonius's *Optica*.[33] It is most probable that in 1599, the year after he had been accepted himself as a master in the Antwerp Guild, he worked with Vaenius on the triumphal arches designed for the Glorious Entry of the Archdukes Albert and Isabella as Co-Regents of the Netherlands.[34] The experience would prove of value to him thirty-six years later, when he in his turn as leading painter was called on to transform the city by elaborate stagings into a theatre of welcome for the Archduchess's nephew and successor as Governor, the Cardinal-Infante Ferdinand.[35] Vaenius would have made his pupil the more eager to see Italian art at first hand, by dilating upon the wonders of the High Renaissance not only in Tuscany and Rome, but also in Emilia, to judge from *The Mystic Marriage of St. Catherine*, an early masterpiece of his own *alla parmigiana,* which proudly he had had engraved.[36] Furthermore Vaenius had known Federico Zuccaro in Rome, and perhaps through him Federico Barocci, who had worked also for the Vatican in the Casino di Pio IV. With the art of each Rubens was to have direct concern.

On his own paintings left behind in Antwerp we have only two opinions: but both are near to his time and to be regarded. By his mother's account, they were beautiful; and, as his nephew Philip wrote in 1676 to Roger de Piles, 'avant son voyage d'Italie, ils avoient quelque ressemblance avec ceux d'Octave van Veen, son maistre'. Visual evidence in support is scant; and much depends on a little portrait on copper, the so-called '*Geographer*' or '*Architect*' (Plate 2), which is inscribed on the reverse and dated 'P. P. Rubens/1597'.[37] But by close analogies in morphology and in flesh colouring, especially in the treatment of the hands, a three-quarter-length portrait on canvas of an older man, similarly dressed, is acceptable as a plausible attribution[38] (Plate 3). With just the guidance offered by these two male portraits, we have to look for other paintings Vaenian in type, yet decisively too vigorous and intense to be classed with the documented works of Van Veen himself. In this phase there are no traditional ascriptions to Rubens. Indeed there are no securely documented paintings before his earliest public commission in Rome, where during the winter of 1601–2, he was engaged to paint for S. Croce in Gerusalemme first *The Ecstasy of St. Helena,* and then *The Mocking of Christ,* and *The Elevation of the Cross* (Plates 179, 182, 187). Any attributions relating to the period from 1597 to 1602 have to be scrutinized also by the light of these three altarpieces; and the last named is known only in an anonymous seventeenth-century copy on canvas, painted to replace the original panel, which all too soon had rotted on the damp walls of the semi-subterranean chapel.[39] Of a number of Rubens's drawings which are copies after other masters, it is unwise to affirm that this or this was drawn either just before or just after his move to Italy; and within the Italian context it is not always quite sure to what phase of his activity a particular copy belongs. Happily from 1601 onwards, so far as paintings are concerned, there is enough pictorial and other documentation to sustain a framework of attribution; and a reasonably full *oeuvre* may be recon-

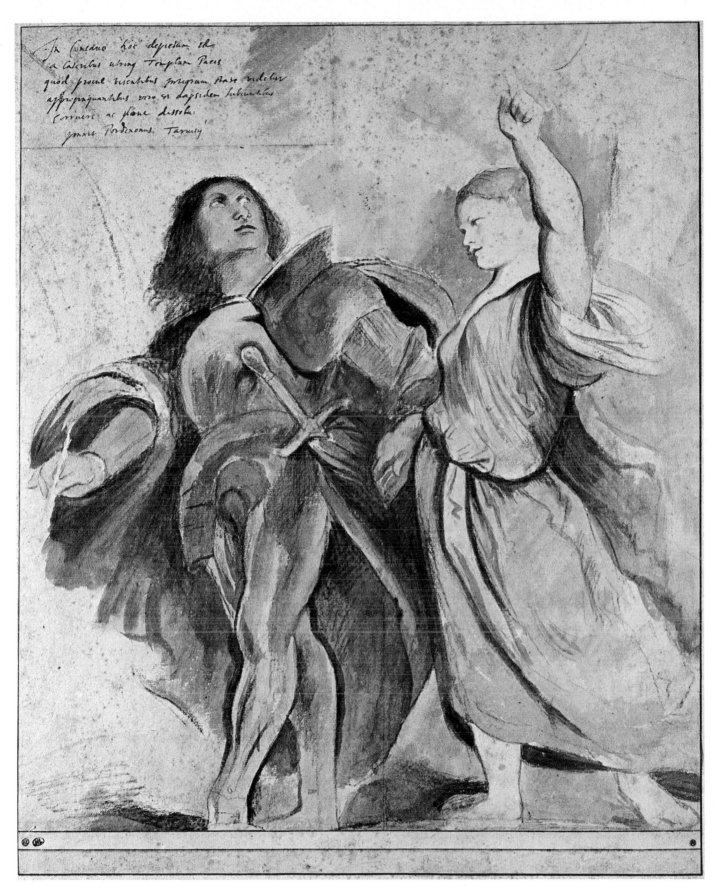

III. *Augustus and the Sibyl* (after Pordenone). About 1600–1. Watercolours and chalks on paper. Paris, Louvre

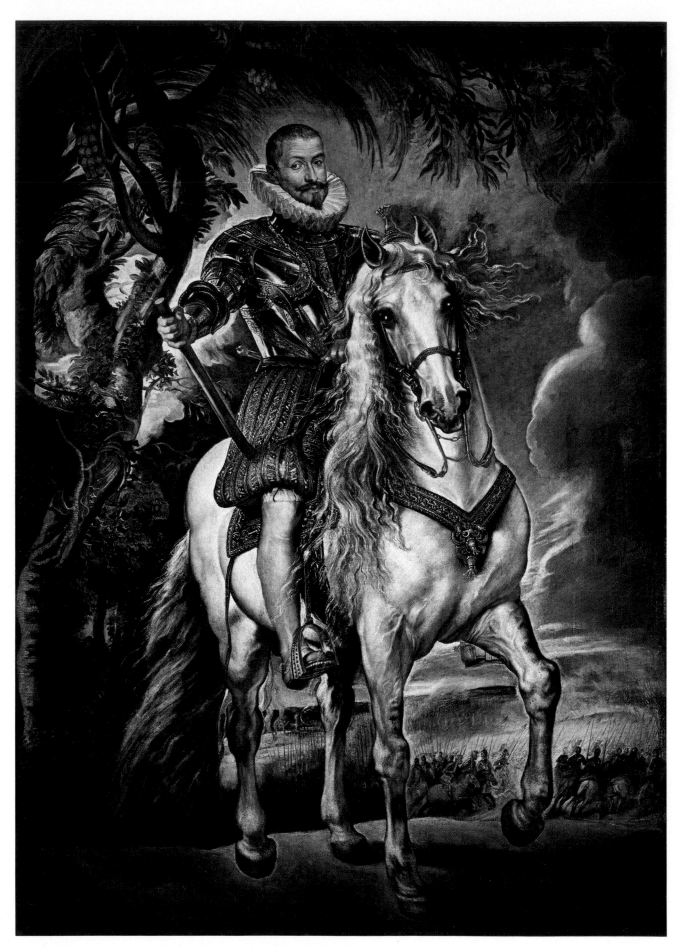

IV. *The Duque de Lerma*. 1603. Oils on canvas. Madrid, Prado

structed for the remainder of his almost incredibly productive career.

Portrait painting by the end of the sixteenth century had long been recognized as a Flemish speciality; and there is nothing that can be meaningfully called Italianate in either the miniature 'Geographer', or in the life-size *Gentleman with a sword* (Plates 2, 3). For the former there are distant, but scarcely apposite parallels in the work of Sofonisba Anguisciola. The latter stands fair and square in the tradition whose most prominent exponent internationally was Sir Antonis Mor. Their significance in the present context is that they indicate the level of performance, doubtless demonstrated again by Rubens in Venice, by which he recommended himself to Mantuan service. Close to his own aspirations as a figure painter are two other works placed convincingly amongst those left behind in 1600. One, *The Fall of Man* (Plate 6),[40] can be interpreted as an imaginative post-Raphaelite exercise: the other, the *Emperor Nero* (Plate 1),[41] as a mark of his as yet harshly mannered and immature embroilment with Roman antiquity, a remote world which in the Flanders of his youth was accessible only to fancy. The interests revealed by these panel paintings grew with his Italian experience, and far outlasted that.

Like Dürer he made his way first to Venice, rather than Rome; although for an Antwerp painter of his generation, who was the most gifted and ambitious pupil of Vaenius and himself wishful to be accepted as a Romanist on his return, a pilgrimage to study at first hand the metropolitan works of Raphael was still indispensable. However, before he set out for Italy he was conversant, and likely enough as a collector, with one important aspect of Raphael's activity, the issue of prints. Stirred by the inventive resources devoted by Swiss, German and Netherlandish artists to print-making, he could gauge also the extent to which reproductive prints advertised powers of *disegno*, as well as providing supplementary income, although there existed no secure means of registering and protecting designs in a Europe which never bound itself by international copyright. He knew, and having been born in Germany surely relished, Vasari's account of how Raphael had been inspired to emulation by the engravings of Dürer, and so 'fece studiare Marco Antonio Bolognese in questa pratica infinitamente'.[42]

The Fall of Man with life-size figures illustrates how confidently the young master, still markedly under Vaenius's influence in his style of painting,

could express his admiration for Raphael in design. The composition is patently based on the engraving of the subject by Marcantonio (Plates 6–7).[43] Background and accessories however are freely invented. A rabbit and a bright green parakeet are introduced, perhaps in thought of Dürer's engraving of 1504.[44] By the reeds on the river bank a monkey crouches asleep. The landscape, its character transformed entirely from the curiously post-Fall (and post-Dürer) view supplied for Raphael's figures by Marcantonio, is an Eden receding in fresh and luminous greens from the browns of the tree boles in the foreground and from the darker greens of the vine tendrils which hide the sexes of Adam and Eve; framed by the figures, it is an accomplished performance in the manner of Coninxloo. But the man and the woman, whilst their poses are basically faithful to Raphael's invention, show more of the characteristic approach of Rubens. The heads in his revision are the one more ardent, the other more tender. The bodies are fuller, at once more heroic and more voluptuous, without being drawn by any unsubtlety of pictorial taste closer to each other. Yet the most revealing change is in the new-found rhetoric of Adam's massive forearm and left hand, the palm no longer burdened with the temptation of two apples. Instead his index finger points upwards to the Tempter, now serpent-headed and intent on Eve (the blemish in the picture's condition is the loss of the top few inches of the panel, where the serpent's head would have been fully displayed). Here, where Rubens elected to make his most radical departure in the spirit of the narrative, *pentimenti* witness his determination to realize the re-interpretation precisely. The treatment of Adam's hand, half open, with the finger tips emphatically filled and rounded, is strongly reminiscent of the 'Geographer' (Plate 2). The distinctive treatment of Adam's hair and beard and of his head turned slightly out of profile towards us, also of his feet and legs, finds analogies on a comparable scale in another panel painting filled with Vaenian types: *The Mocking of Christ* for S. Croce in Gerusalemme (Plate 182). Such a large panel, composite of oak boards, as supports this *Fall of Man* is not likely either to have been transported, or to have been made up for the painter's use on the offchance of a sale, south of the Alps. The painting of it fits best into the period 1597–1600, between the end of his formal apprenticeship and his departure for Italy.

Within this period fits also the *Nero* (Plate 1), from a series of virtually lifesize depictions of

Emperors, framed bustlength within the mannerist device of feigned ovals. By collating incomplete runs of two other sets based on the same patterns, we realize that the prime set must have run from the first Caesar until at least the nineteenth. The *Vitellius*[45] in one of these runs, presumably on account of its pungent, almost brutal strength of design, has been credited to Rubens himself. However, both runs, one of eleven panels and the other of thirteen, are studio replicas. Only the isolated *Nero* is autograph, the head matching the quality of Adam's head in *The Fall of Man*. Albeit sadly damaged and trimmed at the right, its impact is formidable. The wreath of bay leaves crowning the chestnut hair is bound with a mauve ribbon, which contrasts with the carmine of the cruelly powerful mouth and the venous blood-red of the toga. The subdued background is greenish-grey. The panel itself is made up of three vertical boards of oak, and scored half way down the centre board with the mark of the Antwerp Guild. Despite abrasions, by which the forms in the darks have suffered especially and 'DOMITIANVS. NERO.6' has all but disappeared, enough distinction in modelling the features remains to convince us of the master's hand at work. By comparison the better preserved panel of *Nero* in the longer run of replicas shows conspicuous insensitivity in treatment of the mouth, the neck, and the draperies; and the panel in the shorter run, one which happens to have been restored more awkwardly even than the rest, presents a yet sorrier contrast.

The heads of these *Caesars* are unmistakably Vaenian, artificial concepts without ties to archaeological accuracy. They do not derive their plasticity from study of antique sculpture. In Rubens's career that was all to come. More surprisingly, there is no dependence on the impressively full run of Caesars which forty odd years earlier had been etched and adorned with colour blocks by Hubert Goltzius, and whose fresh publication with woodcuts by Cristoffel Jegher was to be encouraged by Rubens himself.[46] Nor is there a detectable reference to the short set of *Caesars* which Aegidius Sadeler had engraved after Titian's paintings at Mantua; although Rubens in his Antwerp training copied at least one engraving after Titian (Plate 65) as well as many after Raphael.

The partial survival of at least two sets of replicas, including in one a remarkable version of the *Vitellius*, suggests how the level of his invention, to twentieth-century eyes uningratiating enough, had already before his Italian journey found favour with clients among the cultivated bourgeoisie at home. Had we clues to the identities of those clients and of his assistants, we might know more of his first steps toward studio organization and commercial success. For these considerations also were an essential part of his preparation for Italy.

3. The High Renaissance: Florence, Rome, Milan, Parma

RIDING TOWARD ITALY in May 1600 Rubens took with him a pupil five years his junior: Deodatus van der Mont, or del Monte. On 19 August 1628, just before leaving Antwerp for his second mission to the Spanish Court, he was to certify that Deodato had accompanied him throughout his early journeys in Italy and Spain;[1] and Deodato was one of two witnesses to his contract of 1608 to paint an altarpiece for Fermo (Plate 340).[2] This companion was of an age to have helped in 1599 or 1600 with repeat orders for the *Caesars*. In Italy he may have assisted him by making measured drawings of buildings to be reproduced in the *Palazzi di Genova* (Plate 344), and by posing in the studio. Indeed, to judge from the appearance of Deodato in middle age, as engraved in Van Dyck's *Iconography*,[3] as well as from likely circumstance, it could have been his head which Rubens studied in 1601 or 1602 as the model for the youth wearing a feathered cap in *The Mocking of Christ* (Plates 180, 182); and which, suitably adapted, would reappear, bareheaded as *St. Thomas,* in the *apostolado* for Lerma. The same youth appears also, but in a different pose, among the crowd who witness *The Transfiguration* painted for Mantua.

The route of Rubens and Deodato is undocumented. However, since Philip Rubens, with Jean Richardot's young brother Guillaume in his charge, travelled in the autumn of 1601 from Antwerp to Padua *via* Paris, Peter Paul presumably decided on the same itinerary. This is what was said in 1718 by Houbraken and again in 1771 by Michel, author of the first monograph on the painter;[4] and each writer may have derived his information from a Rubens family tradition. A route through Northern France would have been customary, and a man of Rubens's tastes would have wished to see what he could of the palatial buildings and collections in Paris and Fontainebleau which bore witness to the efforts of François I and Henri IV.

(i) MICHELANGELO

To Fontainebleau he was able to return in the 1620s, when visiting Paris on the business of Maria de'Medici's first suite of political allegories for her Palais du Luxembourg; and drawings in sanguine show how entranced he was then with the supple grace of Primaticcio's stucco caryatids (Col. Plate

XIV) in the Chambre de la duchesse d'Etampes.[5] But in the spring of 1600, in the first flush of his sightseeing, he would rather have sought in the Jardin de l'Etang a youthful masterpiece by an incomparably grander sculptor; the *Young Hercules*, in white marble standing four *braccia* high, which had been sculpted in Florence by Michelangelo, apparently sold by the Strozzi in 1529 to François I, and set up on a pedestal designed by Primaticcio about 1543. Rubens registered, evidently at speed, a boldly extroverted impression of what we may believe to have been this figure; and he accented later with bodycolour both the right hand and the right foot (Plate 12).[6] Not only the vigour but also the manner of his penwork suggests that he had been able to admire in a Flemish collection some drawing, either by Michelangelo himself or at least by a fairly close follower. He would also have known from this moment, perhaps through Rosso's copy, the design of Michelangelo's *Leda*.

To the same vigorous, broad manner and means of the drawing of the *Young Hercules* he instinctively resorted in order to exclaim what he felt when regarding for the first time Michelangelo's frescoes in the Sistine Chapel. His selection of a group of figures from *The Resurrection of the Dead* (Plate 13),[7] despite significant and characteristic transformations in describing heads and their expressions, was both made and drawn before *The Last Judgement* itself. Even Giorgio Ghisi's engraving[8] after the entire altar wall, although doubtless available in Flanders, was necessarily on too reduced a scale to have excited so fiery a reaction. The intense shadows and forceful hatching, the violent contrast of the patches of light, the whole emphatic pulse of the penstroke, accord with a drawing certainly of 1601–2, a study for the central group of his *Mocking of Christ* for S. Croce (Plate 181). He chose to copy from the lowest zone of *The Last Judgement,* where he could come closest to grips with the force of Michelangelo's configurations. At much the same time he must have raised his eyes to the vault, to the *Haman* in the scene of *Esther and Ahasuerus* (Plate 11);[9] and he drew with the same fine frenzy the gallows figure in the huge fresco overhead.[10] Or rather, he drew it again. For we know also a copy penned by him not long before in Antwerp[11] of this very figure, within which Michelangelo had man-

aged to bind so much of an almost boundless excitement about the rediscovered *Laocoön* (Plate 9). Rubens had had before him then an impression of the *Haman* engraving which Jacob Laurens had published in Rome in 1590, a dry enough quotation to work from (Plate 8). Whilst he knew how to instil vitality into an image out of context, correcting and embellishing his pen-work with touches of white bodycolour from the tip of his brush, he could not free the draperies altogether of schematic desiccation, or draw sap into the limbs of the tree. By the wilder fling of the head, by the more fervid attack on the problem of the raised foot, by the rendering of the loin-cloth, by the masterly play of muscle and mass, his copy drawn on the spot conveys the thrill of direct confrontation. Such revision in Rome can be read as a positive form of self-criticism, by which he tuned himself nearer to the pitch of Michelangelo. On a later visit to the Chapel, he concentrated again on the lowest zone of the altar wall, and he selected to copy in chalks the right-hand group of demons (Plate 10), in order to enunciate fully Michelangelo's language of heroic forms.[12] Many years afterwards he saw a way to adapt his analyses of the *Haman* and of groups of falling figures in *The Last Judgement*, so as to display human attitudes *écorchés* in drawings intended for his Anatomy Book.[13] To project the action of these flayed figures with such conviction of choice is the corollary of his mature powers as a painter to invent freely in the spirit of Michelangelo. We may think of mighty compositions such as extend across the inner face of *The Elevation of the Cross* triptych for St. Walpurga's (Plate 190), or such as *The Fall of the Damned*;[14] or of the Michelangelesque allusion contained within such comparatively small oil sketches as *The Capture of Samson*[15] and *Hercules trampling Discord* (Plate 28).[16] Also as an architectural thinker he was to be in Michelangelo's debt. Something very like the apsidal end to the north transept of St. Peter's appears in the background of *The Miracle of St. Francis Xavier* for the Antwerp Jesuits;[17] and the pediment and chamfered soffits of the archway to his Antwerp garden (Plate 345)[18] are massive recollections of the Porta Pia.

On this strenuous process of coming to inward terms with Michelangelo's forbiddingly grand achievement, he concentrated most intently during his early years in Italy. In Florence, probably on his first visit in October 1600, he drew from another of the master's youthful carvings in marble, the sarcophagus-like relief of *The Battle of the Lapiths and Centaurs*[19] in the Casa Buonarroti: but in this instance he used the more deliberate medium of black chalk, and worked by lamp light (Plates 14, 16). He had been in Venice; and he was experimenting, possibly for the first time in his career, with the painterly practice instituted by Jacopo Tintoretto for his family shop, of studying variegations in modelling superficies by different casts of illumination. In Florence also, conceivably during the same visit for the Medici marriage, but more likely in the spring of 1603 *en route* to Livorno to find a ship for Spain, he set black chalk again in his *tocca-lapis* in order to record how to his eyes light and shade governed the obsessive stare of the faun's mask on which the *Night* rests her elbow (Plate 15). On the other side of the paper which he had used, or was to use, for this passing salute to Michelangelo, he sketched with unselfconscious ease, but no whit less passionate attention, a *Pack-Mule* – perhaps a beast in the Mantuan baggage-train – reaching for fodder (Plate 17).[20] Thus, typically, learning from art and observation of nature were conjoined in his quest for knowledge.

His graphic approach was qualified by mood and circumstance. Again in the Medici Chapel at S. Lorenzo he copied, more summarily, the upper half at least of *The Virgin and Child*.[21] He seems to have been striving at once to investigate and to reinterpret the core of movement implied by the contortion of the seated figures and their emotive interaction. Comprehension in this depth could only be attempted before the actual statue. However, outside the Chapel and without risk of disturbance, he could engross himself with his studies of bronze reductions. A sheet of chalk drawings of the *Night*,[22] which he seems to have studied in such a way (Plate 20), had to be enlarged by him to accommodate not only a magnificent full aspect, but also ancillary aspects of the figure's head and back, which are as good as inaccessible in the Chapel even to the most intrepid draughtsman. The ensemble presents a superbly unhurried meditation on both plasticity and surface.

In Rome he devoted equal pains to studying from each significant viewpoint the antique marbles most admired by Michelangelo, very much as Goltzius had studied them: pre-eminently the *Laocoön*, the *Belvedere Torso*, the *Belvedere Antinous*, the *Farnese Hercules*, and the *Dioscuri* on Monte Cavallo.[23] In his oil sketch of *Hercules trampling Discord* (Plate 28), for example, we see how he benefited from the inspiration of the *Adam* in the Sistine *Last Judgement*, all the more because he realized how much of the *Farnese Hercules* had been absorbed in that figure. He

would have drawn, from the dominant viewpoint at least, all Michelangelo's own work in marble to be seen in the metropolis. We divine studies by him of the *Christ holding the Cross* in S. Maria sopra Minerva, a modern sculpture which ranked with the ancient ones, when we regard the three-quarter-length Christ in the Lerma *apostolado*;[24] and the pose of Christ in *The Flagellation* for St. Paul's, Antwerp (Plate 26), is a patent and powerful recollection of the pose, brilliantly developed by Jacopo Sansovino in Michelangelo's manner, for the bronze statuette of *Christ in Limbo* (Plate 27) which belonged to the Este at Modena.[25]

Rubens gazed again and again at the vault of the Sistine Chapel, in order to record worthily those simulations of gigantic sculpture frescoed aloft, the *Prophets* and the *Sibyls*. His *St. Jerome in his study*, a painting of 1609–10, reflects those gazings.[26] His earliest reactions appear in a suite of impressively large copies, drawn in a handsome combination of red and black chalks, which Jabach acquired: *Zacharias, Joel, Ezekiel, Jeremiah* (Plate 19), *The Libyan Sibyl, Daniel, The Cumaean Sibyl,* and *Isaiah*.[27] The suite may well have been complete, and designed for presentation. Of those we know, *The Libyan Sibyl* (Plate 18), is outstandingly fine; and shows by its parallel hatchings Rubens's sympathy for Michelangelo's habit of leaving the marks of the tooth and the chisel on his marble sculptures, and for Michelangelo's corresponding habit as a draughtsman. There was to be a distant echo of this unfeminine figure in the pose of the half-naked old man, with arms outstretched, who kneels on the steps in *The Conversion of St. Bavo*.[28] In addition Rubens drew on almost as bold a scale, perhaps a few months later, at least one *ignudo* (Plate 21): the one on the north side of the Chapel which marks the corner between *The Libyan Sibyl* and *Jeremiah*. The differences in design between his version and the original illuminate the growth of his own graphic personality. Whilst Michelangelo harped on the tension between the sublime presence of the nude body, held within its own laws of ponderation and muscularity, and a countenance troubled by introversion, Rubens made the youth's head incline from the vertical toward the right, enough to range it more sensuously with the main flow of form in the pose; and, in the face, he aroused the senses from their dreamy abstraction to a new vibrancy. For this copy he used the exacting medium of red chalk, accenting his strokes with wash from the point of his brush. He must have made a second, freer rendering of the same *ignudo* in this traditionally Florentine medium. For a counterproof exists of that other drawing, richly re-worked with red wash and white highlights (Plate 22), the completion of this operation being of a much later date, perhaps of the 1630s.[29] Not the least valuable quality which Rubens developed as a draughtsman was the strength to go on learning from himself, even across a gap of a quarter of a century. We may relish this quality again in the large-scale study for a *Worship of the Brazen Serpent* (Plate 25)[30] In the long and complex development of that he incorporated his early copy of the central figure from the pendentive frescoed with the subject on the Sistine vault.

Other, more faithful copies from the vault, the two first-named being drawn most likely in 1601 or 1602, illustrate further the painstaking comprehensiveness of his approach: *The Creation of Eve*;[31] the group of God the Father surrounded by Angels in *The Creation of Adam* (Plate 24);[32] and the major portion of the *Hezechiah* lunette.[33] All three are in sanguine retouched with buff-coloured body-colour, a combination which during his second period in Rome was to become habitual for his copies after High Renaissance masters. The *God the Father* he adopted in 1601–2 as the almost direct prototype for the strange attitude of his crucified Christ in *The Elevation of the Cross* (Plate 187). By comparing such literal quotation with his post-Italian regard for Michelangelo, we can measure growth in the strength and subtlety of his enthusiasm. About 1610, in recollection of the *Tityus*, he disposed a splendidly muscled youth on the floor of his Antwerp studio, and then drew the lad from above (Plate 47) in anticipation of his requirements for the figures of stricken heroes in *The Death of Hippolytus* and the *Prometheus Bound*.[34] By bringing the essence of Michelangelo's design again to the test of life, Rubens revised and enriched his own appreciation of it. He was profiting in this invigorating procedure by the example of his senior contemporary in Rome, Annibale Carracci. He would not have been slow to recognize in Annibale's flesh and blood *ignudi*, ranged gracefully at ease along the cove of the Galleria Farnese, and even more clearly in Annibale's chalk studies for the decorative postures of these youths, a vital lesson how a modern painter could be inspired by Michelangelo without being overwhelmed.

Rubens's occupation with Michelangelo's presentation drawings went beyond the single figure of *Tityus*. He must have been impressed, early perhaps and, if so, lastingly, by the choric unison of force expressed in the *Archers shooting at a Herm*.[35] About

1636, having been commissioned to furnish designs for mythologies to decorate the walls of Philip IV's new hunting-box outside Madrid, he sketched in oils the moment in the *Metamorphoses* when Theseus rescues the bride of Pirithous from Eurytus, one of the lustful centaurs invited to the wedding.[36] The dramatic concentration and force in his illustration to Ovid does credit to his understanding of Michelangelo. He may well have copied, or reworked an old copy of, Michelangelo's design and returned to its message across a considerable gap of years. In the same series of sketches for the Torre de la Parada he again remembered the *Tityus* in *The Death of Hyacinth*.[37] Yet not everything thus absorbed became grist to his mill. He was familiar with the composition of the *Ganymede* drawing made by Michelangelo for Tommaso de'Cavalieri; since he owned, and he delicately retouched in pen and ink, with flecks of white bodycolour, the copy of it drawn in black chalk by Giulio Clovio (Plate 30).[38] However when he came about 1612 to paint, as a neo-Platonic allegory, *Ganymede receiving Hebe's cup*,[39] he avoided the ecstatic swoon invented by Michelangelo for Jove's fancy. His own interpretation is based on a brilliant albeit self-conscious interweaving of allusions. The youth in *contrapposto* evinces a power to create in paint a new son for Laocoön: and his ride upon the eagle with wings outspread, itself a reference to the Capitoline marble sculpture, is an elegant play upon the pattern cast on the reverses of those Imperial medals which were authorized to be lettered CONSECRATIO S.C.[40] References to the antique are combined, typically at this stage of his development, with a mannerist *degradazione*, in order to relate the main action to the subsidiary group of Raphaelite Olympians feasting in the empyrean. That narrative device he took from Battista Franco's fanciful depiction of an event of 2 August 1557, *The Battle of Montemurlo*,[41] a cabinet piece which surely intrigued him, as a devotee of Michelangelo and a reader of Vasari's *Vite,* when he came upon it at Palazzo Pitti on one of his visits to Florence. His *Ganymede* testifies to his capacity to Michelangelize without recourse to Michelangelo.

(ii) RAPHAEL

'La belle Figure de Ganimède enlevé, d'après M. Ange, dessiné à la plume & à la pierre noire: les expressions des têtes doivent être regardées comme des chefs-d'oeuvre de l'art; elles ont été retouchées par Rubens, sur ce Dessin, qui est de Don Giulio Clovio.' This is the catalogue description given by François Basan for part of lot 1022 in the 1775 sale at Paris of Mariette's famous collection. The other part of the lot was a drawing attributed wholly to Rubens (Plate 31): 'La Vision d'Ézechiel, d'après Raphael, à la sanguine supérieurement bien dessiné.' Rubens could have seen Raphael's *Vision of Ezechiel* in the Tribune of the Uffizi on his first visit to Florence: but, more probably, he made his copy[42] of that fascinatingly complex configuration in 1605–8, on one of his journeys between Rome and Mantua. His drawing omits only the landscape. He revered Raphael not less than Michelangelo; and, as we observed in his *Fall of Man*, this reverence antedated his going to Italy.

Before he ever saw Rome, he would have made his record in sanguine of Marcantonio's engraving which adapted to a rectangle Raphael's scene of *God bidding Noah build the Ark*, frescoed on the vault of the Stanza d'Eliodoro.[43] In this case he made no significant variations. With equal fidelity, in the same medium, and presumably also just before or just after 1600, he copied a very different kind of subject, the enchanting *Alexander offering the Crown to Roxana*, which Jacopo Caraglio had engraved after Raphael.[44] Here he used for his model either an impression of the anonymous engraving, which reverses Jacopo's, or a highly finished drawing by Raphael himself; for, at Pierre Crozat's sale in Paris in 1741, lot 125 of the distinguished collection of Raphael drawings was: 'Deux, idem, sçavoir; les Amours d'Alexandre & de Roxane; Dessein très-arrêté & du premier ordre, & de la même composition, mais où les figures sont sans aucune drapperie, Raphael ayant fait un beau Dessein pour servir d'Etude au premier; avec les Estampes qui ont été gravées d'après ces Desseins.' The exquisite composition study in sanguine with the figures envisaged nude, manifestly by Raphael, is in the Albertina, reputed to have been brought to Antwerp from Rome by Rubens.[45] If he did not own or know either drawing at the time of copying, we can only applaud the more how he showed himself to be the man to divine, through the comparatively dry schemata of an engraver working at second-hand, the life of Raphael's original conception.

A drawing, uniquely on parchment instead of white paper, shows two standing figures, excerpted in Rubens's earliest pen style from Raphael's *Calumny of Apelles*: 'Truth' naked, and 'Calumny' herself (Plate 33).[46] No engraving of this composition is known. So Rubens must have worked in Antwerp either from Raphael's own pen and wash drawing, or from a copy of that (Plate 32). The

luxury of the support chosen for his own copy hints that he may indeed have been attending to the original. Remembering his contemporaneous copies after Stimmer and after Amman, we should not be surprised that in this drawing also he considerably enlarged the scale, which is not the way of weaker copyists: and that in his *mise-en-page* the two figures appear redisposed, right for left. There could be no choicer example of his youthful desire to collect knowledge for its own sake.

In Antwerp Rubens could also have known, not only through reading Vasari, how excellent was the engraving of the 'bellissima carta di Raffaello da Urbino, nella quale era una Lucrezia Romana, che si uccidera', by which Marcantonio in youth had recommended himself to the Pope's painter.[47] However, his copy of it, again in the form of a highly finished drawing, but this time on the scale of the original print, is unlikely from consideration of its advanced style to have been made until about 1606.[48] At first glance, we might suspect an impression of the engraving to lie beneath a palimpsest of wash and bodycolour. Inspection shows that the entire work is freehand, on paper washed brown overall, with grey and pink bodycolours and some reinforcement of pen and ink to Lucretia's left leg and thigh. The Greek inscription and the background of trees and buildings were omitted. The sky replacing them is an invention which exploits the luminosity inherent in the mixed technique. The *grisaille* effect echoes appropriately those late works of Mantegna which he knew by heart in Mantua. Numerous and subtle modifications are introduced into the life and amplitude of the drapery, the forms and cadence of which correspond to those developed by him during his second stay in Rome. To secure the apparent stability of Lucretia posed at the instant of aiming the dagger, he lengthened the fall of cloth at her left side, allowing folds to pile on the ground beside the foot which bears her weight. Thus he has left a drawing which is at once a memorial to Marcantonio's skill in interpreting Raphael and a foretaste of those *modelletti* by which he himself was to impose his wishes on his own engravers.

The fascination for Rubens of Raphael's designs recorded by Marcantonio and others outlasted his stay in Italy. His drawing of *Pan and Syrinx* in sanguine, used both as chalk and as a wash applied with the point of the brush, reinterprets, in reverse, the first state of the engraving (Plates 34, 35).[49] He retains, as in the *Lucretia*, the proportions of the original figures, whilst simplifying the background.

He reveals Pan lusting to the very finger tips. He gives a long, natural fall to the hair of Syrinx, avoiding repetition of the calligraphic loop made by one tress over her bent forearm. He modulates the forms afresh, investing the bodies with a distinctively heightened vitality; so that we feel his poetic insight has enabled him to see through the constricting medium of the engraver's interpretation to the inspiration of Raphael. Morphologically his woman and satyr belong to the period of his collaboration with Jan Brueghel, about 1615, in small figures for decorative landscapes. We may think not only of a *Pan and Syrinx*[50] which they painted together, but of the better known panel of *Adam and Eve*.[51]

Where no Raphael original in painting was available, Rubens was prepared, even so late as his second period in Rome, to follow the design from a print. So he made a handsome copy, retaining the scale of the figures, from the Jacopo Caraglio engraving of *The Madonna and Child seated with St. Elizabeth and the Infant John* (Plate 36). Here he deviates from Caraglio only in the idiomatic expression of the faces, and in the fresh inclination of the Madonna's head.[52] This configuration haunted his imagination, to be developed more fully by him in the early 1630s. Then he painted, on the commission of the Archduchess Isabella, across the shutters of the S. Ildefonso triptych *The Holy Family under an Apple Tree* (Plate 37). In adopting the attitude of the Christ Child for his young St. John, he showed himself to be the first artist to understand the message of Raphael's late Madonna compositions.[53]

Naturally he went whenever possible to the direct inspiration of Raphael. On his ride from Mantua to Rome in 1601, he must have taken note in Bologna of the *St. Cecilia*, set in the beautiful Tuscan chapel of S. Giovanni in Monte.[54] He was aware of the sensational effect which its arrival some eighty years before had had on the provincial painters of the city. Evidently its general composition, as much as that of Raphael's *Disputa* in the Vatican,[55] was to be in his mind when he devised for the Antwerp Dominicans, soon after his homecoming, an altarpiece to display a *Discussion of the Real Presence in the Eucharist*.[56] In Rome, within a few months of his visit to Bologna, he was to pay homage to the noble stance and richly brocaded dress of the central saint by the hieratic image of *St. Helena* which he invented for S. Croce in Gerusalemme (Plate 179). Moreover in that Roman altarpiece there are other Raphaelite echoes; the use of Salomonic columns; and the decorative way in which the hair of the cherub perched on the shaft of the Cross streams

sideways, as though this *putto* were in attendance on the *Galatea*.[57] Rubens would have been eager to draw after all the decorations designed by Raphael for the Farnesina; although the finest of these copies known, *Psyche offering the Jar of Proserpine to Venus*, to judge by style, was drawn in the Loggia di Psiche during his second rather than his first Roman visit.[58] The supple flow of drapery and the cloud formation which support his Venus do not derive from any engraving. They are characteristic improvisations to replace the simulated trellis which Giovanni da Udine had contributed to the festive canopy of Agostino Chigi's loggia. On the other side of this sheet Rubens copied in chalk, also directly from the loggia vault, the head and arms of the bearded river-gods, who reclined naked amongst the cloud-born Olympians in the scene of *Psyche's reception at the Council of the Gods*. On this *verso* the hesitations in describing the elbows, and the markedly different degrees of finish in the two figures, are further indications that the fresco itself, and not Caraglio's engraving, was his model; although it is more than likely that he owned, perhaps even at this time, an impression of that print as well as of engravings by Marcantonio after *Jupiter kissing Cupid*, the *Mercury and Cupid with the Three Graces*, and by Marco da Ravenna after *Venus leaving Ceres and Juno*.[59] He would have been interested also in Caraglio's other print from the history of Cupid and Psyche in the loggia, reversing *Mercury conducting Psyche to Olympus*; in *Psyche returning from Tartarus*, engraved in reverse by a pupil of Marcantonio; and in *The Marriage Feast*, published in 1545 by Antonio Salamanca; not to speak of the prints after the *amorini* scenes by Agostino Veneziano and others, particularly the anonymous one which shows the cupid vaulting in the sky, with the harpy in flight to the right of him.[60] In the spring of 1625, anxious to get paid for the prodigious efforts he had made to deliver *The History of Maria de'Medici* punctually and satisfactorily, he presented the Queen Mother's Treasurer with 'a large picture by my own hand, which he seemed to like very much'.[61] *Cupid supplicating Jupiter's consent to his Marriage with Psyche*[62] has for its ostensible theme a contract with a princess whom the supplicant is about to introduce into the company of the immortals. The composition conflates *Jupiter kissing Cupid* and the relevant group in *Psyche received on Olympus*, although anyone who knew the fresco decorations in the Farnesina, or at least the engravings after them, would have been aware that the thunderbolt had been transferred from the beak of Jupiter's eagle to the firm grasp of Cupid![63]

In Italy a considerable number of designs of the Farnesina decorations could have been available to Rubens through engravings. But of other important figures frescoed in Rome for Chigi to the designs of Raphael, the *Prophets and Sibyls* on the wall of S. Maria della Pace, there was only a pair of anonymous engravings, in reverse and of rather poor quality. The splendidly finished copy, in which Rubens recognized the 'grandezza e maestà' of *Baruch copying from the Tablet of Jeremiah*, could not have been derived from one of these.[64] It is drawn in the sense of the fresco, in the Chigi Chapel itself, during his second sojourn in Rome.

To the Papal Apartments Rubens obtained access when first in Rome, presumably through Montalto. His pen and wash copy of the central group from the upper tier of *The Disputa* (Plate 38) was surely made in the Stanza della Segnatura itself, not from the rare engraving of the whole scene which Giorgio Ghisi had made on two plates, and which Hieronymus Cock had published in 1552.[65] This drawing, datable within his first autumn in Rome, is close in style to his copy made in 1600–1 from Leonardo's *Last Supper* in S. Maria delle Grazie (Plate 53).[66] Such an early date must be accepted for that: partly because Philip's letter of 13 December 1601 to his brother implies that the painter had lost no time in visiting the chief centres; partly because in S. Maria delle Grazie Rubens would have sought out also Titian's *Mocking of Christ*,[67] and his knowledge of that almost equally famous painting is implicit in his drawing for his own *Mocking of Christ* for S. Croce (Plate 181); and partly because the colour notes penned on the back of the *Last Supper* sheet are in Flemish, a language he was soon to set aside in Italy as he learned to speak and write the best Tuscan.

In the Stanza della Segnatura also, and probably during his first stay in Rome, he drew a freer copy in sanguine of *Prudence* and her attendant putto.[68] The Agostino Veneziano engraving of 1516, in which a niche and a column appear, would not have served him so well as the actual fresco. His drawing is one of those which Lankrink came to own; but in this case, when the sheet was extended, Lankrink was not the repairer. Rubens himself seems to have completed the putto's right buttock, foot and wing, and Prudence's right foot, where the draughtsmanship as well as the technique are quite characteristic. He departed from the composition of the fresco in the direction given to her foot, which Raphael had painted to project over the parapet, sandalled, and cocked up so as to hide the putto's right foot; in

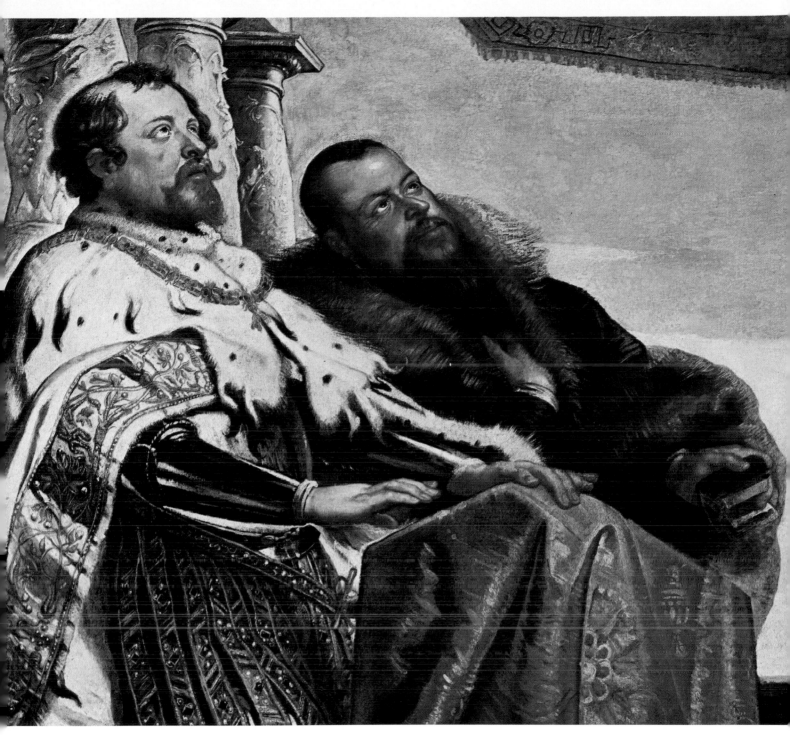

v. Duke Vincenzo I Gonzaga and his Father. Detail from *The Gonzaga adoring the Trinity* (Plate 239). 1604–5. Oils on canvas. Mantua, Palazzo Ducale

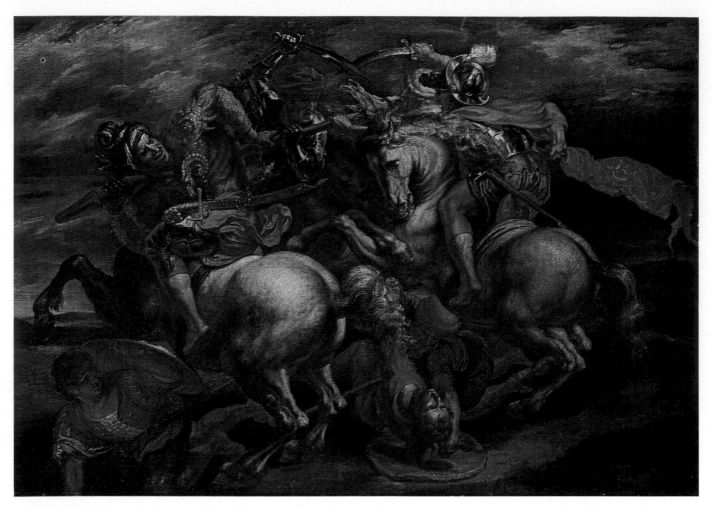

VI. *The Fight for the Standard* (after Leonardo da Vinci). About 1606. Oils on canvas. Vienna, Akademie

showing her left hand, hidden by Raphael with draperies; and in changing the looking-glass, in the course of his own drawing, to give it a more elliptical shape and a more prominent handle.

His excerpt of 'Three Warriors'[69] from *Alexander the Great ordering the Iliad to be stored in a Persian Chest* – the scene below the *Parnassus* in the same room – shows an advance, both in his ease of handling media, and in his readiness to invent in the spirit of Raphael forms idiosyncratically his own. Moreover, by contrast to some of his copies from Raphael designs made during his first sojourn in Rome, he has regained the confidence to increase the scale. That he worked from an anonymous copy which reverses Marcantonio's engraving, rather than from the *grisaille* fresco, suggests that he may well have made this drawing after he had finally left Rome. Conceivably this Raphaelizing exercise belongs to the period when he was collecting his thoughts for *The Life of the Consul Decius Mus*.[70] In any case he had in the Pocket-Book a note, penned on this earlier occasion from Marcantonio's engraving, which is in the opposite sense to Raphael's fresco, of the helmeted veteran standing beside Alexander with right hand raised (Plates 39, 40).[71] And that note bears company on the same leaf with other rapid *ricordi* of Raphael groups; from Marco da Ravenna's engraving, which reproduces *The Fire in the Borgo* in reverse; and from Agostino Veneziano's engraving of *Elymas struck with Blindness*. Thus Rubens kept ready to hand stimulus for refreshment of his figurative ideas at the fountain of Raphael's invention.

In the Stanza d'Eliodoro Rubens seems to have been struck first by the dramatic illuminations depicted in *The Liberation of St. Peter*.[72] Raphael's contrasting sources of light, natural, man-made and divine, elated him; as appears directly in his own exploitation of this nocturnal conflict in his *Mocking of Christ* for S. Croce in Gerusalemme (Plate 182). And, at a remove of a dozen years or so, we can see how vivid in his imagination was his memory of the liberating angel, incandescent with supernal radiance, when he came to paint the angel who greets *The Three Maries at the Sepulchre*.[73]

For his record of *The Fire in the Borgo* he did not rely exclusively on the Marco da Ravenna print and on his own jottings from that. He chose to copy the nude figure dropping from the wall (Plate 23).[74] Possibly he did this from the fresco, omitting the piece of drapery and giving a more intense expression to the man's face and hair. More probably he worked from a preparatory study by Raphael – or at least a copy of one. Raphael's absorption in

Rome of the message of Michelangelo Rubens recognized superbly; and he rendered appropriately the combined grace and dynamism of the action – which figured in his inspiration when he came to sketch *The Defeat and Death of Maxentius*[75] some fifteen years later – in the opulent combination of media used by Michelangelo himself for a finished study for one of the *Bathers*.[76] Furthermore, we may guess from the aspect of the group seen from behind in the foreground of his projected triptych for *The Conversion of S. Bavo*[77] that he had some record of *The Expulsion of Heliodorus from the Temple*.[78]

Of *The Acts of the Apostles*, Rubens painted copies, as his inventory of 1640 records; five kept together; and a sixth itemized separately, perhaps because it was done at a recognizably different period or on a different scale.[79] These are likely to have included *The Healing of the Lame* and *The Sacrifice at Lystra* as well as *The Blinding of Elymas*, and to have been developed from his studies of the cartoons rather than the Vatican or Mantuan tapestries; for, with access to the cartoons – the copy which he drew about 1600 of *St. Paul's Sermon at Athens* (Plate 41)[80] certifies that he had such access – he would have preferred to make them his models. If so, these painted copies would have served eventually as a basis for the young Van Dyck's highly expressive studies of heads from *The Sacrifice* and *The Blinding*.[81] In his own work of the same time, about 1619, Rubens turned his knowledge of the stricken Elymas to account when studying the action of a man groping forwards for *The Miracle of St. Francis Xavier*, one of the alternating high altarpieces commissioned by the Antwerp Jesuits. His study in black chalk of a man holding this pose (Plate 46)[82] is a reaction to Raphael, equivalent to his reaction to Michelangelo in his earlier study, in that same medium and on much the same scale, which is based on the *Tityus*. The architectural background to his more or less contemporaneous oil-sketch for *The Martyrdom of St. Adrian*[83] implies a fresh look at his copy of *St. Paul's Sermon*. His penchant for introducing Salomonic columns in other compositions of this period, such as the Boston *Tomyris and Cyrus*,[84] reflects *The Healing of the Lame,* to copy which conveniently with pen and ink, adding buff bodycolour (Plate 42), he had availed himself of Parmigianino's *chiaroscuro* woodcut with etched outlines.[85] Even when in Italy, he chose to do this rather than tackle from the tapestry itself the design which Parmigianino's elegant print varies in several particulars.

In remarking how determinedly he sought to

wrest from Raphael the secrets of his power, it is instructive to turn to his reactions to Raphael's last painting. Not only did he copy elaborately, when first in Rome, the huddle of Apostles in the lower left corner of *The Transfiguration* (Plate 45)[86] – the morphology of the bearded heads is suggestive of his style at that time – but he sought closer acquaintance with Raphael's creative processes. Here the engraving by the Master of the Die was certainly inadequate to satisfy him. Somehow he got access to at least two of Raphael's working drawings, or to studio repetitions. From these designs he made splendid copies. In one he interpreted, with extraordinary sensibility to the drama of light and atmosphere, the scheme at the stage when *The Transfiguration* was the single subject (Plate 43).[87] In the other he revised, engendering unity by the same sensibility, the much more advanced scheme (Plate 44) which in essentials had had to be changed finally only by the redisposition of the Apostles in the lower left corner (already the subject of a special note), and in the position of Christ and the Apostles on Mount Thabor.[88] This second copy he inscribed 'Rafael da Urbino'; not because he himself might otherwise have forgotten the source, but as a guide to assistants, who would be set to copy this and other choice models of *disegno* in his Antwerp studio. We may imagine that he, of all painters the most effectively conscious of the history of art, might have pointed out to these youths how Raphael in 1520, considering the attitude and drapery of Christ, had harked back to a spring of his inspiration in Florence, the reliefs in enamelled terracotta by Luca della Robbia: in this case, to the lunette of *The Ascension* over the entry to the south sacristy in S. Maria del Fiore.[89]

He himself in 1604–5 was to paint a *Transfiguration* (Plate 247) for the *cappella maggiore* of the Mantuan Jesuits.[90] On that vast stretch of canvas the outburst of radiance from the Christ, the flaring light in the trees, the fringes of illumination which darken by contrast the excited silhouettes of the crowd, the murky and livid colours, all are eloquent of his enthusiasm for Tintoretto in the Scuola di S. Rocco: but the stance of Christ, the attitudes of many caught up in the miraculous happenings, the very challenge offered by the occasion to maintain the doubly laden narrative in his own treatment of the subject, show how he already felt the strength to invite comparisons with Raphael. No evidence has been brought forward that Duke Vincenzo or Duchess Eleonora, or any of their Court, appreciated the significance of this prodigious assertion by

the young foreigner of his artistic power. Within a few months of the consecration of the chapel in S. Trinità, Mantua, the first *principe* of the Accademia di S. Luca left Rome for employment in Savoy and Piedmont. Visiting Mantua, Federico Zuccaro was intoxicated by an invitation to join a ducal hunting-party, part of the celebrations of the marriage of Francesco Gonzaga to Margherita di Savoia. He could only just take note in passing of the decorations by Giulio Romano, who had been officially one of the artistic heirs of Raphael.[91] He had not a word for the recent work of Rubens.

At the time when Rubens was being promoted by Serra for the Oratorian commission at the Chiesa Nuova, nobody in Rome appears to have taken account of what he had painted in North Italy. But Rubens himself, once had had the coveted commission in the metropolis, did not shed his attachment to Raphael. In his pen sketch for this commission at an early stage, in the way in which he projected the amplitude and dignity of St. Gregory the Great (Plate 320), there is an echo of the Aristotle in *The School of Athens*.[92] Indeed recollections of single figures from Raphael's Roman works reappear in vivid revisions to suit fresh contexts during the two decades following his return to Antwerp. About 1612 the crippled beggar in his *modello* for *The Miracle of St. Bavo* was inspired by the equivalent figure in *The Healing of the Lame*.[93] In the middle 1620s a memory of the harpy in flight which he had seen frescoed in the Farnesina Loggia, or an engraving of it, provoked the drawing of the harpy who was to wing her way through the lower zone of *The Duke of Buckingham, assisted by Minerva, triumphing over Envy and Anger*.[94] And he drew extensively on the education won from Raphael when he came to plan groups of figures for his first tapestry cycle on a theme of Roman history, *The Life of the Consul Decius Mus*. His recourse both to the *Sala di Costantino* and to the cartoons for *The Acts of the Apostles* became even more obvious when he undertook to the order of Louis XIII the design of tapestries reinterpreting *The History of Constantine the Great*.[95]

In portraiture, Rubens owed to Raphael scarcely less than he owed to Titian. His inventory in 1640 lists 'un pourtrait jugé pour estre de *Raphael d'Urbin*'.[96] Years before, in order to provide a setting magnificent enough for his portrayal in Genoa of *The Marchesa Veronica Spinola Doria* (Plate 262), seated in an armchair, he had turned to the concepts of space and of the spread of stiff draperies used by Raphael for his presentation of Julius II

(Plate 263) in the guise of *Gregory IX giving the Decretals*. Behind the senatorial dignity of the silk merchant *Rogier Clarisse*, whom he was commissioned to paint in Antwerp in 1610 or 1611, lies the Papal dignity of the *Julius II*.[97] And, sometime after 1620, when he was at home painting on oak panels his copies after portraits by Holbein and by Matsys, he chose to copy also the most Venetian-looking of Raphael's portraits, the *Baldassare Castiglione* (Plate 48), of which he, like Titian, could have known the original in Casa Castiglione at Mantua.[98] Whether he developed his portrayal (Plate 49) on the basis of some careful drawing which he had made on the spot, or from some old and reliable copy of the painting available in Antwerp, we do not know. His tribute to Raphael's conception ranks as a masterpiece in its own right. In the words of the present owner, 'Raphael's *Castiglione* is a type of the Renaissance portrait, stable, balanced and self-contained; Rubens by completing the hands and imparting a slight twist to the body, created a figure which is free in space and instinct with "presence"; in short, it is a Baroque portrait.'

Rubens turned to Raphael not only for ideas in portraiture, for figures and groups in compositions, and for pictorial devices such as Salomonic columns or the simulated effect of tapestry. Any distinct trace of these borrowings faded from his paintings after he went in 1628 to Spain for his second encounter with the Titians of the Habsburg collection.[99] What lasted from the day at Verona in 1602, when he promised his friend Jan van der Wouvere the dedication of the first engraving after one of his own compositions, until 1638, that last *annus mirabilis* of print-making from his designs, was his post-Raphaelite sense of the importance of this disseminatory activity. With the singular exception of *The Calumny of Apelles* drawing (Plate 33), it seems to have been through the prints of Marcantonio, and of Marcantonio's pupils and followers, that he had had in his formative years his first access to Raphael. The promulgation of his own work through prints was to present more difficult problems than any which had appeared for reproductive media, at least up to the time of Raphael's very last style in painting. The skill to produce through the essentially linear schemata of engraving satisfactory equivalents for the painterly style, at its full development in him, required a graphic artist of unusual gifts. From Lucas Vorsterman outstandingly, and later from Vorsterman's most gifted pupil Paul du Pont, he demanded and got interpretative skill of an order quite beyond the powers and old-fashioned talents of such a craftsman as Philip Galle, with whose services he had earlier to be content.

The rigour and rate of these demands drove Vorsterman in 1621 to a mental breakdown of an aggressively dangerous sort. Rubens had to drive men harder than had Raphael, whose working life had been considerably shorter and less peripatetic. He got his best service when Van Dyck during the late teens of the century, or Jordaens just after 1620, or he himself in the thirties, was on the spot to provide a *modelletto* which relieved the printmaker of uncertainties in the adjustment of scale or in redistribution of lights. No such refinement of working method seems to have been called for in Raphael's organization. However, Rubens's luck in finding a man of Jegher's talents in woodcutting, and his exploitation of these talents from 1632 onwards, reflect in a general way the relationship between Raphael and Ugo da Carpi. Significantly it was by a *chiaroscuro* woodcut of '*Doge Giovanni Cornaro*',[100] based on the copy painted by Rubens[101] of a Tintoretto portrait (Plates 85, 86), that Jegher recommended himself to his notice. This was an historically minded reattachment of the technique, as practised by a specialist, to the service of a major painter. For in the Low Countries during the sixteenth century, the leading practitioners of *chiaroscuro*, Bloemart, Floris and Goltzius, had all been creative artists in their own right; all three had used the technique as an independent means of expressing their graphic ideas. Had Rubens lived to employ Jegher longer, the two of them would probably have combined further to exploit the market amongst connoisseurs for woodcuts. In earnest of this we have, on the reverse of an impression of *The Rest on the Flight*, in black and white, a trial proof in black and orange of the same print, corrected by Rubens in white bodycolour.[102] We have also a black and white impression of the '*Conversation à la mode*', washed in a greyish brown and heightened with white by Jegher, in order to try the effect in *chiaroscuro*.[103] Unfortunately we know nothing beyond Vasari's account of the working relations between Raphael and Ugo da Carpi, or between Raphael and his engravers, to allow us to suggest more precise parallels or contrasts with Rubens's organization in this aspect.

Besides 'Un pourtrait faict après Raphael de *Baltazar de Castillion*', and 'Cinq pièces des actes des Apostres faicts après *Raphael*', there was in Rubens's house at his death another of his copies painted after Raphael: item 77, 'Une teste de S. Jean après *Raphael*'. This has disappeared. However there was

also, item 76, 'Une Psyché après *Raphael d'Urbin*'.[104] And on 30 December 1653, in the inventory of Jeremias Wildens, the painter, item 31 was 'Een Epchige geschildert van Rubbens naer Raphael Urbine'.[105] This panel (Plate 50), formerly at Bridgewater House, was manifestly painted by Rubens for his own pleasure, both in the groups of figures, which are essentially reassortments of those which had rejoiced him in the Loggia di Psiche, and in his own lovely invention of the landscape of Tartarus above which they rise and soar.[106] The superb flesh tints on Venus and on the Graces (Col. Plate xv), the broken colours of Psyche's dress – mauve broken with rose and pale gold – and the ease with which the generally more voluminous draperies and bodily forms are given a fluency of movement, all indicate a date not far from the National Gallery *modello* for the Duke of Buckingham's ceiling. There the hardly less Raphaelesque group of the Graces, to say nothing of the winged harpy introduced in the definitive composition, were distinct echoes of Rubens's experience twenty or so years beforehand in the Farnesina.

The *Psyche* from Bridgewater House is unlikely to antedate the meeting between Rubens and Buckingham in Paris in 1625, out of which grew the commission for the Duke's ceiling; and it must precede the diplomatic voyages in Spain and England, and the rekindling of his passionate interest in Titian. It is a tribute by a painter in his fifties to the decorative and narrative achievement of the master whose work in Rome he had so deeply revered. Baroque movement is achieved, characteristically, not only through contrast of repose with energetic action, but through a *degradazione* of figure scale enhanced by a lightening of tonality and a heightening of the colour key. A whole series of incidents is unified by a dramatic illumination, rich in *chiaroscuro*. These are the qualities of mastery in oil painting which Raphael himself anticipated by the final altarpiece of his career. And Rubens did not forget the grand object lesson of *The Transfiguration* any more than the gaiety and luxury of the Loggia di Psiche. His own telling of the Psyche story is rendered with scarcely a hesitation: the left wing of the Cupid with the Graces was higher and more extended; above them at first was a winged putto puffing wind, like the one below; there are signs of drapery which he painted out below the hands of Cupid in the same scene; and he has had to feel for the silhouette of Mercury's left calf. For the elements of his figure groups he had not to rely exclusively on his own drawings of twenty years before. He would

have known two Caraglio engravings: one which reverses *Mercury conducting Psyche to Olympus,* chosen for his central incident; the other which reproduces *The Council of the Gods*. From the latter he selected almost all the figures which he required for redeployment in the upper zone of his painting. He changed Raphael's Juno into a Ceres, who would be less offended by the sight of *Jupiter kissing Cupid* (which incident he conflated with the remains of Raphael's *Council* scene); and he made considerable modifications to the attitudes or attributes of Pluto and Neptune, as well as those of Diana and Minerva. For *Jupiter kissing Cupid* and for *Cupid with the Three Graces,* he could have refreshed his memory with engravings by Marcantonio; although in the latter group he felt free to transform the character of Raphael's design, both physiognomically and in the more lavish display of the roundings of the black-haired Grace at the right. An engraving by Cherubino Alberti could have furnished a convenient model, although in reverse, for his *Venus ascending to Olympus*;[107] and since this print is dated 1628, we have another pointer to the likely date of his painting. Further indication that he had a fairly comprehensive collection of prints at hand when planning his composition is the way in which his Apollo is seated with the lyre fully displayed. This, unlike the poses of Hercules and Bacchus, does not follow the pattern of the fresco, nor that of the Caraglio print: but that of an engraving by the 'Master of the Die'[108] after Coxie's adaptation of the Raphael theme.

Rubens like Raphael collected engravings by Mantegna and by Dürer for their intrinsic beauty and interest, and for the education of assistants as well as himself. For at least thirty years he paid close attention to prints after Raphael, most of which he is likely to have come to possess. He made highly idiosyncratic *ricordi*, not only in drawings, but also, at either end of this period, in finished paintings: *The Fall of Man* about 1598 and *Psyche* about 1628. The extent and importance of print-making in Raphael's organization became the paradigm for his own. He drew after Raphael's preparatory studies as well as after Raphael's definitive works; and he may himself have owned Raphael drawings, besides a painting believed to be autograph. Such unidentifiable items as 'twee tekeningen van Rubbens naer Raphel', in the inventory of Canon Jan Philip Happart in 1686, are tantalizing.

He reacted sensitively to the nature and scope of Raphael's achievement in both religious and secular art: as a narrator, as a decorator, as a portraitist, and

as a designer of a vast range of works, from small devotional paintings to cartoons for tapestry. To match the grandeur of the frescoes in the Vatican, the special glory of High Renaissance painting in Rome, he produced huge triptychs on panel for St. Walpurga's, and for the Cathedral in Antwerp; and he planned a third for St. Bavo's in Ghent. In these ways he placed himself as the heir of Raphael, both as a master of *disegno* and as a *caposcuola*.[109] In the history of western painting they rank together as the supreme impresarios.

(iii) LEONARDO DA VINCI

The direct relationship of Rubens's art to that of the founding master of High Renaissance style was briefer and more specialized. While it lasted, it was nonetheless intense. So far as can be ascertained, no paintings or drawings by Leonardo were available to him as a young man in Antwerp. Of works accessible to the public in Italy, only *The Last Supper* and *The Fight for the Standard* had been engraved during the sixteenth century; in either case rather uninvitingly. Whether Rubens copied any part of them before he crossed the Alps, we do not know.

To see *The Last Supper* in Milan must have been the principal objective of one of his earliest expeditions from Mantua. His copy in pen and wash (Plate 53) shows how he had to improvise in order to compensate for the blurred design below table-level of the sadly perished mural.[110] From this large drawing we might suppose that his interest was focussed entirely on the expression and on the dramatic paragraphing of the groups in light and shade; that is, until we turn overleaf and find, penned in his Flemish script, careful colour notes of the robes. However, we should be right in any such first impression, in so far as it was this interpretation of Leonardo's almost manic way of conveying emotion through a concert of heads which passed from that moment into his vocabulary. We can observe this in a group of narrative trials, closely knit in style of pen and wash, which belong to his first period in Rome: two sheets of studies for a *Last Supper* of his own invention (Plates 193, 194), a composition emulating both Raphael and Leonardo, in which by introducing the backview of a young disciple he signals also his recent attention to Caravaggio's *spadaccino* in *The Calling of St. Matthew*; a study at a more advanced stage for a *Deposition from the Cross* (Plate 148), in which his composition derives from knowledge of Cigoli's treatment of the subject; a highly finished drawing of *The Washing and Anointing of the Body of Christ* (Plate 195), in which, as in the *Deposition* drawing also, the curious motif of the man gripping the shroud between his teeth was probably derived from the engraving of *The Entombment* by Battista Franco, in his turn inspired by Lotto. This histrionic vein in Rubens's ink drawings, associable with his reactions to *The Last Supper* in S. Maria delle Grazie, is to be found also in his studies for *The Suicide of Thisbe* and for his *Studies for a Medea* (Plates 218, 219, 216).[111] The aftermath extends no more than a year or two beyond his return from Antwerp.

The other masterpiece of Leonardo's *disegno* which fascinated Rubens in Italy, and which continued to fascinate him for another decade, was *The Fight for the Standard,* the pivotal incident in *The Battle of Anghiari.* This Leonardo had begun in 1505 for a wall of the Council Chamber in the Palazzo della Signoria in Florence, but had never finished; and it had been covered, still incomplete, by Vasari's battle scenes in 1557. That threat to Leonardo's work had prompted presumably the immediate preparation, and publication in 1558, of Lorenzo Zacchia's engraving of *The Fight for the Standard.* Zacchia's print survives as the only dated copy of the fresco: but Rubens is likely to have known also early sixteenth-century copies in oils, including one belonging to the Medici, and perhaps a copy drawn of the standard-bearer, now in the Louvre, which could have aided him in drawing his remarkable reconstruction (Plate 54).[112] Nevertheless it seems to have been entirely his idea to show a sword, rather than the battle-axe of Zacchia's print, held by the upraised arm of the horseman second from the right. This substitution accords better with Vasari's description of 'upraised swords'. The same rider's headgear in Rubens's drawing is likely also to have been his invention: since it corresponds neither with Zacchia's print, nor with the fantastical helmet which appears in the other known copies. In his drawing however, as in Zacchia's print, there is no dagger in the hand of the soldier struggling with an adversary on the ground; and no horse's head at the further side of the combat to the left. The most significant idiosyncrasy is the tampering, in order to heighten the drama, albeit in one detail illogically, with the very fulcrum of the composition. What the rider at the right handles is no longer his own spear, but the top half of the standard-pole; so the spearhead which points to the fracture of the pole has no longer any apparent means of support.

Rubens's edition of *The Fight for the Standard,* resplendent in grey and white bodycolours as well as washes of ink, is one of the treasures of the

Louvre. It could have served magnificently as a model for a skilled engraver; although it was not so used until the late seventeenth century, and then by Gerard Edelinck, a man not born until several months after Rubens's death. However, the existence of a second drawing at The Hague, more precise in the delineation of the horses' curling manes and in the modelling of their bodies, suggests that that, rather than the more celebrated drawing in Paris, may have been intended for a printmaker to follow.[113] The fact is that before the advent of Vorsterman nobody was available to interpret satisfactorily the other drawing's more painterly qualities. The Hague drawing disregards those additions made by Rubens to all four sides of his sheet in Paris: conspicuously at the right, the horse's tail and the extension of the standard; at the left, the near forehoof of the standard-bearer's horse; and above, the sword-hands of the two other riders. But it inserts the horse's head above the shoulder of the standard-bearer, a likely feature of Leonardo's design. Otherwise it varies the composition of the Paris drawing only by a less Leonardesque helmet worn by the rider on the right.

Not content with drawing, Rubens painted two or three years before he left Italy, exceptionally in oil colours on a bolus-prepared canvas, another copy, almost twice as large (Col. Plate VI).[114] In this brilliant summary of his investigations the illogicality of the no longer accountable spearhead is removed. Nothing could evoke better the spirit of embattled fury engendered by Leonardo's masterpiece. The repercussion on Rubens's own powers of composition was resounding. His pen and wash drawing in the British Museum, another *Battle Group* (Plate 56), is so Leonardesque as to make us wonder whether it could be a free rendering of some missing design by Leonardo himself rather than an original invention.[115] The plungings of the terrified horses were used by Rubens almost unmodified in his *Fall of Phaethon* (Plate 235 and Col. Plate VII).[116] At least three other paintings of his Italian years belong to the same strand: *The Destruction of Pharaoh's Host in the Red Sea* (Plate 236);[117] *The Conversion of Saul* for Burgomaster Rockox (Plate 202);[118] and the over-life-size *St. George slaying the Dragon* (Plate 238) which he kept for himself.[119] But the culminating expression of his feeling for Leonardo in this vein came about 1614 with his *Battle of the Amazons*.[120] As became more evident still later in the tapestry design of *The Battle of the Milvian Bridge*,[121] this feeling was commingled with that for those other canonical battle-pieces of the sixteenth century, Titian's *Battle of Spoleto* (Plate 51) and Raphael's *Constantine defeating Maxentius*, both of which he had copied (Plate 52), at least in parts, when first in Italy.[122]

From very early in his career Rubens must have been intrigued by Leonardo's preoccupation with physiognomy. A small red chalk drawing of a man's head in profile, of Leonardesque type, is probably a copy of some early sixteenth-century drawing by Leonardo himself.[123] In the manipulation of the chalk, both dry from the stick and in solution with the point of the brush, this drawing recalls the head of *Cain cursed by the Lord* which Rubens had copied about 1600 from Michiel Coxie.[124] Equally recognizable is the clarity of modelling by means of fine hatching with the brush. By the end of his time in Italy, Rubens had produced at least three larger and showier demonstrations of his fascination with those wrinkled faces and nutcracker profiles of old men's heads beloved of Leonardo. In red chalk, used wet as well as dry, and heightened with bodycolour, are the so-called 'Nicolò da Uzzano' in New York;[125] the *Elderly Man* in Oberlin;[126] and in Ghent the *Elderly Man*[127] whose features are so reminiscent of those of the Emperor Galba (Plate 292).

De Piles, who had the best opportunities of any Rubens enthusiast to be informed, being in correspondence with the painter's son Albert, wrote in his 'Reflections on the works of Leonardo da Vinci':[128] 'Rubens s'étend ensuite sur le degré auquel Léonard de Vinci possédoit l'anatomie. Il rapport en détail toutes les études & tous les desseins que Léonard avoit faits, & que Rubens avoid faits, & que *Rubens* avoit vu parmi les curiositez d'un nommé Pompée Leonie, qui étoit d'Arezzo. Il continue par l'anatomie des chevaux, & par les observations que Léonard avoit faites sur la physiognomie, dont Rubens avoit vu pareillement les desseins, & il finit par la méthode dont ce peintre mesuroit le corps humain.'

Some evidence of what Rubens saw in 1603 at the home of the sculptor Pompeo Leoni is provided by a sheet of caricatures and heads in the Albertina (Plate 55).[129] The pen work, particularly the tricks of forming the eyes, mouths, and hands, matches that found in the two sheets at Chatsworth of *Studies for a Last Supper* (Plate 193, 194) which belong to the same phase of his addiction to Leonardo. Indeed, since his copies on the Albertina sheet, on which even Leonardo's left-handed shading is aped, can only have been made in front of the originals, we have a further point for dating that important group

of early drawings in pen which includes also *The Washing and Anointing of the Body of Christ* and *The Descent from the Cross* (Plates 195, 148). He compiled this record of his visit to the Codex Atlanticus by copying attentively, but with characteristically subtle modifications, the following drawings, all now in the Royal Library at Windsor: 12,449 *A Grotesque Betrothal*: 12,448 *Grotesque Profile of a Man wearing a hat*, to the right; from 19,004 *verso*, the head and neck of an *Old Man's Profile*, to the left; from 12,446, the topmost of three *Profiles of a Youth*, to the left; and three other unidentified profiles of men facing right, on a smaller scale, one being rather similar to 12,452.

Rubens's investigation of Leonardo's physiognomical and anatomical interests went deeper. There is a fine pen drawing of his at Chatsworth of a man's head and neck, shown *écorché* in great part so as to reveal the muscle system and bone structure (Plate 291).[130] He annotated it neatly in Latin, as though for publication, perhaps with whatever was in the 'vero modo per l'anatomia' section of the Pocket-Book, and with other material in an Anatomy Book whose separate existence was implied by de Piles. This material includes also three sheets in the Budapest Museum with pen drawings after parts of a human skeleton; and a man's legs *écorchés*, in the Albertina.[131] There was furthermore a drawing copied and annotated by Willem Panneels, the assistant entrusted by him with his studio material during his extended absences from Antwerp on diplomatic voyages 1628–30. 'Dese twee handen', wrote Panneels on his copy, 'heb ick geteeckent uit den anatomieboeck van Rubbens, die ick ook van't cantoor van Rubbens hebbe gehaelt'.[132] Among such material from the *cantoor* as is preserved at Copenhagen, there are several drawings by the master's own hand, including an admirable study in black chalk of the hindquarters and legs of a horse.[133] This, together with copies in the same collection by Panneels or by some other assistant, confirms the account of de Piles.

Rubens could share Leonardo's scientific interest in anatomy and in human physiognomy, studied both in heads of ordinary beings under stress and in grotesques. He could share his passion for the wildness and nobility of horses. He could emulate Leonardo's affective power to stage dramatic actions. But in whatever was mysterious or ambiguous in Leonardo's forms he hardly seems to have felt himself engaged. Between these artists of genius there was a divisive discrepancy of temperament.

(iv) ANDREA DEL SARTO

If, when he crossed the Alps, Rubens lacked adequate apprehension of Leonardo's scope and achievement, his inkling of the achievement of Andrea del Sarto was no stronger. However, he came to esteem Andrea; first and foremost for his narrative frescoes *en grisaille*, technically very large brush drawings on plaster, subtly rich in tonal contrast. On a visit to Florence, not necessarily either the recorded visit of 1600 or that of 1603, he copied *The Steward paying the Labourers in the Vineyard* (Plate 59), the parable frescoed on a wall of the Chiostro dei Morti of SS. Annunziata.[134] The black chalk underdrawing of his copy is washed appropriately in brown ink, and heightened with touches of white. Repairs and retouchings indicate that he gave this sheet fresh attention many years later. He also retouched an old drawing of *The Nativity of the Virgin*, which Andrea had painted in the *chiostricino* of SS. Annunziata.[135] However, Rubens's chief concentration, as we might expect, was on the fresco cycle of the early 1520s which is one of Andrea's supreme achievements and a foretaste of the style which he himself was then developing: *The Life of the Baptist* on the walls of the Chiostro dello Scalzo. Delicately, using brown ink with the point of the brush, he copied the *Salome bringing the Baptist's head to Herodias* (Plate 58).[136] Almost certainly he copied at least the figure of the executioner in *The Decollation*; for that was to be the prototype of the executioner painted for him in the Prado *Judgement of Solomon*. A veritable instance of his excerpting a single figure which took his fancy is a drawing rich in sanguine, used both from the stick and in solution, of the serving man's backview in *The Dance of Salome* (Plate 57).[137] Had this sheet not been shorn of its corners, we might well have seen on it '*Andrea del Sarto*' in his script: for a pupil's repetition of this show piece of profitable study is to be found in the *cantoor*.[138]

Nor did he neglect the panel paintings of Andrea's maturity. *The Assumption* commissioned by Margherita Passerini for S. Antonio Abbate at Cortona, *The Sacrifice of Isaac* which was in Medici hands in Florence, and *The Holy Family* painted for Ottaviano de' Medici seem to have been in his thinking when he came to compose his own treatments of these subjects in Antwerp. It may well be that the skill in rendering draperies luminous on panel, with boldly broken colours, which he developed during the middle 1620s, was spurred as much by memories of Andrea's beautiful practice as by anything he had extracted from Venice.

(v) CORREGGIO

Vaenius's masterpiece of 1589, *The Mystic Marriage of St. Catherine*, introduced Rubens to the fascination of the Correggesque. Reckoning with that, and with his own reading of Vasari – for there were few fine engravings after Correggio from which to work in Antwerp – it is no wonder that Rubens sought in Italy to win directly from the Emilian master's paintings the key to this combination of graceful inflection, *sfumato* forms, and effulgent light. At Mantua he encountered, and was in due course instructed to copy for the Emperor in Prague, both *The Education of Cupid* and *Jupiter and Io*.[139] Moreover he would soon have become aware of the revival of interest in Correggio stimulated at Bologna by the Carracci. His own expeditions to Emilia were to include a visit to Modena, where he drew in pen and wash a spirited copy of *The Madonna with St. George* (Plate 60);[140] and there were to be reflections of that in his work in Rome, both in the Colonna *Entombment* about 1602 (Plate 199) and in the trial piece of 1606 for the high altar of the Chiesa Nuova (Plate 323). From his *Nativity* for Fermo (Plate 340), we can infer that he studied also *The Nativity* in S. Prospero, Reggio.[141] He had to investigate the luminous and atmospheric magic in the '*Notte*', no less than the grace of posture in Correggio's day scenes. Furthermore he must have climbed to the roof of Parma Cathedral, in order to draw through an oculus of the drum the awe-inspiring figure of one at least of the apostolic witnesses to *The Assumption* in the dome above (Col. Plate II). This stupendous copy,[142] resplendent in sanguine with heightening in white and ochre, was inscribed by him, 'Ant.º da Correggio'; again, as with his copy of Raphael's drawing for *The Transfiguration*, not because he himself was liable to forget the authorship, but because he chose to put it as an example of *disegno* before his students in Antwerp to copy in their turn.

His most fully Correggesque work is his altarpiece of 1605 for the Genoese Gesù. The glory of angels above the scene of *The Circumcision* (Plate 249),[143] like those in the 1608, Fermo,[144] and 1609, Antwerp,[145] versions of *The Nativity* (Plate 340), could scarcely have been conceived without intense study of Correggio's works *in situ*. The rabbinical figures, larger than life, shaghaired and staring-eyed, are cast in the mould of the Parma Apostles. The attitude of the rabbi cutting the foreskin reflects that of the Magdalene in the '*Giorno*'.[146] The light emanating from Jesus is inspired by the '*Notte*'. The distinguishable influence of Correggio persists in his work for the Oratorians; in the Fermo altarpiece; and, in the final version of the Chiesa Nuova altar (Plate 333), in the cherubim heads almost evaporated in light-filled cloud, and in the magnificent seraph genuflecting in the right foreground. Then, soon after his homecoming to Antwerp, it dissolves into the general sum of his experience. Had he returned to the Italian cities and been commissioned to fresco vaults and domes, it is a fair guess that he would have shown himself the gainer by further study of Correggio; but the canvases he designed for ceilings in Antwerp and London are more clearly the fruit of his studies of Giulio Romano and the Venetians.

(vi) PARMIGIANINO

As distinct from the art of Correggio, the art of Parmigianino could have reached Rubens through the numerous prints circulating well beyond the territories of Parma; and these prints included a *chiaroscuro* woodcut with etched outlines based on Raphael's *Healing of the Lame* (Plate 42).[147] Whatever youthful attachment Rubens might have had to this highly mannered style could have been confirmed in 1629–30 by the occasion to peruse the anthology of Parmigianino drawings at Arundel House. But of positive reactions to Parmigianino's painting in his own work, no more than two, scarcely connected examples are known, both of them free copies: one of the *Cupid sharpening his bow* (Plates 61, 62), a canvas which he signed and dated 1614;[148] and the other of the *Allegorical Portrait of the Emperor Charles V*, formerly in the Gonzaga collection at Mantua. The latter copy has come down to us only in what appears to be a studio repetition of a Rubens of the middle 1630s.[149] The first, by contrast to Joseph Heintz's substantial but unimaginative copy[150] of the picture, is robust comment on the febrility of the original; but plainly an awareness of the antique prototype in marble sculpture for the main figure and of the Leonardesque group of the *putti* embracing in the background prompted his invigorating exercise of talent, as much as any involvement in the art of Parmigianino. The second, a rendering prompted by a lifelong interest in historical portraiture, was effectively an addition to his own repertoire, rather than a salute to the painter who was the Emperor's brilliant young contemporary; and, significantly, the head of the Emperor has been Titianized. Neither copy implies empathy with the range of Parmigianino's achievement.

4. The sixteenth-century Venetian tradition

RUBENS saw his first Venetian pictures of importance when he reached the Veneto. Nothing accessible to him before 1600 could have prepared his eyes for the paintings which enriched walls and ceilings in the churches and palaces and *scuole grandi*, or for the light of Venice itself, reflected around and within these buildings. His preview of the masterpieces of sixteenth-century *disegno* was essentially monochromatic, limited mainly to prints and perhaps to a few original drawings. His foreknowledge of Venetian colour hardly extended beyond a few inconsequential copies in oils: and from those he could have derived only a very inadequate notion of the sensuous pleasure of Venetian brushwork.

In black and white, some major compositions were familiar. Presumably he was introduced to Jacopo Tintoretto's vast *Calvary* in the Scuola di S. Rocco through Agostino Carracci's engraving of 1589. He certainly knew those impressively large woodcuts after Titian, *The Destruction of Pharaoh's Host in the Red Sea*[1] as well as *The Triumph of Faith*,[2] besides engravings by Cornelis Cort after a number of Titian's paintings such as *The Martyrdom of St. Lawrence* and the 'Gloria';[3] and, again through an Agostino Carracci engraving, he would have known the *Calvary*[4] after Veronese's altarpiece in S. Sebastiano. Moreover, his interest in elements of at least two of the Titian designs cut in wood by Boldrini persisted well beyond his Italian period. He was clearly to benefit by them in his own treatments of the subjects painted in Antwerp: *The Capture of Samson* for Nicolaes Rockox;[5] and *The Adoration of the Shepherds*,[6] now in the National Gallery of Scotland.

Attracted to the Veneto by the fame of her greatest masters, Titian, Tintoretto and Veronese, Rubens discovered there also aspects interesting to him of the art of Giuseppe Porta, of Pordenone and of Farinati; and in Rome of Muziano. He was excited by the recent work of northerners in Venice, Schwarz, Rottenhammer and Elsheimer: but not at all by the work of such senior contemporaries of his from south of the Alps as Palma Giovane or Sante Peranda.

(i) TITIAN

In Antwerp Rubens's earliest reactions to Venetian art of which we have record had been pen copies of what caught his attention in prints: the group of Callisto held by two nymphs (Plates 66, 65), excerpted from the 1566 engraving by Cort which adapted Titian's *Discovery of the Shame of Callisto*;[7] and two heads of women, copied from *The Triumph of Faith* (Plate 68).[8] Stylistically the former resembles his copy of *Lot and his Daughters* engraved by Agostino Carracci (Plates 63, 64),[9] as well as his *Diana's Nymphs disrobing*, in which he copied details from two plaquettes by Jacob Cornelisz.Cobaert.[10] His own early exercise[11] on *The Discovery of the Shame of Callisto* theme (Plate 67) combines awareness of Titian's composition, reached by way of Cort's print, with knowledge (doubtless reinforced by another of his copies in pen) of a figure from a third of Cobaert's plaquettes: and it is on the *verso* of this very exercise that we find the heads from *The Triumph of Faith*.

The pen drawing from the Cort engraving shows him copying attentively. At the same time he intensified the vitality, introducing a more elegant rhythm to the wrist and fingers of Callisto's left arm, grasped by the right arm of the nymph standing behind her. Characteristically he emphasized contours and shadows, slightly enlarging the scale of his model. His copy is one of his earliest drawings known, a prime token of his interest in Titian's treatment of the Ovidian theme. The *poesia* (Plate 69),[12] despatched by Titian to Philip II in 1559, Rubens first saw in 1603, on his mission to the Court of Philip III. We do not know what his reaction may have been then to this particular masterpiece, experienced in the context of the Habsburg collection with its incomparable array of Titian's mature achievement. But on his second visit to Spain, a quarter of a century later, he was to record 'en trois crayons' the heads of three of Diana's nymphs (Col. Plate XVI); and this *ricordo* is on the same sheet as a head taken from *Venus and Adonis,* and as a female nude and another head with an arm taken from *Diana surprised by Actaeon*.[13] By then he must have contemplated painting for himself full-scale copies of all three of these *poesie*. For, according to Velazquez's father-in-law, Pacheco, he copied every Titian in the collection of Philip IV.

Even if Pacheco exaggerated, Rubens can be believed to have made at least careful drawings with colour notes of very many of the Titians then in

Habsburg possession. Two of his full-scale copies of the *poesie* painted for Philip II are known: *The Rape of Europa*[14] and *The Discovery of the Shame of Callisto* (Plate 70).[15] The latter copy, besides that of *Diana surprised by Actaeon*, came into the possession of Charles I of England: and, as we know from Rubens's Inventory in 1640, he copied all four *poesie* which had actually been delivered to Spain. His *Rape of Europa* and *Discovery of the Shame of Callisto*, compared to his still later copies after the Titians from Alfonso d'Este's *camerino d'alabastro*, *The Worship of Venus* and *The Bacchanal of the Andrians*,[16] are conspicuously faithful to the original compositions, even to the forms of landscape and sky; and this fidelity was facilitated by his taking canvases of almost the same proportions. But he used finer canvases than Titian, primed with light grey paint instead of brown bolus, and the ground tone of his copies is thus cooler, allowing both a higher key in luminosity and freer play for his favourite warm colours. In *The Discovery of the Shame of Callisto*, for example, vermilion and ochre combine in the bright orange of the quiver, as against Titian's subdued red; and ochre and madder in the flesh, accented with vermilion, are either used opaquely, or scumbled thinly over the grey ground in order to impart to the flesh painting a nacreous effect not to be matched in the original. His other colouristic changes are of the same order: an enrichment of the golden effect of the yellow drapery hung in the trees: and a use of rose-madder for the drapery rather than the gold broken with mauve chosen by Titian. Titian, working from the general warmth of his habitual bolus ground, accented blue while subduing red, conspicuously in the blue of the distant hills and in the saturated blue on the huntress with the bow at the extreme right. Confrontation of details in the original and the copy, corresponding to that part of the composition which had first caught the eye of Rubens as a draughtsman thirty years before in Antwerp, reveals how the modelling in the copy is more opulent and explicit, yet without any loss in the subtlety of *chiaroscuro* or in dramatic expression.

Rubens painted the *Callisto* copy virtually without hesitation. Only one pentiment has become obvious, in the foot of the nymph who exposes Callisto's shame. The full-scale copies in this group, of which at least *Venus and Adonis* and *Diana surprised by Actaeon* remain to be rediscovered, seem too many and too carefully prepared to have been done in Spain in 1628. The facture, and the use of light grey primings on fine Flemish canvases, differ from those of the posthumous *Philip II on horse-back*,[17] which he painted in Madrid on a Spanish canvas of a coarser weave, prepared with brown bolus, and which is documented to that year. His copies of the Habsburg Titians remarked by Pacheco in *El arte de la pintura* are likely to have been slighter affairs. Rubens had little notion how long Spanish delays in diplomacy might keep him in Madrid. Furthermore time available for painting on his own account was curtailed by calls to supply the Archduchess with portraits of the royal family.

By copying idiosyncratically the *poesie* for Philip II, and, more freely still, the *Bacchanalia* painted in the 1520s for Alfonso d'Este, Rubens in his fifties acknowledged gloriously one side of Titian's achievement. But the triumphs of Titian's mythological paintings to be seen in Madrid and in Rome were of less interest to Rubens in his twenties than the heroic actions conceived by Titian in the 1540s: *The Mocking of Christ* in Milan;[18] and in Venice, the ceiling pieces for S. Spirito in Isola,[19] *The Battle of Spoleto* for a wall of the Doge's Palace,[20] and the '*Ecce Homo*',[21] which he first saw in the house of a fellow countryman. *The Mocking* was in his mind when he was occupied with his own treatment of this subject (Plates 181, 182). Evidently on an early visit to S. Spirito, he copied from the vault as carefully as he could *The Sacrifice of Isaac* (Plate 71).[22] As we may guess from the actions of *Hercules vanquishing Envy*,[23] in the Whitehall ceiling, and of *Hercules wielding his club,* atop the rear face of *The Arch of the Mint*,[24] which he was to design for the Entry of the Cardinal-Infante Ferdinand into Antwerp, he must have taken account in S. Spirito also of *Cain slaying Abel*. The mural of *The Battle of Spoleto* had been destroyed by fire twenty-six years before he set foot in the Doge's Palace; but he was able to work from an old copy in oils and from the Fontana engraving. In his own copy (Plate 51) he concentrated, as in his copy from Leonardo's *Battle of Anghiari* (Plate 54), on the heart of the combat, omitting the landscape background. For his earliest copy[25] of the '*Ecce Homo*' (Plate 72) he used appropriately the same typically Venetian medium, black chalk on *carta azzurra*, as he used also to copy *The Sacrifice of Isaac*; there are characteristically piquant corrections on it in brown ink, both with a pen and with the point of the brush, as well as heightening in white and buff with traces of rose and green bodycolours. As with *The Sacrifice of Isaac,* he took liberties in copying the sky. The draperies – we may remark especially the ermine-collared dignitary in the foreground – are, by comparison with those of Abraham, more freely rendered; and there is a revealing change in the inclination of the

hand and in the facial expression of the child held by his mother. This stupendous masterpiece of Titian's maturity haunted his imagination. It is reflected in the crowd at the foot of the steps in the *modello* which he painted about 1614 in Antwerp for the projected triptych of *The Miracle of St. Bavo*, and even more clearly in his *Miracles of St. Benedict*.[26] Two figures redolent of it found places in the huge *Santa Conversazione* which he was able to complete for the principal altar of the Antwerp Augustinians in 1628, before departing on the round of his diplomatic voyages.[27] There they stand, the Baptist and St. William of Aquitaine, with a third saint who echoes the S. Bernardino in the woodcut after Titian's votive picture for Doge Andrea Gritti,[28] in sign of that recrudescence of his love for Titian's art which immediately preceded his chance to revisit the Habsburg collections in Spain. We may gauge his deepening familiarity with Titian as a designer by confronting his drawing of the 'Ecce Homo' about 1600 with the looser and more idiosyncratically rhythmic interpretation which he drew of it in 1629 in London,[29] when he could enjoy the picture again every day in York House where he lodged (Plates 72, 73).

An even more spectacular progress *vis à vis* Titian may be observed in his successive reactions to *The Fall of Man*.[30] In 1603 he saw this painting for the first time in Madrid (Plate 74). The *carta azzurra*, on which he then recorded the composition in black chalk, has greyed; and the surface is worn.[31] But rubs of time do not disguise the sensitivity of the drawing (Plate 75), nor the nice assurance with which the modelling is heightened with brush and bodycolour on the belly of Adam and the thigh of Eve. The morphology and the muscling of the bodies are subtly but unmistakably his. His is the new rhythm in the tree trunk, the new turn of Eve's left arm and wrist, and the new tension in the gesture of protest by Adam's left arm. His, not less characteristically, is the idea to clear the foliage from the profile of Eve. We may imagine how he kept this small souvenir near at hand during the twenty-five years before he had the chance to stand again, and at more leisure, in front of the picture in Madrid and to paint his full-scale reinterpretation, a glowing masterpiece in its own right (Plate 76).[32] Then, indeed, by the insistent throb of his reds, by the sensuous energy in the new-found response of his Adam to his Eve, he surpassed the vitality of the original invention.

In Venetian churches, on leave from Mantua and perhaps as late as 1605, he drew Titian altarpieces: the S. Maria Nuova *Penitent St. Jerome*[33] and the S. Spirito *Pentecost* (Plates 78, 81).[34] These copies are patently more advanced than those drawn of *The Sacrifice of Isaac*, the *Ecce Homo* and *The Fall of Man*. More elaborately treated with brown washes and bodycolours, they are luminous and palpitating with relief, products of a rapidly developing plastic sense. He must have looked many times at *The Assumption*[35] which commands the length of the Frari; and he was stirred to emulate this first public triumph of Titian in Venice two decades later in Antwerp, when commissioned to paint the subject for the high altar of the Cathedral.[36] He must have been attracted also by one or other version of *The Adoration of the Magi*,[37] particularly by the commotion of horses and attendants, mounted and dismounted, at the right of the scene; and he introduced a variation on this elegant motif into his own treatment of the subject which he had painted for the Antwerp City Hall, when in Madrid in 1628 he had the chance to revise and extend the composition.[38] His *Martyrdom of St. Lawrence*[39] was invented in thought of Titian's masterpiece for the Gesuiti.[40]

In addition he noted single figures: the *Danaë* in Rome, painted for Ottavio Farnese some sixty years before; and Gabriel in the upper left canton of the 1522 polyptych for SS. Nazzaro e Celso, Brescia. His drawing of the *Danaë* looks to be knowledge acquired for its own sake.[41] The delicate shaping of head and thighs, and the folding of the drapery are idiomatic. The delineations with the point of his brush dipped in grey wash have paled from exposure; and the accents in black chalk tell by contrast too strongly. Yet, considered in a fair light, the coherence and beauty are apparent; and time has not harmed the rehearsals of Danaë's left foot, firmly and finely drawn in the black chalk. When, shortly after he had resettled in Antwerp, he painted an *Annunciation* there (Col. Plate XIII) for the Maison Professe,[42] the Gabriel was more or less overtly a tribute to Titian's at Brescia,[43] particularly in the power and urgency conveyed by the ample swirl of drapery about the arm. The same intensity was relayed in a *St. Francis in prayer* (Plate 80), drawn during the latter half of his Italian years on *carta azzurra*, mainly in charcoal with some black chalk, and with traces of red chalk on the cheek, ear, and fingers.[44] A restorer has 'completed' this sheet at the right by a vertical strip, adding upon it the saint's feet, clumsily, in a combination of red and black chalks. On the original portion, inscribed '*titiano*' in black chalk apparently by Rubens, the artist himself

has partially obliterated with greenish bodycolour a previous position of the saint's left hand. None but he can have been responsible for the vigorous accentuation of the head in buff, cream, and white, and for the basic work in charcoal and chalks. The shaping of the figure and the folds of the robe and cowl are as indicative of his hand as the inscription.

The sale inventory taken in his house at his death itemizes no fewer than six 'draughts' attributed to Titian, Tintoretto and Veronese.[45] These included what seems to have been a large *ricordo*, sketchily done, of Titian's *Death of St. Peter Martyr* in SS. Giovanni e Paolo, the composition of which fired his imagination when he came to paint *The Martyrdom of St. Livinus*.[46] This and a grisaille by Veronese were to be bought from his estate for Philip IV of Spain. Unfortunately, neither item can now be traced. Classed by his heirs for sale with the paintings, they must have been sufficiently finished to be framed for show, although frames are not specified. Record of them, even with incomplete identification, at least reinforces our suppositions of his continuing interest in Venetian sketches as well as in finished paintings. Nevertheless it is in the finished paintings listed that we find the most impressive evidence of his devotion to Titian over four decades of his working life: twenty-five copies of portraits, including the full-length *Philip II* (Plates 223, 224) made in 1603,[47] and the double-portrait of *Charles V seated with the Empress Isabella* made in 1628;[48] 'Une pièce des Cupidons se batons, prise de *Philostrate*' with 'Une pièce des Bacchanales des bergers et bergères dansans et beuvans, aussi de *Philostrate*', these final commentaries on two of Titian's subjects for the *camerino d'alabastro* at Ferrara being classified not surprisingly as his own independent works;[49] and seven other more or less free copies: of the four *poesie* for Philip II, of two pictures of *Venus*, and of *The Fall of Man*. In addition to these copies, far more than he had painted of any other master's work, he died possessed of four paintings believed to be Titian originals, besides 'Deux visages de nostre Seigneur, qu'on croit estre de *Titian*' and 'Une Psyché avec une bouteille à la main, retouchée par *Titian*'. Of the four reputed originals, one at least was indeed by Titian's own hand, the battered but still marvellous *Self-Portrait in old age*, now in the Prado.[50]

(ii) TINTORETTO

Fittingly, Rubens came to own also a *Self-Portrait* by Tintoretto;[51] for if his love for Titian's art was to develop over a much longer period, he became in Italy, it seems by a *coup de foudre*, an ardent disciple of Titian's one-time pupil. The heroic back view in Tintoretto's *Hercules and Antaeus*,[52] as well as figures from the Scuola di S. Rocco *Calvary* (Plates 184, 186),[53] were surely in his mind's eye when he came to compose *The Elevation of the Cross*[54] for S. Croce in Gerusalemme (Plate 187). Tintorettesque outbursts of light rend thunderous skies in a succession of his Italian works: the London National Gallery's early *Judgement of Paris* (Plate 208);[55] the Villa Borghese *Entombment* (Plate 199);[56] the Mantua *Martyrdom of St. Ursula* (Plate 234);[57] the Yale *Hero and Leander* (Plate 232);[58] the privately owned *Fall of Phaethon* (Plate 235);[59] and, most sensational of all, *The Transfiguration* for Mantua (Plate 247), now in the Musée de Nancy.[60] The fringes of light which silhouette hair and fur and foliage are seen not only on that huge canvas, but in *The Circumcision*[61] for the high altar of the Genoa Jesuits (Plate 249) and in the life-size equestrian portraits of *The Duque de Lerma*[62] (Col. Plate IV) and of *Marchese Doria* (Plate 266)[63]. These illuminations were inspired by what Rubens saw in the late style of Tintoretto. Consonant with them was his emulation of Tintoretto's brush stroke, moving swiftly and often jaggedly, as it were a pencil of light, over the bolus-prepared surface of his own canvases; and here we may think also of his full-length portraits of Genoese ladies[64] and of his *St. George slaying the Dragon* (Plate 238).[65]

Rubens in Italy was fascinated by Tintoretto's spectacular foreshortenings. *St. Mark rescuing a Slave* in the Scuola di S. Marco[66] provided him not only with an idea, taken from the attitude of the slave, how to pose a model on the floor of his own studio,[67] but also with the inspiration from the miraculous apparition of the patron saint, for Hero plunging fully clothed from her tower in his *Hero and Leander* (Plate 232). And he responded vigorously to the nervous extravagance of the postures invented by Tintoretto for displaying the male form in action; not only the Hercules in *Hercules and Antaeus*, and the men straining to raise the thief's cross in the S. Rocco *Calvary*; but also the figure in *Vulcan's Forge*[68] who kneels with his back to us, and the pikeman fording the Taro in one of the Gonzaga battle scenes for Mantua.[69] The last mentioned seems to have inspired an equivalent figure in *The Destruction of Pharaoh's Host in the Red Sea* (Plate 236),[70] which he painted in Italy; the penultimate, one which he was to introduce into the foreground of *The Miracle of St. Francis Xavier,*[71] painted for the Antwerp Jesuits. Rarely, however, compared to an Antwerp predecessor of his in Venice, Frans Floris,

did he employ any of Tintoretto's figure compositions. The most significant example is again to be found in one of his huge canvases for the *cappella maggiore* of the Mantuan Jesuits: in *The Baptism of Christ* (Plate 246) the principal group reflects his attention to Tintoretto's treatment of the subject, now in the Cleveland Museum (Plate 244).[72] But the prominent use of steep steps to give an almost overpowering verticality to his final composition of *The Conversion of St. Bavo*[73] may refer to Tintoretto's *Presentation of the Virgin*[74] in the Madonna dell'Orto.

Besides the *Self-portrait*, Rubens came to own three other portraits by Tintoretto. Two are hard to identify, of unnamed Venetians. But 'Un très beau portrait d'un homme couvert d'une Robbe fourrée, de *Tintoret*' is almost certainly the portrait formerly in Sir John Leslie's collection, since Rubens copied for his own pleasure the head and shoulders (Plates 87, 88).[75] His painted copy testifies to the internal life of his collection, its procreativity. Again we may remember that Jegher recommended himself to his service by a chiaroscuro woodcut of the so-called 'Doge Giovanni Cornaro' showing the head and shoulders as painted by him[76] after a Tintoretto portrait now in the Los Angeles County Museum (Plates 85, 86). And in the summer of 1622, as we know from letters to him from Peiresc, he was able to buy in Paris a Tintoretto painting of *The Last Judgement*. This may have been among the paintings and other treasures of his collection which he sold to Buckingham in 1626.

The 1640 inventory included also two 'draughts' by Tintoretto, an *Assumption* and a *Last Judgement*. The first might have been a sketch connected with the Crociferi commission for the church in Venice which was later to become the Gesuiti:[77] the altarpiece described by Boschini as 'una delle singolari opere del mondo', which understandably had so impressed the Carracci. The other, not to be confused with Rubens's 1622 purchase, may have been connected with the commission for the Madonna dell'Orto, where he drew freely a partial copy of the altarpiece; and it may have given a lead to his *Last Judgement* for the high altar of the Neuburg Jesuits[78] – not so much in detail as in the general movement in and out of a fitful illumination of a configuration pierced by more intense celestial light from beyond.

Rubens must have studied aspects of Tintoretto's very painterly draughtsmanship. An antique group in marble, visible in Rome at the house of Cardinal Ferdinando de'Medici, may have been the point of departure for his drawing of *Two Naked Youths Wrestling*[79] (Plate 83): but the far from sculptural manner in which he illuminated with white heightening and brown wash the velocity of that action, the rhythmic foreshortening and the loose cyphering of extremities, these speak of some familiarity also with composition trials such as Tintoretto had made for his *Mars, Venus and Vulcan*.[80] The profiles of the head of the *Farnese Hercules* which he drew either side of a single sheet by different casts of light (Plates 279, 280) relate more than coincidentally in technique and approach to those views of antique marble heads which were drawn in black and white chalks by Jacopo or other members of the Tintoretto family.[81]

His most dazzling response as a draughtsman to Tintoretto however was not to the masterpieces of the 1550s, but to one of the supreme creations of the last years, *The Battle between St. Michael and Satan* (Plates 82, 84).[82] In his drawing he clung to the configuration of the original painting: but, in drastically changing both scale and medium, he recast the combat by a light less mysterious but more ardent. The archangel and the angelic host, gloriously incandescent, swoop out by a sunburst instead of by the lurid flare of myriad torches.

(iii) PAOLO VERONESE

A century ago, in his *Recollections of Rubens*, Jacob Burckhardt said of him perceptively, but overemphatically: 'It is obvious that his deepest kinship by far was with Paolo Veronese; here two minds converged, and there have been pictures which might be attributed to either.' The range of Rubens's interest in Veronese is suggested by two copies. One, made in Italy, is a large drawing of *The Feast in the House of Simon* (Plate 91).[83] The other, painted in oils some years after his return, is of a three-quarter-length portrait of a *Lady in a rust-coloured dress* (Plate 89, 90).[84]

The first, inscribed by him for the benefit of his pupils, 'Paolo Calliari da Verona', shows him fascinated on a visit to SS. Nazzaro e Celso in Verona by the way that Veronese staged fashionable throngs, shining within grandiose architectural settings. He himself was to display taste of this sort by his altarpiece for the Mantuan Jesuits (Plate 239).[85] Across that canvas he spread likenesses of three generations of the Gonzaga, the five children with their pet terrier, as well as the reigning Duke and Duchess, and the Duke's parents, all assembled on a balustraded terrace, all but the dog kneeling. The sunlit scene is flanked by colonnades shading halberdiers

in Swiss uniforms, two on one side and a third on the other.

The second copy shows his delight in the luxury of silks and bows, the colours of stuff enhancing the colours of hair and flesh.[86] He has adjusted the age of the sitter in order to glamourize her; and he has concentrated the effect by a substantial reduction of decorative detail.

As a painter Rubens was less interested in the refinements of Veronese's lighting than in the organized profusion of figures and the splendour of their apparel. In the decade after he left Italy this admiration for such scenography reached a peak: in his project for Ghent, a *Conversion of St. Bavo* triptych, of which the upper zone is filled by an arcaded *loggia* and a balustraded terrace enlivened with bystanders; and in his monumental canvases for the high altar of the Antwerp Jesuits. However, the fullest expression of his feelings awaited the middle 1630s, when he invented in several versions the '*Conversation à la mode*',[87] a dream of luxurious dalliance in a park. This paean of his praise for the secular side of Veronese's art corresponds to his *Feast of Venus Verticordia* for Titian's.

In Italy Rubens seems to have taken the *Calvary* as authority for depicting in his *Elevation of the Cross* the Madonna fainted in the arms of a Mary. He must have noticed, whether or not he copied, other religious compositions of Veronese's maturity. *The Adoration of the Magi* in S. Corona, Vicenza, is reflected about 1602 in his own tenderest treatment of that subject (Plate 200).[88] The *St. Menna* organ-shutter in the Venetian church of S. Geminiano[89] probably inspired the stance of one of the guards in the Gonzaga altarpiece of 1604–5. Recollection of the compositional device of a brick arch, with steps up the left side and an iron railing to the platform above, a feature of *The Visitation* (Plate 92),[90] was crucial to the development almost a decade later of his treatment of that same subject on the left wing of *The Deposition* triptych for Antwerp Cathedral (Plate 93).[91] Most exciting of all must have been the ceilings to be seen in Venice, in S. Sebastiano and in the Doge's Palace. The S. Sebastiano *Esther before Ahasuerus* was to be acknowledged spectacularly in his design of the subject for the Jesuit Church in Antwerp,[92] and again in composing *The Union of the Crowns of England and Scotland* for the Banqueting House at Whitehall.[93] On that same ceiling in London, *The Benefits of the Wise Government of James I*[94] exhibits by its illusion of architectural pomp, and by the steep foreshortening of the figure in flight, his debt to *The Triumph of Venice* in the Sala di Maggior Consiglio;[95] indeed the division of the rectangular ceiling by 'cornishes' into nine compartments, including elliptical fields at the corners, shows how Inigo Jones was ready to adapt the lay-out of the Sala dei Dieci ceiling, which Veronese had embellished for the Doge.

Although the paintings or sketches attributed to Veronese which Rubens came to own are not identifiable with certainty, the *Lady with a Lapdog*[96] may be the portrait in the Thyssen collection; *The Vision of St. Helena*[97] was perhaps similar to the London National Gallery picture; and the *grisaille* sketch was among the pictures bought for Philip IV of Spain. Furthermore we may guess that Rubens owned at least one of those drawings in pen and wash which Veronese brought to a delicate and luminous finish with touches of white bodycolour: for in just that manner, which Veronese had perfected in the 1570s, he himself invented a group of figures in order to complete to a rectangle the roughly triangular left-hand portion torn from the surviving fragment of Federico Zuccaro's composition trial for *The Conversion of the Magdalene*[98] in S. Francesco della Vigna (Plates 141, 142).

(iv) GIUSEPPE PORTA

Rubens thus treasured and honoured what remained of a fine drawing by Zuccaro. He owned also a drawing for a painting in another major Venetian church: Giuseppe Porta's *modello* for *The Purification* over the Valier altar in the Frari (Plate 95).[99] In this case, the right-hand corner had been cropped apparently by Porta himself, he or his patrons being dissatisfied with that part of the proposal. In the altarpiece, with which Rubens must have become conversant, St. Mark sits by the feet of St. Gregory.[100] This seated figure seen laying aside an open book, attentive at the moment of revelation, derives from Raphael's St. Andrew who, compositionally and dramatically, fills the lower left corner of *The Transfiguration*; and, in preparation for his St. Mark, Porta drew a youth partly draped, an elegant revision of Raphael from nature.[101] Rubens replaced the corner of Porta's drawing in his richly plastic manner of 1606–8, evoking appropriately the Roman works of Raphael; and his work there contrasts with the shimmering manner which he was to evolve in the mid-thirties on the inspiration of Veronese.

The extent to which Rubens worked over the rest of Porta's drawing, as it eventually came to him, and thus far impressed his own personality on it, may be

assessed with unusual precision. There is a painstaking copy by a later sixteenth-century hand of the *Purification* model (Plate 94), partly mutilated as it was before he acquired it, and of almost the same dimensions.[102] This copy follows pedantically the style as well as the design of the original. Not only does it lack generally independence of artistic personality, but examination of the oddly incoherent form of St. Anna's right arm, where it should be supporting the casket, suggests that the copyist may not have been a professional painter, but rather some enthusiastic amateur.

The copy makes clear how Rubens turned the damaged upper zone of Porta's drawing to his own account. He introduced an effect which he favoured during these years when most conspicuously influenced by the illuminations of Tintoretto: a burst of light from an unseen source breaking through clouds. He restored the cluster of figures about the infant Mary. He obscured one acolyte; and he linked the other to the Rabbi with a train of rumpled drapery, so that figures which were set static and separate gather collective movement in response to the urgent gesture of St. Anna's offering, without upsetting the balance of the whole design. Finally he suggested with a rapid outline in black chalk, and then abandoned, a figure kneeling to the right of the remaining acolyte, more or less in the position where Porta did, in fact, introduce a boy into the finished altarpiece.

Consideration of the *Purification* model and the related figure study helps us to understand why Porta enjoyed such reputation both in his own day and in the period when Rubens was in Italy; it also illustrates the latter's taste and habit as a collector. There is further evidence for Rubens's interest in this painter, who, after years spent in Venice cultivating the manner of Titian, Tintoretto and Veronese, had had the chance shortly before undertaking the Valier commission to renew his eyes with the grandeur of High Renaissance Rome, and, in particular, with the achievement of Raphael. Rubens in the Borghese *Entombment* (Plate 199) showed himself to be in some respects, even after eighteen busy months of seeing Italian masterpieces in their intended settings, to be still only the most gifted pupil of Vaenius. The treatment of the head of Christ, for example, and the flesh painting overall is, in that early essay on the theme, tellingly close to *The Carrying of the Cross*[103] which his master had painted for St. Gudule, Brussels. But his picture has significantly closer affinities to Venetian than to Antwerp mannerism. The jagged *impasto* highlighting the shroud, the luminous fringe silhouetting leaves and hair and fur against the sky, and, once more, the radiance bursting through clouds, these are lessons in illumination learned of Tintoretto. Moreover, just as the head of Christ is an image not seen directly in nature, but a reflection of another man's concept, so the faces and attitudes of the mourners reflect types already coined. Comparison with Porta's *Christ mourned by three Angels* (Plate 197)[104] suggests that morphologically at least the art of that master was of direct interest to Rubens at the outset of his career in Italy. Both painted figures rather less than life-size, and both grouped them closely. There are similarities of attitude, disposition of persons and employment of iconographic necessities, tomb and shroud. The same calligraphy determines the swell of arms and the flat planes of fingers; while the physiognomy and expressive eye-rolling of Rubens's Madonna appear only a reversal of those seen in one of Porta's angels.

Porta's *réclame*, for at least a generation after his death, could have attracted the attention of any ambitious young man from Northern Europe, magnetized by the fame of sixteenth-century Venetian painting. His special appeal for Rubens, lately arrived, lay in the sight of his mature endeavour to bring something of the plasticity and majesty of High Renaissance art in Rome, to which by professional education he was heir, as a substantial refreshment to the special glory of the Venetian tradition in colour and light. This effort to achieve the long-sought marriage in art between Venice and Rome became for Rubens also a major preoccupation, and that almost from the start of his employment in Italy.

(v) PORDENONE

An enthusiast for the heroic aspects in the painted work of Titian and Michelangelo might be expected to have taken interest in comparable works by Titian's reputed rival, Pordenone. Rubens, on an early visit to the Veneto, went to Treviso Cathedral. There, in the apsidical Malchiostro Chapel, he no doubt studied Titian's *Annunciation*. He certainly settled down with chalks and watercolours to copy Pordenone's frescoes from the conch, *Augustus and the Sibyl* (Col. Plate III);[105] and, from the cupola, *God the Father supported by angels*.[106] His handsome copy of *Augustus and the Sibyl* is annotated in Latin, which he used as an alternative to Flemish in the years before Italian came easily enough to be his second language. Such mastery of noble gesture, and of the sweep of draperies in foreshortening, was

what he himself would require for the ceiling decorations to be placed in the Jesuit Church in Antwerp and in the Banqueting House at Whitehall. His record of *God the Father supported by Angels* evidently seemed to him most apposite about 1611–14; and the cherubim who encircle the Madonna in two paintings of the *Assumption,* a *modello* belonging to Buckingham Palace[107] and an altarpiece belonging to the Kunsthistorisches Museum in Vienna,[108] are happy recollections of those which he had drawn a dozen years earlier in Treviso. He is likely to have copied also in the Malchiostro Chapel Pordenone's *Adoration of the Magi*; for the Caspar in the fresco looks to be the inspiration of his own Caspar in the altarpiece he painted in 1633–4 for the White Nuns of Louvain.[109]

Rubens's attraction to Pordenone seems to have gone beyond the Cappella Malchiostro frescoes. A third drawing after this master, a *Decapitation,* is recorded by a manuscript inventory of 1731 as having been in the collection of Valerius Röver at Delft.[110] Each of the equestrian figures known to us from his Italian period can be viewed as a controlled adaptation to portraiture of Pordenone inventions for Venetian patrons: the *Lerma* (Col. Plate IV) advancing on us in the imperious style of the much admired *St. Martin*[111] in S. Rocco; and the *Marchese Doria* (Plate 266) leaping forward with the resolution, if not the frenzy, of *Marcus Quintus Curtius* frescoed at ground floor level on the façade of the Palazzo d'Anna.[112] As late as 1630, reflecting on 'his abode and employment' in England, he introduced a mounted standard-bearer with a large ensign in order to flank the composition of the *Landscape with St. George*.[113] He may then have had in mind a comparable motif in Pordenone's huge *Calvary* frescoed on the entrance wall of Cremona Cathedral; the late afternoon landscape itself being in the Titian vein. He may even have owned a Pordenone drawing. That Jordaens copied a variant of, or preparation for, the Cortemaggiore *Disputa,*[114] suggests that either a composition trial by Pordenone for this altarpiece, or a record of one by Rubens, was available to him in Antwerp.

(vi) PAOLO FARINATI

Paolo Farinati died at Verona in 1606 when Rubens, his junior by more than fifty years, was still in Mantuan service. Farinati must have appeared to the young Fleming – whether or not they actually met – as an old and old-fashioned artist; nonetheless a living link with the manner and decorative achievements of Paolo Veronese. Rubens's cult of sixteenth-century Venetian art extended to the *terra ferma.* Farinati's '*Filosofi*' drawing at the British Museum bears the mark of his attentions.[115] In 1768, at De Julienne's sale in Paris, part of lot 500 was 'Le Triomphe de Silène, par Paul Farinati, que Rubens a retouché et rehaussé de blanc au pinceau.' A third drawing, which entered the Hermitage that same year with the collection of Count Cobenzl as by Paolo Veronese, is Farinati's study for *The Conversion of Saul* painted in 1590 for the parish church at Prun di Negrar, near Verona.[116] This Leningrad drawing, originally and typically in pen and wash with fine hatchings of white, has been largely converted by Rubens, brushing on a brown ink, with rose and pale buff bodycolours, to his own forms and rhythms. He has remodelled the heads, particularly the faces of the standard-bearer and of the soldier to the right of Saul. His intervention is most telling in the plasticity with which the convert's left shoulder has been invested, in the ridge of drapery swung across his left knee, on the folds of his cloak, and in the hatching with brown ink below his beard which contravenes Farinati's original statement of the form. But the collector's hand has been busy in many places – from the soldier's helmet to the end of the horse's tail. The enthusiasm with which he worked may indicate that, at Farinati's death, he made it his business to acquire more of the artist's output than these three drawings; and not all of what he might have obtained would he necessarily have chosen to retouch.

So far as we know, Rubens at no time modelled his own drawing-style on that of Farinati. But there is a pleasing suggestion of his having absorbed one of Farinati's decorative ideas: in the twin friezes of *putti,* gambolling with wild beasts and cars and swags, which from the outset featured as an integral part of his ideas for the Whitehall ceiling.

(vii) GIROLAMO MUZIANO

Muziano, and his youthful success in Rome, attracted Rubens as a fellow admirer of Titian's way of setting a single figure heroically in a landscape. This attraction is well attested. The 1640 Inventory included, as item 20, 'St. Francys by Mutiano'.[117] Among the drawings by Rubens and his followers which were bought in 1671 from Jabach by Louis XIV are two in black and white chalks on *carta azzurra,* untouched originals by Muziano, both now in the Louvre: a study for the *Penitent St. Jerome* at Bologna (Plate 98); and, close in style, a *St. Francis in prayer*.[118] Both probably belonged to Rubens, the cross-legged *St. Jerome* offering him a striking sug-

VII. Detail from *The Fall of Phaethon* (Plate 235). About 1605. Oils on canvas. London, private collection

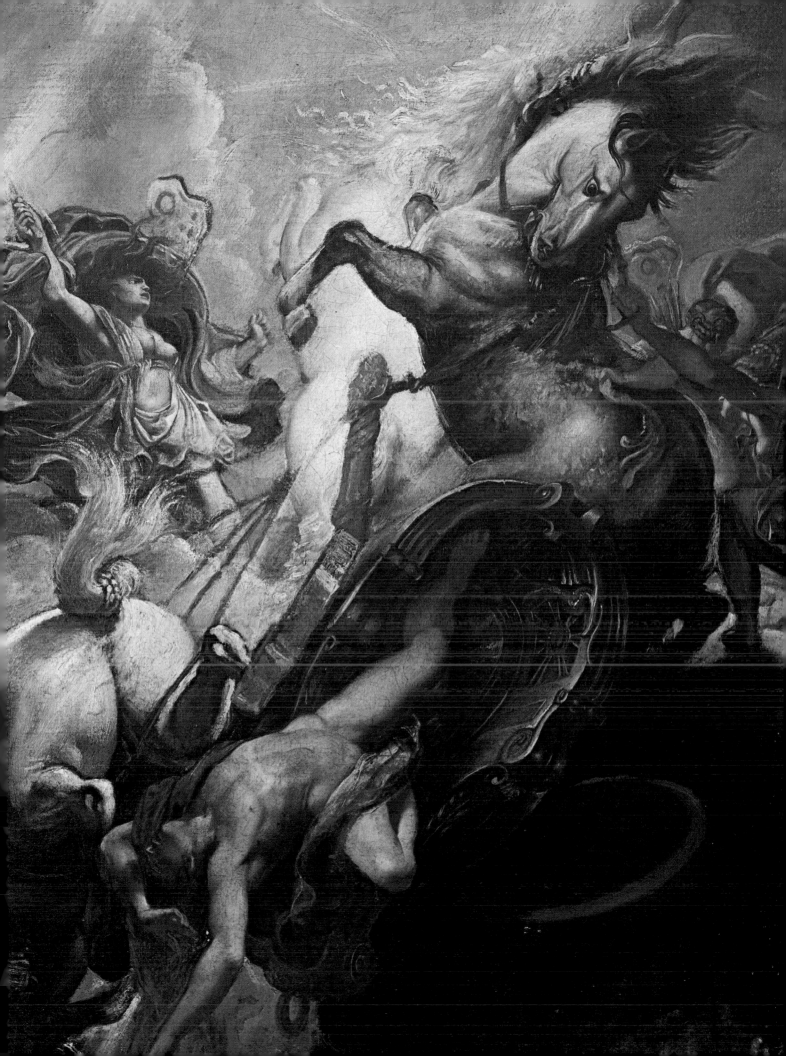

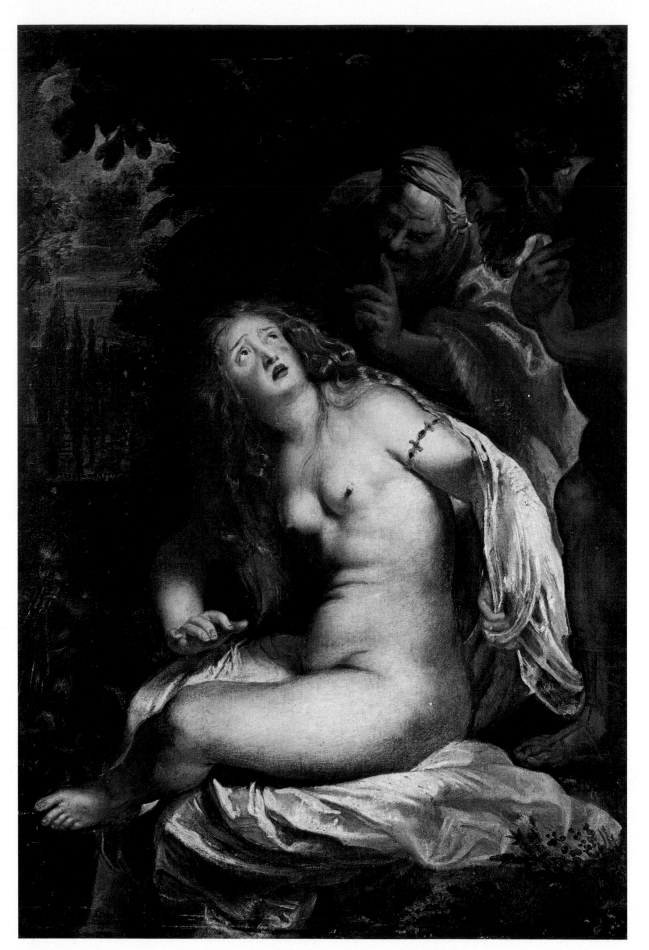

VIII. *Susanna and the Elders*. About 1607. Oils on canvas. Rome, Galleria Borghese

gestion of the pose to be studied from life for the young prophet in his *Daniel in the Lions' Den* (Plate 99). Elements of this figure style of Muziano are reflected in *The Raising of Lazarus*,[119] drawn by Rubens about 1606, in which he seems to have been copying a Muziano composition. In 1741, in Paris, Mariette catalogued as No. 633 at the Crozat Sale, 'Trois grands Desseins de Paisages à la plume très terminés, dans l'un desquels est representé saint Onufre, dans une autre saint Eustache, et dans le troisième saint Magdelaine (*sic*). Ils ont appartenu à Rubens qui a dessiné quelque chose dans un de ces Dessins.' Mariette's *expertise* may be checked by scrutiny of the signed and dated *modelli* drawn for the *Landscape with St. Onophrius* and for the *Landscape with the Magdalene* in this 'Great Penitents' series.[120] The Magdalene of 1573 shows a touch of white bodycolour on her hand, and some reinforcement in pen on patches of leaf and bough, decisive enough to be by Rubens. And there is a drawing by him in wash and bodycolours of a hermit, presumably St. Onophrius, in a landscape independent of this series, which in all probability is derived from Muziano.[121] Furthermore, in the Budapest Museum there is an engraving of the *Penitent St. Jerome*, proofed when the plate had only been worked with the kneeling saint, his lion, and part of the foreground.[122] Known in no other impression nor in a more advanced state, the design is redolent of Muziano; and the scheme for translating it into engraving could well be that of Cort. The cardinal's hat and crumpled cloak, also the landscape background, were added in pen and wash by Rubens of his own invention, without trespass on the printed area. Close comparison may be made with his drawing in this technique for *The Stigmatization of St. Francis*. His power to absorb Muziano's manner of rendering foliage is apparent. The dating of this *unicum* must be close to *The Stigmatization*, about 1615, when he may also have been planning the *Daniel in the Lions' Den* with Muziano's *St. Jerome* uppermost in his mind (Plates 98, 99).

The motif of upraised hands ecstatically clasped, used in a mannered way by Muziano for his Bologna *St. Jerome* and reinterpreted by Rubens for his Daniel, arms compact in a baroque thrust aslant the upright body, originates in the stable, pyramidal form which Michelangelo invented and passed to Sebastiano del Piombo for use in the Viterbo *Pietà*. Michelangelo's supplicant, drawn in sanguine, has had contours of hands and wrists insensitively retraced in pen (Plate 96),[123] whereas the other side of the same sheet, on which Michelangelo had drawn a seated youth from life for one of the Sistine *ignudi*, is untouched (Plate 97). Both sides have been inscribed near the upper edge by a later hand: 'C. P. P. Rubens', on the *recto*; and 'coll. P. P. Rubens', on the *verso*. If this plausible information is correct, then Rubens may be taken to have possessed also another, earlier drawing by Michelangelo, a pen study of *Three Men draped in Mantles*: for on that 'P.P.R.' appears in the same script at the lower right corner, suggesting not that he was ever in consideration as the author, but that at one time he was the owner of this sheet.[124] Again we remember the pen style of his early copies in the Sistine Chapel.

Attention to Rubens's self-involvement in the Venetian tradition returns us appropriately to Michelangelo and to the High Renaissance in Florence and Rome. But before turning from the Veneto and its art, we may note how Rubens was prepared to involve himself in one aspect of that wide range of Venetian painting by keeping his eyes open for a friend. Kaspar Schoppius claimed in his *Hyperbolimaeus*, the quarto which he published at Malines in 1607, that Rubens had told him that not a few paintings to be seen in Italy bore clear and authentic signatures of Paris Bordone. The work of Paris Bordone, even in landscape, was surely not of primary interest to the young Flemish painter: but while Schoppius was engrossed in tracing the descent of Scaliger of Leyden from the *Burdo* family, Rubens himself missed no detail of possible significance on his tours of curiosity.[125]

5. The predecessors at Mantua

(i) MANTEGNA

In solemn celebration of Philip Rubens's first visit to Italy, Peter Paul portrayed his brother and himself confronting before a windowless embrasure a third man, most likely their fellow countryman, Jean Richardot (Col. Plate 1 and Plate 253). This central conception was broadened to include three profiles: Justus Lipsius, imagined to be standing behind the brothers; and, at the far left, two others presumably of the same neo-Stoic circle who, like Lipsius, may have been present only in thought.[1] The ostensible location of this imaginary meeting of kindred spirits is not in doubt: the view opened is of the Ponte di S. Giorgio reaching across the Mantuan lake to the church and suburb beyond, as seen in late afternoon from the painter's quarters in the Reggia Gonzaga. Rubens chose almost the same background for his bust-length, lifesize figures as his greatest predecessor in Gonzagan service had done for the exquisite *Dormition of the Virgin*.[2] His choice of a pergola setting for a *Mystic Marriage of St. Catherine* some thirty-five years later may have been as deliberate a tribute to Mantegna's *Madonna della Vittoria*.[3]

Mantegna is one of very few Quattrocento masters in whom Rubens can be shown to have taken and maintained an active interest; and the *St. Sebastian* in Berlin, depicted in solitary grandeur, was surely a conscious evocation about 1615 of Mantegna's heroic treatment of the figure.[4] The touching theme of *The Madonna supporting the Child on a parapet*, developed by Rubens in several version about 1617,[5] can be regarded as a recreation in Baroque terms of an invention by Mantegna's brother-in-law, Giovanni Bellini; and at Venice in the Frari, besides taking note of Titian's *Assumption* and of Porta's *Purification*, Rubens made a beautiful copy in pen and bodycolour of *Sts. Benedict and Paul* (Plate 100) on the right wing of Bellini's triptych.[6] When he died he was the owner of an unidentified *Fall of Phaethon*, No. 31 in his Inventory, attributed to Pietro Perugino, whose mythological paintings are of extreme rarity. But perhaps even before he reached Italy, he penned two excerpts, singularly fine copies charged with personal feeling, from Mantegna's famous engraving of the *Bacchanal with Silenus* (Plates 101, 102).[7] At Mantua he must have been impressed by the family groups of the

Gonzaga, with their servants, dwarf and dogs, frescoed on the walls of the Camera degli Sposi; and this impression appears to have reinforced the splendour of his *Lady Arundel with her page, dwarf and dog, accompanied by Sir Dudley Carleton*,[8] which he painted twenty years later in Antwerp. From *The Triumph of Caesar*, he copied in pencil profiles of three prisoners (Plate 104); and his painting of the head of the second man about 1609 has been revealed by unscrupulous 'cleaning' of the background colour with which he intended to set off a head study to be used for the St. Paul's *Discussion of the Real Presence*.[9] Visiting London in 1629–30, he had the chance to feast his eyes again on pieces of Mantegna's noble suite of decorations, then in the collection of Charles I. He drew, in pen and wash, several variations of the figure of the corselet-bearer (Plate 103);[10] and he was inspired further for his own pleasure to paint, in a full panoply of colour, the most luscious imaginable tribute to two of the nine scenes (Plate 115).[11] Five years later his admiration of the antique spirit which they had evoked was to be proclaimed in the streets of Antwerp by his design for the principal field on the rear face of *The Arch of Ferdinand*.[12]

(ii) GIULIO ROMANO

His painted gloss on Mantegna's *Triumph of Caesar* contains more than a suggestion of Giulio's tapestry design for *The Triumph of Scipio Africanus*, of which he had reworked a large counterproof.[13] Among many opportunities offered at Mantua, one of enduring signficance for him was daily acquaintance with the decorations produced by Giulio's extraordinary resource and invention.

His interest in this side of his predecessor's achievement was first expressed graphically. We may think of his drawing of an episode frescoed by Giulio's assistants on the cove of the Sala di Troia in the Reggia.[14] By the time that Rubens took up residence in Mantua, Giulio had been dead fifty-four years. But in addition to the frescoes and stuccoes designed by the Roman artist for the Gonzaga palaces, the house which he had built for himself in the ducal capital still stood. Indeed from his design for the stucco panel over the chimney in his *salone*, Rubens drew a free copy (Plate 105) as a souvenir of the master he admired.[15] This omits the

architectural setting, and shows a woman and a naked child inserted between the group at the left and the figure mounted on the pedestal. Drawings by Giulio, or copies in pen and wash by assistants or followers, he could have found handy among undispersed effects of the studio, either in the Casa di Giulio, or in the quarters which he came in his turn to occupy at the Palazzo Ducale.

Rubens's use for such sixteenth-century copies was described by Mariette, cataloguing the collection of Pierre Crozat in 1741: 'Lorsque Rubens rencontroit des Desseins mediocres, ou mal conservés, d'après de grands Maîtres, il se plaisoit à les retoucher, & à y mettre de l'intelligence, suivant ses principes. Il les transformoit ainsi dans son propre goût, de sorte qu'à l'invention près, ces Desseins doivent être regardés comme des productions de ce grand homme, & on l'en peut beaucoup apprendre pour le clair obscur.' The connoisseur's esteem for this special category of graphic work can be amply justified.

Lot 814 of the Crozat Sale, for example, consisted of 'Quatre, idem (i.e. Desseins de Rubens), autres grands Desseins tirés du Cabinet de l'Evêque de Gand; sçavoir le triomphe de Scipion & le ravissement d'Hylas par les Nymphes d'après Jules Romain, la Bataille de Ghiaraddadda de Titien,[16] & une Frise d'un Auteur inconnu,[17] le tout dessiné ou retouché par Rubens, avec une intelligence dont il n'y avoit que lui qui fut capable.' The large drawings designated as after Giulio in this group which had belonged to Antoine Triest, Bishop of Ghent, have been identified: The Triumph of Scipio with the heirs of Clifford Duits in London (Plate 113),[18] and the Hylas carried off by the Nymphs at the Fondation Custodia in Paris (Plate 107).[19] Both sheets exhibit those qualities of relief and of rich contrast in light and shade which Rubens could infuse by his pen and brush into old copies of another's drawings. Over complete drawings in pen, whose incidents were picked out with fine strokes of white, he has washed with brown ink to establish a general tone. On this preparation he has hatched with brown ink, and brushed strokes of white and of buff bodycolours onto the principal figures, in order to impart a striking fullness of modelling. The designs remain Giulio's, yet marvellously converted to a new personality. It is no surprise that there should have come down to us a virtual replica of The Triumph of Scipio,[20] bearing the marks of distinguished provenance and of high quality of execution; that there should be also a freer, but entirely autograph repetition of the Hylas

carried off by the Nymphs,[21] and that these two sheets should have been drawn in Rubens's manner of the middle 1630s. For Triest, who died on 28 May 1657, must have become possessed of his Rubens drawings some months at least before Rubens's heirs were entitled to dispose of them; and perhaps, by an exceptional favour to a distinguished contemporary, within the artist's lifetime. These capital sheets could thus have been replaced by Rubens himself for his own collection.[22] Rubens's attention to The Triumph of Scipio bore fruit two decades later in his Triumph of Henri IV, and even more clearly in his Triumph of Infante Ferdinand in 1634.[23] The Hylas composition engaged him already in his Mantuan days. A sheet of his own pen drawings shows on one side[24] studies manifestly inspired by the action of the Nereids; and these studies connect more or less directly with his composition of Hero and Leander, painted about 1604 (Plates 229, 232). Some thirty years later, when engaged on his last great commission for the Habsburgs, to supply some sixty mythological scenes for rooms in the Torre de la Parada, he returned to the inspiration of Giulio. The model which he then provided for Cornelis de Vos to paint full-scale, The Birth of Venus (Plate 108),[25] shows a goddess, who, if truly Rubensian, is at the same time a luscious tribute to Giulio's treatment of the subject a century before (Plate 106), frescoed in a ceiling compartment of the Sala delle Medaglie in Palazzo del Tè. The nymphs swimming shorewards after Rubens's Venus, and the putto flying above her, carry within them reminiscences of the Hylas. Indeed this kind of profit derived from his youthful studies can be paralleled more than once in the Torre decorations: his model for The Fall of the Titans, destined to be painted in large by Jordaens, recalls his elaborate enrichment during his Italian years of a copy from a Giulio Romanesque design for that subject;[26] Cupid and Psyche reveals no less strongly his interest in the subject composed by Giulio as a night scene for the ceiling of the Sala di Psiche;[27] and in his Death of Eurydice the figure of Eurydice is based on a pose found in Giulio's Death of Procris.[28] But the reflection of the Hylas and Procris designs in the work for Philip IV's hunting-box may have especial propriety of association; since, like two other Giulio elegies of comparable form and feeling, The Death of Adonis, and The Death of Meleager, they may have adorned the walls of a room in the Gonzaga hunting-box at Marmirolo. In Italy Rubens found an old copy[29] of The Death of Adonis, and retouched it with that intelligence of which Mariette wrote so justly.

At the Palazzo del Tè, he interested himself further in the Sala d'Atilio Regolo, reworking extensively a *ricordo* of *The Judgement of Zaleucus*.[30] He copied, in a combination of ink and chalk and bodycolour, the ceiling fresco of *Psyche wafted on the Sea by Zephyrus* in the Sala di Psiche (Plate 114).[31] He took still more passionate interest in the frieze of the Sala degli Stucchi, were Giulio had employed Primaticcio as *stuccatore*; and the Louvre has inherited from the Royal Collection of France a long suite of anonymous copies from *The Triumphal Entry of the Emperor Sigismund* (Plates 109, 111), which show over many areas the enlivening touch of Rubens's brush, hatching and washing with brown ink in order to impart relief to the figures, or redefining their outlines in order to increase the intensity of expression or the elasticity of tread.[32] Confrontation of a section of the finished frieze with Giulio's design shows that the Louvre copies thus reworked were taken, with minor errors of omission and commission due presumably to the difficulty of descrying particulars from floor level, from the stucco and not from any preparatory drawing. Rubens's hand reveals itself most satisfyingly in details: such as the reworking of the youth who marches between the mounted and dismounted lictors, holding up his halberd with a heroic gesture; such as the redrawing of the horses' hooves nearby; such as the camels and their drivers. The contrast between parts which he chose to retouch for his own gratification and parts which he left in their feeble state of copydom is sufficiently exhibited by the section where the procession reaches the corner of the room with the figure of the mounted centurion. There faces retouched and unretouched, both of men and horses, are to be seen side by side.

His style of work on this Louvre suite suggests a date within his early years at Mantua. By and large it exemplifies his method of acquiring knowledge for its own sake. Nevertheless there are not so distant echoes of it in his subsequent undertakings. In *The Baptism* of 1604–5 (Plate 246) for SS. Trinità, Mantua, the two men standing to the right of the tree, struggling with their clothes, although in physique quite openly Michelangelesque – and the St. Peter of *The Last Judgement* comes to mind – are enlarged reflections of two Giulio figures, one who strips and one who dresses himself at the fording of the Mincio; and the notion of closing a composition by means of a mounted centurion with outstretched bâton, put to signally effective use in *The Elevation of the Cross* of 1609–11 (Plate 190) for St. Walpurga's, Antwerp, might well have grown from study of the corresponding figure at the corner of the Sala degli Stucchi.

Rubens's interest in Giulio included also tapestry designs. At least two for the *Puttini* series were touched by him in bodycolours, and in one case also in ink.[33] Knowledge gained from such delicate transformations must have assisted the invention of his *Putti gathering grapes*, an improvisation inspired by Giulio's designs for Cardinal Ercole Gonzaga.[34] And in 1627 the witty device of projecting figure subjects on fictive tapestry fields for his own tapestry suite of *The Triumph of the Eucharist*[35] recalls the designs frescoed by Raphael's heirs in the Sala di Costantino of the Vatican.

Two drawings in the British Museum illuminate the comparison between the personalities of Giulio and of Rubens as draughtsmen; that is, of Rubens considered as the man who could infuse a fresh and personal meaning into Giulio's design by impressing his own pictorial taste upon an old copy. *Perseus disarming* (Plate 112) exemplifies Giulio's highly evocative pen style at its mature best. Upon a tame outline drawn by a mediocrity, Rubens worked so intensively that the design, washed, shaded, and heightened to the degree of bas-relief, is recreated as his, although the sheet remains a monument to his devotion to Giulio. Their figures breathe such different atmospheres that, set beside the airiness and freedom of Giulio's original creation (Plate 110), Rubens's drawing seems more than ever sonorous and heavy-laden, deeply pondered yet not at all prosaic.[36]

The poetry that he drew from songs set by Giulio shines again in *The Nursing of Jupiter*.[37] Giulio's design is known in the Bonasone print, in the original drawing and in copies and variants of that, any one of which may be set beside the one touched extensively by Rubens. With Giulio's presentation of this idyll he has taken yet greater liberties than with *Perseus disarming*. With dark washes he has obliterated as irrelevances both the dog beneath Amalthea's head and the streaming hair of the corybant who holds the cup. The lighting and atmosphere with which he has infused the scene are his discovery. In delicacy of feeling his reinterpretation of the Virgilian mood was scarcely matched before Claude. In his touch with figures set against foliage he anticipates even the eighteenth-century masters of France. As our eyes traverse this sheet, they seem to travel from Giulio's world to the world of Fragonard.

A mid-eighteenth-century manuscript, the *Bibliotheca Scriptorum Antwerpiensium*, which passed

from the library of M. Verdussen to the Bibliothèque Royale in Brussels before 1794, includes in the volume for 1625–7 a succinct account of Rubens's early employment by Vincenzo Gonzaga. This slightly amplifies the statement attributed to the painter's nephew already noted, 'In illa enim aula,' wrote the anonymous author concerning the palace at Mantua, 'tot illustribus pictoriae artis cimeliis instructa occasionem nactus est illa attente considerandi, quae eandem perficiunt similandi (? sc. *artem*) praestantissimorum pictorum prototypa, & praecipue Julii Romani, cujus magnam conceperat Ideam, (et) plurimum profecit.'[38]

From the outset of his Mantuan career the young Fleming wished to place himself as a modern artist, conscious of his heritage, in the tradition of all that would have been regarded by early sixteenth-century Rome as high achievement in design. He found himself a successor in office to a Roman who had been at once the artistic heir of Raphael and an inventive genius in his own right, one of the great decorators of all time. The scale and grandeur of Giulio's work as Raphael's principal collaborator in the Vatican found a natural response in Rubens. The enterprise and wit manifest in the mythologies painted for the ducal houses of the Gonzaga made no less appeal. He compiled as complete a record as he could of what he saw in these palaces of Rome and Mantua. He enhanced and refreshed this knowledge both for its own sake and because he must have become aware early of the kind of large-scale commissions which his unresting ambition sought, and which by his qualities he might confidently win. In successive tasks of his working life as the pre-eminent master-decorator north of the Alps, furnishing models for tapestries, or for the painted enrichment of princely walls and ceilings, he showed how a conspicuously productive part of his universal nature had been nourished by Giulio's abundance.

(iii) FRANCESCO PRIMATICCIO

Rubens was first confronted with Primaticcio's aptitude for graceful decoration in the Sala degli Stucchi of the Palazzo del Tè. In this sense his encounter two decades later with Primaticcio's work at Fontainebleau was an extension of his Mantuan experience. On one of his visits to France in the early 1620s, when employed by Maria de'Medici, he evidently drew a copy on *carta azzurra* with pen and ink, heightening it elaborately in bodycolours, of *The Rape of Helen,* which Primaticcio had painted for the Chambre de Saint-Louis

(Plate 118);[39] and in the Chambre de la duchesse d'Etampes, he used the unretouched *verso* of a pageant drawing of the School of Fontainebleau in order to copy in sanguine, making characteristic variations, three of Primaticcio's stucco caryatids with swags of fruit (Col. Plate XIV).[40] The attraction for Rubens in his mid forties, ever hungry for Italian art, of Primaticcio's spirit thus expressed at Fontainebleau we can take almost for granted. It was for him an invitation to irradiate with plastic energy the interlacing of bodies in violent action; and his *Rape of Helen* drawing stands out as a fiery example of such a reaction. Nonetheless it has been found surprising that he should still have been interested in figures as stylishly mannered as the caryatids. In fact the long-limbed elegance and extravagant torsions of the bodies, with which he has tampered generally by filling out forms, and in particular by recrossing a pair of legs, made a distinct appeal. We recognize this in the type of nude which appears as Cybele in his more or less contemporary oil sketch for *The Union of Earth and Water*,[41] and even later as Occasio painted in *The Victorious Hero takes occasion to conquer Peace*.[42]

He was gripped by the possibilities of bringing Primaticcio's ideas up to date in his own idiom. Not only did he draw, with special fidelity, a copy of *Penelope weaving* (Plate 116), inscribing it '*Francesco da Bologna*' as yet another paradigm of *disegno* for his pupils to copy;[43] but he also encouraged Theodoor van Thulden to prepare for publication in 1633 a *Galerie d'Ulysse*, engraved after Primaticcio's frescoed scenes at Fontainebleau. The seahorses in van Thulden's drawing after the '*Quos Ego*' he retouched with rose and white bodycolours (Plate 117).[44] Then, after the publication, he made a whole series of reinterpretations aided by van Thulden's reproductions and doubtless by other copies: *Ulysses meeting the shade of Tiresias in Hades*; *Ulysses's Arrival at Aeaea*; *The Departure for Hades*; *Pluto sentencing the Souls in Hades*; *Ulysses's Vision of Minerva*; and *The Washing of Telemachus's Feet and Hands*.[45] In every case he relieved Primaticcio's linearities and clearly-defined colour schemes, whilst retaining, through the effect of watercolour combined with bodycolour on white paper, the tonalities of fresco.

Furthermore he interested himself at Fontainebleau, as at Mantua, in the steep foreshortenings of formal compositions on ceilings. In painting such a small sketch in oils as is inspired by Primaticcio's *Chariot of Apollo*[46] he was paying tribute ultimately to the inspiration of Giulio.

6. Mannerisms and modernity in Rome and Florence

(i) THE RAPHAEL CIRCLE

Rubens's enthusiasm for Raphael in Rome and for Giulio in Mantua extended to the work, particularly in decoration, of others of the Raphael circle: Giovanni da Udine, Perino del Vaga, Polidoro da Caravaggio, and Baldassare Peruzzi. He approached them through their drawings, being himself a tireless draughtsman and an avid collector. Reading his copy of the 1568 edition of Vasari's *Vite dei più eccellenti pittori scultori ed architetti*, he became familiar with the author's notion of being the first systematic collector of drawings.[1] Vasari's pride in ownership rested on having mounted in the five volumes of his *Libro* what he had confidently assembled as authentic examples of graphic work by the subjects of his biographies; and so he was able to illuminate at home as many as possible of those individual stages in the progress of the arts which he described in his publication. Rubens, starting his collection nearly three quarters of a century later, was not in this sense guided by historical considerations; although, in the course of a lifetime, he seems to have provided himself with a conspectus of sixteenth-century achievement in *disegno* inclusive enough to have won the respect of any latter-day Vasari.

His impulse was primarily aesthetic and practical. In that sense he, rather than the author of the *Vite*, was to be the model for a succession of artist collectors: Lely, Lankrink, Reynolds, Lawrence. He, more than any of these, relished the wealth and variety of his available heritage in the art of design, and wished to nourish thereon the fecundity of his own gifts. He was also a star impresario, with the call to train assistants by select examples to an acceptable pitch of competence as draughtsmen. As material for the workshop whilst he lived, and, after his death, as a potential legacy of inestimable value to any son or son-in-law of his who might come of age as a painter, his drawings, both of his own hand and of his collecting, were kept together. Significantly there appears to have been no firm distinction between categories; and, within reasonable limits, none need be made from any dogmatism of critical method. For the sheets of drawings which he sought were in many cases to become the fields on which he was to express his own responses. In amassing a hoard of visual intelligence, both original drawings by masters, and copies by himself or by others, he did not hesitate to retouch even the originals in order to stimulate his imagination. He enhanced in them, or invested them with, any or all of those interrelated qualities which he prized in design: plastic vitality, the convincing semblance of movement, palpitation of light and shade. Using inks, occasionally watercolour washes, and for lines a quill or the point of a fine brush, most characteristically in combination with some bodycolour, ochrous, white, green or rose-red, he would retouch – sometimes to the point of almost masking – he would correct, or he would repair, as might seem needful, much of what came to his hand. His attentions far exceed the occasional tamperings in which Vasari had indulged himself as a collector. Rubens wrought highly idiomatic transformations. Often we can recognize his ownership by the mark of his personality which he impressed thus on drawings set before him; although he surely did not feel a need to improve every drawing which he acquired.

He was responsible evidently for the fine hatchings and white heightenings superimposed on a sixteenth-century Italian drawing in black chalk (Plate 119),[2] which is related in design to one of the tapestry series of *Children's Games* discussed by Vasari in his *Vita di Giovanni da Udine*. He retouched with brown wash and bodycolour another sixteenth-century drawing in pen, which reflects the stylish *Cupid and Psyche* design by Perino del Vaga for the Castel Sant'Angelo (Plate 121),[3] and, similarly, a third drawing, which is a contemporary and close copy of one of the large monochrome scenes from *The Life of Alexander the Great* frescoed by Perino in the Sala Paolina of the same papal stronghold.[4] Such intrinsic distinction as these sheets have is due to his intervention, the work, we may suppose, of his second period in Rome. A drawing in Oxford, at Christ Church, of *Running and walking Women,* a damaged original of the sixteenth century, he repaired along the base and extensively reworked (Plate 124).[5] In supplying the missing portion, chiefly the feet and skirts of the two walkers, he imparted to the figures more elegance by elongation, a process characteristic of his taste in the early 1620s, when he was in contact with the

style of Primaticcio at Fontainebleau. Using the tip of his brush dipped in brown ink for both outline and shading, as well as buff and white bodycolours and black chalk, he increased over the whole surface the sense of plasticity and lively movement. The source for the runners is uncertain: but they may connect with one of the dozen *basamento* scenes frescoed on the inner side of the Vatican Loggie, as do the walkers, copies from the pair who close at the right the frieze of *Joshua addressing the Israelites*.[6] The execution of these scenes in monochrome, today virtually indecipherable, has been credited, since Vasari wrote in praise of them, to Perino. Nevertheless at least the preliminary ideas, since they were to be so conspicuous and integral a part of the whole Loggie decoration, must have had the authority of some sketch by Raphael himself.

The upper part of a fully independent work of Perino is the likely origin of a *Madonna and Child with Angels* which Rubens copied splendidly in sanguine (Plate 126) during the latter part of his Italian period.[7] By form and sentiment the design comes close to the relationship of the equivalent figures in the *tondo* belonging to the Liechtenstein collection at Vaduz of *The Madonna and Child with St. Joseph*, a painting formerly attributed to Raphael;[8] and in that affinity to Raphael would have lain a part of its charm for Rubens. A still more beautiful drawing, *The Flight of Nessus and Dejanira* depicted in an intricate combination of brown ink with green, white and brown bodycolours, is also entirely his (Plate 127); albeit the old inscription, 'Perinus del Vaga', very probably identifies the inventor of this graceful and spirited design.[9] Once again the work is too sophisticated to be dated earlier than his last years in Italy. By contrast a larger, but much less ingratiating drawing is his more or less faithful copy[10] from the engraving, traditionally ascribed to Bonasone,[11] which helped to make famous *The Shipwreck of Aeneas* designed by Perino for one of the principal ceilings of Palazzo Doria in Genoa (Plates 120, 122). This could have been drawn before Rubens left Antwerp. However, he modified rocks, clouds and waves; and he ignored one of Aeneas's ships which Perino made to sail behind the rocks. He gave a beardless, younger face to the man being hauled to safety; and, perversely, a beard to the inert figure in the group at the left, which was inspired by one of the antique groups of *Menelaus and Patroclus*. Of more significance than these fancies is his excision of the central swimmer, whose proximity to the plunging hooves of Neptune's horses relates their action to the

struggle for survival, instead of relating it to the spectator – as the Baroque instinct dictates. Similarly, by raising the trident over Neptune's head, he invigorated the action of command. More than thirty years later he recollected the horizontal form of the composition, the prominent line of the distant ships and the break in the sky, elements in his youthful reinterpretation, when he himself had to represent the scene in order to welcome the Glorious Entry of the Cardinal Infante Ferdinand to Antwerp.[12] Fairly early in his Italian career he copied the design for *The Meeting of Hannibal and Scipio*, which was to be published in reverse by Salamanca. His pen drawing, extensively washed and heightened, later to be in Lankrink's collection, is inscribed sensibly enough 'Pierino'.[13]

Yet even these testimonies to Rubens's continuing love of what Perino invented, for Genoa as well as for Rome, pale beside the big sheet on which he sped through, and beyond, the design commissioned by Paul III for a tapestry to hang below Michelangelo's *Last Judgement*. This is the 'Frise d'un Auteur inconnu' catalogued by Mariette for Crozat. The timid drawing over which Rubens worked (Plate 123) is probably a contemporary copy by an assistant of Perino.[14] He added at the left a strip to accommodate two captives, bound figures conceived in the spirit of Michelangelo and cousins to those he himself was to develop by copying, about the same time, two captives invented by Salviati for the *Fasti Farnesienses* (Plate 125).[15] His wit in reforming the sixteenth-century drawing includes the provision of goat legs for the satyrs, originally terminal figures ending in lion-footed consoles; the transformation of the youthful head of the right-hand figure into that of an elderly satyr complete with beard and horns; the addition of wings to the eagles' heads on the escutcheon; the enlargement of the swag below the outstretched arm of the left-hand satyr; the increase of fruit below the right forearm of the same figure; and the alteration of the profile mask below the winged female's left knee into a voluted escutcheon. This catalogue of liberties plods after his exhilarating progress in retuning Perino to the pitch of Michelangelo, fusing thereby the decorative and the heroic into a force hitherto unmatched. Here the Baroque style can be observed in genesis. We may think of *The Obsequies of Decius Mus* to come ten years later.[16] No wonder that at least two highly accomplished copies were to be made in Antwerp of this 'copy' of Perino's *basamento* for the Sistine Chapel!

Rubens's graphic enquiries of Polidoro were no

less persistent. The Roman housefronts decorated in monochrome *all'antica* by Polidoro and Maturino had been for many an open-air academy, their accessibility by Rubens's day having been increased manifold through the publications of G. B. Galestruzzi and of J. Saenredam, not to speak of the innumerable drawn copies by then in circulation. A handsome drawing in the Louvre of *St. Paul*, twice inscribed "Polidoro" by anonymous hands, is one of Rubens's copies from another aspect of the master's work.[17] The stance of the saint in his ample draperies, his bearded head sunk on his chest the better to scan the book which his right hand supports on his hip, was to be reflected in the *St. Amandus* for the shutter of *The Elevation of the Cross* in Antwerp.[18] Reworking of the features and other outlines, with similar hatching and wash, has given a Rubensian character to a second drawing in the Louvre, an otherwise undistinguished copy of a Polidoro design for a frieze of Roman history;[19] a reworked drawing from Goethe's collection at Weimar, a scene from a naval battle, has the same status;[20] and such examples can be multiplied. Mariette made a showpiece of Rubens's direct copy of part of Polidoro's *sgraffito* on the front of Palazzo Ricci,[21] which is known to us in the tidy form of Cherubino Alberti's etching; and the great French collector understandably paired this prized piece of *The Rape of the Sabines* with another frieze drawn by Rubens in comparable fashion from an antique marble.[22] Esteem for Polidoro, as an authority on the spirit of antiquity almost equal to Raphael and to the visible remains of ancient Rome, far outlasted Polidoro's own century.

'Polidoro da Caravaggio' in Rubens's script on his copy of one of the trophies decorating the Via della Maschera d'Oro front of Palazzo Milesi, denotes it as one more paradigm for his assistants in Antwerp.[23] Like his copy of the left half of *Apollo shooting the children of Niobe*,[24] it is on blue paper. It bears touches of rose and white bodycolours as well as brown wash, the drawing of the lower half of the helmet at the bottom right being in mauve applied with the point of the brush. Yet another of his superb series of copies from the Palazzo Milesi decorations, drawn this time with the brush in brown ink, and with some pen and ink and white bodycolour, is of a *Youth leading a Horse* (Plate 130), the central motif of the frieze painted immediately above the ground floor;[25] and there are others, in equally rich combinations of media, reproducing the parts of the frieze which illustrate *The Oath of Mucius Scaevola*[26] and *The Castration of Uranus*.[27]

This series of technically related drawings illustrate how he was at pains to work up to his level of excitement ideas offered dry, in black and white, by the reproductive engravings. However, one of the single figures of bearded and heavily muffled philosophers, reproduced by him for a change in sanguine on white paper, seems to have been drawn in front of the palace; later an offset was taken from it, and retouched by him about 1618[28] with a view to using it for the *St. Peter*[29] to be painted on the shutter of the Fishmongers' triptych at Malines.

Apart from the Palazzo Milesi designs, Rubens copied of Polidoro *The Death of the Infants of Niobe*;[30] also *Perseus showing the Medusa's head to his enemies*,[31] the original drawing being in the Louvre, and the painting from that in Genoa; and several more representations of ancient combats in the form of friezes not otherwise known. Thereby he lastingly enriched his syntax. In other ways he may have been encouraged by Polidoro's example. The rare subject of *The Vestal Tuccia proving her innocence*,[32] with which he was to experiment in the early 1620s, had been treated by Polidoro and Maturino for a house façade on Montecavallo near Sant'Agata.[33] Somehow he knew, perhaps owned, Polidoro's large *Entombment* drawing (Plate 176), now in the Louvre;[34] and, as we shall notice in discussing his reconsideration of that theme as treated by Michelangelo Merisi, the other major painter from Caravaggio, he was to make good use of its imaginative design in his own oil sketch of about 1616 (Plate 177).[35] Finally he may have been aware that it was Polidoro, during the last phase of his career in Messina, who began sketching in oils in order to try out on a small scale the compositional flow of large works to be realized in the same medium. Polidoro's sketches for his last major altarpiece, *The Road to Calvary*,[36] are characteristically painted in tones of umber and white, with a few decisive indications of colour (Plate 128). When Rubens came to paint his marvellous, largely monochrome sketch (Plate 129), now in Copenhagen, for the Afflighem *Road to Calvary*, could he not have had in mind one of these pioneering trials of ninety years past?[37]

From Vasari's *Vite* Rubens knew that the inspiration for the successful partnership of Polidoro and Maturino in house front decoration derived from the example of Peruzzi. So it was in line with his own resolute exploration of 'the modern masters' that he should have come to own a sheet of Peruzzi's pen drawings which, on one side, shows *Caesar and Augustus* sketched for the decoration of Francesco Buzio's house in Rome, and, on the other,

copies of antique sculpture (Plates 131,132).[38] The first side only, being somewhat damaged, he judiciously retouched, imparting to it a plasticity and expressive force beyond anything which it might have had in its pristine state. In advance of his visit to Italy he copied in pen and wash, with touches of buff and white bodycolour, and in the form of a rectangle, the hexagonal scene of *Adam blaming Eve before God* from Peruzzi's fresco on a cove in the Cardinal Vicar's apartments at the Cancelleria. He was able to draw so closely in the manner of Pieter Coecke van Aelst that his paper is inscribed on the front, 'Mr. peter van aelst 1540 ca', and, on the back, by a different hand, '(?pieter) Koek van aelst'.[39] The style and accomplishment of this copy parallels that of two copies which he drew in red chalk and wash of figures from the *Cain and Abel* painted by yet another of the Flemish admirers of Raphael and his circle, Michiel Coxie;[40] and the likely explanation is that he gained his first impression of Peruzzi's design through a copy, doubtless in rectangular form, made by Pieter Coecke in Rome. However, the most impressive evidence of Rubens's direct attention to Peruzzi is a very large sheet, all but ignored, on which he copied in pen, with truly astonishing enhancements by brushwork of lighting and modelling, *The Presentation of the Virgin* frescoed in the Ponzetti chapel of S. Maria della Pace (Plate 133).[41] The only name risked in association with this copy has been that of Annibale Carracci, echoes of whose style in Rome are to be detected in the wonderfully free handling of pen and wash which gives life and presence to the bystanders at the right. Yet nobody but Rubens could have imparted the luminous plasticity which imparts such substantial presence to the youth holding the horse and to the crowd of figures in the foreground.[42]

(ii) PIRRO LIGORIO

In scanning beyond the Raphael circle for another artist with a special concern for using knowledge of antiquity, Rubens lit on Pirro Ligorio. He acquired and retouched at least two of Pirro's independent designs. To the red chalk of *The Marriage of Bacchus and Ariadne*[43] he added relief by deft touches of yellow and white bodycolours, and some hatching in a sanguine wash with the point of his brush (Plate 135). The fine penwork of *The Israelites and their flocks*[44] he enriched considerably with brown and grey inks, and buff, yellow and white bodycolours (Plate 136).

While there is no evidence that the attraction of Pirro outlasted Rubens's study years in Rome, he made use of Pirro's play on knowledge in a remarkable way. A New York collector owns a drawing, inscribed 'Pirro Ligorio' by Rubens after his own improving hand had been at work (Plate 134).[45] This is based on the figures in the left third of Donatello's *Miracle of the Ass of Rimini* in Padua,[46] but with a curious reassortment of groups, approximate halves of this third being exchanged left for right. Nevertheless such an attentive reader of Vasari as Rubens would hardly have involved Pirro's name through ignorance of the Donatello connection; and as a collector he was in a position to gauge Pirro's style in fine penwork – he had only to refer to such a drawing as *The Israelites and their Flocks*. He would have realized that he had before him a drawing in Pirro's idiom.

We may sympathize with the struggle of Pirro or his assistant to record effectively a part of the much admired relief at the back of the altar in S. Antonio. The mutations in the recording were not confined, however, to those enforced by the parameters of the copyist's means and situation. Gone is 'the passionate movement of the Paduan crowds' and 'the fluid, wavelike rhythm that binds together spectators'.[47] It was the cooler, classicizing approach of Pirro in the New York drawing on which Rubens was to seize. Pirro had reassorted the paragraphs of figures on either side of the architectural *caesura*. Rubens by the enriching process of his brushwork so skilfully transmogrified the copy that it evokes the sort of marble bas-relief on which Donatello himself had drawn for his vocabulary *all'antica*. Changes in detail between the design of the Renaissance bronze and that of the unretouched copy are instructive. No attempt is made to reproduce Donatello's chiselling of the architecture. The face of the man standing, third from the left in the relief and there partly hidden by the column, is omitted; so is the figure of the man kneeling behind the bearded elder who kneels staff in hand. The profile of the old woman behind the mother kneeling with her child is levelled, instead of tilted, and separated from the head below. There are alterations to the head and arm of the man perched on the pedestal of what Donatello had indicated as a fluted pilaster (by the time that Rubens finished, this figure had become a highly Zuccaresque spectator, peering round a column!). All these changes could have been due to oversight, or to the difficulty of describing details of a crowded composition in dark metal. Others are due not to possible misreadings of Donatello's work, but to an approach essentially at odds with his. No foot strays, nor is going to stray, beyond the

frame. Draperies are more pedantically antique in their fashion. The arm of the bearded man who reaches forward to support himself on the pedestal of the column is rendered as it were bare. Oddest of all, considering the model, is the copyist's introduction of a sibylline, post-Michelangelo figure to the right of the mother and child. The contortion of the body and drapery, the interlocking curves, and the frontality of the head are all in the taste of Baccio Bandinelli. This idiosyncratic substitution for Donatello's kneeling man was left untouched by Rubens, out of respect – so we may suppose – for such a curious invention. His emendations elsewhere on the sheet include, as we have come to expect, the enlivening and intensifying of expressions; outstandingly in the faces of the child and of the bearded men.

(iii) FRANCESCO SALVIATI

Rubens was intrigued by Francesco Salviati not only as the master revered by the young Giuseppe Porta, but as the exploiter of mannerisms found in late Michelangelo. He took elaborate pains to copy *Two warriors bound as prisoners* from the fresco of Farnese annals in Palazzo Farnese (Plate 125);[48] and the formal sense which he imparted to these nudes is closely comparable to that which he imparted also to that other pair of prisoners added by him to Perino's design for the Sistine *basamento*. Excited by the strength immanent in Salviati's group he augmented his paper, in order to furnish fully a design which he himself might use. At the right he added a shield; at the left, weapons and a drum. The low viewpoint from which the drum is seen suggests a large-scale design for wall decoration, perhaps for a 'passtuck' in tapestry, such as an expanded suite of *The History of the Consul Decius Mus* might have required for some special situation, say between palace windows. Of two copies known of that extremely distinguished copy by Rubens, one was drawn by Jordaens; and Jordaens, in the same informal apprenticeship, copied another copy of his, after a battle frieze designed either by Polidoro or in Polidoro's manner.[49] Rubens owned moreover an outstandingly good sheet of drawings by Salviati, with designs for *The Fall* and *The Expulsion* which were to be separated in a wide lunette by a narrow, round-headed window (Plate 137).[50] *The Fall*, as we have it, is untouched. By contrast *The Expulsion* is the scene of great liberties. Rubens redrew Eve's legs in brown ink with the point of his brush; and, with a combination of buff and white bodycolours and brown ink, invested the bodies of our first parents with a plastic fullness and force unforeseen by the sixteenth century.

(iv) TADDEO ZUCCARO

The sheer brilliance in the art of the short-lived Taddeo Zuccaro was a beacon to Rubens, which burned the brighter from acquaintance with Taddeo's younger brother Federico, his own senior contemporary in the metropolis. His interest in compositions of the elder, more gifted brother, is evinced in five instances. The first is a drawing of the rare subject of *The Blinding of Elymas*,[51] which he considerably reworked (Plate 138). This may preserve a rejected design by Taddeo for the left wall of the Frangipani chapel in S. Marcello. In the sparklingly dramatic composition of the fresco Taddeo moved further from the example of Raphael; employing few columns and spectators, excluding women and children, and focussing on the stricken sorcerer, whose silhouette is framed by the open archway. The second drawing is basically a studio copy of a rejected design by Taddeo for *The Last Supper* on the vault of the Mattei chapel in S. Maria della Consolazione, differing from the fresco in the lower left corner. It was made presumably for the 1575 engraving by Alessandro Caprioli, being gone over for that purpose with a stylus; and Caprioli's engraving also would have been known to Rubens.[52] The third drawing, a *Frieze with a procession of Lictors*, appears to be the work of Taddeo himself, inspired in his youth by Polidoro. Rubens retouched it in green and white bodycolours.[53] The fourth and fifth drawings are entirely his. One, which belonged to Lely, may well be connected with Taddeo's earliest commission of consequence in the metropolis, to paint nine scenes from the *History of Camillus* for the house front of Jacopo Mattei.[54] The other (Col. Plate x) reproduces, with a rich assortment of colour washes and heightening, Taddeo's design for the *Naval Battle* in the service of Castel Durante ware which the Duke of Urbino commissioned as a present for Philip II of Spain.[55] No more pleasing example could be found either of Rubens's readiness to acquire knowledge for its own sake or of the refinement of his connoisseurship.

(v) FEDERICO ZUCCARO

Federico Zuccaro, however inferior his talent to Taddeo's, was not to be overlooked by a young Northerner in the first years of the century. He remained an artist of consequence, as well as an established personality on the metropolitan scene. In

Rome Rubens retouched a *Sposalizio*,[56] correctly inscribing it, 'f. Zuccaro' (Plate 139); and, in consequence of this transformation wrought with bodycolour and ink wash, and signally in the figure of the Virgin, the drawing received from a later owner, Lankrink, the additional inscription, 'P. P. Rubens'. Similar work may be recognized on another capital sheet, Federico's very large drawing of *The Last Supper*,[57] an extravaganza on Veronese's *Wedding Feast at Cana* teeming with accessory figures (Plate 140). Rubens's hand is especially clear on the groups of servants and musicians in the foreground. The most remarkable instance of his attention to Federico has been discussed: the replacement, drawn in the shimmering style of the middle 1630s, of approximately the right half of the preparatory design for *The Conversion of the Magdalene*[58] in the Grimani chapel of S. Franceso della Vigna, Venice (Plates 141, 142). We shall see how in Rome he adapted the scheme of Federico's *Adoration of the Name of God* in the Cappella degli Angeli of the Gesù (Plate 332), when revising his own altarpiece for the Chiesa Nuova.

Visiting another Roman church, S. Giovanni dei Fiorentini, Rubens must have been struck by Giovanni Balducci's imaginative depiction of an architectural setting for the scene of *Carloman's Investiture*;[59] for that fresco of the 1590s suggested a way to stage *The Miracle of St. Ignatius Loyola* when he had to provide the principal altarpieces for the Antwerp Jesuits.

(vi) SENIOR CONTEMPORARIES IN FLORENCE

Rubens's zest for depicting the violence of combat led him beyond the classic prototypes of Leonardo, Raphael and Titian, to Polidoro's work in Rome. His relish for envisaging the wilder actions of horses and horsemen led him also to a prolific artist of his own day who worked there and in Florence, Antonio Tempesta, a pupil of the Fleming Stradanus. The precise evidence for this is the configuration of *The Fall of Phaethon*, which he was to design for the Torre de la Parada on the basis of Tempesta's engraving of the subject for the *Metamorphoses*. Tempesta's illustrations to Ovid were published while Rubens was in Italy.[60] Recently a vigorous pen drawing has come to light, which displays an agitated group of foot soldiers and mounted men, the cavalry rearing in alarm. Attached to it, not surprisingly, is a 19th-century attribution, 'A. Tempesta and Rubens'. The design however corresponds in essentials to that of the

lower left block of a large woodcut *Conversion of Saul* by a mid-16th-century follower of Titian, omitting the convert! It is vividly corrected and developed by Rubens in a characteristic combination of brushwork and penwork, using a different shade of ink and white bodycolour (Plate 143).[61]

In Florence Rubens did not overlook the equestrian monument to the Grand Duke by Giovanni Bologna, his own compatriot.[62] But the senior contemporary there, of more profound and lasting importance to him, was Ludovico Cardi, il Cigoli, a fellow enthusiast for the art of Federico Barocci. A pen drawing unattached to any known composition of his own could have been inspired by Cigoli's *St. Peter and the Cripple* of 1606.[63] Rubens's drawings of *écorchés*, published posthumously in the 'Livre à dessiner', appear to follow the suggestion offered by Cigoli's studies and by the *bronzetti* cast after those.[64] Distant but clear recollections of Cigoli's *Last Supper* which was to be placed in the Collegiata at Empoli (Plate 146), with the apostolic company seated in a dark hall at a round table lit from above, and with the apprehensive Judas in the right foreground, played their part in the 1630s in his evolution of a *Last Supper* for St. Rombaut's, Malines (Plate 147).[65] Cigoli's winning entry, in the 1606 competition with Caravaggio and Passignano to paint for Monsignor Massimi a half-length '*Ecce Homo*' with three figures, North Italian fashion, doubtless affected Rubens's own treatment of the subject within a few years of his return home;[66] and Cigoli's most Tintorettesque altarpieces of the late 1590s, *Christ at Emmaus* and *The Lapidation of St. Stephen*,[67] were to be scarcely less influential upon Rubens's later depictions of those subjects. However, the unshakable witness to his regard for Cigoli, as a living representative of the serious Florentine tradition in designing large altarpieces to be painted on panels, is a sheet of drawing (Plate 148)[68]: a free rendering of *The Deposition* which was to be delivered to S. Stefano, Empoli, in January 1607. This slowly developing masterpiece he could perhaps have seen, in something like its definitive form (Plate 145), as early as May 1603, as he passed through Florence on his way to Livorno. The style of his drawing suggests that date. In it the back views of the Magdalene and St. John are reinterpreted; but the Christ has been taken over almost unchanged, except for a reversal in the direction of the legs. The fainting Madonna with the supporting Mary differ from the figures in the corresponding group: but, as a group, they continue somewhat separate from the

principal action. Reading what remains of Rubens's Latin inscription in the upper left corner, we see that he intended to modify the sobriety of the composition further by adding two handlers on the ladders, in imitation of the most famous treatment of the subject in Rome: Daniele da Volterra's fresco in S. Trinità dei Monti (Plate 144). Commissioned a decade later in Antwerp to paint a triptych on the same theme for the Arquebusiers' altar in the Cathedral,[69] he returned to the ideas with which he had experimented in this drawing of his early years in Italy (Plate 191).

Cigoli died in 1614. Since Rubens had admired him as a composer, and perhaps knew him in Florence, his own special agents, so we may conjecture, took steps to buy drawings from the heirs. Such acquisitions could well have included typical studies of draped figures, substantially drawn in white on toned paper, with the features and the shading realized in brown ink. Studies of this sort would have taken the eye of Jordaens, who never saw Italian art in Italy, but had to rely largely on what he could see at the Rubens house in Antwerp. As nothing else around him could have done, Cigoli drawings would have offered Jordaens encouragement to develop his peculiar manner of regarding drapery as a luminous but stiffly independent entity, by excavation of angular and irregular hollows between ridges.[70]

(vii) FEDERICO BAROCCI (ca. 1535–1612)

Federico Barocci captivated Rubens both as a draughtsman and as a composer. Pen and wash trials of groups required for the inner faces of the wings of the Antwerp Deposition[71] (Plate 188) show striking resemblances, in style and technique, to figure compositions drawn by Barocci for paintings which Rubens knew by heart in Rome, such as The Visitation at the Chiesa Nuova (Plates 153, 154).[72] When Federico died at Urbino on the last day of September 1612, his very considerable stock of drawings became the inheritance of his nephew Ambrogio di Simone, the last Barocci. The fact that within a few months Rubens in Antwerp made for a while a markedly sympathetic change in his own drawing style suggests that somehow he managed to secure at any rate a few examples of the dead painter's graphic work, and that he was responding by the sincerest form of flattery.

He knew, perhaps owned, studies also of trees and banks drawn by Barocci, either with the brush in inks and white heightening (Plate 151), or with coloured chalks.[73] Observations of nature are no-toriously hard to date by appearance only: yet, ranging from the Fitzwilliam Museum *Path in Spring* (Plate 152), probably drawn about 1614,[74] to the very late 1630s, the period of the two paintings now in Stockholm which interpret Titian's *Bacchanals*,[75] there is a varied succession of Rubens's delicate but firm responses to the light-filled, feather-light foliage, to the slender boles and roots, and to the vernal sprays shooting from pollard willows, to these several elements in the lyricism which Barocci brought to Italian art. Appreciation of Barocci was crucial to Rubens's shift from a Venetian-based style of rendering the details of landscape; and this is noticeable in his draughtsmanship even before his return to Antwerp. Comparing his copy of Titian's *Penitent St. Jerome*[76] with the painting which was before his eyes in Venice,[77] we are struck by his substitution of a luminous and penetrable background alive with light and feathery trees and twisted trunks for the dark bank of trees with dense and heavy fronds (Plates 77, 78). The source of the transformation is apparent if we turn to such a masterpiece of Barocci's draughtsmanship as the British Museum *Stigmatization of St. Francis* (Plate 79).[78]

Two further facets of Barocci's method were observed by Rubens. The way of rendering the alternation of warm and cool reflections of light from human skin, by juxtaposition of areas of rose and blue, guided his own experiments in flesh painting for a comparatively brief period after his return to Antwerp, as we can see from *The Annunciation* for the Maison Professe (Col. Plate XIII). More lastingly, he was interested in the *modelli* for altarpieces painted by Barocci in full colour on small canvases. These were the culminating stages of long and painstaking chains of preparation, which had involved pen and ink composition trials, life studies in black chalk, and colour trials, particularly of heads, in combinations of chalks. Only the *modelli*[79] for '*il Perdono*' and for *The Circumcision* are known of the greater number, to be inferred from Bellori's account, which were extant when Rubens was in Italy. When, in fulfilment of his contract with the Provincial, Rubens submitted models for the canvases to be set over the aisles and galleries of the Jesuit church in Antwerp, these panels can be said to have been painted after Barocci's precedent; just as the slighter oil sketches in monochrome, which preceded these models in colour, followed the swifter practice of the Tintoretto shop.

Such thorough acquaintance with the ways of Barocci almost implies a visit to the old master

himself. Not only did Rubens copy in pen the group of Aeneas, Anchises and Ascanius from the version of *The Flight from Troy* (Plate 158), which was conveniently for him in Cardinal Borghese's collection in Rome[80]; but he travelled at least as far as Ravenna, drawing there Barocci's altarpiece in the Olivetan church (Col. Plate XI). Urbino, although hardly an active art centre apart from Barocci's studio, would have beckoned him as the birthplace also of Raphael, and as the former scene of enlightened patronage of northern painters by the reigning family. He may have drawn comparable copies of other Barocci altarpieces: at Arezzo, of '*The Madonna del Popolo*',[81] since its general composition is reflected in his *Saints Dominic and Francis protecting the World from the Wrath of Christ*;[82] and at Loreto of *The Annunciation*,[83] which may have suggested the disposition of figures in his own composition for the Antwerp Jesuits.[84] However, in the latter instance there was a reproductive engraving of high quality which could have sufficed as a record for his purposes.

(viii) ADAM ELSHEIMER (1578–1610)

Whether or not Rubens knew Barocci personally, he was certainly a friend of Elsheimer in Rome. He is likely to have become acquainted, possibly through Rottenhammer, with paintings showing the influence of Veronese and Tintoretto which were left by Elsheimer in Venice; and to have recognized early, not only that the Frankfurt painter's exiguous production was to be cherished, but that the magnitude of his achievement bore little relation to the diminutive size of his pictures. The cherubim in the S. Croce in Gerusalemme *Ecstasy of St. Helena* are large cousins to those which hover above Elsheimer's *Baptism* (Plates 179, 178).[85] Nevertheless it was Elsheimer's work in Rome which was really consequential for his own art. The appeal of rearing and plunging horses, wild lighting, and of the intricacies of violence and speed in *The Conversion of Saul*[86] was strong for the future author of paintings of the same subject (Plates 159, 160) and of *The Defeat of Sennacherib*.[87] Of a reassortment of picturesque orientals plucked from the background of *The Lapidation of St. Stephen*[88] he penned a copy (Plates 155, 156)[89] which, like his copy of Leonardo's *Last Supper*, was to have the exceptional distinction of being etched in Antwerp by Pieter Soutman.[90] Such an exercise soon bore fruit in the little *Adoration of the Magi*[91] which he painted on his first visit to Rome (Plate 200), as well as in *The Mocking of Christ* for S. Croce (Plate 182); and in the former, besides the exoticism which he relished, we can see how the *contre-jour* effort of Melchior's left hand extended above the incense burner indicates serious attention to Elsheimer's way with lighting.

Elsheimer's poetic pre-occupation with varieties of illumination fascinated Rubens. In *The Shipwreck of St. Paul*[92] he saw flying sparks and the glow of firelight on faces (Plate 161). He echoed these about 1620 in the *Winter*.[93] He saw also flaring light on the stormstruck trees; and echoed that in the little *Landscape with a Windstorm* (Plate 162) of his second Spanish journey.[94] In '*The Flight of Our Lady into Egypt*', in which his keen interest shows in his letter to Faber of January 1611,[95] the scattering of light in the foliage, the moonlit sky and the reflection of moonlight in still water, inspired his own treatments of the subject about 1614; and, many years later, the '*Night upon bord*', item 173 in his 1640 Inventory, a picture which he intended originally to be a *Rest on the Flight*.[96] A pen drawing shows how he developed, by two rehearsals, the touching relationship between the Christ Child and the giant on whose shoulder He was carried, from the little *St. Christopher*[97] towards his own monumental solution of the problem on the shutters[98] of *The Deposition* in Antwerp Cathedral (Plate 29); and at the same time, in his imagination, he developed from Elsheimer's example the emotive contrasts between the supernal radiance, the science of the night sky, and the artificial shine of the lantern.

He fed his passion for Elsheimer's art by collecting. He was to own the *Judith slaying Holofernes*; another night piece, *Ceres turning Stellio into a Lizard*; an *Annunciation*; and a circular *Landscape*;[99] and these four paintings were listed in the first section of the 1640 Inventory with those by Italian masters. When the report of Elsheimer's untimely death in Rome reached him in Faber's letter of 18 December 1610,[100] he grieved so revealingly that the substance of his letter of four weeks later[101] needs to be repeated:

'Surely, after such a loss, our entire profession ought to clothe itself in mourning. It will not easily succeed in replacing him; in my opinion he had no equal in small figures, in landscapes, and in many other subjects. He has died in the flower of his studies, and "his wheat was still in the blade". One could have expected of him "things that one has never seen and never will see; in short, destiny has only shown him to the world."

For myself, I have never felt my heart more profoundly pierced by grief than at this news, and I

shall never regard with a friendly eye those who have brought him to so miserable an end. I pray that God will forgive Signor Adam his sin of sloth, by which he has deprived the world of the most beautiful things, caused himself much misery, and finally, I believe, reduced himself to despair; whereas with his own hands he could have built up a great fortune and made himself respected by all the world. But let us cease these laments. I am sorry that in these parts we have not a single one of his works. I should like to have that picture on copper (of which you write) of the "Flight of Our Lady into Egypt" come to this country, but I fear that the high price of 300 crowns may prevent it. Nevertheless, if his widow cannot sell it promptly in Italy, I should not dissuade her from sending it to Flanders, where there are many art-lovers, although I shouldn't want to assure her of obtaining this sum. I shall certainly be willing to employ all my efforts in her service, as a tribute to the dear memory of Signor Adam.'

He recognized intimately that the loss was not only of a painter of genius. Elsheimer was the 'Signor Adam' whom, with the assiduous engraver of his all too rare works, Hendrik Goudt, and with Schoppius, Rubens had named in a previous letter to Faber[102] as 'friends whose good conversation makes me often long for Rome'. In that letter from Antwerp, dated 10 April 1609, he had disclosed the quandary in his affairs, unburdening himself thus:

'I have not yet made up my mind whether to remain in my own country or to return forever to Rome, where I am invited on the most favourable terms. Here also they do not fail to make every effort to keep me, by every sort of compliment. The Archduke and the Most Serene Infanta have had letters written urging me to remain in their service. Their offers are very generous, but I have little desire to become a courtier again. Antwerp and its citizens would satisfy me, if I could say farewell to Rome.'

He yearned for Rome, not only from the point of view of his career; he missed the most congenial society which he had so far known. This is the personal context in which he was to paint a decade later his overt tribute to Elsheimer's achievement, his freely enlarged interpretation of the left side of 'Il Contento', the passage which had struck his imagination most forcibly.[103]

(ix) PAUL BRILL (1554–1626)

When Rubens reached Rome, his countryman Brill was established as the specialist in landscape, the

Studius of his age. Like Elsheimer, Brill was to be met at Faber's. The mark of Rubens's association with the older painter is the *Landscape with the History of Psyche* (Plate 150), dated 1610, which was item 26 in his 1640 Inventory.[104] He himself added to Brill's landscape the forlorn princess being offered by the Eagle (Jupiter in disguise) the cup of Immortality. This impressive prospect of mountainous woodland and waterfall shows Brill's earlier Flemish manner moderated by contact in Rome with the work of Muziano and of Annibale Carracci; his way of projecting landscape has shifted, to borrow Giulio Mancini's categories, away from 'scenica maestà' towards the 'prospetto di paese' which fully characterized his works from about 1620. Such a naturalistic evolution was sympathetic to Rubens, who in his turn was affected in landscape by Muziano and Annibale as well as by Elsheimer, and, later, Barocci. He may have gone sketching with Brill in the Campagna. Brill's influence is reflected in his *Shipwreck of Aeneas*,[105] in which the scene is fretted by incidents and the scattering of light (Plate 149). Views of Roman ruins which feature in his trial piece for the Chiesa Nuova (Plate 323), in the *Landscape with Ruins of the Palatine*, and in the '*Four Philosophers*'[106] exude a quite personal flavour of archaeological gravity: but the picturesque silhouettes of the raised skylines are attuned to Brill. We detect Brill's lingering influence again in the scenic construction, and in the relation of figures to scenery, in three other landscapes painted by Rubens during the decade following his return to Antwerp: in the alternating planes of light and dark, and the intricate rhythms of banks and trees of the *Polder Landscape* at Vaduz;[107] in the dark screen of fancifully tangled trees which sets off the luminous action of the Dresden *Boarhunt*,[108] in combination with the thrust from the foreground of the dead tree he had studied in nature; and in the locating and lighting of rocky masses framed by twisted trees in the Hermitage *Landscape with a cart stuck in the mud*.[109]

(x) THE CARRACCI: LODOVICO (1555–1619), AGOSTINO (1557–1602), ANNIBALE (1560–1609)

Rubens, before visiting Italy, could register through Agostino Carracci's prints after Tintoretto and Veronese something of the impact which Venetian art had made on him. He knew also Agostino's engraved *Lot and his Daughters* (Plate 63); and the attraction for him of these late Raphaelesque forms, designed by Agostino to be more elegant in the

mode of Polidoro, needs no special elucidation. He copied the figures (Plate 64),[110] transposing the disengaged daughter right for left by a quirk of assimilation noted already in his copy of two figures from Raphael's *Calumny of Apelles* (Plate 33); and his penwork corresponds to that of other early copies made by him in Antwerp, from Cobbe's Italianate figures for the cast and chased decoration of dishes, and from Cort's engraving after Titian's *Discovery of the Shame of Callisto* (Plate 66). The compact plasticity of the *Penitent St. Jerome*, the famous print left unfinished at Agostino's death in 1602, must also have appealed to him; and its composition, suitably reversed, may have suggested his own treatment of the subject in 1615.[111] In Italy, however, he appears to have ignored both Agostino's painting and Agostino himself, who had by then moved in Farnese service from Rome to Parma: that is, with the signal exception of the *Last Communion of St. Jerome* in the Charterhouse of Agostino's native Bologna.[112] The way of viewing landscape through a triumphal arch in his first altarpiece for the Roman Oratorians (Plate 327), as well as, more obviously, the composition of his *Last Communion of St. Francis* for the Antwerp Recollects,[113] demonstrates his debt to Agostino's masterpiece.

When Rubens visited Bologna, Lodovico, elder cousin of Agostino and Annibale, was the last of this family partnership in business in their city, and still in charge of the celebrated Accademia degli Incamminati, which Montalto as Papal Legate had licensed. Rubens's prior knowledge of Lodovico was almost certainly by reputation only. In Bologna his attention seems to have fastened on just two altarpieces: *The Coronation of the Virgin* in the Corpus Domini Church[114] was to suggest the layout of the upper zone of his own treatment of the subject in 1611, now in Leningrad;[115] and from the 1597 *Transfiguration*[116] he adapted the figures of Christ and Moses for his painting in S. Trinità, Mantua (Plate 247). These references seem almost casual when considered beside his early, deep and lasting involvement in the practice of life study inculcated by the Carracci Academy.

The key personality in this tuition by constantly fresh example was Agostino's younger brother, Annibale. As Rubens could see from the frescoed frieze of the *salone* in Palazzo Magnani, Annibale had already supplanted Lodovico as the leading spirit before his departure to work for Cardinal Odoardo Farnese in Rome. Rubens did not need to go to Rome, or to the Cardinal's palace, to make his copy, a faithful one in red chalk, after Annibale's engraving of the *Drunken Silenus* (Plate 163).[117] The Giulio Romanesque flavour of this famous design for the Farnese dish might have appealed to any painter in Mantuan service. But Vincenzo Gonzaga's Flemish painter certainly hastened to Palazzo Farnese in order to acquaint himself not only with Salviati's frescoes on the walls of the Great Hall, but also with the most recent triumph of Annibale and his team on the vault of the Galleria. The luxury and controlled energy in the unprecedentedly complex engagement of pagan narrative and decoration was to make this room the cynosure of a tremendous range of young artists, from Bernini and Pietro da Cortona to Domenichino and Poussin. It was not to be out of fashion for a century and a half. Rubens was in the first wave of those who could appreciate it as a new wonder of modern Rome. There, and in the Loggia di Psiche of the Farnesina, which Annibale had emulated and excelled, he pondered not so much his likely tasks as a decorator of palace rooms (for in that he was not to be in high mode of the Seicento, frescoing ceilings), but rather his steadily forming ambition to be master of a studio organization capable of realizing undertakings of every major sort.

Nevertheless Rubens troubled to copy in the Galleria itself at least one section of the cove (Plate 164), including a figurated roundel surrounded by detached figures, an *atlante* with a swag, a seated *ignudo*, and, below a shell, a *putto* playing with an animal skull.[118] He inscribed his drawing, 'Annibale ', despite the fact that *Leda and the Swan* appears in the roundel instead of *The Flaying of Marsyas* actually depicted. The explanation of this substitution lies in the material facts. The original paper shows an irregular, presumably accidental tear; and the missing area has been made good by a second paper backing it. The composite sheet is by no means an example – such as his copy of Francesco Salviati's *Two Warriors bound as prisoners* (Plate 125) is conspicuously – of his having outrun the limits of the paper first taken, and so having added more or less immediately neat rectangular pieces to augment the working surface, but of a drawing mutilated and, after a considerable interval, repaired by him. His preliminaries in black chalk remain visible under the brown ink on the original paper, including the upper part of the roundel, where that pre-figures not *Leda and the Swan* but very possibly *The Flaying of Marsyas*: whereas they are not to be seen on the portion which he added perhaps a quarter of a century later, supplying there freely with his brush a

fresh design quite in the spirit of Annibale yet of his own invention.

Rubens seems to have had access not only to the fresco decorations, but to Annibale's drawings for ideal figures such as the *ignudi*;[119] and to have delighted in Annibale's exceptionally bold scale of draughtsmanship as well as in the assertion of the swelling rhythms of athletic form. His own copy in sanguine of Michelangelo's *ignudo* seated to the right of *The Libyan Sibyl* (Plate 21), drawn in Rome, shows how the graphic scope of his senior contemporary from Bologna enabled him, as a youth from beyond the Alps, to comprehend the enormous suggestion of the figures on the vault of the Sistine Chapel. The features and expression of his figure, no less than the scale of drawing, although the copy remains faithful to Michelangelo, are subtly but revealingly Annibalesque. From this drawing he took a counterproof to be retouched copiously with his brush in various shades of red; and, since the counterproof sheet could not accommodate the whole of the *ignudo*'s right foot, he rehearsed the ball and the thumb toe separately, below the much enlivened drapery. The enrichment by additional drapery, the development of the Michelangelo drapery into a garland of oak leaves and acorns, and the refashioning of the face, makes it appear a conscious evocation of his admiration for Annibale (Plate 22); and his work must date, like the repair made to his copy drawn in the Galleria Farnese, from the early 1630s. The pose thus reversed and revised was then adapted for the figure of Bounty on the Whitehall Ceiling.

Rubens must have seen also examples of another genre of drawing by Annibale, observations of men at their common avocations. To an Antwerp-trained painter of his generation this habit of studying everyday attitudes and emotions must have been a revelation, since Annibale had carried it beyond the studio into the *trattoria* and the street. Rubens could have known such a study as the *Man on crutches, seen from behind,* now in the Armide Oppé collection.[120] A witness of this sort of opportunity taken is his own drawing in the Fitzwilliam Museum of a *Bystander in hat and cloak*.[121] The *recto* of this was inscribed by Padre Resta, '(A)nnibale Carracci, ma … studio di Rubens … Habé scol? di Vandic(k) … (?e)bbi in Roma nella morte d'un fanciullo suo erede', indicating the collector's desire to correct confusion, current already before the end of the seventeenth century, between the interest and style of Rubens in Rome and those of Annibale. Resta claimed to own other Rubens drawings,

stating, 'Delle sue imitationi de Carracci n'habbiamo alcune poche nel seguente Tomo quarto di questa'.[122] Both *recto* and *verso* of the Fitzwilliam *Bystander in hat and cloak* confirm this collector's attribution to be reliable in that instance. There is no call to doubt his attribution of those other, unidentified drawings, which may well have been of similar character if they were not copies of Annibale's paintings and engravings. Among the Jabach drawings in the Louvre there is one in sanguine, touched with white and yellow body-colours, of a *Mother and two infants, with a maidservant and a cat, in front of a fire* (Plate 167), a nursery scene recorded by Rubens in a spirit fully sympathetic to that of the pen and wash drawings made by Annibale in Bologna.[123]

More consequential even than these affinities, indeed fundamental to his subsequent production, was Rubens's ready acceptance in Italy of Annibale's method of preparing any important composition. Ideas adumbrated by a pen and ink trial would be revised critically, sometimes crucially in the light of studies of individual attitudes or expressions. By the example of Annibale he was able to break free of that tyranny of mannerist calligraphy which had constrained the morphology of his earlier production. The first independent, securely datable drawing in which he reveals to us how decisively he had set aside the inhibitions of a Vaenius pupil is the magnificent study in chalk, black with touches of red, which he made of a young *Halberdier* (Plate 241)[124] to stand beside *The Gonzagas in Adoration of the Trinity* in 1604–5 (Plate 239): but his revision by life study of ideas culled from Tintoretto for the *Back view of a man raising the Cross* (Plate 185), which he needed for the S. Croce in Gerusalemme *Elevation* of 1601–2 (Plate 187), was drawn in accordance with Annibale's practice, albeit both the rhythms and the choice of materials are Tintorettesque.[125] The superb series of his studies of the male body in action, drawn for participants in the Antwerp *Elevation* eight years after the picture in Rome, manifest him a confirmed disciple of Annibale.[126]

Rubens's most brilliant tribute in painting, however, to the example of Annibale was to come about 1627 in his portrayal of his friend Gaspar Gevaerts, the Secretary to the City of Antwerp, seated in his study. *Gevartius* turns his head from his writing table to face us as Annibale's *Claudio Merulo* turns his (Plates 166, 165). The historian in Antwerp, like the composer in Perugia, is disturbed in the very act of putting thoughts to paper. Such capture of an instant is of the essence of Baroque portraiture.[127]

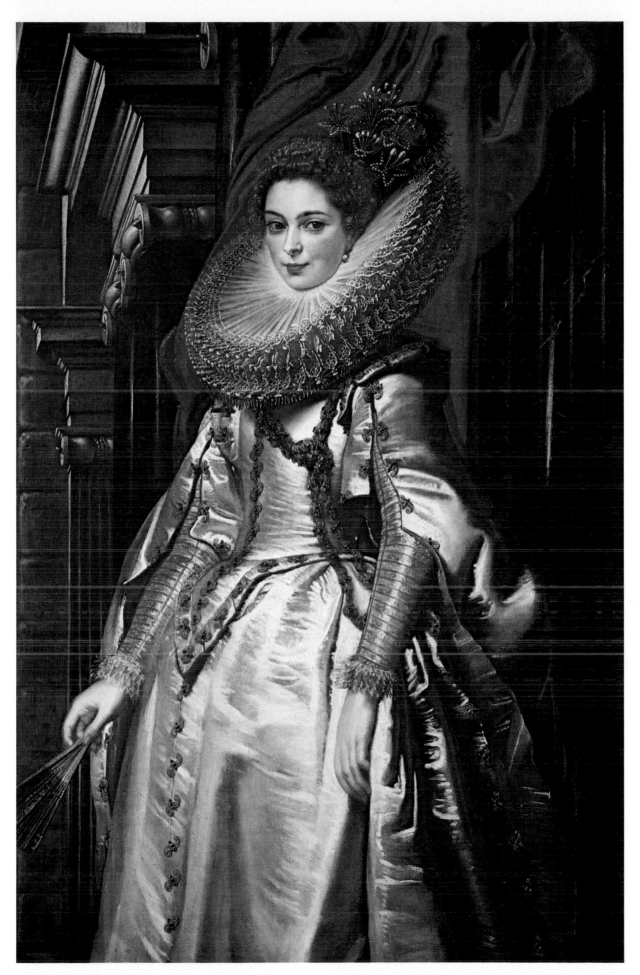

IX. *Marchesa Brigida Spinola Doria*. 1606. Oils on canvas (fragment). Washington, National Gallery of Art (Samuel H. Kress Collection)

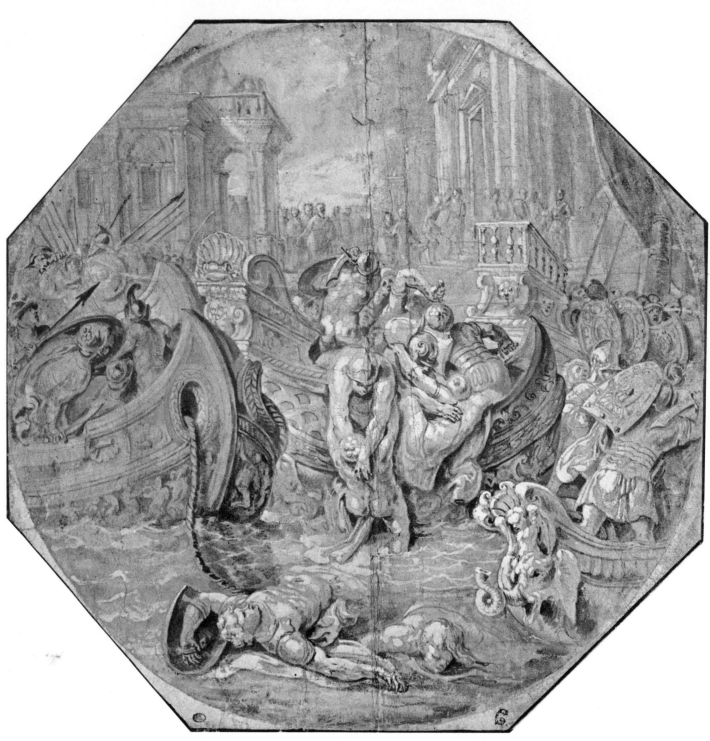

x. *A Naval Battle* (after Taddeo Zuccaro). About 1608. Watercolours, heightened with bodycolours, on paper. Paris, Louvre

(xii) MICHELANGELO MERISI DA CARAVAGGIO (1573–1610)

Caravaggio was the greatest painter in Rome, apart from Annibale, when Rubens arrived in 1601; but, by contrast to Annibale, he had evolved no studio organization, and had no working method to impart. Rubens probably came across Annibale, as Bernini in old age was to claim that he had done as a precocious boy, on some occasion when Annibale went to the Academy to pose the model and to draw. He could have been well acquainted with him. He may never have met the stormy petrel Caravaggio, who cared nothing for academic drawing, nothing for Annibale's way of planning compositions by stages of trial, correction and rehearsal. Caravaggio would never have produced a *modello* for a client, let alone a cartoon. He fought out his solutions, campaign by campaign, on the canvas. Nevertheless Rubens, like some other young Northerners who came later to Rome, was fascinated by the power and strangeness of Caravaggio's style of religious painting. According to Honthorst's pupil Sandrart, who conversed with him twenty years later in Holland, the great Flemish master adopted Caravaggio's strength of colouring (by which presumably we should understand saturation and contrast), but, finding Caravaggio's way of proceeding 'too ponderous and slow', abandoned it for his own 'swifter and more fluent' manner.

Temperamentally Rubens was unsuited to become a follower of Caravaggio for longer than an experimental period, but his interest outlived his stay in Rome. His most Caravaggesque experiments took place in the five years after his return to Antwerp; although these were technically at odds with his preference at home for brushing paint over the smoothly prepared surfaces of oak panels, as opposed to the rough tooth of bolus-covered canvases which he, as well as Caravaggio, had used south of the Alps.

When first in Rome he must have lingered in the Contarelli Chapel of S. Luigi dei Francesi, digesting the import of the artistic sensation of the metropolis, the three canvases the novelty of which Federico Zuccaro had dismissed as nothing but 'the manner of Giorgione'. In *The Calling of St. Matthew* (Plate 168) the seated *spadaccino* quickly took Rubens's fancy, as we may observe in the attitudes of the shepherd in his *Judgement of Paris*[128] about 1601 (Plate 208), and of the youthful apostle on the near side of the table in his contemporaneous trials for a *Last Supper* (Plates 193, 194).[129] The arrangement of figures at the left-hand end of the table in *The Calling*, as well as the angel in the *St. Matthew writing his Gospel*, were to be recalled by him in the *Four Evangelists*,[130] now at Sanssouci. The loose sketch of a *Tavern Brawl*,[131] lightly drawn in black chalk on the reverse of his early *Project for a Memorial to a Famous Man*,[132] indicates another aspect of his readiness to express anew ideas engendered by the expressive violence and fancy costumes depicted in the side wall paintings.

Rubens knew also the earlier version of Caravaggio's *Supper at Emmaus* (Plate 169).[133] The outflung arms of the elder disciple there surely prompted his corrective memorandum on one of his own *Last Supper* drawings (Plate 193), 'Gestus magis largi longique/brachiis extensis' (Gestures larger and longer, with arms extended); and the intensely naturalistic treatment fused with sharp memories of the composition of Titian's *Supper at Emmaus*[134] in the Gonzaga collection (Plate 170) to guide his own treatment of the subject, recorded in Willem Swanenburg's engraving of 1611 (Plate 171).[135] The simple-seeming devotional lesson of exposing the bare and dusty feet of pilgrims kneeling to the Madonna and Child was not lost on Rubens; and the clearest echo of the S. Agostino altarpiece[136] comes from his pen and wash drawings for *The Presentation in the Temple* (Plate 188)[137] on the right wing of *The Deposition* triptych, where Joseph kneels humbly before Simeon.

His longest-lived interest in Caravaggio's painting was from the viewpoint of a collector. In 1607 he recommended and negotiated the purchase for the Gonzaga gallery, including arrangements for exhibition in Rome and despatch to Mantua, of *The Death of the Virgin*[138] which had been rejected as indecorous by the Discalced Carmelites of S. Maria della Scala. He must have been impressed by the weight and emotion in this incomparable masterpiece, and by its authority in narrating the awful plainness of the natural event. He may have known also in Italy *The Madonna of the Rosary*,[139] which Pourbus the same year recommended in vain to Duke Vincenzo. That altarpiece was to be acquired appropriately for the Dominican Church in Antwerp ten years later, Rubens himself leading the body of subscribers.

For his own collection no original by Caravaggio was available. But item 36 in his 1640 Inventory was, 'A Christ, in short, a Coppie after Caronaggio', to be identified with the very free re-interpretation which he painted about 1612 (Plate 173), evidently on the basis of some more literal record taken by

him of Caravaggio's altarpiece in the Vittrice Chapel of the Chiesa Nuova (Plate 172). His little painting[140] is a marvellous reminder of his experience, at one point daily experience, of Caravaggio's invention. However, not only is the scale vastly reduced, and the texture and luminosity materially changed by use of a panel support rather than canvas such as the original had, but also the composition has been tampered with. The eerie fan of mourning hands has been suppressed; and once again a memory of a Titian at Mantua, on this occasion *The Entombment* (Plate 174),[141] has been conflated with that of a Caravaggio in Rome by the introduction of the relation of two heads, those of the Madonna and Mary Cleophas. Furthermore, whereas Caravaggio's tightly locked configuration in bas-relief beseeches the worshipper's aid in releasing tension and receiving the dead weight of Christ, Rubens characteristically imparted the semblance of movement and the potential of further movement, by means of which Michelangelo and Raphael would have approved. His St. John has stepped down with his right foot beyond the Stone of Unction; and the appearance of Joseph of Arimathea at the right, immobile and just clear of the sweep of drapery made by Mary Magdalene's sleeve and the skirt of Nicodemus's garment, adds tension to the movement implicit in the main group. No less characteristically, he has created a sense of space for this movement by suggesting an apsidal recess in the rock.

Rubens continued to be obsessed by the ways in which Caravaggio's invention was fraught: the gloom of the sepulchre, the lurid illumination, the physical immobility and the emotional stress. He explored them further in a pen and ink drawing,[142] belonging to the Rijksmuseum, by regrouping the figures (Plate 175); by engaging Joseph of Arimathea with the actual shroud of Christ, and by shifting the others so as to give a compact diagonal of movement downwards. Then, in an oil sketch[143] about 1616, he took his cue from an imaginative project for the scene drawn by Polidoro in brown ink and white bodycolour (Plate 176), and increased the size and elaboration of the setting in relation to a more strung-out arrangement of figures (Plate 177). Even if he took this new composition no further in painting, it may not have been his last reconsideration of the problems set by Caravaggio in the first years of the century.

With Caravaggio's followers as such Rubens had no special concern, although he may have had some contact with Orazio Gentileschi, who was friendly with Caravaggio about the time that he himself first came to Rome, and who worked in a strongly Caravaggesque manner from about 1605 to about 1620. He was certainly to draw, in pen, figures of women playing musical instruments[144] from an English work of Gentileschi, *Apollo and the Muses* (Plate 157), and he adapted this group about 1630 for the women of Jerusalem welcoming *The Triumphal Return of David*.[145] In Utrecht in 1627 he had visited Honthorst, and had been fêted by him at a banquet before leaving for Amsterdam; and it was on that journey by barge that the young Sandrart[146] had been deputed to accompany him. According to Sandrart, the great man singled out for praise Honthorst's mature style of painting, especially in his night scenes, and Bloemart's draughtsmanship and Poelenbergh's little landscapes with figures. Nevertheless, whereas on his rapid round of the Dutch studios, or as an outcome of it, Rubens acquired paintings[147] by Poelenbergh and by Porcellis the Elder, by de Vlieger, Palamedes, den Vuyl, Dirk Hals and Willem Claesz Heda, to judge from his Inventory of 1640, he acquired, or at least retained, nothing by Honthorst. He was diplomatic in talking to Honthorst's pupil; but for him the more or less Caravaggesque style in which Honthorst continued to paint had lost its magic.

(i) THE RELIGIOUS WORKS IN ROME

Rubens's first public commission, recorded by Baglione,[1] was to paint during the autumn and winter of 1601–2 a principal altarpiece and then two others for the Cappella di S. Elena at S. Croce in Gerusalemme.[2] This semi-subterranean chapel, in what had been the titular basilica of the Archduke Albert until he relinquished his cardinal's hat, was of especial sanctity; and the Archduke had presented to it a particle of the True Cross.[3] The name of the patron having suffered the previous winter in Rome from scandal about his failure to pay a goldsmith 300 ducats for a monstrance,[4] his agent Richardot had recommended the commissioning of paintings for the walls of the chapel, so as to complete what was outstandingly lacking from the decoration. On 8 June 1601, the Archduke gave his approval, with full discretion to Richardot, provided that the expense did not exceed 200 scudi. So Richardot had the chance to extend a favour to a family friend, who had as yet no reputation on which to base a higher charge.

A predecessor of the Archduke as Cardinal Priest of S. Croce in Gerusalemme, Cardinal Lupo di Carvajal, had restored the chapel vault, and had begun to enrich it with mosaic. Small scenes from the Legenda Aurea were designed for it by Baldassare Peruzzi, and the work had been continued for the Archduke by Antonio di Nicolò Pomarancio. These *istoriette* illustrated *St. Helena authorizing the search for the relics of Calvary, with the Finding of the three crosses*; *The Visionary recognition of the True Cross*; *The Division of the Cross into particles*, and *St. Helena in adoration of the Cross*. Untried subjects had therefore to be sought for the altarpieces which were to fill round-headed recesses in the end wall and in the two side walls. Half a century earlier, in the Orsini chapel dedicated to St. Helena at S. Trinità dei Monti, the principal field had been frescoed by Daniele da Volterra with a *Deposition from the Cross* (Plate 144), which had become at once, and remained in Rubens's day, one of the sights of Rome.[5] That choice of subject paid homage both to the Passion of Christ and to the cult of St. Helena; but for an unknown young foreigner to essay it again in the artistic metropolis would have invited rebuke. At S. Trinità the ancillary scenes on vault and walls, as on the vault at S. Croce, dealt with the canonical stages of the miraculous recovery and identification of the Cross.

For S. Croce Richardot and Rubens picked three subjects unfamiliar in Rome, the Archduke apparently not having specified any. The main altar was to show *St. Helena in ecstasy* (Plate 179), a majestic image of the patroness upright beside the True Cross, the weight of which is sustained by cherubim. The representation of the Crown of Thorns close beside the Cross served to introduce themes from the Passion as subjects for the supporting altars, in reference to the Basilica's owning a thorn in addition to the particle. The lesser altar on one side was to have the *Mocking of Christ* (Plate 182), with emphasis on the mock coronation more explicit than in Titian's classic treatment of the theme for S. Maria delle Grazie in Milan. The other was to have a subject exceedingly rare south of the Alps, *The Elevation of Christ on the Cross* (Plate 187), in which, as we might expect, ideas used by Tintoretto for the raising of the thief's cross (Plate 186) in his S. Rocco *Calvary* were to be developed afresh by Rubens (Plate 189).

Rubens was anxious to display the pictorial sophistication which he had been acquiring in Italy since midsummer the previous year. The concept of his *St. Helena* takes account of the antique marble of a Roman matron which in the sixteenth century had been discovered in the precinct of S. Croce and restored as a venerable effigy of the saint.[6] However, the eloquence of his figure, particularly the tilt of the head with eyes ecstatically upraised, and the splendour of her dress, respond more strongly to Raphael's *St. Cecilia*. There are other Raphaelite echoes: in the setting of Salomonic columns, familiar from *The Acts of the Apostles*; and in the ornamental effect of a cherub's hair streaming sideways, explicable from more recent acquaintance with the Farnesina *Galatea*. At the same time both the types and the play of the flight of cherubim reflect Rubens's growing attraction to the art of Elsheimer, in such a painting as *The Baptism of Christ* (Plate 178).

A rapid sketch in pen (Plate 181), on the reverse of a sheet of paper used by him to note the crouching Magdalene from Marcantonio's engraving of *The Feast in the House of Simon*,[7] reveals his primary

intention for *The Mocking*: to stress by lighting as well as by intensive movement the derision in the act of crowning Christ, over whose head an oil lamp offends with its sickly flame the aureole of divinity. The peculiar splay of Christ's legs and the torsion of His body, expressive of humiliation and suffering, witness the impression made by Titian's masterpiece in Milan. In his painting Rubens went on to develop the conflict of illumination by which, as in Raphael's *Liberation of St. Peter*, moonlight contrasts with man-made and with supernal sources: but he regulated the attitude of his Christ to the taste of a public schooled to revere the *Torso* and the *Laocöon* in the Vatican Belvedere. Black chalk drawings show how assiduously he had studied both these antique marbles (Plates 276, 306); and he seized his first opportunity to incorporate in one mass the body of one with the legs of the other. Such hefty quotation might be taken as typical of any Antwerp Romanist in the making. No less mannered are the abrupt change of scale in the figures from foreground to background; the pun of fashioning the prison lantern in the classical form of a *tempietto*, complete with a miniature balustrade so as to echo the larger but more distant balustrade beside which is placed an Elsheimerish figure in a turban; and the device of focussing on that diminutive, furthermost figure, as though to introduce by him to an unseen crowd the shameful story enacted immediately before us. Yet these ideas begin to be tempered, as was to be increasingly characteristic of Rubens, by the test of life. We have his vibrant study for the head of the youth in a feathered cap, painted from a model (Plate 180), and likely from the cheapest one available, Deodato.[8] For the half-naked man kneeling between us and this youth, there must have been a special study in chalks, such as Annibale Carracci prepared in Bologna for the man who lifts stones beside the plough of Romulus in the scene to be frescoed at Palazzo Magnani. Moreover the symbolic crossing of the hands of Christ, here with the empty palm of the lower upturned as though ready to receive the iron nail, is more poignant than any pose invented by the mere exercise of mannerist wit.

The tragic figure of the Christ in *The Elevation*, like the one in *The Mocking*, remains morphologically in the taste of Vaenius, but is arranged after the fashion of Michelangelo's *God creating Adam*, which Rubens had copied (Plate 24).[9] The back view of the man supporting the weight of Christ's body is a mark of his admiration for the standing figure in Tintoretto's *Hercules and Antaeus* (Plate 184);[10] and of that he may have been reminded, again in the *salone* of the Palazzo Magnani, by Annibale's figure of the man raising the plough for Romulus. In any case it was Annibale-like to revise, through a pose suited to the exact requirements of his own composition, an heroic idea discovered by Tintoretto. Rubens's study survives (Plate 185), worked in a Venetian combination of black chalk and charcoal with white heightening over the mid tone of a tinted paper. The rhythm of outlines, particularly where the schema shows least correction from fresh observation, at the base of the back and the buttocks, is revealingly Tintorettesque. The man wrapping himself round the foot of the Cross, and the man hoisting it by a rope bent round the tie, reflect a more general inspiration from the men raising the thief's cross in the S. Rocco *Calvary* (Plate 186). But the immediate inspiration of the whole comes not from any Roman, or Bolognese, or native Venetian prototype; but from a design by another Northerner, who had died ten years before in Munich after a career in Venice, Christoffel Schwarz. From the handsome engraving executed by Jan Sadeler in 1589 after this design (Plate 183), Rubens developed the strongly diagonal pattern made by the shank and the bar of the Cross: the emotive device of the man tugging at Christ's loin-cloth; the triangular peep through the *bas-relief* made by the foreground group, which allows further figures to be descried; even, perhaps, such a detail as a soldier with a plumed helmet. That Rubens continued to be attracted to the vigorous imagination of Schwarz is manifest in a pen drawing of about 1604.[11] In this he copied with characteristic speed and brilliance Schwarz's *Defeat of Sennacherib*, a painting he could have known in one of several versions (Plate 233).

Seven years after Rubens's *Elevation* had been placed in Rome, he essayed the subject again on a much enlarged scale (Plate 190): as the inner face of a triptych for the high altar of the oldest parish church in Antwerp, St. Walpurga's. That commission, one of those which established his public reputation on his return, was obtained through the good offices of a wealthy merchant and amateur of the arts, Cornelis van der Geest. In form the altarpiece for this Gothic church followed Flemish tradition: a central field, with shutters painted figuratively inside and out, surmounting three *predelle* of additional narrative; and above, with elaborate cresting, *God the Father* framed centrally and flanked by triumphant angels cut in silhouette. The three main fields, however, with shutters open, show a revolutionary advance, his mature criticism[12] of the necessarily more confined treatment of the subject

for S. Croce. The narrative, continuous from wing to wing, is interrupted only by the wooden framing of the panels. The Madonna no longer lies fainting, supported by a Mary, as in Veronese's *Calvary* and Daniele da Volterra's *Deposition* (Plate 144): but, on the left wing, she stands supported by John, in accord with Tridentine precepts. Counterbalancing her group, on the right wing, is a mounted centurion directing the action with outstretched bâton: a monumental recollection of one designed by Giulio Romano to close a composition long familiar to Rubens in the Sala degli Stucchi of Palazzo del Tè (Plate 109). Christ in agony, recast in the spirit of his studies from the *Laocoön* (Plate 307), becomes a heroic figure caught at the peak of bodily and spiritual crisis. He appeals in the broad day to His Father painted above, who blesses Him as Raphael's Eternal Father blesses Christ and Christ's bearers in the Baglioni *Entombment*; and not, as in the candlelit confines of the Cappella di S. Elena, sentimentally to devout women at their prayers only a few yards away. At St. Walpurga's the tense bow of Christ's body was to subsume within itself the expressive force of every other figure engaged in the close-knit action about Him; and beyond Him of each element of mourning and command, involving the congregation below and summoning their worship Heavenward by His glance.

This revolutionary advance can be gauged also by Rubens's advance in understanding Michelangelo. In the S. Croce altarpiece the uncanonical attachment, by hands only, of Christ to His Cross, a strangeness remarked by Sandrart,[13] seems the outcome of an almost pedantic insistence on referring to the crossed legs of *God creating Adam* (Plate 24), flying with right arm outstretched, on the vault of the Sistine Chapel; and the man tugging at Christ's loin-cloth, whose gesture is equivalent to the stripping of the white pall in *The Mocking* (Plate 182) opposite, ostentatiously fails to align the diagonal of Christ's body to the rising shaft of the Cross, and thereby avoids concealing the allusion to the fresco. In the Antwerp triptych there are no discernible quotations from Michelangelo. Yet the rhythms of muscular stress and the controlled violence of expression proved Rubens there in the field of sacred history to be a painter of an order which Michelangelo himself could have disdained only through mere jealousy.

The Mocking he did not attempt a second time. But within a year of his return to Antwerp he began to exploit another theme of cruel betrayal, whose psychological overtones he again felt that he could treat best by eerie lighting as a nocturnal and claustrophobic drama, *The Capture of Samson*; and the way to success of his eventual masterpiece on that theme, painted for the chimneypiece of Burgomaster Rockox's principal room,[14] was prepared not only by a dazzling sequence of oil sketches and ink drawings, but also by the early struggle with the comparable problems in S. Croce. If we look for his mature criticism of *The Ecstasy of St. Helena* (Plate 179), we should find it in his design of *Sancta Barbara Virgo et Martyr*, engraved about 1618 by Schelte a Bolswert,[15] in which the ecstatic stance of the solitary saint and the expressive amplitude of her draperies seem to prepare the way for Bernini's *S. Bibiana*.[16]

From late July 1601 until February or March 1602, Rubens was under the wing of Cardinal Montalto, of whom he envisaged and perhaps painted a portrait (Plate 258).[17] If, as is likely, he produced for this protector also some religious work, that could well be either *Christ and Veronica*, known to us through Conraet Lauwers' engraving (Plate 196)[18] and through an old copy painted on panel,[19] or *The Entombment*, eventually to be in the Borghese collection (Plate 199),[20] or indeed both. In the crowding of figures within a shallow space, in the stressing of diagonals, in the Vaenian visage of Christ, and in the style of draperies and armour, both these compositions stand close to the work for S. Croce. The dimensions of the canvas on which *The Entombment* is painted, with figures about three-quarters life size, make it improbable that the picture was executed except on commission; and the old copy of *Christ and Veronica* indicates that, even though the original was smaller than *The Entombment*, the figures were of comparable scale. No invention of Rubens, as he was to remind Chieppio in 1608, hung in the Gonzaga gallery;[21] and in Rome at this stage he had no patron to our knowledge but Montalto.

The head of the guard holding the rope in *Christ and Veronica* is based on a head drawn by Rubens after the Farnese *Hercules* (Plates 279, 280). Some of his drawings from that were made in Tintoretto's manner of studying sculpture, using black and white chalks on tinted paper, and copying the object on either side of the same sheet by different casts of light.[22] Similarly, whilst the sarcophagus reliefs in *The Entombment* evoke the antique, it is the antique refracted by Titian. The Joseph of Arimathea looks to be a Titian-inspired figure. *Christ and Veronica*, with half-length figures pressed close to each other in the foreplane, is again in the Titian tradition.

Moreover, as we have seen, the deployment and the sentiment of the figures in *The Entombment* reflects Rubens's taste for Giuseppe Porta, just as the lighting is a sign of his response to Tintoretto. In these two pictures, neither evidently for a public site in the metropolis, he painted more in a Venetian than in a Roman manner. His ability to be at will, and according to circumstance, more or less Roman in Rome, we shall meet again in reviewing his undertakings of 1608 for the Oratorians.

A devotional picture on a considerably smaller scale belongs by style to Rubens's first stay in Rome. This *Adoration of the Magi* (Plate 200) seems to be his earliest and most tender treatment of a theme in which he revelled repeatedly during the next thirty years. The choice of setting, the Temple of Vesta at Tivoli, remembered in the seventeenth century as the church of S. Maria della Rotonda, suggests a date after his first chance to explore the Campagna. Without that setting it might be dated regardless of his Roman experience. The composition, with Mary and Joseph standing amid the ruins of a circular temple, and thereby raised above the visiting crowd, recalls one engraved after Rosso Fiorentino (Plate 201) which could have been known to him already in Antwerp.[23] The positions of Caspar and Melchior relative to each other suggest that he had visited S. Corona, Vicenza, and studied there Veronese's altarpiece on the same theme: but the trickle of attendants reflects the exoticism which he relished in Elsheimer more sharply than anything seen directly in Veronese; and the *contre jour* effect of Melchior's left hand extended above the incense burner again reminds us how well aware he was of the master from Frankfurt. The charm of this painting for David Teniers the Elder is such that ideas have been entertained of his having been its author. Its scale is within the compass of that minor master, and so, conceivably is the rather gauche Balthasar in profile: but he could never have brought off the spirited painting of the other foreground figures, especially the glistening white robes of Caspar and the glowing forms of Melchior's crimson brocade, nor a Mary so like the Madonna of the Borghese *Entombment*, nor so firmly constructed a pyramidal design with figures and architecture.

Both the Borghese *Entombment* and this small *Adoration* were painted on bolus-prepared canvas, following the practice of sixteenth-century Venice in establishing overall a warm middle tone, from which to work up a depth and resonance of colour. The S. Croce in Gerusalemme paintings, and prob-ably the original of *Christ and Veronica*, were on wood. The head study for *The Mocking* (Plate 180) is on paper.[24] Rubens continued also to use in Italy a fourth material as support for painting, one to which he had grown accustomed in his apprentice-ship, copper; and by far the smallest of this group of religious works which appear to have been painted within his first two years in Italy is an *Entombment* (Plate 198) recorded in the collection of his brother's employer, Cardinal Colonna.[25] The mourners differ from those of the Borghese picture, being more crowded and more extravagant in bodily expression; and the focal figure is more sinuously contorted. Nevertheless the com-positional sense, both in the pattern of figures and in the organization of light, is comparable; and there are close similarities in the emotional treatment of Joseph of Arimathea and of the Magdalene. The Colonna picture may be regarded therefore as Rubens's trial for the more restrained and larger-scale composition of the Borghese picture, highly finished yet slight enough to be kept by him for four or five years before parting with it to the Cardinal. His ideas for a *Last Supper* (Plates 193, 194), for a *Deposition* (Plate 148), and for a *Washing and Anointing of the Body of Christ* (Plate 195),[26] do not seem to have found a patron in Italy ready to commission them in painting.

Rubens during his first years south of the Alps, in seeking a market for his small-scale paintings, may occasionally have sent some picture to a client in Antwerp who had a continuing interest in his development. It has been suggested, quite plausibly, that one such may have been his spectacular treat-ment on an oak panel about 1601–2 of *The Con-version of Saul* (Plate 202), since this could well be identical with a panel painting inventoried at the death of Nicholas Rockox; and the picture has long hung in what was the Rockox house in Antwerp, 'Het Gulden Rink', there traditionally but in-correctly ascribed to Vaenius.[27] The hectic vigour of the turbulent action, the eerie flaring and raking of the light on the figures, the very decision to express the drama uncanonically as a night scene, these mark it as an early *tour de force* by Vaenius's most gifted pupil. In it Rubens strove to come to terms with the message for him of *The Battle of Anghiari*, in the context of his recent experience of Elsheimer both in Venice and Rome, as well as of Tintoretto in Venice. We may think not only of Elsheimer's treatment of the same theme, but also of his *Deluge*[28] about 1600; and we catch reflections of Elsheimer's taste for noc-turnal illuminations and of Elsheimer's exoticism.

(ii) MYTHOLOGIES AND ROMAN HISTORY

Rubens used a small sheet of copper to sketch the composition of his earliest known *Judgement of Paris* (Plates 207, 208),[29] which hangs in the National Gallery near to the famous Orléans picture of about 1635.[30] Both these finished versions are painted on composite panels of oak, of approximately identical dimensions; and the juxtaposition offers a peerless opportunity in London to observe the span of his pictorial progress, particularly in an assimilation of the art of Titian which was quickened and deepened by his second experience of the Habsburg collections in Spain.

The early *Judgement of Paris* shows awareness of the classic statement of the theme engraved by Marcantonio after Raphael.[31] But the resemblance is confined to the disposition of the actors, to the riverside setting emphasized by the river-god seated with the naiad, to Juno's pose, and to the decorative deployment of Minerva's drapery, shield, and plumed helmet. Rubens departed from the engraving with considerably more freedom that he had done in basing his *Fall of Man* on the relevant Marcantonio print after Raphael (Plates 6, 7), about two years earlier in Antwerp. Of Minerva's pose he retained only the stance, but substituted for the upper part of her body another back view of a naked goddess, which he culled from a scarcely less well-known design, that of *Juno* engraved by Caraglio after Rosso Fiorentino (Plate 204) for the series initiated in Rome in 1526.[32] The relationship of his *Paris* to his *Venus* was almost certainly inspired by a third print, the *Adam and Eve* engraved in 1579 by Jan Sadeler after Marten de Vos.[33] The line of the man's bare shoulders, the rhythm of the male and female arms in diagonal foreshortenings, his bent and hers outstretched, the focal clasp of their left hands on the apple, all this would have excited him to project the tension of the fateful exchange with a still greater dynamism. In Marcantonio the linear undulations of the figures look flaccid by comparison; and his apple of Eris appears discordant only in so far as it interrupts the fall of Juno's drapery. The counter-movement given by Rubens to his Juno, the sharply foreshortened right hand thrust like a weapon through her drapery, concentrates more effectively the drama of the group.

Inspiration from these sixteenth-century engravings would have been available in Antwerp; and the physiognomy of his figures, their ridged and nervously broken draperies, even the types of the cloud-borne *putti*, have still not evolved far from the morphology practised by him under the tuition of Vaenius. We may even think ahead to Vaenius's *Christ and the Four Great Penitents* (Plate 4).[34] Yet some elements in both conception and execution of Rubens's *Judgement of Paris* must post-date his first arrival in Venice. The burst of radiance through dark clouds and the bold foreshortenings of figures in flight depend on experience of the Scuola di S. Rocco. There is a trace also of a passing attraction to the art of a fellow Northerner, a dozen years older than himself and established in Venice since 1596, Hans Rottenhammer. Rottenhammer had digested what he could of Tintoretto, evolving a decorative approach to figure composition whose appeal for Rubens can be sensed in the sway and proportions of his goddesses, especially Venus and Minerva. This affinity between the young man from Antwerp and his senior from Munich, inevitably from their artistic natures no more than transient, is still more evident if we compare these two goddesses in the oil sketch on copper which Rubens painted for his picture about 1601, with the corresponding figures in Rottenhammer's dainty and highly finished cabinet piece on the subject, also on copper, painted in Venice in 1597 (Plates 207, 203).[35] It may be more than coincidence that, whereas in the Marcantonio print a grave, adult, Roman figure of Victory crowns Venus, Rubens, like Rottenhammer, entrusts the wreath to a *putto*; that Rubens's Mercury, like Rottenhammer's but quite unlike Marcantonio's, uses his caduceus to point to the hovering child who is about to crown the goddess; and that both Rubens and Rottenhammer have two satyrs emerging half-length from the thicket beyond Paris. Rottenhammer, about the turn of the century, could thus attract to his style a far more consequential Flemish painter than Hendrik van Balen!

Rubens could hardly have managed the system of illumination, the lusciousness of the nudes, and the strength of the *scorci*, without first-hand and extensive acquaintance with art in Venice. The physique of his Paris suggests experience also of antique sculpture, in particular of drawing the muscular back of the Belvedere *Torso*.[36] Only after a visit to the Contarelli Chapel could he have adapted so effectively for Paris the way in which Caravaggio's youthful *spadaccino* sits alert and twists on a stool (Plate 168). That figure caught his eye in Rome in the summer of 1601; as we have noted, a reminiscence features on a sheet of his studies for a *Last Supper* (Plate 193). Those are penned in the same style as the trials to revise that part of the Marcan-

tonio design which satisfied him least, the pose of Paris and of Paris's dog in relation to Juno (Plates 205, 206). We may infer direct knowledge of both ancient and up-to-date art in Rome, as well as of late sixteenth-century art in Venice.

His oil sketch is appreciably more Venetian than his finished painting. Indeed the only trait distinctively Roman in the former is the loose reference to the Caravaggio pose for Paris, far lither and more sinuous than that figure becomes with the admixture of the Belvedere *Torso*. Quite apart from the Rottenhammer-like group of Juno and Venus, the movement and draperies of Mercury and Minerva suggest the general influence of Veronese, even of a particular *Judgement of Paris* by that master. X-rays of the finished painting reveal how Rubens tried Minerva's legs and draperies in at least two positions similar to those in his sketch.[37] The more active representation of her rôle was then abandoned in the interests of a more Roman ponderation and *gravitas*, such as he had evolved for the judge of the fairest.

Circumstances allow the sketch to have been painted soon after he reached Rome with the recommendation, dated 18 July 1601, to Montalto. Coming '*per copiar et far alcuni quadri di pittura*',[38] he may well have had this patron in mind. Montalto had been Papal Legate at Bologna, and was conversant with Annibale Carracci's progress thence to the metropolis. Such a person might have appreciated – or might actually have suggested to the Duke of Mantua's Flemish painter – a change of pose in his Minerva to something more metropolitan in taste, corresponding to the prints after Rosso and after Raphael; especially since Annibale himself had recently adapted the engraved *Juno* to serve as the personification of Vice in *The Choice of Hercules*, which was to be frescoed on the ceiling of the Camerino Farnese. Rubens presumably revised his ideas almost immediately; for his painting on panel fits best the late summer or autumn of 1601, before he was fully committed to the altarpiece for S. Croce in Gerusalemme. The drapery, conspicuously the brocade of Juno, as well as the radiance of the sky, comes close to that in the *St. Helena*. But, whereas *The Judgement of Paris* might only just have preceded the work commissioned for the Archduke Albert, it would not have been allowed to interrupt the course of that. On the other hand, it can hardly post-date *The Assembly of the Olympians*, a large canvas, which, on grounds of iconography and style, has been placed convincingly towards the end of 1602 (Plate 220). This relative dating is confirmed by comparison of the

river-god and the naiad at the right of *The Judgement of Paris,* a rather awkward paragraph introduced after Marcantonio's example in order to amplify the breadth and depth of the composition, with the partly nude figures on Juno's side in *The Assembly of the Olympians*: the latter show a decisive growth of confidence in the treatment of plastic volumes, in the handling of draperies, and in the functional integration of their forms within the whole context.

The composition of *Thisbe falling on the sword*, for which brilliantly Raphaelite trials exist both on the *verso* of a Louvre drawing for the Paris-Juno group of 1601 (Plate 218) and on a fragment from the same sheet at Bowdoin College (Plate 219), has not come to light in a picture painted by Rubens at this period;[39] nor has any such realization of *The Return of the Victorious Horatius*, a scene from Livy penned on the *recto* of a sheet in the Metropolitan Museum.[40] On the *verso* of that there are studies for an unknown *Baptism* of more Venetian character than the Mantuan piece of 1604–5, and as a further study for the 1601 Paris (Plate 205).[41] Nor do we know a *Discovery of the Shame of Callisto* which develops a pen sketch in Berlin for the Callisto group (Plate 67).[42] However, we know another painting, contemporary in style although in scale smaller than the 1601 *Judgement of Paris*, and likewise on oak panel, a *Leda and the Swan* (Plate 209).[43] The malachite green of Leda's drapery, and the flesh painting, match those of the naiad in the *Judgement of Paris*, the uncertain breaking and meander of the folds being congruent to those of herself and the river-god. The treatment of her hair, the piquant vermilion of her lips and exposed nipple, the degree of looseness in the actual brushstrokes, all find equivalents in the other picture.

This *Leda*, to be dated within eighteen months of Rubens's arrival in Italy, is patently modelled on Michelangelo's tempera painting for Alfonso I d'Este, which had gone to Fontainebleau. There Rubens would have seen it on his southward journey. His painting in oils, now in London, is clearly allied to his realization of the same subject on a scale just larger than life, the picture in Dresden (Plate 210).[44] The former is sketchier and less ambitious, although no less intensely felt: but it was not by intention a sketch for the latter, in the mode that Rubens was beginning to evolve such relationships in his working practice. X-ray photography reveals how the group in the London picture was projected initially within a painted ellipse, as it were the pictorial enlargement of an antique jewel.[45] The enframement contained every essential

of the composition but Leda's left elbow, and the ball and toes of her right foot. As a commentary on Michelangelo's design this device shows the imaginative insight of Rubens. Nevertheless he chose to avoid procrustean manipulation and to preserve without elision or other modification the inherited pattern; although by engaging himself to bring into play the whole rectangle of his panel, he was forced to relax the sculptural concentration.

The London *Leda* was developed in its own right; but the larger, more finished picture in Dresden was a proper sequel. There Rubens made a virtue of accepting a rectangular field, by control of those elements of drapery and landscape unforeseen in Michelangelo's design. The drapery is changed from green to white combined with glowing crimson. This crimson not only becomes important in the symphony of reds, together with vermilion in the lips and nipple and rose-madder accents scattered in the flesh, but it may even reflect better Michelangelo's intention to use a red drapery. The river landscape, by the light of a late afternoon sky, accords with the greener and more sunlit view in the 1601 *Judgement of Paris*. Like that, it is still Northern rather than Venetian in character; and at the same time remarkably personal in its assurance. Rubens's attention to the foreground plants is worthy of Dürer. Sour grasses and anemones, white and yellow, grow near the bank; farther from the water's edge, towards the right, flourish in their natural order sweet grasses, arabis, and field plants. The conjunction of the heads of Leda and the swan epitomizes the match of sensuous painting and sensual feeling in this early masterpiece.

Within months of painting the Dresden *Leda*, perhaps soon after regaining Mantua, Rubens attempted more ambitious illustrations of classical mythology. Two[46] we know in sadly damaged condition. They were painted with lifesize figures on canvases of the same dimensions, and were apparently regarded as pendants, being described by Bellori as *Hercules and Iole* (Plate 215) and *Adonis dead in the arms of Venus* (Plate 214) when together in the collection of Gian Vincenzo Imperiale; and this ownership implies patronage from Genoa in advance of Rubens's first likely visit to the city in the early weeks of 1604. For, although the tree trunks and foliage of *The Lament for Adonis*[47] are close in character to those of *The Baptism* (Plate 246), which was to be ready for S. Trinità, Mantua, by Trinity Sunday 1605, the mannerisms of form, lighting and composition suggest a date before the Gonzaga mission to the Spanish court; and the motif of plants

in the foreground resembles that of the Dresden *Leda*. The interweaving of forms about the dead hunter recalls the Colonna and Borghese *Entombments*; and the companion piece, *Hercules and Omphale*, reinforces the impression of the earlier dating. The posture of Hercules is more overtly based than Christ's in *The Mocking* on a combination of the Belvedere *Torso* and the *Laocoön*; and the hag's features revive in paint second-century Roman sculpture of the type of the *Old Market Woman* in the Metropolitan Museum.[48] Underlining these heavy allusions to antique marbles is a relief inset in the socle on which Omphale stands, pictorially akin to the relief in the Borghese *Entombment*. A more Venetian note is struck by the two little spinstresses seated at the left, Raphaelized versions of the children Veronese inserted in his *Supper at Emmaus*.

In painting *Hercules and Omphale* and *The Lament for Adonis* Rubens had by no means freed the silhouetting of his forms from the tyranny of mannerist calligraphy: although by this period his composition trials in ink on paper, as we can see from the study for *The Mocking* and from the sheets which include studies for *The Judgement of Paris*, were more liberated by contact with the Raphael tradition. The gap between the more vigorous pull of the pen line, with fierce hatching and blotting of shadows, and the more consciously stylish undulations of the brush-stroke on canvas has led critics to dissociate a sequence of three such drawings for a *Lament for Adonis* (Plates 211, 212, 213) from the Imperiale painting.[49] In the first of these Rubens took as his *point de repère* a *Menelaus and Patroclus* in the courtyard of Palazzo Pitti, a marble group restored, possibly by Giovanni Caccini, on the basis of a frieze at Mantua. In the second drawing the droop of the hunter's body is retained, although his head is turned into profile; and the *amorino* who crouches to nurse his wounded thigh is the same but for a turn of the head. An extra *amorino* in flight is introduced, supporting the torso with his right leg; and the upper part of Venus is extensively modified in thought of the *Polymnia*. That contemplative attitude was discarded as too cold to satisfy the spirit of Bion's Elegy. 'Spiritum morientis excipit ore' (She draws out the soul of the dying with her mouth), wrote Rubens against the adumbration of a more passionate embrace with the lovers' heads in profile. The relationship between the principal figures he rehearsed more fully in the third drawing. In that the gap between the mouths has widened, due to the retention of the comparative verticality of Venus in contemplation. There were doubtless

more experiments before he reached a solution in painting which includes the mourning nymphs, as well as an *amorino* holding the hunter's horn reversed like a mourning brand.

The latest, the most imposing and the most successful of these large scale mythologies, *The Assembly of the Olympians* (Plate 220),[50] is to be connected with Mantua rather than with Rome or Genoa. Olympus was a Gonzagan *impresa*; and at Mantua Jupiter signified the reigning member of the family. There was never anything perfunctory about Rubens's approach to subject matter. The zodiac appearing behind Jove and Jove's eagle above the cloud bank, and to Apollo below, encircles notionally also Venus and Amor descending in the foreground. The constellation refers to the end of 1602, an astrological confirmation of the dating by analysis of style. At the beginning of 1603 Venus was to move into Pisces, which her son is already approaching in the picture, in order to be exalted by drawing nearer to the sun. The picture therefore presents a favourable prognosis of an early solution to the conflict between Venus and Juno. The angle from which the assembled gods are viewed, and the witty extreme of foreshortening the topmost figures, perched on clouds, witness Rubens's admiration for Giulio's decorations in the Palazzo del Tè. His picture must have been intended for a ceiling, or at least to be hung high in a palatial room. But it is unrecorded in the Mantuan inventory of 1627; and its presence earlier in the ducal collection would not tally with his complaint in 1608 that no work of his, that is to say of his invention, hung in Vincenzo's gallery. Perhaps it did not find, or did not retain, the Duke's favour; and so may have survived at Mantua only through the interest of Chieppio. ': L:' painted at the bottom right of the canvas indicates that it was purchased for Prague from a collection established within the first half of the seventeenth century; but

its provenance before it was first recorded in 1685 at Prague Castle remains conjectural.

In *The Assembly of the Olympians*, apparently Rubens's major undertaking during the last months of 1602, we recognize the dichotomy, unresolved as yet, between his Antwerp education and his studies in the Italian cities. Apollo seated on a sphinx, and even more clearly Venus, are adaptations of the Adonis and the Venus in a Roman relief at Mantua (Plate 217) which illustrates the fateful hunt of the Calydonian boar.[51] The voluptuous nymph reclining in the left foreground, akin to the Dresden *Leda* (Plate 210), is a creation in the spirit of Michelangelo's *Night*. The *amorini* in flight bearing garlands, Jove with his companion gods, and the cloud formations on which they sit, still resemble the style of Vaenius. What distinguishes such an effort from the classicizing eclecticism of Rubens's master – and we may think of Vaenius's *Nativity* in the Maagdenhuis at Antwerp (Plate 5)[52] – is the exuberant vitality manifest throughout the invention, and supremely in the blaze of the goddesses' quarrel.

To measure Rubens's astonishing change of pace and direction during the two or three years which include first-hand experience in Italy, we should compare his *Domitianus Nero* of the late nineties (Plate 1) with a painting of about 1602, also on panel, showing bust-length a juxtaposition of *Seneca and Nero* (Plate 221).[53] Both heads in the latter are founded on antique prototypes instead of feverish fancy. They are blood likenesses; not merely sculpture translated into paint, but formidably robust. The theme is neo-Stoic, in terms of a historical relationship of personalities. The painter could have found no worthier recipient than the prize pupil of that sage who had corresponded as preceptorially with Paul V as Seneca had done with Nero: his own brother.

8. The mission to Spain and the return to Mantua

(i) SPAIN

On 5 March 1603, Duke Vincenzo and Annibale Chieppio signed and countersigned instructions to Annibale Iberti, Mantuan resident at the Court of Spain, about a cargo of gifts ready that day to leave the Duchy in the charge of Rubens. Philip III was to be offered a shooting-brake *de luxe* with six bay horses, eleven arquebuses, and a vase of rock crystal filled with perfumes. Other vases of silver and gold were intended for the real ruler of the country, the Duque de Lerma, together with pictures – sixteen being painted on order from Pietro Facchetti after select masterpieces in Rome, chiefly of Raphael. Lerma's creature, D. Pedro Franqueza, Secretary of State, was to get two rock crystal vases and some precious damask embroidered with gilt thread. Finally Lerma's sister, the Condesa de Lemos, *cameriera mayor* to the Queen and wife of the future Viceroy of Naples, was to be treated, on account of her reputation for being devout, to a rock crystal crucifix and a pair of candelabra for the furnishing of her altar.[1]

The purpose of these presentations, which Vincenzo had been planning since at least June 1602, is indistinct. The Duke is known to have coveted the post of admiral, then vacant through the disgrace of Giovanni Andrea Doria of Genoa. What was afoot is referred to in the official correspondence as 'the negotiation', or 'the affair'. It was certainly not a Spanish match for one of the Gonzaga princelings: inasmuch as the Infanta Anna, eventually the bride of Louis XIII, was hardly a year old when Vincenzo ordered the copies from Facchetti on 31 August 1602; and her siblings were unborn. Yet some advantage was to be gained by a small Italian duchy from the protection of Spain, still a great power south of the Alps.

The only remotely diplomatic business with which Rubens had been entrusted hitherto had been in the late summer of 1601 when despatched, initially for a few weeks, to Montalto's household in Rome. That he, an inexperienced young foreigner, was put in charge of this extraordinary mission less than two years later, in charge at least until he could hand over responsibility to Iberti in Spain, is a mark of the extraordinary confidence felt in him by Chieppio rather than by the Duke himself or by the Steward of the Palace. Moreover, once the prime purpose was accomplished, he would be expected to paint portraits at the court of Philip III and then at the court of Henri IV, in order to gratify the Duke's gluttony for additions to his 'Gallery of Beauties'.

Rubens had no choice but to accept the incompetent planning of the route chosen by the palace officials for him and his cumbersome and costly baggage train. It soon became evident that he would have to supplement from his own pay the paltry provision of funds. These were inadequate to meet the tolls, not to speak of the tips and other incidentals of a slow and needlessly roundabout journey. Instead of proceeding directly from Mantua to Genoa, thence taking ship for Spain, he had to find an ox-cart (in default of mules) to drag the carriage over the Apennines to Florence and to Pisa, on the offchance that he might find at Livorno a galley ready to sail directly for Spain, although more likely the voyage would be *via* Genoa. He was patient and adroit, enlisting at each city the aid of the principal merchants. His equanimity appears to have been ruffled only once: one March evening in Pisa, when the Grand Duke Ferdinando sent for him after dinner and civilly disclosed such minute knowledge of the mission as could only have been had from efficient spies, kept at Vincenzo's court in Mantua. Ferdinando himself, two years earlier, had been anxious to find favour again with Spain and had sent to Lerma a real masterpiece, the marble fountain with Giambologna's *Samson and the Philistine*[2] as its crowning glory; so he could afford to take cognizance of Vincenzo's efforts with almost effortless superiority. Rubens, having no particular instructions how to deal with such a *prepotente* as the Grand Duke, got on well. His Italian must already have been excellent. And he was in fact engaged through his fellow countryman, Jan van der Neesen, to take an extra palfrey and a table of marble on Ferdinando's behalf to D. Juan de Vick, Captain of the Port at Alicante. Yet nobody, either in Mantua or in Tuscany, seems to have informed him that, when he eventually disembarked at Alicante, he would find himself not, as he expected, three or four days from Madrid and his journey's end, but with a much longer haul ahead to reach the Spanish Court. As Ferdinando at least knew well, this had been moved at the instance of Lerma to Valladolid. The

removal from Madrid, which lasted until 1606, was nominally to encourage Old Castile by the royal patronage and presence: but actually in order that Lerma might keep the futile, albeit amenable, King and Queen frittering away their days in hunting, or in supervising the decoration of a vast new palace built on land which he had sold them and which was surrounded by territory remaining under his control. So Rubens, having made Alicante about 20 April, had to endure twenty days of travel, and through appalling rain storms at that. He did not reach Valladolid until 13 May, the very day that the royal pair had set out on an expedition to Aranjuez and Burgos, of which the high spot was a *battue* of rabbits! However, the unexpected absence of the shooting party gave a much needed respite. On 24 May it was discovered on unpacking the pictures that, despite precautions both in transit and during the opening and resealing of the cases at the customs, rainwater had soaked in, causing paint to moulder, blister and flake. At first Rubens was in despair. The horses, thanks to the avoidance of long stages and to the provision of wine baths and other expensive attentions, had arrived as sleek as they had stepped from the Gonzaga stables. The carriage soon got fresh glosses. But the paintings, whose state touched Rubens more nearly, looked to be (with the fortunate exceptions of a *St. Jerome* by Quentin Matsys and a portrait of *Duke Vincenzo I*) as good as lost. However, careful bathing in warm water and drying in the sun, according to Iberti's subsequent report, put a more cheerful complexion on things. Not unexpectedly, the conventional pedant Iberti took the conventional Italian view of a Flemish painter. This young foreigner could easily supply 'una mezza dozena de quadri di cose boscareccie' (half a dozen pictures of woodland scenes) to make up whatever had to be written off from the gift. That was just what Flemings were good for: portraits, copies and little landscapes. Not so Rubens. He did not welcome Iberti's first suggestion of engaging local help to repair damage, since he feared the maladroitness of painters in Spain and possible claims by any incompetents thus employed that they had as good as repainted by their own skill the pictures in question. Now he brushed aside this further suggestion of turning out a batch of trifling landscapes to order. Instead, when he found that he could retouch all but two of the paintings, he invented as a substitute for these a figure subject of his own. Iberti wrote of 'un quadro di Democrito et Heraclito ch'è stimato assai buono'. For the weeping philosopher of this *Democritus and Heraclitus* (Plate 222),[3] Rubens put to effective use his knowledge of an antique head which he had drawn in Rome[4] during his stay with Montalto. He found that he had already some reputation in Spain. This was his chance to confirm it by a prompt display of prowess. He was too proud to risk it, either by association with those he rated markedly his inferiors as painters, or by taking refuge in what was still considered to be an inferior branch of the art.

Nevertheless he was apprehensive. He had had a glimpse of the treasures in Madrid and at the Escurial. On the strength of this, he had written to Chieppio from Valladolid on 24 May about Lerma, in anticipation of the presentation: 'He is not without knowledge of fine things, through the particular pleasure and practice he has in seeing every day so many splendid works of Titian, of Raphael and others, which have astonished me, both by their quality and quantity, in the King's Palace, in the Escurial and elsewhere. But as for the moderns there is nothing of any worth.'[5] Lerma, thought Rubens, needs must be too much of a connoisseur to be flattered by copies of *The Creation* and *The Planets*, done by a Mantuan hack after Raphael's frescoes in the Vatican Logge and in the Chigi Chapel of S. Maria del Popolo. He had no call to worry. Although Iberti, a functionary jealous of his status, was to prevent him getting near enough to the King, during the first presentation, even to make a silent obeisance, he was not prevented from observing Lerma's reactions to the pictures. The Royal favourite, a man saddened by the recent death of his wife, said little; but he plainly accepted the lot as originals. This was easier done since the deftness with which Rubens had retouched the damages conferred a certain air of age and distinction. It would be fascinating to identify any of the pictures now, especially the portrait of *Vincenzo I* which was painted by Frans Pourbus the younger, a specialist in portraiture then employed at Mantua like his fellow countryman Rubens. The sight of this, perhaps slightly retouched by Rubens in order to conceal damage, caused Lerma to ask Iberti whether the young Fleming who had accompanied the presents could also portray his master the Duke from memory, or otherwise, as Iberti reported in his letter of 18 July to Mantua, whether an existing portrait by him could be written for from Italy. Iberti solved the problem by producing for Lerma the portrait by Rubens which Vincenzo had sent to him privately for his own keeping.[6] Surely Lerma's approval of this princely bust-length – recorded in Lerma inventories from the Duke's lifetime as a canvas one

vara high by 'Pedro Paulo Rubenes' – led to Rubens being invited to paint Lerma's own portrait. The decision to make that equestrian and in armour, the grandest way to display a grandee, would have been governed by the image in the minds of both painter and sitter: Titian's *Charles V on the field of Mühlberg* (Plate 225).[7] For the *Lerma* we know Rubens's finished study (Plate 260), showing a groom up instead of the fifty-year old Duke. Of the head and shoulders in the Titian, he had painted a copy (Plate 226).[8] Like his full-length of *Infante Philip standing in armour*,[9] it is a faithful enough *ricordo* (Plates 223–4), made probably on a return to Madrid from Valladolid (for there would hardly have been pause for him to have painted careful copies on his journey north-west with the gifts): but it is hardly a penetrating analysis. His eye and spirit had attuned themselves more readily to the messages of Tintoretto and Veronese. He had drawn copies of Titian in Venice, being attracted more by the heroic energy of figure composition than by the personality and substance in portraiture which could be conveyed through high intensity of perception, high as only Titian had attained. During his Italian years Rubens was to grasp the outward forms of Titian's art, not yet their inward meaning. When he came to conceive the *Lerma*, did he not remember also the implacable advance of *Duke Vespasiano on horseback*, first of the ten Gonzaga captains carved life-size in wood which were marshalled in the Sala delle Aquile of that prince's palace at Sabbioneta? The spread of foliage over *Lerma*, the assertions of his silhouette, the flarings of light which fringe his charger's mane and tail, the adumbration of the advancing troops in the distance, and the uncompromising dash of the brushstrokes by which these painterly effects were rendered, together remind us how Rubens sought to emulate the mature Tintoretto as well as the mature Titian. The brilliant synthesis gave a signal impetus to the Baroque style in portraiture. Rubens himself was to return in thought to this invention when, twenty years later, he had to put Ferdinando de' Medici's daughter Maria into a context of dignity and command.[10] Van Dyck knew one or other of Rubens's drawings connected with it; and was to exploit repeatedly the potentialities of painting horse and rider pacing grandly toward us, the modern match of the *King Antigonos on horseback* which Pliny records as having been admired by connoisseurs before all other works of Apelles. No more resonant depiction could have been imagined in 1603 for the personal glory of the man who had been appointed only that

spring Captain-General of the Spanish Cavalry. Lerma, who retained Rubens at Ventosilla during the autumn in order to plan and complete this astonishing work, must have been highly gratified; and he may have signalled his satisfaction to the Archduchess Isabella, his childhood companion, as well as to Duke Vincenzo. Sitter and painter were to remain in touch long after the painter had voyaged back over perilous winter seas to Genoa. In April 1618, the painter, almost a decade after he had ridden from Rome, was to offer Sir Dudley Carleton, British Envoy at The Hague, 'Twelve Apostles, with a Christ, done by my pupils, from originals by my own hand, which the Duke of Lerma has.'[11] The style of the original *apostolado* of thirteen panels, which were intended presumably to be hung around the sacristy walls of some church patronized by Philip III's favourite, although no mention of them appears in any Lerma Inventory, suggests that they were painted in Antwerp about 1612–13, and thence despatched to Spain.

(ii) MANTUA

During the period of rather less than two years which extends from Rubens's return by way of Genoa to Mantua in the first months of 1604 until his departure for Rome in December 1605, there are two documented commissions: the first, a threefold decoration for the walls of the tribune in the Jesuit church at Mantua, carried out on Gonzagan orders between August 1604 and 25 May 1605;[12] the second, a single canvas, the high altarpiece commissioned by Nicolò Pallavicini for the Jesuit church at Genoa, which was in place by 1606.[13] These large-scale enterprises gave Rubens opportunities to show his mettle both in imaginative treatment and in boldness of execution; and he showed himself both daring and brilliant. In the Mantuan temple dedicated to the Santissima Trinità he proclaimed in paint his readiness, aged twenty-eight, to be judged by the standards set by Michelangelo and Raphael, Tintoretto and Veronese. Working for Genoa, he challenged also Correggio in terms of Tintoretto and the Antique. We should reckon that smaller works, privately commissioned or painted for the market during this period, were likely to have been pitched at the same level of confident assertion.

Five such paintings are known. One, *The Destruction of Pharaoh's Host in the Red Sea,* survives only as a fragment (Plate 236); and for that reason it may best be dealt with last, although quite possibly the earliest. The key work of this group is *Hero and Leander*, now at Yale (Plate 232). The composition

was tried out on the *recto* of a sheet of pen drawings, now in Edinburgh, which is inscribed by Rubens, 'Leander natans Cupidine praevio' (Plate 229).[14] It shows the dire fate of the youth of Abydos, led by love toward Hero waiting across the Hellespont at Sestos, only to be drowned in the tempestuous night. At this stage, neither Love personified nor Hero is indicated; although all but one of the other actors in the painting are already present. Leander, unidealized and bloated, has surfaced in the trough of an immense wave. One nereid has swum close. Fine strokes of the pen suggest eleven of her thirteen companions, distraught and storm-tossed, who have yet to reach the body and support it shorewards. Indeed, these watery creatures themselves seem helpless, caught in a maelstrom. Meanwhile the shoulders of Leander rest on the curving tail of a great, gaping fish.

Most of these figures were to be redistributed in order to present Leander, in the painting a heroic, Michelangelesque corpse, as the focus of the action, the nymphs garlanding him with their lament; and in order to fill the narrative, both with the flight overhead of the pair of Loves, and with the heartbroken plunge of Hero from her tower. The pen sketch adumbrates the paragraphing of each of two pairs of nereids, although the activity of the second pair was to be shifted from a position above and to the right of Leander to one far left: the first pair, who breast the waters frantically, remain in the middle distance beyond Leander's feet; the second pair (one with her ample back to us), seeming to ride the crest of the waves, is displaced, like the great fish, from a position in line with Leander's face.

This second pair carry the story of art from Michelangelo to Delacroix. Rubens reconsidered the relative position of the figures, and especially the nearer nymph *a tergo*, her hair streaming, in an unusually careful study in black chalk, heightened with white chalk (Plate 231);[15] and, in order to complete his stupendous design, he presumably took similar pains over other groups or single figures. The nereid in the pen drawing nearest to the right of the pair just discussed, who flings herself forward, is a *primo pensiero* to be developed in the painting, there stretching out her arms to gather the feet of the drowned man. The most spectacular development, however, is due to his appreciation of Tintoretto's art in Venice; we see it in the foreshortening of Hero and of the two Loves, and in the sky riven by lightning. The drama of his composition trial is scarcely concerned with wild illuminations. The wash barely conveys the inkiness of

high seas at night. Essentially he wished to pen down the rage of the waters and the actors' reactions. The inspiration of this turbulent vision probably antedates his experience of Mediterranean storms on the crossing from Spain. It lies more likely in the impression made on him by Leonardo's 'Deluge' drawings, which he had seen in the house of Pompeo Leoni.[16]

The decorative way in which the nymphs pamper the corpse in the painting, the rich plasticity of their bodies, and the palpitating vigour of their twists and turns, all recall another artistic interest, which in Mantuan service he had special opportunities to pursue; the work of Giulio Romano, and in particular the suite of *Hylas carried off by the Nymphs, The Death of Adonis*, and *The Death of Procris*. His enthusiasm for these designs, all lamentations for stricken youths, led to his elaborate reworkings of drawings after them.[17] The nereid clasping what appears to be a broken spar at the left of the Edinburgh sheet, although omitted from the composition of the Yale painting, connects his study of Giulio's *Hylas* composition (Plate 107) to the evolution of *Hero and Leander*; and another group of pen studies of nymphs (Plate 230) comes into consideration. These are on the *verso* of a sheet in Paris[18] which bears on the *recto* studies for a *Kiss of Judas* and for a *Meeting of two apostles*; among them is a nymph rehearsed in three derivations from her who reaches both hands to touch the face of Hylas. This nymph is sister to one sketched in reverse on the Edinburgh sheet (Plate 229); and the relation of the head and outstretched arms of the nymphs drawn next the uppermost of these three rehearsals can just be descried in the nereid nearest to Hero in the painting, making a gesture of horrified protest at the priestess's fatal plunge.

In designing the scene on the *verso* of the Edinburgh sheet (Plate 227), Rubens had Leonardo's *Battle of Anghiari* in the forefront of his mind; although the motif of two horses fighting is not quite so conspicuous as in another pen drawing, at the British Museum, of *A Battle of Greeks and Amazons* (Plate 228).[19] That evidently he drew at a slightly more advanced stage, when his interest in the way of depicting intricate combat on sarcophagus reliefs was also to the fore. The action of rearing and plunging horses, ridden and riderless, and the *mêlée* of fallen figures, is more diffuse on the Edinburgh sheet. Nevertheless the principal elements of the London sheet are predicated, and the drawings can hardly be far apart in time. Rubens's four annotations in Latin on the earlier sheet all refer

to this battle: 'Sun', at the upper left – the rays are just flicked in; then 'the light is clearer at the feet,' below the hooves of a galloping horse; then, 'A great deal of dust in the likeness of a cloud or fog', written amongst cloud-like forms above the head of a horseman; and, to the right, 'dust drawn out a long way behind becomes white'. These notes call attention not only to his habit of recording phenomena, but also to the fact that the *verso* is concerned mainly with a sunlit, dry arena for the violence depicted, in contrast to the nocturnal and watery setting of the *recto*.

Adjacent to the *Hero and Leander* in style, in scale, even in dimensions of the canvas, is *The Fall of Phaethon* (Col. Plate VII, Plate 235).[20] Jove's lightning intervention sweeps the action of the figures, who leap and tumble in the blazing sky, across concentric circles made by the spectral haloes of the sun. Pentiments are visible in the crimson traces which harness the dapple grey, rearing at the right, to the upset chariot, gilded and silvered; in the traces grasped by the central figure of the Midnight Hour, whose mauve-grey cloak has just caught aflame; and to the right of the rearing horse, where the rim of cloud cuts the foot of the Hour who seeks to restrain him. Otherwise the prodigious interplay of forms in movement is painted without apparent hesitation directly and by means of a light *impasto*, using the effect of the ground in the half-tones. The drive of the main diagonal is controlled by the sunburst, which rends the blue-black sky and gives to the form of one grey horse a ghostly transsubstantiation into light. Flames stain the clouds orange. The emphatically dark silhouettes of Hours and horses are fringed with this Tintorettesque illumination. Blue complements orange on the draperies of the Hours, who flourish their green whips in vain. Elsewhere are rose reds and dun colours, ochres, greys, and buffs. The main lights are on the white and dappled coats of the horses. The keynote is the magenta-lake of Phaethon's cloak and the red accents which give vitality to his lustrous chariot. One wheel falls molten into the storm cloud. Below, in a sketchy suggestion, the green earth of Africa flames, scorched by the passage of the cataclysmic day.

Not in *The Battle of Spoleto* nor in *The Battle of Anghiari* (Plates 51, 54) are the wild plunges of distracted horses more astonishingly invented or more boldly foreshortened; but attention to the marvellously atmospheric drawing in pen and wash, now in the British Museum, in which Rubens created the semblance of a Leonardesque battle-group (Plate 56),[21] suggests that his dappled grey rearing from the chariot borrowed by Phaethon, at the right, and the pure grey plunging headlong to destruction, at the left, have each some formal as well as spiritual descent from Leonardo's chargers. Indeed the ultimate sources which fed his creative powers are characteristically complex, and profitably rich in their diversity. Phaethon tumbled from Sol's chariot is conceived in the vein of Michelangelo's *Phaethon* and *Tityus*. The horse falling head foremost, belly upmost, alludes to the drawing presented by Michelangelo to Tommaso de'Cavalieri. The pose of the winged Hour crouching beyond the grooms is a modern refreshment of the *Crouching Venus* of Doidalsas. These elements fuse in the heat of his personal vision.

With the two spectacular mythologies we need to consider three small religious paintings: a sketch, also on a bolus-prepared canvas, for a *Martyrdom of St. Ursula* (Plate 234);[22] an *Arrest of Christ*,[23] sketched on panel (Plate 192); and, on canvas, the fragment of a *Destruction of Pharaoh's Host in the Red Sea* (Plate 236).[24] All are crowded with figures in violent action; and there is marked congruence in figural types and expressions. *The Martyrdom of St. Ursula* is a sparkling essay on a theme to which Rubens was to return about 1620 in a more famous sketch on panel, now in Brussels.[25] The early version came to the Palazzo Ducale in Mantua from the Convento di S. Orsola, which was new-built in 1603 by the Duke's sister, Margherita, herself an Ursuline. In its principal motif it is a harbinger of the more mature and compact composition to come. The configuration of the heavenly apparition is suggestively Raphaelesque. The figure of the saint, shimmering in white amid the colours of her tormentors, may well have been inspired by Veronese's *St. Afra* in Brescia. But of more consequence than these recollections is the pervasive influence of Tintoretto, in the flicker of the brushwork as well as in the lighting, which suggests how Rubens had been enthralled by the great master's oil sketches then still to be seen in Venice amongst the undispersed effects of the family shop. Attention to a sheet of his own pen drawings[26] in Museum Boymans-van Beuningen reveals first a trial for the principal motif, and then by turning the paper through a right angle, another configuration conceivably connected with *Hero and Leander*. In any case these paintings cannot be widely separated in his *oeuvre*: and *Hero and Leander* perhaps could be interpreted as a courtly warning by the widowed Margherita to her nephew Francesco of the dan-

gers of his unsanctioned love for Margherita di Savoia.

Patently *The Arrest of Christ*, in the movement and ponderation of individual figures, owes more to Rubens's investigations of Michelangelo in Florence and Rome than to his investigations of any painter in Venice; but overall he seems to be revising Michelangelo's late style in the painterly terms of Tintoretto. The turmoil and overcrowding mark no great advance on *The Conversion of Saul* (Plate 202): but in handling, despite inevitable differences between painting on panel and painting on canvas, it is a fair match for the early version of *The Martyrdom of St. Ursula*. That the projects presented in these two sketches of about 1604 were not adopted points to the limitations of Gonzagan patronage.

The quality of *The Destruction of Pharaoh's Host in the Red Sea* is harder to assess; although the heart of the composition survives, the canvas appears to have been cut on all sides to somewhat less than half its original dimensions. At the left the bearded Pharaoh brandishes his gold sceptre at the unruly sea. He makes a brave show of local colour, his blue harness furnished with gold, his sleeves mauve, and a rose-red cloak blowing in the wind. At the further side can be made out the right foot of Moses, surmounted by the fore-edge of his gold tunic and blue shirt. He stands commandingly on the shore, while Israelite families flee with their beasts and chattels to safety. The fragmentary composition balances, as the whole must have done, about the intersection of the diagonals between the central horses. The eyes of those creatures glow like carbuncles. The fire and frenzy of the quadriga takes our breath away. Bridles are green, gilt-mounted; muzzles, rose-pink, and manes flare with yellow and rose, so that the gleam of white on their heads iridesces. More-over, the body of the grey surging above the waves is flushed; and behind the flying horse hair stream the pink banners of Egypt.

The horse whose crest flies highest was to reappear almost exactly, within a year or so and on a heroic scale, in the charger of *St. George killing the Dragon* (Plate 238), rearing in one masterful diagonal across the canvas. So *The Crossing of the Red Sea* stands not so far from that tribute to the concepts of Leonardo for equestrian monuments. The *St. George* might have been intended for an altar where some Genoese patron had rights: but it found no home in the city of St. George, being *Un S. George à cheval, sur toile*, item 155 in the Inventory of the painter's art collection in Antwerp, whence it passed to Philip IV of Spain.

The type and pose of the rescued princess relate closely to the St. Domitilla of the first altarpiece for the Chiesa Nuova (Plate 327); and both figures may have been based by Rubens on his studies of an antique *Leda and the Swan*.[27] To convey the extravagant performance of St. George, sword raised to give the *coup de grâce* to the dragon at his horse's feet, Rubens sketched brilliantly with pen and wash (Plate 237).[28] In this drawing the mask of the overturned monster is indicated at the lower left corner, while its paw claws the belly of the rearing charger. Horse and rider accordingly twist their heads further than in the altarpiece. In this the dragon's head has been shifted centripetally to a point below the saddle-cloth; and its claw, tugging at the broken lance in its throat, is directly below the saint's left hand, on which the composition pivots. Another major change, implying uncertainty about the picture's destination, is in the fall of light; denoted by washes in the drawing as from the right, and in the painting from the left. This was anticipated by a *modello* in oils on paper,[29] a small painting prepared with special care presumably for some prospective client; although cisalpine taste, in the first decade of the century, was not full-blooded enough to stomach such *bravura*.

We know no oil sketch for *The Baptism*, or for *The Transfiguration* or for *The Gonzaga in adoration of the Trinity*, the triad of canvases for S. Trinità, Mantua. But at least one superbly finished drawing in black chalk survives for *The Baptism*, prepared at an advanced stage and squared for enlargement (Plate 245).[30] Between this design and that of the painting, however, there were consequential amendments; in the stance of the Baptist, in the number and disposition of background figures, in the introduction of a pair of cherubim in flight, and in the elimination from the central foreground of the youth displayed against the tree bole. This mannered figure, as appears from a drawing which was to be recorded in chalks by Panneels,[31] is based closely on an antique statue lacking both arms and a foot. By a characteristic economy of resource, Rubens edited him anew ten years later for the St. Sebastian in both the oil sketch and the pen drawing of *All Saints*[32] and, in still another context, for his painting of *The Feast of Achelous*.[33] His amendments to the Mantua *Baptism* allowed a massive concentration of figures, a more intense Michelangelizing. Michelangelo's own ideas for a *Baptism* were accessible in Rome through the redaction painted by Daniele da Volterra and his assistants for the Cappella Ricci in S. Pietro in

XI. *The Martyrdom of St. Vitalis* (after Federigo Barocci). About 1605. Chalks and washes on paper. Wilton House, Earl of Pembroke

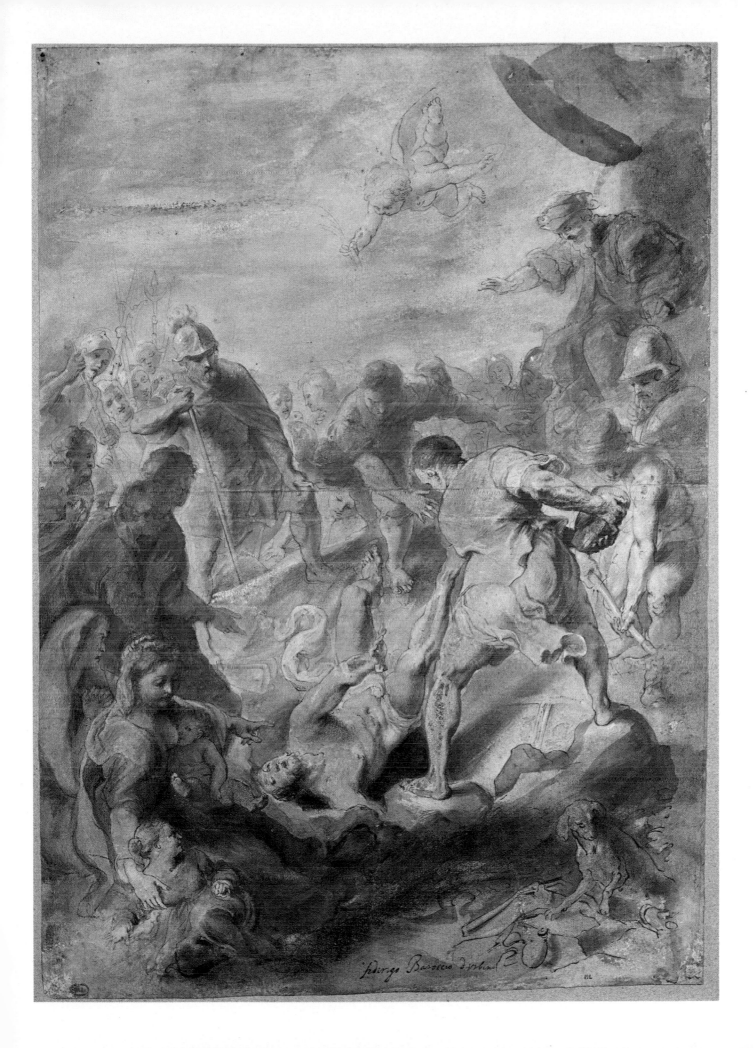

Federigo Barocci d'urbino

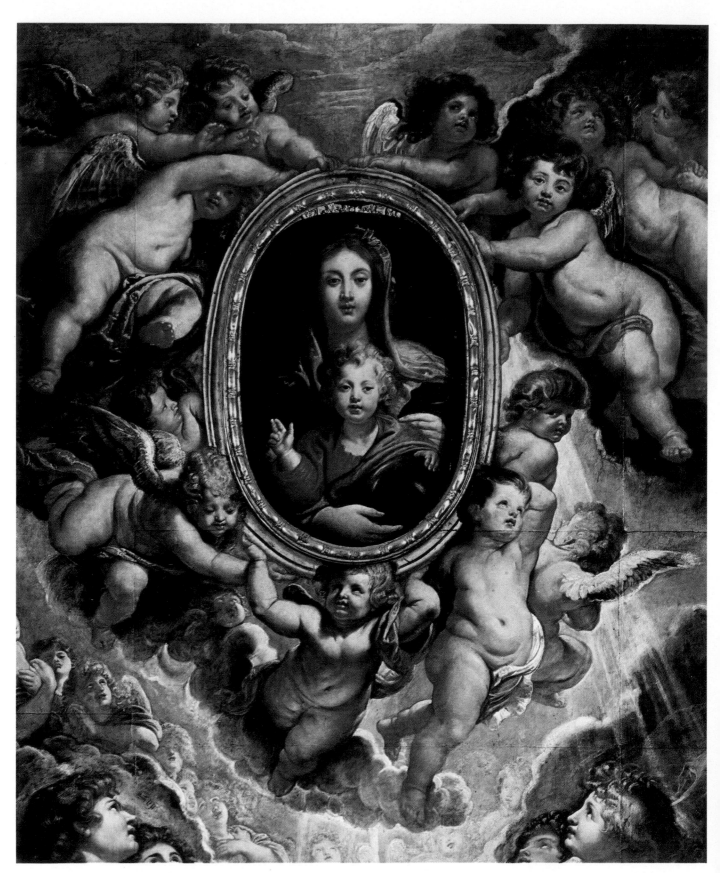

XII. Cherubs. Detail from *The 'Madonna della Vallicella' adored by Seraphim and Cherubim* (Plate 333). 1608. Oils on slates. Rome, S. Maria della Vallicella

Montorio;[34] and this more vertical composition included, among other characteristic features, a man bending to shed his shirt whilst another, seated in front of him, eases his foot. This second man in Daniele's fresco was based on the bronze *Spinario* in the Capitol, which Rubens himself was more than once to use as a model for posing a studio boy (Plate 273).[35] The bearded elder standing further to the right in Rubens's canvas, who is being helped to strip, derives on the other hand directly from the Adam of *The Last Judgement*. Being out to impress Mantua by his impressions of Rome, he did not involve in his design any trace of the two nudes, figures less purely Michelangelesque, which he had excerpted for future reference, in a highly finished drawing in sanguine, from Jan van Scorel's *Baptism* in Haarlem.[36]

Rubens's claim to rival Michelangelo by emulation was put so forcibly in *The Baptism* that the extent of the other potent influence at work in his picture-making, that of Tintoretto, has often been overlooked. That is to be reckoned with not only in the treatment of foliage and water and in the illumination, but also in the group to the left of the *caesura* provided by the tree. The angels hovering with Christ's garment, Christ Himself and the Baptist, together recall Tintoretto's *Baptism* now in the Cleveland Museum of Art (Plate 244).[37] What Rubens had learned from Michelangelo directly, or by way of Daniele, was sensationally synthesized with what he had learned from Tintoretto; just as what he had learned from Tintoretto and from Raphael was synthesized in the still more electrifying drama of *The Transfiguration* which he painted for the opposite wall of the chapel (Plate 247). In the altarpiece itself, the colonnading and balustrading which articulate the setting are, besides the Swiss, the children and the pet dog which flank the dukes, all conceived in the Veronese vein; as we see, in the case of the Swiss, from the splendid study in chalks of a *Young Halberdier* (Plate 241),[38] which Rubens prepared for the right hand side of the painting. Nevertheless the extreme foreshortenings of the angels who bear up the golden carpet of the Vision are, like the stormy black and white and crimson of the ducal apparel and *prie-dieu*, brought off in the spirit of Tintoretto (Plate 239).

The carpet is really golden, a reflecting field of leaf applied to the reddish-brown bolus preparation of the canvas, in order to manifest fittingly the Trinity to three generations of the Gonzaga. These nine princes and princesses are ranged in their ranks, much as Rubens had seen the Habsburgs monumentally ranged by Pompeo Leoni[39] beside the huge columns at the head of the sanctuary steps in S. Lorenzo in Escurial (Plate 240). Those two bronze groups, resplendent with gilding and gems, must have impressed him lastingly as he looked toward the Capilla Mayor of the monastery church. Working for the Gonzaga he remembered its visionary effect. With breathtaking control he swept his loaded brush across a canvas whose surface in one place was prepared only with bolus, in another already coated by paint, in a third glistering with foil. No such technical feat, no such spectacular manipulation of materials had been seen in his generation, let alone in the duchy of Mantua. Was there a Mantuan to appreciate his daring?

Only in Genoa was he anywhere near to being fully appreciated at this momentous stage. How we should wish to know what the Pallavicini or the Serra, Jacomo Serra at least, thought in their city when they saw a modern Correggio, a modern Tintoretto, announcing himself in the modello submitted for *The Circumcision*,[40] and in what terms they expressed themselves when they saw the finished altarpiece set up in their Gesù (Plates 248, 249) in all its fulgurous splendour!

9. The business of a Flemish painter

(i) PORTRAITS

In 1600 Rubens recommended himself to Vincenzo Gonzaga through fortuitous acquaintance with a member of the suite; and, we may presume, by showing that he could paint portraits, perhaps also small figure subjects involving landscape. We have no evidence that he had any other form of introduction. Presumably also he followed his new employer to Mantua when the ducal party left Venice on 22 June. The Duke must have considered himself in need of portrait specialists from Flanders, inasmuch as he was to write on 10 August to Francesco Marini in Brussels, asking that Pourbus, whom he had met a year before on his five-day visit to the Archdukes, should now be sent; and on 10 September Pourbus set out for Mantua.

There has been discussion about such Flemish-looking portraits as survive of Vincenzo and his family, and of the ladies of his court. Which are by Pourbus, which by Rubens? Which by Sante Peranda, Tullio India or others less easy to name? The style of Pourbus in Italy seems clear and consistent enough. We know in various versions, on canvas from bust-length[1] to full-length,[2] his portraits of the Duke; as well as the basis of at least one of them, a black chalk study of the Duke's head, a drawing which belongs to the National Galleries of Scotland.[3] We know corresponding bust-lengths of the Duchess.[4] We know a bust-length of the heir apparent, *Francesco*.[5] These appear ineloquent, if acceptable likenesses, efficiently painted, but without mark of temperament except in the fiery accentuation of the rumpled hangings in the backgrounds. Pourbus's outstanding success, in overcoming a sort of geometric immobility of effect by energizing drapery, is his full-length of the little *Margherita of Savoy*,[6] the princess who was shortly to marry Francesco Gonzaga. That is the acme of his performance as a court portraitist before transferring his service in 1609 to Maria de' Medici in France. Yet it should not confuse judgement of what is to be credited to Rubens along the rising line of accomplishment which runs from the miniature of the '*Geographer*' (Plate 2), dated 1597, to the full-length equestrian *Lerma* (Col. Plate IV), signed and dated 1603, to the half dozen or so heads of 1604–5 cut from the documented altarpiece of *The Gonzaga*

kneeling in adoration of the Trinity (Plate 239), to the full-lengths of 1606–7 which he made fashionable in Genoa.

For the first three years of Rubens's employment at Mantua only three court portraits convincingly by him are known, none having been conceived as anything more imposing than a bust-length. One, to be described in Van der Doort's Inventory for Charles I of England as 'the picture of the deceased young duke of Mantua's brother done in armoure to the Should[rs] by Sir Peter Paule Rubins when he was in Italie', is a portrait of *Francesco Gonzaga*,[7] who was to succeed his father Vincenzo as 5th Duke, and whose glamourized likeness as a boy some two years older features in the family altarpiece of 1604–5 (Plate 254). Neither the attribution nor the identification of the sixteen-year-old sitter should be in doubt. The shining fullness of eye, the ripeness of lips, the flocculence of brown curls, the whole alertness of personality, all fit Rubens's certified achievement. Even the more pedestrian passages, the folding of the white collar, and the red sash aslant the breast plate, are consonant with the rather perfunctory aegis which he had given to each of his *Roman Emperors* (Plate 1) in Antwerp. The life and quality of the *Francesco Gonzaga* contrast with Pourbus's stiffer portrait of the same young prince. Knowledge of it reinforces the traditional attribution of a picture of less illustrious provenance, the so-called '*Dama dei Licnidi*'[8] in Verona (Plate 250), whose paint surface has been badly cracked by tight rolling of the canvas. In this portrait the treatment of dress and ornaments is without special distinction: but the undamaged parts of the woman's eyes and lips and hair carry still the conviction of a work by Rubens before his middle twenties. Its stiff frontality suggests that it may have preceded the *Francesco Gonzaga*. The third portrait, published as that of the Duke's sister, *Margherita, widowed Duchess of Ferrara* (Plate 251),[9] is close in painting to that of her nephew. No hand is shown in this, but the head is sufficiently preserved to convince us both of the authorship and of the sitter's identity.

Despite such paucity of surviving evidence, portraiture must have burdened Rubens when first at the Gonzaga Court. We have inferred that he might have been well enough thought of in this class of work to have been selected in 1603, rather than

Pourbus, his senior, to produce a bust-length of *Vincenzo I* as part of the Duke's present to Lerma. From his letter late that year to Chieppio, we realize how distasteful this side of his employment had become to him. 'Che vili de' ritratti', he wrote of those which he would be expected to turn out for his Duke at the courts of Spain and France. If Vincenzo would be content to employ local painters, Rubens continued, 'then I should not have to waste more time, travel, expenses, salaries (even the munificence of His Highness will not repay all this) upon works unworthy of me, and which anyone can do to the Duke's taste.'[10]

For portraiture of a private sort we may rejoice in two examples, the more important being the *Self-Portrait with friends at Mantua* (Plate 253). The six men are shown bust-length in the sixteenth-century Venetian mode; and the central trio, between whose heads appears the view across the Mantuan lake, is a close configuration in thought of an antique cameo. They are to be understood as presences. To our right the painter and his brother, who evidently had come from Padua to visit him, stand side by side. Behind them appears in profile, as a tutelary effigy, Philip's mentor, Lipsius. Confronting them, the principal figure on the other side is not so certainly identifiable. He has been recognized variously as Erycius Puteanus, a member of the same neo-Stoic circle, who was in Milan in 1601-2, and who may have been available for a reunion with the Rubens brothers in Mantua; as Woverius, who was with Philip Rubens at Verona in July 1602; as Frans Pourbus; and, which is most plausible, as Jean Richardot. His juniors standing beyond him are further still from identification. Their profiles are superimposed as in cameo; and they, like the much more important Lipsius, whose head their two heads balance in the design, may not have been on the spot. To compare this group, apparently painted in Mantua in 1602, with the celebrated 'Four Philosophers' in Palazzo Pitti, is to remind ourselves of nine years advance in Rubens's skill at the intellectual exercise of composing the semblance of a collective presence. But the earlier painting impresses upon us his talents, as well as his ambitions; and, particularly in his own portrait (Col. Plate I), it shows a *bravura* of execution which would not have shamed the young Tintoretto.

In Palazzo Pitti another portrait merits, on grounds of style and quality, the same attribution: a half-length of an unidentified *Gentleman with a Sword* (Plate 259),[11] which has been attributed variously to Velazquez and to Pourbus, although costume alone rules out the former. The smouldering intensity of expression, the firmness of modelling in head and hands, the distinction with which the man's bearing is conveyed, all speak for Rubens. The sense of illumination, notably the high-lighting of the doublet, accords with that in the *Self-portrait with friends at Mantua*. Could the intelligent and distinguished-looking person be Schoppius? This portrait takes a worthy place in the tradition of Titian and Tintoretto. With the stylistically contemporary group portrait, it marks the phase in which Rubens sheds the Flemish tradition of Vaenius and the elder Pourbus for a neo-Venetian manner of his own. What a portrait he might have painted of Claudio Monteverdi, court composer at Mantua while he too was employed by Vincenzo Gonzaga![12]

Nothing we know from this phase, however, really prepares us for the startling conception of the equestrian portrait of *Lerma* (Col. Plate IV), painted during the autumn of 1603 at Ventosilla; unless we infer a finished painting from a pen sketch for a three-quarter-length portrayal of a prelate seated in an armchair (Plate 258).[13] This drawing in the style of the Chatsworth *Studies for a Last Supper* and the Hermitage *Deposition* belongs with the graphic work of the first period in Rome (Plates 193, 194, 148). The head, as well as the pose and costume, is studied not only from life but apparently from the august patron himself; and the head is distinct enough to say that the cast of features, trim of beard, and possible age fit no other member of the Sacred College but the one most likely in circumstance, Cardinal Montalto. Rubens's stimulus to depict his protector in Rome in such a way could have come from Caravaggio's recent masterpiece, *Cardinal Maffeo Barberini*.[14] But in the massively assertive curl and sweep of Montalto's draperies, we sense rather his response to Raphael's *Julius II*. He was not to surpass himself in this genre until he sketched with chalk, more than a decade later, *Hendrik van Thulden*,[15] pastor of the St. Joriskerk in Antwerp.

Rubens's pen sketch for the *Lerma* (Plate 260), approximately two years after the *Montalto*, shows a new magniloquence. The scale of conception and the inexorable onset of the rider proclaim something more sonorous than the basically iconic and symbolic, but no more than incidentally decorative, function of previous state portraiture. This project was calculated for a particular situation. Mount and man, framed by the writhing tree trunk and its canopy of foliage – in the finished picture the framing effect is completed by the rolling back of the war cloud at the right – these were given power

to command the length of a gallery in Lerma's palace at Valladolid.[16] It was Titian's *Charles V on the Field at Mühlberg* (Plate 225) that Rubens emulated in order to impart lustre to this modern general: yet the storm lighting which silhouettes the grandee's head, fringing the plate armour and the foliage, and suffusing the mane and tail of his grey charger, is a lesson learnt of Tintoretto in the Scuola di S. Rocco.

Grandeur of scale distinguishes Rubens's altarpiece for the Santissima Trinità, Mantua, which was reported ready on 25 May 1605. The pleasure-loving Duke frequented Venice; and he should have been pleased that the conception of three generations of his family, kneeling on their terrace in confident devotion, in order to receive a vision of the Trinity, had been treated by his Flemish painter no less sumptuously than Titian had treated the Pesaro and the Vendramin. In 1798 troops of the French Revolution, occupying Mantua, turned the former Jesuit Church into a commissary store.[17] These soldiers reckoned nothing for the terms of fealty claimed by Casa Gonzaga at the Court of Heaven. They slashed from the huge canvas saleable portraits of the five princelings, even that of the pet terrier; as well as heads of the three halberdiers who stood guard in the twin colonnades flanking the composition. The over-life-size heads, both those, now scattered, of the family, and that of the single halberdier which survives at Mantua, were rendered by Rubens with unsurpassed verve (Plates 242, 243, 252, 255). Nowhere in the immensity of his production do we feel more strongly the controlled passion in directing the flow of paint from a loaded brush, exercising his whole height and the full reach of his right arm. Even the heads of the Duke's parents, who were no longer alive in Rubens's time at Mantua, are infused with astonishing vitality. The painting of the Duke's own head, richly impastive and making brilliant use of white lead and rose-madder over the dusky preparation of brown bolus, is in scale and breadth of handling a premonition of that of James I in *The Union of the Crowns of England and Scotland,* which was to be set aloft in the Banqueting House at Whitehall (Col. Plate v).[18]

After the portrait heads in the Mantua altarpiece Rubens was ready to astound the Genoese in their pride with full-length glorifications. There is no trace of individual portraits which he may have painted in Rome during the latter half of his time in Italy: of Cardinal Borghese, of Monsignor Serra, or of Dr. Faber; or even of his fellow painters, Els-

heimer and Brill. Nor is there a trace of a self-portrait between the Mantua group and the betrothal portrait which he painted in Antwerp of himself with Isabella Brant seated in the bower of honeysuckle. But enough portraits which he painted in Genoa on his visits of 1606 and 1607 survive to show what Van Dyck had to contend with there fifteen years later. We know at least half a dozen; despite such obvious gaps in our knowledge as the appearance of the *Agostino Spinola and his wife*, about whose unfinished state Marchese Agostino wrote to Chieppio on 26 September 1606.[19]

The most appealing to the young Van Dyck – Van Dyck's portrayals both of *Paola Adorno* and of *Elena Grimaldi Cattaneo*[20] depend from this very portrait – was that of *Brigida Spinola Doria*[21] standing on her terrace in the sunlight (Col.Plate IX), near to that day in 1606 when, at the age of twenty-two, she married her kinsman Giacomo Massimiliano Doria. The canvas has been sadly cut to scarcely more than a three-quarter-length and trimmed on either side; but this fragment is resplendent enough for us to envisage the whole, since we have also a pen and wash drawing[22] from an advanced stage of preparation (Plate 261), complete with colour notes in Flemish for the setting, the satin of the dress being understood to be white. The plant in the pot, and the foliage beyond the balustrade would have coolly complemented the lush warmth of the red curtain, which enhances her auburn curls and high complexion. The application of paint is of the vigour which distinguished the Mantua altarpiece, and which none but the greatest Venetians had achieved. Yet the personality of the subject is not eclipsed by *bravura* of brushwork. The preparatory drawing, like the drawing made at approximately the same stage for the *Lerma* (Plate 260), suggests that a member of the retinue may have saved the tedium of posing; but in either case the painter must have made a careful study of the true subject's head, probably in the form of a drawing *en trois crayons* such as those which he made about 1604 of at least two of the Gonzaga boys (Plates 256, 257).[23]

Within the pen and wash drawings for the equestrian *Lerma* and for the standing *Brigida Spinola Doria* attention focuses on sensuous contrasts: windblown hair and foliage, with the unyielding surfaces of steel and wood; the rustle and crumplings of fashionable stuffs, with the classicizing architecture of a Ligurian villa. The humps and hollows of Brigida's dress make a terrain as exciting as the bronze vestments which Donatello invented

in Florence for the statue of *St. Louis of Toulouse*.[24] Indeed, Rubens's invention of this Genoese noblewoman's portrait, like that of his portrait of the Spanish grandee, is of a genius to rank him with the supreme masters of the Renaissance.

In aiming to please the mighty of Genoa, he turned consciously to his inheritance. To display Brigida's cousin, *Veronica Spinola Doria*, daughter of Ambrogio Spinola by his second marriage, he enthroned her in a red velvet chair before a round-headed niche (Plate 262).[25] That concavity and the patterned marbling of the floor determine the arena for her magnificence, which he amplified by shimmering cascades of silk falling from her shoulders over the arms of her chair, and from her lap to the rug beneath her feet. Raphael's *Gregory IX giving the Decretals* (Plate 263)[26] must have been the paradigm; although Rubens may have taken from Moroni the hint that a full-length, seated, was not too presumptuous a pattern of portraiture for a woman, and a woman not of royal birth at that. For a splash of colour to accent the silvery white, gilt-threaded dress, staged thus in front of stonework paned with black marble, Rubens introduced, possibly for the first time, a favourite device: a blue and yellow macaw, to complete with the chair a bouquet of saturated primaries. So successful was this portrait pattern that he repeated it, somewhat more austerely, to the order of Veronica or her family (Plate 265). Veronica chose to set off her fair looks this time in Spanish black, the dress lined with gold; and her niche is black and gold, with hangings of red, gold and silver.[27] We can appreciate how consequential this setting is to the full-length portraits, both spatially and in stateliness, by comparing them to a three-quarter-length version of the one in which she wears white.[28] Whilst that autograph repetition gains a sense of conversational range, it misses the clang of the sitter's nobility.

Contemporary etiquette dictated that a lady seated should employ one hand with a fan, the other with a handkerchief – else she should rest one disengaged on the arm of her chair. Veronica is a model of decorum. Rubens posed *Caterina Grimaldi*[29] in the same convention (Plate 264). The lapdog pawing Caterina's dress makes a contrast as lively as the macaw gnawing the upholstery above Veronica's shoulder. But whereas the plumage of Veronica's bird is no more than pictorially piquant, Caterina has a companion besides her pet; and the nearness to her of this dwarf, unsentimentalized and without caricature, is poignant. The picture is no mere exercise in juxtaposing youthful looks and middle-aged deformity; nor is it a commonplace of social commentary. The relationship between these creatures is free of vulgarity. Perhaps the tone is best caught in the nervous delicacy with which the white clematis is painted; and in the subaqueous flare of luminescence as the light finds its path beneath the chair. Intimacy and grandeur are so masterfully combined that Rubens could hardly hope to excel himself even twenty years later, when he came to compose in Antwerp *Lady Arundel with her page, dwarf and dog, accompanied by Sir Dudley Carleton*.[30]

The chairs in these portraits of Genoese ladies are canted to the picture plane, seemingly in response to invisible pendants. Caterina, like Veronica, was in 1607 newly married. What patterns were devised to depict their husbands we know in the latter instance only: the equestrian portrait of *Marchese Giacomo-Massimiliano Doria*,[31] a Knight of Santiago dressed in Spanish black (Plate 266). This 'cavaliere perfetto ed osservatissimo', like a personage from Tasso, bounds towards us on his dapple grey, his liver and white spaniel prancing beside him, as though to pass breathtakingly close between us and a tree, in which is perched an eagle, the badge of his house. The red scarf streaming from his forearm is outlined against the sky in parallel movement to the horse's tail and the action of the dog; but the most mobile and dramatic element is the fringe and flare of the light. Nothing in the previous history of portraiture compares with this spirited performance in honour of a young Genoese patrician. It offers so vivid a contrast to Titian's vision of *Charles V*, lonely and remote in the glow of his victory at Mühlberg. Like the *Lerma*, the *Doria* is to be hailed both as an innovation and as an inspiration. Rubens himself took the next step in 1634, with *Cardinal-Infante Ferdinand commanding at Nördlingen*.[32] In admiration of that triumph of the brush, Philip IV gave his order for an equestrian statue from the studio of Tacca in Florence to be erected in Madrid.[33] A succession of Baroque monuments followed, dominating public places in almost every European capital, of which the latest, most stirring, and most famous is Falconet's *Peter the Great*[34] on its rock base above the bank of the Neva.

(ii) LANDSCAPES

Foliage in the *Doria*, as in the *Lerma*, is a dark foil which frets the sky and canopies horse and rider: an equivalent in nature for the colonnades and curtains which are the man-made trappings of the *Caterina Grimaldi* and of the standing *Brigida Spinola Doria*. Twisted trees and spreading fronds fulfilled similar

functions in *The Death of Adonis* (Plate 214) and in the Mantua *Baptism* (Plate 246). Occasionally in Italy Rubens put to use studies of the sort which he seems to have made of landscape throughout his career: in narrative, for the garden setting of the Borghese *Susanna* (Colour Pl. VIII); and evocatively, both for the view across the lake in his *Self-portrait with friends at Mantua* (Plate 253), and for the view of Roman ruins in the trial-piece which he painted to gain the Chiesa Nuova commission. However, he did not wish to become known and classed south of the Alps as a landscape specialist, as Brill was, not even to the extent that Elsheimer was; any more than he wished to be known and classed as a portrait specialist, like Pourbus. He firmly set aside Iberti's suggestion at Valladolid that he should turn out a quick half dozen woodland scenes to replace those paintings in the Mantuan gift to Lerma which seemed irreparably damaged. It is not surprising therefore that we know only one landscape by him, not a large picture, which can be placed confidently within his Italian years.

The title, inferred from the figures huddling for warmth and shelter in the foreground, is *The Shipwreck of Aeneas* (Plate 149).[35] The location, according to the lettering of Schelte a Bolswert's engraving, is Porto Venere.[36] The motif is a storm-swept headland, with a lighthouse as the distant focus flaring its warning to mariners. The composition, its rhythm fretted by picturesque business, reflects the influence of Brill. That this was engraved so many years later indicates that it was painted, and almost certainly retained, by Rubens to regale himself. The unkindness of the scene may touch on some fearsome incident on his Spanish journey in 1603. The tempestuous quality of the depiction seems to have caught quickly the eye of David Teniers the elder. Teniers's *Adoration of the Magi*, painted three years after he himself left Italy for good in 1605, is unthinkable without knowledge of the surge and thrust of Rubens's promontory into the distant rage of the sea; although his borrowing of the motif is incongruous to his subject, the meaning of which he failed thereby to enlarge.[37]

In addition to *The Shipwreck of Aeneas*, a work evidently of 1603–5, Rubens may have painted at least one Roman landscape in Italy: the missing picture on which Schelte based his engraving of a *Landscape with the Ruins of an Antique Temple*.[38] The Louvre *Landscape with Ruins of the Palatine*,[39] engraved by the same man in the same series, appears just to postdate the return to Flanders; although it is evidently based, like the backgrounds to the trial piece for the Chiesa Nuova, and to the '*Four Philosophers*', on drawings done on the spot. However, unlike *The Shipwreck of Aeneas*, the Louvre landscape is painted over a light priming, not the brown bolus which Rubens came to use in Italy habitually for work on canvas, following the revival by the modern masters of Bologna of sixteenth-century Venetian practice.

(iii) COPIES

The copies after Raphael for presentation to Lerma were painted in Rome by Facchetti, a professional copyist from Mantua, not by Rubens. Nevertheless, making copies of Italian masterpieces was regarded as part of the Fleming's duties at the Gonzaga court; and one occasion is documented, although the copies in question have disappeared. On 25 April 1605, a month before the canvases for the Jesuit Church in Mantua were ready, the Emperor Rudolf II wrote to Duke Vincenzo – probably on the advice of his court painter, Hans van Aachen, who had seen the Mantuan collection in November 1603 – and asked for Rubens to prepare copies of two of the Mantuan Correggios: presumably *The Education of Cupid* and *Jupiter and Antiope*.[40] Vincenzo himself reported them finished on 30 September, and they reached Prague safely on 24 October. For a man of Rubens's promptness, free to start work at the end of the first week in June, to have taken four months to execute such an order, suggests that he used more than diplomatic care to perfect a task congenial to him.

RUBENS READ SUETONIUS AND TACITUS; and before he went to Italy he had painted according to his fancy a set of *Caesars* (Plate 1). He was familiar with Pliny's descriptions of works of art in antiquity; and the appearance of the Rhodian *Laocoön* in the Belvedere of the Vatican, for example, had reached Antwerp through the engraving by Marco Dente.[1] By way of other loose prints, such as Marcantonio's engraving of the *Belvedere Torso*[2] and Giuseppe Nicolo Vicentino's chiaroscuro woodcut of the *Hercules overcoming the Nemean Lion*,[3] he could have gained further ideas of the extant variety of antique forms for which there was no *ekphrasis* in classical literature. He knew the 1598 edition, well illustrated by Theodoor Galle, of Fulvio Orsini's *Illustrium Imagines*. He may even have had knowledge of the magnificent copies which Goltzius, visiting Rome in the early 1590s, had drawn in red or black chalks, beyond those of the *Belvedere Apollo* and the *Farnese Hercules*[4] widely available through engravings made by the draughtsman himself on returning to Haarlem.

However, the substantial acquaintance with antique art which Rubens sought began in Gonzagan service: in the Duchy of Mantua itself, in Grand Ducal Tuscany, in Venice, and, above all, in Rome. With the opportunities of his cisalpine years his zestful study of the remains spread rapidly over the field of sculpture, from monumental figures and groups to busts, reliefs of every kind, *bronzetti*, coins and cameos. On the other hand his interest as a painter was less readily aroused by Roman painting or mosaic, even by such a celebrated survival as *The Aldobrandini Wedding* which the artist nearest him, Van Dyck, was to record across a spread of his Italian Sketchbook.[5] Only in September 1636 do we have reference, in a letter thanking Peiresc, to his having received a 'disegno colorito' of this painting which was discovered during his young days in Rome, and which on his own submission, was passionately admired by every amateur of painting and antiquity in the city. Following Michelangelo and Raphael, he chose rather to develop his plastic sense by exercising his draughtsmanship before objects in the round or in some degree of relief. Without putting himself ahead of his time by preoccupation with niceties of origin, identity or dating, he was in love as much with the aura and content of antique sculpture as with the authority of its forms and fascination of its detail. As eventual curator of the Gonzaga collection, and on extended leaves in Rome, sharing there a house with his learned brother, he acquired an understanding of antiquity which far outranged Polidoro's or Pirro's, and which was rivalled in the Seicento only by Poussin.

Undoubtedly the Rubens brothers read and discussed the classical authors. Together they saw the sights, pored over small treasures, and argued the propriety of particular poses or falls of drapery which they observed on the statues. The fruits of their conversations were strung into the *Electorum Libri duo* (Plate 303), which their friend Jan Moretus was to publish at the Plantin Press the year after Philip's return to Antwerp. This quarto of 1608 is crammed with curious information about the customs, morals and dress of the ancients. Philip states in the text that Peter Paul assisted him not only with his hand, that is in preparing drawings for the plates, but also with his acute and sure judgement in compiling the expository notes and observations taken from the Greek and Roman writers.

(i) FIGURES IN THE ROUND

The drawings which Theodoor Galle's younger brother Cornelis engraved for the four folding plates have disappeared; but these illustrations to a publication, for which a Privilege was obtained on 15 November 1607, document for Rubens's second sojourn in Rome his style of drawing finished copies after the antique. Moreover the images of St. Nereus and St. Achilleus in the Chiesa Nuova painting of 1608 (Plate 336) were based unmistakably on views of the same statue as was illustrated full face and in two side views on the plate captioned, 'Iconismus statuae togatae I' (Plate 303).[6]

'Iconismus duplicis statuae tunicatae' illustrates the so-called '*Flora*' in the Farnese collection,[7] referred to in the text as a 'certain goddess' ('*deae cuiusdam*'), together with the *Roma* in the Cesi garden.[8] At Palazzo Farnese Rubens drew also the colossal *Hercules* and *The Punishment of Dirce* (Plates 282, 284).[9] In the Cesi collection, in addition to the *Roma*, he must have taken note of the *Leda*,[10] and of one of several version of the famous *Crouching Venus* of Doidalsas (Plate 274);[11] he alludes to this last in

The Fall of Phaethon, and, by revising the pose from life, reintroduces it in the foreground of *The Regency of Maria de'Medici,*[12] and thereafter, towards the end of his career, in the *Nymphs and Satyrs*[13] which belongs to Heinz Kisters. Other echoes of the Doidalsic pose, perhaps from other revisions, or perhaps from different versions of the statue altogether, are to be found both in the *Venus frigida*[14] of 1614 and in the more or less contemporary *Lament for Adonis,*[15] paintings of his most overtly classicizing period. Such development of figurative ideas through his assimilation of the antique was to be characteristic. Possibly in Rome, he made chalk studies of a nude youth seated (Plate 273) in poses departing successively from that of the Hellenistic *Boy extracting a thorn from his foot;*[16] or again he may have been working at these in his Antwerp studio on the basis either of a reduction or of some more precise copy which he had drawn in front of the Hellenistic bronze in the Palazzo dei Conservatori.

Rubens's diversions on the 'Spinario' do not happen to have been directly employed, so far as we know, in his painting; but they doubtless quickened his sense of the uses made of the figure by Raphael and by Daniele da Volterra. By contrast his suite of elaborate copies in black chalk of the front, three-quarter, rear and profile views of the *African Fisherman* (Plate 275)[17], held in the Borghese collection to represent Seneca, were to lend authority to the noble, neo-Stoic memorial to *The Dying Seneca*[18] which he was to paint within two years or so of his return home. Less directly but no less essentially, his copies from the *Laocoön* (Plate 307), drawn not only from the group as a whole, frontally, but also from sidelong view of the individual figures and their heads and limbs, prepared him for his supreme effort in the Christ of the Antwerp *Elevation of the Cross* (Plate 190) to convey the anguish of spiritual crisis through bodily stress.

Copies from the *African Fisherman* and from the *Laocoön* (Plates 275, 306), many of which found their way back to Rome in the hands of 'Monsù Habé', and so eventually to a special album assembled by Padre Resta,[19] were prominent, with others drawn from the *Belvedere Antinous* and from the huge marble horses of the *Dioscuri* (Plate 297), among those set before his pupils in Antwerp; that is, if we are to judge by the imitations deposited by Panneels and others in the *cantoor.*[20] More black chalk drawings of the same type, copies by Rubens from another of the *mirabilia* of Rome, the *Farnese Hercules,* were available also as select models for imitation; but these investigations of Glycon's tremendous marble exceed the likely limits of a beginner's need to grasp Lysippan forms. He himself had been introduced through Goltzius's engraving to the statue as restored by Guglielmo della Porta; but in Palazzo Farnese he was to delve its meaning deeper than Goltzius ever reached. Two of his notes taken on the spot, a summary of the back view which had engrossed Goltzius, with a more worked up impression of muscularity and mass in the side view from the right, lie together on one side of a sheet (Plate 284).[21] On the other he lavished extra care in registering the impact on his vision made there probably that same day by the bull's head and shoulders in *The Punishment of Dirce* (Plate 282), which had been described by Pliny as the work of Apollonius and Tauriskos of Tralles.

The ferocity of the marble bull thus expressed helped him to elucidate in the privacy of his Pocket-Book,[22] which Van Dyck alone of his disciples was to be privileged to explore, taurine as well as leonine qualities in the head of the *Hercules.* Taking suggestion from Giambattista della Porta's *De Humana Physiognomia,*[23] he devoted a page to showing the sympathetic relationship between the crest of a bull's neck and the neck of the hero, between the hero's face and the mask of a lion when roused. To him the rhythm of muscular movement revealed the kinship of all creatures within one harmonious order; how in their several passions each one may partake recognizably of another's essence, and still, by the force of that paradox, express more vitally its own. On either side of another page[24] he demonstrated, according to the Ptolemaic theory of proportions, the formal reduction of the imposing mass presented by the whole figure of the *Hercules,* and of the potent expression of the head, to the basic constructions of the cube, the circle and the equilateral triangle (Plates 281, 283). 'Vir HERAKLES' is shown to derive his forbidding strength not from the surface accidents of his appearance, but from the absolute and irreducible notions which inform his substance. The birth of his fabulous physique takes place in the pure realm of mathematics. The cube – and we may think metaphorically of the sculptor's block of unworked marble – is fundamental. Subsequent growth emerges from the circle and the triangle. The *Hercules* is then analysed by parts. From cubes proceed squares; angles from triangles; and, by extrapolation, arcs from circles. Breasts, shoulder blades, thighs and buttocks are accounted. The muscling about the eyes; the squareness of the forehead, the angle of the beard with the jaw are all noted; for from these exhales the soul. That he

drew, literally drew, a lively satisfaction from these concepts of the nature of form may be seen in a pen drawing made by him independently of the Pocket-Books. In this he presented the *Head of Hercules*[25] in a finished manner (Plate 278), yet with a tough assertion that could outstare not merely Hydra or the Nemean lion but the very gods. The hero's head, sunk in rest in the Farnese statue, is raised to meet all comers. Beneath the fiercely knitted brow, the strong curling of the beard along the jaws, and the proud swell of the neck, lives also the sense of the underlying logic of square, triangle and circle. Yet such an abstract and intellectual awareness tautening his emotional response did not preclude a sensuous, more painterly approach; he drew in Tintoretto's manner, using black and white chalks either side of a sheet of blue paper, the head of the Farnese statue (Plates 279, 280), by different falls of light so as to relish the crinkling of the hair and the bold cutting of the features in profile.[26] The triumphantly Herculean quality of *St. Christopher*,[27] painted on the shutters of the Antwerp Cathedral *Deposition* (Plate 29), and of the *Hercules in the Garden of the Hesperides*,[28] formerly in the collection of Marchese Stefano Cattaneo Adorno, is due to his having learned in Rome to capture both the profundities and the superficies of things.

Dating of Rubens's drawings in black chalk after antique statues in Rome can only be tentative. However, his first copies[29] of the Apollonian *Torso* are likely to have been made in the Vatican Belvedere on the 1601–2 visit, his autograph drawings known to us (Plate 276) being at once close in character to the Goltzius copies and patently more inhibited than, say, the Dresden three-quarter rear view of the priest *Laocoön* studied from below (Plate 307).[30] His interest in the back of the *Torso*, registered by copies in the *cantoor*, is further implied by the figure of the shepherd in *The Judgement of Paris* (Plate 208), datable on other grounds also in the summer or autumn of 1601. Similar restraint and care in drawing are evident in a rear view which he took of a youthful torso (Plate 269), and which he annotated 'acht de Lyf',[31] such use of Flemish in Italy being an additional pointer to so early a date. Another record of a marble fragment, a *Colossal Right Foot*[32] without a heel (Plate 270), probably that of *Constantine* in the Palazzo dei Conservatori, may belong to this phase, during which he is likely to have studied also the Capitoline *Eagle*,[33] rendering the imperial spread of its wings with grandeur and precision (Plate 267), and, from several angles, the Belvedere *Nile*;[34] although his interest in the last

is ascertainable today only in the Pocket-Book, through a copy, which shows how the infants at play pleased him as much as the hoary and splendidly muscled river-god. These chubby creatures, together with *Romulus and Remus suckled by the Wolf*, which he also drew in the Belvedere,[35] and the *Boy struggling with a Goose*[36] provided an index to the ideal forms of *putti*. To represent the age of man between theirs and that of the younger of *Laocoön*'s sons, he chose the pubescent *Boy advancing with a Cloak*,[37] studying the action from either side on the *recto* and *verso* of the same sheet, now in Dresden (Plates 271, 272). This may be yet another drawing made while he was Montalto's protégé. For a canon of womankind the range of his choice was wide enough. Among the draped figures he may not have concerned himself particularly with the '*Flora*' in Palazzo Farnese, nor with the *Roma* in the Cesi garden, until his second sojourn; but he must have taken early note of the Cesi *Leda*[38] and the Vatican '*Pudicitia*'.[39] The *Leda* inspired the figure disrobing to the right of the principal tree in the background to *The Baptism*; and the same inspiration appeared much modified in the princess rescued by *St. George slaying the dragon*. The Madonna's gesture with her right arm, raised to her cheek and veil, in the Genoa *Circumcision* is patently inspired by the '*Pudicitia*', the mould of virginal modesty. A summary in pen of that statue full length, the left arm drawn horizontally across the body in support of the right elbow (Plate 315), is to be found appropriately on a sheet of his trials for *The Return from the Flight*.[40] The distinctive attitude was resumed by him afresh for the Madonna of *The Visitation* on the left wing of the Antwerp Cathedral *Deposition* (Plate 93); and the whole pose, virtually unmodified except for more voluminous drapery, was used contemporaneously for a Mary in *The Maries at the Sepulchre*, and again eight years later for Prudence attending the Queen in *The Reconciliation of Maria de' Medici with her son*.[41]

Circumstance as well as style however suggest that the majority of Rubens's copies in chalk were drawn in Rome between 1605 and 1608. Within that period, during which Cardinal Scipione Borghese became one of his backers, he may be supposed to have drawn in sanguine[42] the *Borghese Hermaphrodite* (Plate 290), so as to disclose from above the rhythm of the voluptuous body held in troubled sleep. In the Borghese collection also, to judge from a foreground figure painted in *The Conclusion of Peace*[43] for the first Medici cycle, he must have drawn also the *Gladiator*. *The Regency*[44] in the same

cycle, a haunting ground of classical statuary, contains an overt reference to the *Belvedere Apollo*, placed close to a fresh revision of the Cesi *Leda*. Again in the old Borghese palace on the Campo Marzo he drew, this time with black chalk, the *Mars and Venus*,[45] a Roman copy after a fifth- or fourth-century Greek original. The head and the gesture of the right arm of the Venus in this group may have guided him for the figure of the Madonna in *The Deposition* which he was to paint about 1618 for the Capuchins of Lierre.[46] Five years later the inclination of the head in the Mars, in combination with the elegant bend of his left wrist and extended fingers, was converted for Maria de' Medici in *The Flight from the Château de Blois*.[47]

The numerous copies of the *Nile Fisherman* would have been made, with those of the *Hermaphrodite*, the *Gladiator* and the *Mars and Venus*, in the period when he frequented Casa Borghese. He drew there also the views of the *Centaur with Cupid on his back* (Plate 316),[48] which were selected to be engraved posthumously by Pontius for the so-called '*Livre à dessiner*';[49] and his record of this captivating group, which reproduces a lost Hellenistic bronze, may well have inspired his rendering of *The Education of Achilles by Chiron*.[50] He had access with his brother to other collections. In Agostino Chigi's *vigna* he drew a full-length *Silenus*,[51] swag-bellied and bibulous, but propping himself more or less upright, with his right forearm cushioned on a wineskin (Plate 293). Congruent to the *Mars and Venus* copy are two others from statues which were both to be in Arundel's collection in London by 1618, but which were evidently still in Rome while Rubens was there: the alleged '*Homer*' (Plate 304),[52] an Hellenistic portrait of about 300 B.C., which he was to use for the figure of Chronos in *The Regency of Maria de' Medici*;[53] and the *Young Nero* (Plate 305)[54] which stood in another *vigna*. In addition to these gravely togaed figures he drew with gusto the *Comic Actor*[55] in the Vatican (Plate 298), rehearsing the detail of the left hand resting on the fellow's lap as well as the grotesquely fearsome mask; and his drawing gives a distinctive edge to a conception sadly blurred in the marble.

In exercising this gift of revitalizing inert substance, and to a higher degree even than Annibale Carracci, Rubens does not appear to have been troubled that almost all the figures and groups which he drew were Hellenistic or late Roman, often no more than competent copies of lost masterpieces. Only in two cases to our knowledge does he seem to have had the chance to copy from an Attic original: one being a Pentelic marble *Canephora*[56] of the Erechtheum type which stood in the *vigna* of Villa Montalto; the other being a *Horse's head*[57] of approximately the same date (Plate 296), apparently also in marble, which has not been identified, but which resembles closely the famous bronze in the Medici collection in Florence.

(ii) BUSTS AND HEADS

The ancient Roman talents for portraiture and satire attracted Rubens as a draughtsman to intensify the expressive modelling that he found. Lankrink owned a telling likeness in black chalk of a young patrician's head, which is presented in three-quarter profile with beetling brows; and he inscribed it justly, 'Rubens from the Antique'.[58] The Hellenistic sculpture from which Rubens drew may well have been the version of this portrait which was in the collection of Ciriaco Mattei. Another study rich in *chiaroscuro* of an older, baldheaded man (Plate 277), nearly full face, with parted lips and upturned eyes,[59] shatters the constraints of marble; and we gasp at the power to recover humanity from within the stone. Rubens liked also to consider subjects from unusual angles. About 1619, when considering his altarpiece of *The Miracle of St. Ignatius Loyola* for the Antwerp Jesuits, he drew the heads and throats of *Galba*[60] and of the supposed '*Seneca*'[61] sharply foreshortened from below (Plates 308, 309). These *tours de force* insist on the folding of an old man's skin, the prominence of bone, the cording of sinew, on those superficially trivial *maccaturae* to which he called special attention as marks of artistic quality in *De Imitatione (Antiquarum) Statuarum*,[62] the essay reproduced by De Piles as a foretaste and guarantee of fuller publication of the Pocket-Book. Indeed, practised attention to such incidents of form was indispensable in Rubens's view to a modern painter who would give fresh life to the peculiar character of antique sculpture. He himself attended keenly to its peculiarities: such as the hermathene busts of *Herodotus and Menander*[63] recorded by him in the collection of Fulvio Orsini (Plate 317); such as the contortions of a satyr's mask, drawn instinct with life on one side of a sheet (Plate 294), on the other side of which he drew in the same medium of black chalk the head of a greybeard elder seated before him (Plate 295).[64] The boundary for him between prying into art and into life was paper-thin. We may recall the *Pack-Mule* (Plate 17) drawn in Florence, on the back of his record of the mask of Michelangelo's *Night* (Plate 15).

In Italy Rubens could not have afforded much as a

collector; but he must have acquired there, or soon after leaving, the 'Seneca' bust[65] which is featured so proudly as a vital presence in the 'Four Philosophers' and which was to be engraved for him by Vorsterman in 1638 after one of his own drawings.[66] It was then still prized as one of the antiquities which adorned his domestic pantheon in Antwerp; and was almost certainly one of the 'beautiful antique heads in marble' mentioned without specification in the Inventory of 1640.

(iii) MARBLE RELIEFS

The illustrations to the *Electorum Libri duo* register reliefs as well as statues drawn by Peter Paul in Rome between December 1605 and May 1607, when Philip returned to Antwerp. The start of a chariot race was copied from a frieze belonging to the Temple of Vespasian;[67] and the probable prototype for the actual 'Missio mappae' was to be found 'in aedibus Barberini'.[68] The helmet and weapons, 'Iconismus apicis in lapide clivi de capitolini', are taken from a bas-relief frieze on the Temple of Concord.[69] Earlier, working from Trajan's column, as engraved by Ciacon, Rubens had made several excerpts, including the scene of *Dacian prisoners being taken back to camp*;[70] and from a sarcophagus in the Villa Mattei, showing an elderly poet flanked by muses, he drew, evidently during his first period in Rome, the three full-length figures (Plate 302),[71] annotating them jokingly as 'Socrates procul dubio' (Socrates without doubt), 'Xantippe qua stomachatur' (Xantippe by whom he is vexed) and 'vide os columnatum' (notice the pillared face). The last refers to Periplectomenus's description of Palaestrio in Plautus's *Miles Gloriosus*; the confusion of the muse Polyhymnia with the peevish Xanthippe follows upon his fancy to identify the bearded man as Socrates; and the head of that figure he rehearsed separately in order to bring out further its conformity with current ideas of Socratic appearance. Plautus, like Quintilian, was frequently to be quoted in the *Electorum Libri duo*. In his jocular as in his solemn moods, Rubens rejoiced in the illustrative value of antiquity.

One of his earliest responses to antiquity in Italy was the rapid pen sketch of *The Flight of Medea*[72] from a second-century sarcophagus in the Vatican Belvedere, which could have been known to him in Antwerp through the engraving by Giulio Bonasone, or indeed in Mantua through another example of the marble in the Gonzaga collection. The *éclat* of this drawing should not blind us to the more demure sparkle of contemporaneous copies penned and neatly annotated by Rubens on one side of a single sheet.[73] These record two white marbles: the sepulchral cippus of Atimetus and the six figures of a Bacchic procession encircling an archaistic crater which he saw in the 'vigna di Julio'. But his most vibrant copy so far recognized from any antique marble relief was drawn in black chalk about 1606; the three principal figures from the famous Bacchic *Vase* of the first century B.C. (Plate 289), the pride of the Borghese collection.[74]

On two occasions about 1615, he transformed antique figure compositions, which he had extracted from circular reliefs in Rome, by superb reorganization of them quadrilaterally in painting (Plates 287, 288):[75] the *Drunken Hercules* in the Mattei collection, and the *Hercules overcoming the Nemean Lion*[76] at the Villa Medici (Plate 286). Both his drawing of the Mattei relief and the relief itself have disappeared: but the latter is known through an engraving of 1779.[77] His drawing of the damaged Medici relief, which has since been repaired and inset into the garden wall, is in pen and ink (Plate 285),[78] as vigorously handled as his copy of *The Flight of Medea*. The rehearsal of the brute strength in the profile of the hero's head and neck is the stylistic match of those snatched by his pen from coins of the Roman Emperors in a group of drawings which were to be acquired from Lankrink by the 2nd Duke of Devonshire; and we may think particularly of the *Vespasian* and the *Galba* (Plate 314).[79]

(iv) COINS, CAMEOS AND GEMS

These passionate jottings, now at Chatsworth, witness the intensity of Rubens's researches. In the British Museum there is part of another series drawn by him with a finely sharpened pen after other coin and gem types, some showing heads, others the action of figures.[80] In these various scrutinies he was aware of the sculptural as well as the graphic properties common to such material. On occasion he would take bodycolours as well as inks; and, working with the tip of a sable brush, he would recreate the likeness of a coin as though it was as richly modelled and as translucent as a gem. A choice example, the colour of warm honey and milk on a black ground, is the profile of *Alexander the Great* (Plate 311), from a Macedonian coin type displaying the head of the ruler as Zeus Ammon.[81] This coin, according to the inscription on the back of the drawing, he drew in Rome in the collection of Hans Hemelaer. Hemelaer was a learned ecclesiastic from The Hague, who was for six years in the

household of Cardinal Cesi, becoming later a canon of Antwerp Cathedral. Conveniently for Rubens, his silver piece had been illustrated in 1598 by Galle for the *Illustrium Imagines* of Fulvio Orsini,[82] the previous owner; and the Plantin Press had issued a posthumous edition of the book in 1606.[83] Rubens's transubstantiation of the image puts it on a par with two drawings in which he recorded real gems (Plate 310): *Germanicus Caesar*, cut in sardonyx,[84] and 'Solon', really *Maecenas*, cut in amethyst,[85] a fabulous rarity signed by Dioscourides himself. Both stones, having been in the collection of Fulvio Orsini, were illustrated in the 1606 edition of the *Illustrium Imagines*;[86] so that Rubens had this aid to work from, as well as the originals bequeathed to Cardinal Farnese. No more sensitive interpretation of such precious small objects exists: of the way in which their brilliance of modelling is designed to catch the light, and of the way in which their subtle monumentality may be discreetly expressed.

The habit of a connoisseur of cameos began for Rubens in Gonzagan service. He was to write from Antwerp on 9 September 1627 to Pierre Dupuy in Paris:[87]

'I received with pleasure the drawing (although badly done) of the cameo of Mantua. I have seen it several times, and have even held it in my hands, when I was in the service of Duke Vincenzo, father of the present Duke. I believe that among cameos with two heads it is the most beautiful piece in Europe. If you could obtain from M. Guiscard a cast of sulphur, plaster, or wax, I should be extremely grateful.

[*In margin*: I have seen plaster casts of it at Mantua.]'

Besides this huge sardonyx of *Ptolemy and Arsinoë*,[88] which he had evidently omitted to draw at Mantua, he must have been exceptionally impressed in Florence by another cameo with two heads belonging to the Medici, *Tiberius and Agrippina*:[89] for this further example of a man's profile partially superimposed upon that of a woman provided him with almost the exact pattern for his beautiful paintings of the same subject about 1612, now at Chapel Hill and in Washington.[90] Such superb relics of antiquity never ceased to excite him. Illustration of them would have been the glory of 'the Book of Cameos' about which Peiresc had written from Aix on 23 June 1623 to Aleandro,[91] another of this in-

ternational circle of antiquaries and collectors. Rubens's task then was to supply the drawings for the engraver; Peiresc himself had agreed to supply the text. Alas, this project never got beyond the preparations, under Rubens's direction, of some half dozen of the plates – among them one from the sardonyx *Gemma Tiberiana*, which he had drawn from the original in Paris,[92] another from the *Gemma Augustea* belonging to Rudolf II in Prague, which he had to draw from a cast,[93] and a third from *The Triumph of Licinius* in Paris (Plates 312, 313).[94] A posthumous title-page for these was lettered *Varie figueri de Agati Antique desiniati de Peetro Paulo Rubbenie Grave Par Lucas Vorstermans e Paulus Pontius*. Rubens himself would never have settled for such a barbarous-sounding description of such a highly civilized intention.

Not until 1619, at the Foire St.-Germain in Paris, did Rubens acquire the 4th–5th-century agate vase which was to be the jewel of his own collection of antiquities,[95] something as precious as the sardonyx *Gonzaga Vase*, which he had cared for in Mantua.[96] Not until 1625 did he acquire from M. Gau in Paris the silver spoon, engraved with a seated Mercury in the bowl, which he believed to be as true an antique as the handle.[97] But in Rome or Mantua he drew with an almost proprietary air small figures in bronze. These his avid eye devoured from every angle. His intensively hatched pen drawings of a *Hercules pissing* (Plate 299),[98] of a *Commodus as Mercury* (Plate 300)[99] and of an *Apollo*[100] remain together in the *cantoor* with a single exception, the most delicate of the four drawings of the *Apollo* (Plate 301).[101] This lay unremarked in Dresden, having acquired an implausible but not insignificant inscription in the late eighteenth century, 'Gulio Romano' (*sic*). There was indeed no limit in range or scale to his interest in what survived of the ancient world. In an album at the Hermitage, supposedly compiled of his architectural studies, is a noble drawing in black chalk, unmistakably by his hand, of a pilaster's *Corinthian Capital* (Plate 268).[102] The juicy curling of the acanthus leaves, the crisp scrolling, the taut silhouette of the abacus, all manifest his passion for the object before him. At the same time his drawing symbolizes his response to the remains of a civilization unrivalled for splendour, unmatched for authority, supremely eloquent and perennially fruitful in its long decay.

RUBENS MUST HAVE got leave during November 1605 to reside in Rome for an extended period. This was to be by far his longer stay in the city.[1] On 11 February 1606, Giovanni Magno, Mantuan Resident at the Holy See, wrote to Chieppio acknowledging that the painter was to be paid 25 scudi a month.[2] However, not until 31 March was Chieppio able to implement this instruction. He wrote then to Magno:[3] 'I send you two remittances, one for Signor Pietro Paolo, of whom I have had no notice for ages, and the other for Signor Tessis, on whose behalf I have been solicitous, even if the successful outcome is late. I am not writing to these gentlemen, as time is short: but in any case it will mean little to them to have letters full of compliments because they now have some cash.'

We may echo Chieppio's complaint at lack of news through the winter of 1605–6.

Magno replied promptly on 8 April:[4] 'I have handed the letters of credit to Tessis and to the Flemish painter. With these they are much comforted: but in making this payment I don't really feel relieved, trusting all the same in your consideration and protection. I shall soon be reaching out for your favours, because these six months past I am getting more and more entangled as the excess of expenditure over provision goes on growing by the hundredfold.'

Chronic failure of the Court of Mantua to pay its servants punctually, and the consequent embarrassment in which they found themselves over protracted periods, was a spur to them to look elsewhere for remuneration, however loyal in spirit they might remain to their Gonzaga masters. This is to be remembered when assessing Rubens's enterprise in dealing with the Oratorians.

Letters to Chieppio from Rome, both written in Peter Paul's name by Philip Rubens, are dated 29 July and 2 December 1606. They reveal that the painter's salary for the three months from 1 January to 1 April 1606 had been paid promptly, but was overdue for the next three months; and that he had been living in the city since the previous December.[5] A legal document of 4 August 1606[6] shows that he was established with his brother and two servants in a house in Via della Croce, near the Piazza del Popolo.

During the seven months of Philip Rubens's employment as librarian to Cardinal Colonna, his brother must have taken full advantage of his company. The 'Electorum Libri duo' (Plate 303) is the tangible outcome of their shared interest in the customs and costumes of antiquity. In the letter to Chieppio of 2 December, Peter Paul owned that he had employed the whole summer 'nei studii dell'arte'. Clearly he had devoted much of these studies to collaboration on that book, and to filling his notebooks with those copies of, and observations on, classical forms that provided the substance of his personal revival of the antique world. These months gave him admirable opportunities. He had also what was for him a severe misfortune, to be kept inactive for precious weeks by a grave pleurisy. The picture of a cock which he painted for his friend and healer, Johann Faber, is untraced; but the grateful relief of so vigorous and generous a nature at recovery is not hard to imagine.[7]

The letter of 29 July indicates the painter's situation in Rome. Unless Chieppio could once more secure payment of his retainer, he would have to seek elsewhere for profitable employment, of which he would find no lack. His illness is not mentioned. Yet that must have aggravated his need for funds to continue his studies. Four days later there was a laconic entry in the *Liber de' Decreti* of the Congregation at the Chiesa Nuova: 'The icon of the Madonna is to be transferred to the High Altar, and the offer of the painter who wants to paint the altarpiece is to be accepted, allowing that the price is set by two gentlemen at 450 scudi.'[8] It is unthinkable that Rubens was not aware at the time of sending his letter that the Oratorian Fathers were likely to come soon to some decision about the decoration of their high altar, and that his own chances of the commission were favoured.

The 'Imagine della Madonna' was the Madonna della Vallicella, which had miraculous power to stanch bleeding. Of little artistic value, it was nevertheless among the most sacred possessions of the Chiesa Nuova, having been preserved from the much older church on the site, reputedly built by St. Gregory the Great.[9] From another entry in the *Decreti* we know that this icon had been placed over the altar next the main portal; that is, as far as possible from the tribune.[10] The question of its transfer, and the fresh decoration required for the

high altar, must have been discussed by the Fathers, though apparently not in formal Congregation, as there is no previous reference in their *Decreti* to such discussion. Rubens, like every other painter of ambition – and his ambition knew no limit – must long have kept watch for the chance of painting the principal altarpiece for the new church. The commission had been in the public eye at least since the consecration of the sanctuary in 1599;[11] and there was surely the keenest prospection as to what form the Congregation would give to it. From the first the programme was to dedicate each altar to one of the Mysteries of Our Lady.[12] Her Nativity was reserved for the high altar; and on 7 May 1603 the completion of a painting by Barocci on this very theme was requested by the Fathers of Cardinal Federico Borromeo, according to the design of one commissioned from that painter, almost twenty years earlier, for the Duke of Urbino but then abandoned. It had been understood that the direction and expense of the decoration of the tribune would be the charge of the chief benefactor of the church, Cardinal Angelo Cesi.[13] However, Cesi's money available for works of piety was absorbed in the unexpectedly costly construction of the great façade; and this was not completed until 1605. He himself died in the following year.

On 25 September 1606, a remarkable contract was drawn between Padre Flamminio Ricci and Padre Prometeo Peregrini, representing the Congregation, and Rubens, two other Oratorians being witnesses to their hands.[14] Padre Peregrini was doubtless responsible for the legal elaboration, although the script does not conform to his signature. He had been received into the Congregation seventeen years before, having long practised as a notary in Rome; and he may have come to replace Padre Pompeo Pateri as their man of business.[15] Northerners with surnames barbarous to Italian ears may not be astonished that 'Sr. Pietro Paolo' had to inscribe 'Rubenio' with his own hand into the body of the document.

The import of the circumspect preamble is plain enough. Padre Artemio Vannini[16] had put forward to Padre Ricci during the past months the interest of an unnamed benefactor, and the claims of a particular painter nominated by the same.

The painter, Rubens, had shown to the Congregation some work of his, and had furthermore submitted his proposed design for their high altarpiece. This latter, fulfilling their requirements, had been accepted; and so the secondary stage of approbation was safely past. Thus the first decision

of the Congregation on 2 August may be interpreted as an authorization to him to prepare this 'disegno o sbozzo'; for, although his name seems to have been of no special interest to the Congregation at this stage, none but he can then have been considered for the work.

The Monsignor, prelate of the Court of Rome, the benefactor whose conditional offer of 300 scudi was gratefully accepted, must have been Jacomo Serra, Commissary-General of the Papacy. His name in connection with the Chiesa Nuova altarpiece is first given by Rubens in a letter to Chieppio of 9 June 1607.[17] The receipt of 26 October 1608 which the painter wrote for the Congregation acknowledges the 300 scudi from Serra, which he was liable to surrender to them with 50 scudi of his own, so soon as the valuation was made. After he had had to return to Flanders, it was Serra who signed on his behalf the agreement of 28 November 1609 about the final arrangement of payment for the works at the Chiesa Nuova. It was to Serra that he addressed himself from Antwerp on 2 March 1612, when he sought to collect from the Oratorians the last of the money due to him.[18]

Not being himself an Oratorian, Serra had needed one of the Fathers as his representative in 1606. Padre Vannini's business had been to make clear in conversations with Padre Ricci that the Monsignor was not just interested in a work of charity at the Chiesa Nuova, but that he wished to make known the worth of a particular painter. If the Congregation found themselves unable to come to terms with this man, the offer of 300 scudi would be withdrawn. The referees, who were to fix a bonus – all that the Congregation was ready to promise to the painter, providing all went well – were to be 'dui gentilhuomini o dui Card. li da eleggersi uno per parte'. Which gentlemen or Cardinals were thought of we do not know: but the letter which Scipione Borghese wrote on Rubens's behalf to Duke Vincenzo on 11 June 1607[19] suggests that he might have been the Cardinal ready to stand for the painter. The Congregation may have intended to choose Cardinal Baronius, himself an Oratorian and the great Papal historian. His particular interest in the *cappella maggiore* was considerable. The transfer thither of the relics of the martyred eunuchs St. Nereus and St. Achilleus had been his doing; and he had paid the cost of one of the two silver heads used as their reliquaries on the High Altar.[20] It is unlikely that he was not consulted in determining the subject of the altarpiece.

Just when and how Rubens made this valuable

friendship with Jacomo Serra is uncertain. The Serra were Genoese, allied by marriage and in financial dealings with the Pallavicini.[21] Nicolò Pallavicini was the Gonzaga's principal banker in Genoa; and to Genoa, in 1603, Rubens had been referred for any necessary repayment of expenses connected with the embassy of gifts to Philip III and the Spanish Court. Rubens certainly did incur extraordinary expenses in the course of that unexpectedly long mission. When, after many anxious weeks, news reached Vincenzo I of the complete success of the presentations, Chieppio wrote to Iberti in Spain:[22] 'The good success of the presentations which have been made has quite sweetened His Highness's opinion of the Fleming (he was not at first content with so much expense). So now I believe that everything will be accepted more easily. If you will get hold of the money and send it to Genoa, also on behalf of Signor Bonatto, they will pay immediately.'

Even if Rubens had not had to reclaim his expenses on his return from Spain in 1604, Genoa was the normal port of entry to north-western Italy. Presumably he met at least Nicolò Pallavicini on this occasion. Certainly in 1605 he painted at Pallavicini's charge a picture of notable splendour and power for the high altar of the Genoese Gesù; and this *Circumcision* (Plate 249) must have caused a sensation among those in the city interested in painting. Jacomo Serra would have seen it or heard of it. Rubens himself was in Genoa some time in the following year, 1606, painting portraits of the leading families (Col. Plate IX and Plates 262, 264, 265, 266); and he might have made Serra's acquaintance then, had he not already done so either there or in Rome. He may well have painted his portrait. By the summer of 1606 Serra was a rising star in Vatican service – he remained Papal Treasurer even after he was made Cardinal – who knew that Rubens was capable of painting an important altarpiece and who was ready to stake handsomely on his claims. The qualities which were later to attract him to the work of another young painter, Guercino, boldness of relief and foreshortening, would have stood out amongst those on which he fastened in the work of Rubens.[23] To Rubens this wealthy patron proved himself a steadfast friend.

The subject for the Chiesa Nuova altarpiece agreed in 1606 differed totally from the 'Nativity of Our Lady' originally considered. It was to be a Santa Conversazione with six saints. The space available, as Rubens implied in his letter to Chieppio of 2 February 1608 describing his first altarpiece, was not wide but high.[24] In the centre was to be Gregory the Great, the Pope whose name had been added to that of the Madonna in the title of the church, in memory of the earlier foundation and the generosity to the present building of his namesake, Gregory XIII. On one side were to be the Roman martyrs, St. Papianus and the military St. Maurus, for whom reliquary heads in silver stood upon the altar.[25] On the other was to stand St. Flavia Domitilla, niece to the Emperor Domitian, with her fellow martyrs, St. Nereus and St. Achilleus, in attendance. Above was to be represented the *Madonna della Vallicella* herself, 'with many other ornaments'. The symbolic concentration of so much that was most holy in the story of the Chiesa Nuova suggests that the ardent martyrologist Baronius was indeed author of the scheme. Five years before he had arranged for a representation of the sacred *Madonna* to be engraved as the key motif on the title-page of his massive church history. Implicit in the programme for the altarpiece is the notion of a title-page on the monumental scale. Serra and Rubens had to bow to the wishes of a Congregation quite properly more occupied with pious imagery than with the difficulties of depicting, so as to fit a rather narrow space, two principal and four supporting figures, themselves far from unimportant, on a scale large enough to be effective down the length of the great church, and of including furthermore appropriate representation of an icon of fixed size without overloading the whole design.

Rubens's gesture in offering to surrender 200 scudi of his own from the valuation of the finished work, to accompany the 300 offered by Serra, '*ad utilità di essa chiesa*', is duly noted in the preamble to the contract. The painter's offer, it is made plain, was a condition of granting him the commission. On the basis of this double offer the Fathers were prepared to treat. But they required first to see in Rome some example of his work. Then the design that he should propose must meet their requirements. If the finished painting should not please them, they were not obliged to accept it, but could simply return it to him. If it were acceptable, they were not prepared to pay him anything beyond such bonus as they pleased, and such as seemed suitable to them in respect of the customary valuation by 'due Pittori intelligenti'. The terms, from the painter's point of view, were hard. His readiness to advance towards a contract on such a basis is the measure of his determination to obtain the commission.

Although the document of 25 September 1606 specifies no dates to mark the preliminary steps in the negotiations, we may assume that this account

represents the measure of agreement reached, on the question of acceptance and payment, by 2 August when the Congregation met and resolved to accept the painter's offer. When it was understood by the Fathers that, if they did not employ Rubens, the charity would go elsewhere, they modified two proposals in favour of the painter: first, that once the finished work had been shown to the public, they would no longer be entitled to refuse it; secondly, that after the two painters had made their valuation, and Rubens had surrendered his 200 scudi, then a special committee of two referees, gentlemen or Cardinals, were to fix an appropriate bonus. Either party to the agreement should choose one referee, and both parties agreed to abide by their joint decision.

The time was now ripe for subscribing to a contract in full form; and the binding part of the document of 25 September is that which runs from the naming of the parties. The contract so written, although stringent, was more favourable to Rubens than the previous proposals. The exact bonus recommended by the referees was to be paid to him as soon as the finished work should be accepted, and before the picture was shown in public. For his part, Rubens undertook to deliver the work in eight months, that is by 25 May 1607; and he was to bear his own expenses in materials. Furthermore he was to be responsible for securing for the Chiesa Nuova the 300 scudi from Serra. However, the sum that he personally was to add to this charity was reduced from 200 scudi to 50. Having made in the past weeks of bargaining a protracted test of his sincerity in his original offer of the much larger sum, the Fathers felt that they could be thus far magnanimous. They must have been somewhat impressed already with his boldness and resolution. At the same time Rubens must have congratulated his good fortune, and felt most indebted to his Genoese patron, that he, a man not yet thirty and a foreigner, had secured on honourable, if somewhat unusual, terms an outstandingly important public commission in the metropolis.

Rubens's letter of 2 December 1606 to Chieppio protests that since, during a year's residence in Rome, he had received from Mantua no more than 140 scudi, less than six months' salary, he was compelled to accept 'alcune opere d'importanza'. Magno had written to Chieppio on the preceding 12 August[26] that he had about 70 scudi in hand which he would make up to 75 as a quarter's salary for Rubens.

Presumably, either less than 75 scudi were ac-

tually handed to Rubens by Magno, or the letter of credit sent from Mantua on 31 March was for less than the 100 scudi due as back payment. Certainly Chieppio must have failed to secure the arrears besought from him on 29 July. Rubens's financial straits were genuine enough. Nevertheless he was disingenuous toward Chieppio in attributing to them solely his call to undertake the task which he goes on to describe:[27]

'Therefore, when the finest and most splendid opportunity in all Rome presented itself, my ambition urged me to avail myself of the chance. This is the high altar of the new church of the Oratorians, called S. Maria in Vallicella, without doubt the most celebrated and frequented church in Rome today, situated right in the centre of the city, and to be adorned by the combined efforts of all the most able painters in Italy. Although the work mentioned is not yet begun, personages of such rank are interested in it that I could not honourably give up a contract obtained with so much glory against the pretensions of all the leading painters of Rome. Besides I should do the greatest injustice to all my patrons, and they would be very much displeased.'

Rubens's characteristic luck in being available with powerful backing at this moment should not blind us into regarding his phrase, '*un impresa ottenuta con tanta gloria contra le pretentioni di tutti li primi pittori di Roma*', as vainglory intended only to impress Mantua. What does it really mean? The artist of whom we might think first as his obvious rival, Caravaggio, had painted only a few years before for the Chiesa Nuova a masterpiece whose invention worked upon the imagination of Rubens for many years to come:[28] but, conveniently for Rubens's chances in Rome, Caravaggio had had to flee the city at the end of May 1606. Annibale Carracci, the other established modern master of real distinction, was no longer mentally fit. Federico Zuccaro had left Rome in 1604 for North Italy. But other seniors of renown could have been considered: the Cavaliere Giuseppe d'Arpino, who was later to be given the commission at the Chiesa Nuova to paint *The Coronation of the Virgin* for the altar of the Glorieri;[29] and Cristofano Roncalli, the Cavaliere Pomarancio, who was not only the most fashionable painter of the day,[30] but also the author of an altarpiece for Baronius in his titular church, showing precisely *St. Domitilla between St. Nereus and St. Achilleus* (Plate 334).[31] Moreover Pomarancio, although he was away from Rome in 1606 travelling with the

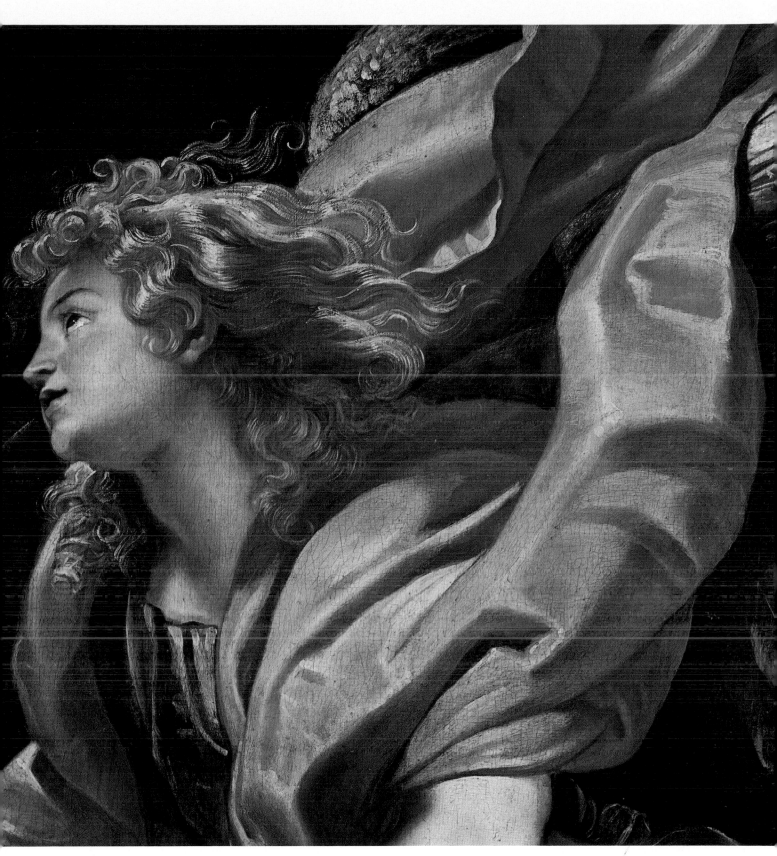

XIII. The Archangel Gabriel. Detail from *The Annunciation*. About 1609. Oils on canvas. Vienna, Kunsthistorisches Museum

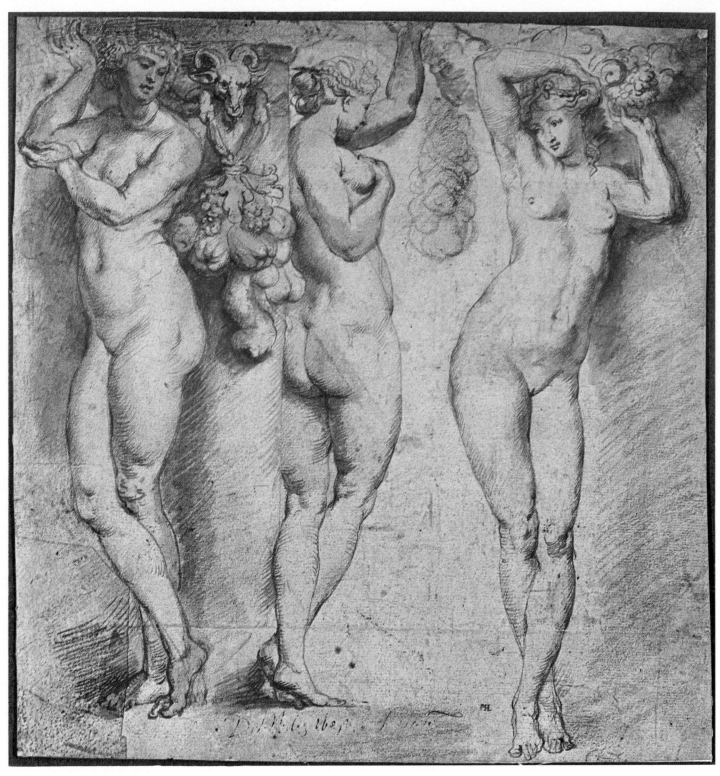

XIV. *Caryatids* (after Primaticcio). Early 1620s. Chalk, heightened with bodycolour, on paper. Rotterdam, Museum Boymans–Van Beuningen

Marchese Vincenzo Giustiniani, stood as a sort of official painter to the Congregation, having done the portrait of Baronius besides decorations in the Chapel of the Nativity at the Chiesa Nuova. Finally, even if we discount after the lapse of the 1603 proposals the possible rivalry of Barocci, who had completed two very distinguished altarpieces for the church, but was now elderly and known to be a slow worker, living far from Rome, we must consider the claims of Rubens's near contemporary, Guido Reni.[32] D'Arpino had brought the young Bolognese master to Rome once already, to paint *The Crucifixion of St. Peter* for S. Paolo alle Tre Fontane. There was no reason, about the time of Rubens's obtaining the Chiesa Nuova commission, why Reni should not have been recommended again in Rome; in fact he subsequently painted for the Oratorians their altarpiece of *St. Philip in Adoration*. Even if the particular proposals of Serra were unexpected as well as opportune, the Congregation, not to mention Cardinal Cesi, would have continued their informal discussions between the summers of 1603 and of 1606 about the choice of painter for their high altarpiece.

In this same letter of 2 December 1606 Rubens, whilst expressing his duty to do the bidding of his lord Vincenzo at any time, begs Chieppio to obtain for him either an additional three months' leave from Mantua, or else an assurance that he would be allowed to return to Rome in the spring in order to finish his task. He names here specifically Cardinal Borghese as one of the patrons who would speak on his behalf. Eleven days later Vincenzo, then at Comacchio, wrote to Chieppio granting permission for Rubens to remain a further three months in Rome: but stating emphatically that he must return to Mantua for Easter. Easter 1607 did not fall until 15 April. So Rubens could foresee a fairly liberal interpretation of the quarterly extension, which would still allow him to return to Mantua in time to play his rôle as a court painter in the preparations for the Easter Carnival. In fact a correspondence ran from 17 February to 28 April 1607, between Magno in Rome and Chieppio at Mantua, on the subject of obtaining Caravaggio's *Death of the Virgin* for the Gonzaga Gallery.[33] In these negotiations, which resulted in the purchase of that rejected masterpiece for a mere 280 scudi, Rubens played the principal part. He had evidently to remain in Rome beyond 14 April, when, after it had been on exhibition for a week, the picture was handed over to his supervision for packing. He was still in Rome on 28 April, after the Easter festivities; a travelling case had then been made and the picture could be despatched, as we know also from a letter he wrote to Chieppio on that date. He does not appear to have returned to Mantua at all during the spring of 1607. We next hear of him early in June, again busy with Mantuan affairs in Rome. On the ninth of the month Magno wrote to Chieppio about the inspection of Palazzo Capo di Ferro as a possible Roman residence for Ferdinando Gonzaga, recently made cardinal. The business was eventually dropped, the price asked being too high; although Mantua was slow to accept the advice against purchase given by Rubens, who had managed to make as he was required a discreet tour of the house, 'as a foreigner, and on any pretext which would not reveal that a contract was in consideration'.[34]

We may assume therefore that Rubens, except for these and perhaps similar distractions, was engaged continuously in Rome on the Chiesa Nuova altarpiece during the whole eight months originally agreed as the time limit for the work; furthermore, since there is no suggestion to the contrary in the church records, that he had indeed done all but finishing touches by 25 May.

The next disturbance was more considerable. On 9 June he wrote to Chieppio about his being recalled suddenly to accompany his lord to Flanders.[35] By leaving Rome within three days, in unseemly haste, he could reach Mantua several days before the 25th, for which date the start of this progress was evidently planned. He wrote that the altarpiece was ready to erect. The delay in erection was occasioned by the absence of Serra, who was with the Papal troops before Venice. Only at this point does he reveal to Chieppio, with whom he had been on confidential terms at least from the time of his mission to Spain in 1603, something of Serra's part in the affair: 'to him was entrusted this business of mine from the first.' Regarding the business which concerns both this patron and himself, he continues, 'I do not care to have it transferred to anyone else because of the affection in which he holds me.' Even then he does not, perhaps was bound not to, write quite openly. For the affair, of course, could not finish at all without Serra.

The implication of his next statement in this letter of 9 June is not fully apparent:

'Also the sacred image of the *Madonna della Vallicella*, which is to be placed at the top of my picture, cannot be transported before mid September. The two things go together, and one cannot be unveiled without the other. Besides it will be necessary for

me to retouch my picture in its place before it is unveiled, as is customary in order to avoid making a mess of things.'

Obviously he could neither place his own work nor do final retouchings until the *Madonna della Vallicella* was sited anew. But why, almost a year after the decision to transfer it to the High Altar, was this additional delay of three to four months necessary? No explanation is forthcoming from the records of the Congregation. We can only infer from later entries in the *Decreti* that there was all along some opposition amongst the Fathers to the transfer. On 9 July 1611, when the *Madonna* had been in her new position almost three years, there is an entry: 'a long discussion took place, each one speaking his mind about the return of the *Madonna* to the chapel where she was formerly.' On 27 March 1612 the Congregation put the whole series of projects of 1606–8 in jeopardy: 'There was several times argued the wish to return the *Madonna* to the same place where she was formerly located, that is over the last altar by the great door. There was fresh discussion and the matter was put to the ballot whether she ought to be put back and a painting made for the High Altar. It was unanimously agreed to do so.' Evidently the party in favour of leaving things as they then were, but not present and voting, was strong enough to frustrate this decision. The entry for 12 August 1615 shows how they moved: 'by a secret vote it was agreed to have a crown made for our *Madonna*, of copper set with artificial gems, at a cost of about 25 scudi.' This gewgaw crown was made; and the adornment remains. On 14 March 1616 the Congregation decided to ballot again the transfer of the *Madonna* to her old position. When the matter was put to the vote a week later, twenty were in favour of displacing her, six against. At this point it was discovered that the move was in any case impracticable; and the matter was finally dropped.[36] The difficulties of 1607, however, may have been due more immediately to the absence from Rome also of Padre Ricci. Of this Rubens says nothing, although Ricci had direct responsibility in the affair. Ricci was in Naples, trying to settle disputes between the most consequential Congregations, the Neapolitan and the Roman.

Rubens made known to Chieppio his embarrassment at being ordered from Rome so precipitately in these circumstances. By leaving he stood to lose his whole reward for the commission. He owed ready obedience to his lord: but he asks the favour of leave to return to the city just for a month, in order to put his affairs in order once the Mantuan Court was back from Flanders. That he asks for a month suggests that he had also private work on hand for 'some prominent people who profess to favour me.' We may think of three of his smaller histories designed to display nude figures in landscape settings; of his earliest known treatment of *Susanna and the Elders* (Colour Pl. VIII),[37] always in the Borghese collection, a succulent picture with saturated colours most likely to have been painted to delight Cardinal Scipione; of *Venus wounded by a Thorn* (Plate 318),[38] a lively advance on *The Lament for Adonis* (Plate 214) in pathos, and in the compacting of a *bas-relief* configuration of this type; and of the Prado *Judgement of Paris* (Plate 319),[39] in which the spacing across the panel is more fluent, and the silhouettes gracefully tauter, than in his previous essay. The sophisticated manner of these closely related works indicates that they belong to the same 1606–7 period of his ever-varied activity as his first undertakings for the Oratorians.

Two days after this cryptic, very important letter of Rubens to Chieppio, Scipione Borghese himself wrote to the Duke to confirm that the painter was returning to Mantua. The Cardinal asks that Rubens should be allowed back to Rome at least for the few days needed to perfect the work. The painter had made no empty boast about having powerful allies.

Whilst Rubens was travelling to Mantua, the Duke changed his mind about going to Flanders, and opted for San Pier d'Arena instead. So Rubens spent his summer with the Mantuan Court, installed in grand style at this seaside resort of the Genoese patriciate. Apart from his anxiety about the altarpiece for the Chiesa Nuova, he must have welcomed the change, to be near a city and in a civilization to which he felt more attachment than to any in Italy outside Mantua and Rome. He had already formed valuable connections with the Genoese: not only with Jacomo Serra and with Nicolò Pallavicini, but also with Gian-Vincenzo Imperiale, for whom he had painted the two life-size mythologies of *Hercules and Omphale* and *The Lament for Adonis* (Plates 214, 215); and with the Spinola, Grimaldi, Doria, and with others doubtless, who had commissioned from him their portraits. Such connections he would have strengthened on this occasion. He could have hoped that in Genoa itself the palaces and churches, then new-built or building, would provide splendid opportunities to show his resource in decoration. He surely did not anticipate, as he busied himself during weeks of sunshine and festivity, that this visit to the

Ligurian coast was to be his last, nor that he was to leave Italy altogether in little more than a year.

On 27 June 1607, shortly before Vincenzo and his suite reached San Pier d'Arena, Ricci was recalled to Rome by word that Baronius was fatally ill. Three days later the Cardinal was dead.[40] We can only guess how this event affected future decisions in the Congregation about the scheme of decoration in their *cappella maggiore*. At any rate news of such a notable death would have spread far; and Rubens could well have heard of it before the Mantuan Court left San Pier d'Arena on 26 August.[41] Vincenzo reached Mantua again on 7 September. Presumably Rubens got leave to return to his work for the Oratorians almost at once, if he really succeeded in his determination to be back in Rome by the middle of the month. Unfortunately we have no definite information about his movements during the whole autumn of 1607. On 5 August the Archduke wrote from Brussels to Vincenzo, requesting the return of his subject to Flanders; and this may have been at the instigation of Philip Rubens, recently made one of the Secretaries of Antwerp, who had reasons for wanting his brother to return home. Vincenzo replied from Quignentola on 13 September that Peter Paul had no wish to leave his service, nor he to lose him; and on 16 September he wrote again to the Archduke to reinforce the message, saying of his painter, 'at present he is in Rome, having gone there some months ago with my permission, in order to perfect his art.'[42] How precise may have been this indication of Rubens's presence in Rome at that moment is hard to tell. A fragment of a letter in his handwriting, dated November 1607, is tantalizing. The place of origin cannot be made out, and the picture discussed in the few surviving lines is not identifiable either as his own work or as that of another.[43]

The next information is to be found in the Oratorian *Decreti*. On 30 January 1608, in General Congregation, it was resolved:

'Signor Pietro Paolo, the painter, having offered to redo the painting for the High Altar on the same conditions already agreed with him (Car. III above), changing the composition of the upper half inasmuch as what he has done has not pleased, this is accepted, there being less than nine votes against. Authority was given to treat and settle whatever came up about the picture, without further reference to a general meeting, to the Reverend Father Rector and a committee of Fathers Pietro, Peir.e., Pompeo, Tomaso, Adriano and Fabiano.'[44]

The upshot of this meeting, the vote and the appointment of an *ad hoc* committee headed by Ricci, were communicated promptly to Rubens. Three days after his offer to redo his work had been accepted thus in principle, he himself, and Magno on his behalf, wrote to Chieppio explaining the situation.[45] He was exact in writing that it was he – rather than the Congregation, usually so hard to please – who was dissatisfied with the appearance in its intended position of his altarpiece, which, despite the objections to his treatment of the upper half, had succeeded well as a picture. His letter and Magno's were complementary. Unfavourable lighting in the *cappella maggiore* destroyed the carefully studied effect of the heads and draperies. In a better light the picture had shown itself to be, in his words, 'without doubt the best and most successful work I have ever done'. It was valued at 800 scudi, the value which had been set in 1603 on the *Pentecost* which his countryman Wenceslas Cobergher had been commissioned to paint almost ten years earlier for the Cappella di S. Spirito in the same church: but the price was at stake. For the Fathers were unwilling that it be removed unless Rubens promised them by his own hand 'a copy to be painted above the same altar on stone or on some other material which will absorb the colours so that they will not suffer from reflections by the contrary lighting'; and two almost identical altarpieces in Rome, even were another church to be found for the first, would do him no credit. The happiest solution, which both Rubens and Magno proposed, was that the Duke should buy the discarded altarpiece for Mantua. The Duke, however, did not live up to their hopes, nor to his own professed wish to have something by the hand of his painter for his gallery. So Rubens was left with an acknowledged masterpiece, in the circumstances an embarrassment to dispose of; of which, moreover, by the terms of the contract, he stood to lose the price. He could now only recover the benefits of more than sixteen months of work and worry by doing what must have been least in his heart to do, 'far copia meno accurata'. His idea to paint this copy on slate no doubt came from his study of the practice in painting with oils on stone, which was despised, as Vasari records, by Michelangelo, but which Sebastiano del Piombo had put to good use in his *Flagellation* for S. Pietro in Montorio, where he also had had to contend with 'perversi lumi'.[46] Rubens saw the present application of this sixteenth-century example. However, in his temporary dismay, fortune and favour came almost as quickly to his aid as his own resourcefulness.

On 23 February 1608 Padre Ricci wrote from Rome to Padre Francesco Francellucci, Superior of the Oratory at Fermo:[47]

'I have contracted with the painter who has done our picture for the High Altar (which has just been valued at 800 scudi), that he should paint a picture of *The Nativity* for the altar about which you write to me, taking due account of the measurements sent, of the information about lighting, and of the price which I have fixed at 200 scudi. There will be in addition the stretcher on which he has to do the painting – which means an extra 6 julians (it would have cost more than 20, but I am making use of one which I had made for one of our own altars by having it enlarged in both directions). When the picture is finished it will have to be taken off the stretcher in any case, and sent rolled up; so it won't remain on this makeshift. I'll pay carriage to you; and I hope that it will be finished at Easter. I'll give you notice near the time, in order that the money may be available on the dot; because when this work is done, he will go off to Mantua. He is ordinarily employed by the Duke. He is a Fleming, but from his youth schooled in Rome (E fiammingho ma da putto allevato in Roma). I hope that in colouring and grace it will be the greatest success and give satisfaction.'

This is official confirmation that 800 scudi, which Rubens and Magno both mention in writing to Chieppio, was the agreed valuation of the altarpiece in Rome.

Ricci was himself a member of a noble Ferman family. Indeed he had been asked for by the Oratorians in his native city to be their Superior: but Baronius had refused him leave to take up the appointment. One of the dearest and ablest followers of St. Philip Neri, he was too valuable to the parent Congregation. Naturally the Ferman Congregation applied to him for help when they wanted an altarpiece. He had from the outset been in correspondence with them about the decoration of their church: both in general, on the programme to be followed, since he wished the series of altars to be devoted to the principal mysteries in the life of the Madonna, as at the Chiesa Nuova; and in particular about the exact arrangements for patronage. For example, on 7 September 1600 he wrote from Rome to Padre Vulpiano Costantini, then Superior of the Congregation:[48]

'I wonder at what stage the building of the Church

may be: whether you have put in hand again the crossing where the side chapels are, and whether the chapel of the High Altar has been allotted to anyone, because there is somebody who has made known to me an inclination to spend 300 scudi just on having a picture painted, another 300 on decoration and 400 on an endowment, that is about 1,000 altogether . . .'

Rubens, through the impression he had made at the Chiesa Nuova, had won an entirely fresh commission from the Oratorians. The opening sentence of Ricci's letter of 23 February 1608 makes clear that he was expected at that time to be able to complete his work in Rome shortly; that is to say, to have in mind to paint essentially a rough repetition of what he had submitted the previous autumn. In his letter to Chieppio of 2 February he had written of the proposed repetition: 'This I shall despatch as soon as possible – in a couple of months at most, since I shall not need to make new studies for it.' Even so he would have had to work fast to finish before he had to return to Mantua for the Easter festivities; for Easter 1608 fell on 6 April. The fee proposed for the Fermo altarpiece, since it was for a church outside Rome, was comparatively modest: 200 scudi, a sum which would be covered easily by a donation on the scale of that on offer for the High Altar. Ricci was able to suggest to the Fermans the way in which an existing stretcher might be adapted for the painter to use in Rome with minimal expense to them. The altar and tabernacle frame of soft grey, Istrian stone, were *in situ*; particulars could be given therefore of the dimensions required and the lighting.

On the day that Ricci wrote to Costantini, Rubens wrote to Chieppio.[49] He accepts with good grace that Chieppio's failure during the past fortnight to persuade the Duke to buy his altarpiece for the Gallery at Mantua was not through want of trying; indeed that it may have been fortune in disguise that his proposal was not accepted by the Duke, then embarrassed with the expense of a Gonzaga wedding. He writes also of the picture which he has commissioned from Pomarancio, on instructions from the Duchess, for her private chapel in Mantua. The ducal treasury objected that the charge proposed by the Roman painter for this altarpiece was too high, far more than had been paid for Caravaggio's *Death of the Virgin*; and Rubens had to negotiate a substantial reduction. This matter and the letter-writing involved must have taken most of the time that he could spare from the Chiesa Nuova during February. He does not hint that he

considered it a slight that his own claims to such a commission had been overlooked. But his thoughts being directed towards the work of Pomarancio, he may then have conceived the idea of turning to his own purpose the composition of the *St. Domitilla between St. Nereus and St. Achilleus* (Plate 334), which Baronius had commissioned over a decade before for a side chapel of SS. Nereo ed Achilleo.

Ricci's plan seems to have been satisfactory to the Ferman Congregation: and, on 9 March 1608, Rubens gave him a receipt[50] for an advance of 25 scudi undertaking thereby to deliver a finished picture of *The Nativity* within six months of 1 April that year, entirely at his own expense and for a total recompense of 200 scudi. The picture was to be 13 palms high and 8 wide, and to include at least five large figures, the Madonna, St. Joseph and three shepherds, and the Christ Child, with a glory of angels above.

In settling these terms, Ricci may have had in mind the specifications of a contract made by the Roman Oratorians for their *Nativity*. The picture which Durante Alberti painted about 1601 to decorate the relevant chapel in the Chiesa Nuova would have fitted the programme.[51] Without being in any sense a model for Rubens, it could have served as a convenient basis for agreement. Of the two witnesses to Rubens's hand, Giustiniani was a member of the Roman Oratory, the Padre Fabiano of the select committee formed there on 30 January; and Deodato van der Mont was the youngster with whom the painter had set out from Antwerp in May 1600

Meanwhile Rubens must have been out to persuade the Congregation at the Chiesa Nuova to adopt an entirely novel scheme for their *cappella maggiore*, a scheme in which, by physical separation of parts of the iconographic programme, actual space was to be visually and emotively involved in the composition. When he returned to Rome after Easter, this entry appears in the *Decreti* for 24 April 1608.[52]

'Signor Pietro Paolo, the painter, who during the past months has dealt with the picture for our High Altar, painting in it the figures of our six saints, allowed it to be understood that he would gladly change the design already made; and he offered, in full Congregation, to do it in such a way as to remove from the altarpiece the figures of the six saints, and to surround the *Madonna* (which would stand in the middle of the picture) with various ornamentations of angels, while painting the six saints, three on the right-hand side of the High Altar, and three on the left, in those niches which are under the two windows. This was proposed in full Congregation; and, after various and diverse speeches the matter came to the ballot. From 21 Fathers of ten years seniority the proposal got 16 white balls, on condition that the painter first made drawings and showed them to the full Congregation.'

What Rubens proposed was the disposition in which the pictures are still seen today. The occasion was extraordinary, as the painter was allowed to argue the merits of his own proposal in the Congregation; and he won there the confidence of a considerable majority. Almost four-fifths of those senior enough to vote were prepared at any rate for him to submit models for his new scheme. Ricci's letter to Francellucci of 12 March that year, enclosing a copy of Rubens's agreement to paint the *Nativity* for Fermo, indicates further the esteem in which he at least held him.[53]

'Wishing to have the agreement settled with the painter for him to paint the picture of the Nativity, I've drawn the document dated 11 March, of which I send you a copy, and furthermore I have given him 25 scudi on account as you'll see by this same document. I did not want to prescribe the form nor any other detail concerning the figures or other aspects of the picture, because I am advised thus by the quality of the painter that it may be better to leave him at liberty. He is now on the point of acquiring a great reputation; and he is not one of those who have acquired one and then slack off, as one might say. The said 25 scudi can be remitted to Padre Milutio Brancadoro on account of certain others which I hold of his cash takings from his benefices at Orvieto. Tell him that I will quickly arrange to have the rest sent by my sister, and we will settle the acount.'

A remarkable tribute by an obviously remarkable man! Rubens did not fail this trust. On 17 May Ricci could report to Fermo good progress. In a week's time he proposed to bring two connoisseurs to view *The Nativity* (Plate 340). The last day of the month he wrote again to Francellucci:[54]

'This week I've brought two of my friends who are intelligent about painting to see the picture which is by now finished. One is a lay religious and an able painter called Padre Blasio, one of the Theatine Fathers of Monte Cavallo. The other, Signor Giambattista Crivelli, is a Roman gentleman. It

pleased both of them very much; and they told me that the money had been very well spent and it will give great satisfaction. This I wanted to say because your Signor Girolamo Gabrieli, who has seen that it is so well changed from what he saw, now praises it and it pleases him but he did not believe that the cost should reach 200 scudi, but should only be 150. So I wanted to ask those two people I mentioned about this very point. They tell me that on this score of the expense we can rest content. It remains only to retouch the Madonna a bit, and to give it the finishing touches, which he'll do next week. Your Reverence will see to remitting the money by way of Macerata or in some way that appears better, because my sister has also to send me money by that route; and will tell the muleteer that he should come and find me in order that he can send him to finish off this business, which is one of those that remain for me to despatch before the way is closed.'

There was not much to be said for the meanly provincial ideas of Girolamo Gabrieli about the value of a painting.[55] The Fermans could be satisfied that the picture about to be sent over the mountains, rolled on muleback,[56] was a good bargain.

On 9 July Ricci sent instructions after the picture already despatched:[57]

'I forgot to warn you, by the painter's instruction, that if the wrapping paper should be stuck to the painting it is possible to wash it off gently with a little warm water, and that if in this way the picture does not come out with complete success in the light, give it a fresh coat of varnish (which all the same will be left on, and it will become browner in effect); and finally that, for this same resolution of the light, take care in putting it in its position, to have the top hung in such a way that it is inset far less into the enframement than the lower part.'

The hints for unpacking the picture, freshening the varnish, tilting it forward in its frame so as to obviate disturbing reflections, these emerge from Rubens's experience, both of transporting pictures to Valladolid in 1603 and of working for the Chiesa Nuova since 1606. He forgot no lesson; although Ricci was not so mindful of the importance of passing on his instructions to the distant Congregation.

Despite all care, *The Nativity* did not arrive quite as impeccably as the Fermans expected. The last letter from Ricci on the subject is dated 16 July 1608. He writes to Francellucci:[58]

'I am sad that there is some small defect in the picture, as I feel much pleasure in understanding that the rest of it has given and may continue to give satisfaction. You blame the painter; and I (*sc.* myself), in so far as I did not warn you sooner of the advice which he gave in this particular as you have been able to see by my subsequent letter, and really that I kept it to myself, concluding that there you were among such painters as know how much can and should be done in a comparable case of an oil painting, and, if one does not really know, it is better to defer unrolling it. There is no need to discuss the facts of the matter further. The gentleman wishes that this may be as the other satisfactions of this world, which are never complete! I will see to obtaining what you write for, on a chance to pass by *The Madonna* in order to go into Lombardy: but for two months at least he will only be able to give attention to our High Altar paintings, which will be three in number, one on the altar itself and two at the sides of the tribune.'

So the Ferman commission, which arose from the Roman commission, leads back to the Chiesa Nuova. For at least two more months Rubens's duty to finish there would keep him in Rome. Clearly his fresh models had been accepted already by the Fathers, and he was at work in the tribune on the three fields of slate. When he finished, we do not know. But between mid-July and October he presumably heard from his brother that their mother's asthma was worse, and that she was in a sickness likely to be her last. He was in haste then to get such payment as he could, and be gone to her bedside in Antwerp. He could scarcely have found time to go to Fermo and retouch his work before 28 October, when he had to take the fastest way home.

On 25 October appears the last entry in the Roman *Decreti* concerning him:[59]

'That as a token of gratitude to Signor Pietro Paolo, the Flemish painter, we excuse him the 50 scudi which he promised to subtract from the valuation made of the High Altarpiece; and we issue 200 scudi in advance on account of what more he is to have for all the three paintings.' 'We issued 5 scudi as a tip to the servant of the aforesaid Signor Pietro Paolo, painter.'[60]

Rubens's receipt for this advance of 200 scudi shows that the bonus due on acceptance of his work on the actual altarpiece had not yet been fixed. Unaware of the decision about the 50 scudi, he reiterates his

liability to surrender that amount of the estimated value; and he confirms that he has received from Serra the 300 that he has likewise to surrender. This document makes clear furthermore that for the two additional paintings a separate payment had been agreed: 200 scudi apiece, the money being payable by the end of three years at the rate of 100 each year and 100 immediately on acceptance of the completed work. He was thus able to ride from Rome three days later with 200 scudi in his purse, owed another 200, and with a bonus to come if his paintings on slate were highly esteemed. A note of 18 September 1610 added to this same document shows that Serra, by then a Cardinal, was paid, evidently on his behalf, 100 scudi as arranged. There was no payment during 1609.

In flat disregard of the contract, no move was made at the Chiesa Nuova to establish a valuation until 28 November that year, when the finished work must have been on view for a full twelve months. Then an agreement was made, no doubt prompted by Serra. The signatories were Padre Angelo Velli, Provost of the Congregation, on their behalf, and Serra himself on behalf of the absent painter. They nominated referees. Giovanni Battista Crivelli, the Roman gentleman invited by Ricci to give his opinion on *The Nativity* for Fermo, was named by the Congregation. Pompeo Targone, a Roman architect who had worked as an engineer at Mantua during the early period of Rubens's employment there, was named by Serra.[61] These referees, who may or may not have been the same who had valued the first altarpiece at 800 scudi, decided after two weeks that 350 was enough for this second one. Of their valuation 300 stood accounted for by Serra. In regard to the remaining 50 the Fathers quietly decided to stand again on their rights, under the contract of September 1606, to the extra scudi from Rubens; and they felt free to pay him 20 scudi less than the 200 which was their debt outstanding to him on 12 December 1609. No bonus was proposed.

When Rubens wrote to Serra on 2 March 1612, he was still short of 80 scudi. He asks his patron to use influence to obtain these for his friend Jacomo de Haze, the bearer of his letter to Rome. By this time he had lost patience with the Fathers, who seemed to hold him as far out of mind as of sight. He asked that de Haze 'sappia niente della Chiesa nova ne habbia da trattar con quelli Padri'. However, de Haze, the Superior of the Dominicans in Antwerp, was accustomed to dealing with *padri*; and he wrote his acknowledgement of the 80 scudi from Padre Julio Cesare on the same sheet as Rubens's letter. This receipt remained at the Chiesa Nuova for the Fathers to read the Flemish painter's aspersion on their dealings with him since his departure from Rome. It is the quittance of their legal debt. It marks the end of a connection almost six years old.

Certain features stand out: the essential rôle taken by Serra, and the widespread importance of Genoese patronage in this epoch of Genoa's wealth and civilization; the aristocratic enlightenment active within the Roman Oratory, in the person of Ricci; and the enormous and justified confidence of Rubens in his own powers to excel in any endeavour. How can we situate his paintings and drawings in relation to the documents?

In a painting on canvas, now in Berlin, [62] *St. Gregory, St. Domitilla, St. Maurus, and St. Papianus* (Plate 323), St. Gregory holds the centre, as grandly Roman as Raphael's Aristotle, while St. Domitilla holds the right, like an antique statue in Venetian dress. Her profile is cut with the sharpness of a cameo; but the staging and pose in relation to St. Gregory echo those of St. Catherine and St. Nicholas in Boldrini's woodcut after Titian's *Madonna and Child with six saints*; and from a hasty record in pen of Titian's *Madonna and Child with the Holy Ghost and two angels,* we know that Rubens had taken note, as we might expect, of the actual altarpiece in S. Nicolò dei Frari. Richly broken draperies, St. Gregory's shining white, St. Domitilla's violet with a pale-blue bodice, surge towards each other and fall away like seas responsive to lunar attraction. Behind St. Gregory, as though addorsed to the jamb of the archway, stands an antique Nerva, in the guise of St. Papianus, cloaked in the subdued but saturated red beloved of the Bolognese painters. St. Maurus in Roman uniform – and how pleased Rubens must have been with the authentic spirit this evokes – mounts the steps with an elastic tread, a figure inspired by Correggio's *Madonna with St. George*, of which he had penned a copy (Plate 60). The view of Roman ruins seen through the archway anticipates this sort of landscape by Brill; but the idea of introducing landscape thus into a religious subject, large foreground figures being set off by disproportionately small architecture, which serves only to emphasize their visual order, is one which derives from Agostino Carracci's *Last Communion of St. Jerome*. Nothing was better calculated to please metropolitan taste of the first decade of the Seicento than this Berlin picture. As Ricci wrote of Rubens, 'E fiammingho ma da putto allevato in Roma'. If it is not some quite

independent work painted by him in Rome – and with its peculiar choice of saints it would be perverse to believe so – and if it does relate directly to the Chiesa Nuova commission, it is not to be dated after the commission of 25 October 1606; for this specifies that St. Nereus and St. Achilleus also should be shown on the same side as St. Domitilla, and that there should be a representation of the Madonna with other ornaments above. Nor is it of a size to be a *modello*. The scale on which Rubens painted *modelli* of this period is exemplified by those for *The Circumcision* of 1605 and for the *Madonna and Child adored by Angels* of 1608 (Plates 248, 330). A true *modello* would have had to prefigure in all essentials the first altarpiece of *St. Gregory and St. Domitilla with four other Saints in adoration of the Madonna* (Plate 327).

The explanation of its function lies in the opening clause of the commission, which reflects the situation in the immediate past. This reads, 'p.o che sia loro dato sodisfattione prima d'ogni altra cosa poter vedere qualche opera fatta dal Pittore nominando'. The recent powers and style of the painter were not sufficiently illustrated in Rome by his works of 1601–2 at S. Croce in Gerusalemme (Plates 179, 182, 186), nor by the Borghese *Entombment* (Plate 199) almost contemporary with those. In those paintings he appeared still as the brilliant pupil of Vaenius struggling to find, and to use with effect, the implications for him of his earliest first-hand studies of Michelangelo and the Roman Raphael, of Jacopo Tintoretto and Annibale Carracci. By 1606, however, he was ready to speak with a voice of his own. His altarpieces of 1605 for the Jesuits of Mantua and Genoa seem to have attracted no notice in Rome. They would have appeared remote, even alien, to the Oratorians. Only *St. George slaying the Dragon* (Plate 238) might have been nearer at hand to demonstrate his up-to-date style on a monumental scale.

The Berlin picture therefore seems to be a trial essay, painted fully to show his mettle, temptingly close to what was surmised to be the actual requirement of the Fathers, and on a considerable scale, though not so large as to involve overmuch labour in execution, nor to render it hard to dispose of were matters to go awry. As a valiant bid to secure the commission, it just precedes the first acceptance of the painter's offer on 2 August 1606, and in any case before 25 September 1606, by which date some more precisely appropriate design must have been shown. The beautiful drapery study with ink and brush, now in the Metropolitan Museum

(Plate 326), was for the St. Domitilla of this picture. The pen sketch, which likewise was formerly in Ludwig Burchard's collection, with the spread of the figures and the pose of St. Gregory closer to the inspiration of Raphael, might well be Rubens's first thought for the *santa conversazione* required (Plate 320); and on the back of that is his equally rapid sketch for an *Entombment* (Plate 321), unconnected with any known undertaking.

Except that the space within the frame for the *Madonna della Vallicella* is bare of figures, a magnificent drawing in Montpellier[63] fulfils the conditions of the 'disegno o sbozzo' exacted by the commission (Plate 322); and an oval outline and shading in black chalk does in fact show beneath and beyond this frame the position which the sacred picture would occupy. The brown ink is used with the utmost freedom and mastery by means of the point of the brush, the pen, and the broader effects of wash amending a fine underdrawing in chalk. In character and technique this work recalls Rubens's copy of Correggio's *Madonna with St. George* (Plate 60). It recalls also, particularly in the St. Maurus, the penwork and bold use of washes in his preparatory drawing for *St. George slaying the Dragon* (Plate 237). The enframement in feigned stone, the device wherein the *Madonna della Vallicella* was to be displayed, is of special interest. A pentiment visible in the finished altarpiece, now in the Musée de Grenoble (Plate 327), reveals an earlier and possibly incomplete idea painted on that canvas for an enframement larger than that of the cartouche, as it actually appears, although of a form perhaps more oval and more like the final solution in the Chiesa Nuova. Rubens's hasty sketch of the composition of the sacred *Madonna* on the back of his copy of Titian's *Entombment* shows how from the start he visualized the problem of containing this icon as a retention of the oval.[64]

The saints in the Montpellier drawing stand as firm as the architectural elements which reinforce their positions. This sculptural grouping is set off by the airiness with which *putti* and garlands are sketched. The treatment of the landscape-peep through the archway, a variant of the view in the Berlin picture, and of the vegetation on the column, is anticipated by the palm tree drawn to canopy the mounted groom who sat for the *Lerma* portrait in 1603 (Plate 260). Work closely comparable was to appear also in the terrace view beside which was posed the standing portrait of *Brigida Spinola Doria* (Plate 261).

It is in no way surprising that Rubens should have

xv. Cupid and the Three Graces. Detail from *The Ascent of Psyche to Olympus* (Plate 50). 1625–8. Oils on panel. Mertoun House, Roxburghshire, Duke of Sutherland

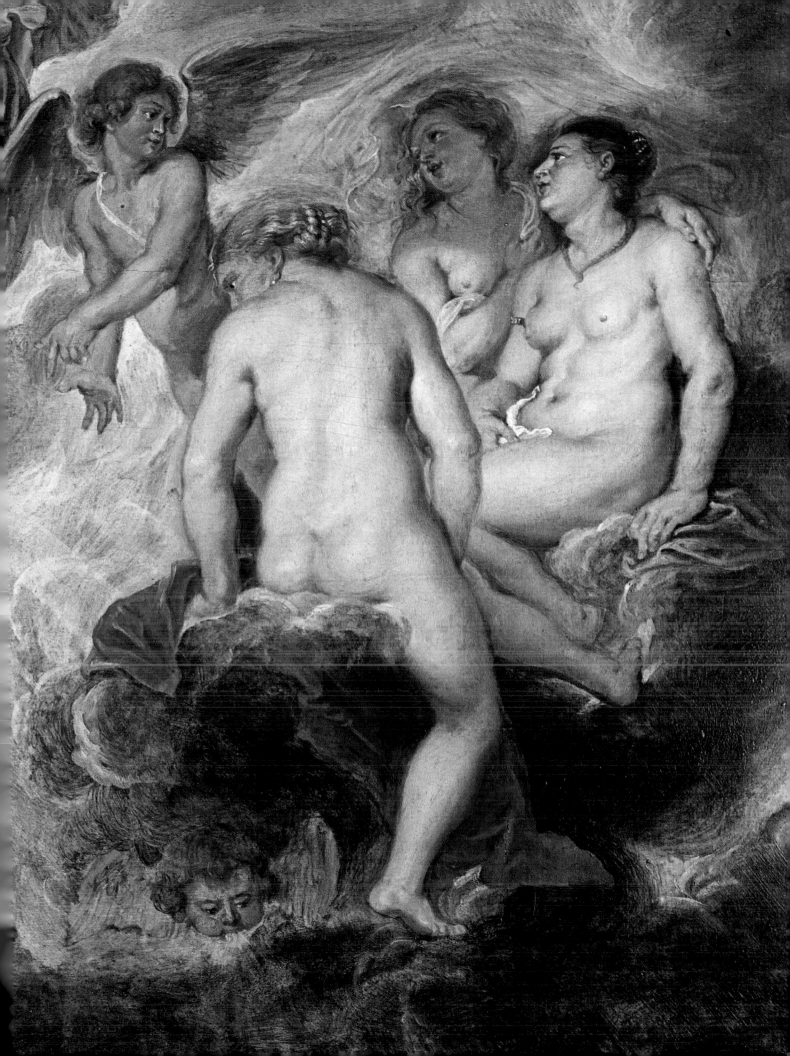

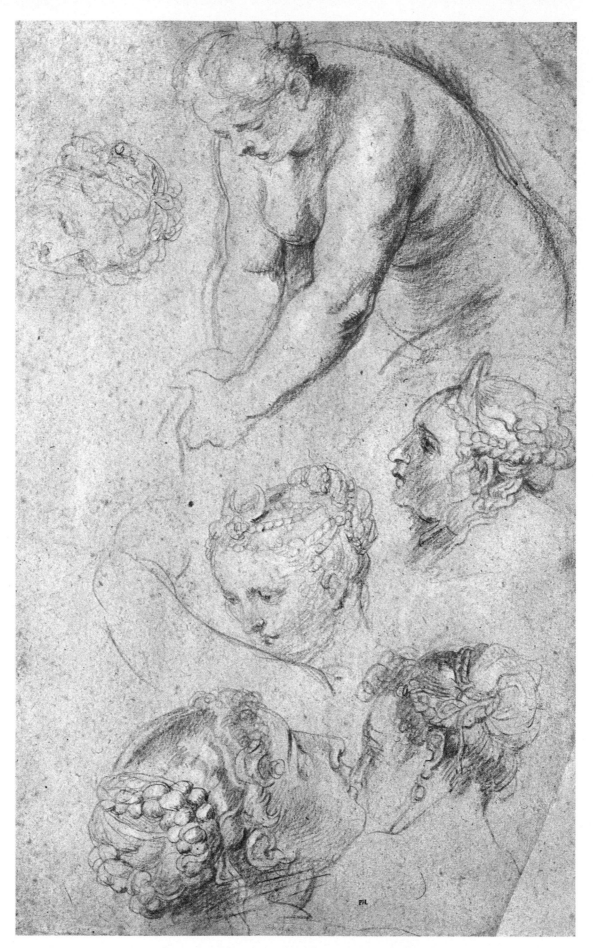

xvi. Heads selected from Titian's *poesie*. 1628. Chalks on paper. Zurich, Dr. Anton Schrafl

offered to such a conservatively minded Congregation of Roman ecclesiastics a model prepared in this traditional Renaissance form, a drawing in ink on paper, rather than the novelty of a painted model such as he had offered to Pallavicini for the high altar of the Genoese Gesù (Plate 248). Nevertheless a sketch in oils was becoming part of his working practice. Between the Montpellier drawing and the Grenoble altarpiece there are important modifications, not only to the figures and to the architecture, but also to the treatment of the heavenly illuminations. So early in his career, and with so much at stake, even the dazzlingly confident Rubens needed to make some intervening trial on a small scale of the definitive arrangements, whether or not that had to be checked by the clients; and it suited him to paint a sketch on panel.

In the Montpellier drawing the light descends in front of the archway. In the oil sketch, which belongs to Count Antoine Seilern (Plate 325),[65] and in the first altarpiece, although there understandably less palpable, the light streams down behind. Even the indications of colour in the Seilern sketch suggest that it is unlikely to have been painted after the full colours of the first altarpiece were to be seen. Had there been call for such a sketch after the first altarpiece, it would have been painted in rather precise detail, either *en grisaille* or reflecting the colours of that altarpiece. Moreover, formal differences between the Seilern sketch and the Grenoble picture, the height of the arch in relation to the figures, the inclusion of the *putto* with the tiara, the altered gaze and arm positions of St. Domitilla, these are hardly so crucial as to have required yet further trial on a small scale from a painter of Rubens's promptness in improvisation. When painting on the huge fields of slate *in situ* not many months later, he deviates in the *Madonna and Child adored by Angels* from the pattern of his painted *modello* to very much the same extent as he had in the Grenoble picture from the Seilern sketch (Plate 330, 333).

Documentary evidence does not disturb the visual impression that the Seilern sketch precedes the Grenoble picture. The Vote of 30 January 1608 makes clear that such objections as the Fathers had to the altarpiece first offered were confined to 'l'inventione dal mezzo in sopra', presumably to the inadequate manner of presenting the *Madonna della Vallicella*. To present the *Madonna* fittingly was throughout the negotiations the overriding concern of the majority. Yet for this part of the design the Seilern sketch proposes nothing beyond what is offered by the first altarpiece; rather it allows, by giving greater height to the arch in relation to the figures, significantly less room for the desired prominence to be given to the icon. To the Congregation matters such as the *putto* with the tiara and the attitude of St. Domitilla seem to have been of comparative inconsequence, of aesthetic rather than liturgical moment. There is no call to associate these changes with plans for a 'copia meno accurata' contemplated during February and March 1608.

On 29 September 1610, according to Sweertius's *Monumenta Sepulchralia* of 1613, the discarded altarpiece (Plate 327) was placed by Rubens as a monument to his mother in St. Michael's Abbey at Antwerp. Bellori identifies it there as the first version of the work intended for the Chiesa Nuova. Apart from horizontal cracks, and consequent repaints, caused by rolling such a large canvas for a long journey, the picture, now in Grenoble, can be judged to be in fine condition. The St. Domitilla is resplendent in Venetian silks; blue, red, gold, and sumptuous violet. Her gorgeous colouring is set off by two studies of a man's head, brilliantly and quickly sketched, which serve to indicate St. Nereus and St. Achilleus. A few considerable pentiments are visible on the figures; in the painting out of the martyr's palms of St. Domitilla and St. Maurus – the latter slanted originally across the bare torso of St. Papianus; and in St. Domitilla's hair at the back of her head, which was altered by Rubens perhaps to suit fresh sight lines in the Antwerp church. The massive painting of St. Maurus, and the violent manner of illuminating his silhouette and armour, leave no doubt that we see this figure much as he was seen when the picture excited the general admiration of Rome. Only the representation of the sacred image presents a problem. A volute is painted out beneath the scroll at the base of the simulated stone frame, just to the left of the keystone, suggesting that a larger opening had been intended for the *Madonna*. In the final resolution, as we have it in the Chiesa Nuova (Plate 333), it is the dimension of the iron oval painted with the representation of the *Madonna* which indicates the measures of the original aperture: that is 100 × 78 cm. The Grenoble representation, without its 'stone' frame, measures 88 × 48 cm. and to the outer border of the frame 106 × 68 cm. Three things are to be remembered, however; first, when Rubens was painting his original altarpiece, the *Madonna della Vallicella* was not in position, whereas for his final version he was working over the high altar itself, with the aperture

cut; secondly, the paler colours and tamer execution of the representation of the *Madonna* in the Grenoble picture could imply that this part of the work as we see it may only have been completed by a different light in Antwerp; thirdly, the criticism of the Congregation on 30 January 1608.

For the revised composition of the altarpiece we know a pen and wash drawing (Plate 329), a *modello* painted on canvas (Plate 330), and, from an intervening stage, a study in chalks (Plate 328) how to represent the *Madonna* in an enframement surrounded by angels.[66] The panel painted by Federico Zuccaro for the Cappella degli Angeli of the Gesù, *The Adoration of the Name of God* (Plate 332), provided a respectable example in Rome for the organization of the figure groups. That Rubens's solution was acceptable to Oratorian taste is proved not only by the continued acceptance of it by the majority of the Roman Congregation, but also by a later altarpiece, conceived on a similar plan for the figures, which hangs in the right transept of the Gerolomini, the vast church of the Neapolitan Congregation.

The *fa presto* in painting on the slates is revealed by the cherubim who swarm about the representation of the Madonna (Col. Plate XII). The cherub with his back to us was not envisaged in the *modello*; and this is one instance of many to be found in the work of Rubens, in all phases of his career, of astonishing resource in improvising to suit himself. If these flying creatures are cousins to those who attend the Madonna in the Frari *Assunta* of Titian, the figure of the seraph rising from his knees to the right shows the potent use to which he could put lessons learned of Correggio. It is, however, in the *modello* rather than in the final work, which omits the topmost zone of illumination where angelic faces appear in the clouds (Plates 330, 333), that Rubens displayed most freely his admiration for the grand procession of light within the Parma dome. For the two lateral pictures (Plates 335, 336) also there were probably *modelli* in oils, as well as the pair of ink drawings in the British Museum;[67] and an excellent brush and bistre drawing for *St. Gregory, between St. Maurus and St. Papianus* is known (Plate 331).[68] A drawing corresponding to this Chantilly drawing surely existed for *St. Domitilla between St. Nereus and St. Achilleus* for which Pomarancio's altarpiece (Plate 334) seems to have suggested the composition.

Rubens wrote to Chieppio on 2 February 1608 of 'l'esquisitezza del colorito, e delicatezza della teste a panni cavati con gran studio dal naturale'. These drapery studies have disappeared, with the exception of the brush drawing used for the *St. Domitilla* (Plate 326). One life study,[69] however, painted at an early stage, is known for this very figure (Plate 324). The lady seen in sharp-cut profile, bust-length, seems from the frond of bows that she carries to be a courtesan. Her physiognomy is modelled as though she were a graven statue, antique as her trade. In addition there must have been, for example, a study for 'San Mauro martire in abito militare, eseguito con l'intenzione di Paolo Veronese'.

For the Fermo commission we have a study (Plate 338) drawn[70] in advance of the painted *modello* (Plate 339). The left hand of the young shepherd, as in the *modello*, clasps his staff above his right hand. This attitude was changed to an outstretched gesture in the altarpiece, so as to make, with the hand of the old shepherdess and the hands of the Madonna, the fourth corner of a frame of adoration about the sleeping Child. Each of the four hands there acquires in return a different significance from the unearthly incandescence which emanates from Him, His strawbed and His draperies. Technically the drawing shows not only the way in which Rubens superimposed the figure of the young shepherd upon that of the old shepherdess in constructing his composition, but also his power to assimilate to his own more violent means of expression in pen and wash the luminous and atmospheric message of Correggio. In a sense beyond his evident involvement in the '*Notte*', he responded to the art of his great forerunner. There is no point in trying to place the *modello* itself, now in Leningrad, after the Fermo altarpiece (Plates 340), in order to account for the adaptation painted for St. Paul's, Antwerp. The idea first stated fully for Fermo continued to work in his mind; and there may be more revisions of it to be found.

Anticipating Rubens's *Nativity* for Fermo by hardly more than a year at most is an apparently independent treatment by him of the subject in a small picture (Plate 337), originally on panel and presumably intended for private devotion.[71] This may have been closely discussed, in connection with the Ferman commission, between Ricci and the painter. Could it not have been painted for Ricci?

With the inspiration of Correggio in the Fermo altar springs that of Titian: in the crumbled gold and brown and grey dress worn by the young shepherdess, and in the idyll of the sheep on the hillside, flocking from wolves by the night fires. Admiration for the landscape style of Titian appears also in the Borghese *Susanna* (Col. Plate VIII), in *Venus wounded*

by a Thorn and in the Prado *Judgement of Paris* (Plates 318, 319). The letters and contracts prove that he expressed these North Italian, painterly interests in illumination and atmosphere, and in the poetic and religious feelings that they engender, in the very months that he expressed also his high Roman interest in design and sculptural relief, in the grave disposition of figures, and in the grandeur of sentiment. His work for the Chiesa Nuova shows his ability to seize the contemporary significance of antiquity, renascent in his studies in Rome, and of Raphael, and of Veronese. It shows also his promptness to take suggestion from fashionable seniors, Zuccaro and Pomarancio. There we see how he transposed into his idiom the classic grace which he found in the art of Correggio and of Titian; we feel at the same time the implications for him of their more dramatic qualities in his painting for Fermo. These linked undertakings of his last years in Italy manifest two major aspects of his creative process which appear concurrently at successive stages in the next two decades of his painting life.

In the Oratorian commissions he sought to establish himself on a footing with native-born Italians, as a metropolitan and no longer just a Mantuan painter. His first rival, had he been able to return after his mother's funeral to compete in the Roman lists, would have been Reni; as we may judge from Reni's fresco of *St. Andrew led to Martyrdom* (Plate 343), another of the artistic sensations of 1608, and from the highly finished record which Rubens found time to draw of it.[72] About this time probably he acquired a superb life study drawn by Reni, which was to be available in Antwerp for his pupils to copy (Plates 341, 342).[73] Almost certainly he himself would have had to learn to paint in fresco. As a result his palette would have lightened many years earlier than it actually did. The ease with which, as he found, his first altarpiece for the Chiesa Nuova could have been disposed of elsewhere in Rome, and the value of the connections which he had formed both in Genoa and among the Roman patrons, were strong arguments to return, provided that he could loose the 'golden fetters' of the Governors of the Spanish Netherlands which bound him in the North.[74]

On 10 April 1609, some five months after his urgent ride from Rome, he wrote to Faber, his Asclepius:[75] 'non saprei in adesso che resolutione pigliarmi che fermarmi nella Patria o di ritornare per sempre in Roma donde vengo sollecitato con buonissime conditioni'. We may wonder how the course of European art would have changed, had he journeyed south again across the Alps.

12. Italy and Rubens in the seventeenth century

(i) CRITICISM

A genial intuition of Rubens's place in the Seicento, based on his final achievement in the metropolis, is discernible in what is, after Father Ricci's 'da putto allevato in Roma' and 'non di quelli che . . . lavorano a la straccha',[1] the earliest known characterization by an Italian of his qualities: Giulio Mancini, a Sienese physician eminent in Rome about 1620 and an intelligent amateur of painting, noted how his manner was 'molto risentita di colorito e di disegno.'[2] The description fits the undeclared aims of this 'putto', who was reared outside the pictorial traditions of North Italy on the one hand and of Florence and Rome on the other.

Mancini's *Considerazioni sulla Pittura* remained unpublished until 1956. However, his private summary is for us as much to the point as the comments of Baglione, a professional painter, who published his chronicles in 1642 after Bernini and Pietro da Cortona had triumphed in Rome. Baglione simply accepted the artistic conditions of that aftermath. He allowed Rubens's portraits painted in Mantuan service (Plate 250, 251, 254, 259) to be 'assai belli'; the S. Croce in Gerusalemme *Elevation of the Cross* (Plate 187) to show 'forza' and 'buon gusto'; and the first version of the Chiesa Nuova altarpiece to be an 'assai buon quadro' (Plate 327). He exceeded such moderate approbation only by outspoken admiration for the cherubim in that discarded work, 'molto belli'; by granting that there were few rivals in the kind of portraiture which Rubens had produced in Genoa (Col. Plate IX and Plates 262, 264, 265, 266); by praising his tapestries; and by according him beyond the grave the title of 'pittore universale'. Basically he approved of the famous man, the best painter of Flanders, in so far as he had come to study the *mirabilia* of ancient and modern Rome, acquiring thereby good taste and 'una maniera buona Italiana'.

It was for Bellori, publishing more than thirty years after Rubens's death, to project something more extensive and more critical. Bellori complimented this foreigner by including both him and his principal follower Van Dyck in the selection of subjects for *Vite,* while excluding conspicuously Pietro da Cortona as well as Bernini. The choice was made not just because he could claim that Rubens, an admirer of Titian, Veronese and Tintoretto, had introduced Venetian colour to Flanders; and that he

had proved himself a devotee of Raphael and the Antique. Indeed, for Bellori's taste Rubens's colouring was too matter of fact, insufficiently refined; the use of Raphael and the Antique too idiosyncratic; the heads not idealized enough; the types coarse; and the grace of bodily contours distorted by a peculiar manner of drawing. Nevertheless, Bellori lauded Rubens for putting a lively genius to the ennoblement of art, by contrast to Caravaggio, who had used his so much to debase it; and, by implication, he appears to have welcomed him to the company of those who followed his prime hero, Annibale Carracci, even if he could not rank him with Domenichino and Poussin as one of Annibale's true disciples. He realized that, 'non era egli semplice prattico, ma erudito'. Furthermore Bellori praised Rubens's promptness in invention and fine frenzy of brushwork in a phrase unmatched in his appreciations: 'la gran prontezza e la furia del pennello.'

These are Roman viewpoints. Outside the metropolis, we hear little of serious critical reception of Rubens's works: from Mantua, silence; from Fermo, Oratorian mutterings; from Genoa, on the part of Carlo Grimaldi, tacit acceptance in 1622 of the dedication to *Palazzi di Genova* (Plate 344) – of commissions sent to Antwerp and there fulfilled, no murmur of acclaim before the publication of the eighteenth-century guides. Only from a book published in Venice in 1619 come notes more resonant:[3] Marini's madrigals. Giambattista Marini held that the purpose of art is to astonish. *Leander lying dead in the arms of the Nereids* and *Meleager and Atalanta,* paintings which he knew of Rubens, met his requirement. His fancy scarcely revealed to his readers great art in these mute *favole*; nevertheless it is remarkable that he, the leading Neapolitan poet of the age, should have given them voices. He did not do the like for any other painter from beyond the Alps.

(ii) PRINTS AND TAPESTRIES

Both Baglione and Bellori call attention to the flow of prints reproducing Rubens's designs, and to their European circulation. Baglione even mentions the woodcuts, which are many fewer; and he lists more than a dozen of the copper engravings besides *The Battle of the Amazons* on six sheets, which particularly impressed him, and *St. Roch,* esteemed best

of all. When in the mid 1620s Bernini created in marble the ecstatic stance of his life-size *S. Bibiana*, with her emotive gestures and ample drapery movements, he could have been prompted by a pair of Schelte à Bolswert's engravings, *St. Barbara* and *St. Catherine of Alexandria*,[4] invented by Rubens a few years previously. Salvator Rosa in Naples could have been stirred to depict the wildness of stormy landscape, nature dwarfing humanity, by Schelte's print after the *Landscape with Philemon and Baucis*.[5] An *Adoration of the Magi*, maybe the engraving listed by Baglione, was in the mind of Carlo Dolci in Florence in 1646 when painting the background figures for his *St. Andrew adoring his Cross*.[6] Moreover, in addition to these loose prints, there were book illustrations designed by Rubens for the Plantin Press. Those for the *Electorum Libri duo* of 1608 may not have attracted more notice amongst Italian artists than those he designed for the *Vita beati P. Ignatii Loyola*,[7] to be published the following year in Rome. But in 1616 the title-page for another Jesuit book, Cornelius a Lapide's *Commentaria in Pentateuchum Mosis*, in a number of advance copies, surely travelled in the author's baggage from Antwerp to the Collegio Romano.[8] Thereby Bernini was offered, in the ecstatic seraphim kneeling on either slope of a broken pediment, prototypes for the architectural and sculptural conception of the tabernacle which he designed for the altar of S. Agostino[9] soon after finishing at S. Bibiana.

Baglione and Bellori show themselves aware of the importance, in Rubens's copious and various production, of designing coloured cartoons for tapestry. Bellori describes at length *The Triumph of the Eucharist* series ordered by the Archduchess in her widowhood for the Descalzas Reales in Madrid. Baglione emphasizes the beauty and strength of the inventions to be observed in other tapestries which came to the eyes of Rome. Conspicuous among those, whether or not the *Decius Mus* series for Genoa was known in the metropolis, was *The History of Constantine the Great*. Seven pieces of that, woven in Paris, were given by Louis XIII in September 1625 to Urban VIII's legate, the Pope's own nephew, Cardinal Francesco Barberini.[10] Rubens himself had been in the French capital when the Papal legation made their state entry on 21 May; and subsequently he was able to meet there, as he had wished, congenial spirits in the retinue, Girolamo Aleandro, Cassiano del Pozzo, the Cardinal's secretary, and Giovanni Doni, all *eruditi*. The royal gift of France transported to Italy was to be the foundation for Cardinal Barberini's tapestry works;

and Pietro da Cortona was commissioned to complete the series. Thus the vision of Pietro, as well as of his patrons, was dazzlingly arrested, at a crucial moment in planning to decorate the *gran salone* of Palazzo Barberini, by the scale and vigour of Rubens's inventions. *Constantine's defeat of Maxentius at the Milvian Bridge* was one of the tapestries unpacked in Rome; and, in the stupendous turmoil colourfully depicted, Pietro, prepared by knowledge in black and white of *The Battle of the Amazons*, was ready to digest a compound of elements drawn from the very masters whom he had himself learned chiefly to emulate, Titian and Raphael, and from Giulio Romano. The exuberant orchestrations of his own changed style, a marked development from that of his frescoes in S. Bibiana, appear in *The Rape of the Sabines* of 1628–9 and in *Alexander's defeat of Darius at Issus* in about 1635.[11] These huge canvases proclaim, beyond obvious references in the one to Bernini's *Pluto and Proserpina* and in the other to the battle scene frescoed in the Sala di Costantino, the quality of Pietro's response to Rubens's configurations; just as the more decorous rhythms of his *Xenophon's sacrifice to Diana*, painted after 1653, display how later he took suggestion from the mature works of Poussin. Over the main field of the huge vault in Palazzo Barberini he stretched to fresh conclusions his experience of Veronese's decorations in the Doge's Palace and of Correggio's in the domes of Parma; and in his pick of illusionistic devices he showed himself to be yet another heir of Annibale Carracci. His debt to Rubens in the dramatic strugglings of the giants at the corners, and of the tapestry-like compositions which they flank, has been curiously overlooked.

Outside Rome and Genoa there was demand for weavings of *The History of Achilles*, designed by Rubens during the earlier 1630s: one set, expanded by two pieces designed *en suite* by Jordaens, was for Maria Christina of Savoy to hang at Turin; another, confined to the eight cartoons designed by Rubens himself, was inventoried in January 1709 in the collection at Venice of Ferdinando Carlo, last Duke of Mantua.[12] Acquisition of this second set, many years after Mantua had been sacked and the ducal collections sold, speaks not only for the persistence of Gonzagan extravagance, but also for appreciation on a worthy scale of the talents of a great artist who had been in Gonzaga service.

Bellori recounts – and his source may have been Van Dyck's friend, Kenelm Digby, an acquaintance in Rome – how Rubens enlarged the information acquired by his own hand in Italy: by collecting all

manner of prints; and by retaining young draughts-men in Rome, Venice and Lombardy to supply graphic news of whatever excellent was being done. Padre Sebastiano Resta, a collector well aware of the situation in Rome and Milan, specified among these *giovani*, Abraham van Diepenbeeck.[13] There was also return traffic to Italy in Rubens's own drawings, besides commerce in prints reproducing his com-positions. Resta himself, very possibly the first Oratorian since Ricci really to appreciate the art of Rubens, bought an impressive group of black chalk studies, drawn for the most part in Rome and after antique sculpture. The vendor, he records, was a pupil of Van Dyck, 'Monsù Habé'.[14]

It is not easy to determine to what effect Rubens received such copies of Italian masterpieces drawn by Diepenbeeck and others; beyond gratification of his unflagging interest in keeping abreast of artistic developments in the best way open to him, short of revisiting the peninsula. Through these same *giovani* he may have obtained drawings of far more moment from the many left in Barocci's studio and in Cigoli's studio when those painters died. Nor can we gauge how far Resta's hopes were fulfilled, that his album especially mounted with exemplary sheets of Rubens's studies after the antique statues in the Vatican and Borghese collections might educate the aspiring draughtsmen of Milan.[15]

Direct effects of Rubens's own paintings on Seicento artists are more definable. The young Bernini, working for Scipione Borghese, must have been excited by the convolution and plasticity of the *Susanna's* pose (Col. Plate VIII). Domenico Fetti became court painter to Ferdinando Gonzaga from 1613; and his training by Cigoli in Rome may have helped to predispose him to Rubens's technique, especially to his tonalities in flesh painting. Before he moved from Rome to Mantua, Fetti may have felt also some influence from Orazio Borgianni; and Borgianni had striven on his return to Rome in 1605 to shed the bizarre mannerisms of his style in Spain, in favour of a more acceptably modern style based not only on the Parmese and Venetian revivals which had been inaugurated by the Carracci but also on the art of his close contemporary, Rubens. Borgianni's *Holy Family with the Dove*[16] shows quite remarkable affinities in interpretation to Rubens's treatment about 1608 of the same very rare sub-ject;[17] and he may have been attracted like Rubens, or even by him, to Elsheimer's *St. Christopher*.[18] Guercino would have had the pictorial triumphs in the Chiesa Nuova called to his attention by Cardinal Serra, his patron, who had been the patron of

Rubens; and his sumptuous altarpiece of the mid-1620s, *St. Gregory the Great with St. Ignatius Loyola and St. Francis Xavier*,[19] is magnificent witness to his appreciation of *St. Gregory with St. Maurus and St. Papianus* (Plate 335). Young Guercino might have been one of the few Italians of his generation to grasp the boldness of relief and foreshortening in the paintings for S. Trinità, Mantua. In Rome more-over, Rubens's innovatory scheme to give a tri-partite treatment of a figure subject in the *cappella maggiore* at the Chiesa Nuova, with two sets of saints disposed laterally so as to act at the same time as spectators of a vision and as intermediaries, anti-cipated and may well have influenced Bernini's dramatic development of this device in the Cornaro Chapel of S. Maria della Vittoria.[20] In Genoa Bernardo Strozzi's *St. Augustine washing Christ's feet*[21] exhales Venetian experience flavoured with the sensation of *The Miracle of St. Ignatius*, then recently installed by the Pallavicini in the Gesù; and, almost a quarter of a century later, Giovanni Benedetto Castiglione, the most original Genoese painter of his time, was to hark back in his altarpiece in the Oratorio di S. Giacomo della Marina, for the equestrian figure of *St. James driving the Moors from Spain*,[22] to Rubens's breathtaking conception of the *Marchese Doria* forty years previously (Plate 266). In Naples Giuseppe Ribera's patron, the Flemish mer-chant Gaspar de Roomer, commissioned *The Feast of Herod*[23] from his celebrated countryman; and this astounding masterpiece was on view to the aston-ished Neapolitans by 1640. Rubens's excitement in the depiction of slightly over-life-size figures react-ing to a focus of horror would have affected Mattia Preti in such a picture as *The Feast of Absalom*.[24] Ribera's *Drunken Silenus* of 1626 was already red-olent of some acquaintance with Rubens's treatment of subject matter. It is noteworthy also that the only paintings by a living Italian in Rubens's Inventory in 1640 were two by Ribera, received perhaps in part exchange for *The Feast of Herod*: an *Arrest of Christ* and a *Belshazzar's Feast*.[25]

Some aspects, however, of his own painting, if admired, were not effectively understood by his contemporaries and juniors in Italy. Most of those active in Genoa who were attracted to Flemish painting, ranging from such a feeble imitator as Vincenzo Malò to such distinguished performers as Castiglione and Valerio Castello, took their cue rather from Van Dyck, who was active in their city for considerably longer periods than Rubens; al-though in 1661 Castiglione, in his capacity as a dealer, was proud to offer to Duke Carlo II Gonzaga

the two early mythologies by Rubens from the Imperiale collection, *Ercole che fila* and *Adone morto con Venere e le Gratie* (Plates 214, 215),[26] works which should have hung from the day of their painting in one of the Mantuan palaces. Indeed, it was through the example of Van Dyck's re-interpretations and divagations that such an able portraitist as Carbone came to be any sort of follower of Rubens. However, no cisalpine Rubenist appears to have noticed the dependence of the most important and successful altarpiece painted by Van Dyck in Italy, the *Madonna del Rosario* for Palermo,[27] on Rubens's first version of the Chiesa Nuova altarpiece, transferred to Antwerp a decade previously. Moreover, the Bruegelian elements in the *Rainbow Landscape* sent to Genoa, or in *The Return from the Harvest* sent to Florence, awoke no evident response in Seicento painting.[28] What picture by a Florentine offers even a pale reflection of the heady lessons to be learned from *The Horrors of War*?[29] Who in Milan was moved to rival the charm of Cardinal Federigo Borromeo's *Madonna and Child in a flower garland*,[30] the combined effort of Rubens and Jan Brueghel? Who in Venice beside Carlo Ridolfi thought it remarkable that Nicholas Regnier had brought there with other paintings from Antwerp a 'figura di San Girolamo maggior del vivo, col Leone à canto, che par rugisca, di Pietro Paolo Ruben'?[31] Did anybody but Van Dyck in the 1620s take note of the sparkling sketch of *The Martyrdom of St. Ursula* now in Brussels, but then in some Italian city, as like as not Mantua?[32]

(iii) ARCHITECTURE AND SCULPTURE WITH PAINTING

By his paintings and drawings, as well as by his numerous inventions for tapestries and prints, Rubens nevertheless continued after 1608 to make south of the Alps a presence which could hardly be overlooked, however imperfectly comprehended; and the range of those there who profited from an awareness of that presence is neither narrow nor inconsequential. Only his designs for actual sculpture in an architectural setting may have been beyond their ken: for the façade and tower and tribune of the Jesuit church in Antwerp,[33] for the tabernacle of the high altar of St. Michael's Abbey,[34] and for the embellishment of his own house on the Wapper; although two views of this last building, with its famous triumphal archway and garden pavilion (Plate 345), were published by Harrewijn's engravings of 1684,[35] exemplifying the uses to which Rubens had put his studies of Michelangelo

and of Sebastiano Serlio. Yet Rubens's discovery of the magnified power of painting and sculpture in combination with architecture, by directed light, carries with it an intoxicating suggestion: that, had he been able to take up the offers of further employment in Rome, there might have been some mutually stimulating partnership between him and Bernini. This speculation offers itself as we face the proscenium of the sanctuary in the Lady Chapel (Plate 346) which was completed for the Antwerp Jesuits soon after 1625, and in every luxurious detail to the designs of Rubens.[36] Sunlight admitted through a window concealed to the right of the altar vibrates across the altarpiece, originally an *Assumption*,[37] in which Rubens had depicted the illumination to respond to light from such a source, and across the marble figure of God the Father hovering to crown the head of the painted Madonna. The removal of the altarpiece from this superbly calculated setting, and the substitution of a feebler painting by another artist on another subject, has made it all too easy to overlook the significance of a brilliantly Baroque invention, anticipating by almost twenty years Bernini's contrivance in the Raimondi Chapel of S. Pietro in Montorio, and his even more spectacular effect in the Cornaro Chapel of S. Maria della Vittoria.[38]

It is not to belittle Bernini's mature achievements in Roman churches thus to qualify, after three centuries, the assertion of his biographer, Baldinucci: that it was 'common knowledge that he was the first to unite architecture, sculpture and painting in such a way that they together make a beautiful whole'. Rubens's frustration was to have to work far from Rome, interpreted in Antwerp by sculptors of no greater calibre than Hans van Mildert and André de Nole, when the paramount sculptor of the age was jealously retained in Papal service. The amazing extravagance in the construction and finish of the Jesuit Church in the Korte Nieuwstraat earned a rebuke from the Collegio Romano; and Father Pierre Huyssens, the official architect to the Maison Professe, whom Rubens had guided after the death of Aguilonius, was suspended from practice.[39] For decades this 'temple of marble' on the frontier of Catholicism stood for the Company as the paradigm of excess. Bernini, who frequented the Jesuits in Rome, was surely informed about it; and probably in some detail. His own work in the 1620s for S. Bibiana and S. Agostino suggests that he was already sensitive to precedents set by Rubens. Might he not have become so again in the 1640s, in the years which followed Rubens's death?

Notes

For Bibliographical abbreviations see pp. 121–3

Chapter 1

1. W. von Reiffenberg, *Bulletin de l'academie royale des sciences et belles-lettres de Bruxelles*, 10, 1837, 15.
2. CDR I, 19.
3. Vincenzo I Gonzaga arrived in Florence on 2 October 1600 for the marriage on 5 October of Maria de'Medici. Rubens was in the Duke's suite. The bride and her companions did not leave Florence until 13 October. So Rubens had presumably ten days' residence in which to find hours free for sightseeing.
4. CDR I, 36; and LUZIO, 38. Chieppio wrote (8 December 1600) to the Duke, who had been offered some copies of paintings: '*essi quadri non sono a proposito per V.A. la quale non ha bisogno di copie ma ricerca originali di buona mano et degni di stare fra molti altri che l'A.V. si ritrova di pittori principalissimi.*' This was the acquisitions policy whilst Rubens was at the Mantuan Court. In 1604 Vincenzo gave a feof valued at 50,000 scudi for the '*Madonna della Perla*' attributed to Raphael!
5. JAFFÉ 1965, I. 28, no. 27, pl. 22. See also *Bologna 1975*, no. 132.
6. CDR I, no. VII.
7. CDR I, 19.
8. CDR I, no. IV. Rubens was to write in (?November) 1603 from Valladolid to Chieppio in Mantua, saying, 'I have the examples of Spain and Rome in my own case: in both places the prescribed weeks dragged into as many months.' (MAGURN, no. 12).
9. Grasse, Hôpital de Petit-Paris. CDR I, no. III. MUELLER HOFSTEDE 1970 gives the latest discussion: but omits notice of JAFFÉ 1965 II, where the importance for Rubens's *Elevation of the Cross* of the Sadeler engraving after Chr. Schwarz was first published. I do not believe that the small painting in a Basel private collection (canvas, 65 × 49 cm.) can be a *modello* by Rubens for the *St. Helena* of this commission; although Dr Müller-Hofstede, in publishing it, *ibid.*, 69, Abb. 3, chose to use my name in this connection. It appears to be a small copy of the altarpiece, with minor variations, by another hand.
10. CDR I, no. XVIII.
11. MAGURN, no. 168.
12. MAGURN, no. 29. The large paintings, in oils on canvas, are at Vaduz, Liechtenstein collection: but the true cartoons for tapestry, which were presumably in tempera on paper, are missing.
13. Genoa, S. Ambrogio. CRLB VIII, 11, no. 116, fig. 47. The altarpiece reached Genoa in 1620.
14. JAFFÉ 1971, III, 362, 364.
15. Genoa, S. Ambrogio. KdK, 22.
16. See chapter 11.
17. KdK, 13–15.
18. Madrid, Prado. See chapter 4, n. 62.
19. Madrid, Prado (except for the missing *Christ*). CRLB VIII, 1, nos. 6–18, figs. 14–62.
20. Jacksonville (Fla.), Cummer Gallery. *Rotterdam 1953*, no.

2. The painting, which belonged to Mr. H. Sperling, New York, at the time of this exhibition, was at Sotheby's, S. G. Davies sale, 4 July 1941 (122), bt. Dix. An old copy on a canvas of similar dimensions was with Ian Askew, London, 1956–7.
21. MAGURN, no. 216.
22. LUGT, LOUVRE, 10 and 20–21.
23. VDAS, I, 17.
24. BELLORI, 254.

Chapter 2

1. Hartford (Conn.), Wadsworth Atheneum. JAFFÉ, 1961, II, 10–26.
2. HELD, no. 162, pl. 165; and 56.
3. Nos. 179, 180: 'Two pictures of a man and a woman, by John van Eyck'. These may have been a pair of portraits.
4. LUGT, LOUVRE nos. 1116, 1117, 1118, 1119, 1120, 1121: HELD, no. 166. pl. 166.
5. LUGT, LOUVRE, nos. 116, 1118, 1119. For a (?contemporary) copy after a missing sheet of Rubens's own copies from Jost Amman, see C-L. Küsten, *Jahrb. der Hamburger Kunstsamml.*, Bd. 8, 1963, 25–6.
6. LUGT, LOUVRE, nos. 1111, 1112, 1113, 1114; ALTENA 1972, Afb. 10; Museum Boymans-van Beuningen, nos. V. 100, 101. Two more in the same technique, and presumably from the same sketchbook, hitherto unpublished, were drawn to my attention by Mr. Julien Stock in a London private collection (stuck down on a P. J. Mariette mount, inscribed by him 'J. Burghmair Inven./P. P. Rubens Delin.', cf. LUGT, LOUVRE, no. 1111). One excerpts the main figure group from 'Vom glueckseligem Wuerfelspiel' (133 × 174 mm.); the other from 'Von Wirtschaften' (132 × 149 mm.).
7. Amsterdam, art trade. ALTENA 1972, 3–24.
8. SANDRART, 106.
9. R. Ingrams, *Burl. M.*, CXVI, 1974, 190–7; also A. and O. Kurz, *Nederlands Kunsthistorisch Jaarboek*, XXIII, 1973, 275–90.
10. HELD, no. 68, pl. 79, illustrates the pen drawing in the Fondation Custodia collection, Paris. No convincing original of this much repeated painting has come to light, although one was no. 90 in Rubens's 1640 Inventory (DENUCÉ, 60).
11. F. Lugt, AQ, VI, 1943, 103. Rubens's drawings after the *Self-Portrait* by Stimmer and the *Self-Portrait* by Lucas van Leyden were nos. 1015 and 1016 in F. Basan's catalogue of the P-J. Mariette Sale, Paris 1775. The *Lucas van Leyden* belongs now to the Fondation Custodia, Paris.
12. The panel referred to in Rubens's letter of 26 May 1618 to Sir Dudley Carleton is the one in the collection of the Dukes of Westminster. The claim of EVERS II, 95–6, that the Hermitage painting, a weaker variant, is the original, is unfounded.
13. London, Count Antoine Seilern. SEILERN, nos. 20, 57, Pls. XLVI and CXI.

14. London, British Museum. JAFFÉ 1965 I, no. 36, p. 27
15. SEILERN, no. 24, pls. LVII, LVIII, as c. 1620.
16. Madrid, Prado, no. 1688 (no date is proposed in the 1963 catalogue).
17. Boston, I. S. Gardner Museum. GORIS-HELD, no. 6, pls. 16, 18, 20.
18. London, British Museum. JAFFÉ 1965 I, 20 n. 36, pl. 26b.
19. Chatsworth, Devonshire collections. HELD, no. 168, pl. 178.
20 Berlin Kupferstichkabinett. HELD, no. 157, pl. 167.
21. Antwerp, Cathedral. KdK, 52.
22. Dorset, private collection. JAFFÉ 1965 I, 29, n. 38: K. Andrews, 'Dürer's Posthumous Fame', in Essays on Dürer, Manchester 1973, 85–6, fig. 33. Mr. Andrews's notes to his article make no mention of this published source of his information, nor of the photograph having been provided by the present writer. Such uncharacteristic omissions apparently were due to an editorial ruling in the University of Manchester, Department of History of Art.
23. L. Demonts, Musée du Louvre. Inventaire Général des Dessins des Ecoles du Nord. Ecoles Allemande et Suisse, To. I, Paris 1937, no. 172, as 'copie libre' of Dürer. This drawing in brown ink and pen on white paper, 185 × 145 mm., although a masterly piece from the Jabach collection, is not reproduced.
24. ALTENA 1972, 19, Afb. 41, as 'P. P. Rubens naar A. Dürer': but Demonts, op. cit., no. 150, pl. LX, correctly as 'une copie, retouchée par Rubens'.
25. KdK, 247: W. Kurth, The Complete Woodcuts of Albrecht Dürer, New York 1963, 180.
26. LUGT, LOUVRE, nos. 1121–1123 pl. LVI; JAFFÉ 1958 I, 401; BURCHARD-D'HULST, no. 10.
27. LUGT, LOUVRE, nos. 1049–1056, as 'd'après un maître néerlandais plus ancien'. This suite of drawings, perhaps designs for stained glass, is clearly attributable to Jan Swart van Groningen. Compare T. Helbig, Glasschilder Kunst in België, Antwerp 1951, nos. 129, 130, pl. LIII, and A. E. Popham, Catalogue of Drawings by Dutch and Flemish Artists preserved in the Department of Prints and Drawings in the British Museum, v, London, 1932, nos. 17–20 (under Jan Swart), Figs 19, 20
28. Rotterdam, Museum Boymans-van Beuningen. JAFFÉ 1956, 6–12. BYAM SHAW, nos. 1378 a and b.
29. Paris, Louvre. JAFFÉ 1966, 131–2, pls. 7–9.
30. Leningrad, Hermitage; London, British Museum. JAFFÉ 1965, I, 25–6, pl. 18a: HIND, no. 32, pl. V.
31. After B.32. I am grateful to Mr. E. Croft-Murray for calling in 1966 this drawing, then in the collection of Lord Rennell of Rodd, first to my attention. It was subsequently sold by Lord Rennell: Sotheby's, 10 December 1968 (56), bt. in, and 9 April 1970 (79).
32. Paris, Fondation Custodia. London/Paris/Berne/Brussels 1972, no. 81, pl. 37.
33. Dorset, private collection. JAFFÉ 1971 III, 362–6.
34. J. Bochius, Historica Narratio profectionis et inaugurationis Serenissimorum Belgii Principum Alberti et Isabellae, Austriae Archiducum . . . , Antwerp 1602; BAUDOUIN, 34–45, contains the most useful recent account of Rubens and Vaenius. See also, especially for suggestions of Vaenius–Rubens collaboration in easel paintings and of Rubens's earliest independent style, the proposals put forward by J. Müller-Hofstede, Münchener Jahrb. der

bildenden Kunst, XIII, 1962, 179–215.
35. CRLB, XVI; E. McGrath, JWCI, XXXVII, 1975, 191–217, and idem, Les Fêtes de la Renaissance, II, Quinzième Colloque International d'Etudes Humanistes, Tours, 10–22 July 1972.
36. Brussels, Musée Royal des Beaux-Arts, 479. GERSON, 50, pl. 33A. The fact that this painting, dated 1589, is engraved is unpublished. An impression of the print at the British Museum was found by the present writer in 1964, classed there with anonymous prints after Parmigianino.
37. New York, Mr. and Mrs. J. Linsky. GORIS-HELD, no. 19, pl. I, as 'Geographer'. J. Müller-Hofstede, Pantheon 1962, 281, as 'Architect'.
38. Norfolk, Virginia, Chrysler Museum (gift of Walter P. Chrysler). the painting bore an old inscription, 'PETRUS PAULUS RUBENS PI.'.
39. M. de Maeyer, Gentse Bijdragen tot de Kunstgeschiedenis, XIV, 1955, 75–86.
40. Antwerp, Rubenshuis. JAFFÉ, 1967 II, 98 ff.; BAUDOUIN 33–43.
41. Paris, formerly Dr. H. Wendland. JAFFÉ 1971 II, 300–3, figs. 8–10.
42. VASARI, IV, 232.
43. B. XIV, no. 1.
44. K. A. Knappe, Dürer, das graphische Werk, Vienna/Munich 1964, pl. 43.
45. Stuttgart, Staatsgalerie, Inv. nr 2241. JAFFÉ 1971 III, fig. 6.
46. v.d. WIJNGAERT, no. 323.

Chapter 3

1. CDR, IV, 256.
2. See Chapter 11, note 50.
3. M. Mauquoy-Hendrickx, l'Iconographie d'Antoine van Dyck, Brussels 1956, no. 78, illustrates the first state of the Déodat Delmont.
4. H. Houbraken, De Groote Schouburgh der Nederlantsche Konstschilders en schilderessen, Amsterdam 1718–21, 3 vols., 32; J. F. M. Michel, Histoire de la Vie de P. P. Rubens, Brussels 1771, 26; JAFFÉ 1966 II, 130 I, nn. 19–21.
5. Rotterdam, Museum Boymans-van Beuningen. HELD, no. 166, pl. 172; JAFFÉ 1966 II, 131.
6. LUGT, LOUVRE, no. 1073, pl. XLVI; C. de Tolnay, GBA, LXIV, 1964, 129–34. As Dr. Paul Joannides pointed out to me, the possibility exists that Rubens, having seen the statue at Fontainebleau, was actually drawing either after the model in the Casa Buonarroti, or after a Michelangelo drawing connected with that project: see also I. Chatelet-Lange, Pantheon, 1972, 455–68, who denies Tolnay's thesis about Rubens's drawing in the Louvre.
7. Paris, Louvre. JAFFÉ 1966 II, pl. 6.
8. B. XV, no. 25.
9. L. Goldscheider, The Paintings of Michelangelo, London 1939, pls. 42, 45.
10. Dorset, private collection. Pen and brown ink, over preliminaries in black chalk, 455 × 232 mm; stuck down on an old mount, which is inscribed 'Rubens d'après Michelange' in an eighteenth- or early nineteenth-century hand: JAFFÉ 1966 II, 131 no. 23 (not there repr.).
11. LUGT, LOUVRE, no. 1039, pl. XXXIII.
12. LENINGRAD, HERMITAGE. Dresden 1970, no. 68.

13. v.d. WIJNGAERT, no. 557. 7, 9, 10.

14. Munich, Alte Pinakothek. KdK, 36, 194.

15. Chicago, Art Institute, GORIS-HELD, no. 38, pls. 43, 44.

16. Rotterdam, Museum Boymans-van Beuningen. *Rotterdam 1953*, no. 16 repr.

17. Vienna, Kunsthistorisches Museum. G. Smith, *Jahrb. der Kunst. Samml. in Wien*, 45, Abb. 20, 28. CRLB VIII. 11, no. 104, fig. 6.

18. EVERS I, Abb. 77, 80.

19. Rotterdam, Museum Boymans-van Beuningen; and Paris, Fondation Custodia. *Amsterdam 1933*, nos. 97, 98. In *London/Paris/Berne/Brussels 1972*, no. 75, pl. 39. Van Hasselt suggests that Rubens may have had some introduction to Michelangelo's great-nephew at the Casa Buonarroti in spring 1603; but the style of these copies makes the 1600 date more likely.

20. *Dresden 1970*, no. 62, describes and illustrates the *Faun Mask* (W. Schmidt acknowledging my attribution and identification at Dresden of this drawing, hitherto classed as anonymous). The *Pack-Mule* (also referred to by JAFFÉ 1965 IV, 380) has not been illustrated hitherto.

21. Edinburgh, National Gallery of Scotland (D.712). Black chalk on white paper, 200 × 278 mm. Collections: Richard Cosway; David Laing; Royal Scottish Academy. First recognized and brought to my attention by Mr. Keith Andrews.

22. Paris, Fondation Custodia. *London/Paris/Berne/Brussels 1972*, no. 76, pl. 38.

23. For Rubens's drawings, now in Dresden and Milan, after the *Laocoön*, see *Dresden 1970*, no. 60; BURCHARD-D'HULST no. 15; FUBINI-HELD, 125–133, pls. 1–4. For his drawing now in Antwerp after the *Belvedere Torso,* see *Antwerp 1956,* no. 11, and *Amsterdam 1933*, no. 93 repr. For his drawing after the *Belvedere Antinous,* see *Cantoor.* For his drawings after the *Farnese Hercules*, see HELD, 51, 113, 114 and FUBINI-HELD, pl. 5. For his drawings after the *Dioscuri,* see the studio copy in *Cantoor* III, 2.

24. CRLB VIII. I, no. 6, fig. 14, deals with the Ottawa version.

25. KdK, 87: J. Pope-Hennessy, *Meesters van het Brons der Italiaanse Renaissance,* Rijksmuseum, Amsterdam 1961, no. 137, Afb. 71.

26. Potsdam, Sanssouci. CRLB VIII, 11, no. 120, fig. 65.

27. LUGT, LOUVRE, nos. 1040–1048, ps. XXXVI–XXXIX.

28. Ghent, St. Baaf. BURCHARD-D'HULST, no. 20: CRLB VIII.I, no. 72, fig. 123.

29. London, British Museum. BURCHARD-D'HULST, nos. 18 and 19.

30. FUBINI-HELD, 125–6, figs. 2, 3, discusses both Rubens's original drawing in the British Museum and the copy in Padre Resta's Rubens Album in the Ambrosiana, Milan.

31. LUGT, LOUVRE, no. 1036, XXXII.

32. Lulworth (Dorset), Sir Joseph Weld. JAFFÉ, 1957 II, 376, fig. 17.

33. LUGT, LOUVRE, no. 1036, pl. XXXIV.

34. LUGT, LOUVRE, no. 1029, pl. XXVII.

35. A. E. Popham, *Raphael and Michelangelo: selected drawings from Windsor Castle*, London 1954, pl. 5.

36. CRLB IX, no. 37, pl. 136.

37. CRLB LX, no. 32a, fig. 123.

38. Paris, M. Jacques Petit-Horry. JAFFÉ 1970 II, 23–4, pl. 33b.

39. Vienna, Fürst Schwarzenberg. *ibid.,* pl. 30.

40. *ibid.,* pl. 31.

41. Florence, Pal. Pitti. *ibid.,* pl. 33a.

42. Florence, Museo Horne. JAFFÉ 1967 II, 102, fig. 8.

43. LUGT, LOUVRE, no. 1036, pl. XXXIII; BURCHARD-D'HULST, no. 22; JAFFÉ 1967 II, 99.

44. LUGT, LOUVRE, no. 1079, p. XLVII is corrected by JAFFÉ 1967 II, 96, 99.

45. F. Stix and L. Fröhlich-Bum, *Beschreibender Kat. der Handzeichnungen der Graph. Samml. Albertina* III, Vienna 1932, 118 (repr.), as 'Penni (?)'.

46. Paris, M. Jacques Petit-Horry. Brown ink, with pen and white heightening, on parchment, 265 × 286 mm. The owner, for whose permission to publish this drawing here I am grateful, kindly called my attention also to the very damaged drawing after Raphael, which indicates clearly enough the design copied by Rubens: see G. Rouchès, *Musée du Louvre. Les Dessins de Raphaël,* (s.d.), no. 12 (Inv. No. 3.878), brown ink with pen and brush, over traces of preliminaries in black chalk, 314 × 468 mm.

47. VASARI, IV, 299; B. XIV, 155, no. 192.

48. Dorset, private collection. JAFFÉ 1967 II, 99, fig. 3.

49. London, British Museum. *ibid.,* 99–100, fig. 4: B. XIV, 246, no. 325.

50. London, E. Speelman. JAFFÉ 1967 II, 100, fig. 5.

51. The Hague, Mauritshuis. KdK, 219.

52. JAFFÉ 1967 II, 103: B.XV, 69, no. 5. LUGT, LOUVRE, no. 1057, pl. XLI.

53. Vienna, Kunsthistorisches Museum. POPE-HENNESSY II, 243, pl. 233. See also CRLB VIII. II, no. 118, fig. 61.

54. JAFFÉ 1967 II, 100. Raphael's *St. Cecilia* altarpiece in the Pinacoteca, Bologna, is illustrated by POPE-HENNESSY II, pl. 217. A representation of it appears in Prado no 1394: *The Sense of Sight,* signed and dated 'Brueghel F. 1617', in which Rubens added the live figures.

55. DUSSLER, 39–40, fig. 88.

56. Antwerp, St. Paul's. BELLORI, 223; BAUDOUIN, 49, pl. 20.

57. Rome, Farnesina. DUSSLER, 99–100, pl. 157.

58. New York, Pierpont Morgan Library. JAFFÉ 1967 II, 100 fig. 11, discusses the *verso*; the *recto* is discussed in *Cambridge (Mass.)/New York 1956,* no. 19, pl. XII (Held believing that this was drawn from Caraglio's engraving).

59. B. XIV, 256–7, nos. 324–4, and 247, no. 347.

60. B. XV, 86, no. 50; 36, no. 5; 43, no. 14 and XIV, 179, no. 218 (for example); and XV, 39, no. 8.

61. New York, Forbes collection. JAFFÉ 1970 II, 20. J. R. Martin and C. L. Burns, in *Rubens before 1620,* Princeton 1972, 21, dated this painting 1612–15, contemporaneously with the Schwarzenberg *Ganymede.*

62. *ibid.,* 21, colour plate IV and pl. 25. On loan to Princeton University.

63. Rome, Farnesina. *Raphael* KdK, 154, 155.

64. Amsterdam, I.Q. van Regteren Altena. JAFFÉ 1967 II, 101; *Amsterdam 1933*, no. 69 (repr.) as *c.* 1601–2.

65. Turin, Royal Library. JAFFÉ 1967 II, 101, fig.6.

66. Dijon, Musée. VDAS I, 32, 64–5, 88 no. 37, pl. XX.

67. Paris, Louvre. WETHEY, I, no. 26, pl. 132.

68. JAFFÉ 1967 II, 101. Agostino Veneziano's engraving is B. XIV, 273, no. 357. K. Andrews, *Fifty Master Drawings in the National Gallery of Scotland,* Edinburgh, 1961, no. 29, illustrates the sanguine drawing (D.1787), to which there is reference also in BURCHARD-D'HULST, 22.

69. JAFFÉ 1967 II, 101. The engraving is reproduced by H. Delaborde, *Marc-Antoine Raimondi*, Paris, n.d., 218, pl. opp. 216. See also, for Rubens's copy, J. Müller-Hofstede, MD II.1, 1964, 11–13, pl. 5.

70. Vaduz, Liechtenstein collection. KdK, 142–7.

71. Berlin, Kupferstichkabinett. VDAS I, 18, fig. VIII; fig. IX illustrates this version, on which Rubens drew a free copy of *The Judgement of Solomon* frescoed by Raphael on the vault of the Stanza della Segnatura.

72. DUSSLER, 81, pl. 137.

73. Los Angeles (Cal.), Norton Simon collection. KdK, 79.

74. London, British Museum. JAFFÉ 1967 II, 101–2, fig. 7.

75. London, Wallace Collection. KdK, 232.

76. J. Wilde, *Italian Drawings in the Department of Prints and Drawings in the British Museum. Michelangelo and his Studio*, London 1953, no. 6 recto, pl. XII.

77. London, National Gallery. CRLB VIII.1, no. 71. fig. 122.

78. Rome, Vatican. DUSSLER, 79–80, pl. 135.

79. DENUCÉ, 59, nos. 71–5, 80.

80. Uppsala, University Library. MUELLER HOFSTEDE 1965, 275, Abb. 199, illustrates the drawing made known by I. Q. van Regteren Altena, *Burl. M.*, LXXVI, 1940, 194, ff, n. 6.

81. Copenhagen, Kongel. Kobberstiksamling. JAFFÉ 1967 II 102, n. 48. Müller-Hofstede, *loc. cit.*, regards these as having been drawn by Rubens.

82. Vienna, Albertina. CRLB VIII.2, no. 104d, fig. 13.

83. Antwerp, Rubenshuis. CRLB VIII.1, no. 61a, fig. 108.

84. GORIS-HELD, no. 83, pls. 67, 69, 71, 74.

85. Washington D.C., National Gallery of Art. Pen and brown ink and buff bodycolour on white paper, 249 × mm. Collections: Sir J. C. Robinson sale, Christie's, 12 May 1902 (343) bt. Anstruther; F. A. White sale, Christie's, 20 April 1934 (82) bt. Moss; H. L. Constant sale, Christie's, 8 July 1975 (120 repr.), always as Rubens after Raphael. The exact source used by Rubens was identified by me for the catalogue of this last sale. Exhibited: London, Guildhall 1895.

86. JAFFÉ 1967 II, 100, fig. 9, correcting LUGT, LOUVRE, no. 1061.

87. Paris, Louvre. K. Oberhuber, *Jahrb. der Berliner Museen* IV, 1962, 116–49, Abb. 1.

88. *ibid.*, Abb. 3.

89. J. Pope-Hennessy, *Italian Renaissance Sculpture*, London 1958, pl. 45.

90. Nancy, Musée. KdK, 15.

91. F. Zuccaro, *Il passaggio per Italia, con la dimora di Parma*, Bologna 1608.

92. London, heirs of L. Burchard. CRLB VIII.11, no. 109a, fig. 24. The composition as a whole echoes that of Boldrini's woodcut after Titian's '*Sei Santi*', based on the altarpiece in S. Nicolò dei Frari (MURARO-ROSAND, scheda no. 44).

93. JAFFÉ 1967 II, 104.

94. *ibid.*, fig. 10. G. Martin, *Burl. M.* CVII, 1966, 613–618 gives the latest discussion of the commission. His fig. 21 illustrates the ceiling piece as it was at Osterley Park, in the collection of the Earl of Jersey (the painting was burnt in the Second World War).

95. Philadelphia, Museum of Art. DUBON, *passim*.

96. DENUCÉ, 57, no. 19.

97. San Francisco, De Young Museum. JAFFÉ 1953 II, 387–0.

98. SEILERN, no. 24, pls. LVII, LVIII. C. Norris, *Burl. M.* XCVII, 1955, 398, dates this panel *c.* 1630 (SEILERN, *op. cit.*, *c.* 1620) and is followed in this by W. Stechow, in *Rubens before 1620*, Princeton 1972, 23.

99. Gregory Martin kindly called my attention to the *putto* painted out by Rubens in the National Gallery *Judgement of Paris* (KdK.344) between Venus and Juno. This figure more or less reverses the *putto* clinging to Hebe in Raphael's *Council of the Gods*. This pentiment of the 1630s would seem to reinforce, rather than weaken my general contention.

100. *Paris 1965–66*, no. 255; and see ROOSES, no. 1323.

101. M. Rooses, *Bulletin-Rubens* V, Antwerp 1897, 88–9. Oils on panel, 59 × 48 cm. Collections: Rousselle, Brussels; with Kleinberger, Paris, in 1911; L. Koppel, Berlin, in 1914; with F. Mathiessen, London, in 1956; H. Wetzlar, Amsterdam, when it was exhibited in 'Kunstschatten', Laren, June-August 1959, Singer Museum, no. 68, pl. 36.

102. *Paris 1965–6*, no. 251.

103. Dorset, private collection. JAFFÉ 1965 IV, 381.

104. DENUCÉ, 59.

105. *ibid.*, 155.

106. Roxburghshire, Duke of Sutherland. JAFFÉ 1967 II, 105.

107. B. XVII, 85, no. 107.

108. B. XV, 223, no. 68. The impression of this engraving at Chatsworth bears the collectors' marks of both Lely and Lankrink. It could be the one to which Rubens referred. Illustrated by JAFFÉ 1967 II, fig. CXIV.

109. Both Rubens and Raphael, when dealing with clients, insisted on the distinction between work of their own hands and that of assistants. See V. Golzio, *Raffaello nei documenti . . .*, Vatican 1936, 76; and MAGURN, 60–1.

110. See note 66 above.

111. HELD, nos. 7 (pl. 7), 3 (pl. 4), 4 (pl. 5), 8 and 9 (pls. 9 and 10), 7 *verso* (pl. 8).

112. Paris, Louvre. HELD, no. 161, pl. 173. The Edelinck engraving is v.d. WIJNGAERT, NO. 170.

113. Het Loo, H.M. The Queen of the Netherlands. Black pencil, grey heightening, some reworking in pen on white paper, 435 × 565 mm. MUELLER HOFSTEDE 1964, 101, fig. 14, argues that this drawing corresponds to the first stage of the Louvre drawing and is a copy of that before it was strengthened by Rubens.

114. Vienna, Akademie. K. F. Suter, *Burl. M.* LXI, 1930, 226, and *Das Rätsel von Leonardo's Schlachtenbild*, Strasbourg 1937, 84 ff. An old copy of Rubens's painting belongs to Mr. Paul J. Zeman, Seattle (Wash.).

115. JAFFÉ 1958 IV, 416, fig. 5.

116. London, private collection. *ibid.*, fig. 8.

117. London, Mr. and Mrs. P. Goldberg. *ibid.*, 411–13, figs. 1, 6.

118. Antwerp, Rockoxhuis. MUELLER HOFSTEDE 1964, 95–106, figs. 1, 5, 8.

119. Madrid, Prado. CRLB VIII. 11, no. 105, fig. 17.

120. Munich, Alte Pinakothek. KdK, 196.

121. DUBON, no. 4, pls. 15–22.

122. A. J. J. Delen, *Cabinet des Estampes de la Ville d'Anvers. Catalogue des Dessins Anciens (Ecoles Flamande et Hollandaise)*, 2 vols., Brussels 1938, no. 189, Pl. XXXIV: LUGT, LOUVRE, no. 1083, pl. XLIX.

123. Hamburg, Kunsthalle. JAFFÉ 1970 IV, fig. 9.

124. London, Count A. Seilern, BURCHARD-D'HULST, no. 32.

125. GORIS-HELD, no. 121, pl. 103.

126. GORIS-HELD, no. 120, pl. 102.

127. JAFFÉ 1968, 184–7, fig. 19; *Antwerp 1971*, no. 57, pl. 3.

128. DE PILES, 94, 95; VDAS I, 33, 43.

129. JAFFÉ 1966 II, 129–30, pl. 5. K. Clark, *The Drawings of Leonardo da Vinci in the collection of Her Majesty the Queen at Windsor Castle*, (2nd edn.) London 1968, under no. 12459, ignoring this attribution of the drawing, writes only, 'A copy is in the Albertina, Vienna'.

130. VDAS I, 43, fig. XL.

131. *ibid.*, figs. XLI–XLV.

132. *ibid.*, fig. XLVIII.

133. *Cantoor*, VI, 84.

134. LUGT, LOUVRE, no. 1059, pl. XL. SHEARMAN, 221, no. 34.

135. Vienna, Albertina. SHEARMAN, 212, pls. 32, 33b. quotes the younger Richardson on the study for *The Nativity of the Virgin* in his father's collection, 'something damaged by time and Rubens'. This drawing was published by O. Benesch in *Walter Friedlaender zum 90. Geburtstag,* Berlin 1965, 45, Abb. 9.

136. Paris, Louvre. VDAS I, 69, fig. XXII.

137. LUGT, LOUVRE, no. 1107, pl. LII.

138. *Cantoor* IV, 57.

139. London, National Gallery; and Vienna, Kunsthistorisches Museum. POPHAM, pls. XCVIII a and b.

140. JAFFÉ 1959, 25, tav. 17; the Correggio in the Dresden Gallery is illustrated by POPHAM, pl. LXXXVII.

141. Dresden, Gemäldegalerie. POPHAM, pl. LXXXV.

142. LUGT, LOUVRE, no. 1105. pl. LII.

143. Genoa, S. Ambrogio. KdK, 21.

144. JAFFÉ 1959, tav. 28.

145. BAUDOUIN, 49, fig. 19.

146. Dresden, Gemäldegalerie. POPHAM, pl. LXXXIX.

147. See note 85 above.

148. OLDENBOURG, 101, Abb. 59, 60, discusses and illustrates both Parmigianino's original painting in Vienna and the Rubens copy in Schleissheim.

149. S. J. Freedberg, *Parmigianino. His works in painting*, Harvard 1950, Pl. 132, publishes the copy in the Cook collection at Richmond; J. Müller-Hofstede, *Münchner Jahrbuch der Bildenden Kunst*, 1967, 33–96, Fig. 27, publishes the copy in the Residenz-galerie at Salzburg, as by Rubens. A studio repetition of a Rubens original was in the Northwick Park sale, Christie's, 29 October 1965, lot 40.

150. Vienna, Kunsthistorisches Museum, no. 1523.

Chapter 4

1. The Domenico dalle Greche woodcut is MURARO-ROSAND, Scheda no. 8b.

2. *op. cit.,* Scheda no. 1.

3. WETHEY, I, no. 115, pl. 180, dated 1541; J. C. T. Bierens de Haan, *L'Oeuvre gravé de Cornelis Cort*, The Hague 1948, no. 111, pl. 30, dated 1566.

4. B. XVIII. no. 21.

5. Hamburg, heirs of August Neuerburg. EVERS II, 151–67, fig. 54.

6. JAFFÉ 1969 IV, 22, fig. 11.

7. Hamburg, Kunsthalle. JAFFÉ 1970 IV, fig. 2, 3.

8. Berlin, Kupferstichkabinett. JAFFÉ 1965 IV, 379, fig. 39.

9. Copenhagen, Cantoor. B. XVIII, no. 127; JAFFÉ 1957 II, 379, figs. 20, 21.

10. Chatsworth, Devonshire Collections. BURCHARD-D'HULST, no. 11.

11. HELD, no. 1, amplified by JAFFÉ 1965 IV, 376.

12. National Galleries of Scotland (Ellesmere loan). JAFFÉ 1970 IV, fig. 5.

13. Zurich, Dr. Anton Schrafl. BURCHARD-D'HULST, no. 158.

14. Madrid, Prado. WETHEY III, no. 32 (copy 5), pl. 209.

15. Knowsley, Earl of Derby. JAFFÉ 1970 IV, figs. 6, 8.

16. Stockholm, Nationalmuseum. WETHEY III, nos. 13 (copy 1), 15 (copy 1), pls. 65, 66.

17. Madrid, Prado, no. 1686.

18. Paris, Louvre. WETHEY I, no. 26, pl. 132.

19. Venice, S. Maria della Salute. WETHEY I, nos. 82–4, pls. 157–9.

20. Destroyed by fire. WETHEY III, no. L-3, fig. 54.

21. Vienna, Kunsthistorisches Museum. WETHEY I, no. 21, pl. 91.

22. Vienna, Albertina. GLUECK-HABERDITZL, no. 2; JAFFÉ 1966 II, 129.

23. London, Banqueting House. J. S. Held, *Burl. M.*, CXII, 1970, 274–81, and O. Millar, *Rubens: The Whitehall Ceiling* (Charlton Lecture), London 1958.

24. CRLB XVI, no. 51, fig. 100.

25. Paris, Louvre. JAFFÉ 1966 II, 128–9, pl. 3.

26. Brussels, Musée Royal des Beaux-Arts. CRLB VIII. I, nos. 71, 73, fig. 122, 125.

27. Antwerp, Augustinerkerk. KdK 305.

28. WETHEY I, no. 69; MURARO-ROSAND, scheda no. 77.

29. New York, Mrs. Kaplan. HELD, no. 167, pl. 174.

30. Madrid, Prado. WETHEY III, no. 63, pl. 162.

31. Paris, Louvre. JAFFÉ 1966 II, 128–9, pl. 2.

32. Madrid, Prado, no. 1692.

33. Haarlem, Teylers Stichting. GLUECK-HABERDITZL, no. 4. WETHEY I, no. 105, pl. 171, illustrates the altarpiece, now in the Brera.

34. Boston, Mass., private collection. Brown ink with pen and wash, over preliminaries in black chalk, with heightening in white and buff oils, on white paper, 428 × 564 mm. Sidney Freedberg kindly called this hitherto unpublished drawing to my notice, and I am grateful to the owner for permission to publish it. Titian's painting is discussed and illustrated by WETHEY I, no. 85, pl. 104, which also illustrates the altarpiece in S. Maria della Salute, Venice.

35. Venice, S. Maria Gloriosa dei Frari. WETHEY I, no. 14, pls. 17–19, 21–2.

36. Antwerp, Cathedral. KdK, 301.

37. Cleveland (Ohio), Museum of Art. WETHEY I, no. 5, pls. 122, 123.

38. Madrid, Prado. KdK 26.

39. Munich, Alte Pinakothek. CRLB VIII.I, no. 126, fig. 71.

40. WETHEY I, no. 114, pls. 178, 179.

41. Bayonne, Musée Bonnat. JAFFÉ 1966 II, 129, pl. 4. WETHEY III, no. 5, pl. 81, illustrates the painting in the Museo di Capodimonte, Naples.

42. Vienna, Kunsthistorisches Museum. KdK, 47.

43. WETHEY I, no. 92, pl. 72.

44. Paris, Louvre. JAFFÉ 1966 II, 127–8, pl. 1.

45. J. M. Muller, *Burl. M.* CXVII, 1975, 371–7.

46. Brussels, Musée Royal des Beaux-Arts. WETHEY I, no. 133, pls. 153, 154; CRLB VII.11, no. 127, fig. 74.

47. Chatsworth, Devonshire Collections. WETHEY II, no. 78 (copy I).
48. Madrid, Alba Collections. *op. cit.*, no. L-6, pl. 151.
49. See note 16 above.
50. Madrid, Prado. JAFFÉ 1969 II, 650, fig. 10.
51. *ibid.* The *Self-Portrait* of Tintoretto may be one painted in the mid-1550s, now in the Askali collection, New York.
52. Hartford (Conn.), Wadsworth Atheneum. JAFFÉ 1965 II, 52.
53. Venice, Scuola Grande di S. Rocco. TIETZE, 374–5, folding plate, and fig. 134.
54. Grasse, Hôpital de Petit-Paris. CRLB, II, no. 112.
55. See chapter 7, note 31 below.
56. See chapter 7, note 20 below.
57. Mantua, Pal. Ducale. JAFFÉ 1958 IV, 412, fig. 4; CRLB, VIII.11, no. 158, fig. 134.
58. New Haven (Conn.), Yale University. JAFFÉ *loc. cit.*, 419, figs. 9, 10.
59. *ibid.*, 415–6, figs. 7, 8.
60. KdK, 15.
61. Genoa, S. Ambrogio. KdK, 21.
62. Madrid, Prado. See Sotheby & Co., *El Retrato Ecuestre del Duque de Lerma de Pedro Pablo Rubens, propriedad de los Herederos de la Condesa de Gavia*, London 1962, 7–24, colour plates of details, and black and white repr.
63. Florence, Pal. Communale. R. Siviero, *Second National Exhibition of the works of art recovered in Germany*, Florence 1950, no. 21, pls. CLI–CLX.
64. L. Burchard, *Jahrb. der Preussichen Kunstsammlungen*, L, 1929, 319 ff.
65. Madrid, Prado. CRLB, III, 2, no. 105, fig. 17.
66. Venice, Accademia. TIETZE, 362, figs. 21, 22.
67. LUGT, LOUVRE, no. 1028, pl. XXVI.
68. Venice, Doge's Palace. TIETZE, 364, fig. 226.
69. Munich, Alte Pinakothek. *op. cit.*, 356, fig. 220.
70. London, Mr. & Mrs. P. Goldberg. JAFFÉ 1958 IV, 415.
71. Vienna, Kunsthistorisches Museum. CRLB, VIII.11, no. 104 fig. 6.
72. Antwerp, Mus. Roy. des Beaux-Arts. KdK, 14. JAFFÉ 1963, 460–2, fig. 3, illustrates the Tintoretto in the Cleveland Museum of Art.
73. Ghent, Sint Baaf. CRLB VIII.1, no. 72, fig. 123.
74. TIETZE, fig. 98.
75. JAFFÉ 1969 II, 650, figs. 10, 11.
76. Amsterdam, Dr. H. Wetzlar (formerly). Oils on oak panel, 59 × 48 cm. An old copy of this was exhibited in *Amsterdam 1933*, no. 43, oils on oak panel, 45.3 × 35.3 cm., as by Rubens. Dr. Wetzlar's picture is the one noted in that catalogue entry as in the collection of Leopold Koppel, Berlin.
77. TIETZE, 367–8.
78. VDAS, II, 239, pl. XXI; KdK, 118.
79. Cambridge, Fitzwilliam Museum. BURCHARD-D'HULST, no. 45.
80. TIETZE, fig. 55.
81. SEILERN, no. 53, pls. CIV, CV; cf. JAFFÉ 1962, 234, frontispiece.
82. TIETZE, 349, fig. 268. The Rubens copy, hitherto unrecognized, is in Brussels, Musées Royaux des Beaux-Arts, no. 3089: brown ink with pen and wash over black chalk preliminaries, with heightening in white oil, on white paper, 368 × 254 mm. Collections: Lanier (?) (L.2908);

P. H. Lankrink (L.2090); J. Richardson jr. (L.2170); Sir T. Lawrence (L.2445); de Grez, 1913.
83. HIND II, no. 45. BERENSON, pl. 1057, illustrates Veronese's painting.
84. Dublin, National Gallery of Ireland.
85. EVERS I, 42–50, Abb. 11, 17. The most recent discussion is by C. Norris, *Burl. M.*, CXVII, 1975, 73–9.
86. The late Ludwig Burchard first recognized this portrait, in the collection of Mr. M. Q. Morris, London.
87. HELD, no. 152; BURCHARD-D'HULST, no. 180; see also a review of both these selections by JAFFÉ 1965 IV, 381.
88. Vicenza, S. Corona. BERENSON, pl. 1074. *London 1953*, no. 1, repr., discusses the Rubens painting now in the collection of Baron C.-A. Janssen, La Hulpe (Belgium).
89. Modena, Galleria. R. Palluchini, *Veronese,* Bergamo 1949, tav. 43, 44.
90. Barber Institute of Fine Arts, University of Birmingham. JAFFÉ 1958 II, 80.
91. KdK, 52.
92. SEILERN, no. 27, pl. LXI and fig. 23.
93. KdK, 334 (illustrates the Hermitage *modello*).
94. KdK, 335 (illustrates the *modello* in the Vienna Akademie).
95. Venice, Doge's Palace. Palluchini, *op. cit.*, tav. 141.
96. ed. R. Heinemann, *The Thyssen-Bornemisza Collection,* Castagnola 1969, no. 320, pl. 262; BERENSON, no. 442.
97. Palluchini, *op. cit.*, tav. 99.
98. Lulworth (Dorset), Sir Joseph Weld. JAFFÉ 1965 I, 25, pl. 16 and figs. 4, 5.
99. Paris, Fondation Custodia. JAFFÉ 1955, 331–40, figs. 1, 2; *London/Paris/Berne/Brussels 1972*, no. 74, pl. 40.
100. JAFFÉ 1955, fig. 3.
101. Oxford, Ashmolean Museum. JAFFÉ 1955, fig. 7.
102. Munich, Kupferstichkabinett. JAFFÉ 1955, fig. 4.
103. Brussels, *Musées Royaux des Beaux-Arts de Belgique, Catalogue de la peinture ancienne*, Brussels 1949, no. 480.
104. Dresden, Gemäldegalerie. JAFFÉ 1955, fig. 6.
105. LUGT, LOUVRE, no. 1065, pl. XLIII (as 'Saint Liberale and an angel'); BURCHARD-D'HULST, 45.
106. London, Count A. Seilern. BURCHARD-D'HULST, no. 24.
107. London, H.M. The Queen. One of the alternative *modelli* offered by Rubens in 1611 to the Chapter of Antwerp Cathedral.
108. BAUDOUIN, fig. 24. Formerly Antwerp Jesuit Church, Houtappel chapel.
109. KdK, 351 (reproduces the oil sketch in the Wallace Collection, preparatory to the altarpiece now on the High Altar of the Chapel of King's College, Cambridge).
110. BURCHARD-D'HULST, 45.
111. FIOCCO, pl. 130; cf. HELD, 127.
112. The lost fresco in Venice is recorded by a drawing, *ex* coll. Padre Resta, in the Victoria and Albert Museum, no. 2306. Pen and brown ink on white paper, 412 × 557 mm.; see H. Burns, *Andrea Palladio 1508–1580,* Hayward Gallery, London 1975, no. 271, as a copy after Pordenone. The Marcus Q. Curtius appears on one of the vertical panels on the ground floor of the façade. Rubens would have known almost certainly the chiaroscuro woodcut after this scene, B. XII, 151, no. 19, as well as the actual fresco.
113. London, H.M. The Queen. KdK, 311. Central part 1630.
114. Vienna, Albertina. *Ottawa 1968*, no. 170. R.-A. d'Hulst,

Jordaens Drawings, London/New York 1974, II, D.7, says, 'there is nothing in this work to justify regarding it as by Jordaens', a dismissal as unimpressive as it is peremptory. The drawing has been attributed to Jordaens by competent authorities at least since 1794.

115. JAFFÉ 1955, 338 n. 4, fig. 9.

116. Leningrad, Hermitage. JAFFÉ 1965 I, 27, pl. 21.

117. JAFFÉ 1964, 385.

118. JAFFÉ 1964, 384–5, pls. 10, 13.

119. SEILERN, no. 51, pl. CII.

120. Paris, Fondation Custodia. JAFFÉ 1964, 385, pls. 12, 13; and see M. Winner, *Pieter Bruegel d. Ä als Zeichner*, Kupferstichkabinett Berlin, Berlin 1975, no. 206, Abb. 206, for the *St Onophrius* of this series, signed and dated by Muziano 1574.

121. Vienna, Albertina. JAFFÉ 1957 I, 8–9, fig. 8.

122. JAFFÉ 1964, figs. 1, 2.

123. Vienna, Albertina. JAFFÉ 1964, 385, pls. 14a, b.

124. Vienna, Albertina. JAFFÉ 1964, 385–7, fig. 3.

125. C. Ruelens, *Rubens–Bulletijn*, IV, Antwerp/Brussels 1890, 113–5.

Chapter 5

1. H. Vey and A. Kesting, *Katalog der Niederländischen Gemälde von 1550 bis 1800 im Wallraf-Richartz-Museum und im öffentlichen Besitz der Stadt Köln*, Cologne 1968, Dep. 248, Abb. 134. J. Müller-Hofstede in *Wallraf-Richartz-Jahrbuch 30, 1968* argues that this painting is to be interpreted as a 'Mantuaner Freundschaftsbild von Rubens und Frans Pourbus.'

2. Madrid, Prado. P. Kristeller, *Andrea Mantegna*, London 1901, 220, fig. 72.

3. KDK, 343 (now in the Toledo Art Museum, Ohio); G. Paccagnini, *Andrea Mantegna* (Mostra), Venice, 1961, no. 40, figs. 55–7.

4. CRLB, VIII.2, no. 145, fig. 108.

5. The prime version is with W. Feilchenfeldt, Zurich. See JAFFÉ 1972, 107–14, colour plate I, figs. 7–11.

6. London, British Museum. A. E. Popham, OMD I, 1926–7, 45.

7. (i) LUGT, LOUVRE, no. 1075, pl. XLVI, copies left side of B.20; (ii) Berlin, Kupferstichkabinett, inv. no. 1551, 1930 cat., 253, copies the single figure of the youth.

8. Munich, Alte Pinakothek. EVERS I, 88–91, Abb. 38–40.

9. Boston, I. S. Gardner Museum. BURCHARD-D'HULST, no. 21. See also GORIS-HELD, no. 33, pl. 29. None of these authorities appear to realize that, in the Metropolitan Museum head study, the head first painted by Rubens was painted out by him in painting his study for the St. Paul's altarpiece. It is therefore not by the painter's intention a *Study of Two Heads*.

10. Paris, Louvre. JAFFÉ 1956 II, 318, fig. 34.

11. London, National Gallery. MARTIN, 163–70, gives the latest, full and careful discussion.

12. CRLB, XVI, no. 40a, fig. 74.

13. London, British Museum. V. GELDER, 16, 20 (repr.).

14. The National Gallery of Canada, Ottawa, No. 14583, *The Flight of Meriones*. Pen and ink and brown wash on faded blue paper, heightened with rose and white bodycolours, 255 × 374 mm. Inscribed in pen, on the old backing paper,

'Giulio di', '204', and, in red ink, 'Lot 291'. Bought from Max de Beer, 1964.

15. London, formerly Mr. C. R. Rudolph. JAFFÉ 1958 III, 325, fig. 1, 2.

16. Antwerp, Prentenkabinet. V. GELDER, 6, 7 (repr.).

17. London, British Museum. *ibid.*, 8, 9 (repr.) identifies POUNCEY-GERE, no. 194 as one of Crozat's drawings (see Chapter 6, n. 14).

18. V. GELDER, 9–11, colour plate.

19. JAFFÉ 1958 III, 326, fig. 3; V. GELDER, 6–7.

20. New York, Mr Emile E. Wolf. Brown ink with pen and wash over black chalk, heightened with buff and white bodycolours, on white paper, 423 × 573.3 mm. Collections: Lankrink (L.2090); Earl Spencer (L.1530); Earl of Warwick (L.2600). I am grateful to Mr. Wolf for his permission to publish his drawing here.

21. Dorset, private collection. Brown ink with pen and wash over black chalk, heightened with buff and white bodycolours, on white paper, 293 × 562 mm. I am grateful to the owner for permission to publish this drawing here. (See Chapter 6, n. 4).

22. This hypothesis may account for there being copies also of 'une Frise d'un Auteur inconnu' (POUNCEY-GERE, no. 194). (See Chapter 6, note 4 below).

23. V. GELDER, 18, 19 (repro.) notes only the *Triumph of Henri IV* in this connection, as does CRLB XVI, no. 41, fig. 72 also.

24. Paris, Fondation Custodia. *London/Paris/Berne/Brussels 1972*, no. 73, pls. 46, 47, reproduces *recto* and *verso* of this sheet.

25. Brussels, Mus. Roy. des Beaux-Arts. JAFFÉ 1958 III, 326, fig. 5, and CRLB, IX, no. 58.

26. Brussels, Mus. Roy. des Beaux-Arts. JAFFÉ 1958 III, figs. 6, 7, and CRLB, IX, no. 25.

27. CRLB IX, no. 13, figs. 88, 89.

28. CRLB IX, no. 22, figs. 103, 104.

29. JAFFÉ 1958 III, 326 n. 16. See also R. Kultzen, *Jahrbuch der Hamburger Kunstsamml.* II, 1966, 217, Abb. 5, who shares my opinion that the drawing is by an anonymous sixteenth-century hand after Giulio Romano, extensively retouched by Rubens.

30. Arbury Hall, Nuneaton. JAFFÉ 1964, 390, pl. 19.

31. Sotheby & Co., Ellesmere Sale, 5 December 1972 (27), brown ink with pen and point of brush over black chalk, heightened with buff bodycolour on ochre prepared paper, 200 × 200 mm. Collections: N. Lanier (L.2885); Sir P. Lely (L.2094); Richard Cosway; Sir Thomas Lawrence; Lord Francis Egerton. Inscribed, in black chalk, 'Giulio Romano'. The authorship of this drawing, then mounted in the Giulio Romano album, was identified by the present writer at Mertoun House in 1966.

32. Paris, Louvre. JAFFÉ 1958, 327, figs. 9–14 BYAM SHAW, no. 1375.

33. London, Victoria & Albert Museum; and Copenhagen, Kongel. Kobberstiksamling. JAFFÉ 1964, 390, pls. 17, 18.

34. Oxford, Christ Church. *ibid.*, fig. 6.

35. e.g. *Rotterdam 1953*, no. 73 (now in the Los Angeles County Museum).

36. JAFFÉ 1958, 327–8, figs. 17, 18.

37. Paris, Louvre. *ibid.*, figs. 19, 20.

38. Brussels, Bibl. Royale, Cab. de MSS. Fonds Général, no. 5729, fol. 31.

39. LUGT, LOUVRE, no. 1078, pl. XLVIII.

40. Rotterdam, Museum Boymans-van Beuningen. HELD, no. 166, pl. 172 (see Chapter 3, n. 5).
41. Cambridge, Fitzwilliam Museum. JAFFÉ 1960, 448, fig. 41.
42. BURCHARD-D'HULST, no. 168.
43. Darmstadt, Hessisches Landesmuseum. JAFFÉ 1964, 392, pl. 24, fig. 7.
44. Vienna, Albertina. *ibid.*, pl. 25.
45. BURCHARD-D'HULST, 252.
46. Hamburg, heirs of August Neuerburg. V. PUYVELDE, no. 54.

Chapter 6

1. B. Degenhart and A. Schmidt, 'Methoden Vasaris bei der Gestaltung seines "Libro"', in *Studien Zur Toskanischen Kunst. Festschrift für Ludwig Heydenreich*, Munich 1964, 45–64; the copy of the 1568 edition of Vasari's *Vite*, presented to Rubens and annotated by him, disappeared from the library at Holker Hall before the Second World War (see JAFFÉ 1964, 383).
2. Paris, Louvre. JAFFÉ 1964, 393, pl. 29.
3. Paris, Louvre. *ibid.*, pl. 30.
4. POUNCEY-GERE, no. 195, pl. 163.
5. JAFFÉ 1966 II, 138, pl. 11; and BYAM SHAW, no. 380.
6. JAFFÉ 1966 II, fig. 9.
7. Madrid, Prado. *ibid.*, 139–40, pl. 12.
8. VENTURI, IX², 428, fig. 361.
9. POUNCEY-GERE, no. 196, pl. 163.
10. Edinburgh, National Gallery of Scotland. JAFFÉ 1966 II, 140, pl. 13.
11. *ibid.*, fig. 10; B. XV, 140, no. 104.
12. Dresden, Gemäldegalerie. CLRB, XVI, no. 3.
13. Vienna, Albertina. JAFFÉ 1965, 21, pl. 9.
14. POUNCEY-GERE, 194, pl. 162.
15. Angers, Musée Pincé. BURCHARD-D'HULST, 93.
16. Vaduz, Liechtenstein Collection. KdK, 147.
17. JAFFÉ 1964, 391, pl. 21; and 1966 II, 134, fig. 4.
18. Antwerp, Cathedral. JAFFÉ 1966, 134, figs. 2, 3.
19. Louvre Inv. no. 20. 245; JAFFÉ 1964, 391, pl. 22.
20. JAFFÉ 1964, 390–1, pl. 20b.
21. *ibid.*, 392, pl. 27. Another Rubens copy after Polidoro, from Mariette's collection, is in the Berlin Kupferstichkabinett, Inv. Nr 5114, Allegorical Scene, brown ink with pen and brush, heightened with yellow and white bodycolours, 312 × 337 mm., as 'Rubens nach Polidoro' (on mount). I am grateful to Dr Richard Cocke for calling my attention to this unpublished drawing.
22. Paris, private collection. *ibid.*, pl. 26.
23. Leningrad, Hermitage. JAFFÉ 1964, 391–2, pl. 23.
24. LUGT, LOUVRE, no. 1071, pl. XLV.
25. POUNCEY-GERE, no. 225, pl. 196.
26. Truro, Royal Institution of Cornwall. Grey and brown washes over black chalk preliminaries and fine penwork, retouched with yellow, buff and white bodycolours on white paper, 276 × 399 mm., *doublé*. Collections: Benjamin West (L.419); A. de Pass, cat. no. 114.
27. London, private collection. Brown wash over black chalk preliminaries and fine penwork, retouched with buff and white bodycolours. This may be contrasted with POUNCEY-GERE, no. 223, pl. 194, by Ambrogio Figino (?).
28. London, Baron P. Hatvany. *London 1950*, no. 48.
29. KdK, 174.
30. LUGT, LOUVRE, no. 1072, pl. XLIII.
31. LUGT, LOUVRE, no. 1074, pl. XLV, as 'copie anonyme, retouchée par Rubens, d'un dessin de Polidore conservé au Musée du Louvre, décrit dans Tauzia, *Dessins His de la Salle*, no. 28.'
32. Paris, Louvre. HELD, no. 50 *recto*, pl. 52.
33. HELD, 114.
34. P. M. R. Pouncey, *Burl. M.* XCVI, 1954, 23 (repr.).
35. SEILERN, no. 23, pls. LIII–LVI and Frontispiece.
36. A. Marobottini, *Polidoro da Caravaggio*, Rome 1969, pls. XL–XLII.
37. *Rotterdam 1953*, no. 93; JAFFÉ, 1954 I, 57.
38. Veste Coburg. JAFFÉ 1966 II, 141, pls. 14a.
39. *ibid.*, pl. 15.
40. Cambridge, Fitzwilliam Museum; and London, Count A. Seilern. BURCHARD-D'HULST, nos. 32, 33. Another example of Rubens copying M. Coxie, this time *via* an Agostino Veneziano engraving, is *Psyche in Charon's boat turning a deaf ear to a beggar*; LUGT, LOUVRE, no. 1077, Pl. XLVII.
41. FREEDBERG, 66, pl. 40.
42. Chatsworth, Devonshire Collections. Brown ink with pen and brush, with heightening in white bodycolour, on white paper, 545 × 840 mm. Collection: Flinck. Hitherto unrecognized as by Rubens. I am grateful to Mr. T. S. Wragg for permission to publish it.
43. Oxford, Christ Church. JAFFÉ 1964, 389, pl. 15. The subject is correctly identified by BYAM SHAW, no. 510.
44. Amsterdam, Rijksprentenkabinet. *ibid.*, 389–90, pl. 16.
45. JAFFÉ 1966 II, 142–3, pl. 16.
46. JANSON, I, pl. 297.
47. *op.cit.*, II, 186.
48. Angers, Musée Pincé. BURCHARD-D'HULST, no. 93 (HELD, 152, says 'only the reworking in lead white can be credited to the master himself').
49. Vienna, Albertina. *Ottawa 1968*, 46, figs. II and III. These attributions are not recognized by R.-A. d'Hulst, *Jordaens Drawings*, London/New York, II, D.23 and 24.
50. Paris, Louvre. JAFFÉ 1965 I, 21, pl. 10.
51. Stockholm, National Museum. *ibid.*, 22, pl. 14, fig. 1.
52. Vienna, Albertina. *ibid.*, 22–23, figs. 2, 3.
53. POUNCEY-GERE, no. 288, pl. 271; JAFFÉ 1965 I, 25.
54. Zurich, A. de Burlet. JAFFÉ 1966 II, 135–7, pl. 10.
55. Paris, Louvre. JAFFÉ 1965 I, 25, pl. 15.
56. Paris Louvre. *ibid.*, 21, pl. 11.
57. Oxford, Christ Church. *ibid.*, pls. 12, 13; and BYAM SHAW, no. 541.
58. Lulworth (Dorset), Sir Joseph Weld. *ibid.*, 25, pl. 16, figs. 4, 5.
59. M. J. Lewine, *AB*, LXV, 1963, 143–7, fig. 2.
60. CRLB IX, no. 50a., figs. 165, 166. J. Müller-Hofstede, *Burl.M.* CVI, 1964, 106 n. 47 pointed out the likely interest for Rubens of Tempesta's 'libretto di battaglie', published in Rome, February 1599.
61. Steeple Bumstead, Essex, Dr. and Mrs. A. Rooke. Pen and brown ink (anon. 16th century), reworked in pen and brown ink with touches of white bodycolour (Rubens), on white paper 187 × 207 mm. An attribution of this hitherto unpublished drawing to 'A. Tempesta and Rubens' is noted on the old mount. Coll.: Geo. Grosvenor Thomas (d. 1923), grandfather of Mrs. Rooke.

MURARO-ROSAND, scheda no. 16 (repr.), discuss the date and authorship of the splendid and rare woodcut. Rubens invented a horseman entering from the right, the hindfeet of the horse bolting, and the leg of a footman hurrying to the left, also the head of the furthest rider (without a helmet). He corrected *inter alia* the summary of the foreground plants and the hindleg of the nearest horse.

62. Florence, Uffizi. E. K. J. Reznicek, *Mostra di Disegni Fiamminghi e Olandesi,* Florence 1964, no. 66. This sheet of *ricordi* in brown ink with pen and wash over pre-liminaries in black chalk, 236 × 320 mm, is illustrated and discussed by MUELLER HOFSTEDE 1965 II, 92–3, fig. 24.

63. BURCHARD-D'HULST, no. 23.

64. e.g. Geneva, Dr. Martin Bodmer, VDAS, I, pl. XXXIX. H. R. Weihrauch, *Europäische Bronzestatuetten 15–18. Jahrhundert,* Brunswick 1967, 236, fig. 285, gives an example of the *bronzetti.*

65. OLSEN I, 62–5; see also W. Friedländer, in *Studien zur Toskanischen Kunst, Festschrift für Ludwig Heydenreich,* Munich 1964, 65–82, figs. 3, 7. KdK, 203, reproduces the Rubens altarpiece now in the Brera, Milan.

66. Friedländer, *loc.cit.,* fig. 19. KdK, 50, reproduces the Rubens painting in the Schlossgalerie, Schleissheim.

67. Friedländer, *loc.cit.,* 81–2, figs. 17, 18, follows OLSEN I, 68, figs. 7, 9. See also CRLB VIII. 2, no. 146, fig. 112.

68. Leningrad, Hermitage. BURCHARD-D'HULST, no. 37.

69. BAUDOUIN, 52, pl. 7.

70. e.g. *Ottawa 1968,* nos. 247, 248.

71. Bayonne, Musée Bonnat; and New York, Metropolitan Museum. HELD, nos. 27, 28, pls. 33, 34.

72. Amsterdam, Rijksprentenkabinet. *Bologna 1975,* no. 152. See also JAFFÉ 1958 II, 18–19 repr. and *Bologna 1975,* nos. 153, 156.

73. e.g. OLSEN II, Frontispiece (Paris, Fondation Custodia) and pl. 40a (London, British Museum). *Bologna 1975,* nos. 316–9.

74. Cambridge, Fitzwilliam Museum. HELD, no. 130, pl. 143, proposes only that 'an earlier date seems more appropriate' than the 1620–5 given by GLUECK-HABERDITZL, no. 137. BURCHARD-D'HULST, no. 206, give 'the presumed date' as *c.*1624–7, without reason.

75. See chapter 4, note 16.

76. Haarlem, Teylers Stichting. GLUECK-HABERDITZL, no. 4.

77. Milan, Brera. WETHEY I, no. 105, pl. 171.

78. cf. also OLSEN II, no. 28, pl. 41a and *Bologna 1975,* no. 80.

79. *ibid.,* nos. 27, 43, pls. 39a, 68a and *Bologna 1975,* nos. 84, 390.

80. Vienna, Albertina, Inv. Nr. 8236, brown ink with pen and wash on white paper, 290 × 248 mm. The autograph replica of Barocci's painting, made in 1598 for Monsignor Girolamo della Rovere, came into the possession of Cardinal Scipione Borghese. Rubens could also have known the subject through Agostino Carracci's engraving after Barocci, dated 1595 (B.XVIII, 99–100, no. 110).

81. Florence, Uffizi. OLSEN II, no. 32, pl. 45 and *Bologna 1975,* no. 106.

82. Lyons, Musée des Beaux-Arts. CRLB VIII. 1, no. 88, pl. 151.

83. Rome, Vatican. OLSEN II, no. 37, pl. 56.

84. Vienna, Kunsthistorisches Museum. JAFFÉ 1967 III, pl. 1 (colour).

85. London, National Gallery. WADDINGHAM, colour pls. VI, VII.

86. Frankfurt, Staedelsches Kunstinstitut. *Frankfurt 1966,* no. 22, pl. 20; M. Waddingham, *Burl.M.* CXIV, 1972, 601, fig. 13.

87. SEILERN, nos. 20, 21, pls. XLVI-LI; KdK, 156.

88. Edinburgh, National Gallery of Scotland. *Frankfurt 1966,* no. 21, pl. 19.

89. HIND II, no. 44, pl. VII.

90. v.d. WIJNGAERT, nos. 643, 531.

91. La Hulpe, Belgium, Baron C.-A. Janssen. *Rotterdam 1953,* no. 1 (repr.), as c. 1606.

92. London, National Gallery. WADDINGHAM, colour pl. XI.

93. London, H.M. The Queen. GLUECK, no. 10.

94. Oxford, Ashmolean Museum. JAFFÉ 1966 I, 414, fig. 44.

95. MAGURN, no. 21. WADDINGHAM, op.cit., XVI.

96. SEILERN, no. 41, pl. LXXXVIII.

97. London, British Museum. HELD, no. 30, pl. 26.

98. BAUDOUIN, 52, fig. 21.

99. DENUCÉ, 58, nos. 32–5. No. 35 'Eene Judith door den gezeyden *Elshamer*' is in the Wellington Museum, Apsley House (Victoria and Albert Museum).

100. MAGURN, 53.

101. MAGURN, no. 21.

102. MAGURN, no. 20.

103. *Frankfurt 1966,* no. 42, pl. 38a; SEILERN, no. 30, pls. LXIV, LXV, as 'shortly after 1620'. See also K. Andrews, *Elsheimer's Il Contento,* Edinburgh 1971, 20–1, fig. 11.

104. Madrid, Prado, no. 1840. There the subject is incorrectly identified as 'Paisaje con Hebe y Jupiter'. The attribution of the landscape to Brill is correctly given in the 1666 Inventory of the Madrid Alcazar. The attribution of the figures to Rubens is due to Bredius. DENUCÉ, 57.

105. Berlin, Staatl. Museen. KdK, 355.

106. Paris, Louvre. GLUECK, no. 11; Florence, Pal. Pitti. KdK, 45.

107. GLUECK, no. 1.

108. KdK, 184.

109. KdK, 185.

110. Copenhagen, Kongel. Kobberstiksamling. JAFFÉ 1957 II, 370, figs. 20, 21.

111. B. XVIII. 75, KdK, 97.

112. Bologna, Pinacoteca. *Bologna 1956,* no. 39 (repr.).

113. BAUDOUIN, 65, fig. 38 and colour pl. 10; JAFFÉ 1970 V, 432, fig. 1, published Rubens's *modello,* which is mistakenly classed as a copy by CRLB VIII. 2.

114. M. B. Dobroklonsky, in *Studies in Western European Art,* III, Leningrad 1949, 17–24, pl. 12.

115. BAUDOUIN, 55–7, fig. 23. The alternative *modello* offered to the Antwerp Cathedral Chapter.

116. Dobroklonsky, *loc.cit.*

117. Chatsworth, Devonshire Collections. JAFFÉ 1957 II, 379, fig. 23.

118. London, Victoria & Albert Museum. BURCHARD-D'HULST, no. 167, ignoring JAFFÉ 1956 II, 317, state: 'The drawing was certainly not done in front of Carracci's fresco in Rome, but may have been done *c.*1630 after a drawing he himself had made in his younger days in Rome, or after a drawing one of his painter friends sent him from Italy.'

119. e.g. BURCHARD-D'HULST, no. 165. These authorities persist in following GLUECK-HABERDITZL, no. 6, and LUGT,

LOUVRE, no. 1106, in designating this splendid drawing of a nude man, from Jabach's collection, '? after Correggio'. They do so despite POPHAM, 130 ('certainly not after our artist (Correggio), but, as suggested to me by Mr. Michael Jaffé, most probably after a drawing by Annibale Carracci').

120. Corfe Castle, Miss A. Oppé. D. Sutton and D. Mahon, *Artists in 17th Century Rome*, Wildenstein's, London 1955, no. 22.

121. CRLB VIII. 2, no. 1946 misses the stylistic difference between *recto* and *verso* of this sheet, emphasized by JAFFÉ 1957 II, 379, figs. 18, 19.

122. P. Sebastiano Resta's MS. cat. in the British Library, under Lib: 1, no. 323.

123. LUGT, LOUVRE, no. 1027, pl. XXVI.

124. Brussels, Bibl. Roy. HELD, no. 72, pl. 82.

125. BURCHARD-D'HULST, no. 57, connects the Ashmolean Museum drawing with the triptych of 1610–11 for St. Walpurga's, Antwerp (the study for the figure in that *Elevation of the Cross* was exhibited by these authorites in *Antwerp 1956*, no. 62).

126. BURCHARD-D'HULST, nos. 55, 56, 58; HELD, no. 70, pl. 81 and fig. 49, as 1601–2.

127. Antwerp, Mus. Roy. des Beaux-Arts. KdK, 304. D. Posner, *Annibale Carracci*, London/New York 1971, II, no. 35; the portrait, now in the Museo di Capodimonte, Naples, is dated 1587.

128. London, National Gallery. MARTIN, 213–15; and see JAFFÉ 1968, 174 ff. FRIEDLAENDER, no. 22b, pl. 29, illustrates Caravaggio's *Calling of St. Matthew*.

129. Chatsworth, Devonshire Collections. BURCHARD-D'HULST, nos. 34r. and 35.

130. KdK, 68.

131. Eyre, Mrs. James de Rothschild. JAFFÉ 1971 I, 269–71, pl. 25.

132. *ibid.*, pl. 24.

133. *cf.* H. Potterton, *The National Gallery, London: 'Painting in Focus'.* 3, 1975 (repr.).

134. Paris, Louvre. *ibid.* (repr.).

135. v.d. WIJNGAERT, no. 665.

136. FRIEDLAENDER, no. 26, pl. 36.

137. New York, Metropolitan Museum; and London, Count A. Seilern. HELD, fig. 50, illustrates the divided sheet, convincingly as though it were reassembled.

138. Paris, Louvre. FRIEDLAENDER, no. 28, pl. 38. CDR I, 363–8.

139. Vienna, Kunsthistorisches Museum. FRIEDLAENDER, no. 29, pl. 39.

140. Ottawa, National Gallery of Canada KdK, 81 (left).

141. Paris, Louvre WETHEY I, no. 36, pl. 75.

142. BURCHARD-D'HULST, no. 38.

143. SEILERN, no. 23, pls. LIII–LVI and Frontispiece.

144. J. Müller-Hofstede, *Pantheon* III, 1965, p. 164, figs. 1, 2.

145. Fort Worth (Texas), Kimbell Art Museum. JAFFÉ 1969 III, 534, fig. 10.

146. SANDRART, 157.

147. DENUCÉ, 69, nos. 291, 292; 307, 308; 289, 290; 314; 305, 306.

Chapter 7

1. BAGLIONE, 247.

2. M. De Maeyer, *Gentse Bijdragen tot de Kunstgeschiedenis* XIV, 1953, 75–83.

3. CRLB, VIII, 2, nos. 110–12.

4. CDR I, 26. J. Richardot's letter from Rome to the Archduke Albert, reporting the scandal, is dated 18 December 1600.

5. FREEDBERG, 329, pl. 205.

6. I. S. Lavin, *Bernini and the Crossing of St. Peter's*, New York, 1968, 33–4, pl. 73–6.

7. Brunswick, Herzog Anton Ulrich-Museum, BURCHARD-D'HULST, no. 25; HELD, no. 5. For the source of Rubens's figure on the *verso*, see B. XIV, 29–30, no. 23. This connection was not noted by these authorities, nor by CRLB, VIII. 2, no. 11a.

8. JAFFÉ 1968, 180.

9. Lulworth, Sir Joseph Weld. JAFFÉ 1957 II, 376, fig. 17.

10. Hartford (Conn.), Wadsworth Atheneum. JAFFÉ 1965 II, 52, first drew attention to Rubens's use of Tintoretto's *Hercules and Antaeus* and of Jan Sadeler's 1589 engraving after Christoffel Schwarz's *Elevation of the Cross*.

11. Vienna, Albertina. H. Geissler, *Muenchner Jahrbuch der bildenden Kunst*, 192–6, Abbe. 1, 2.

12. cf. EVERS II, 104.

13. SANDRART, 291.

14. Hamburg, heirs of August Neuerburg. EVERS II, 151–62, Abb. 54.

15. V. d. WIJNGAERT, no. 74; see also *op.cit.*, no. 726 (L. Vorsterman's engraving after Rubens's 'S. Catherina ex marmore antiquo'). CRLB VIII. 1, no. 68, pl. 119.

16. WITTKOWER, no. 20, pl. 36.

17. M. Winner, *Berliner Museen* XVII, 1968, 12, publishing this drawing in the Berlin Kupferstichkabinett, courteously acknowledged that this revision of attribution (from Guercino to Rubens) had been reached independently by me. Dr. Winner did not attempt to identify the sitter.

18. v. d. WIJNGAERT, no. 366.

19. Mainz, Mittelrheinisches Landesmuseum, Inv. N 1496. Oils on slavonic oak, 102 × 188 cm. There is a second copy of the original painting in a private collection in Florence, oil on oak, 51.1 × 38.8 cm, kindly called to my attention by Professor Alessandro Parronchi.

20. Rome, Galleria Borghese. KdK, 20.

21. MAGURN, no. 17.

22. SEILERN, no. 53, pls. CIV, CV.

23. La Hulpe, Belgium, Baron C.-E. Janssen. *London 1950*, no. 1, then in the collection of Christopher Norris.

24. See note 8, above.

25. See Chapter 1, n. 20.

26. BURCHARD-D'HULST, nos. 34 *recto* and 35, no. 37 and no. 36.

27. MUELLER HOFSTEDE 1964, 95–8, Figs. 1, 5, 8. In addition to the information in that publication, it may be noted that there is an old copy of this painting in a private collection in Florence, oils on oak, which Professor A. Parronchi kindly called to my attention.

28. WADDINGHAM, colour pl. IV.

29. Vienna, Akademie. JAFFÉ 1968, 174–80, fig. 2. MARTIN, 213–5.

30. KdK, 344. MARTIN, 153–63.

31. B. XIV. 245; JAFFÉ 1968, fig. 3.

32. B. XV. 27; JAFFÉ 1968, fig. 4.

33. JAFFÉ 1968, fig. 5.

34. Mainz, Mittelrheinisches Landesmuseum, Inv. Nr. 87; JAFFÉ 1968, fig. 6.

35. Paris, Musée du Petit Palais; JAFFÉ 1968, fig. 8.

36. The frontal view is discussed by H. R. Hoetink, *Narodni Galerie v Praze. Tri stoleti nizozemske kresby*, Palais Kinsky, Prague, 1966, no. 39; and by JAFFÉ 1968, 179 no. 23. It is clear from the Cantoor that Rubens drew other views also of the statue.

37. JAFFÉ 1968, fig. 11.

38. CDR I, IV.

39. HELD, nos, 8, 9, pls. 9, 10.

40. HELD, no. 6, pl. 6.

41. JAFFÉ 1968, 180; HELD, no. 6.

42. HELD, no. 1, pl. 1.

43. London, private collection. JAFFÉ 1968, 180–1, fig. 15.

44. *ibid.*, fig. 16.

45. *ibid.*, fig. 18.

46. BELLORI, 223. See also F. Baudouin, in *Queen Christina of Sweden, Documents and Studies, Analecta Reginensia*, I, Stockholm 1966, 20–2.

47. The *Adonis* has been even more extensively restored than the *Hercules*, on which the paint losses remain visible, as was first pointed out by C. Sterling and L. Burchard, *l'Amour de l'Art*. 9, Paris 1937, 294.

48. G. M. A. Richter. *The Metropolitan Museum of Art. Handbook of the Classical Collection*, New York, 1920, fig. 144.

49. HELD, no. 22, pl. 23, denies the connection of these drawings with the Imperiale painting (exhibited Rubenshuis, Antwerp, during 1953). EVERS II, 135–6, Abb. 35–7, confused the sequence of the drawings. HELD *ibid.* correctly puts the British Museum drawing first: but suggests that the Antwerp rather than the Washington drawing should be placed third, which is visually less plausible.

50. J. Neumann, *La galerie de tableaux du château de Prague*, Prague 1967, 242–50.

51. BAUDOUIN, 39, figs. 12, 13.

52. BAUDOUIN, 53, fig. 15.

53. London, private collection. JAFFÉ, 1957, III, 432.

Chapter 8

1. CDR I, nos. XV–LV, covers Rubens's Spanish mission of 1603–4. See also MAGURN, no. 92, with Rubens's recollection in 1626 of his first visit to Spain, and of the paramount importance of Lerma.

2. J. Pope-Hennessy, *Catalogue of Italian Sculpture in the Victoria and Albert Museum*, London 1964, no. 486, III, 461.

3. Wales, private collection. JAFFÉ 1968, 183–7, fig. 17.

4. Ghent, M. Paul Eckhout. *ibid.*, fig. 19; and *Antwerp 1971*, no. 57.

5. MAGURN, no. 8: but Rubens did not overlook Fernandez de Navarrete, see VDAS, I, 66, XXV.

6. CDR I, nos. XVII and XXXVIII. Giovanni Magno had written to Chieppio from the Castle at Mantua, 5 March 1603: '*Mi haveva dato in commissione S.A. che vedessi se vi era suo ritratto dal mezo in sù, et che lo facesse consignare a Mr. Pietro Pauolo per darlo all'Iberti, ma non so quanto sia per concedermi l'angustia del tempo, massime in questa hora che nimmo se trova in casa*'. At this last moment of hasty preparation Magno may not have found a suitable half-length of the Duke; and so Rubens might have had to supply one at this stage, had Pourbus not been available.

7. Madrid, Prado. WETHEY II, no. 21, pls. 141–3.

8. SEILERN, no. 13, pls. XXX–XXXII. DENUCÉ, 59, no. 79 (attributed in 1640 to Van Dyck).

9. Chatsworth, Devonshire Collections. *London 1950*, no. 28.

10. Paris, Louvre. KDK, 255.

11. MAGURN, no. 28; CRLB VIII. 1, nos. 6–18, discusses the *Apostles* in the Prado.

12. Mantua, Palazzo Ducale; Antwerp, Musée Royal des Beaux-Arts; Nancy, Musée. EVERS I, 44–50, Abb. 14–7.

13. Genoa, S. Ambrogio. KDK, 21.

14. Edinburgh, National Gallery of Scotland. JAFFÉ 1970, 42–50.

15. Berlin, Kupferstichkabinett. J. Müller-Hofstede, MD II 1964, 9–10, pl. 3b.

16. VDAS, I, 33.

17. e.g. Paris, Fondation Custodia. JAFFÉ 1958 III, 325–9, figs. 3, 4.

18. Paris, Fondation Custodia. *London/Paris/Berne/Brussels 1972*, no. 73, pls. 46–7.

19. HELD, no. 2, pl. 2, supports HIND II's attribution, and more or less his dating c. 1600–1608: but himself proposes too early a span, 1598–1602. J. Müller-Hofstede, *Burl. M.* CVI, 1964, 105–6 corrected his own opinion that this sheet antedated 1600. BURCHARD-D'HULST, No. 50, date it after Rubens's return from Italy. D. Rosand, AB, LI, 1969, 37. proposes c. 1600. See also JAFFÉ 1964 III, 380.

20. London, private collection. JAFFÉ 1958 IV, 416–9, fig 8.

21. *ibid.*, fig. 5.

22. CRLB VIII. 2, no. 158, fig. 4.

23. Rotterdam, Museum Boymans-van Beuningen. KDK, 17 (then as Stockholm, collection C. Tamm); J. Müller-Hofstede, *Bulletin Museum Boymans-van Beuningen*, XIII, 1962, 96–8, pls. 10, 12. See also OLDENBOURG, 40.

24. London, Mr. and Mrs. P. Goldberg. JAFFÉ 1958 IV, 411–2, fig. 1. The choice of subject at this stage of Rubens's career may have been influenced by Giulio Romano's picture of it in the Mantuan collection, no. 234 in the 1627 Inventory (LUZIO, 105). The connection should be noted with another fragment showing a rearing horse's head and forequarters (very similar to that of the second nearest in Pharaoh's *quadriga* and to that of the Prado *St. George*). This painting, transferred from panel to canvas, 71 × 49 cm., was purchased in 1770 from the Walpole collection at Houghton by Ambassador Moussin-Pushkin for the Empress Catherine of Russia (Hermitage catalogue, 1901, vol. II, no. 1838, as Rubens); sold in the Stroganov sale, Lepke (Berlin), 1931, it is now with Burt C. Norton, New York (*ex* Ernst Reinhardt, New York). It was engraved in mezzotint by Richard Earlom; and a version of it is in the Herzog Anton Ulrich-Museum, 60 × 50 cm.

25. BAUDOUIN, pl. 23, colour; CRLB, VIII. 2, no. 159, fig. 132. For another, related version mistakenly doubted by Vlieghe, *op. cit.*, see JAFFÉ 1970 V, 435–6, fig. 6.

26. JAFFÉ 1970, III, fig. 6.

27. Engraved by J. B. de Cavalleriis, *Statuarum Antiquarum Urbis Romae Libri II*, Rome 1585 (repr. in reverse, beside Rubens's *St. George* by STECHOW, 60–1, fig. 51).

28. Paris, Louvre. JAFFÉ 1958 IV, 412, fig. 3.

29. Regensburg, Galerie. MUELLER HOFSTEDE 1965 II, 74–5, Abb. 5 (as Rubens): CRLB VII. 11, no. 105 (as copy of Prado no. 1644).

30. Paris, Louvre. BURCHARD-D'HULST, no. 29.

31. *Cantoor* III, 60.
32. GLUECK-HABERDITZL, no. 70. *Rotterdam 1953*, no. 13, pl. 15.
33. New York, Metropolitan Museum. GORIS-HELD, no. 68, pls. 66, 70, 72, 79.
34. FREEDBERG, 331, discusses Daniele's commission for the Cappella Ricci in S. Pietro in Montorio.
35. London, private collection. Black and white chalks, on buff paper, 277 × 186 mm, with an old inscription in pen 'Peter Paul Rubens 1577–1640' and another in chalk 'Rubens'. GLUECK-HABERDITZL, no. 27, HELD, 98, and BURCHARD-D'HULST, no. 16, deal only with the famous sheet in the British Museum.
36. Paris, Louvre. HELD, 53, no. 4, fig. 30, 31.
37. JAFFÉ 1963, 460–2, fig. 3.
38. Brussels, Bibl. Roy. *Antwerp 1971*, no. 59, afb. 2.
39. POPE-HENNESSY I, 403–4, pl. 107.
40. EIGENBERGER, 346 (Inv. Nr. 897, Taf. 73).

Chapter 9

1. *e.g.* collection of the late Morris J. Kaplan, Chicago. This portrait was exhibited by the late M. B. Asscher (from the collection of Major-General Sir Allan Adair), 'Flemish Art 1300–1700', Royal Academy, London 1953–4, no. 261. It has been accepted correctly as the work of Frans Pourbus.
2. *e.g.* LUZIO, 108, lists a full-length by Frans Pourbus in the 1627 Inventory of Mantuan pictures, no. 246. This may be identical with one in the former Egerton collection at Tatton Park (National Trust), which shows in the left background a view of the Ponte di S. Giorgio. A three-quarter length, with Vincenzo holding a bâton against his right thigh, was called to my attention by Mr. Howard Ricketts (private collection, New York); this varies slightly the pattern of a portrait of Vincenzo in the collection of Marchesa d'Arco, Mantua (attributed to Santc Pcranda).
3. Edinburgh, National Gallery of Scotland (D. 1750), *ex* Royal Scottish Academy, as 'Flemish anon. of unknown man (?James I)': black and red chalks, with white heightening, on white paper, 160 × 136 mm.; the *verso* shows a woman, also a *putto*. I am grateful to Mr. K. Andrews for permission to publish this drawing, which I first identified as by Pourbus in 1958; cf. LUGT, LOUVRE, no. 991, pl. v., 'Portrait de Jeune Femme' in red and black chalks on white paper, 215 × 163 mm., inscribed 'Frans Pourbus'.
4. *e.g.* Florence, Pal. Pitti. *Rassegna d'arte*, V, 85.
5. JAFFÉ 1961 III, 374, fig. 3. The inscription identifying the sitter in the San Francisco portrait has been questioned by C. Norris, *Burl. M*, CXVII, 1975, 73–7, in the course of identifying the sitter in another fragment cut from the *Gonzaga in adoration of the Trinity*, despite the evidence of P. Litta, *Famiglie celebri italiane*, Fasc. XXXIII, Milan 1835. Tav. XXI, no. 28 (a medal lettered 'Francesco IIII', in the Musco di Milano), and of LUZIO, pl. preceding p. 49 (a drawing in the Codice Fioreta of 1603).
6. Rome, S. Carlo al Corso. GERSON, 56, pl. 62.
7. Saltram House (National Trust). JAFFÉ 1961 III, 374–8, fig. 1.
8. Verona, Museo Civico. KdK, 18; OLDENBOURG, 54–5.
9. Zurich, Private collection. First recognized by Dr. J. Müller-Hofstede. A portrait, probably of this character, is recorded in Bathoe's catalogue of Charles I's pictures: 'no. 68. A MP (*i.e.*'Mantua Piece') by Rubens. A woman's picture in a black habit and scarf, said to be done by Rubens when he was in Italy; in a wooden frame – L.2f5. B.1g7' (LUZIO, 173).
10. MAGURN, no. 12.
11. Florence, Pal. Pitti. L. Burchard, *Pinacoteca*, July/August 1928, 12.
12. CDR I, 249, no. 2, 372, 436.
13. Berlin, Kupferstichkabinett. JAFFÉ 1970 IV, no. 7.
14. Florence, private collection. R. Longhi, *Paragone*, 1963, no. 165, 3–11 repr.
15. London, British Museum. HELD, no. 86, pl. 97.
16. JAFFÉ 1968, 187, quotes Lerma Archives, C. 23–62, for 8 July 1606, in the Gallery of the Rivera Palace at Valladolid: 'El Retrato del Duque nr. Sn. a caballo de quatro varas de alto' at 5500 reales. In the same gallery were the 7 canvases of the *Planets* (at 350 reales) and 8 of the *Creation* (at 4000 reales) – that is, the Facchetti copies after Raphaels in Rome. The *Planets* are now in the office of the Director of the Prado Museum, as Dr. Xavier de Salas kindly informs me.
17. Norris, *loc. cit.*
18. KdK, 334.
19. CDR I, 393.
20. Berlin, Staatl. Museen; and Washington (D.C.), National Gallery of Art. JAFFÉ 1965 V, 43, figs. 7, 8, 10, 15.
21. Washington (D.C.), National Gallery of Art. GORIS-HELD, no. 2, pl. 14; C. Seymour, *Art Treasures for America: an anthology of paintings and sculpture in the Samuel H. Kress Collection*, London 1961, 144, pls. 135, 136 (colour).
22. New York, Pierpont Morgan Library (1975.28), presented anonymously. Black chalk and brown ink, on white paper, 315 × 178 mm. *London 1950*, no. 55. Sold by Dr. Schilling's widow to a New York collector. The face in the drawing could be Brigida's own, not yet glamourized for the painting.
23. Stockholm, Nationalmuseum. JAFFÉ 1961 III, 374–7, figs. 6, 7, and JAFFÉ 1965 IV, 380. These arguments are overlooked by Norris, *loc. cit.*
24. JANSON 45–56, pls. 66–76.
25. Kingston Lacy, Mr. Ralph Bankes. EVERS I, Abb. 31; and see note 27 below.
26. POPE-HENNESSY, II, fig. 96.
27. J. Lauts, *Staatl. Kunsthalle Karlsruhe. Kat. Alte Meister bis 1800*, Karlsruhe 1966, no. 2505.
28. see *ibid.*; Buscot Park, Faringdon collection (National Trust).
29. Kingston Lacy, Mr. Ralph Bankes. L. Burchard, *Jahrb. der preuss. Kunstsammlungen*, L, 1929, 319.
30. Munich, Alte Pinakothek. EVERS I, Abb. 38.
31. Florence, Pal. Comunale. *London 1950*, 61, argues for the sitter being identified as Marchese Giacomo-Massimiliano Doria, rather than his brother Gian Carlo: but MUELLER HOFSTEDE 1965 II argues again for the identification as Gian Carlo, with the surprisingly early date of *c.* 1602.
32. Madrid, Prado. KdK, 377. A *pentimento* of a couched lance, projecting from under the Infante's right arm, shows in the *modello* painted by Rubens for this portrait (Detroit, Institute of Art), and reflects Rubens's inspiration from Titian's *Charles V at Muhlberg*.

33. POPE-HENNESSY I, 105–6, fig. 138: 'conforme a unos retratos de Pedro Pablo Rubens'.

34. *ibid.*, 106.

35. Berlin, Staatl. Museen, Kat. Nr 776 E. KDK, 355 (as 1630–5); GLUECK, no. 15 (as 1628–30). The suggestion of EVERS I, 505 no. 420, that the subject is *The Shipwreck of St. Paul* (*Acts* 28, 3–6) is at odds with the identification published by Hendrickx and S. a Bolswert in the lettering of the engraving, an identification which is more likely to follow Rubens's own (see note 36 below).

36. v. d. WIJNGAERT, no. 110, dedicated by Gillis Hendrickx to Gevartius, with verses from *Aeneid* III, 194–9.

37. M. Waddingham, *Burl.M.*, CXIV, 1972, 96–7, fig. 52. The painting is dated 1608 on the back.

38. v. d. WIJNGAERT, no. 82; GLUECK, no. 40 (repr.).

39. GLUECK, no. 11.

40. CDR I, no. LXVII.

Chapter 10

1. M. R. Scherer, *Marvels of Ancient Rome*, London 1955, pl. 147. B.XIV, 268, no. 353.

2. B.XIV, 268, no. 353.

3. A. Reichel, *The Chiaroscurists of the XVI–XVII–XVIII Centuries*, Cambridge 1939, 7 pl. 37.

4. H., 147, 145.

5. London, British Museum. MAGURN, no. 239; VDIS, fols. 50 *v*., 51 *r*.

6. EVERS I, 30, Abb. 6. This first illustration, engraved by C. Galle, was reissued in Albert Rubens, *De Re Vestiaria Veterum*, Antwerp 1665. Philip Rubens attests Peter Paul's work in preparing the illustrations, on p. 122 of the *Electorum Libri duo.*

7. v. d. WIJNGAERT, no. 240; *London 1950*, nos. 10, 11.

8. *London 1950,* under no. 11.

9. *London 1950,* under no. 9.

10. MUELLER HOFSTEDE 1965 II, 76, 78, figs. 6, 7.

11. M. Winner, MD, I/3, 1963, 34–7, pl. 20 published a chalk drawing in the Berlin Kupferstichkabinett of a figure posed in the attitude of the *Crouching Venus*, after Doidalsas, which was formerly in the Cesi collection and is now in the Museo delle Terme. See also *idem, Zeichner sehen die Antike. Europäische Handzeichnungen 1450–1800,* Berlin-Dahlem 1967, Kat. Nr. 66, Taf. 37.

12. Paris, Louvre. KDK, 254.

13. Kreuzlingen, collection Heinz Kisters. Oils on panel, I am grateful to Herr Kisters for permission to publish this painting, which was bought by J. Weitzner from Sotheby's in July 1966, and sold to him. Another autograph version is Prado, no. 1666, oil on canvas, 136 × 165 cm.

14. Antwerp, Mus. Roy. des Beaux Arts. KDK, 70.

15. London, Duits. JAFFÉ 1967 I, 3–13 (repr.).

16. London, private collection. See chapter 8, n.35. For another drawing, in the British Museum, see BURCHARD-D'HULST, no. 16.

17. London, Thos. Agnew & Son. See also STECHOW, 29, figs. 14, 15.

18. Munich, Alte Pinakothek. STECHOW, fig. 17.

19. Milan, Ambrosiana. FUBINI-HELD, 123–41.

20. e.g. *Cantoor,* nos.752, VI, 81. STECHOW, 63–5, figs. 52, 53, discusses and illustrates Rubens's *Daughters of Leucippus* (Munich, Alte Pinakothek) in relation to *The Dioscuri* marble groups.

21. British Museum, 1970-9-19-103. *Amsterdam 1933,* no. 92 reproduces only the *recto*, with the head and forequarters of the bull. The drawing was then in the collection of L. Ustinow, whose family heirs sold it to the British Museum.

22. VDAS I, pls. LXVI, LXVII.

23. VDAS I, 40, 93 no. 56.

24. VDAS I, pls. X, XII.

25. New Rochelle (N.Y.), Miss Kathi Baer. *Cambridge (Mass.)/New York 1956*, No. 24, pl. XIV. Collections: Nathan, Marseilles; George Isarlo, Paris; acquired by Curtis O. Baer, 1952; by descent to the present owner.

26. SEILERN, no. 53, pls. CIV, CV.

27. BAUDOUIN, 52, figs. 21, 22.

28. LUGT, LOUVRE, no. 1013, Pl. XV.

29. Antwerp, Rubenshuis. STECHOW, 25, figs. 11, 12.

30. VDAS I, 65, pl. XXX.

31. Oakly Park, Shropshire, the Earl of Plymouth. Black chalk on white paper, 359 × 235 mm, inscribed by Rubens 'acht de Lyf'. Bought on 'the grand tour', with 69 other drawings and prints, by the Hon. Robert H. Clive (1789–1854), son of the 1st Earl of Powis; by descent to the present owner. Hitherto unpublished.

32. Cambridge, Fitzwilliam Museum. Black chalk on white paper, 285 × 216 mm; inscribed by a later, perhaps seventeenth-century hand, 'dall'antico' and, by a third hand, 'di Piero Paulo Rubens 1°'. Hitherto unpublished. See H. Stuart Jones, *A Catalogue of the Ancient Sculptures preserved in the Municipal collections of Rome, the Sculptures of the Palazzo dei Conservatori,* Oxford 1926, 13, no. 19. Rubens shows the foot as it appeared before being mounted on its present pedestal in 1635. I am indebted to Mr. R. V. Nicholls for this reference.

33. New York, Mr. Emile E. Wolf. Black chalk on white paper (watermark: rampant lion), 216 × 276 mm, inscribed in ink '302' by a later hand. Backing the mount is a list with accounts for 'Aout 1731'. The drawing was bought by the present owner in Paris. It may have been in France since the early 18th century. Hitherto unpublished.

34. VDAS. MS. Johnson, fol. 112 recto, inscribed 'circa Nilum in hortis Vaticanis'. REINACH I, 535 and 138.

35. Milan, Ambrosiana. STECHOW, 37–9, fig. 24.

36. For an instance of Rubens's use of this group see *The Worship of Ceres* in the Hermitage (KDK, 83).

37. Dresden, Staatl. Kunstsammlungen. Black chalk (*recto* and *verso*) on white paper (watermark unidentified), 260 × 183 mm. This sheet was identified by me in an album of anonymous drawings.

38. See note 10 above.

39. Moscow, Pushkin Museum. JAFFÉ 1961 II, fig. 12.

40. *ibid.*, 12–13, fig. 11.

41. Los Angeles, Norton Simon; Paris Louvre. KDK, 52, 79, 260.

42. New York, Metropolitan Museum. *Cambridge (Mass.)/New York 1956*, no. 1, pl. II.

43. Paris, Louvre. KDK, 261.

44. Paris, Louvre. KDK, 254.

45. Leningrad, Hermitage. *Dresden 1970,* no. 65, Abb. p. 60.

46. Leningrad, Hermitage. KdK, 90.
47. Paris, Louvre. KdK, 259.
48. Moscow, Pushkin Museum. STECHOW, 28, fig. 13.
49. v. d. WIJNGAERT, no. 557, 20.
50. Rotterdam, Museum Boymans-van Beuningen. *Rotterdam 1953*, no. 62.
51. Orléans, Musée. Hitherto unpublished. A drawing with another view of this statue is discussed by FUBINI-HELD, 141, pls. 9a, b.
52. Berlin, Kupferstichkabinett. BURCHARD-D'HULST, no. 12. The rediscovered marble statue, headless, is now in the Ashmolean Museum, Oxford.
53. Paris, Louvre. KdK, 254.
54. Paris, Fondation Custodia. *London/Paris/Berne/Brussels 1972*, no. 77, pl. 36.
55. Oakly Park, Shropshire, the Earl of Plymouth. Black chalk on white paper, 387 × 257 mm. Provenance: see note 31 above. Hitherto unpublished. I am grateful to Lord Plymouth, in whose portfolio I identified both these drawings in 1965, for permission to publish them here.
56. VDAS I, 37, pl. XXIII.
57. Paris, Fondation Custodia. Black chalk, touches of white chalk, on white paper, 194 × 157 mm. From the Fairfax Murray collection. As M. Lugt pointed out to me, the subject is close to the 5th century B.C. bronze in the Museo Archeologico, Florence.
58. London, heirs of Leo Franklyn. The drawing was in the V. Koch Sale, Sotheby's, 26 June 1949 [111]. MUELLER HOFSTEDE 1965, 292–3, Abb. 211.
59. London, formerly Mr. John Brophy. Black chalk with brown ink and pen, on white paper, 255 × 205 mm. I am grateful for permission to publish here this drawing which I identified in August 1965.
60. VDAS I, pl. XXXVII; BYAM SHAW, no. 1372.
61. Leningrad, Hermitage. *Brussels/Rotterdam 1972/73*, no. 82, pl. 83.
62. VDAS I, 17, 20, 301.
63. LUGT, LOUVRE, no. 1097, pl. LI. Johann Faber described this twin-bust in his commentary to Th. Galle, *Illustrium imagines ex antiquis marmoribus numismatibus et gemmis expressae*, 1606 (1st edn. 1598).
64. Moscow, Pushkin Museum, inv. no. 6208. Black chalk on white paper, 294 × 196 mm. Collection: J. Richardson snr. (L.2183).
65. The 'Seneca' is generally regarded today as a Hellenistic representation of Hesiod.
66. v. d. WIJNGAERT, no. 746. Rubens's pen drawing for this engraving is now in New York, Metropolitan Museum (R. Lehman collection).
67. v. d. WIJNGAERT, no. 240.
68. OLDENBOURG, 46, Abb. 22.
69. The 5th plate in the book.
70. London, British Museum.
71. Chicago, Art Institute. STECHOW, 32–4, figs. 18, 19.
72. Rotterdam, Museum Boymans-van Beuningen. BURCHARD-D'HULST, no. 94; HELD, no. 159, pl. 168. The former authorities do not mention the Roman version of the sarcophagus relief, now in the Museo delle Terme; the latter does not mention the versions in Mantua, Florence and Amalfi.
73. London, Courtauld Institute of Art (Witt Collection).

74. Dresden, Kupferstichkabinett. *Dresden 1970*, no. 64, figs. on pp. 58, 59.
75. STECHOW, 34, fig. 20 (the *Drunken Hercules*, Dresden). The original of the Sanssouci version of *Hercules overcoming the Nemean Lion* (Rooses III, 102, no. 619) has been since 1970 with R. van de Broek, Brussels, oils on canvas, 196 × 173 cm. LUGT, LOUVRE no. 1012, pl. XV, catalogues a sanguine drawing prepared by Rubens for the head and torso of Hercules in this composition.
76. M. Cagiano de Azavedo, *Le Antichità di Villa Medici*, Rome 1951, 65, no. 49, pl. XXVI.
77. STECHOW, fig. 21.
78. Dorset, private collection. JAFFÉ 1965 IV, 381.
79. JAFFÉ 1969 II, 649, figs. 7, 8.
80. HIND II, 55–87.
81. Ephrata (Pa.), Mrs. Karl J. Reddy. Brown ink and white, brown, yellow and grey body colours, the background washed black, 61 × 49 mm., on sized card. Inscribed on the verso, 'P. P. Rubens fecit Roma/coll: H. Hemelaer'. Rubens's treatment of Alexander's hair, especially the forelock, differs from that reproduced, in reverse, by Theodoor Galle for Fulvius Ursinus, *Illustrium Imagines*, Antwerp 1598 (2nd edn. 1606), as 'Apud Fulvium Ursinum in numismate argenteo'. The fame of this coin was further promulgated in Rubens's lifetime by Q. *Curtii Rufi, Historiarum libri accuratissime editi* (Lugd. Batavorum, Elzevir 1633). It appears there, reversed again to its true sense; and an illustration of a coin is especially remarkable as a rarity for an Elzevir publication of a classical text.
82. Th. Galle, *op. cit.* (1598 edn.).
83. Th. Galle, *op. cit.* (1606 edn.).
84. Amsterdam, Rijksprentenkabinet. JAFFÉ 1969 II, 644.
85. *ibid.*
86. Th. Galle, *op.cit.* (1606 edn.).
87. MAGURN, no. 123.
88. Abbé Eckel, *Choix des Pierres gravées du Cabinet Impérial des Antiques*, Vienna 1788, 28–30, pl. X.
89. Florence, Palazzo Pitti.
90. JAFFÉ 1970 I, 21–3, fig. 23, 25.
91. CDR III, no. CCCXXXIV.
92. *Antwerp 1971*, no. 64, Afb. 8.
93. C. Norris, *Phoenix*, III, 7–8. Amsterdam 1948, 1788–188, afb. 5.
94. HIND II, no. 53. Rubens's pen drawing is inscribed by him 'grandezza della Pietra' against the oval showing the actual size of the cameo now in the Bibliothèque Nationale in Paris.
95. Baltimore, Walters Art Gallery. JAFFÉ 1969 II, 641–4, figs. 1, 2.
96. G. Bruns and A. Fink, *Das Mantuanische Onyxgefäss*, Kunsthefte des Herzog Anton Ulrich-Museums, Heft 5, Brunswick 1950.
97. JAFFÉ 1969 II, 646–9, figs. 4, 5, 6.
98. MUELLER HOFSTEDE 1965, I, 284; and *idem* 1965, II, 78–9, Abb. 8–12, where his Abb. 13 illustrates, in reverse, an anonymous engraving from an antique bronze of *Hercules pissing* (A.-C. Ph. de Caylus, *Recueil des Antiquités Romaines*).
99. *Cantoor* III, 51. Pen with brown ink on mealy paper, 158 × 66 mm. The figure was known to Rubens in Mantua. REINACH I, 589, no. 2473.

100. MUELLER-HOFSTEDE 1965, 284–6, Abb. 204–7.

101. *Dresden 1970*, no. 61 (repr.). Identified by me in 1967; among the anonymous Italian drawings (II Garnitur).

102. Leningrad, Hermitage, inv. no. 29783. Black chalk on white paper, 182 × 257 mm. Inscribed, lower right, 'P. P. Rube(ns)'. Identified by me in the so-called 'Livre d'Architecture' in 1959.

Chapter 11

1. For the documentation of this chapter, consult JAFFÉ 1959; also additional information published by G. Incisa della Rocchetta, *Atti della Ponteficia Accademia Romana di Archeologia* III, Rendiconti XXXV, 1963, 161–83. See also J. Müller-Hofstede, *Nederlands Kunsthistorisch Jaarboek*, 17, 1966, 1–78, and J. S. Held, *Burl. M.*, 1976, 776.

2. CDR, I, 303–5.

3. *Archivio Gonzaga* (Arch. di Stato, Mantua), Busta 2704. Gio Batt. Tessis was the special agent of Fabio Gonzaga in Rome.

4. *Arch. Gonzaga*, Busta 981.

5. MAGURN, nos. 13 and 14. The letters are written and signed in Peter Paul's name by Philip Rubens, but surely at the younger brother's dictation.

6. CDR, I.

7. cf. K. Gerstenberg, *Zeitschrift für Kunstgeschichte*, 1932, 109ff. modified by EVERS II, 321 ff.; also G. Gabrielli, *Bolletino d'Arte* 1928, 602 ff.

8. *Arch. Chiesa Nuova*, IV de' Decreti della Congr. dell'Oratorio, II, sec. 2. One of these gentlemen who came forward for the painter was presumably Mons. Jacomo Serra.

9. ROOSES, no. 205.

10. *V. de'Decreti*, 290.

11. III. de'Decreti, 35: *A di 28 giugno 1595. In Congregatione di tutti li Padri s'è concluso si facci l'ornamento all'altare grande con la confessione all'antica per mettere li corpi santi (i santi prima), con martiri Papia e Mauro protettori della Congregazione ivi transportati da S. Adriano cinque anni prima), con l'elemosina ch'il Sig. Cardinale Baronio vol dare per questo: con doi conditioni, la prima che tal'ornamento et confessione si facci col parere del Sig. Cardinale di Firenze, la seconda che ogni volta che Monsig. Rm. di Todi (Angelo Cesi) volesse rendere li danari spesi in detto ornamento et confessione et metere l'arme sue, il sig. Cardinale si contenta, volendo che colli danari spesi si impieghino in ornamento et in sfondare una cappella, come quelle che hoggi sono sfondate, . . .'*

12. L. Ponnelle and L. Bordet, *St. Philip Neri and the Roman Society of his times* (trans. R. F. Kerr, London 1932), 416.

13. See note 11 above.

14. *Arch. Chiesa Nuova*, I, fol. 318. *'Essendo che li mese passati dal R. P. Artemio Vannini da Siena fu proposto al Rettore della Congregazione dell'Oratorio nella chiesa nuova di pozzo bianco di Roma l'infrascritto partito a benefizio di detta chiesa, et dell'infrascritto pittore, cioè che Un Prelato di questa corte di Roma si per far opera di charità verso la detta chiesa come per far conoscere il valore di un Pittore nominando da Sua Signoria Rma, offeriva dare scudi trecento di moneta del suo proprio per parte di quanto fosse poi stimata l'opera compita che alla fosse, et altri 200 simil della medesima stima offeriva rimettere, et rilassare del suo il medesimo pittore at utilità di essa chiesa, et successivamente essendo che sia stato proposto e trattato detto partito dal detto Rettore fra li preti di detta congregatione, et sia*

stato accettato con rendimento di molte gratie al Prelato benefattore con l'infrascritte conditioni, et 1° che sia loro dato sodisfattione prima d'ogni altra cosa poter vedere qualche opera fatta dal Pittore nominando 2° che il quadro da farsi dal detto Pittore in detto altar maggiore, sia conforme a quello, che da essi Preti li sarà ordinato, et al disegno che esso Pittore doverà prima farne, e mostrar loro 3° che non piacendo loro l'opera compita, non siano obligati pigliarla, ma possino liberamente relassarla ad esso Pittore. Ultimo che sodisfacendo, et risolvendosi pigliarla non siano obligati pagarli quel di più, che sarà stimato da due Pittori intelligenti oltre li sopradetti trecento scudi, e remissione di parte di essa stima, come di sopra, ma siano tenuti solamente farli un donativo secondo che piacerà e parerà loro conveniente et finalmente essendo, che il predetto Pittore si sia contentato delle condizioni proposte, ed. dichiaratione però che il Prelato non intenda usare la detta charità di 300 scudi, so non in evento che si conceda di fare il quadro detto al predetto Pittore, ma quando per qualche causa non vada avanti il partito non intenda il detto Prelato fare la detta elemosina. Item che la dichiaratione da farsi da essi Padri circa l'opera, finita che ella sarà, se piace loro o non piace, la vogliono, o non vogliono, si faccia prima che l'opera sia esposta in publico sopra il predetto altare ma doppo che l'haveranno esposta in publico non sia più lecito loro rifiutarla, et che non contentandosi li detti Preti stare alla stima di detti dui Pittori come è consueto; nel qual caso si contentarà il detto Pittore di rimettere scudi 200 della stima. Ma contentandosi solo di far un donativo, questo donativo si dichiari per dui gentilhuomini o dui Cardinali da eleggersi uno per parte, et alla loro dichiaratione l'una e l'altra parte debba stare. Di qui è che hora volendo il Sr Pietro Paolo Rubenio – fiammengo Pittore nominato dal predetto P. Artemio in nome del predetto Monsre et li predetti Rettore, et il P. Prometeo Procuratore di detta Congregatione, stabilire, e fermare detto partito, per la presente poliza, quale vogliono che habbia forza di Instrumento publico, et si possa stender con tutte le clausule, obligationi, et cautele contenute nel più ampia forma di obligatione Camerale, promettono a nome di detta Congregazione dare, et danno a dipingere al detto Sr Pietro Paolo il detto quadro del detto altar maggior della detta loro chiesa secondo il disegno, o sbozzo mostrato loro dal Sr. Pietro Paolo, nel quale da un lato sono li SSti Martiri Papia, e Mauro, dall'altra li SSti Nereo, et Achilleo, et flavia Domitilla, in mezzo S. Gregorio Papa, di sopra la Madonna Sma. con molti altri ornamenti et compito che sarà riuscendo a sodisfattione di detta loro Congregatione, subito che da quella sarà accettato ed approvato, inanzi che sia esposto in publico, fare e pagare al detto Sr. Pietro Paolo in recognitione della sua charità un donativo di quella qualità, che dichiaranno dui gentilhuomini da eleggersi uno per parte et alla dichiaratione loro stare, et non richiamare, ma sodisfare e pagare secondo quella et all'incontro il detto Sr. Pietro Paolo promette dare il detto quadro compito come di sopra a tutte su spese fra termine di otto mesi pigliando sopra di se il peso e pericolo di riscuotere li 300 scudi dal predetto Monsignore, promettendo per quelli non molestrare in alcun tempo li detti preti e Congregatione et relassa liberamente non solo li sudetti trecento scudi da riscuotersi, come sopra ma ancora 50 scudi del vero et giusto valore di detto quadro, contentandosi del detto donativo secondo che sarà dichiarato dai predetti dui gentilhuomini da eleggersi come di sopra anchora degli Azzuri et in fede re in Roma questo giorno XXV di 7bre 1606.

Io Flamminio Riccio Rettore Prometto ed Confermo quanto di sopra/Io Prometeo Peregrini Procuratore prometto et confermo come sopra/Io Pietro Paulo Rubenio prometto et

confermo come sopra/Io Germanico Fedeli fui presente a quanto di sopra/Io Gio. Battista Pio fui presente a quanto sopra'.

15. Ponnelle and Bordet, *op.cit.*, 421. Father Peregrini was admitted at the Vallicella in February 1589.

16. *ibid.*; Father Vannini was admitted in September 1588. Like Fathers Ricci and Peregrini, he was thus a direct follower of S. Filippo Neri.

17. CDR, I, 376–7.

18. A. Pinchart, *Bulletin Rubens*, I, Antwerp 1880, 109, 111, transcribes these documents.

19. CDR, I, 380.

20. *IV de' Decreti*, entries for 4 February and 9 September 1604.

21. *Arch. Gonzaga*, Busta 2708, unpublished letter of 21 July 1607 from Annibale Iberti at San Pier d'Arena to Duchess Eleonora of Mantua. Nicolò Pallavicini married Maria d'Antonio Serra.

22. *Arch. Gonzaga*, Busta 2692. Letter of 14 August 1603 from Chieppio in Mantua to Iberti in Spain.

23. Denis Mahon, *Studies in Seicento Art and Theory*, London 1947, 67–71, and 87.

24. CDR, I, p. 404: '*Et la grandezza de la tavola non è tanto essorbitante, che sia per occupare gran loco, per essere stretta ed alta.*'

25. *IV de' Decreti*; the entry for 17 August 1605 indicates that the heads were in position.

26. *Arch. Gonzaga*, Busta 981. '*In mano mia si trova la somma di scudi settanta intorno, come sta annotata in detto conto, quale io supplirò sino alli 75, a ciò servare di tre mesati al Signor Pietro Pauolo Rubens*'.

27. CDR, I, 354–5; MAGURN no. 14, '*Offerendosi dunque la più bella e superba occasione di tutta Roma mi spinse ancora zelo d'honore a prevalermi della mia sorte. Quest'è l'altar maggiore de la Chiesa nuova delli Preti dell'Oratorio detta S. Maria in Vallicella, senza dubbio hoggidi la più celebrata et frequentata chiesa di Roma per esser situata giusto nel centro d'essa et adornata a concurrenza di tutti i più valenti pittori d'Italia, di maniera che ancora che detta opera non fosse cominciata vi sono interessati personaggi di tal qualità ch'io non potrei con honore lasciar un impresa ottenuta con tanta gloria contra le pretentioni di tutti li primi pittori di Roma, et farei grandissimo torto alli miei fautori che resteranno disgustatissimi*'.

28. A. Seilern, *Burl. M.*, December 1953, 380–3.

29. *V. de' Decreti*, entry for 14 July 1614.

30. CDR, I, p. 413. According to Baglione, Caravaggio was so jealous of Pomarancio's success that in 1605 he attempted to have him assassinated in Rome.

31. Philip Pouncey, *Burl. M.*, December 1952; and a letter from the same writer in the same journal, March 1953, 100.

32. W. Friedländer, *JWCI*, VII, 152ff., discusses Reni in Rome in the first decade of the Seicento.

33. CDR, I, 362ff.

34. *Ibid.*, 373–4; '*come forestiere et sotto ogni altro pretesto che non iscoprisse il pensiero del contratto*'.

35. *Ibid.*, 375–7; MAGURN, no. 16.

36. *IV. de' Decreti*, 264, 290 and *Liber* v, pp. 17, 22, 23.

37. R. Longhi, *La Galleria Borghese*, Rome 1928, 201.

38. E. Larsen, *Revue Belge d'Archéologie et d'histoire de l'art*, XVIII, 1949, 169–75. See also *The Armand Hammer Collection, University of Southern California*, Los Angeles 1965,

48 repr. This painting (canvas, $32\frac{1}{4} \times 24\frac{1}{4}$ in.) has suffered from overcleaning, and compression of the surface in a clumsy relining. A painting of the same subject, attributed to Rubens, was lot 31 in the Richard Cosway sale in London in 1791: 'Venus taking a thorn out of her foot, with Cupids, whose various appropriate occupations are most happily conceived and expressed. This beautiful sketch was left by Mr. Taverner, at his decease, to Athenian Stuart.' The dilettante William Taverner died on 20 October 1772, and James Stuart lived until 1788. This painting may relate closely to the one in the Hammer Collection.

39. Madrid, Prado, no. 1731. See JAFFÉ 1968, 179–80, fig. 10.

40. G. Galenzio, *La Vita e gli scritti del Cardinale Cesare Baronio*, Rome 1907, 807.

41. *Arch. Gonzaga*, letter of 24 August 1607 from Duke Vincenzo I at San Pier d'Arena to Duchess Eleonora: '*Io mi partirò dopo domani*'.

42. CDR, I, 387–90.

43. *Amsterdam 1933*, no. 836.

44. *IV. de' Decreti*, 164, sec. 6.

45. CDR, I, 401ff. See also *op.cit.*, 361, for the commission given by Thomas, brother of Didacus del Campo, on 19 October 1598 to Wenceslas Cobergher.

46. For further notice of Rubens's interest in Sebastiano, see I. Q. van Regteren Altena, *Burl. M.*, June 1940, 199. BAGLIONE, 110, also describes how Cardinal Baronius's favourite painter, Francesco Vanni, also used slate as a support for oil painting in a Roman church.

47. *Arch. Arcivesc. Fermo*.

48. *ibid.*

49. CDR, I, 412–13.

50. *Arch. Arcivesc. Fermo*, true copy in P. Ricci's hand of Rubens's declaration of 9 March 1608.

51. E. Strong, *La Chiesa Nuova*, Rome 1923, 96.

52. *IV. de' Decreti*, 173, sec. 3.

53. *Arch. Arcivesc. Fermo*, letter of 12 March 1608, Ricci-Francellucci.

54. *Arch. Arcivesc. Fermo*, letter of 31 May 1608. Padre Blasio was P. Biagio Betti; see BAGLIONE, 318–19.

55. The Ferman Congregation had 500 scudi to spend on the chapel of the *Nativity*, of which a substantial part must have been spent on the tabernacle. The pediment, and the socles bearing the Costantini arms, are of Istrian stone; the Corinthian columns of *giallo antico*. For a comparison of recent prices of altarpieces sent from Rome, cf. *The Martyrdom of St. Lawrence* ordered from Federico Zuccaro by Astorio Calvucci, a friend of the Capuchins in Fermo. Zuccaro had fixed the price at 600 scudi, but had offered to surrender half as an act of charity to the Capuchins. He eventually accepted 200 for the work, which was delivered sometime before 1604. See P. Fulgenzio da Lapedona, 'I Conventi dei Cappuccini a Fermo', in *Italia Francescana*, Rome 1952.

56. *Arch. Arcivesc. Fermo*, letter of 7 June 1608, Ricci to Francellucci.

57. *ibid.*, letter of 9 July 1608, Ricci to Francellucci. This method of suspension adopted is described in the *Inventario della Congregatione dell'Oratorio di S. Filippo Neri della Città di Fermo*, March, 1729.

58. *Arch. Arcivesc. Fermo*, letter of 16 July 1608, Ricci to Francellucci.

59. *IV. de'Decreti.*
60. The tip is meagre. Was Deodati del Monte the 'servitore' intended?
61. BAGLIONE, 321–31.
62. Berlin, Staatl. Museen. Canvas, 146 × 119 cm. See *Rotterdam 1953*, no. 3; and JAFFÉ 1959, no. 78. J. Müller-Hofstede, *Burl. M.* CVI, 1964, 442–50, sought to establish as a second, autograph trial piece a painting now in the Museum des Siegerlandes (Inv. Nr. R-207), which K. Arndt, *Kunstchronik* XI, 1958, 355, had published correctly as a copy of the Berlin painting. Doubt that the damaged painting in Siegen can have been autograph is shared by CRLB VIII. 2, no. 109r, fig. 26.
63. Montpellier, Musée Fabre, No. 3704. JAFFÉ 1959, no. 89, tav. 13–16. Vlieghe in CRLB VIII. 2, under no. 109f., asserts that 'I cannot accept his (Jaffé's) attribution to Rubens of this sheet which in my opinion should rather be regarded as a somewhat free adaptation of the Roman altarpiece" He chooses not to cite J. Müller-Hofstede, *Burl. M.*, CVI, 1964, 442–50, in support of my view.
64. Whereabouts unknown. Weinmüller (Munich) sale, 13–14 October 1938 (612), charcoal on *carta azzurra*, 190 × 27 mm. This drawing is known to me only in reproduction.
65. SEILERN, no. 14, pl. XXXIII, and *idem, Corrigenda and Addenda*, London 1972, 22–3.
66. GLUECK-HABERDITZL, no. 54. discuss the pen and wash drawing; V. PUYVELDE, no. 5, the painted modello in the Vienna Akademie; and JAFFÉ 1959, appendix, the drawing in chalks in Moscow, Pushkin Museum, inv. no. 7098, which is the original of LUGT, LOUVRE, no. 1008.
67. GLUECK-HABERDITZL, nos. 51 and 52. These authorities are incorrect in stating that these highly mannered, but autograph, drawings by Rubens are omitted by ROOSES. Their no. 51 is his no. 1450, part of Lot 1023 in the P. J. Mariette sale, Paris 1775.
68. Chantilly, Musée Condé. *ibid.*, no. 53.
69. OLDENBOURG, pl. 23, was the first to recognize the authorship, and to comment on the Juno-like features of this imposing study. Cf. also J. B. Descamps, *Vies des peintres Flamands*, Paris 1753, I, 319, writing of Peter Paul's first altarpiece for the Chiesa Nuova, 'On prétend que la tête d'une Sainte Catherine de ce tableau étoit d'après celle d'une courtisanne fort belle et fort connue.'
70. J. S. Held, *Magazine of Art*, November 1951, 290, fig. 10, as *c*. 1606 (following the dating for the altarpiece proposed by R. Longhi, *Vita Artistica*, II, 1927, 191–6, and *idem, Pinacoteca*, I, 1928, 169–70).
71. *The Armand Hammer Collection. University of Southern California*, Los Angeles 1965, 49, repr. This painting (oils on canvas, 32 × 24½ in.) is there regarded as a model for the Fermo *Nativity*, and identified with a painting of the subject in the collection of Ferdinando Carlo, last Duke of Mantua, in 1709. Neither view can be confidently sustained on the evidence presently available.
72. JAFFÉ 1965 I, 28–9, pl. 23.
73. JAFFÉ 1954 II.
74. CDR, I, 432: 'sono sicuro di trovarli qualche buon recapito in Roma istessa'.
75. CDR, VI, 324.

Chapter 12

1. *Arch. Arcivesco Fermo*, letters of 23 February and 12 March 1608, Ricci to Francellucci. Quoted in full, chapter XI (schooled from his youth in Rome'; 'not one of those who slack off').
2. Mancini, 'Discorso di Pittura', (1631), f. 30v.
3. G. B. Marini, *La Galeria*, Venice 1619 ('E del poeta il fin la meraviglia/Chi non sà far stupor vada alla striglia').
4. CRLB, VIII. 1, nos. 68, 69, figs. 119, 120; WITTKOWER, no. 20, pl. 40, discusses the *S. Bibiana*.
5. V. D. WIJNGAERT, no. 109.
6. WATERHOUSE, 164, fig. 141, discusses the Palazzo Pitti painting, mentioning the debt to Andrea del Sarto but not to Rubens.
7. J. S. Held, in *Rubens before 1620*, Princeton 1972, 93–126.
8. JAFFÉ 1953, 131–6.
9. WITTKOWER, no. 23, fig. 28.
10. Philadelphia, Museum of Art. DUBON gives a full discussion, but does not investigate the possible influence of Rubens on Pietro da Cortona.
11. WATERHOUSE, pls. 39, 43; both in the Capitoline Gallery.
12. For the Savoy set, now in Turin, Pal. Reale, see *Ottawa 1968,* under no. 192: for the Gonzaga set, see LUZIO, 318.
13. Bibl. Ambrosiana, Cod. Resta (F.261 Imp. fol. 166). See also S. van Hoogstraten, *Inleyding tot de Hooge School der Schilderkonst*, Rotterdam 1678, V, 193, and de PILES.
14. BURCHARD-D'HULST, 183. Plausibly identified as Gelande Habert.
15. G. Fubini and J. S. Held, MD, II. 2, 1964, fig. 1, published, in disregard of a written agreement drawn by the Avvocato Fubini between him and myself and witnessed by the Prefect at the Ambrosiana, the album Fubini called first to my attention.
16. Rome, Galleria Nazionale. WATERHOUSE, fig. 29.
17. New York, Metropolitan Museum. GORIS-HELD, no. 44, pl. 34. A second and larger version, likewise autograph, is in the Los Angeles County Museum (GORIS-HELD, no. 45, pl. 36).
18. HELD, 106, suggests that Elsheimer's *St. Christopher* may have been influenced by a missing design by Rubens. For Borgianni's *St. Christopher*, see *Amtl. Berichte aus den Preussischen Kunstsamml.*, 1929, 2, 25.
19. London, Denis Mahon. D. Mahon, *Il Guercino, Dipinti*, Bologna 1968, no. 60.
20. WITTKOWER, no. 38, pl. 71, figs. 64, 65.
21. WATERHOUSE, fig. 182.
22. *ibid.*, fig. 191.
23. *ibid.*, 175 and fig. 150. The Rubens *Feast of Herod* is now in the National Gallery of Scotland, Edinburgh.
24. Oil on canvas, 72 × 103 in. Exhibited Agnew's, London, 1975, *Master Paintings: recent acquisitions*, no. 53 repr.
25. DENUCÉ, Nos. 27 and 28.
26. EVERS II, 123, corrected by JAFFÉ 1967 I.
27. VAN DYCK, KdK, 155.
28. GLUECK, nos. 29, 22. *The Rainbow Landscape* is now in the Wallace Collection, London; *The Return from the Harvest* remains in Florence, Pal. Pitti.
29. Florence, Pal. Pitti. HELD, 15, 80, 124, fig. 5.
30. Paris, Louvre. KdK, 226.
31. G. Campori, *Raccolta di cataloghi ed inventarii inediti*, Milan 1870, 442ff.

32. V. PUYVELDE, no. 22 repr. VDIS, 13v.
33. J. H. Plantenga, *l'Architecture Religieuse dans l'ancien duché de Brabant*, The Hague 1926, section II, brings together most, but not all of the material which remains in the Archives of the Sint Carolus-Borromeuskerk.
34. Cf. GORIS-HELD, no. 63, pl. 50; and Heim Gallery, London, July/August 1967, exhibition reviewed by T. Crombie, *Apollo,* July 1967, 61. The marble tabernacle and the three statues (now dismantled) survive in the parish church of Zundert, N. Brabant.
35. V. d. WIJNGAERT, no. 302. The arch with chamfered corners derives from Michelangelo's Porta Pia; the banded rustication on the columns probably from Serlio; the pavilion is inspired by a window in Serlio, Book VII. Rubens owned editions of Serlio as well as of Vignola.
36. F. Prims, *De Kunst-en Kunstenaarskerk Sint Carolus Borromeus te Antwerpen*, Antwerp 1947, 45 (repr. opp. 40), the sanctuary with a photomontage of *The Assumption* in its intended place.

37. Vienna, Kunsthistorisches Museum. KDK, 206. BAUDOUIN, 57.
38. WITTKOWER, no. 46, fig. 59 and no. 48, pls. 71–5, figs. VI, 63–7.
39. Father Huyssens S.J. (1577–1637) joined the Order aged twenty: but he was not permitted to travel to Italy until he was fifty. He was thus largely dependent on Rubens as a source of first-hand knowledge of Italian architecture, when decisions were taken about the design of the Jesuit church in Antwerp. There the remarkable interior feature of the superimposed arcades along the aisles was inspired by the section of 'Palazzo I' engraved for the *Palazzi di Genova*; the coffered vault in stone was inspired by that of S. Andrea, Mantua. Only in the early designs for the façade, which owed something to Vignola's unexecuted project for the Gesù in Rome, could Huyssens, with Villamena's engraving to work from, have been independent of Rubens. His work for other churches is far less Italianate.

Select bibliography : abbreviations

AB *The Art Bulletin,* A Quarterly published by the College Art Association of America.

ALTENA 1972 I. Q. van Regteren Altena, 'Het Vroegste Werk van Rubens' in *Mededelingen van het Koninklijke Academie voor Wetenschappen, Letteren en Schone Kunsten van België,* XXXIV, Brussels 1972.

Amsterdam 1933 J. Goudstikker, *Catalogus der Rubens Tentoonstelling,* Amsterdam 1933.

Antwerp 1956 L. Burchard and R.-A. d'Hulst, *Tekeningen van P. P. Rubens,* Rubenshuis, Antwerp 1956.

Antwerp 1971 F. Baudouin and R.-A. d'Hulst, *Rubens en zijn Tijd. Tekeningen uit Belgische Verzamelingen,* Rubenshuis Antwerp, Tournai 1971.

AQ *The Art Quarterly,* Detroit

BAGLIONE G. Baglione, *Le Vite de'Pittori, Scultori . . .* Rome, 1642.

B. A. Bartsch, *Le Peintre Graveur,* Vienna 1803–21, 21 vols.

BAUDOUIN F. Baudouin, *Rubens et son siècle,* Antwerp 1972.

BELLORI G. P. Bellori, *Le Vite de'Pittori, scultori ed architetti moderni . . .,* Rome 1672.

BERENSON B. Berenson, *Italian Pictures of the Renaissance. Venetian School,* London 1957, 2 vols.

Bologna 1956 C. Gnudi, G. Cavalli and A. Emiliani, *i Carracci,* Bologna 1956.

Bologna 1975, A. Emiliani, *Federico Barocci,* Bologna 1975

Brussels/Rotterdam/Paris/Ghent 1972-73 J. Kusnetsow and T. A. Tscchovskaya, *Dessins Flamands et Hollandais du XVIIᵉ Siècle du Musée de l'Ermitage, Leningrad et du Musée Pouchkine, Moscou,* Brussels/Rotterdam/Paris/Ghent 1972-73.

BURCHARD-D'HULST L. Burchard and R.-A. d'Hulst, *Rubens Drawings,* Brussels 1963.

Burl. M. The Burlington Magazine, London.

BYAM SHAW J. Byam Shaw, *Catalogue of Drawings by Old Masters at Christ Church, Oxford,* Oxford 1976, 2 vols.

Cambridge (Mass.)/New York 1956 A. Mongan, *Rubens Drawings and Oil Sketches from American Collections,* Fogg Art Museum and Pierpont Morgan Library, 1956.

Cantoor Copenhagen, Kongel. Kobberstiksamling, Rubens-Atelier (Cantoor).

CDR *Codex Diplomaticus Rubenianus,* ed. Ch. Ruelens and M. Rooses, Antwerp 1887–1909, 6 vols.

CRLB *Corpus Rubenianum Ludwig Burchard* (to appear in twenty-six parts) London/New York. I J. R. Martin, *The Ceiling paintings for the Jesuit Church in Antwerp,* 1968. VIII H. Vlieghe, *Saints,* 1972–3. 2 vols. IX S. Alpers, *The Decoration of the Torre de la Parada,* 1971. XVI J. R. Martin, *The Decorations for the Pompa Introitus Ferdinandi,* 1972.

DENUCÉ J. Denucé, *De Antwerpsche 'Konstkamers',* Antwerp 1932.

Dresden 1970 ed. Werner A. Schmidt, *Dialoge, Kopie, Variation und Metamorphose alter Kunst in Graphik und Zeichnung vom 15. Jahrhundert bis zur Gegenwart,* Dresden 1970.

DUBON D. Dubon, *Tapestries from the Samuel H. Kress Collection at the Philadelphia Museum of Art. The History of Constantine the Great designed by Peter Paul Rubens and Pietro da Cortona,* London 1964.

DUSSLER L. Dussler, *Raphael. A critical catalogue of his pictures, wall-paintings and tapestries,* London/New York 1971.

EIGENBERGER R. Eigenberger, *Die, Gemäldegalerie der Akademie der Künste in Wien,* Vienna/Leipzig 1927.

EVERS I H. G. Evers, *Peter Paul Rubens,* Munich 1942.

EVERS II H. G. Evers, *Rubens und sein Werk, Neue Forschungen,* Brussels, 1943.

FIOCCO G. Fiocco, *Giovanni Antonio Pordenone,* Venice 1941.

Frankfurt 1966 Städelsches Kunstinstitut, *Adam Elsheimer* (December 1966–January 1967), Frankfurt 1966.

FREEDBERG S. J. Freedberg, *Painting in Italy 1500–1600,* London 1970.

FRIEDLAENDER Walter Friedländer, *Caravaggio Studies,* Princeton 1955.

FUBINI-HELD G. Fubini and J. S. Held, 'Padre Resta's Rubens Drawings after Ancient Sculpture', MD II. 2, 1964, 123–41.

GBA *Gazette des Beaux-Arts*, Paris/New York 1859–.

V. GELDER J. G. van Gelder, 'The Triumph of Scipio by Rubens', *Duits Quarterly* 8, 1965, 5–20.

GERSON H. Gerson and E. H. Ter Kuile, *Art and Architecture in Belgium 1600–1800*, London, 1960.

GLUECK G. Glück, *Die Landschaften von Peter Paul Rubens*, Vienna 1945.

GLUECK-HABERDITZL G. Glück and F. M. Haberditzl, *Die Handzeichnungen von Peter Paul Rubens*, Berlin 1928.

GORIS-HELD J-A. Goris and J. S. Held, *Rubens in America*, New York 1947.

HELD J. S. Held, *Rubens. Selected Drawings*, 2 vols, London 1959.

HIND A. M. Hind, *Catalogue of Drawings by Dutch and Flemish Artists preserved in the Department of Prints and Drawings in the British Museum*, II, London 1923.

H. F. W. H. Hollstein, *Dutch and Flemish etchings, engravings and woodcuts c. 1450–1700*, Amsterdam 1949, 15 vols.

JAFFÉ 1953 I M. Jaffé, 'Two Rubens Drawings Rediscovered', *Art Quarterly*, Summer 1953, 131–6.

JAFFÉ 1953 II M. Jaffé, 'Rubens' Portrait of Rogier Clarisse', *Burl.M.* XCV, 1953, 387–90.

JAFFÉ 1954 I M. Jaffé, 'Rubens at Rotterdam', *Burl.M.* XCVI, 1954, 53–7.

JAFFÉ 1954 II M. Jaffé, 'Some Figure Drawings in chalk by Guido Reni', *Paragone* no. 59, 3–6.

JAFFÉ 1955 M. Jaffé. 'Giuseppe Porta, il Salviati and Peter Paul Rubens', *Art Quarterly*, VIII, 1955, 331–40.

JAFFÉ 1956 I M. Jaffé, 'Cornelis Bos en Peter Paul Rubens', *Bulletin Museum Boymans*, VII, I, Rotterdam, 1956, 6–12.

JAFFÉ 1956 II M. Jaffé, 'Rubens' Drawings at Antwerp', *Burl.M.*, XCVIII, 1966, 314–21.

JAFFÉ 1957 I M. Jaffé, 'A sheet of Drawings from Rubens' Second Roman Period and his early style as a Landscape Draughtsman', *Oud-Holland*, LXXII, 1957, 1–19.

JAFFÉ 1957 II M. Jaffé, 'The Interest of Rubens in Annibale and Agostino Carracci: further notes', *Burl.M.* XCIX, 1957, 375–9.

JAFFÉ 1957 III M. Jaffé, review of Agnew's 'Old Masters', *Burl.M.*, XCIV, 432.

JAFFÉ 1958 I M. Jaffé, 'Rubens' Drawings after sixteenth century Northern Masters: Some Additions.' *Art Quarterly*, XXI, 1958, 400–6.

JAFFÉ 1958 II M. Jaffé, 'Un chef-d'oeuvre mieux connu', *L'Oeil*, 43–4, 1958, 14–20, 80.

JAFFÉ 1958 III M. Jaffé, 'Rubens and Giulio Romano at Mantua', AB, XL, 1958, 325–9.

JAFFÉ 1958 IV M. Jaffé, 'Rubens in Italy: Rediscovered Works', *Burl.M.*, C, 1958, 411–22.

JAFFÉ 1959 M. Jaffé, 'Peter Paul Rubens and the Oratorian Fathers', advance extract of *Proporzioni* IV, 1–39. (eventually published 1963.)

JAFFÉ 1960 M. Jaffé, '"The Union of Earth and Water" revived for the Fitzwilliam', *Burl.M.* CII, 1960, 448–51.

JAFFÉ 1961 I M. Jaffé, 'The Companion to Rubens' Portrait of Roger Clarisse', *Burl.M.*, CIII, 1961, 4.

JAFFÉ 1961 II M. Jaffé, 'The Return from the Flight into Egypt by Peter Paul Rubens', *Wadsworth Atheneum Bulletin*, Hartford, Summer 1961, 10–26.

JAFFÉ 1961 III M. Jaffé, 'The Deceased Young Duke of Mantua's Brother', *Burl.M.*, CIII, 1961, 374–8.

JAFFÉ 1962 M. Jaffé, 'Italian Drawings from Dutch Collections', *Burl.M.*, CIV, 1962, 231–8.

JAFFÉ 1963 M. Jaffé, 'Cleveland Museum of Art. The Figurative Arts of the West c.1400–1800', *Apollo*, December 1963, 457–67.

JAFFÉ 1964 M. Jaffé, 'Rubens as a Collector of Drawings I', MD, II. 4, 1964, 383–97.

JAFFÉ 1965 I M. Jaffé, 'Rubens as a Collector of Drawings II', MD, III. I, 1965, 21–35.

JAFFÉ 1965 II M. Jaffé, 'Peter Paul Rubens, *The Elevation of the Cross*, The Art Gallery of Toronto', *Master Works in Canada*, 2/1965, 52.

JAFFÉ 1965 III M. Jaffé, 'A New Rubens Cartoon?', *Burl.M.*, CVII, 1965, 209.

JAFFÉ 1965 IV M. Jaffé, 'Rubens as a Draughtsman', *Burl.M.*, CVII, 1965, 372–81.

JAFFÉ 1965 V M. Jaffé, 'Van Dyck Portraits in the De Young Museum and elsewhere', AQ, XXVIII, 1965, 41–55.

JAFFÉ 1966 I M. Jaffé, 'A Landscape by Rubens, and another by Van Dyck', *Burl.M.*, CVIII, 1966, 410–4.

JAFFÉ 1966 II M. Jaffé, 'Rubens as a Collector of Drawings, Part III'. MD, 4.2. 127–48.

JAFFÉ 1967 I M. Jaffé, 'The Death of Adonis by Rubens'. *Duits Quarterly* II, 1967, 3–16.

JAFFÉ 1967 II M. Jaffé, 'Rubens and Raphael', in *Studies in Renaissance and Baroque Art presented to Anthony Blunt*, London 1967.

JAFFÉ 1967 III M. Jaffé, *Rubens*, 'The Masters' no. 100, London 1967.

JAFFÉ 1968 M. Jaffé, 'Rubens in Italy Part II; some rediscovered works of the first phase', *Burl.M.*, CX, 1968, 174–87.

JAFFÉ 1969 I M. Jaffé, 'Rediscovered Oil Sketches by Rubens: I', *Burl.M.*, CXI, 1969, 435–44.

JAFFÉ 1969 II M. Jaffé, 'Rubens as a Collector', *Journal of the Royal Society of Arts*, CXVII, 1969, 641–60.

JAFFÉ 1969 III M. Jaffé, 'Rediscovered Oil Sketches by Rubens: II' *Burl.M.*, CXI, 1960, 529–38.

JAFFÉ 1969 IV M. Jaffé, 'Reflections on the Jordaens Exhibition', *Bulletin of the National Gallery of Canada* 13/1969.

JAFFÉ 1970 I M. Jaffé, 'Some Recent Acquisitions of Seventeenth-Century Flemish Painting', *Report and Studies in the History of Art 1969*, National Gallery of Art, Washington, 1970, 7–33.

JAFFÉ 1970 II M. Jaffé, 'Rubens and Jove's Eagle', *Paragone*, 245, 1970, 19–26.

JAFFÉ 1970 III M. Jaffé, 'A sheet of Drawings from Rubens' Italian Period', MD, 1970, 42–51.

JAFFÉ 1970 IV M. Jaffé, 'Figure Drawings attributed to Rubens, Jordaens and Cossiers in the Hamburg Kunsthalle', *Jahrbuch der Hamburger Kunstsammlungen*, Bd. 16, 1971 (Sonderdruck 1970, unpaginated).

JAFFÉ 1970 V M. Jaffé, 'Rediscovered Oil Sketches by Rubens III', *Burl.M.*, CXII, 1970, 432–7.

JAFFÉ, 1971 I M. Jaffé, 'Another Drawing from Rubens' Italian Period', MD, 260–72.

JAFFÉ 1971 II M. Jaffé, 'Rubens's Roman Emperors', *Burl.M.*, CXIII, 1971, 300–3.

JAFFÉ 1971 III M. Jaffé, 'Rubens and Optics: some fresh evidence', *JWCI*, XXXIV, 1971, 363–6.

JAFFÉ 1972 M. Jaffé, 'Rubens's *Le Christ à la Paille* reconsidered', *Apollo*, 1972, 107–14.

JANSON H. W. Janson, *The Sculpture of Donatello,* Princeton 1957.

KdK R. Oldenbourg *P. P. Rubens. Des Meisters Gemälde in 538 Abbildungen,* Stuttgart/Berlin 1921 (Klassiker der Kunst 2nd. edn.).

London 1950 L. Burchard, *A loan Exhibition of Works by Peter Paul Rubens, Kt.,* Wildenstein & Co. Ltd., London 1950.

London/Paris/Berne/Brussels, 1972 C. van Hasselt, *Dessins Flamands du Dix-Septième Siècle. Collection Frits Lugt. Institut Néerlandais Paris, Exposition London, Paris, Berne, Brussels, Ghent,* 1972.

L. F. Lugt, *Les Marques de Collections de dessins et d'estampes,* Amsterdam 1921.

LUGT, LOUVRE F. Lugt, *Musée du Louvre. Inventaire Général des Dessins des Ecoles du Nord. Ecole Flamande,* II, Paris 1949.

LUZIO A. Luzio, *La Galleria dei Gonzaga venduta all' Inghilterra,* Milan 1913.

MAGURN ed. R. S. Magurn, *The Letters of Peter Paul Rubens,* Harvard 1955.

MANCINI Giulio Mancini, *Considerazioni sulla Pittura* (ed. L. Salerno, Rome 1956).

MARTIN G. Martin, *National Gallery Catalogues. The Flemish School circa 1600–circa 1900,* London 1970.

MD Master Drawings, New York.

MUELLER HOFSTEDE 1962 J. Müller-Hofstede, 'Zur frühen Bildnismalerei von Peter Paul Rubens', *Pantheon,* Sept–Oct 1962, XX, H.5, 279–90.

MUELLER HOFSTEDE 1964 J. Müller-Hofstede, 'An early Rubens Conversion of St. Paul. The beginning of his preoccupation with Leonardo's Battle of Anghiari', *Burl.M.,* CVI, 1964, 95ff.

MUELLER HOFSTEDE 1965 I J. Müller-Hofstede, 'Beiträge zum zeichnerischen Werk von Rubens', *Wallraf-Richartz-Jahrbuch,* XXVII, 1965.

MUELLER HOFSTEDE 1965 II J. Müller-Hofstede, 'Rubens's St. Georg und seine frühen Reiterbildnisse', *Zeitschrift für Kunstgeschichte,* XXVIII, 1965, 69 122.

MUELLER HOFSTEDE 1970 J. Müller-Hofstede, 'Die Altargemälde für Sta. Croce in Gerusalemme', *Jahrbuch der Berliner Museen,* 1970, XII, H.I., 61–110.

MURARO-ROSAND M. Muraro and D. Rosand, *Tiziano e la silografia veneziana del cinquecento,* Vicenza 1976.

OLDENBOURG R. Oldenbourg, *Peter Paul Rubens,* Munich/Berlin 1922 (ed. W. von Bode).

OLSEN I H. Olsen, 'Rubens og Cigoli' in *Kunstmuseets Årsskrift* 1950, 58–73.

OLSEN II H. Olsen, *Federico Barocci,* Copenhagen 1962.

OMD *Old Master Drawings,* A Quarterly Magazine for students.

Ottawa 1968 M. Jaffé, *Jacob Jordaens (1593–1678). Exhibition at the National Gallery of Canada,* Ottawa 1968.

Paris/Rotterdam, 1965–66 C. van Hasselt, *Gravures sur bois, Clairs-Obscurs, de 1500 à 1800, Exposition Paris, Rotterdam,* Paris 1965–6.

de PILES R. de Piles, *Abrégé de la Vie des Peintres,* Paris 1699.

POPE HENNESSY I J. Pope-Hennessy, *Italian High Renaissance and Baroque Sculpture,* London/New York 1970.

POPE HENNESSY II J. Pope-Hennessy, *Raphael,* New York 1970.

POPHAM A. E. Popham, *Correggio's Drawings,* London 1957.

POUNCEY-GERE P. M. R. Pouncey and J. A. Gere, *Italian Drawings in the Department of Prints and Drawings in the British Museum. Raphael and his Circle,* London 1962, 2 vols.

V. PUYVELDE L. van Puyvelde, *The Sketches of Rubens,* London 1947.

Raphael KdK G. Gronau, *Raffael. Des Meisters Gemälde,* Stuttgart/Leipzig, 1909.

REINACH S. Reinach, *Répertoire de la statuaire grecque et romaine,* Paris 1897–1904, 3 vols.

ROOSES Max Rooses, *L'Oeuvre de P. P. Rubens,* Antwerp 1886–92, 5 vols.

Rotterdam, 1953 ed. J. C. Ebbinge Wubben, *Olieverfschetsen van Rubens,* Museum Boymans, Rotterdam 1953.

SANDRART J. von Sandrart, *Academie der Bau-, Bild- und Mahlerey-Künste,* 1672 (ed. A. R. Pelzer, Munich 1925).

SEILERN A. Seilern, *Flemish Paintings and Drawings at 56 Princes Gate, London,* London 1955.

SHEARMAN J. Shearman, *Andrea del Sarto,* Oxford 1965.

STECHOW W. Stechow, *Rubens and the Classical Tradition,* Harvard 1968.

TIETZE H. Tietze, *Tintoretto,* London 1948.

VDAS M. Jaffé, *Van Dyck's Antwerp Sketchbook,* London 1966, 2 vols.

VDIS G. Adriani, *Anton van Dyck. Italienisches Skizzenbuch,* Vienna 1940.

VAN DYCK, KdK G. Glück, *Van Dyck, Des Meisters Gemälde,* Stuttgart/Leipzig 1931 (Klassiker der Kunst, 2nd edn.).

VASARI G. Vasari, *Le Vite dei più eccellenti pittori scultori ed architetti,* trans. G. de Vere, London 1912–4, 10 vols.

VENTURI A. Venturi, *Storia dell'Arte Italiana,* Milan 1901–39, 11 vols.

WADDINGHAM M. R. Waddingham, *Elsheimer,* 'The Masters' No. 53, London 1966.

WATERHOUSE E. K. Waterhouse, *Italian Baroque Painting,* London 1962.

WETHEY H. E. Wethey, *Titian,* London 1969–75, 3 vols.

WHITE C. White, *Rubens and his world,* London 1968.

v.d. WIJNGAERT F. van den Wijngaert, *Inventaris der Rubeniaansche Prentkunst,* Antwerp 1940.

WITTKOWER R. Wittkower, *Gian Lorenzo Bernini* (2nd edn.), London 1966.

Index of Works
Bold figures refer to plate numbers

Index of Persons

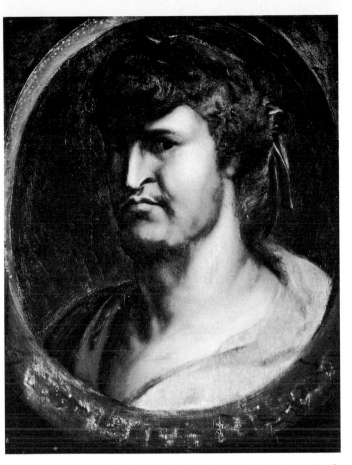

1. Rubens: *Domitianus Nero*. Before 1600. Oils on panel. Formerly Paris, Dr. H. Wendland

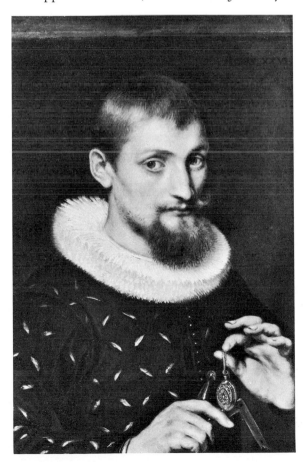

2. Rubens: *A Geographer (? Architect)*. 1597. Oils on copper. New York, Mr. and Mrs. J. Linsky

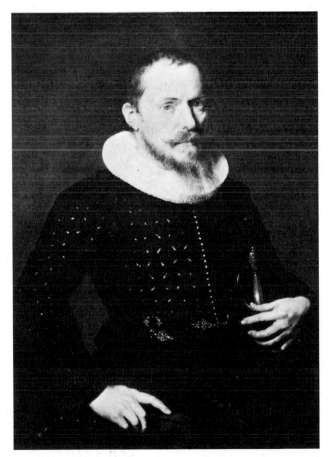

3. Rubens: *A Gentleman with a Sword*. About 1597. Oils on canvas. Norfolk (Virginia), Chrysler Museum

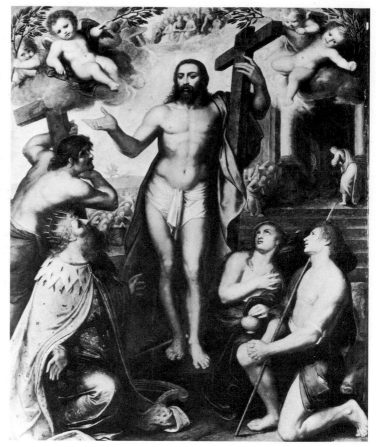

4. Otto van Veen: *Christ and the Four Great Penitents*. 1605–7. Oils on panel. Mainz, Hessisches Landesmuseum

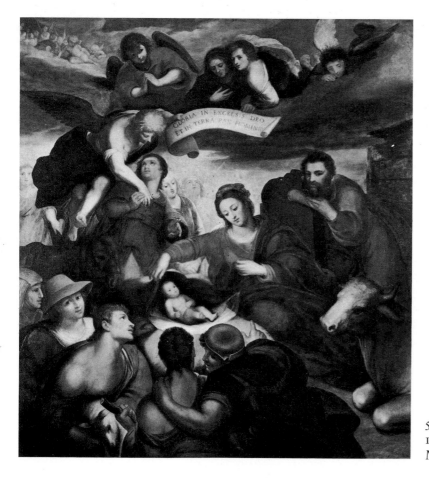

5. Otto van Veen: *The Nativity*. About 1595–1600. Oils on panel. Antwerp, Maagdenhuis

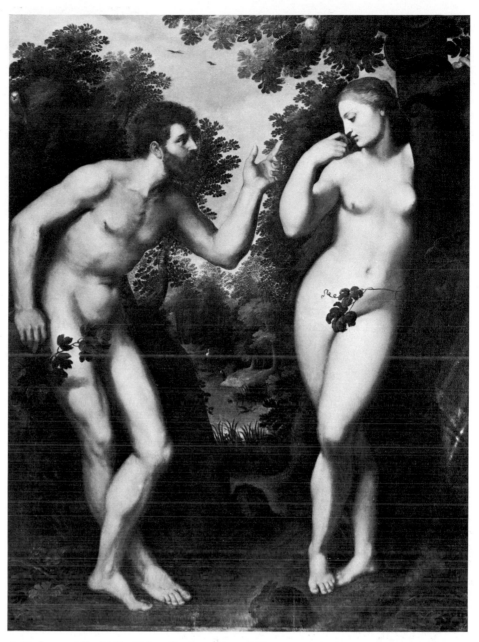

6. Rubens: *The Fall of Man*. Before 1600. Oils on panel. Antwerp, Rubenshuis

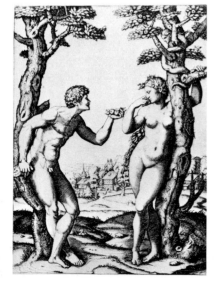

7. Marcantonio Raimondi, after
Raphael: *The Fall of Man*.
Copper engraving

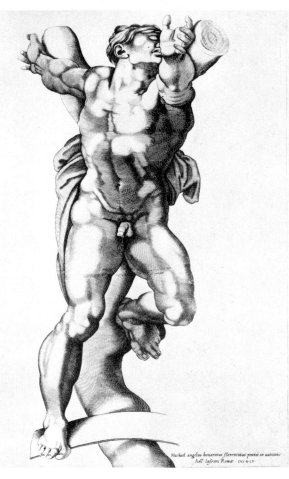

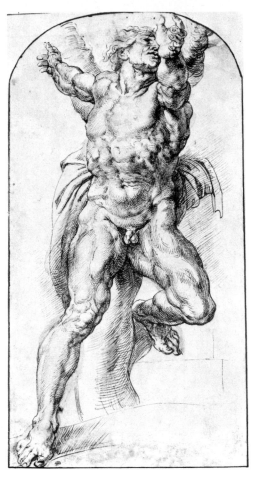

8. J. Laurens, after Michelangelo: *Haman*. Copper engraving

9. Rubens, after Michelangelo: *Haman*. Before 1600. Ink on paper. Paris, Louvre

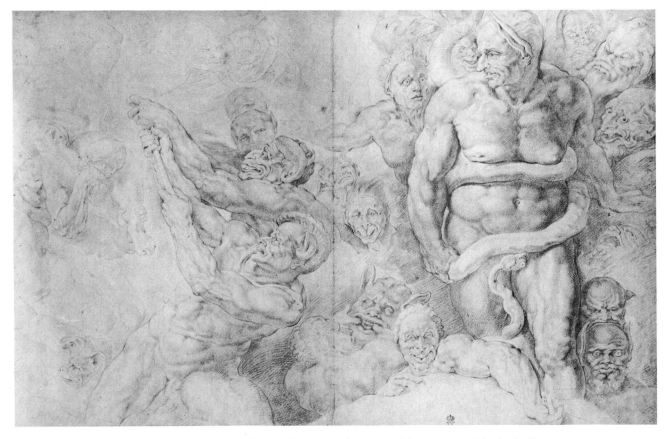

10. Rubens, after Michelangelo: *Figures from 'The Last Judgement'*. About 1600. Black chalk on paper. Leningrad, Hermitage

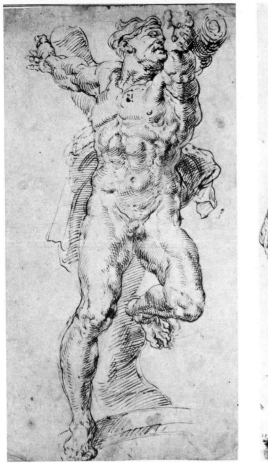

11. (*far left*) Rubens, after Michelangelo: *Haman*. 1601–2. Ink on paper. Dorset, private collection

12. (*left*) Rubens, after Michelangelo: *Young Hercules*. 1600. Ink on paper. Paris, Louvre

13. Rubens, after Michelangelo: *Figures from 'The Last Judgement'*. 1601–2. Ink on paper. Paris, Louvre

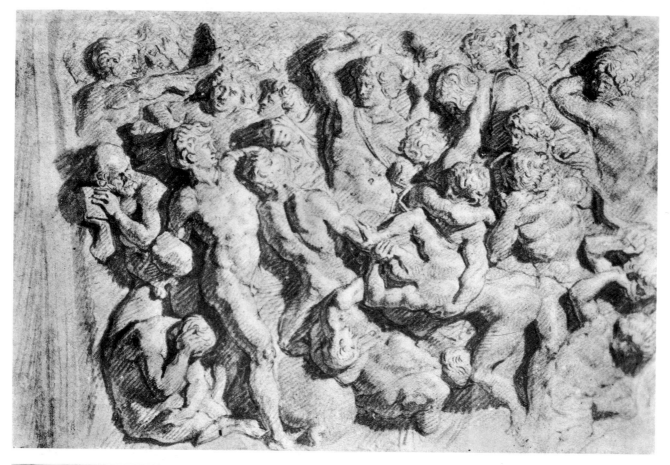

14. Rubens, after Michelangelo: *The Battle of Lapiths and Centaurs*. 1600–3. Black chalk on paper. Rotterdam, Museum Boymans–Van Beuningen

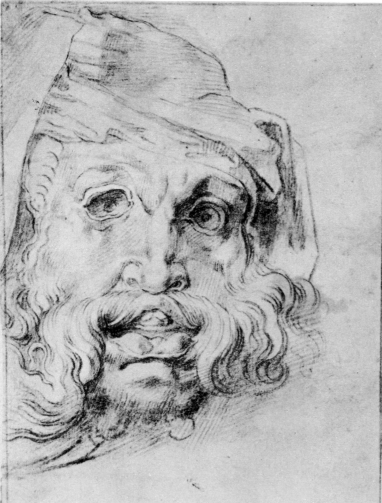

15. Rubens, after Michelangelo: *The Mask of 'The Night'*. 1603. Black chalk on paper. Dresden, Kupferstichkabinett

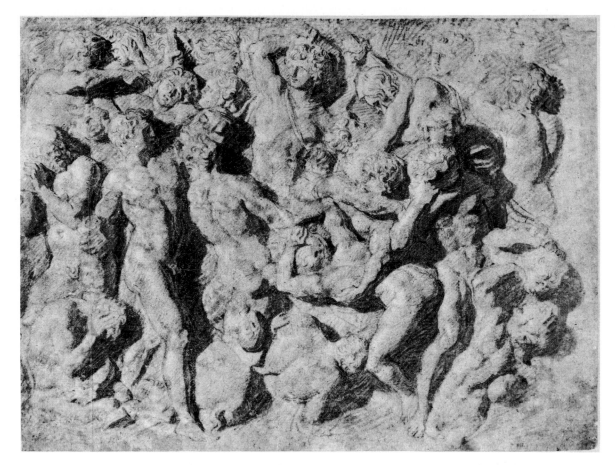

16. Rubens, after Michelangelo: *The Battle of Lapiths and Centaurs*. 1600–3. Black chalk on paper. Paris, Fondation Custodia

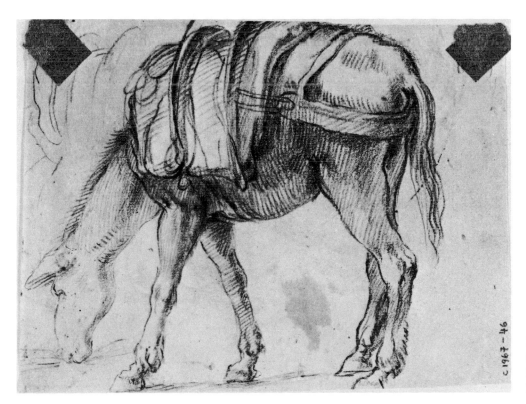

17. Rubens: *A Pack Mule Grazing* (verso of 15). 1603. Black chalk on paper. Dresden, Kupferstichkabinett

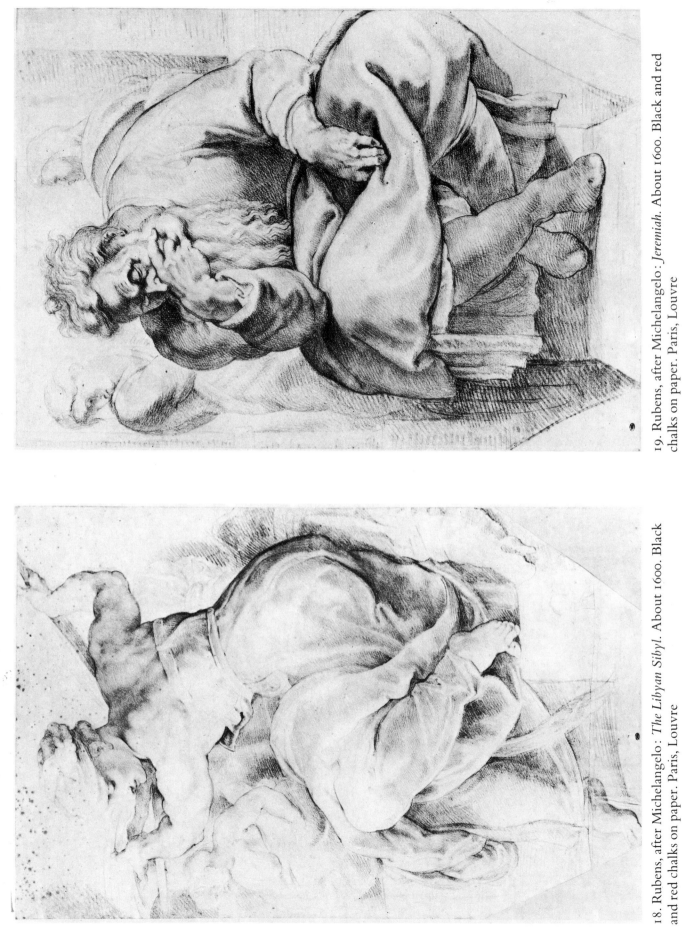

19. Rubens, after Michelangelo: *Jeremiah*. About 1600. Black and red chalks on paper. Paris, Louvre

18. Rubens, after Michelangelo: *The Libyan Sibyl*. About 1600. Black and red chalks on paper. Paris, Louvre

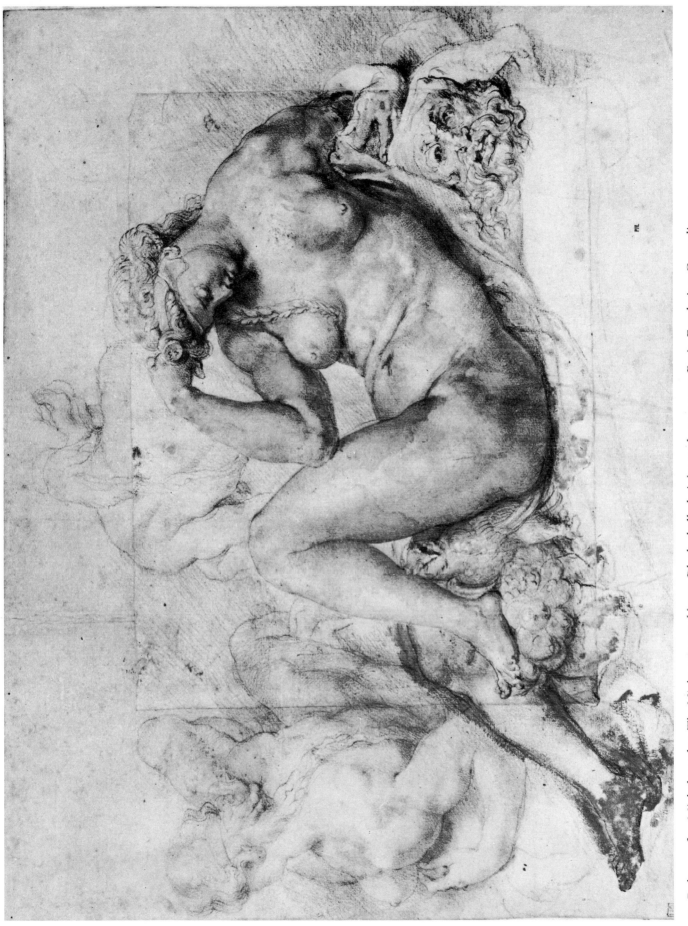

20. Rubens, after Michelangelo: *The Night*, 1603 and later. Black chalk, heightened, on paper. Paris, Fondation Custodia

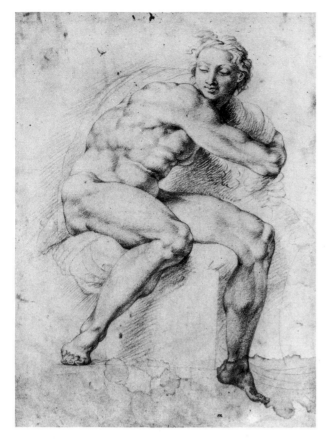

21. Rubens, after Michelangelo: *The Ignudo between the Libyan Sibyl and Jeremiah*. About 1606. Red chalk on paper. London, British Museum

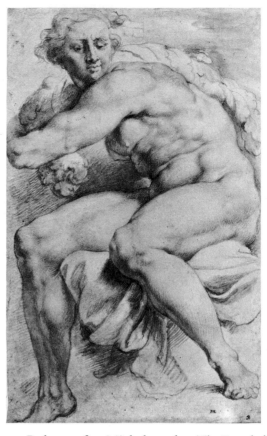

22. Rubens, after Michelangelo: *The Ignudo between the Libyan Sibyl and Jeremiah*. (reworked counterproof of 21). About 1606 and later. London, British Museum

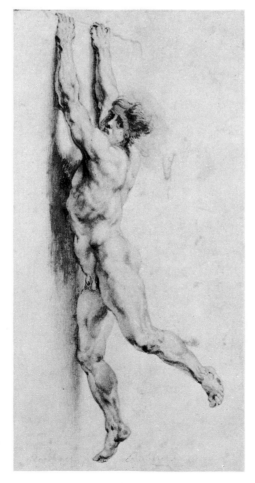

23. Rubens, after Raphael: *A Figure from 'The Fire in the Borgo'*. 1606–8. Ink and bodycolour on paper. London, British Museum

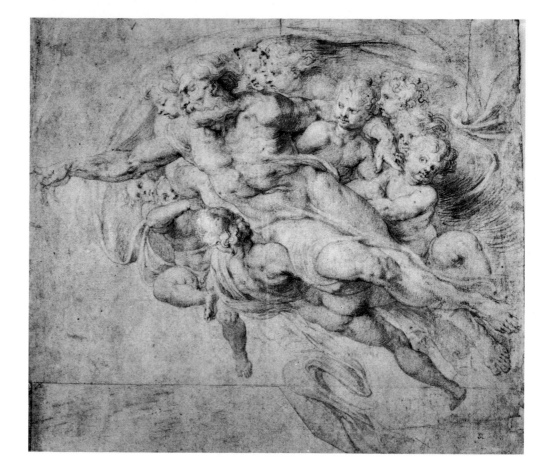

24. Rubens, after
Michelangelo: *God the
Father surrounded by Angels.*
1601. Red chalk on paper.
Lulworth (Dorset), Sir
Joseph Weld

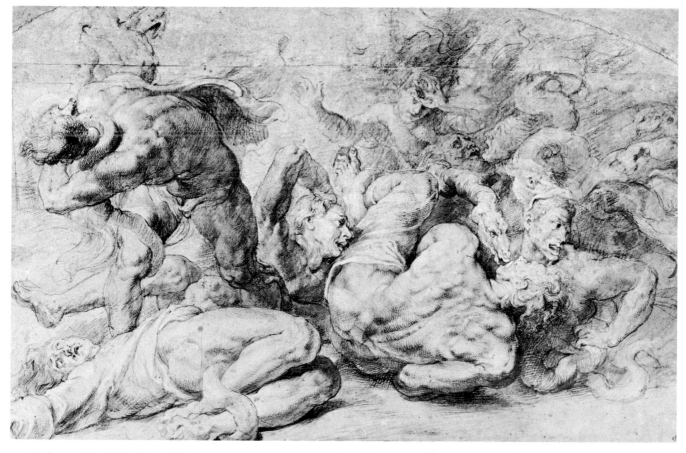

25. Rubens: *The Worship of the Brazen Serpent*. Various dates from about 1606. Black chalk and wash on paper.
London, British Museum

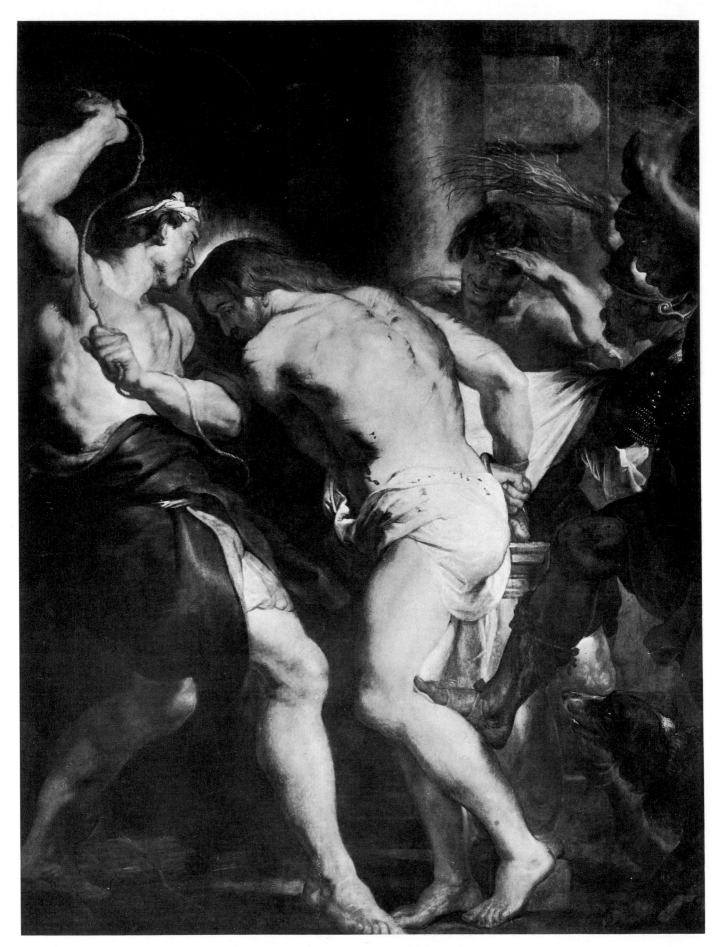

26. Rubens: *The Flagellation of Christ*. 1617. Oils on panel. Antwerp, St. Paul's

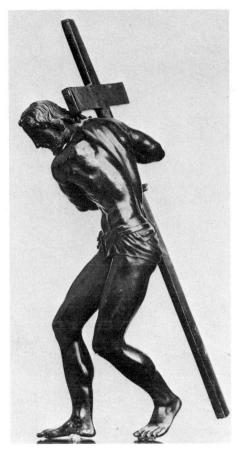

27. Jacopo Sansovino: *Christ in Limbo*. About 1550. Bronze. Modena, Este collection

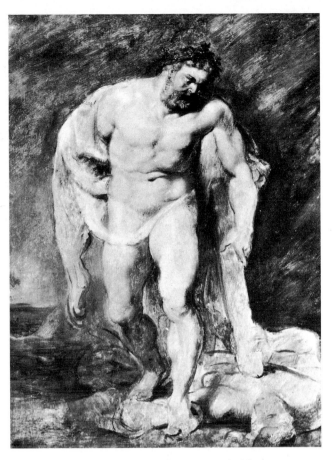

28. Rubens: *Hercules trampling Discord*. About 1614. Oils on panel. Rotterdam, Museum Boymans–Van Beuningen

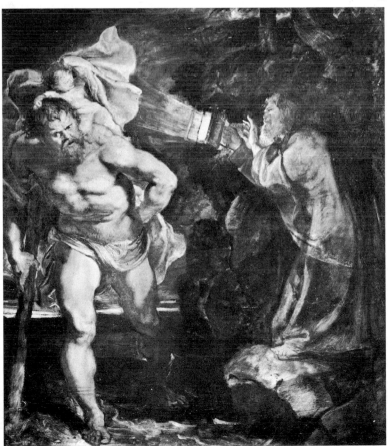

29. Rubens: *St. Christopher and the Hermit* (modello). About 1614. Oils on panel. Munich, Alte Pinakothek

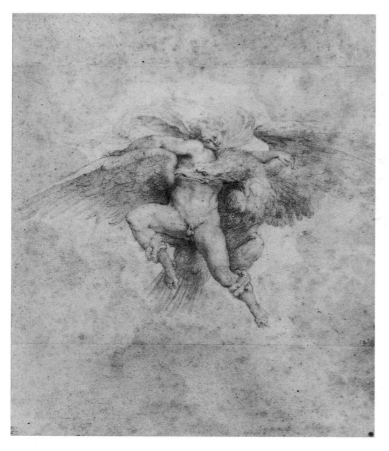

30. Giulio Clovio (retouched by Rubens 1601–8), after Michelangelo: *The Rape of Ganymede*. Ink and bodycolour on paper. Paris, M. Jacques Petit-Horry

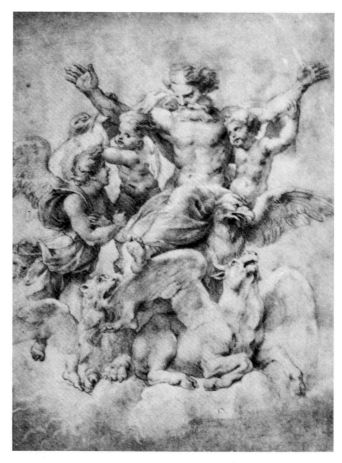

31. Rubens, after Raphael: *The Vision of Ezekiel*. About 1605. Red chalk on paper. Florence, Museo Horne

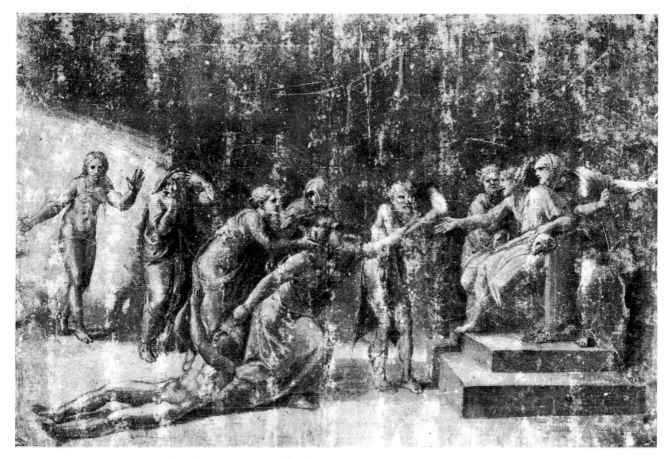

32. Anon., after Raphael: *The Calumny of Apelles*. Early sixteenth century. Ink on paper. Paris, Louvre

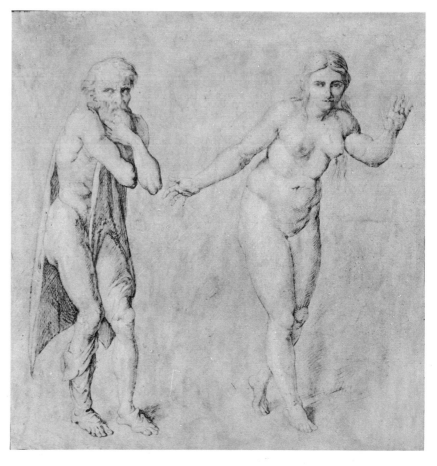

33. Rubens, after Raphael: *Figures from 'The Calumny of Apelles'*. Before 1600. Ink on parchment. Paris, M. Jacques Petit-Horry

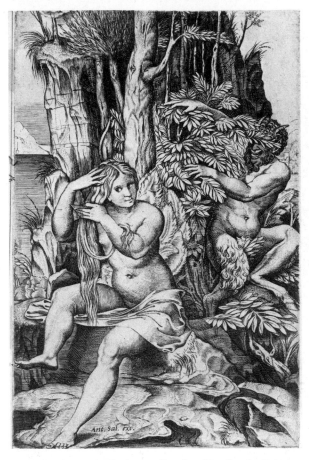

34. Marcantonio Raimondi, after Raphael: *Pan and Syrinx*. About 1520. Copper engraving

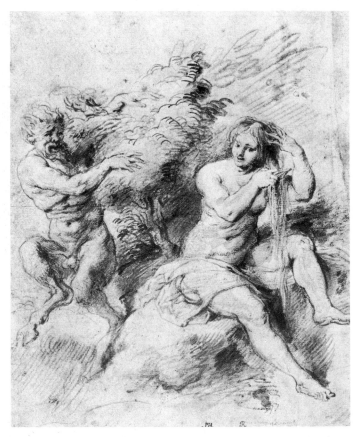

35. Rubens, after Marcantanio Raimondi (after Raphael): *Pan and Syrinx*. About 1615. Red chalk and wash on paper. London, British Museum

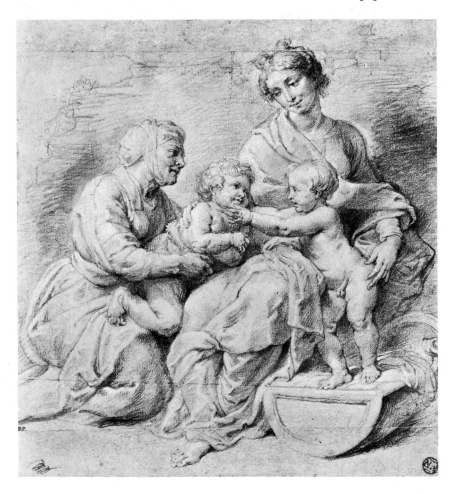

36. Rubens, after J. Caraglio (after Raphael): *Madonna and Child seated with St. Elizabeth and St. John*. About 1605. Red chalk and bodycolour on paper. Paris, Louvre

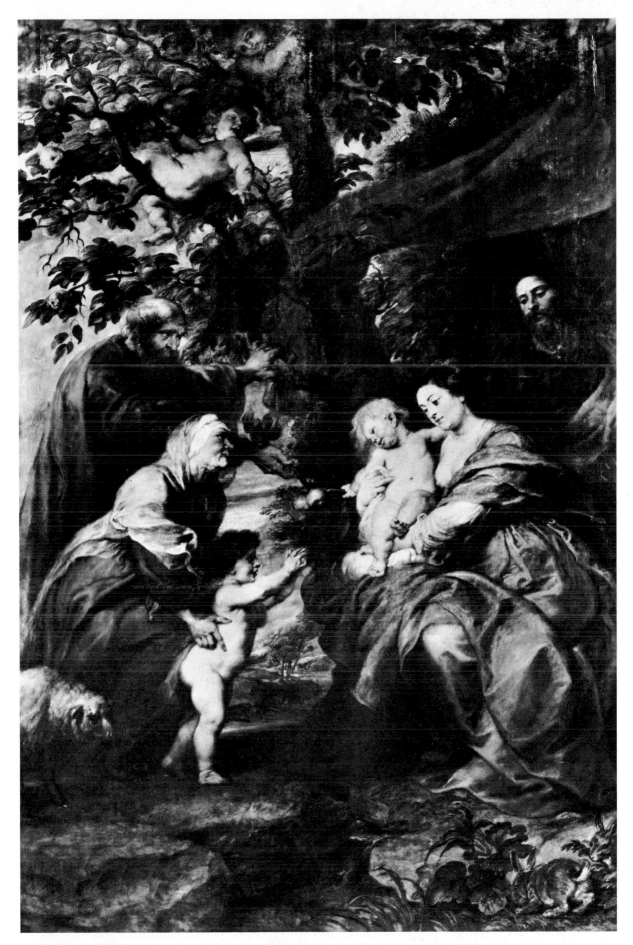

37. Rubens: *The Holy Family under an Apple Tree*. About 1635. Oils on panel. Vienna,
Kunsthistorisches Museum

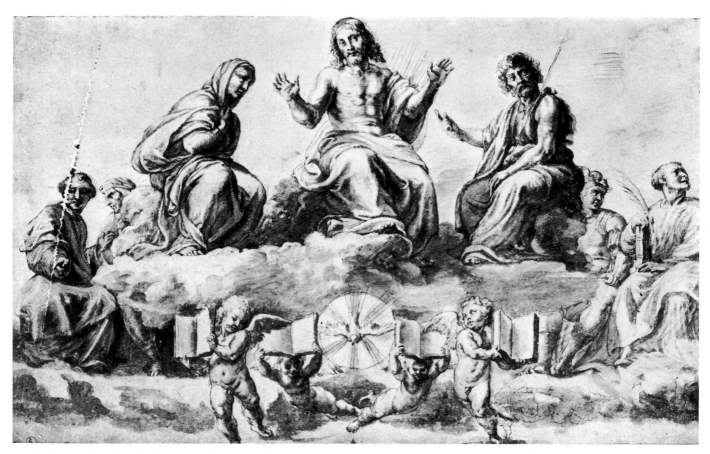

38. Rubens, after Raphael: *Figures from the 'Disputa'*. 1601–2. Ink on paper. Turin, Royal Library

39–40. Rubens, after Raphael: *Leaf from the Pocket-Book* (*recto* and *verso*). Ink on paper, Berlin, Kupferstichkabinett

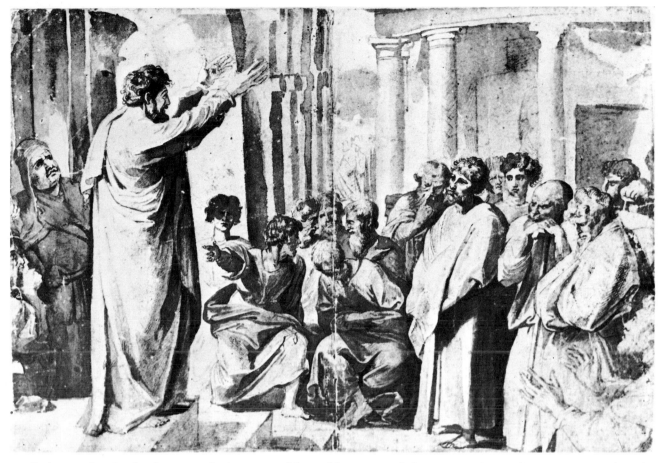

41. Rubens, after Raphael: *St. Paul's Sermon at Athens*. About 1604. Ink on paper. Uppsala, University Library

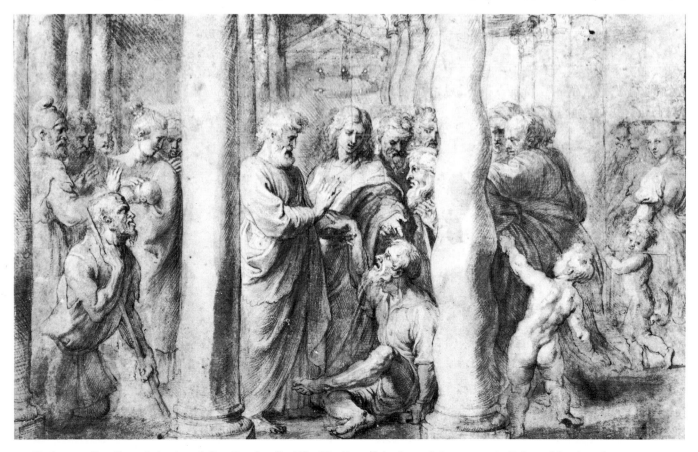

42. Rubens, after Parmigianino (after Raphael): *The Healing of the Lame Man*. 1606–8. Ink and bodycolour on paper. Washington, National Gallery of Art

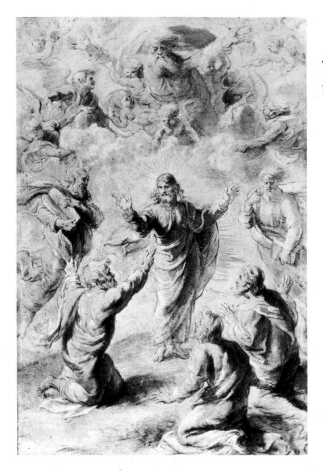

43. Rubens, after Raphael: *Study for 'The Transfiguration'* (earlier stage). About 1605. Ink and bodycolour on paper. Paris, Louvre

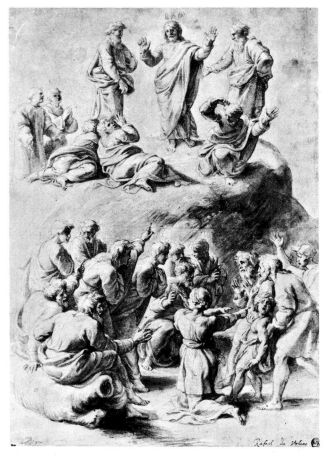

44. Rubens, after Raphael: *Study for 'The Transfiguration'* (later stage). About 1605. Ink and bodycolour on paper. Paris, Louvre

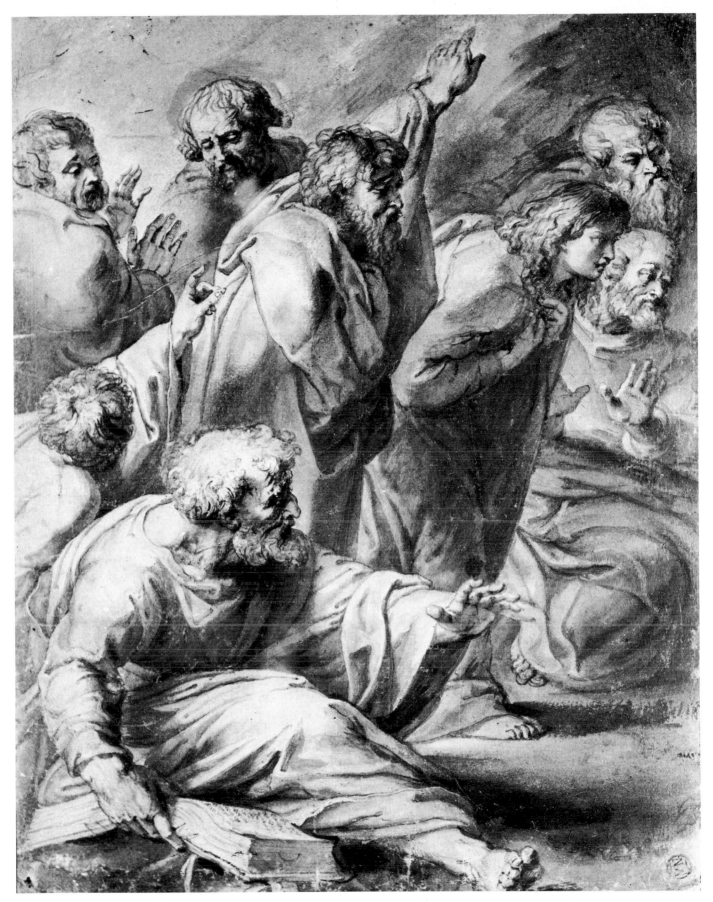

45. Rubens, after Raphael: *Detail of 'The Transfiguration'*. About 1605. Ink and bodycolour on paper. Paris, Louvre

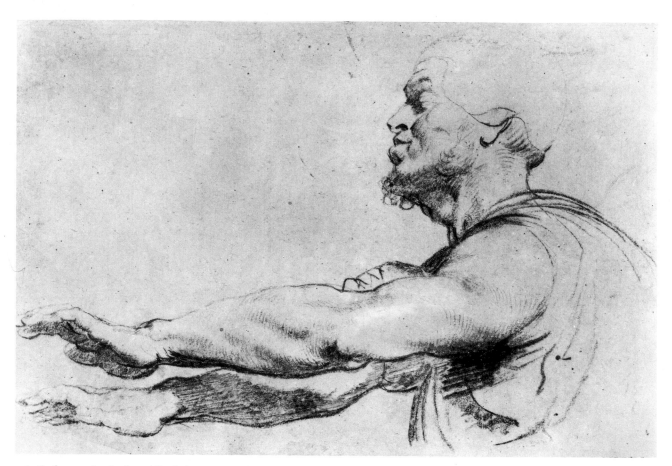

46. Rubens: *Study for a blinded man in 'The Miracle of St. Francis Xavier'*. About 1617. Black chalk on paper. Vienna, Albertina

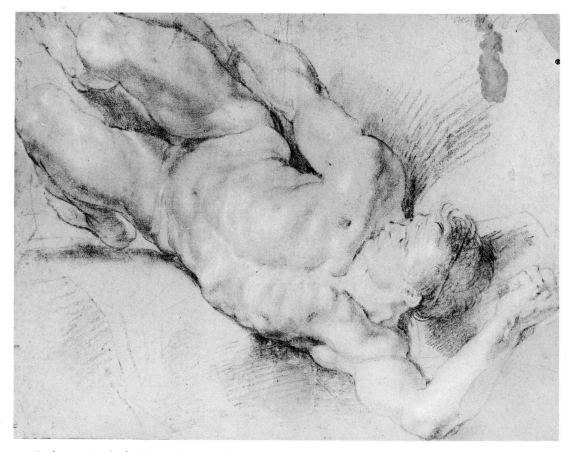

47. Rubens: *Study for 'Prometheus'*. About 1610. Black chalk on paper. Paris, Louvre

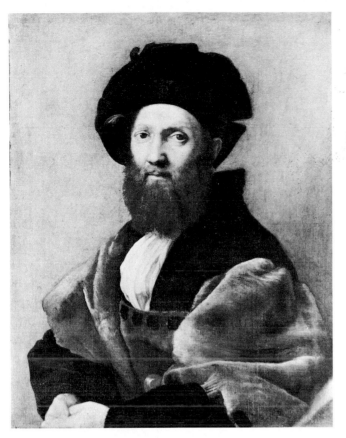

48. Raphael: *Baldassare Castiglione*. About 1517. Oils on canvas. Paris, Louvre

49. Rubens, after Raphael: *Baldassare Castiglione*. About 1620. Oils on panel. London, Count Antoine Seilern

50. Rubens: *The Ascent of Psyche to Olympus*. 1625–8. Oils on panel. Mertoun House (Roxburghshire), Duke of Sutherland

51. Rubens, after Titian: *The Battle of Spoleto*. 1600–5. Ink and bodycolour on paper. Antwerp, Stedelijk Prentenkabinet

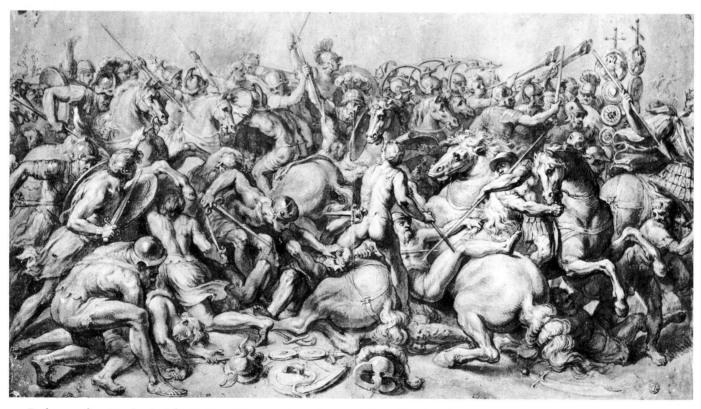

52. Rubens, after Raphael: *The Battle of Constantine*. 1601–6. Ink and bodycolour on paper. Paris, Louvre

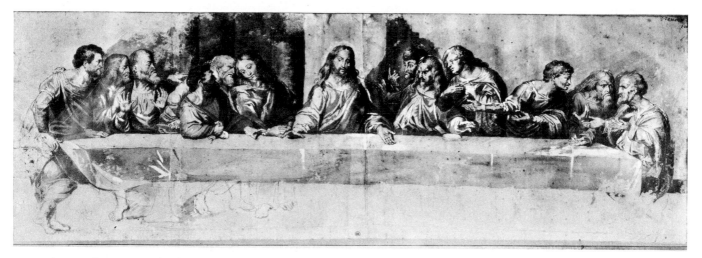

53. Rubens, after Leonardo da Vinci: *The Last Supper*. 1600–1. Ink on paper. Dijon, Musée des Beaux-Arts

54. Rubens, after Leonardo da Vinci: *The Fight for the Standard*. Italian period and later. Black chalk and ink on paper. Paris, Louvre

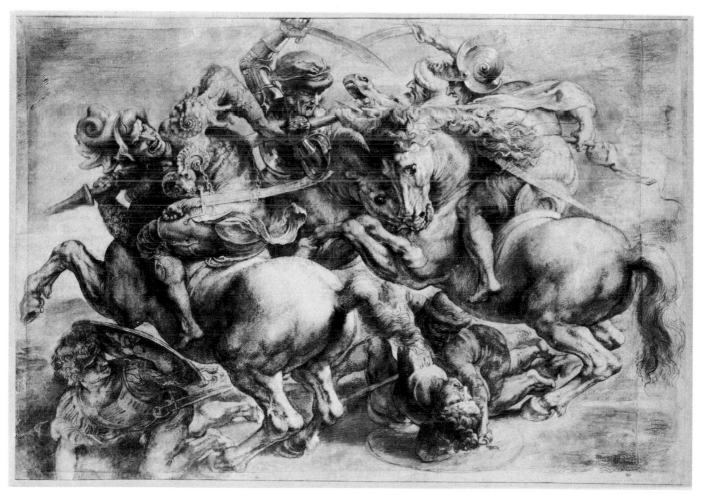

55. Rubens, after Leonardo da Vinci: *Selection of Caricatures*. About 1603. Ink on paper. Vienna, Albertina

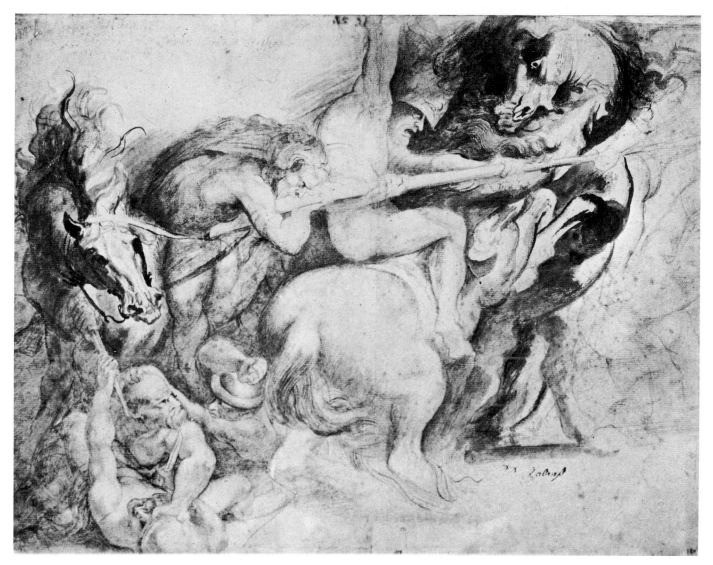

56. Rubens: *Horse and Foot Engagement*. About 1605. Ink on paper. London. British Museum

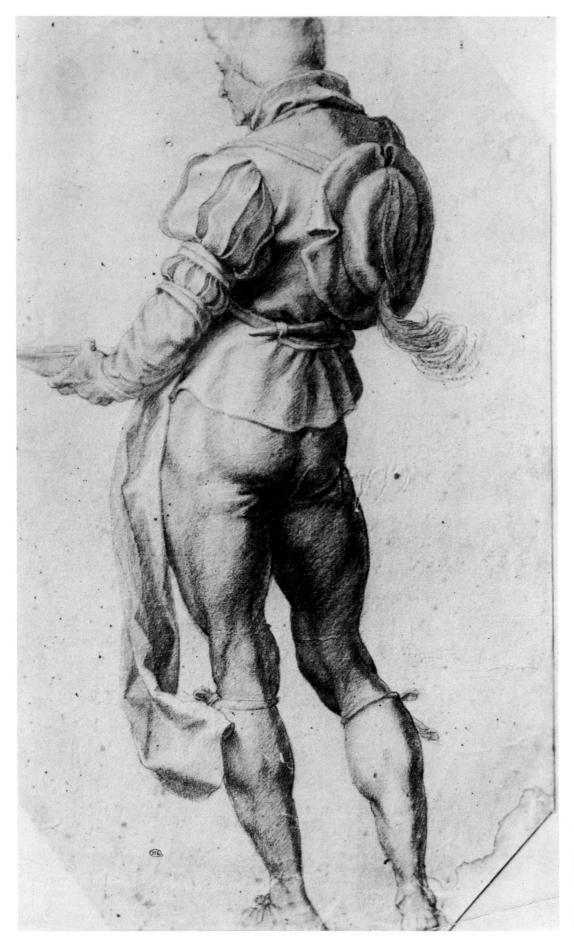

57. Rubens, after
Andrea del Sarto: *A
Figure from 'The
Dance of Salome'*.
About 1604. Chalk
on paper. Paris,
Louvre

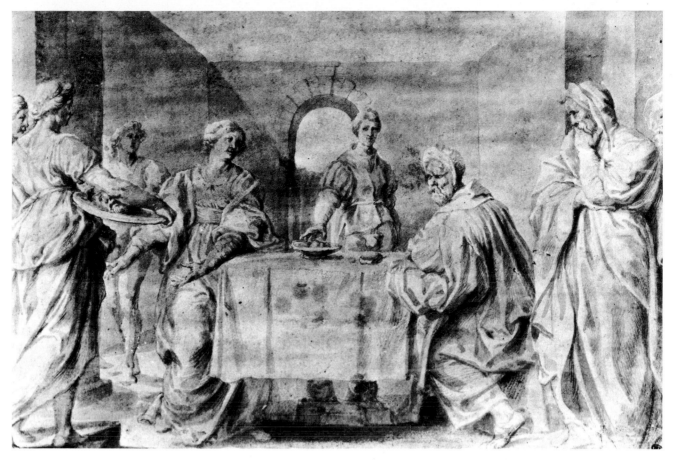

58. Rubens, after Andrea del Sarto: *Salome bringing the Baptist's Head to Herodias.* About 1604. Ink on paper. Paris, Louvre

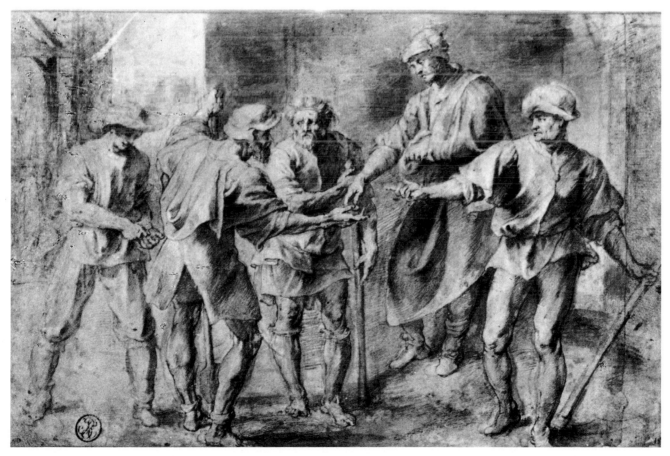

59. Rubens, after Andrea del Sarto: *The Steward paying the Labourers in the Vineyard.* About 1604. Red chalk and bodycolour on paper. Paris, Louvre

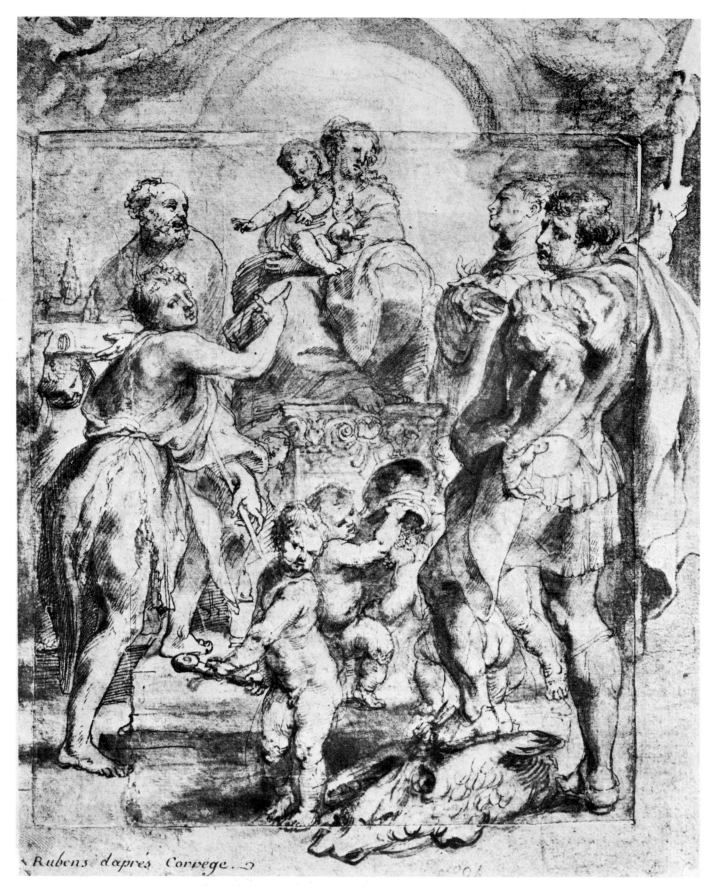

Rubens d'après Correge.

60. Rubens, after Correggio: *The Madonna with St. George*. About 1604. Ink on paper. Vienna, Albertina

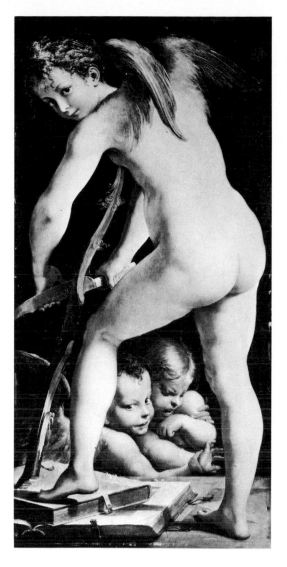

61. Parmigianino: *Cupid sharpening his Bow.*
About 1532. Oils on canvas. Vienna,
Kunsthistorisches Museum

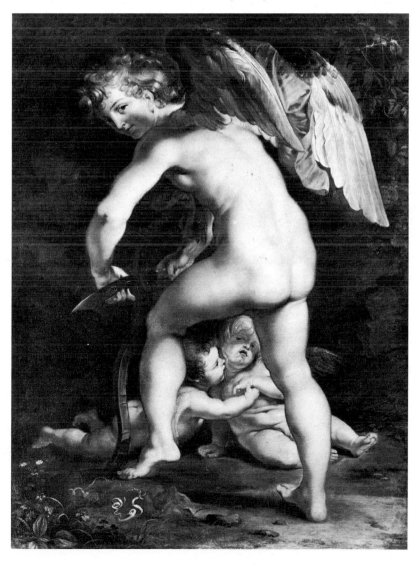

62. Rubens, after Parmigianino: *Cupid
sharpening his Bow*. 1614. Oils on canvas.
Schleissheim, Schloss

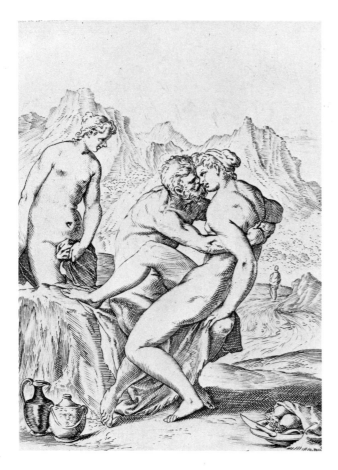

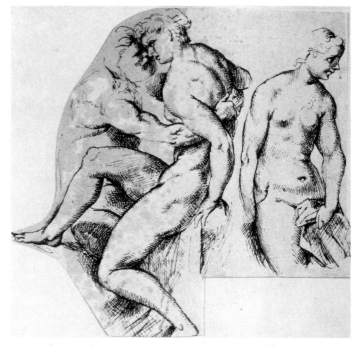

64. Rubens, after Agostino Carracci: *Lot and his Daughters*. About 1600. Ink on paper. Copenhagen, Kongel. Kobberstiksamling

63. *(left)* Agostino Carracci: *Lot and his Daughters*. Copper engraving

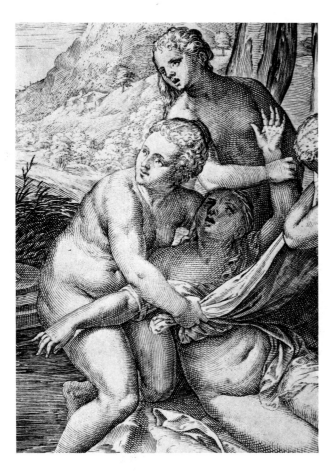

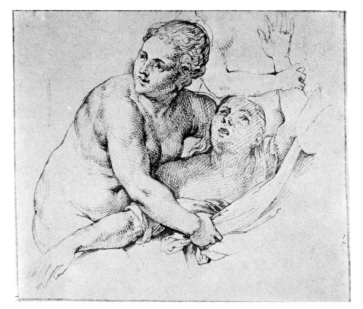

66. Rubens, after Cornelis Cort (after Titian): *The Discovery of the Shame of Callisto*. About 1600. Ink on paper. Hamburg, Kunsthalle

65. Cornelis Cort, after Titian: *The Discovery of the Shame of Callisto* (detail). Copper engraving

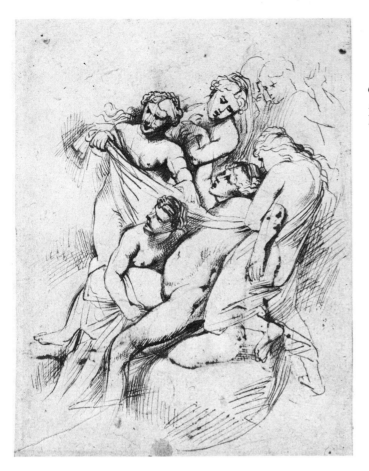

67. Rubens: *The Discovery of the Shame of Callisto.*
About 1600. Ink on paper. Berlin,
Kupferstichkabinett

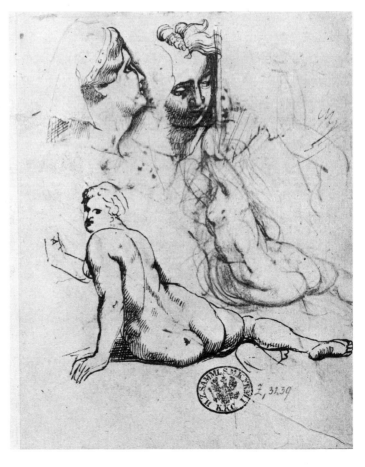

68. Rubens, after Titian: *Two Heads from 'The
Triumph of Faith' and a female Nude (verso of 67).*
About 1600. Ink on paper. Berlin,
Kupferstichkabinett

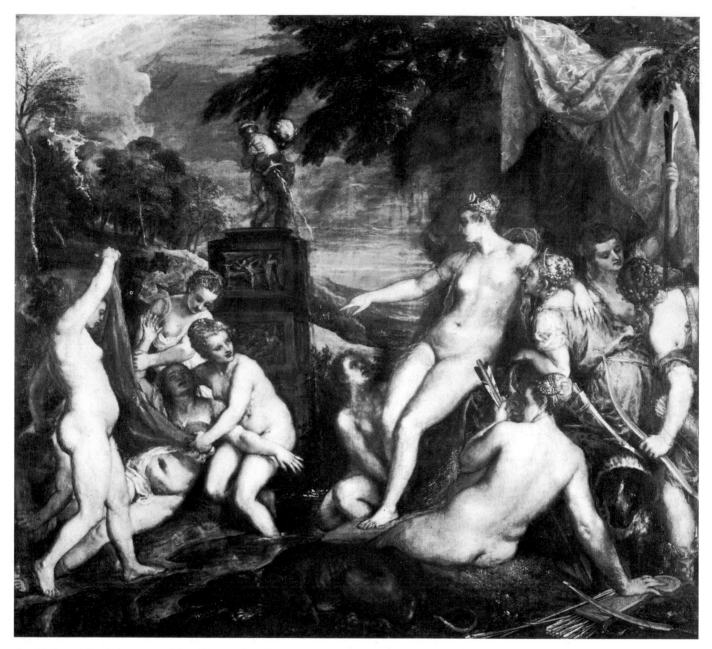

69. Titian: *The Discovery of the Shame of Callisto*. 1559. Oils on canvas. Edinburgh, National Galleries of Scotland (lent by the Duke of Sutherland)

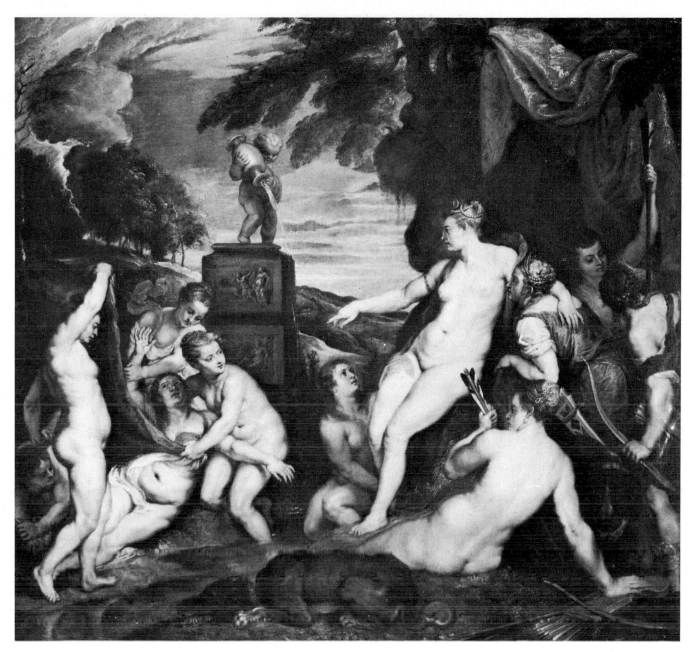

70. Rubens: *The Discovery of the Shame of Callisto*. 1630–5. Oils on canvas. Knowsley (Lancs), Earl of Derby

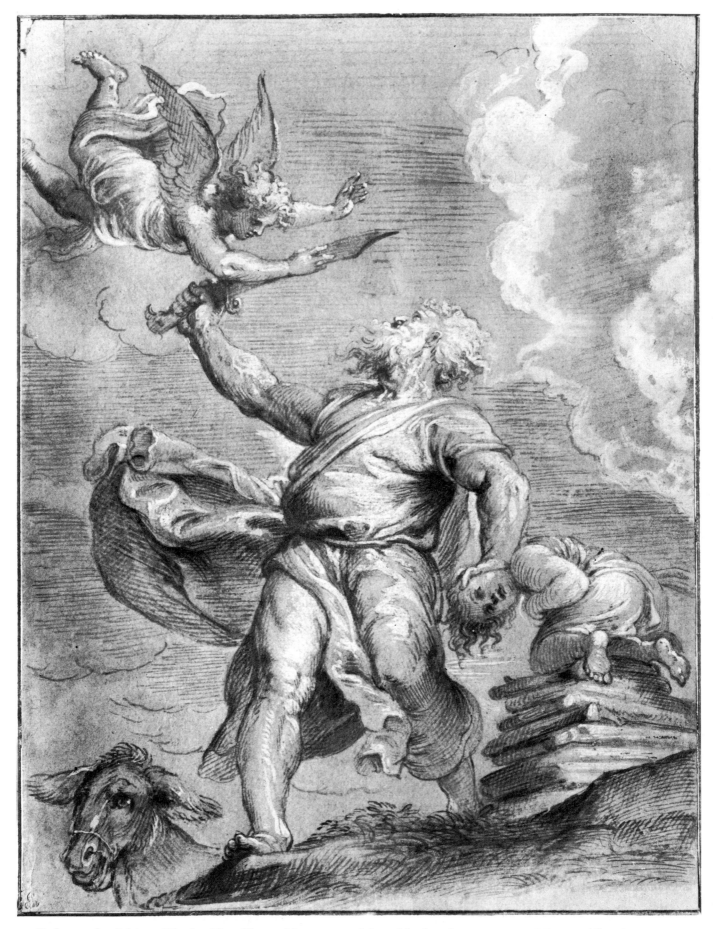

71. Rubens, after Titian: *The Sacrifice of Isaac*. About 1600. Ink and bodycolour on paper. Vienna, Albertina

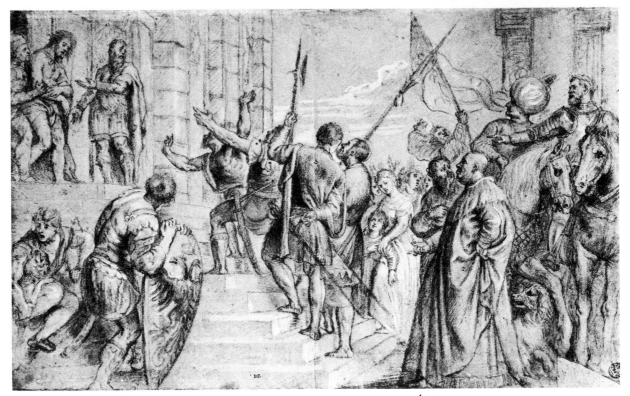

72. Rubens, after Titian: 'Ecce Homo'. About 1600. Chalks on paper. Paris, Louvre

73. Rubens, after Titian: 'Ecce Homo'. 1629–30. Chalk and ink on paper. New York, Mrs. Kaplan

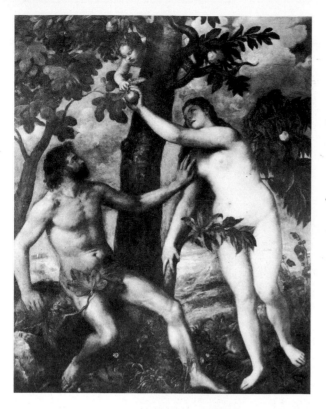

74. Titian: *The Fall of Man*. About 1550.
Oils on canvas. Madrid, Prado

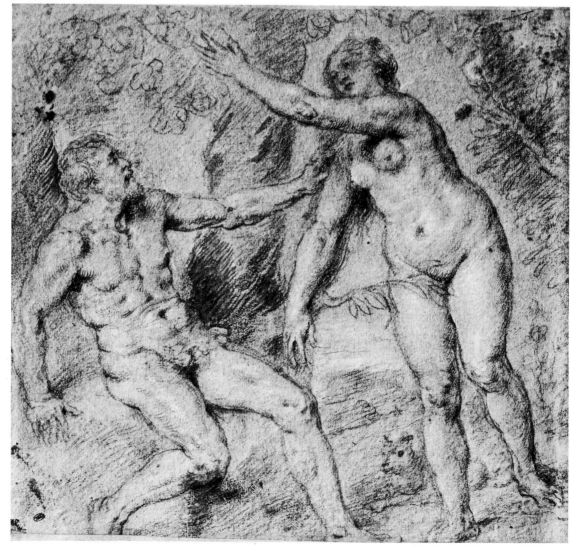

75. Rubens after Titian: *The Fall of Man*. About 1600. Chalks on paper. Paris, Louvre

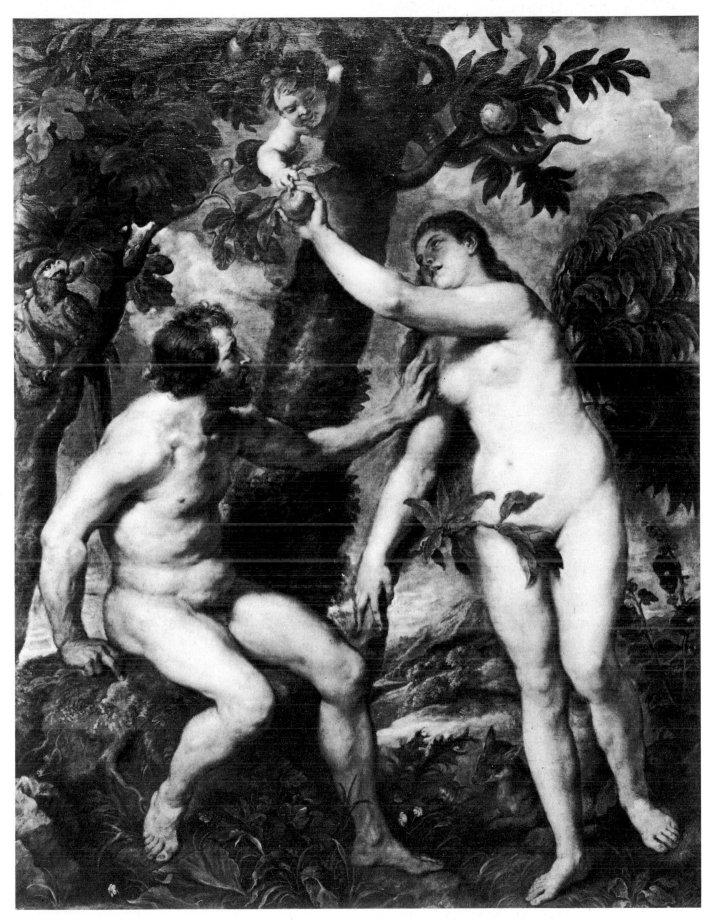

76. Rubens, after Titian: *The Fall of Man*. 1628–9. Oils on canvas. Madrid, Prado

77. Titian: *The Penitent St. Jerome*. About 1555.
Oils on panel. Milan, Brera

78. Rubens, after Titian: *The Penitent St. Jerome*.
About 1605. Ink and bodycolour on paper. Haarlem,
Stichting Teyler

79. Barocci: *The Stigmatization of St. Francis*.
About 1580. Ink and bodycolour on paper.
London, British Museum

80. Rubens, after Titian: *St. Francis in Prayer*. About 1605.
Ink, charcoal and bodycolour on paper. Paris, Louvre

81. Rubens, after Titian: *Pentecost*. About 1605. Ink and bodycolour on paper. Boston, private collection

82. Jacopo Tintoretto: *The Battle between St. Michael and Satan*. About 1580–5. Oils on canvas. Dresden, Gemäldegalerie

83. Rubens: *Two naked Youths wrestling*. About 1605. Charcoal, ink and bodycolour on paper. Cambridge, Fitzwilliam Museum

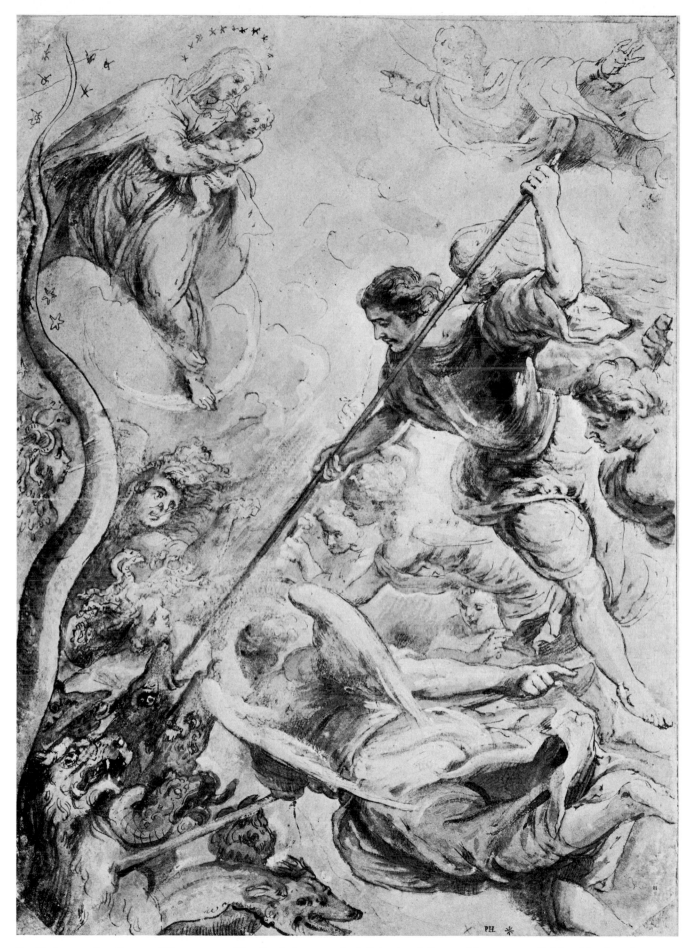

84. Rubens, after Jacopo Tintoretto: *The Battle between St. Michael and Satan*. About 1605. Ink and bodycolour on paper. Brussels, Musée Royal des Beaux-Arts

85. Rubens, after Jacopo Tintoretto: 'Doge Giovanni Cornaro'. About 1625. Oils on panel. Amsterdam, formerly Dr. H. Wetzlar

86. C. Jegher, after Rubens: 'Doge Giovanni Cornaro'. About 1630. Chiaroscuro woodcut (proof retouched by Rubens). Brussels, Cabinet d'Estampes

88. Rubens, after Jacopo Tintoretto: *A young Man.* About 1625. Oils on panel. London, formerly Sir John Leslie

87. Jacopo Tintoretto: *A young Man.* About 1555. Oils on canvas. San Francisco, M.H. De Young Museum

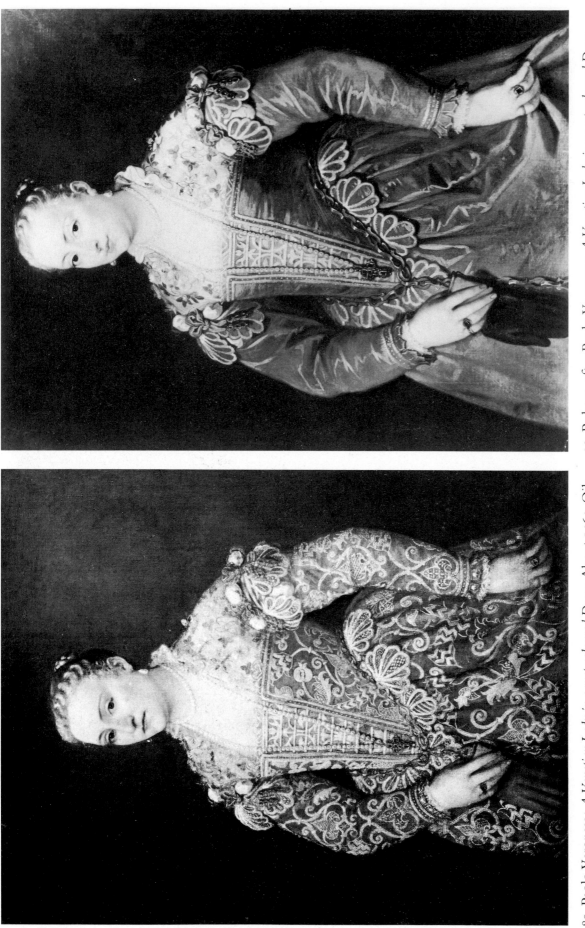

89. Paolo Veronese: *A Venetian Lady in a rust-coloured Dress*. About 1565. Oils on canvas. Dublin, National Gallery of Ireland

90. Rubens, after Paolo Veronese: *A Venetian Lady in a rust-coloured Dress*. About 1625. Oils on canvas. London, Mr. M. Q. Morris

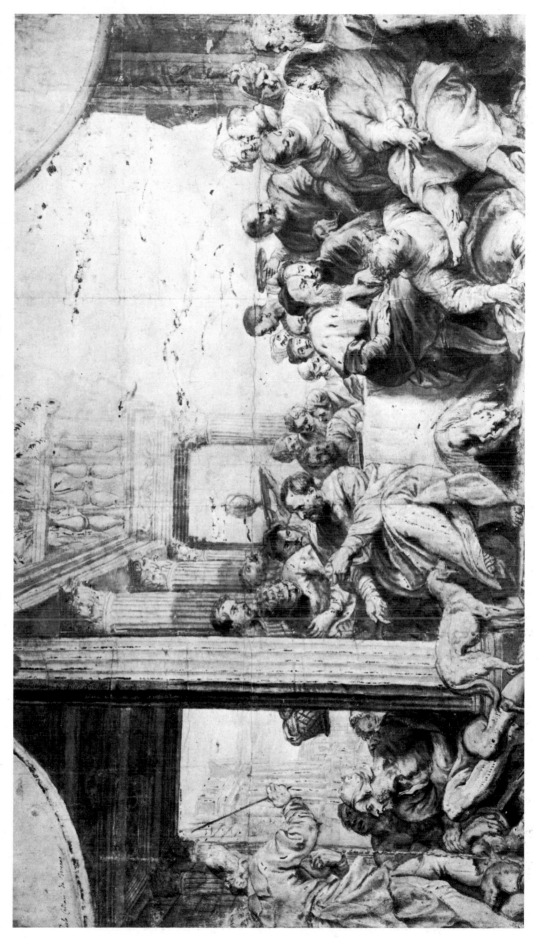

91. Rubens, after Paolo Veronese: *The Feast in the House of Simon*. About 1605. Ink and bodycolour on paper. London, British Museum

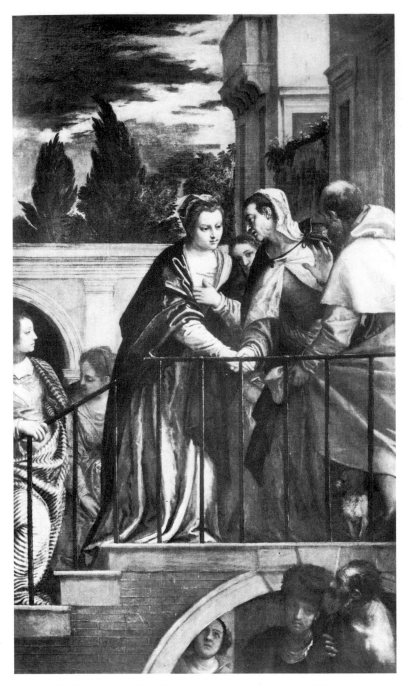

92. Paolo Veronese: *The Visitation*. About 1560–5. Oils on canvas. Birmingham, Barber Institute of Fine Arts

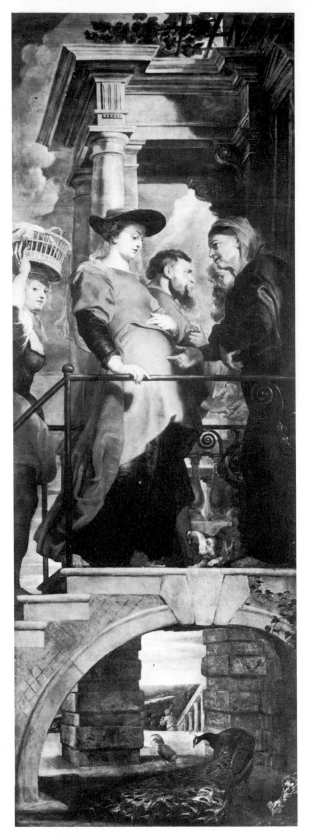

93. Rubens: *The Visitation*. Wing of the Arquebusiers' triptych. 1614. Oils on panel. Antwerp, Cathedral

94. Anon., after Giuseppe Porta:
The Purification (modello). About
1575–1600. Ink, heightened, on paper.
Munich, Kupferstichkabinett

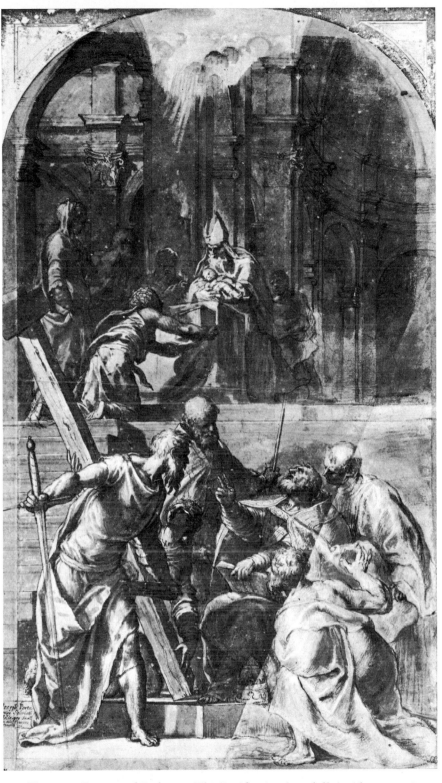

95. Giuseppe Porta and Rubens: *The Purification* (modello). About 1568
and 1606–8. Inks and bodycolour. Paris, Fondation Custodia

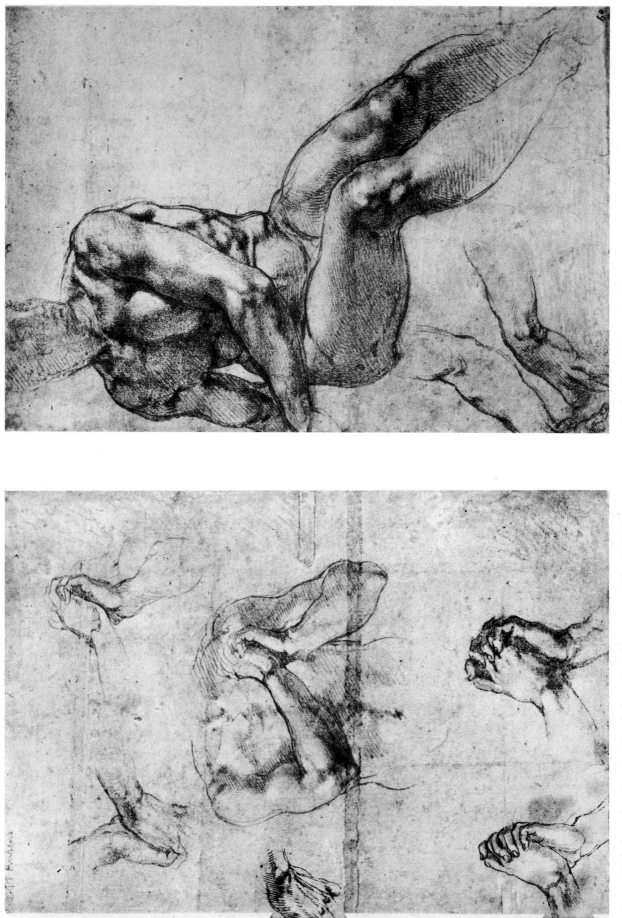

96–97. Michelangelo: *Praying Hands* (recto). About 1515. Black chalk on paper, reworked. – *Ignudo* (verso). About 1505.
Red chalk on paper. Vienna, Albertina

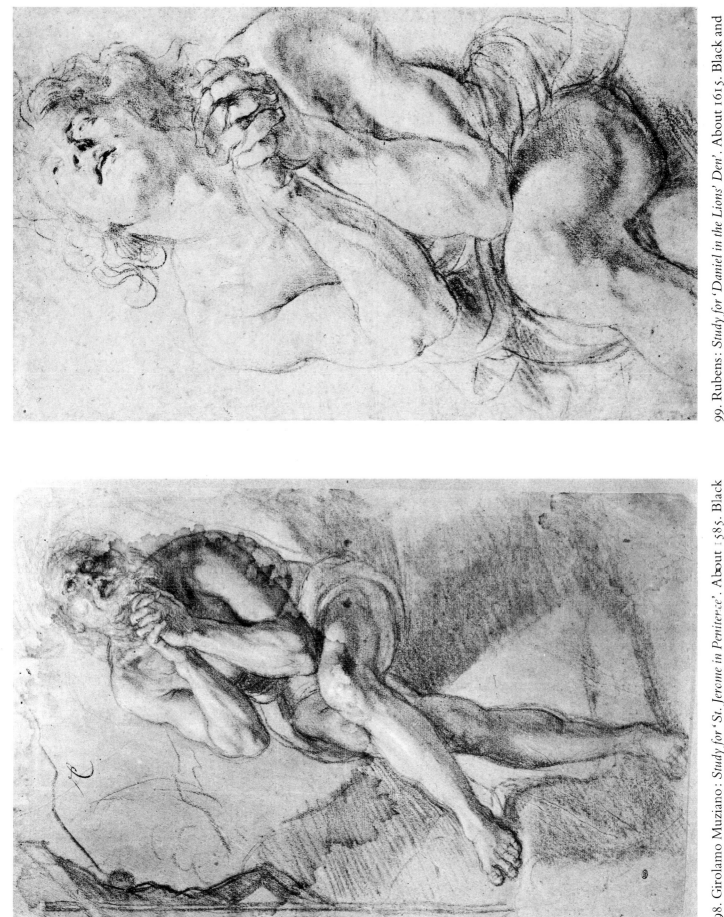

99. Rubens: *Study for 'Daniel in the Lions' Den'*. About 1615. Black and white chalks on paper. New York, Pierpont Morgan Library

98. Girolamo Muziano: *Study for 'St. Jerome in Penitence'*. About 1585. Black and white chalks on paper. Paris, Louvre

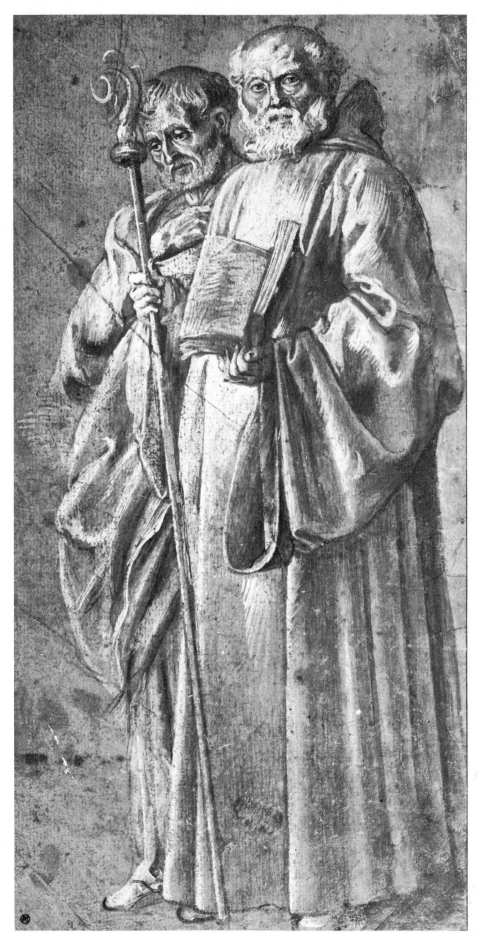

100. Rubens, after Giovanni
Bellini: *Sts. Benedict and Paul*.
About 1605. Ink and bodycolour
on paper. London, British Museum

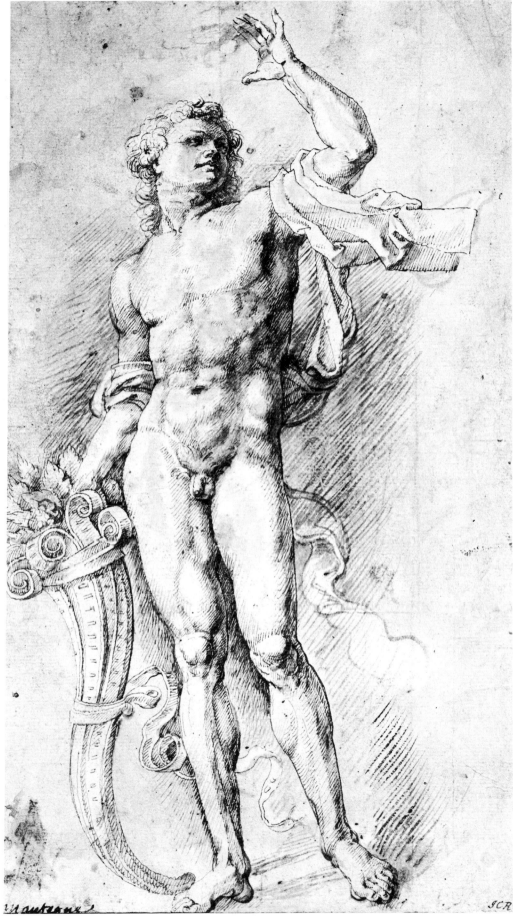

101. Rubens, after
Mantegna: *Figure from the
'Bacchanal with Silenus'.*
1600–5. Ink on paper.
Berlin, Kupferstichkabinett

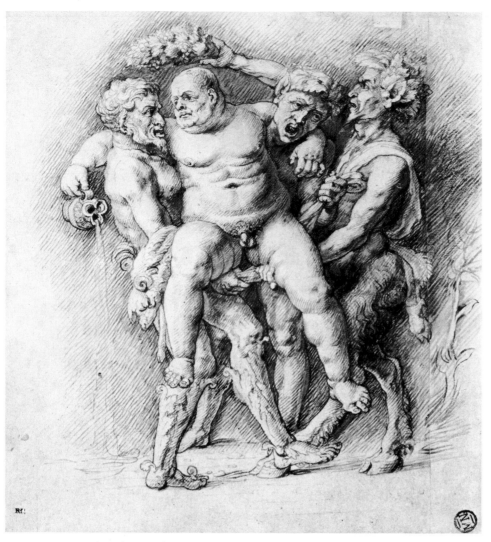

102. Rubens, after Mantegna: *Group from the 'Bacchanal with Silenus'*. 1600–5. Ink on paper. Paris, Louvre

103. Rubens, after Mantegna: *Corselet-bearers from 'The Triumph of Caesar'*. About 1605. Ink on paper. Paris, Louvre

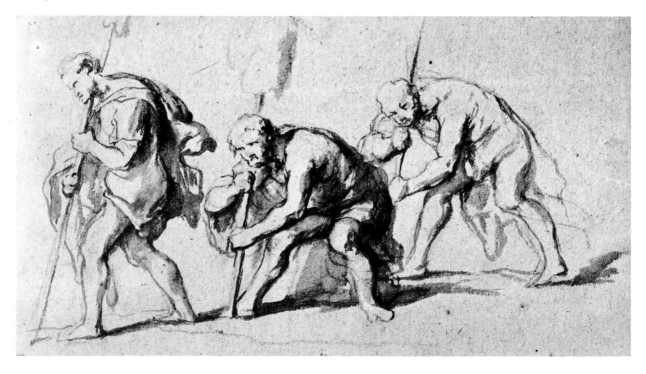

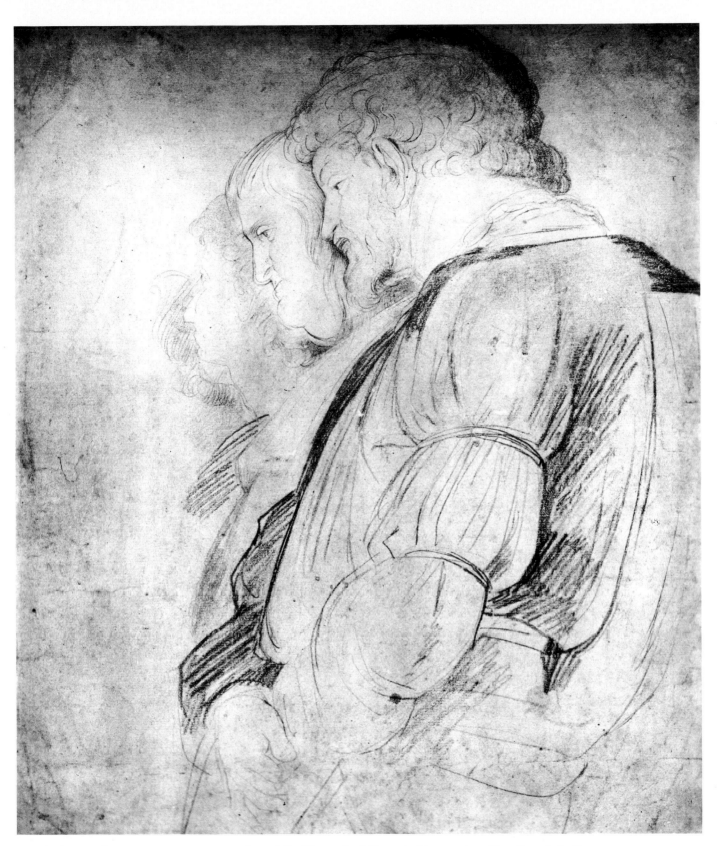

104. Rubens, after Mantegna: *Prisoners from 'The Triumph of Caesar'*. About 1605. Pencil and chalk on paper. Boston, Isabella Stewart Gardner Museum

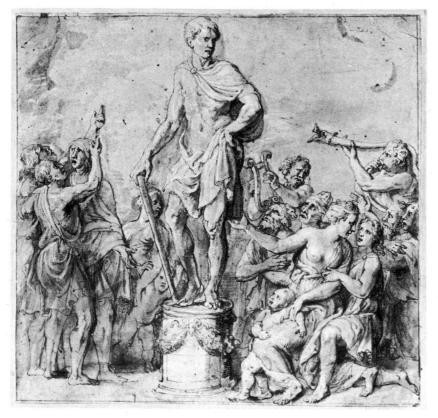

105. Rubens, after Giulio Romano: *Chimney-piece Relief in Giulio's Mantuan Salone*. About 1605. Ink and bodycolour on paper. London, formerly Mr. C. R. Rudolph

106. Giulio Romano: *The Birth of Venus*. About 1525. Fresco. Mantua, Palazzo del Tè

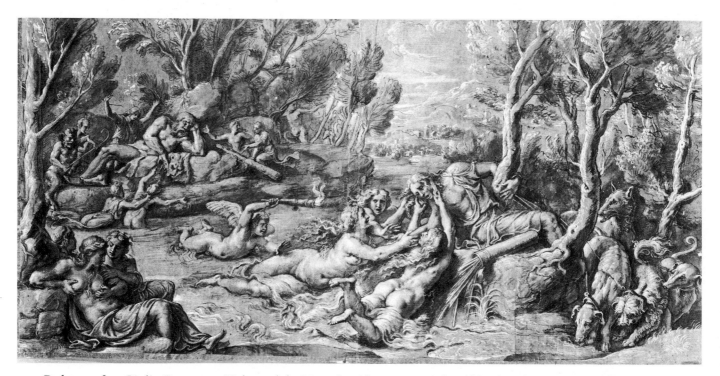

107. Rubens, after Giulio Romano: *Hylas and the Nymphs*. About 1605. Ink and bodycolour on paper. Paris, Fondation Custodia

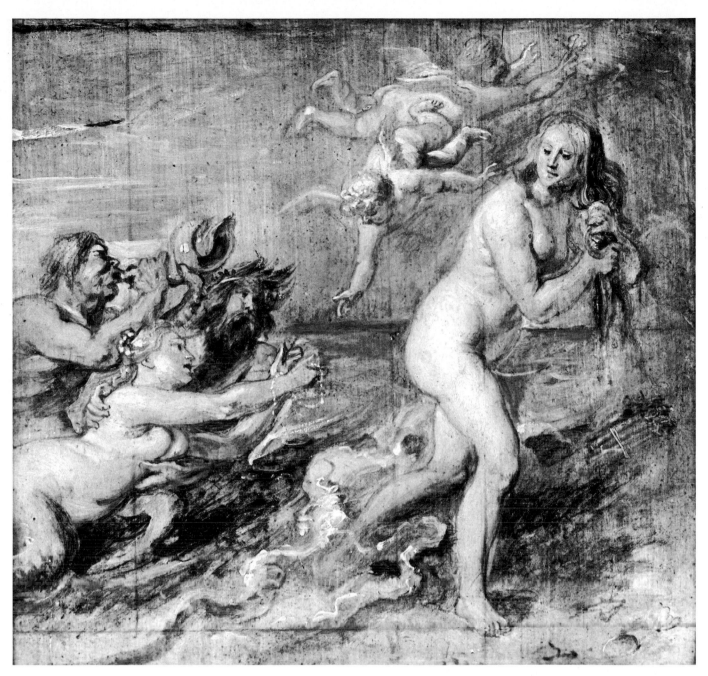

108. Rubens: *The Birth of Venus*. About 1638. Oils on panel. Brussels, Musée Royal des Beaux-Arts

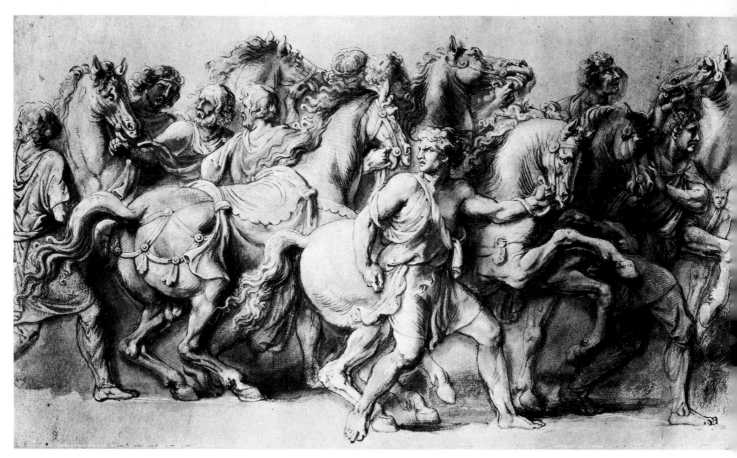

109. Anon., after Giulio Romano (retouched by Rubens): *The Triumphal Entry of the Emperor Sigismund* (detail).
1600–5. Chalk and inks on paper. Paris, Louvre

110. Giulio Romano: *Perseus disarming*. About 1536–8. Ink on paper. London, British Museum.

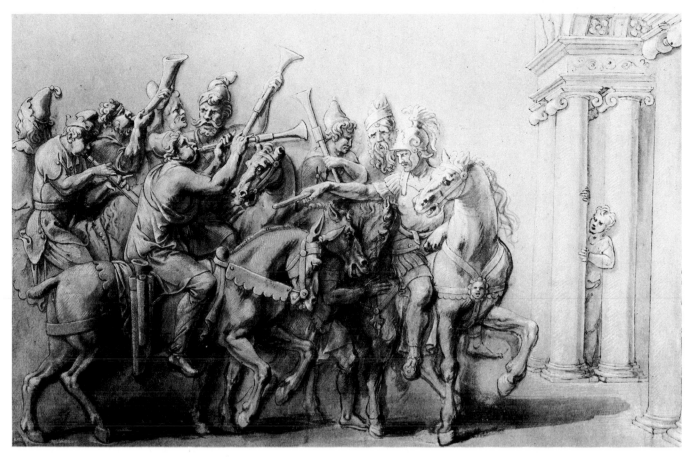

111. Anon., after Giulio Romano (retouched by Rubens): *The Triumphal Entry of the Emperor Sigismund* (detail). 1600–5. Chalk and inks on paper. Paris, Louvre

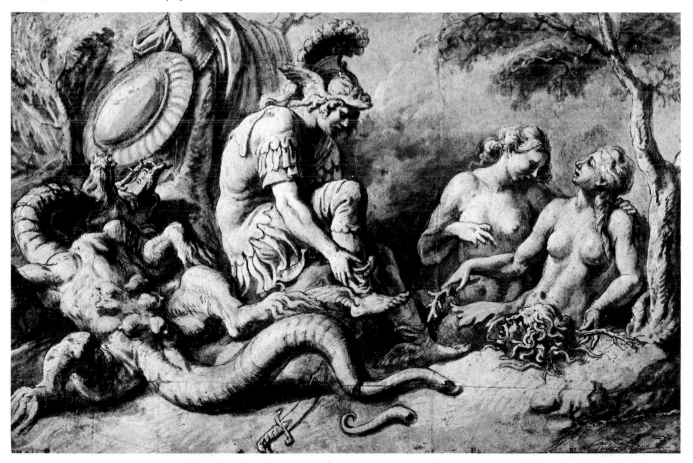

112. Rubens, after Giulio Romano: *Perseus disarming*. 1600–5. Ink and bodycolour on paper. London, British Museum

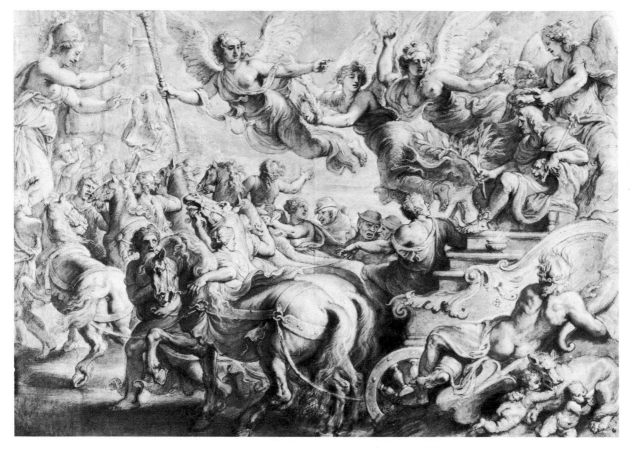

113. Rubens, after Giulio Romano: *The Triumph of Scipio*. About 1605. Ink and bodycolour on paper. London, heirs of Mr. Clifford Duits

114. Rubens, after Giulio Romano: *Psyche wafted over the Sea by Zephyrus*. 1600–5. Ink and bodycolour on paper. Formerly Mertoun House (Roxburghshire), Duke of Sutherland

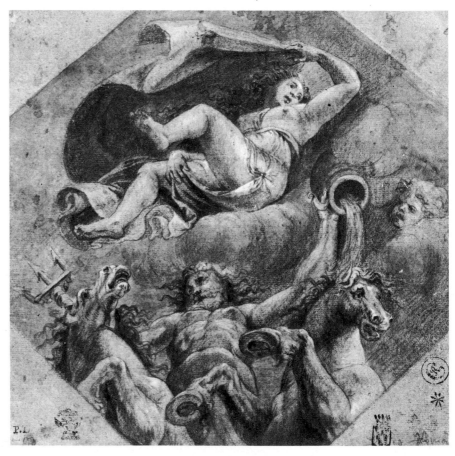

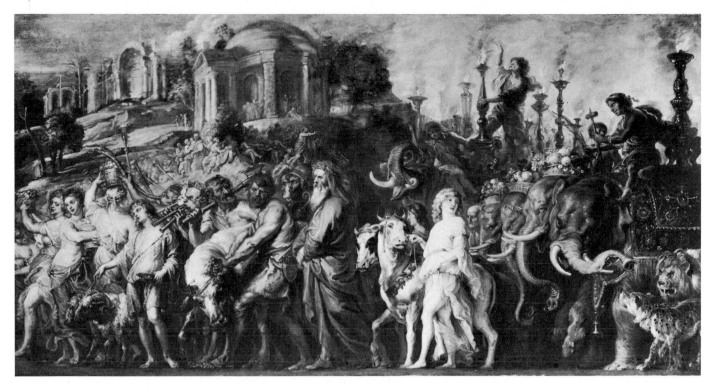

115. Rubens, after Mantegna: *A Triumph of Caesar*. 1629–30. Oils on paper and panel. London, National Gallery

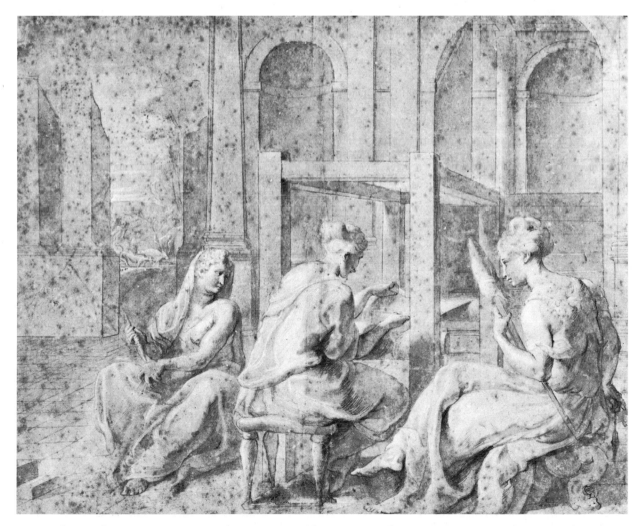

116. Rubens, after Primaticcio: *Penelope weaving*. About 1605. Ink on paper. Darmstadt, Hessisches Landesmuseum

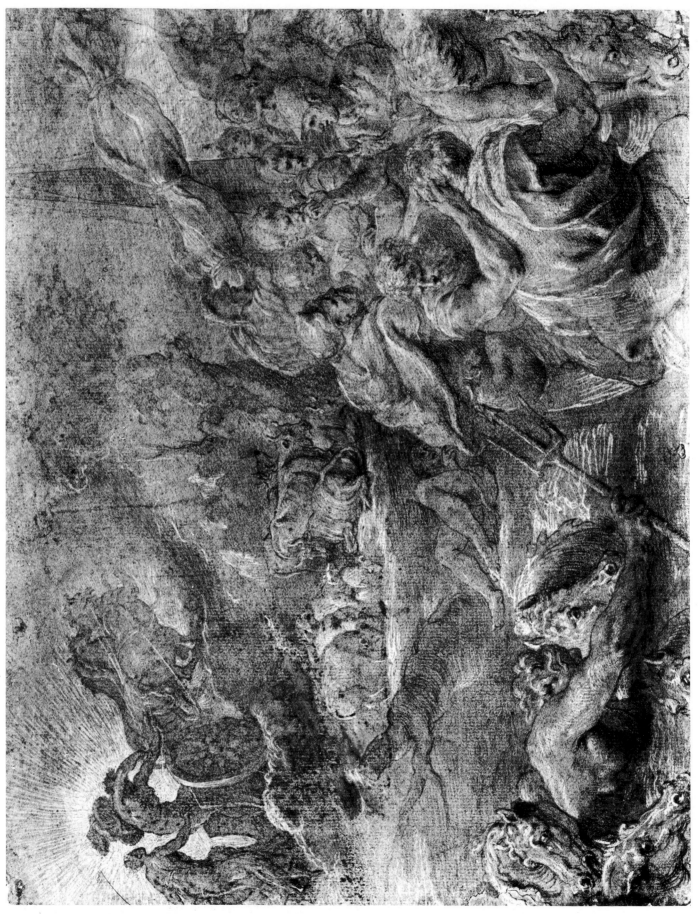

117. Theodoor van Thulden, after Primaticcio (retouched by Rubens): 'Quos ego!'. About 1630. Red chalk and bodycolour on paper. Vienna, Albertina

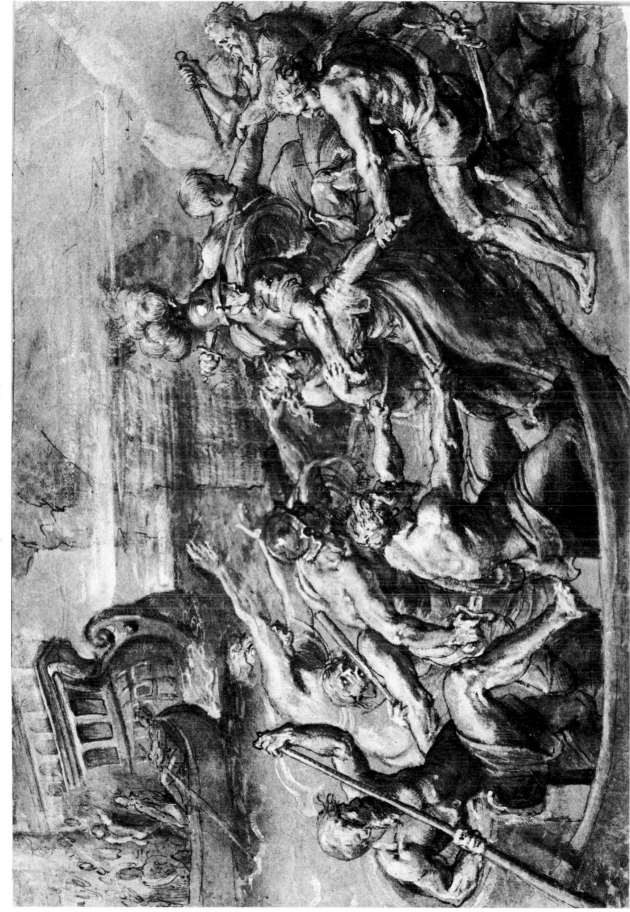

118. Rubens, after Primaticcio: *The Rape of Helen*. About 1525. Ink and bodycolour on paper. Paris, Louvre

119. Giovanni da Udine (retouched by Rubens 1601–8): *Children's Games*. Black chalk and bodycolour on paper. Paris, Louvre

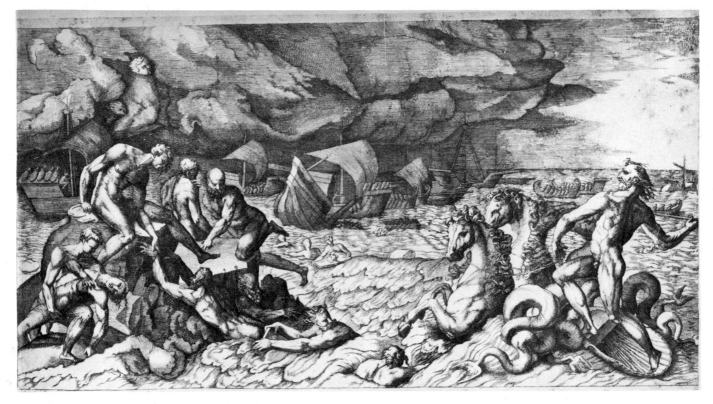

120. Giulio Bonasone, after Perino del Vaga: *The Shipwreck of Aeneas*. Copper engraving

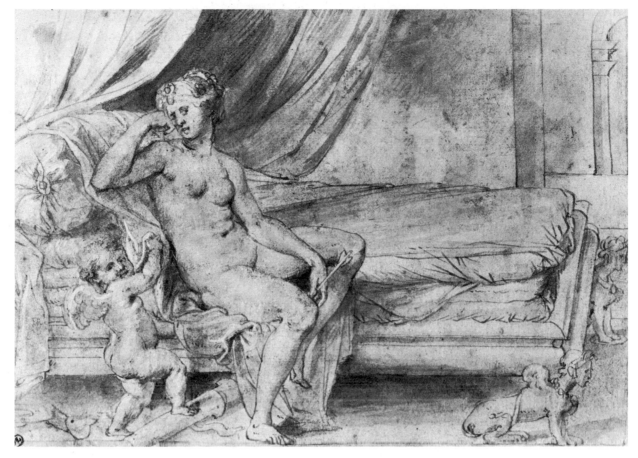

121. Anon., after Perino del Vaga (retouched by Rubens 1601–8): *Cupid and Psyche*. Ink and bodycolour on paper. Paris, Louvre

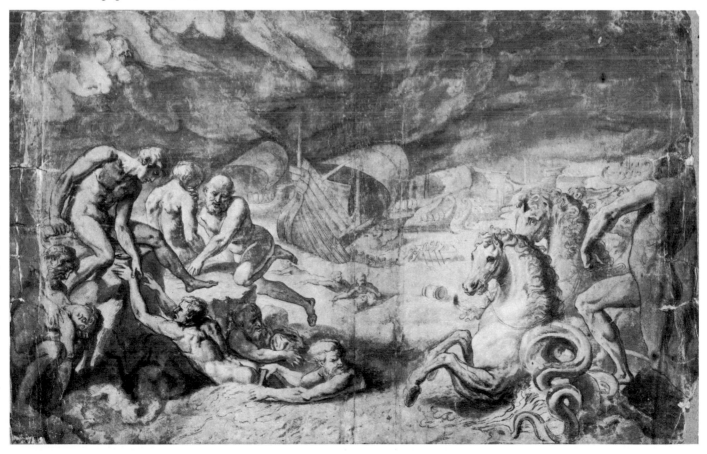

122. Rubens, after Giulio Bonasone (after Perino del Vaga): *The Shipwreck of Aeneas*. About 1600. Ink on paper. Edinburgh, National Galleries of Scotland

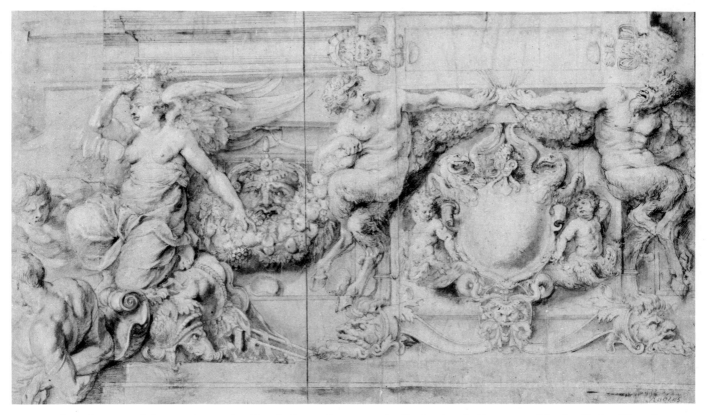

123. Studio of Perino del Vaga (retouched by Rubens about 1605): *Design for the 'basamento' in the Sistine Chapel.*
Ink and bodycolour on paper. London, British Museum

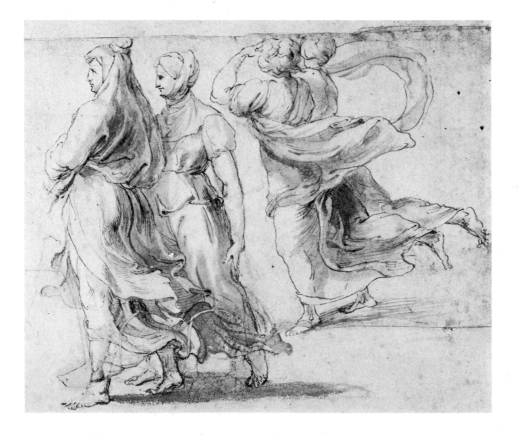

124. School of Raphael (repaired
and retouched by Rubens
1620–5): *Running and walking
Women.* Ink and bodycolour on
paper. Oxford, Christ Church

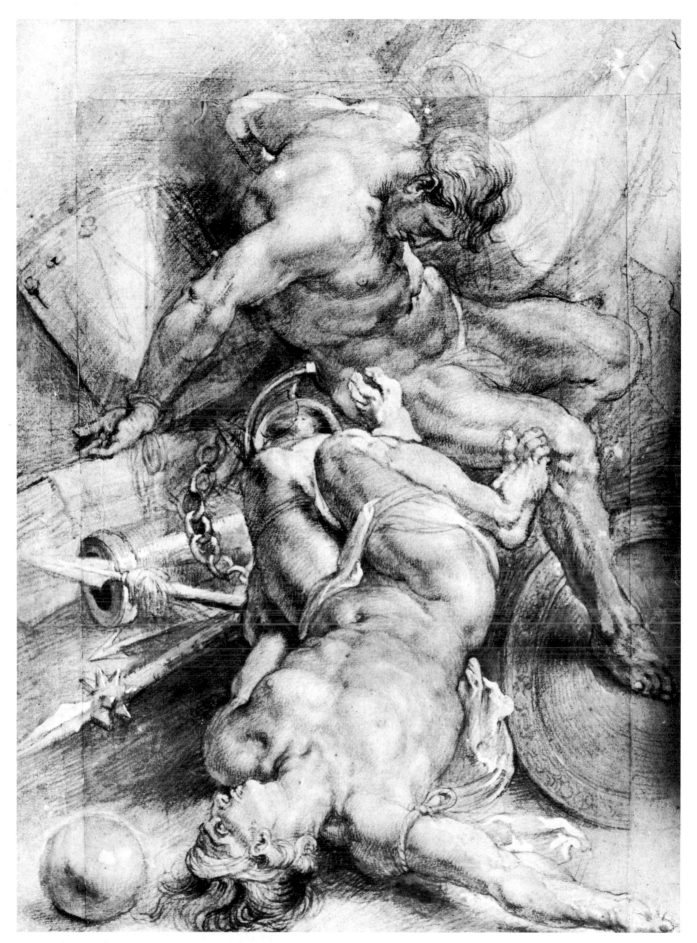

125. Rubens, after Francesco Salviati: *Prisoners from the 'Fasti Farnesienses'*. 1605–8. Ink and bodycolour on paper. Angers, Musée Pincé

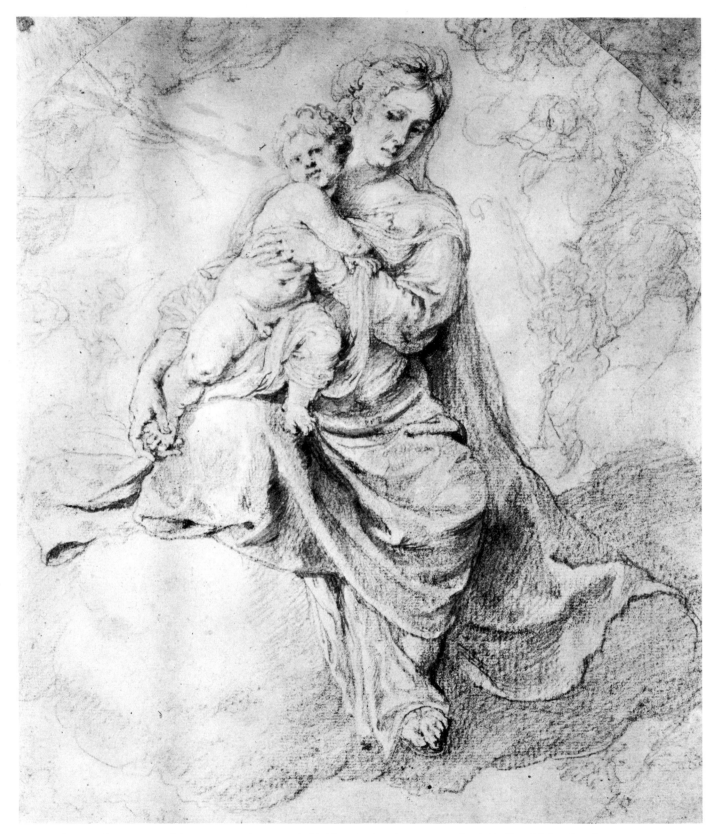

126. Rubens, after Perino del Vaga: *Madonna and Child with Angels*. 1605–8. Red chalk with bodycolour on paper. Madrid, Prado

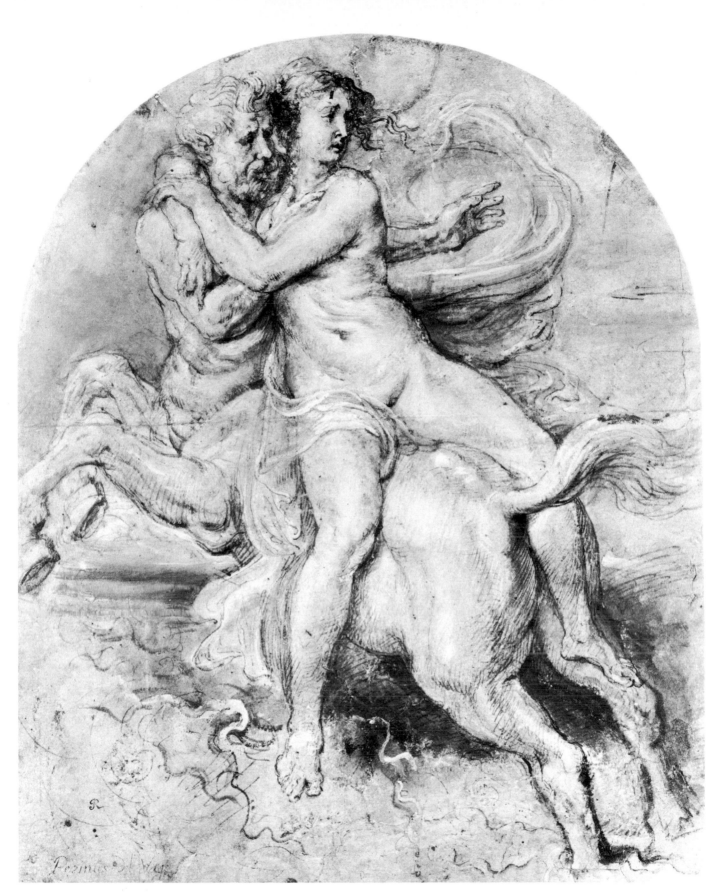

127. Rubens, after Perino del Vaga: *The Flight of Nessus and Dejanira*. 1605–8. Ink and bodycolours on paper.
London, British Museum

128. Polidoro da Caravaggio: *The Road to Calvary*. About 1543. Oils on panel. London, Mr. P. M. R. Pouncey

129. Rubens: *The Road to Calvary*. 1633–4. Oils on panel. Copenhagen, Statens Museum for Kunst

130. Rubens, after
Polidoro da Caravaggio:
Youth leading a Horse.
1605–8. Ink and
bodycolour on paper.
London, British Museum

131–132. Baldassare Peruzzi: *Caesar and Augustus* (*recto*, retouched by Rubens 1601–8), ink and bodycolour on paper; *Roman Antiquities* (*verso*), about 1520, ink on paper. Veste Coburg

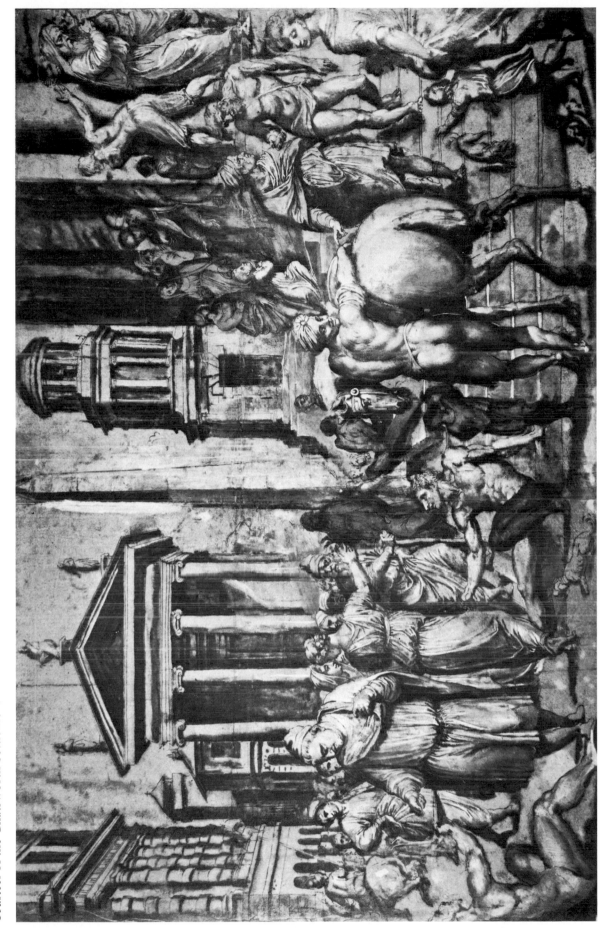

133. Rubens, after Baldassare Peruzzi: *The Presentation in the Temple*. 1605–8. Ink and bodycolour on paper. Bakewell (Derbyshire). Trustees of the Chatsworth Settlement

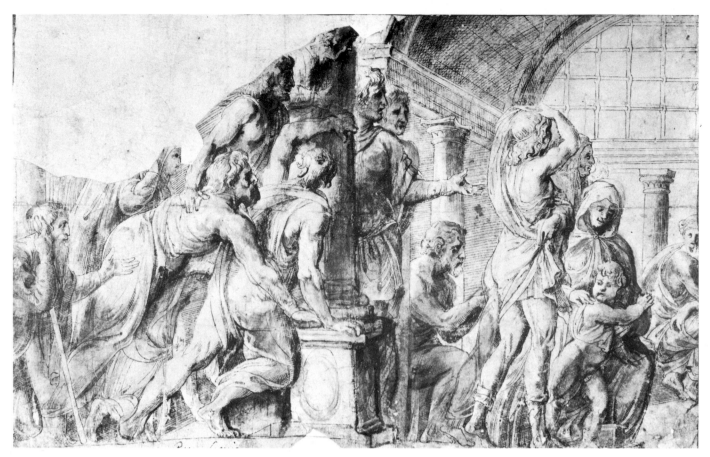

134. Pirro Ligorio, after Donatello (retouched by Rubens 1601–8): *The Miracle of the Ass of Rimini*. Ink and bodycolour on paper. New York, private collection

135. Pirro Ligorio (retouched by Rubens 1601–8): *The Marriage of Bacchus and Ariadne*. Red chalk and bodycolour on paper. Oxford, Christ Church

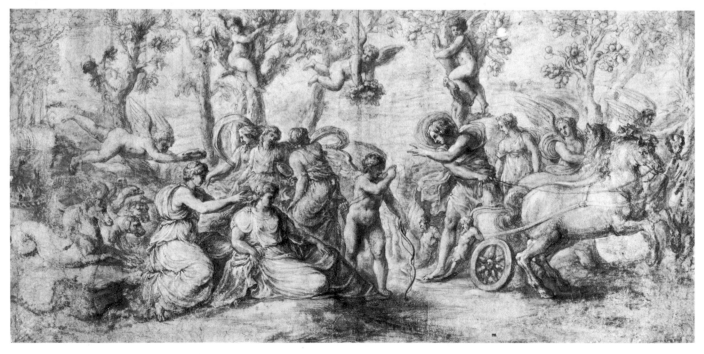

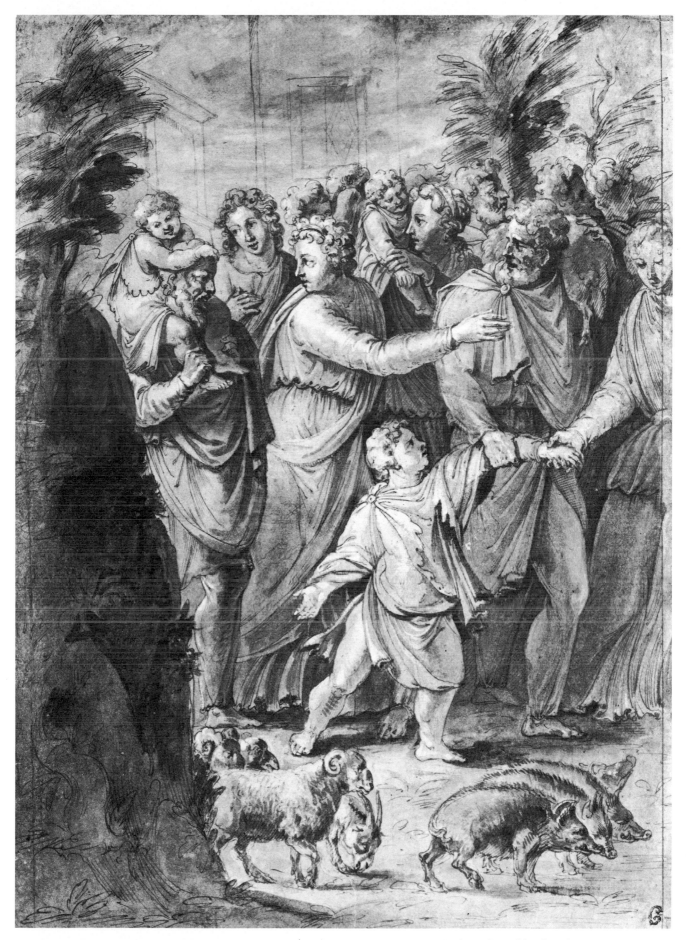

136. Pirro Ligorio (retouched by Rubens 1605–8): *The Israelites and their Flocks*. Ink and bodycolour on paper. Amsterdam, Rijksprentenkabinet

137. Francesco Salviati (retouched by Rubens 1605–8): *The Fall and the Expulsion*. Ink and bodycolour on paper. Paris, Louvre

138. Taddeo Zuccaro (retouched by Rubens 1605–8): *The Blinding of Elymas*. Ink and bodycolour on paper. Stockholm, Nationalmuseum

139. Federico Zuccaro (retouched by Rubens 1605–8): *The Marriage of the Virgin*. Ink and bodycolour on paper. Paris, Louvre

140. Federico Zuccaro (retouched by Rubens 1605–8): *The Last Supper*. Ink and bodycolour on paper. Oxford, Christ Church

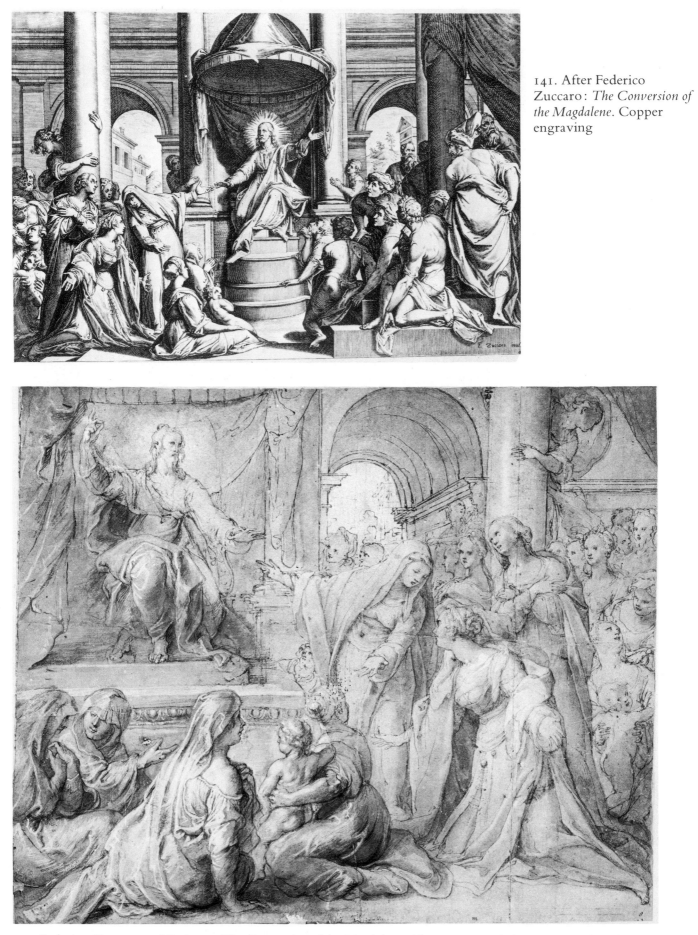

141. After Federico Zuccaro: *The Conversion of the Magdalene*. Copper engraving

142. Federico Zuccaro and Rubens: *The Conversion of the Magdalene*. About 1562 and about 1635. Ink and bodycolour on paper. Lulworth (Dorset), Sir Joseph Weld

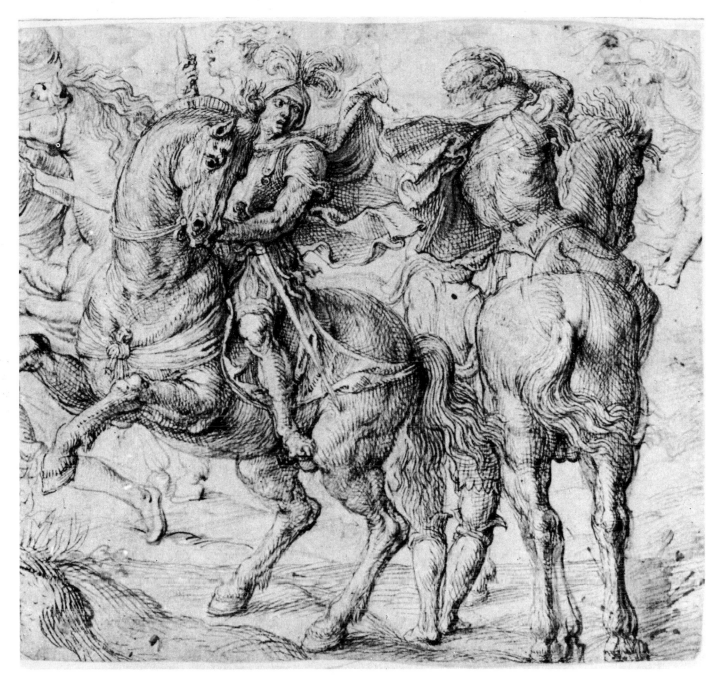

143. Anon., after a follower of Titian (corrected by Rubens 1605–8): *Detail from woodcut of 'The Conversion of Saul'.*
Ink and bodycolour on paper. Steeple Bumpstead (Essex), Dr. and Mrs. A. Rooke

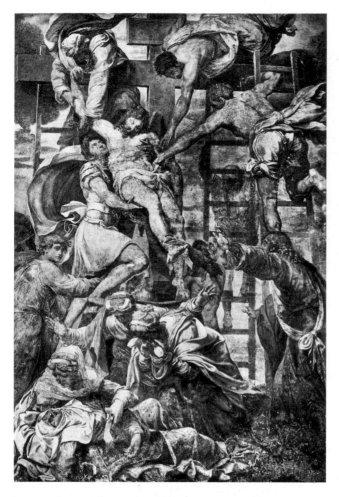

144

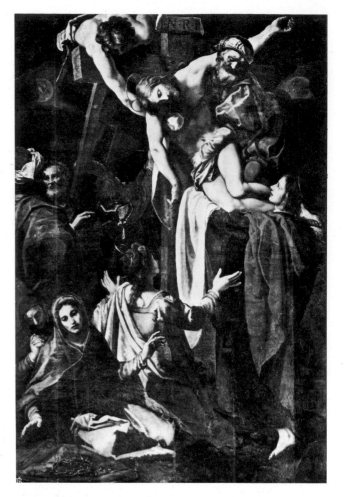

145

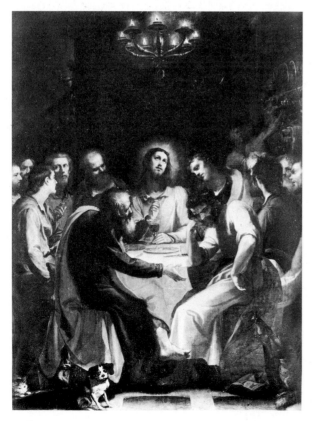

146

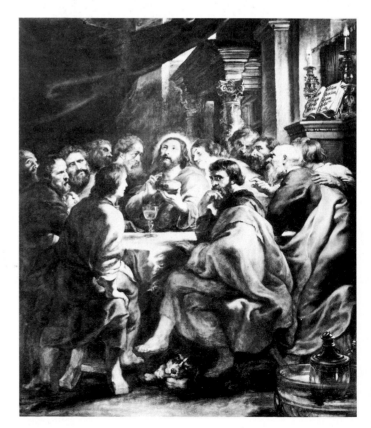

147

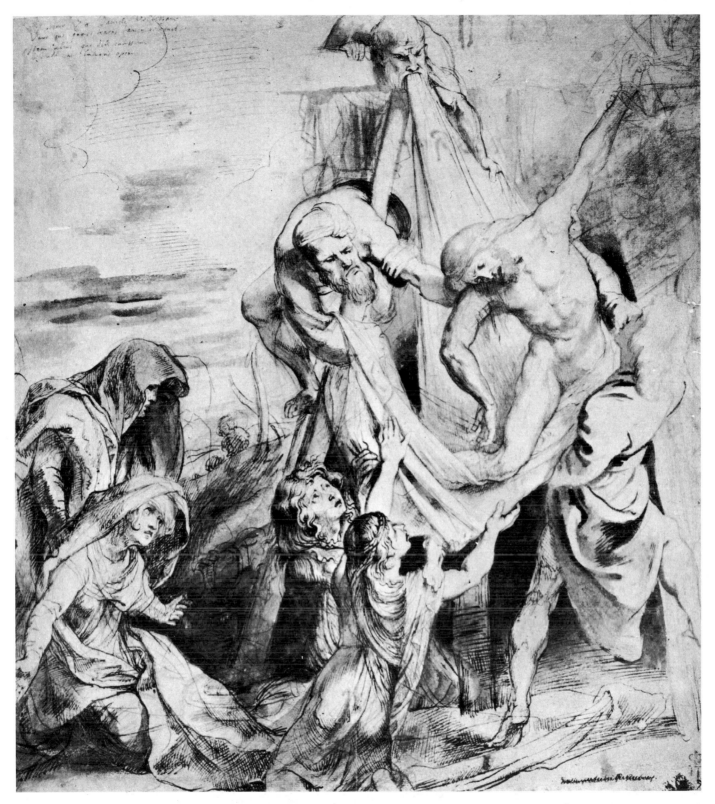

148. Rubens, after Il Cigoli: *The Deposition from the Cross*. About 1603. Ink on paper. Leningrad, Hermitage

144. Daniele da Volterra: *The Deposition from the Cross*. About 1542. Fresco. Rome, S. Trinità dei Monti

145. Il Cigoli: *The Deposition from the Cross*. About 1603–7. Oils on panel. Florence, Palazzo Pitti

146. Il Cigoli: *The Last Supper*. 1591. Oils on canvas. Formerly Empoli, Collegiata

147. Rubens: *The Last Supper*. 1635. Oils on panel. Milan, Brera

149. Rubens: *The Shipwreck of Aeneas*. 1603–5. Oils on canvas. Berlin–Dahlem, Staatliche Museen

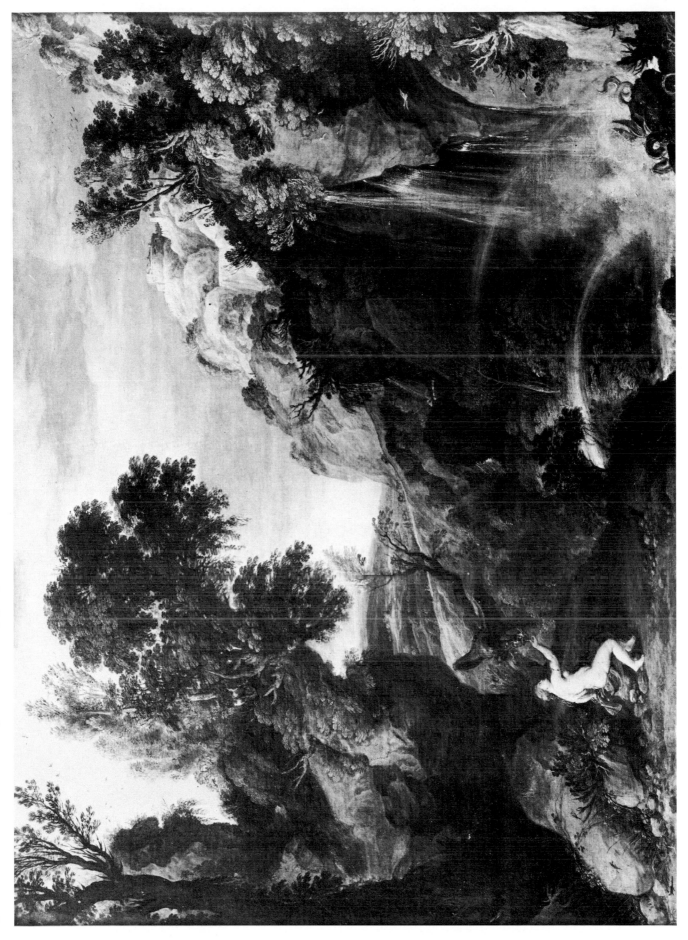

150. Paul Brill and Rubens: *Landscape with the History of Psyche*. 1610. Oils on canvas. Madrid, Prado

151. Barocci: *Tree Study*. About 1580. Ink on paper. Paris, Fondation Custodia

152. Rubens: *A Path in Spring*. About 1614. Black chalk and ink on paper. Cambridge, Fitzwilliam Museum

153. Barocci: *Studies for 'The Visitation'*. Detail.
About 1582. Ink on paper. Amsterdam,
Rijksprentenkabinet

154. Rubens: *Studies for 'The Visitation'*. 1612–14. Ink on paper. Bayonne, Musée Bonnat

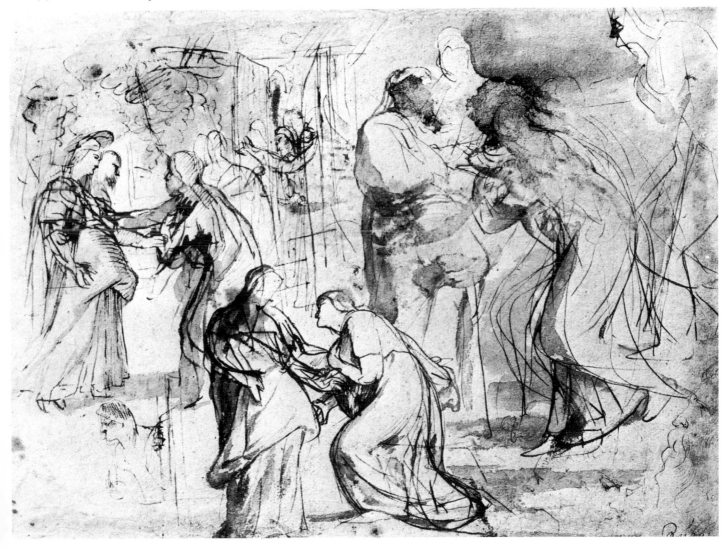

156. Rubens, after Elsheimer: *Figures from 'The Lapidation of St. Stephen'*. About 1608. Ink on paper. London, British Museum

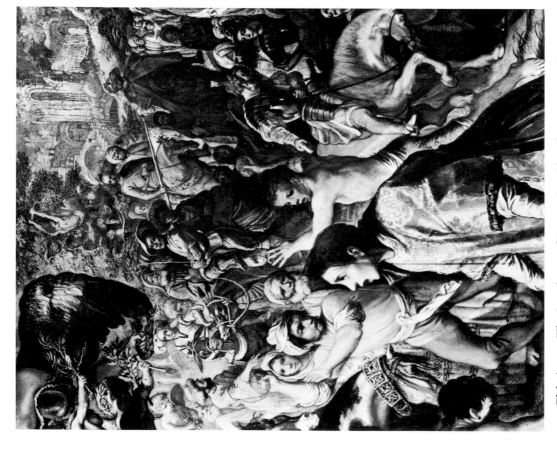

155. Elsheimer: *The Lapidation of St. Stephen* (detail). 1602–4. Oils on copper. Edinburgh, National Galleries of Scotland

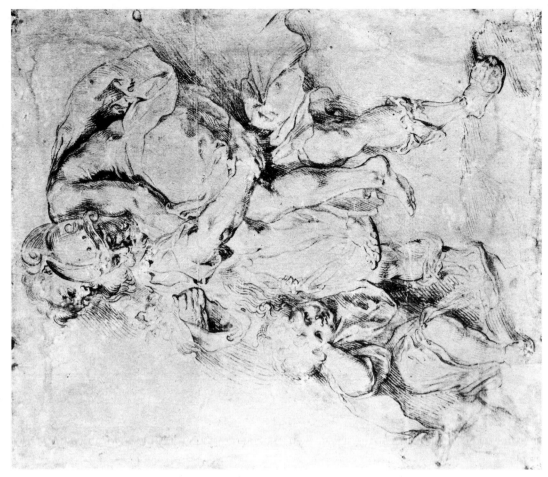

158. Rubens, after Barocci: *Figures from 'The Flight from Troy'*. About 1608. Ink on paper. Vienna, Albertina

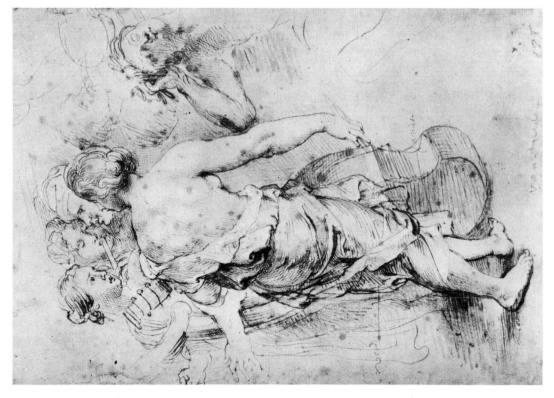

157. Rubens, after Orazio Gentileschi: *Figures from 'Apollo and the Muses'*. 1629–30. Ink on paper. Rotterdam, Museum Boymans–van Beuningen

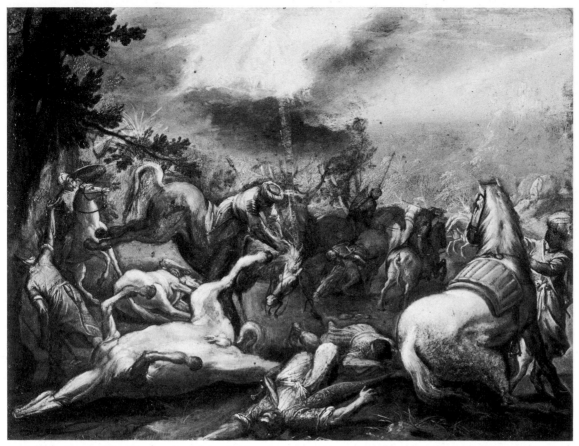

159. Elsheimer: *The Conversion of Saul*. About 1600. Oils on copper. Frankfurt, Städelsches Kunstinstitut

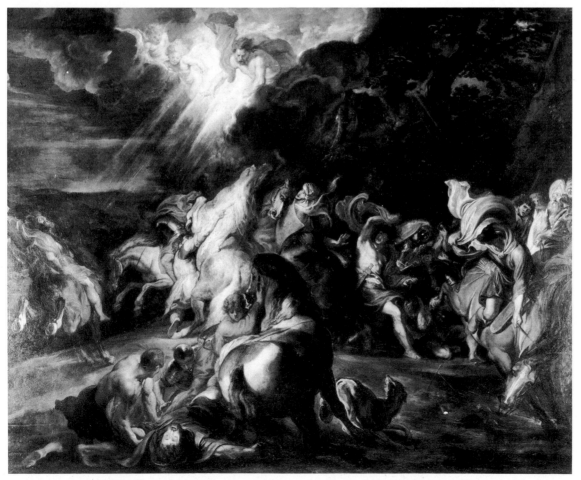

160. Rubens: *The Conversion of Saul*. About 1616. Oils on panel. London, Count Antoine Seilern

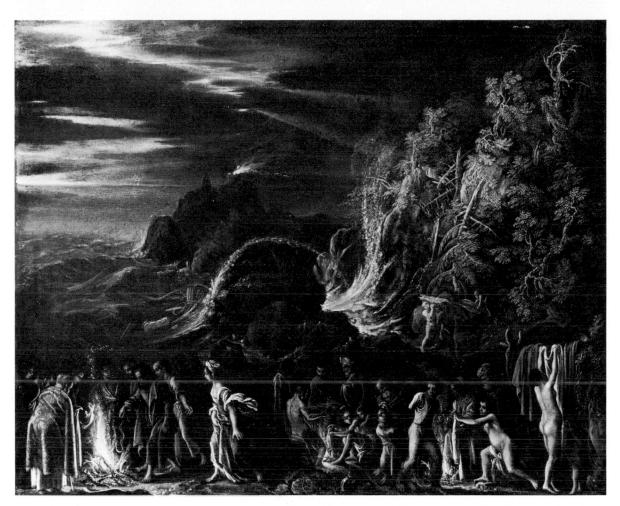

161. Elsheimer: *The Shipwreck of St. Paul on Malta*. About 1604. Oils on copper. London, National Gallery

162. Rubens:
Landscape in a Windstorm. 1628–9.
Oils on canvas.
Oxford, Ashmolean Museum

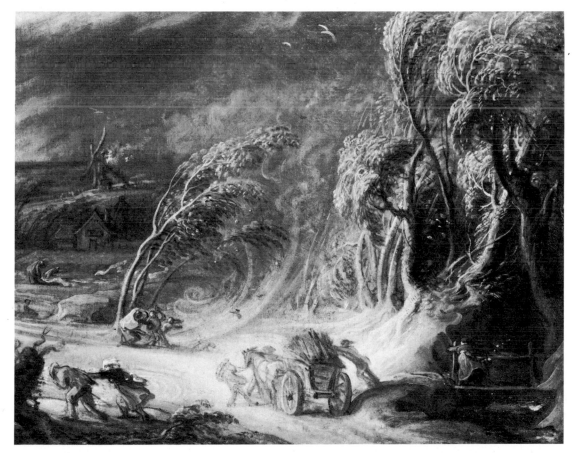

163. Rubens, after Annibale Carracci: *Design for the Tazza Farnese*. About 1605. Red chalk on paper. Bakewell (Derbyshire), Trustees of the Chatsworth Settlement

164. Rubens, after Annibale Carracci: *Section of the Cove Decoration in the Galleria Farnese*. Ink and chalk on paper. London, Victoria and Albert Museum

165. Annibale Carracci: *Portrait of Claudio Merulo.*
About 1598. Oils on canvas. Naples, Pinacoteca
Nazionale

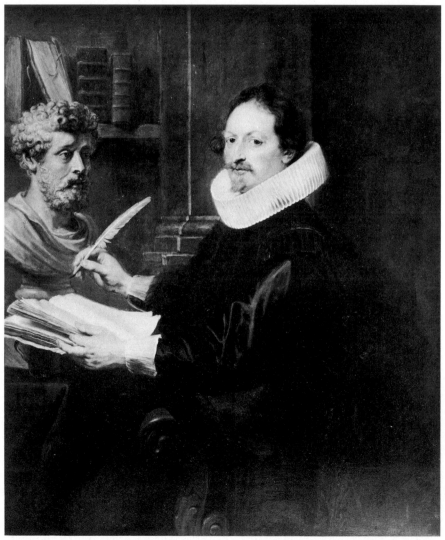

166. Rubens: *Portrait of Caspar
Gevartius.* About 1628. Oils on panel.
Brussels, Musée Royal des Beaux-Arts

167. Rubens: *Nursery Scene*. About 1608. Red chalk on paper. Paris, Louvre

168. Caravaggio: *The Calling of St. Matthew.* About 1600. Oils on canvas. Rome, S. Luigi dei Francesi

169. Caravaggio: *The Supper at Emmaus.* About 1598. Oils on canvas. London, National Gallery

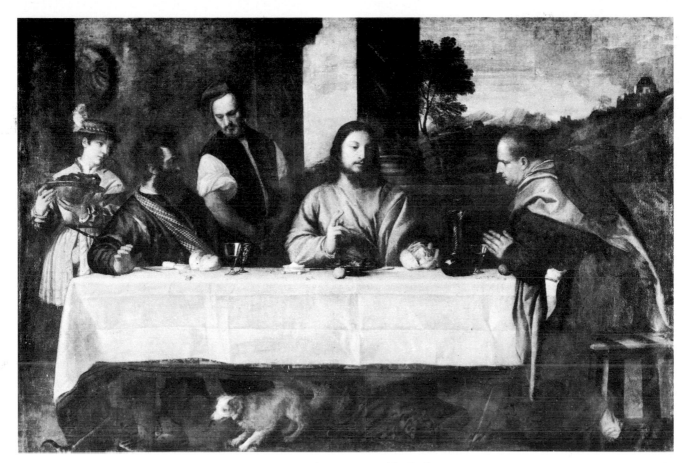

170. Titian: *The Supper at Emmaus*. About 1535. Oils on canvas. Paris, Louvre

171. W. Swanenburg, after Rubens: *The Supper at Emmaus*. Copper engraving

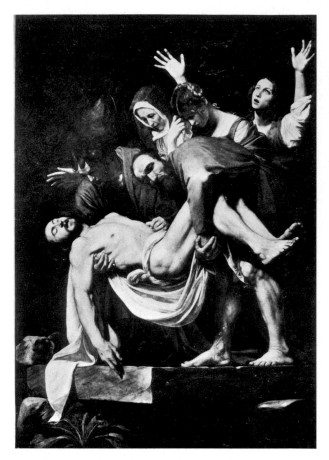

172. Caravaggio: *The Entombment*. About 1602. Oils on canvas. Vatican, Pinacoteca

173. Rubens: *The Entombment*. About 1614. Oils on panel. Ottawa, National Gallery of Canada

174. Titian: *The Entombment* (detail). About 1530. Oils on canvas. Paris, Louvre

175. Rubens: *Study for an Entombment*. About 1612.
Ink on paper. Amsterdam, Rijksprentenkabinet

176. Polidoro da Caravaggio: *Study for an Entombment*.
About 1555. Inks on paper. Paris, Louvre

177. Rubens: *The Entombment* (modello). About 1616.
Oils on panel. London, Count Antoine Seilern

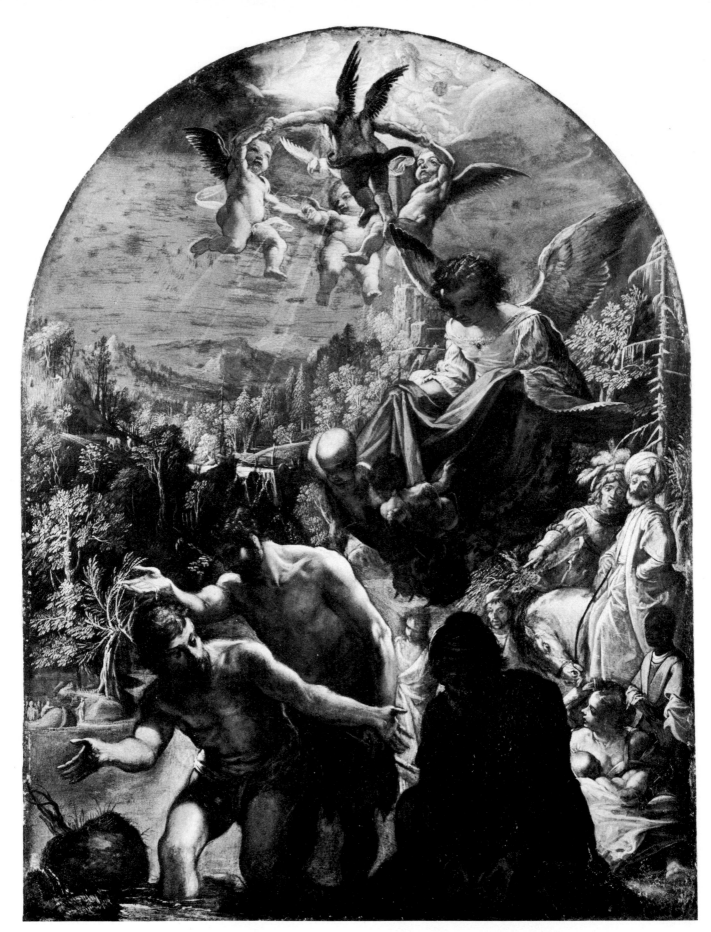

178. Elsheimer: *The Baptism of Christ*. About 1600. Oils on copper. London, National Gallery

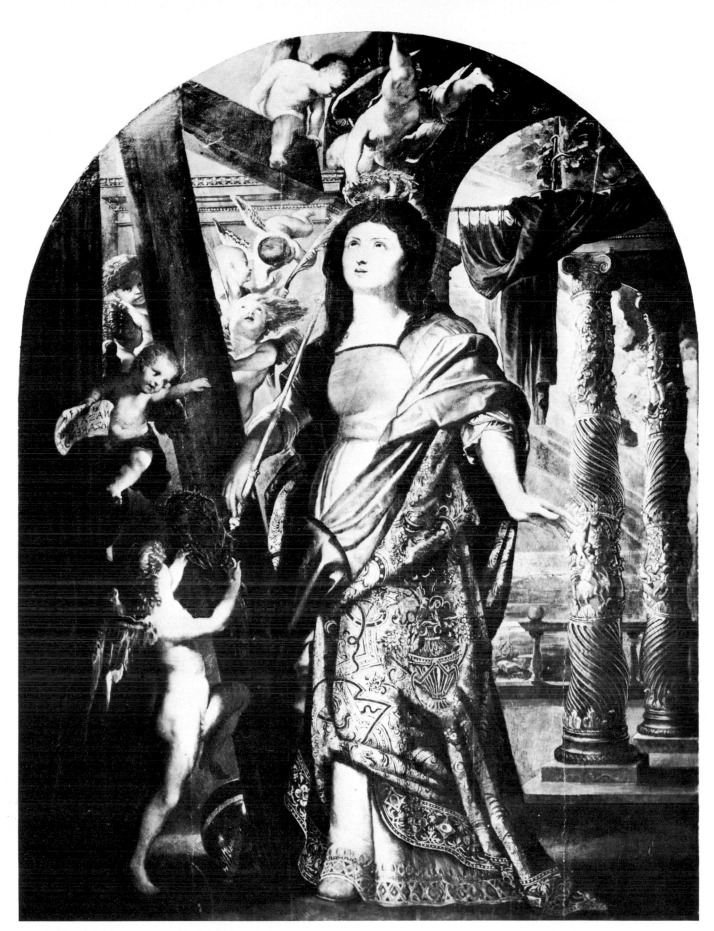

179. Rubens: *The Ecstasy of St. Helena*. 1601. Oils on panel. Grasse, Hôpital de Petit-Paris

180. Rubens: *Study of a Young Man's Head.*
About 1601. Oils on paper. Forest Hills (N.Y.),
Mr. and Mrs. Robert L. Manning

181. Rubens: *Study for 'The Mocking of Christ'.* 1601. Ink on paper. Brunswick, Herzog Anton Ulrich Museum

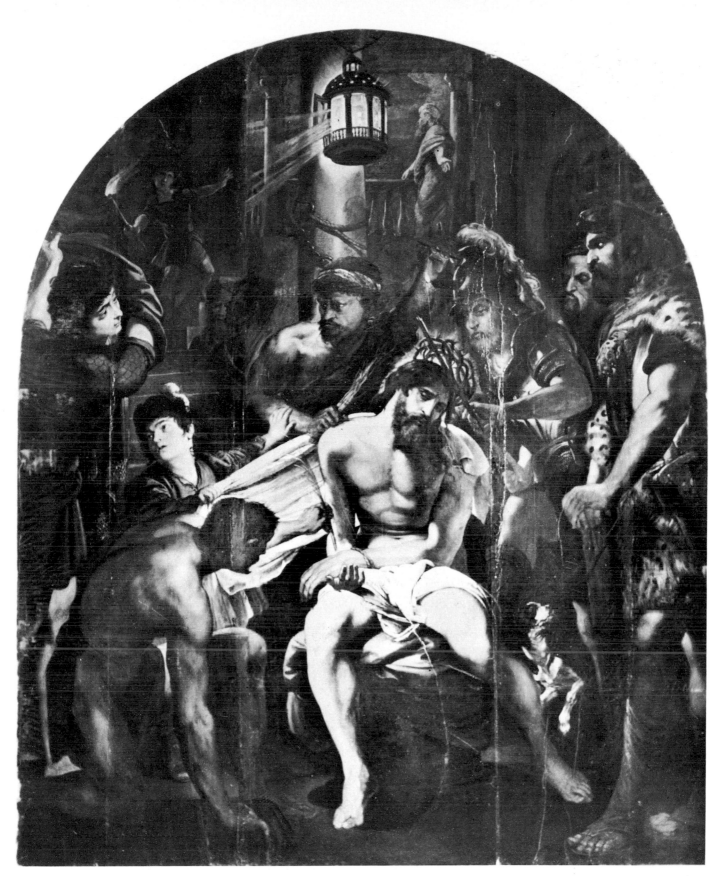

182. Rubens: *The Mocking of Christ*. 1601–2. Oils on panel. Grasse, Hôpital de Petit-Paris

183. (*far left*) J. Sadeler, after Christoffel Schwarz: *The Elevation of the Cross.* Copper engraving

184. (*left*) Jacopo Tintoretto: *Hercules and Antaeus.* About 1550. Oils on canvas. Hartford (Conn.), Wadsworth Atheneum

185. Rubens: *Study for a Man raising the Cross.* About 1601. Black chalk and charcoal on paper. Oxford, Ashmolean Museum

186. Jacopo Tintoretto: *Detail from 'The Crucifixion'*. About 1565. Oils on canvas. Venice, Scuola di San Rocco

187. Copy after Rubens: *The Elevation of the Cross* (seventeenth century; original in oils on panel, 1601–2). Oils on canvas. Grasse, Hôpital de Petit-Paris

Plates 188 and 189 show the recto and verso of an original sheet reconstructed

188. Rubens: *Studies for 'The Presentation in the Temple' (recto)*. 1614. Ink on paper. New York, Metropolitan Museum of Art, and London, Count Antoine Seilern

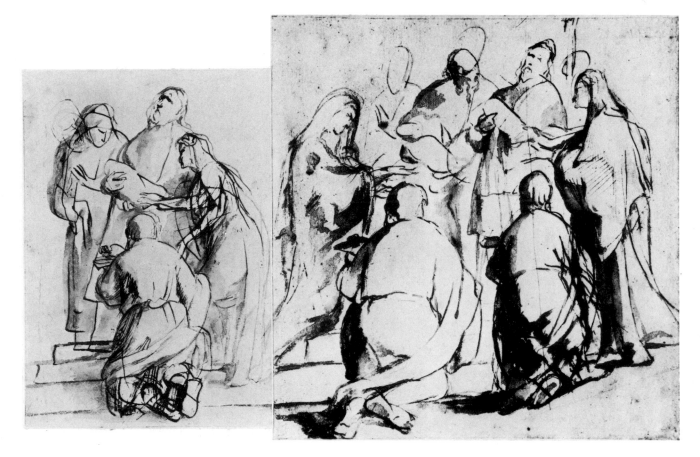

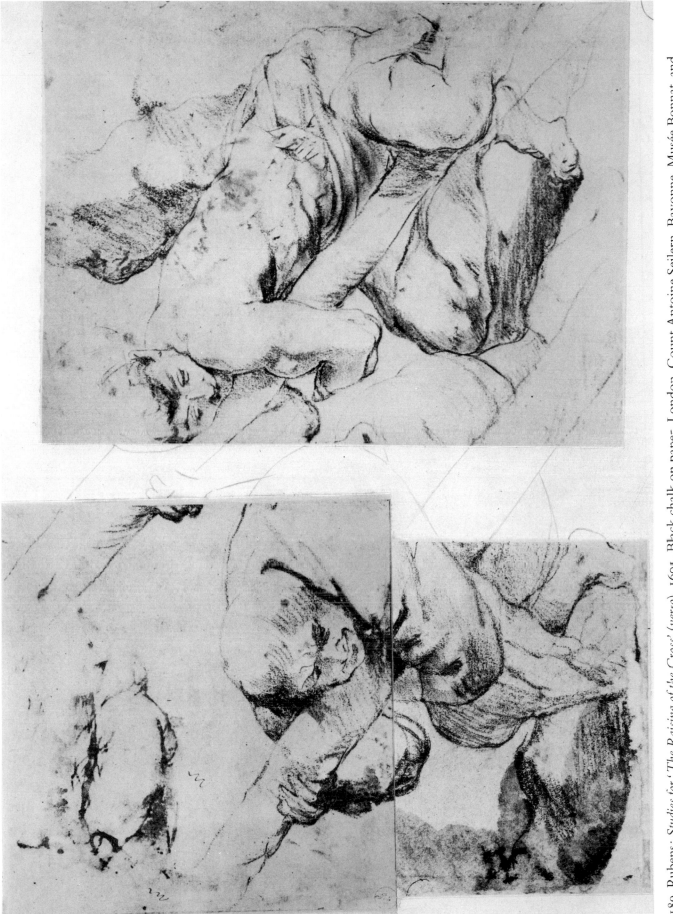

189. Rubens: *Studies for 'The Raising of the Cross' (verso)*. 1601. Black chalk on paper. London, Count Antoine Seilern, Bayonne, Musée Bonnat, and New York, Metropolitan Museum of Art

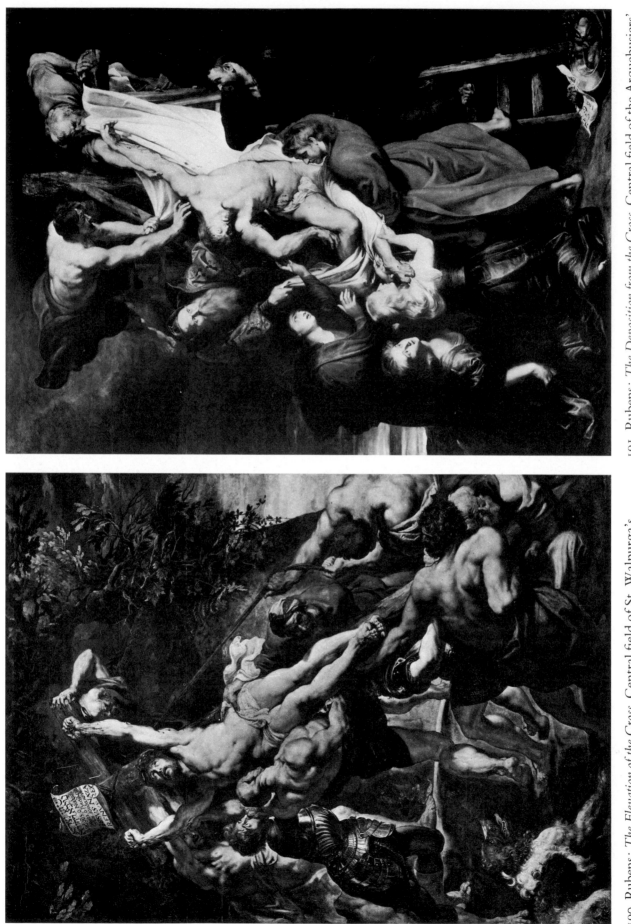

191. Rubens: *The Deposition from the Cross*. Central field of the Arquebusiers' triptych. About 1612. Oils on panel. Antwerp, Cathedral

190. Rubens: *The Elevation of the Cross*. Central field of St. Walpurga's triptych. 1609–11. Oils on panel. Antwerp, Cathedral

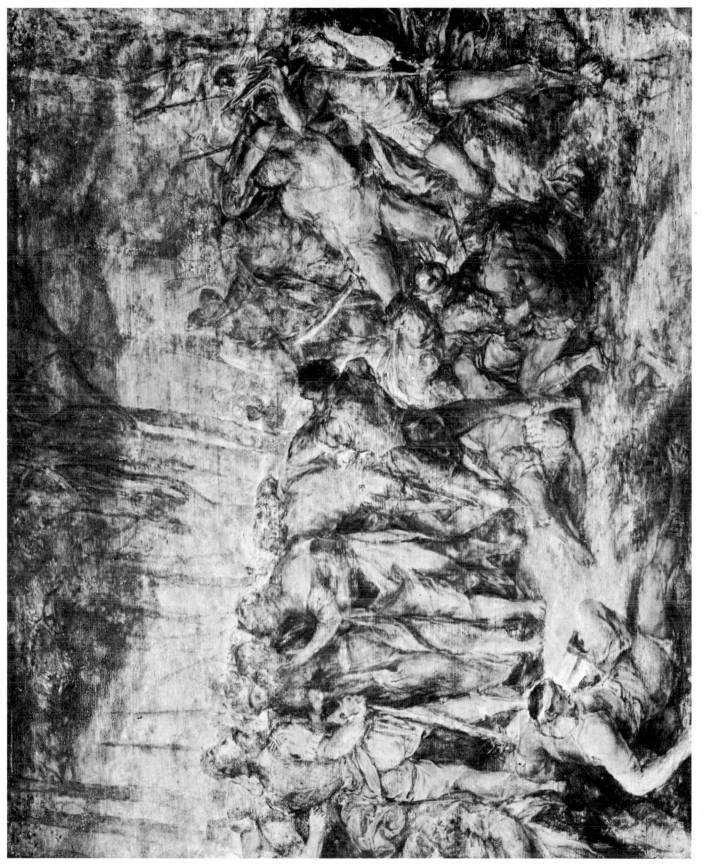

192. Rubens: *The Arrest of Christ*. About 1506. Oils or panel. Rotterdanr., Museum Boymans–Van Beuningen

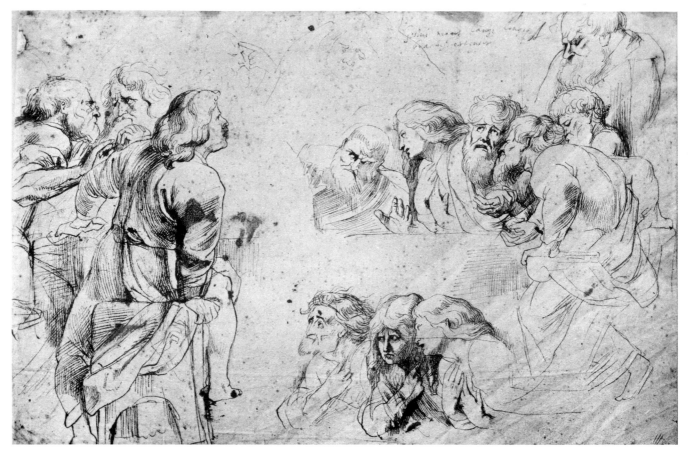

193–194. Rubens: *Studies for the 'Last Supper'* (*recto* and *verso*). About 1601. Ink on paper. Bakewell (Derbyshire), Trustees of the Chatsworth Settlement

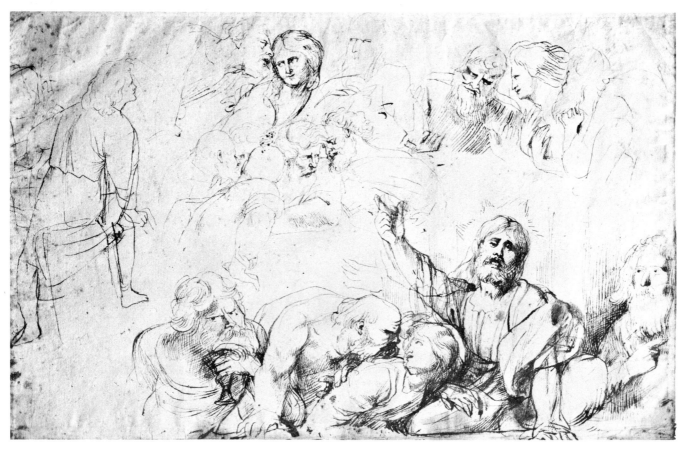

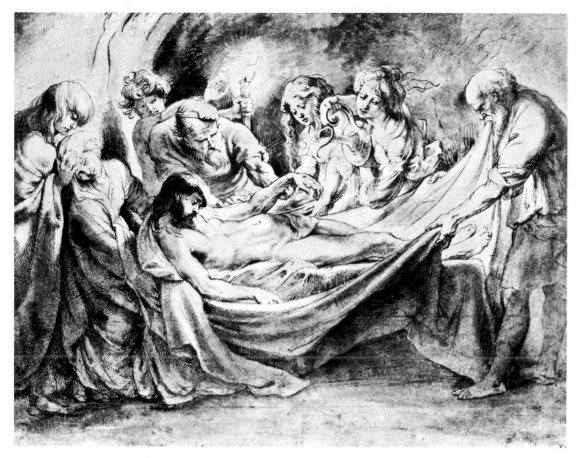

195. Rubens: *The Washing and Anointing of the Body of Christ*. About 1601. Ink on paper. Rotterdam, Museum Boymans–Van Beuningen

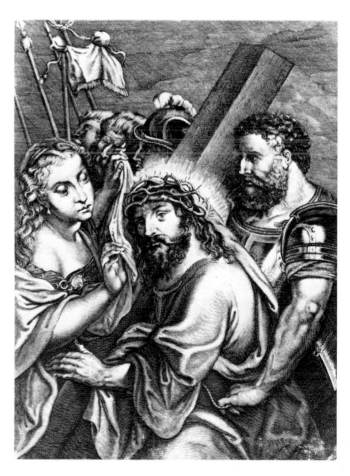

196. C. Lauwers, after Rubens: *Christ and Veronica*. Copper engraving

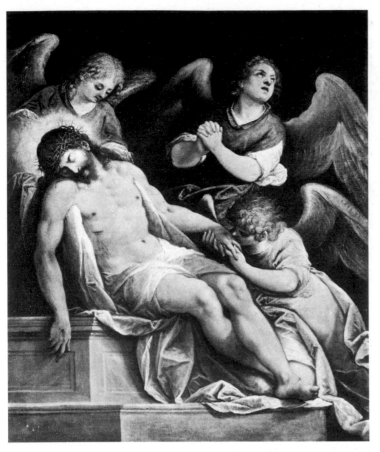

197. Giuseppe Porta: *Christ mourned by three Angels.* About 1560–70. Oils on canvas. Dresden, Gemäldegalerie

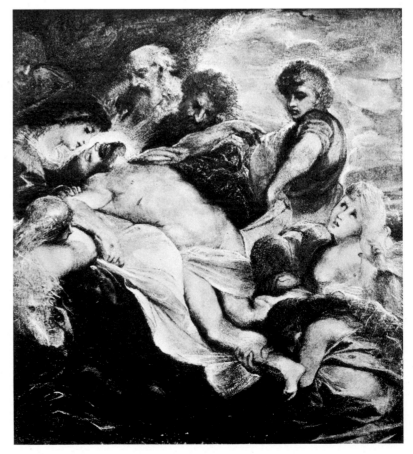

198. Rubens: *The Entombment.* 1601–2. Oils on copper. Jacksonville (Fla.), Cummer Gallery of Art

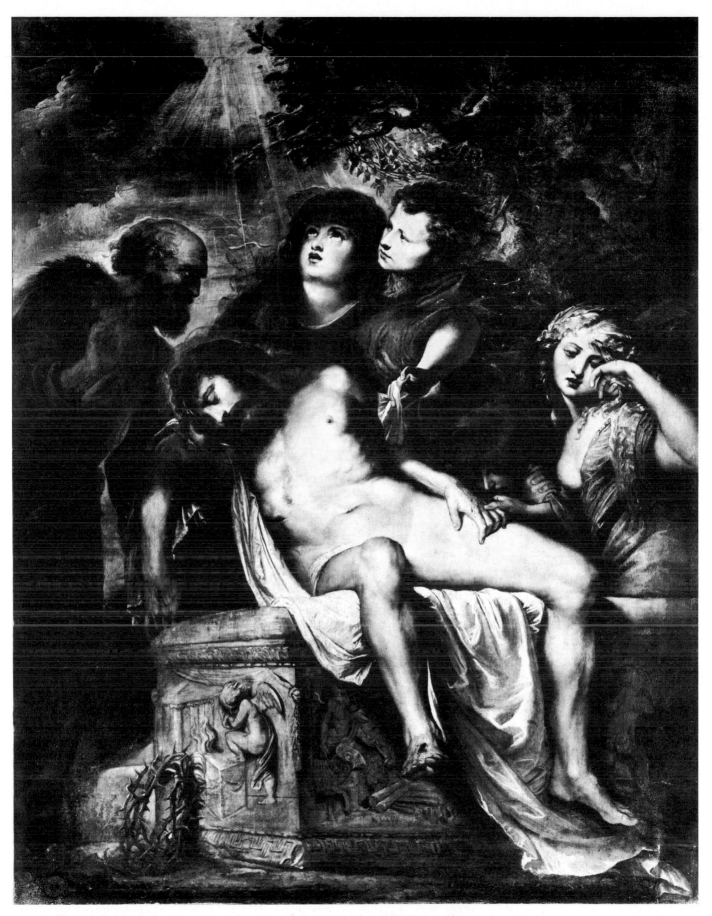

199. Rubens: *The Entombment.* 1601–2. Oils on canvas. Rome, Galleria Borghese

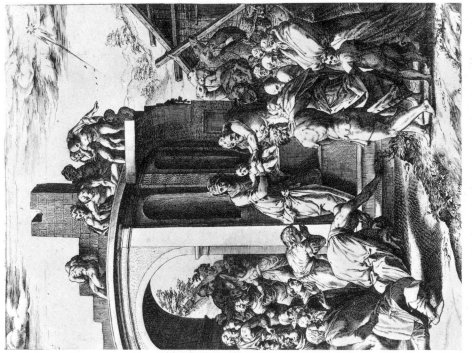

201. After Rosso Fiorentino: *The Adoration of the Magi.* Copper engraving

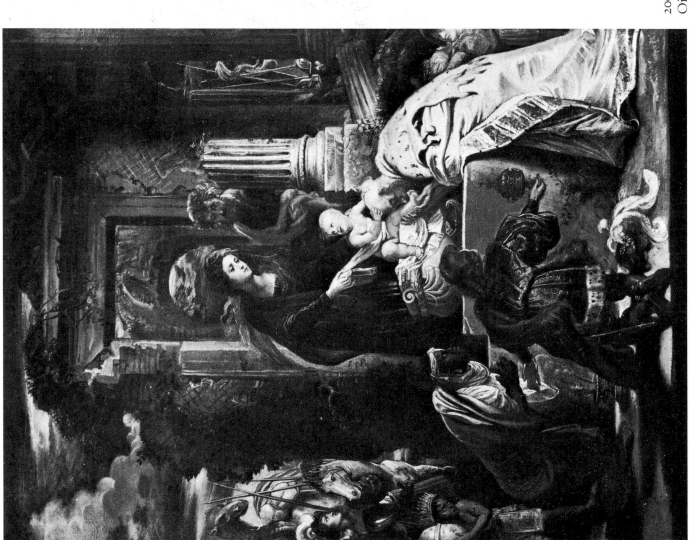

200. Rubens: *The Adoration of the Magi.* About 1602. Oils on canvas. La Hulpe (Brabant), Baron C.-A. Janssen

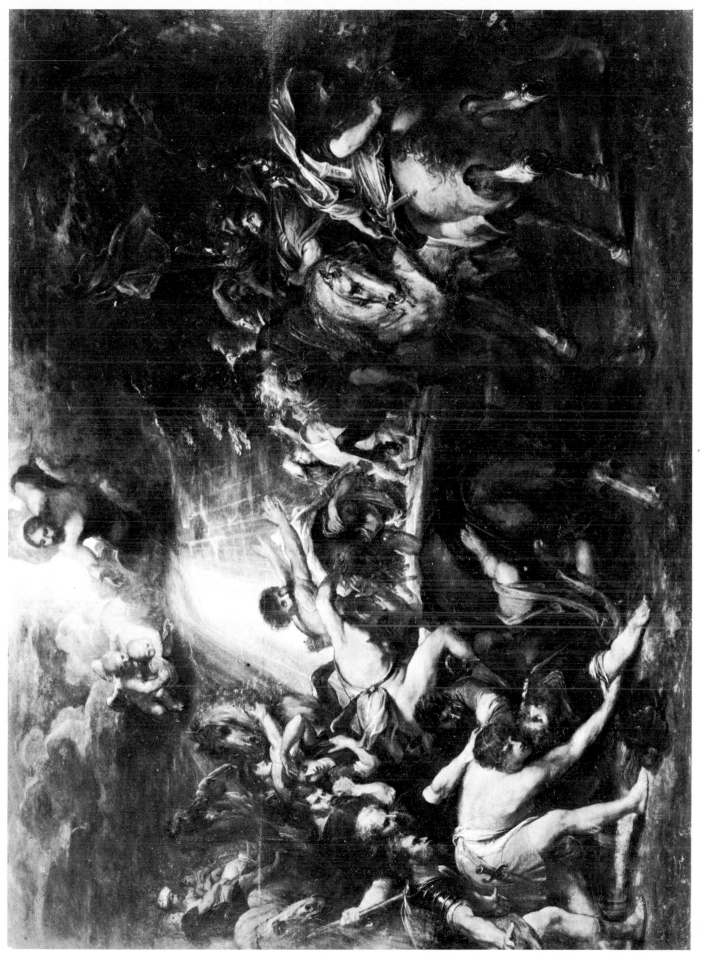

202. Rubens: *The Conversion of Saul*. About 1605. Oils on panel. Antwerp, Rockox House

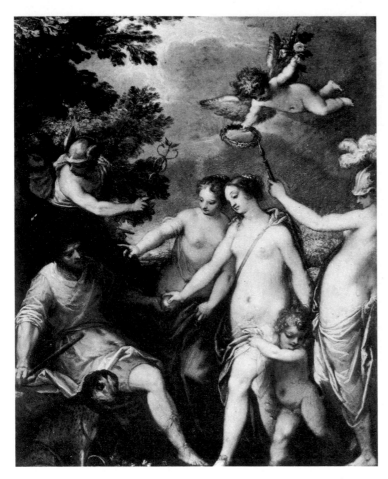

203. Rottenhammer: *The Judgement of Paris*. 1597. Oils on copper. Paris, Petit Palais

·ET· SOROR· ET· CONIVX· IOVIS· EST· SATVRNIA· IVNO·

204. J. Caraglio, after Rosso Fiorentino: *Juno*. Copper engraving

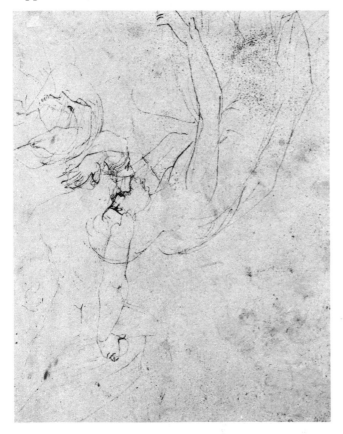

205. Rubens: *Study for Paris* (detail). About 1601. Ink on paper. New York, Metropolitan Museum of Art

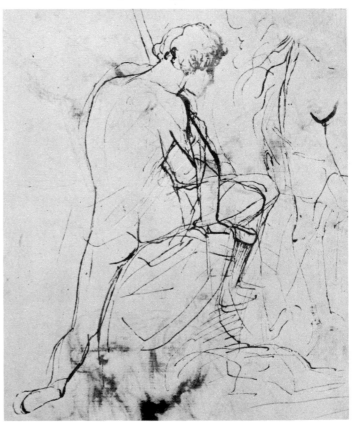

206. Rubens: *Study for Paris*. About 1601. Ink on paper. Paris, Louvre

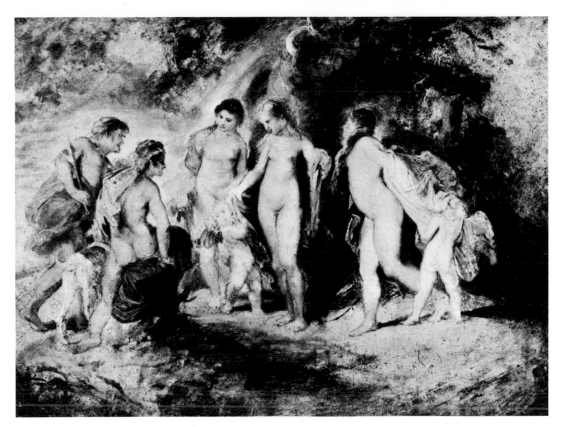

207. Rubens: *The Judgement of Paris*. About 1601. Oils on copper. Vienna, Akademie

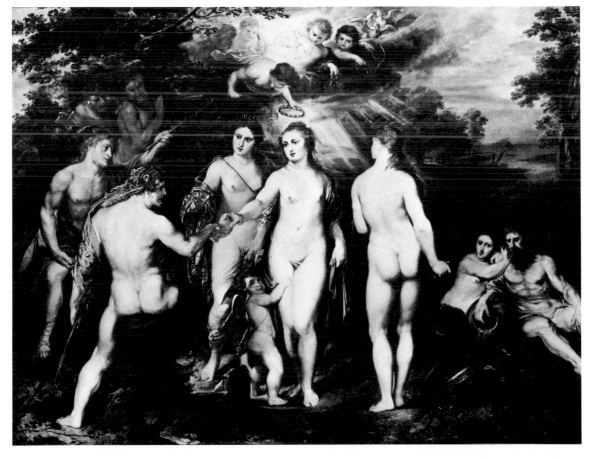

208. Rubens: *The Judgement of Paris*. About 1601. Oils on panel. London, National Gallery

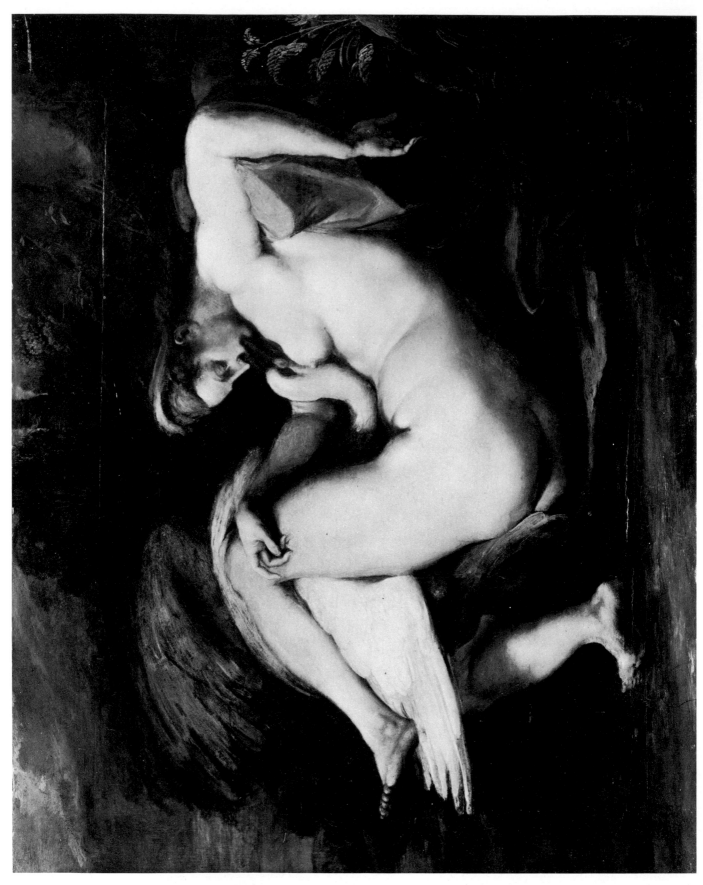

209. Rubens: *Leda and the Swan*. About 1601. Oils on panel. London, private collection

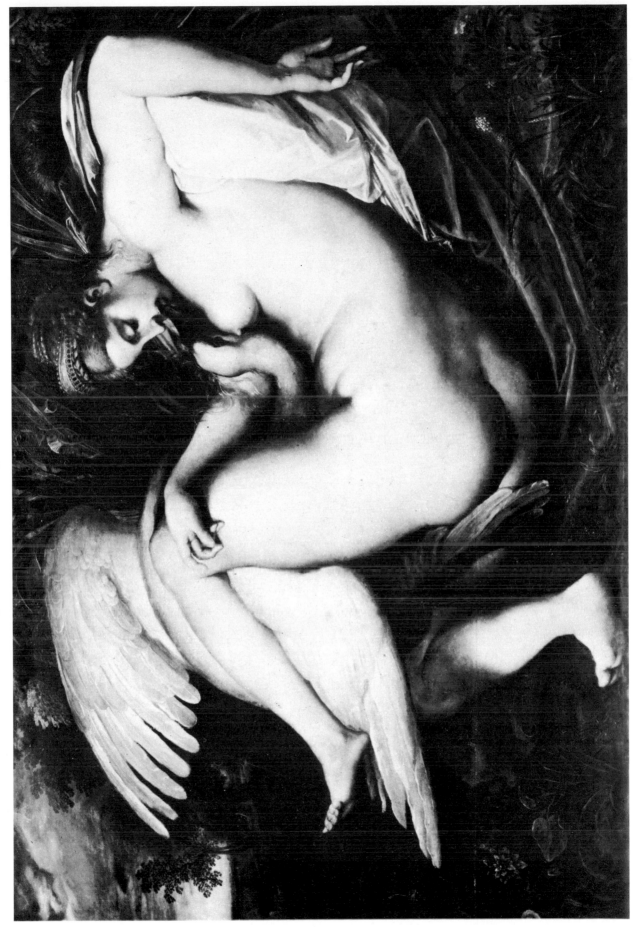

210. Rubens: *Leda and the Swan*. About 1602. Oils on panel. Dresden, Gemäldegalerie

211. Rubens: *Study for a 'Lament for Adonis'*. About 1602. Ink on paper. London, British Museum

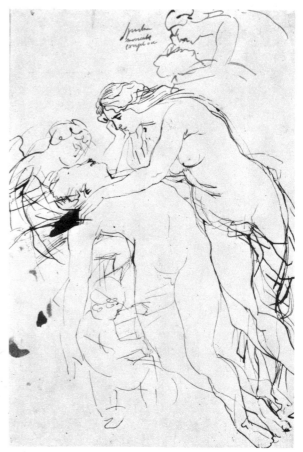

212. Rubens: *Study for a 'Lament for Adonis'*. About 1602. Ink on paper. Washington, National Gallery of Art

213. Rubens: *Study for a 'Lament for Adonis'*. About 1602. Ink on paper. Antwerp, Stedelijk Prentenkabinet

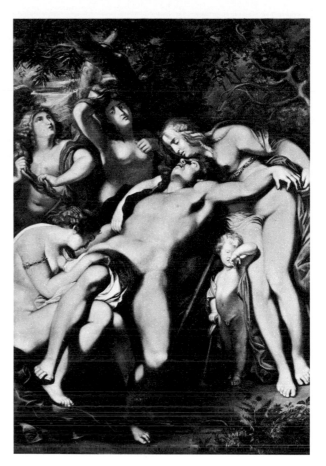

214. Rubens: *The Lament for Adonis.*
About 1602. Oil on canvas. Paris, private
collection

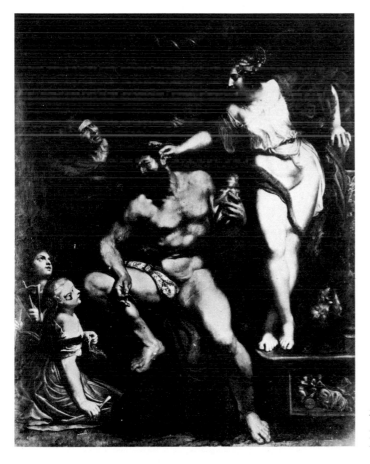

215. Rubens: *Hercules and Omphale.*
About 1602. Oils on canvas. Paris,
Louvre

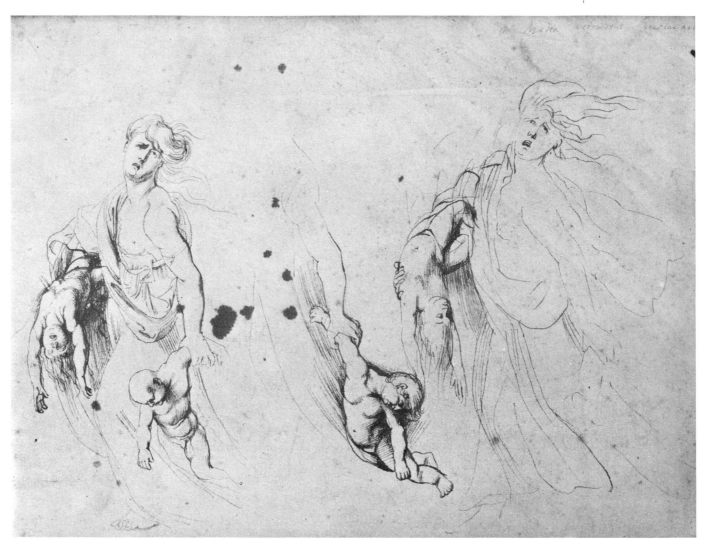

216. Rubens: *Studies for a 'Medea'*. 1600–3. Ink on paper. Bakewell (Derbyshire), Trustees of the Chatsworth Settlement

217. Antique Roman: *The Hunt for the Calydonian Boar*. Marble relief. Mantua, Palazzo Ducale

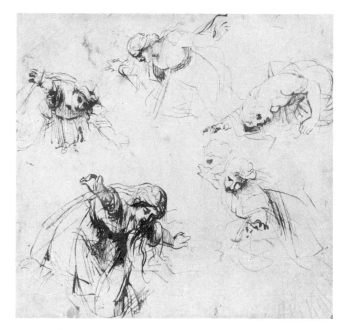

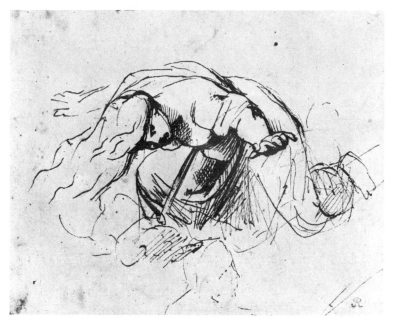

218. Rubens: *Studies for a 'Suicide of Thisbe'*. 1600–6.
Ink on paper. Paris, Louvre

219. Rubens: *Studies for a 'Suicide of Thisbe'*. 1600–6. Ink
on paper. Brunswick (Maine), Bowdoin College

220. Rubens: *An Assembly of the Olympians*. 1602. Oils on canvas. Prague, Castle

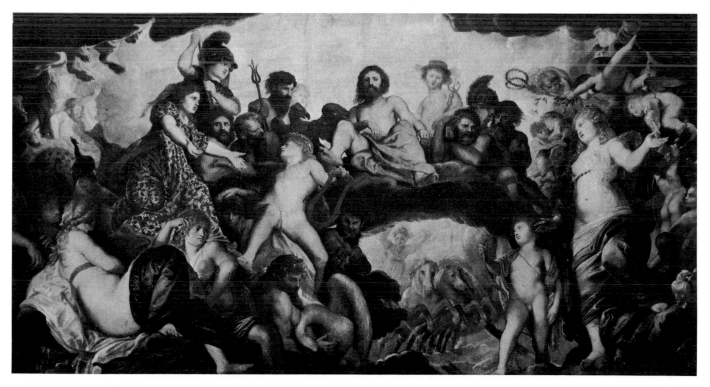

221. Rubens: *Seneca and Nero*. About 1602. Oils on panel. London, private collection

222. Rubens: *Democritus and Heraclitus.* 1603. Oils on panel. Wales, private collection

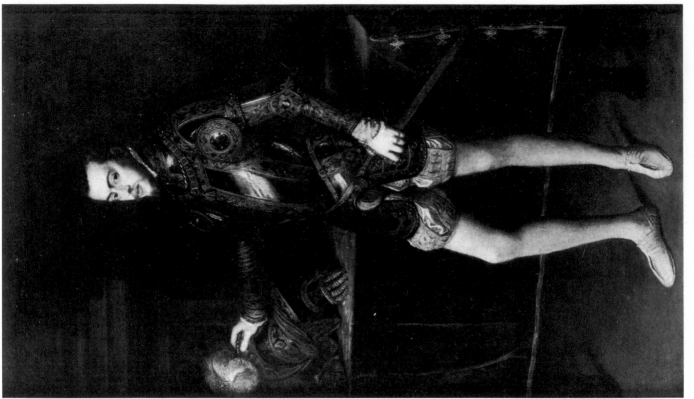

224. Rubens, after Titian: *Philip II of Spain*. 1628. Oils on canvas. Bakewell (Derbyshire), Trustees of the Chatsworth Settlement

223. Titian: *Philip II of Spain*. 1550–1. Oils on canvas. Madrid, Prado

225. Titian: *Charles V on the Field at Mühlberg* 1548. Oils on canvas. Madrid, Prado

226. Rubens, after Titian: *Charles V at Mühlberg* (partial copy). 1603–4. Oils on canvas. London, Count Antoine Seilern

227. Rubens: *Battle between Greeks and Amazons* (verso of 229). About 1605. Ink on paper. Edinburgh, National Galleries of Scotland

228. Rubens: *Battle between Greeks and Amazons*. About 1605. Ink on paper. London, British Museum

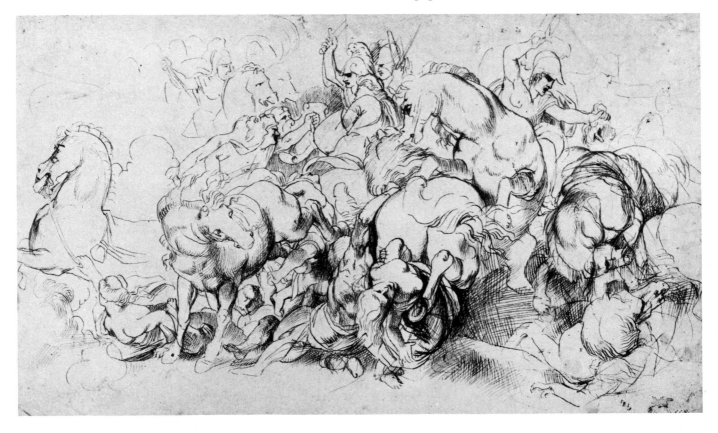

229. Rubens: *Study for 'Hero and Leander'*. About 1605. Ink on paper. Edinburgh, National Galleries of Scotland

230. Rubens: *Nereids*. About 1605. Ink on paper. Paris, Fondation Custodia

231. Rubens: *Study of Nereids for 'Hero and Leander'*. About 1605. Black and white chalks on paper. Berlin, Kupferstichkabinett

232. Rubens: *Hero and Leander*. About 1605. Oils on canvas. New Haven (Conn.), Yale University Art Gallery

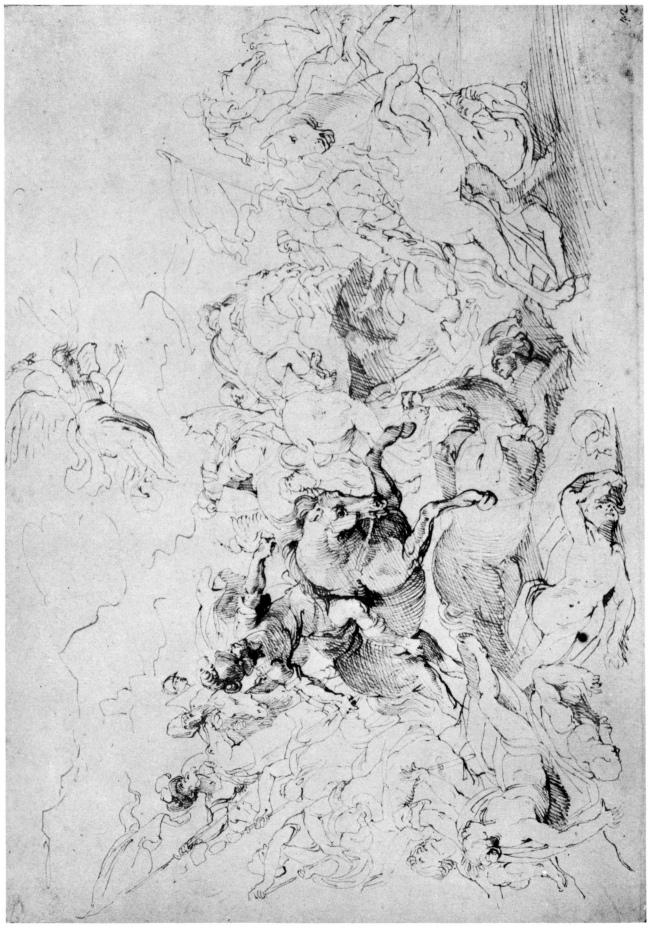

233. Rubens, after Christoffel Schwarz: *The Defeat of Sennacherib*. About 1605. Ink on paper. Vienna, Albertina

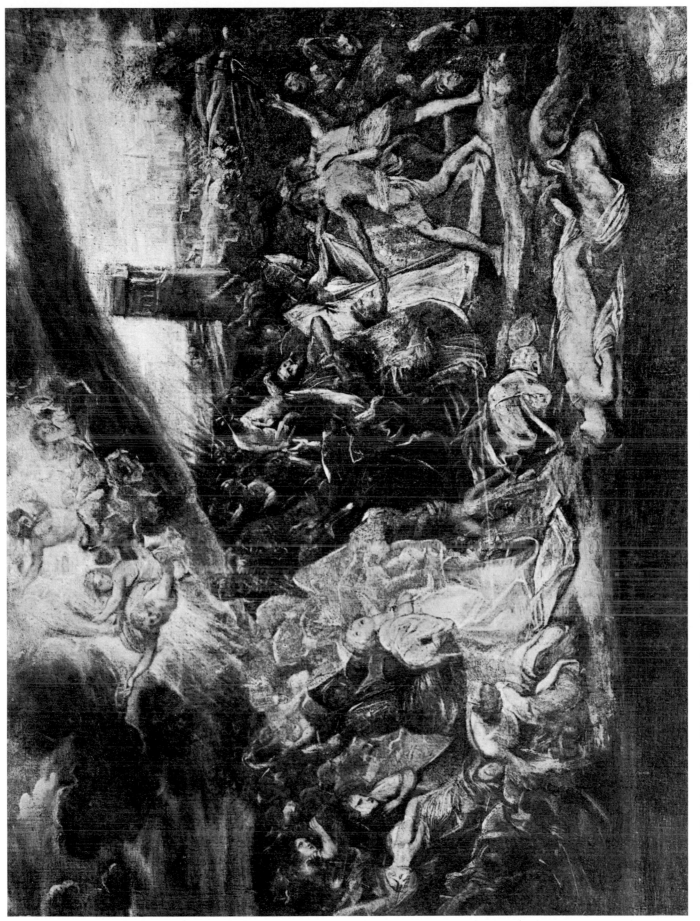

234. Rubens: *The Martyrdom of St. Ursula*. About 1605. Oils on canvas. Mantua, Palazzo Ducale

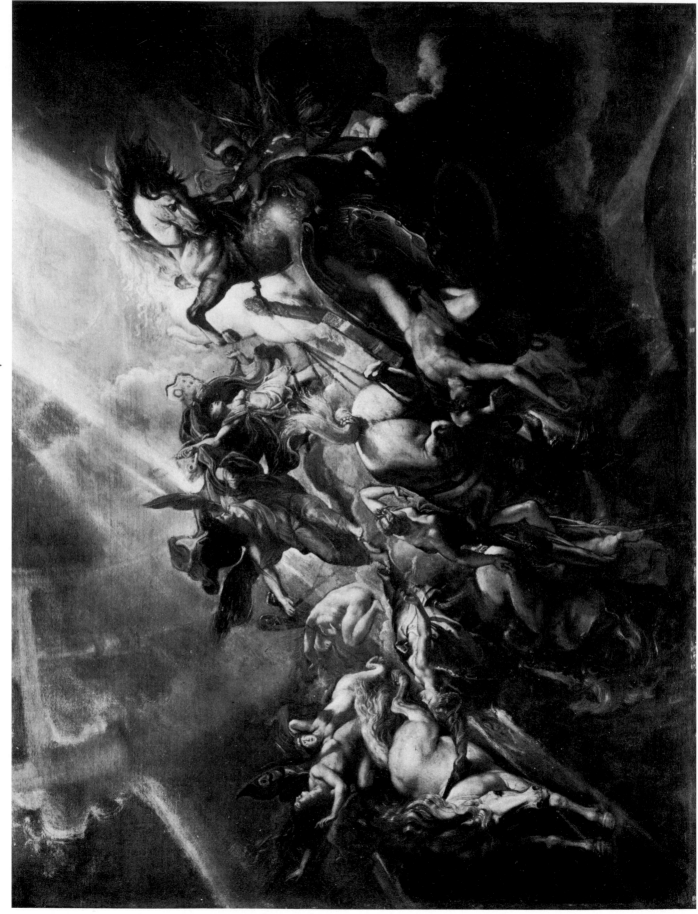

235. Rubens: *The Fall of Phaethon*. About 1605. Oils on canvas. London, private collection

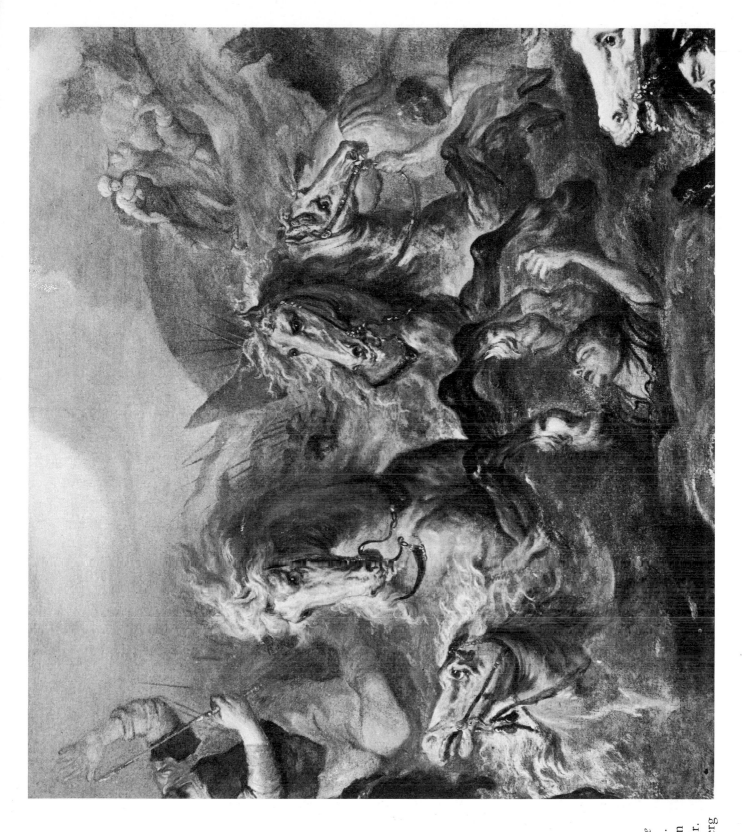

236. Rubens: *The Destruction of Pharaoh's Host in the Red Sea* (fragment). About 1604. Oils on canvas. London, Mr. and Mrs. P. Goldberg

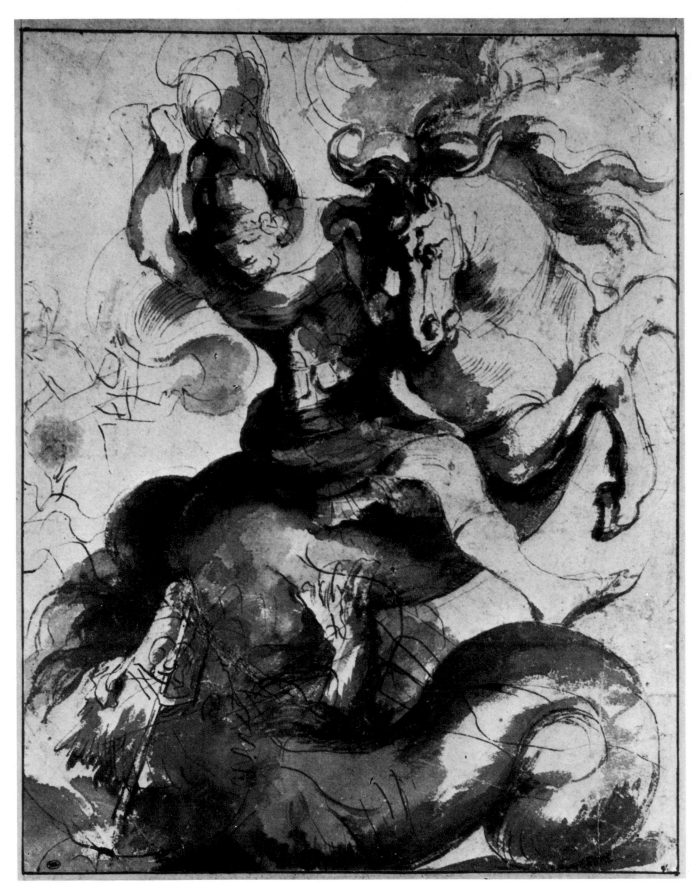

237. Rubens: *Study for 'St. George slaying the Dragon'*. About 1607. Ink on paper. Paris, Louvre

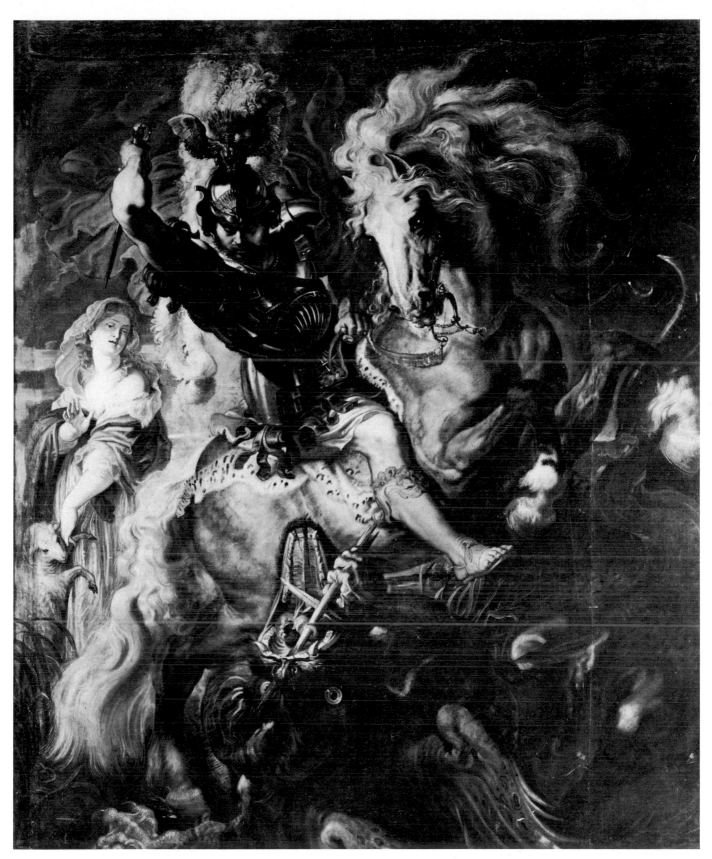

238. Rubens: *St. George slaying the Dragon*. About 1607. Oils on canvas. Madrid, Prado

239. Rubens: *The Gonzaga adoring the Trinity* (fragments). 1604–5. Oils on canvas. Mantua, Palazzo Ducale

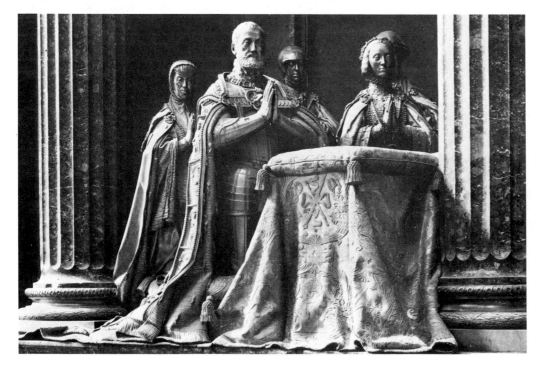

240. Pompeo Leoni:
*The Habsburgs kneeling
in devotion.* 1595–7.
Bronze, parcel-gilt.
San Lorenzo in
Escurial, Capilla
Mayor

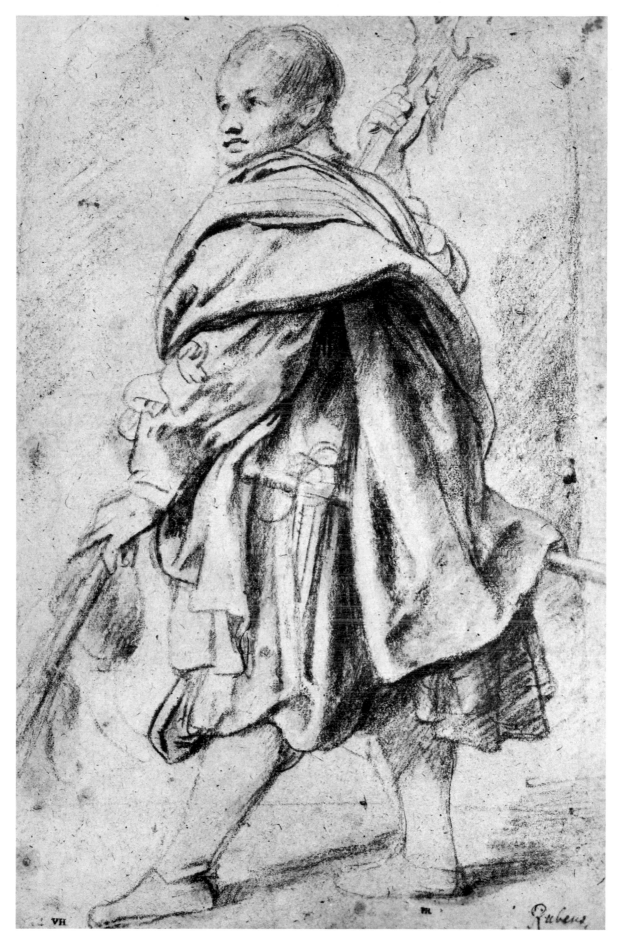

241. Rubens: *Study of a young Halberdier*. About 1604. Black and red chalks. Brussels, Bibliothèque Royale

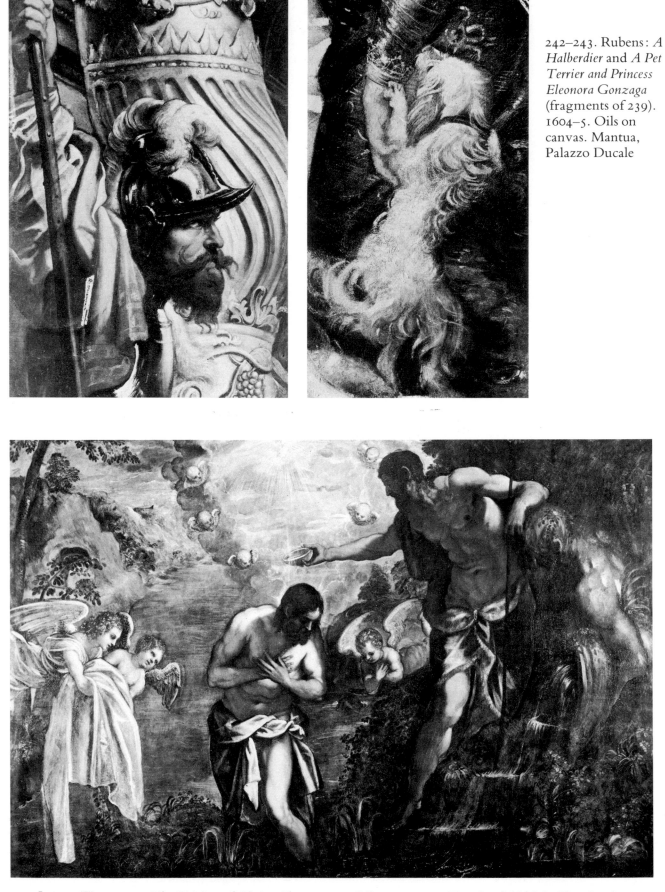

242–243. Rubens: *A Halberdier* and *A Pet Terrier and Princess Eleonora Gonzaga* (fragments of 239). 1604–5. Oils on canvas. Mantua, Palazzo Ducale

244. Jacopo Tintoretto: *The Baptism of Christ*. About 1580. Oils on canvas. Cleveland (Ohio), Cleveland Museum of Art

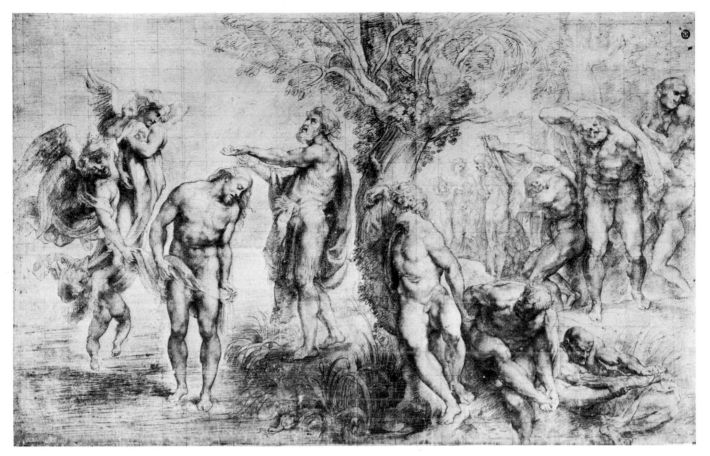

245. Rubens: *The Baptism of Christ.* 1604–5. Black chalk on paper. Paris, Louvre

246. Rubens: *The Baptism of Christ.* 1604–5. Oils on canvas. Antwerp, Musée Royal des Beaux-Arts

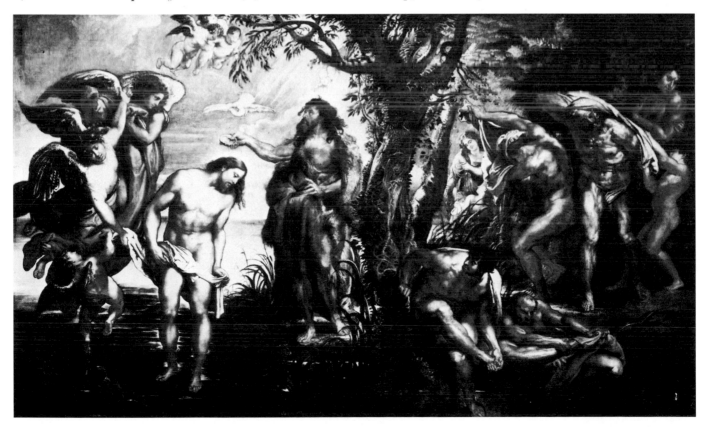

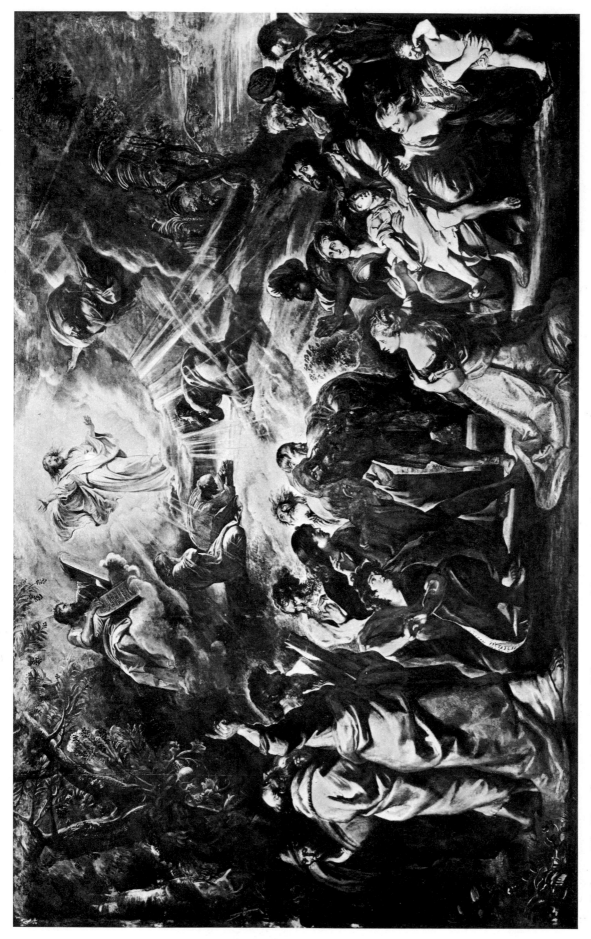

247. Rubens: *The Transfiguration*. 1604–5. Oils on canvas. Nancy, Musée des Beaux-Arts

249. Rubens: *The Circumcision.* 1605. Oils on canvas. Genoa, S. Ambrogio

248. Rubens: *The Circumcision* (modello). 1605. Oils on canvas. Vienna, Akademie

250. Rubens: *'La Dama dei licnidi'*. About 1601. Oils on canvas. Verona, Museo Civico

251. Rubens: *Margherita, Duchess of Ferrara* (detail). About 1601. Oils on canvas. Zurich, private collection

252. Rubens: *Princess Margherita Gonzaga* (fragment of 239). 1604–5. Oils on canvas. London, heirs of Dr. Ludwig Burchard

253. Rubens: *Self-Portrait with Friends at Mantua*. About 1602. Oils on canvas. Cologne, Wallraf-Richartz Museum

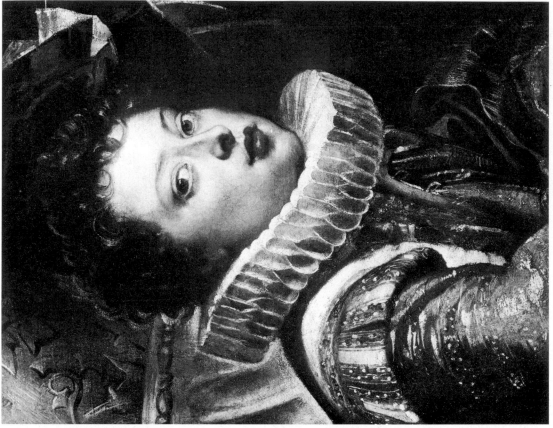

255. Rubens: *Prince Francesco Gonzaga* (fragment of 239). 1604–5. Oils on canvas. Vienna, Kunsthistorisches Museum

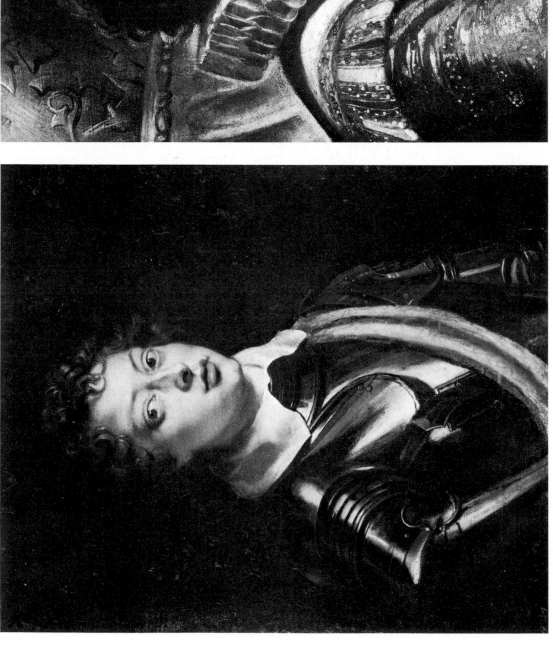

254. Rubens: *Prince Francesco Gonzaga*. About 1602. Oils on canvas. Saltram House (Devon), National Trust

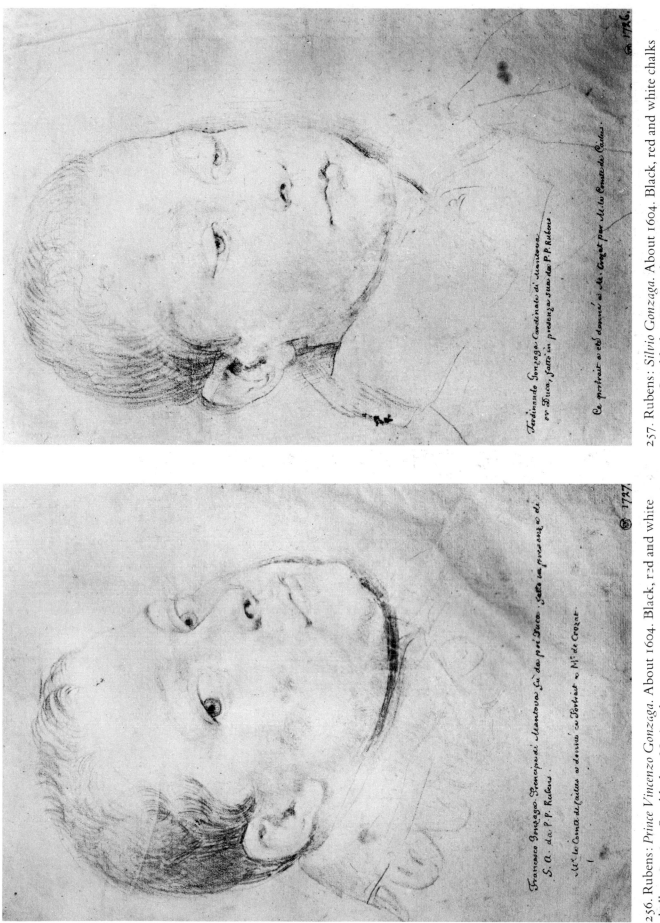

256. Rubens: *Prince Vincenzo Gonzaga*. About 1604. Black, red and white chalks on paper. Stockholm, Nationalmuseum

257. Rubens: *Silvio Gonzaga*. About 1604. Black, red and white chalks on paper. Stockholm, Nationalmuseum

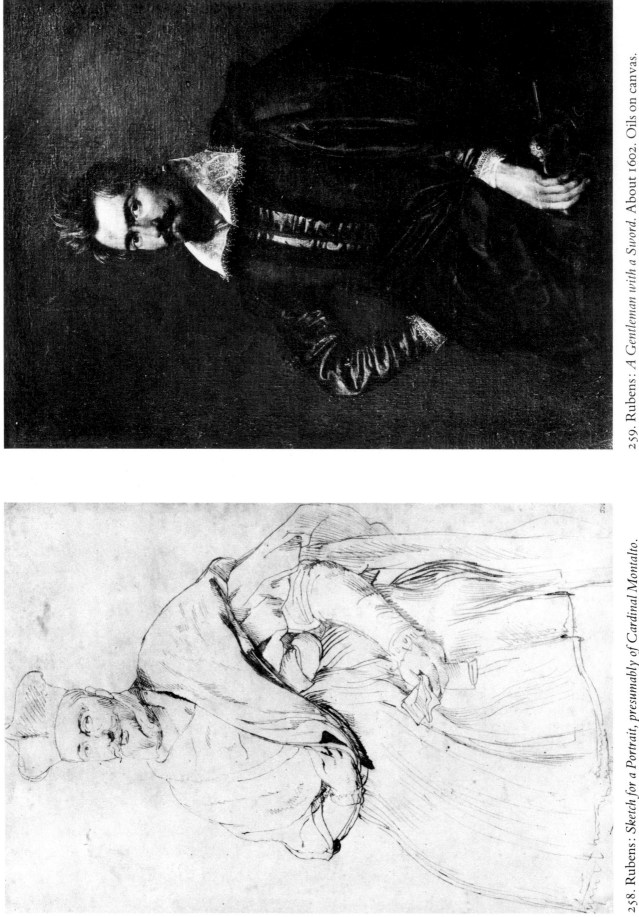

259. Rubens: *A Gentleman with a Sword.* About 1602. Oils on canvas. Florence, Palazzo Pitti

258. Rubens: *Sketch for a Portrait, presumably of Cardinal Montalto.* 1601–2. Ink on paper. Berlin, Kupferstichkabinett

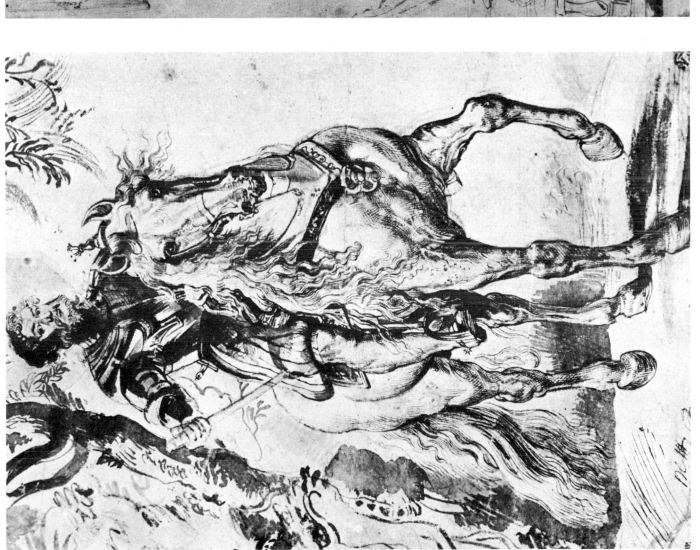

261. Rubens: *Study for 'Marchesa Brigida Spinola Doria'*. 1606. Black chalk and ink on paper. New York, Pierpont Morgan Library

260. Rubens: *Study for 'The Duque de Lerma'*. 1603. Ink on paper. Paris, Louvre

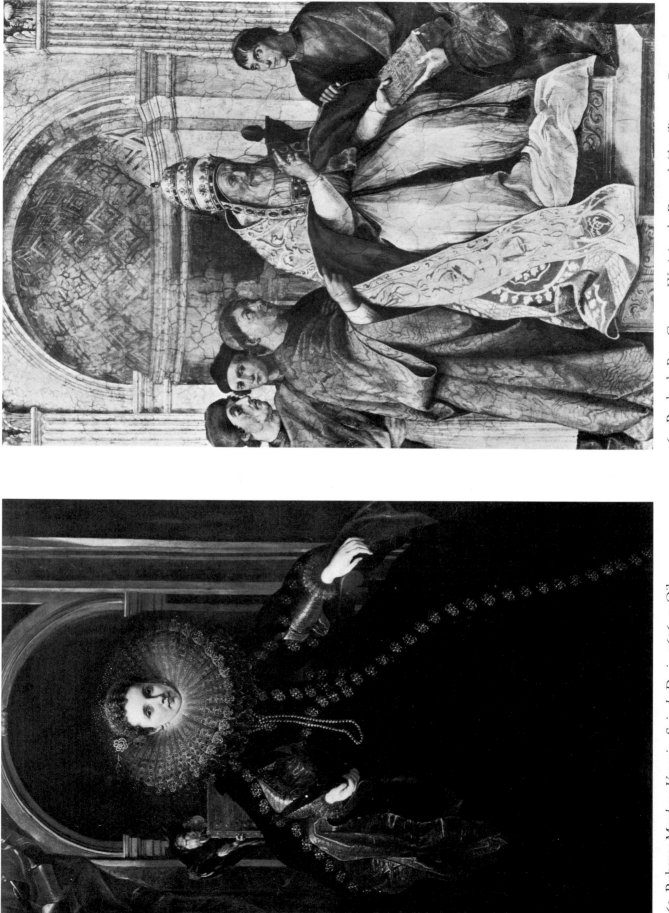

263. Raphael: *Pope Gregory IX giving the Decretals* (detail). 1509. Fresco.
Vatican, Stanza della Segnatura

262. Rubens: *Marchesa Veronica Spinola Doria.* 1606–7. Oils on canvas.
Karlsruhe, Staatliche Kunsthalle

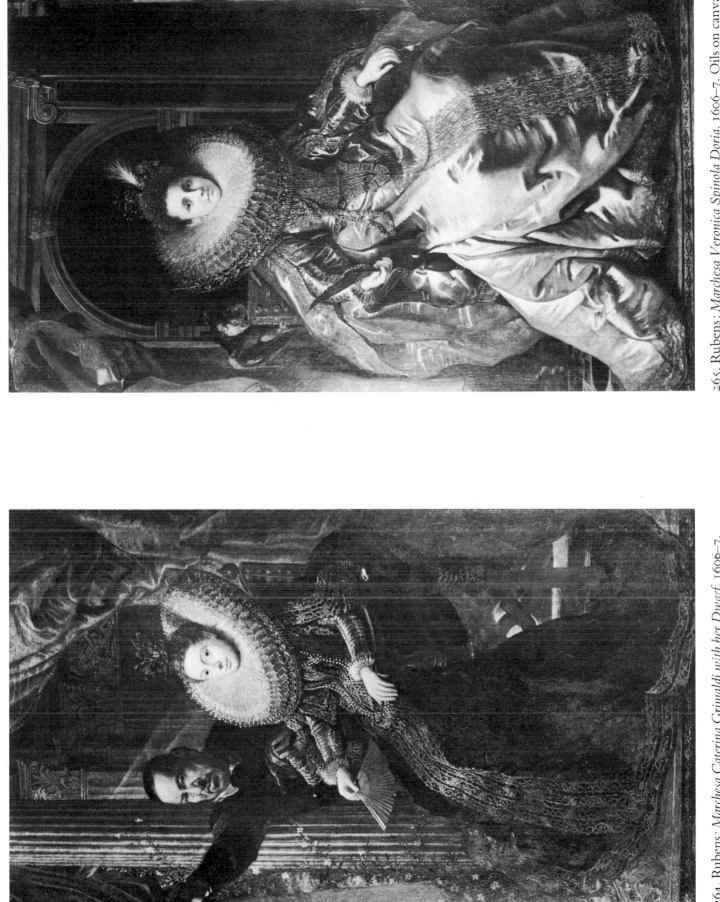

264. Rubens: *Marchesa Caterina Grimaldi with her Dwarf.* 1606–7.
Oils on canvas. Kingston Lacy (Dorset), Mr. Ralph Bankes

265. Rubens: *Marchesa Veronica Spinola Doria.* 1606–7. Oils on canvas.
Kingston Lacy (Dorset), Mr. Ralph Bankes

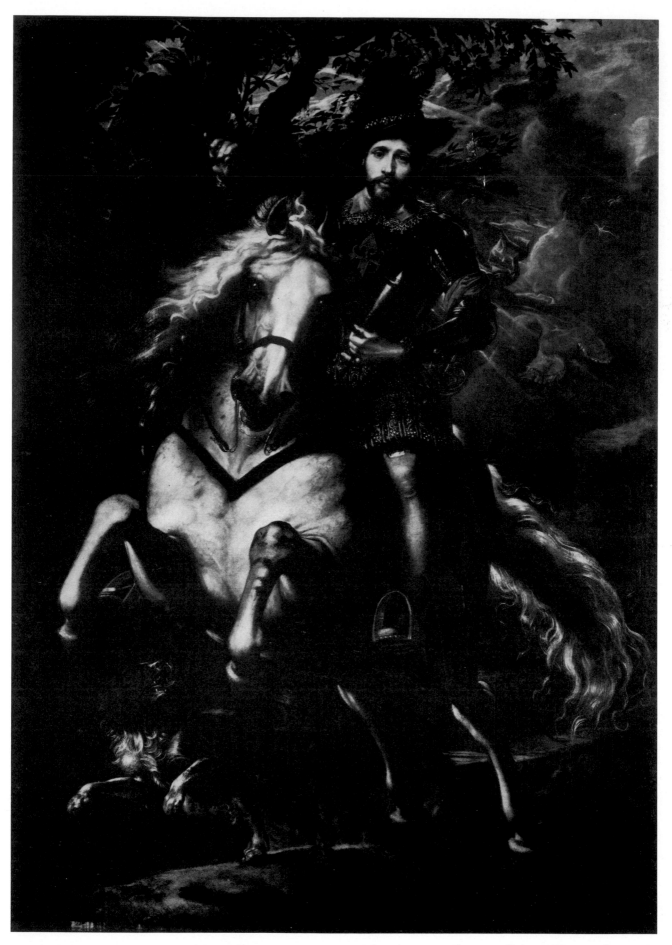

266. Rubens: *Marchese Giacomo Massimiliano Doria*. 1606–7. Oils on canvas. Florence, Palazzo Comunale

267. Rubens, after an antique marble: *The Capitoline Eagle*. About 1601. Black chalk on paper. New York, Mr. Emile E. Wolf

268. Rubens, after an antique marble: *Corinthian Capital*. 1601–6. Black chalk on paper. Leningrad, Hermitage

270. Rubens, after an antique marble: *Colossal Right Foot*. About 1601. Black chalk on paper. Cambridge, Fitzwilliam Museum

269. Rubens, after an antique marble: *Torso of a Boy*. About 1601. Black chalk on paper. Oakly Park (Shropshire), Earl of Plymouth

271–272. Rubens, after an antique marble: *A Boy with a Cloak* (*recto* and *verso*). About 1601. Black chalk on paper. Dresden, Kupferstichkabinett

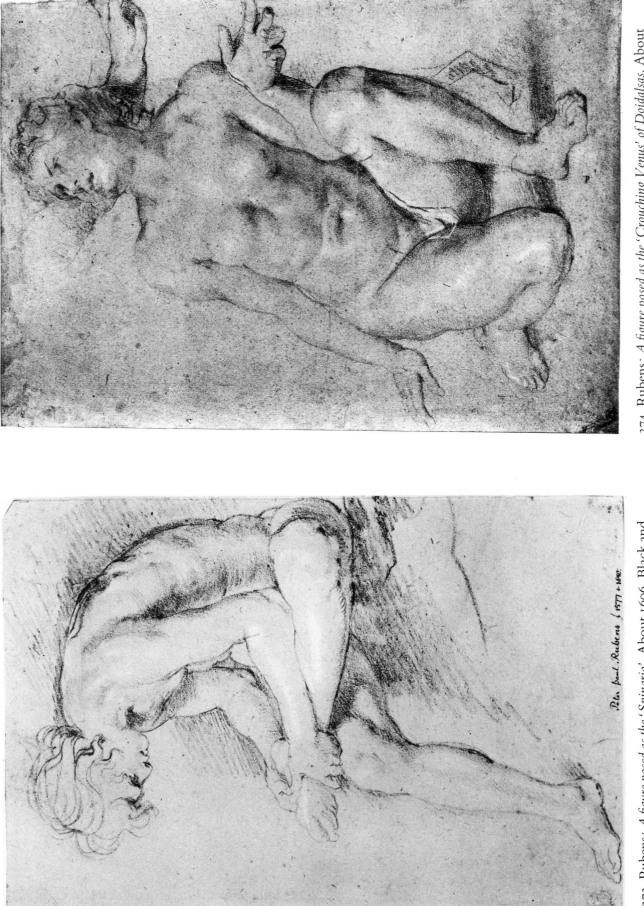

274. Rubens: *A figure posed as the 'Crouching Venus' of Doidalsas*. About 1606. Black chalk on white paper. Berlin, Kupferstichkabinett

Peta Paul Rubens f 1577 + 1640.

273. Rubens: *A figure posed as the 'Spinario'*. About 1606. Black and white chalks on paper. London, private collection

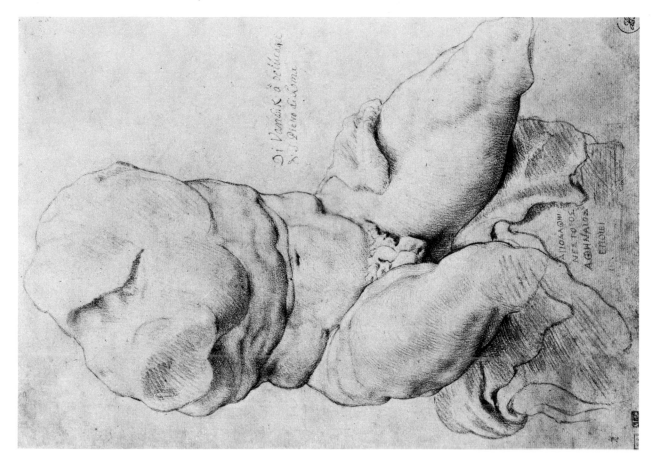

276. Rubens, after an antique marble: *The Torso Belvedere*. About 1601.
Black chalk on paper. Antwerp, Rubenshuis

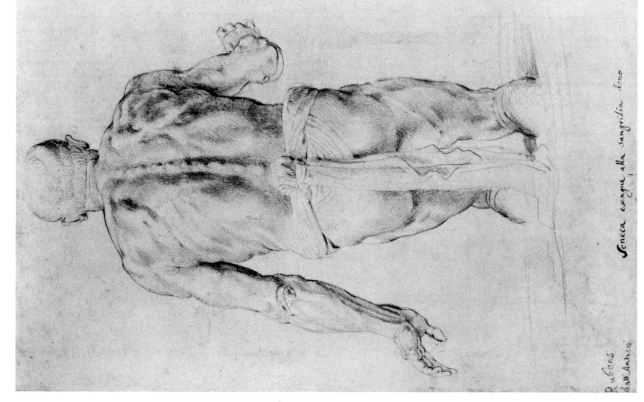

275. Rubens: after an antique marble: *African Fisherman*. About 1601.
Black chalk on paper. London, Thos. Agnew and Son

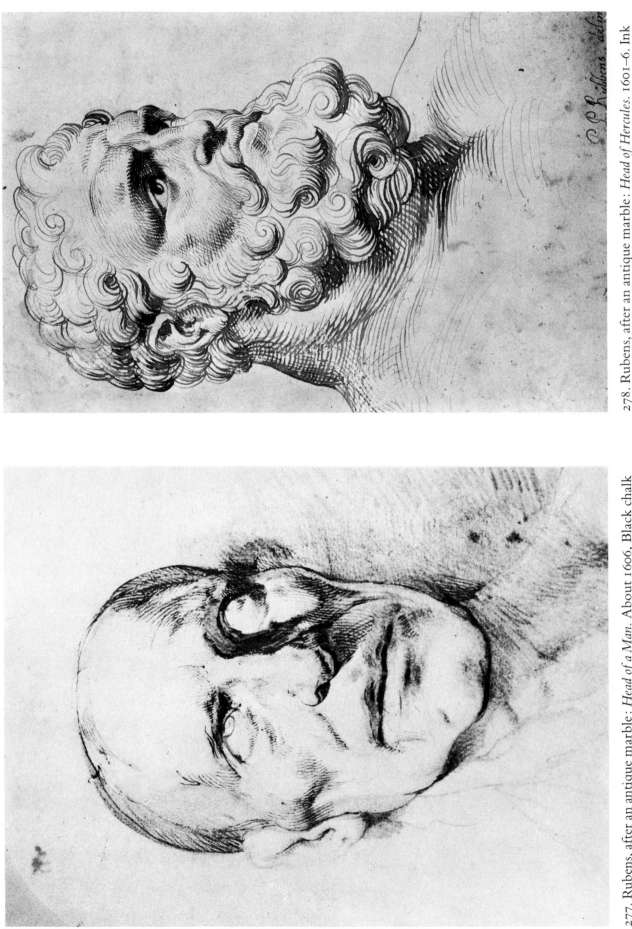

277. Rubens, after an antique marble: *Head of a Man*. About 1606, Black chalk and ink on paper. Formerly London, Mr. John Brophy

278. Rubens, after an antique marble: *Head of Hercules*. 1601–6. Ink on paper. New Rochelle (N.Y.), Miss K. Baer

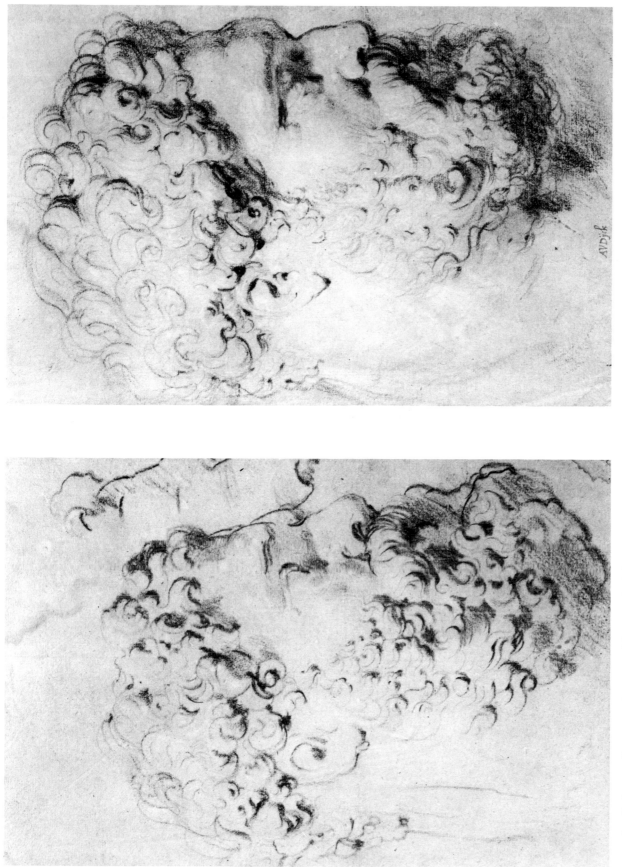

279–280. Rubens, after an antique marble: *Head of the 'Farnese Hercules'* (*recto and verso*). 1601. Black chalk on paper. London, Count Antoine Seilern

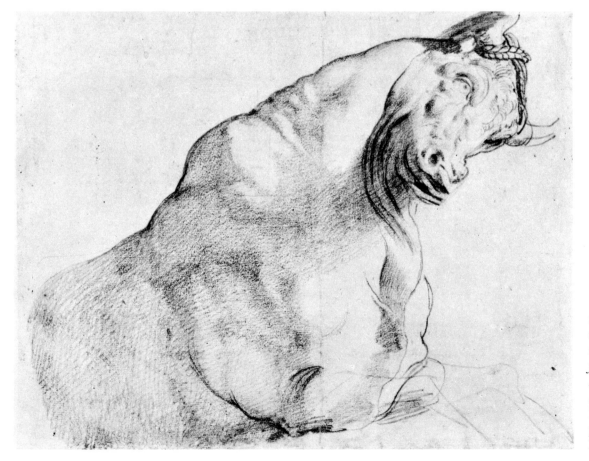

281. Rubens, after an antique marble: *Leaf from the Pocket-Book.* 1601–8. Ink on paper. London, formerly Maggs Bros.

282. Rubens, after an antique marble: *The Bull from 'The Punishment of Dirce'.* 1601–8. Black chalk on paper. London, British Museum

283. Rubens, after an antique marble: *Leaf from the Pocket Book* (*verso* of 281). 1601–8. Ink on paper. London, formerly Maggs Bros.

284. Rubens, after an antique marble: *Studies of the 'Farnese Hercules'* (*verso* of 282). 1601–8. Black chalk on paper. London, British Museum

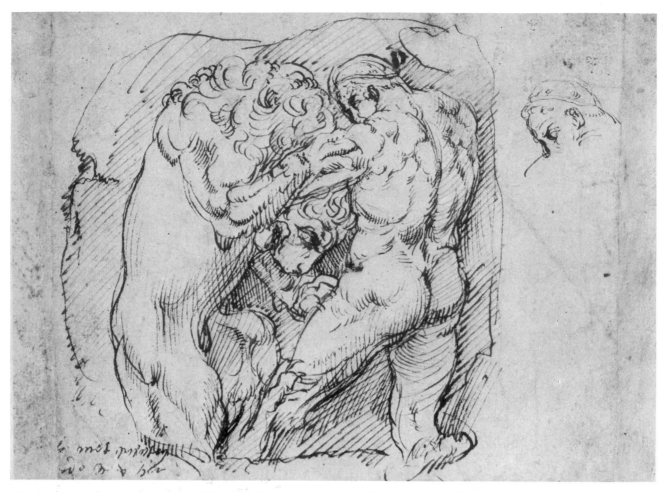

285. Rubens, after an antique marble: *Hercules overcoming the Nemean Lion.* About 1606. Ink on paper. Dorset, private collection

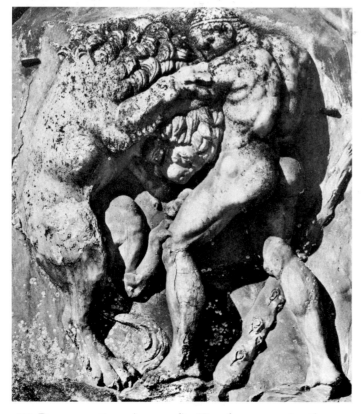

286. Roman antique (restored): *Hercules overcoming the Nemean Lion.* Marble. Rome, Villa Medici

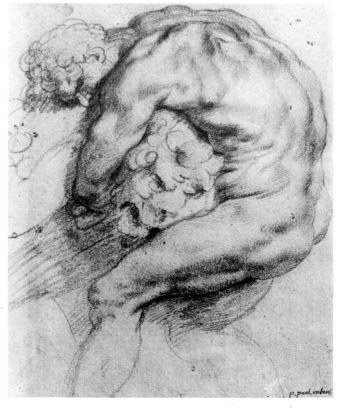

287. Rubens. *Study for 'Hercules overcoming the Nemean Lion'.* About 1615. Red chalk on paper. Paris, Louvre

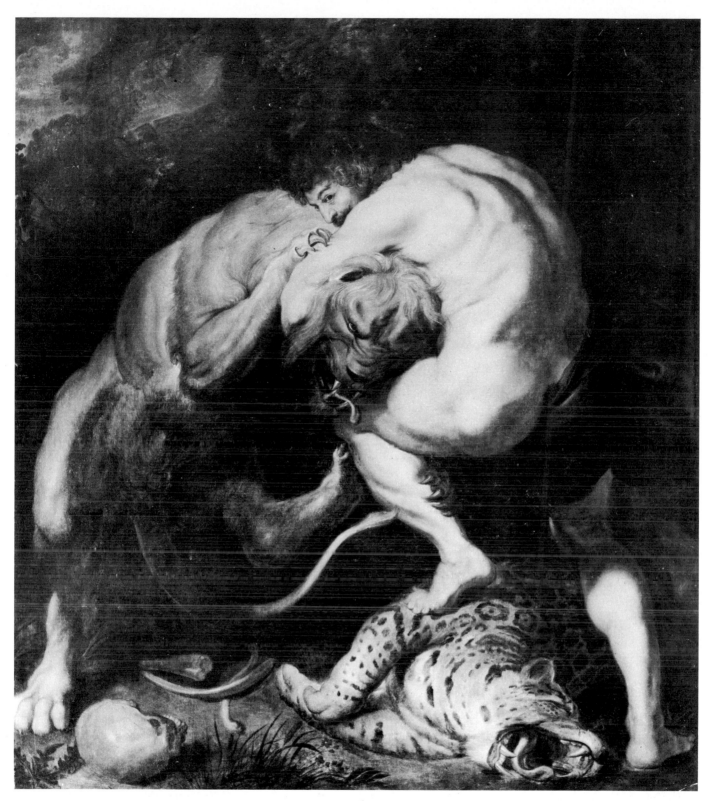

288. Rubens: *Hercules overcoming the Nemean Lion*. About 1615. Oils on canvas. Brussels, R. van de Broek

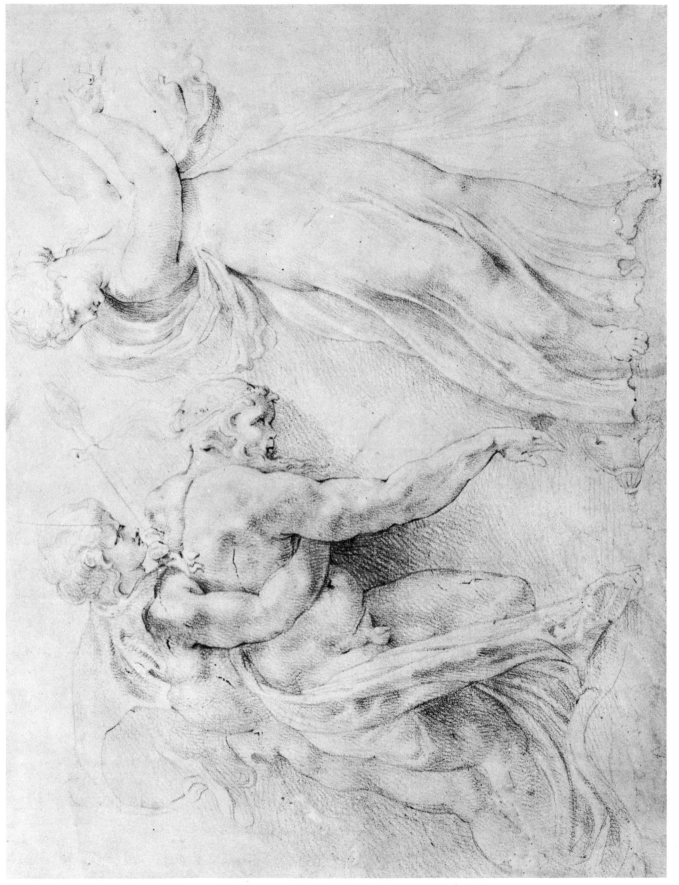

289. Rubens, after an antique marble: *Frieze of the Borghese Vase*. 1605–8. Black chalk on paper. Dresden, Kupferstichkabinett

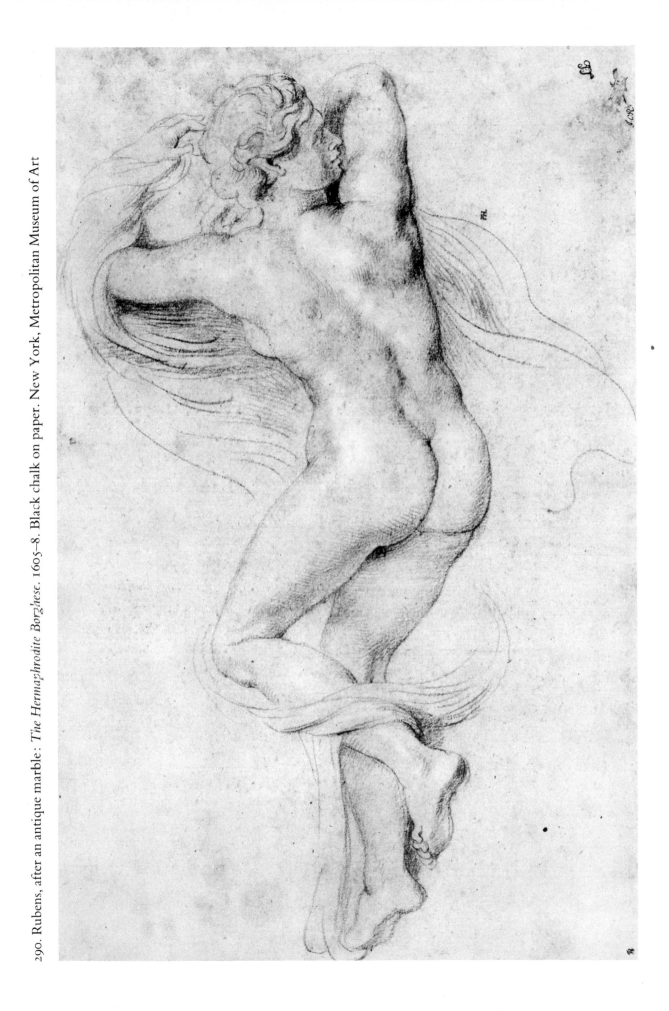

290. Rubens, after an antique marble: *The Hermaphrodite Borghese*. 1605–8. Black chalk on paper. New York, Metropolitan Museum of Art

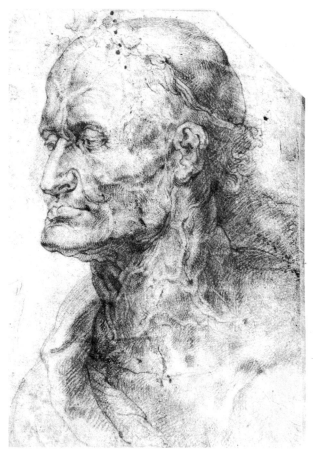

291. Rubens, after an antique marble: *Head écorché, with the artist's notes.* 1605–8. Ink on paper. Bakewell (Derbyshire), Trustees of the Chatsworth Settlement

292. Rubens, after an antique marble: *Head of a Man (? Galba).* 1605–8. Red chalk on paper. Ghent, M. Paul Eckhout

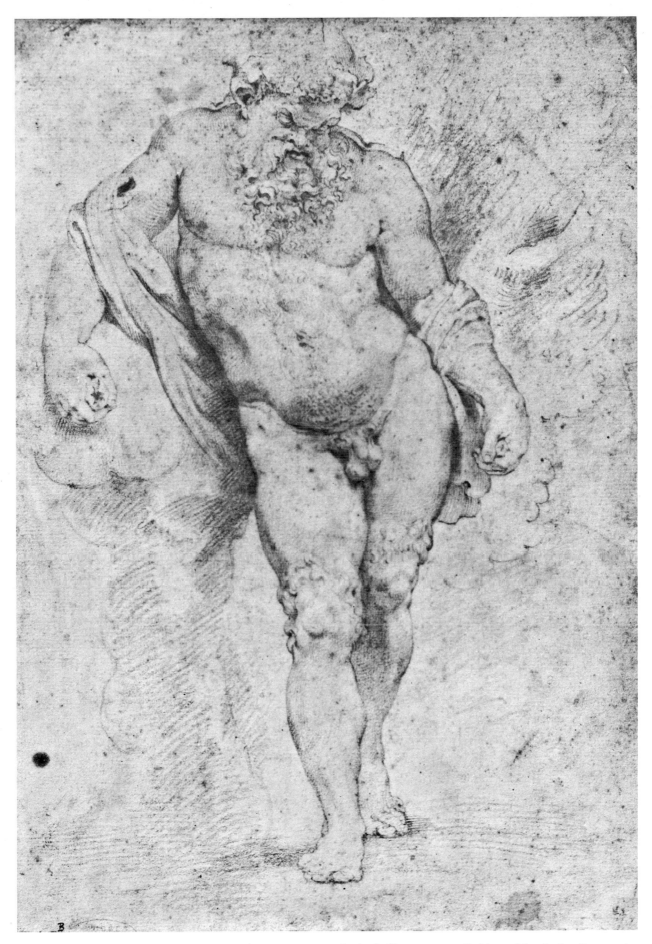

293. Rubens, after an antique marble: *Silenus*. 1605–8. Black chalk on paper. Orléans, Musée des Beaux-Arts

294. Rubens, after an antique marble: *Satyr Mask*.
About 1606. Black chalk on paper. Moscow, Pushkin
Museum

295. Rubens: *A Bearded Man* (*verso* of 294). About
1606. Black chalk on paper. Moscow, Pushkin
Museum

296. Rubens, after an antique marble: *Head of a Horse
(Greek type)*. About 1606. Paris, Fondation Custodia

297. Pupil's copy of Rubens's drawing of about 1606:
Horse of the Dioscuri. Red chalk on paper. Copenhagen,
Kongel. Kobberstiksamling

298. Rubens, after an antique marble: *A Comic Actor, the Slave*. About 1606. Black chalk on paper.
Oakly Park (Shropshire), Earl of Plymouth

299–301. Rubens, after the antique: *Hercules pissing*; *Commodus as Mercury*. About 1606. Ink on paper. Copenhagen, Kongel. Kobberstiksamling.—*Apollo*. About 1606. Ink on paper. Dresden, Kupferstichkabinett

302. Rubens, after an antique marble: '*Socrates procul dubio . . .*'. About 1606. Black chalk on paper. Chicago, Art Institute

303. C. Galle, after Rubens (after the antique): *Iconismus statuae togatae, from 'Electorum Libri duo'.*
Copper engraving

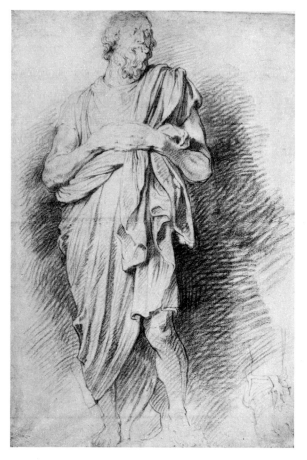

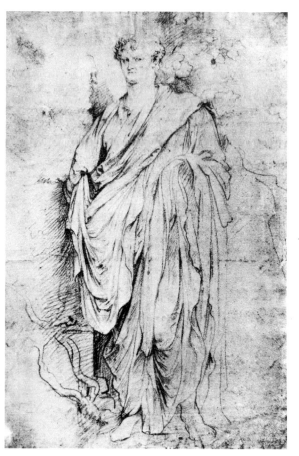

304. Rubens, after an antique marble: *'Homer'*.
About 1606. Black chalk on paper. Berlin,
Kupferstichkabinett

305. Rubens, after an antique marble: *Nero.*
About 1606. Black chalk on paper. Paris,
Fondation Custodia

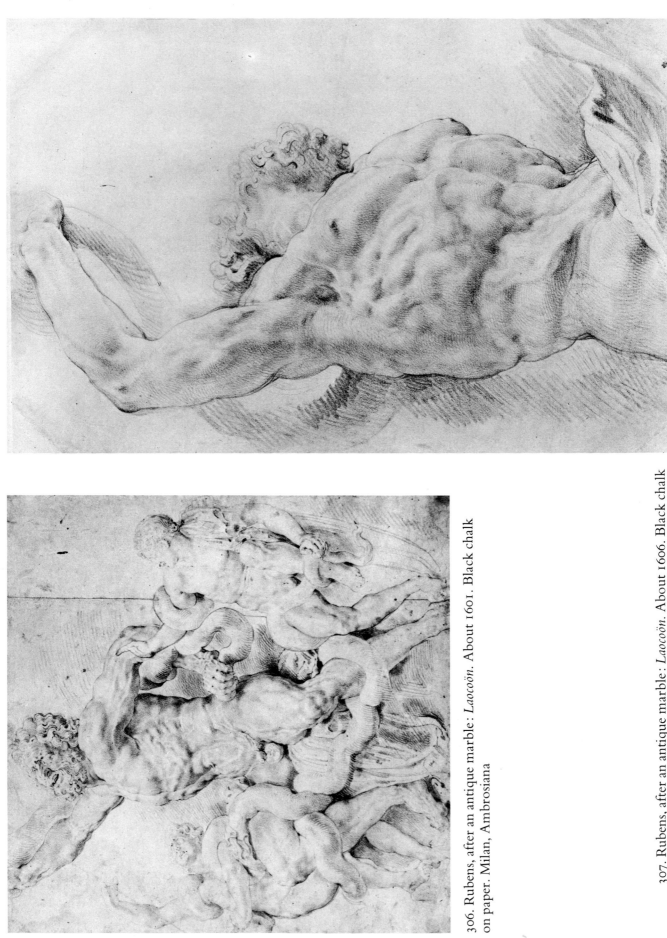

306. Rubens, after an antique marble: *Laocoön*. About 1601. Black chalk on paper. Milan, Ambrosiana

307. Rubens, after an antique marble: *Laocoön*. About 1606. Black chalk on paper. Dresden, Kupferstichkabinett

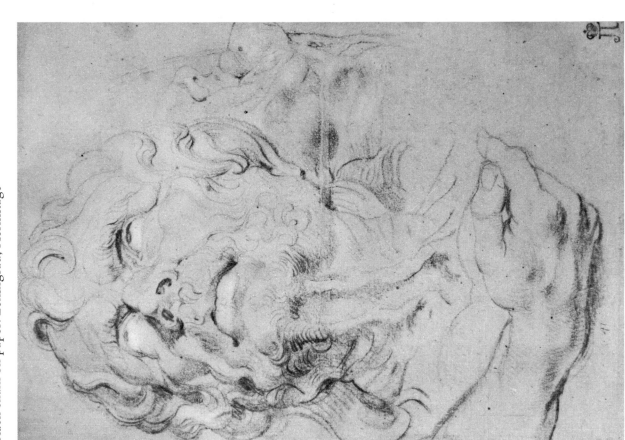

309. Rubens, after the antique: *Heads of 'Seneca' and Galba*. About 1606.
Black chalk on paper. Leningrad, Hermitage

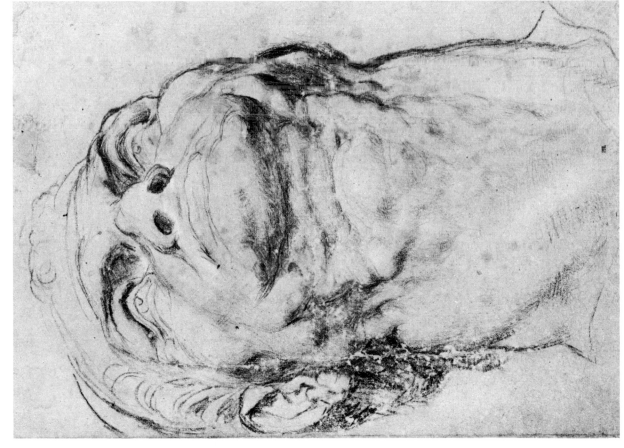

308. Rubens, after an antique: *Head of Galba*. About 1606. Black chalk on
paper. Oxford, Christ Church

310. Rubens, after antique cameos: *Germanicus Caesar* and '*Solon*' (*Maecenas*).
About 1621. Ink and bodycolour on paper. Amsterdam, Rijksprentenkabinet

311. Rubens, after an antique coin: *Alexander the Great as Jupiter Ammon*.
About 1606. Ink and bodycolour on card. Ephrata (Pa.), Mrs. Karl J. Reddy

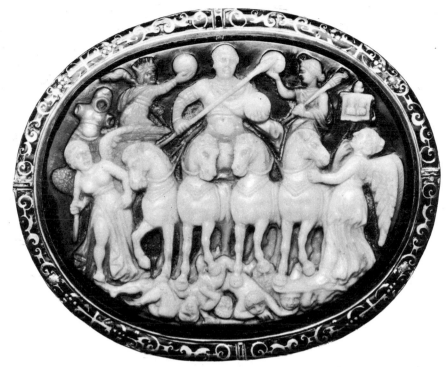

312. Roman antique: '*The Triumph of Licinius*'. Sardonyx cameo. Paris, Bibliothèque Nationale

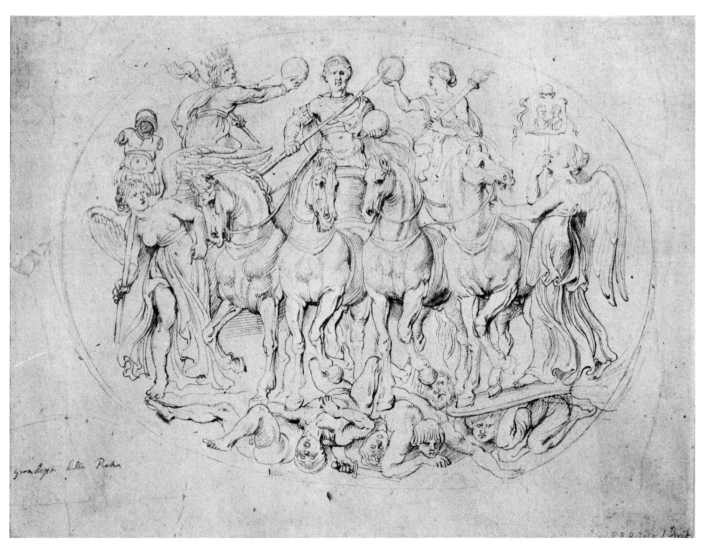

313. Rubens, after an antique cameo: '*The Triumph of Licinius*'. 1620–5. Ink on paper. London, British Museum

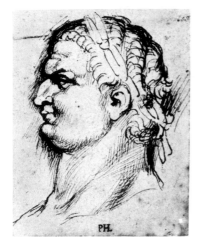

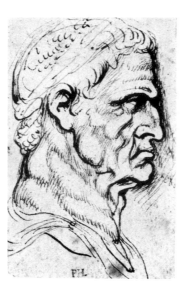

314. Rubens, after antique coins: *Vespasian* and *Galba*. About 1606. Ink on paper. Bakewell (Derbyshire), Trustees of the Chatsworth Settlement

315. Rubens, after an antique marble: *Pudicitia*. About 1614. Ink on paper. Moscow, Pushkin Museum

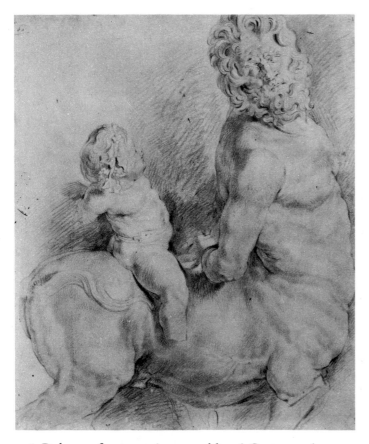

316. Rubens, after an antique marble: *A Centaur and Cupid*. 1605–8. Black chalk on paper. Moscow, Pushkin Museum

317. Rubens, after an antique marble: *Herodotus and Menander* (double herm). About 1606. Black chalk on paper. Paris, Louvre

318. Rubens: *Venus wounded by a Thorn*. About 1607. Oils on canvas. Los Angeles, University of Southern California

319. Rubens: *The Judgement of Paris*. About 1607. Oils on panel. Madrid, Prado

320. Rubens: *Study for St. Gregory, St. Domitilla and other Saints.* 1606. Ink on paper. London, heirs of Dr. Ludwig Burchard

321. Rubens: *Study for an Entombment (verso of 320).* 1606. Ink on paper. London, heirs of Dr. Ludwig Burchard

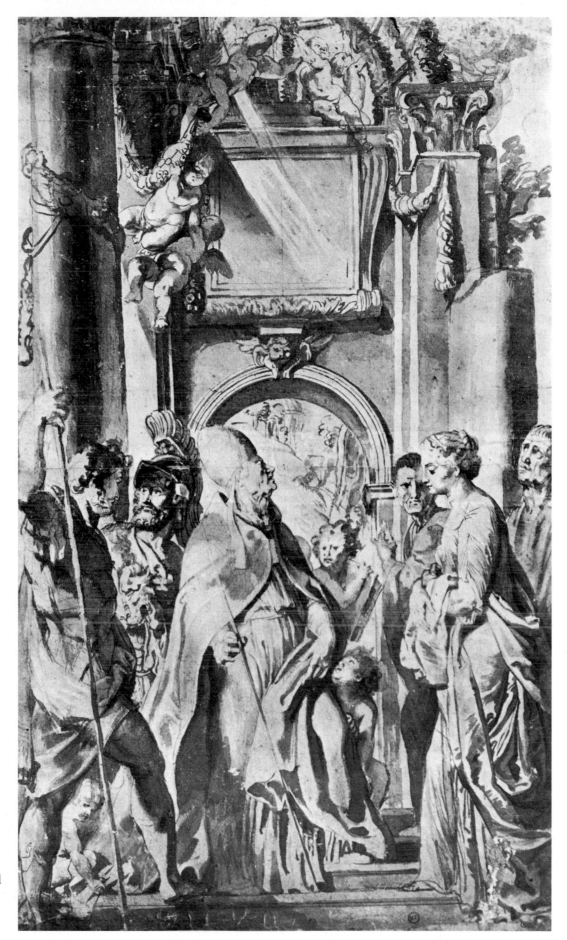

322. Rubens: *Saints
Gregory, Domitilla,
Maurus and Papianus.*
1606. Black chalk and
ink on paper.
Montpellier, Musée
Fabre

324. Rubens: *Study for St. Domitilla.* 1606. Oils on paper. Bergamo, Accademia Carrara

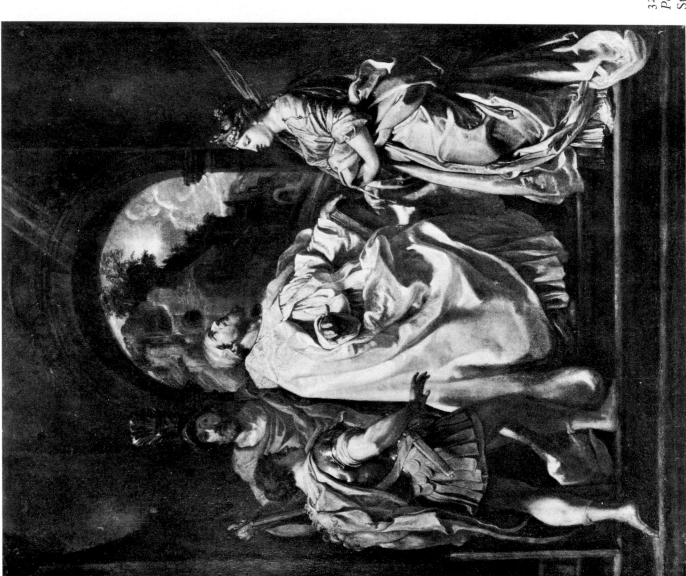

323. Rubens: *Saints Gregory, Domitilla, Maurus and Papianus.* 1606. Oils on canvas. Berlin–Dahlem, Staatliche Museen

326. Rubens: *Study for St. Domitilla*. 1607. Ink on paper. New York, Metropolitan Museum of Art

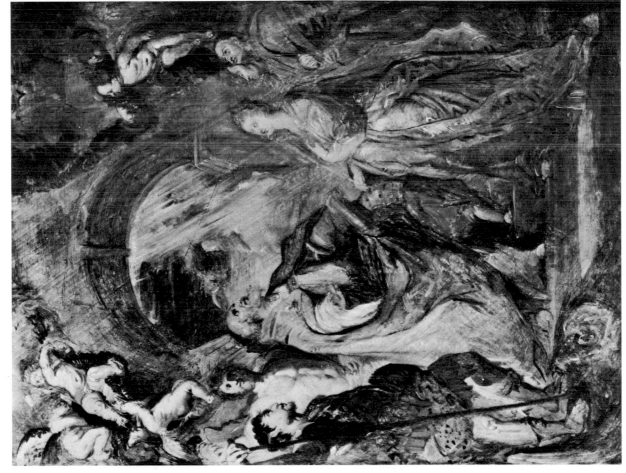

325. Rubens: *Saints Gregory, Domitilla, Maurus, Papianus, Nereus and Achilleus* (sketch). 1606–7. Oils on panel. London, Court Antoine Seilern

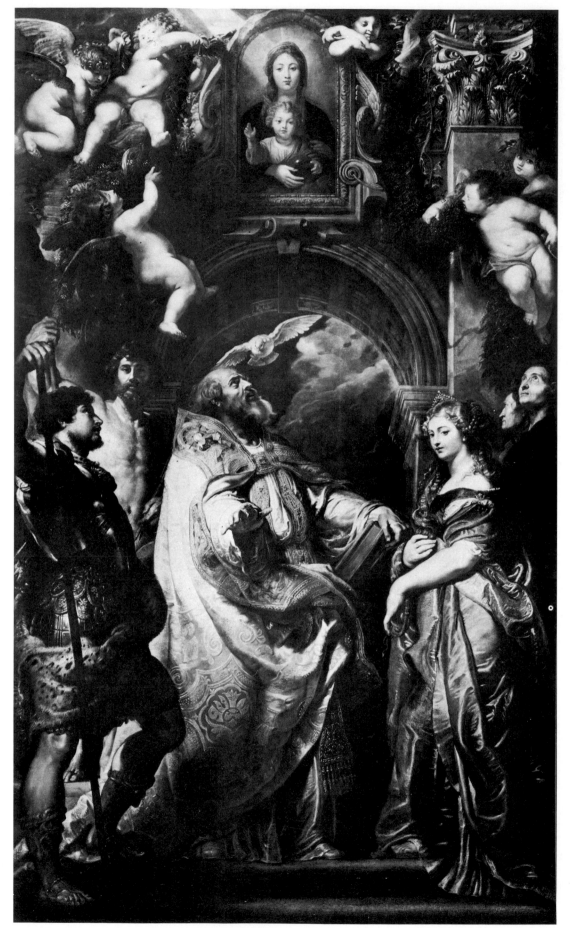

327. Rubens: *The
'Madonna della
Vallicella'
worshipped by St.
Gregory and other
Saints*. 1607. Oils on
canvas. Grenoble,
Musée de Peinture

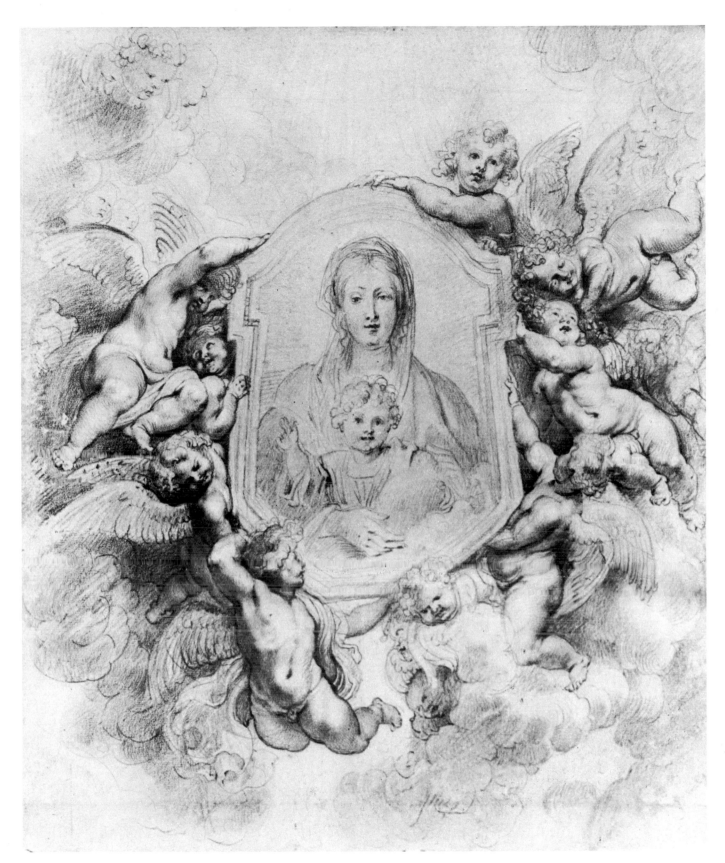

328. Rubens: *Cover Design for 'The Madonna della Vallicella' adored by Cherubim.* 1608. Red chalk on paper. Moscow, Pushkin Museum

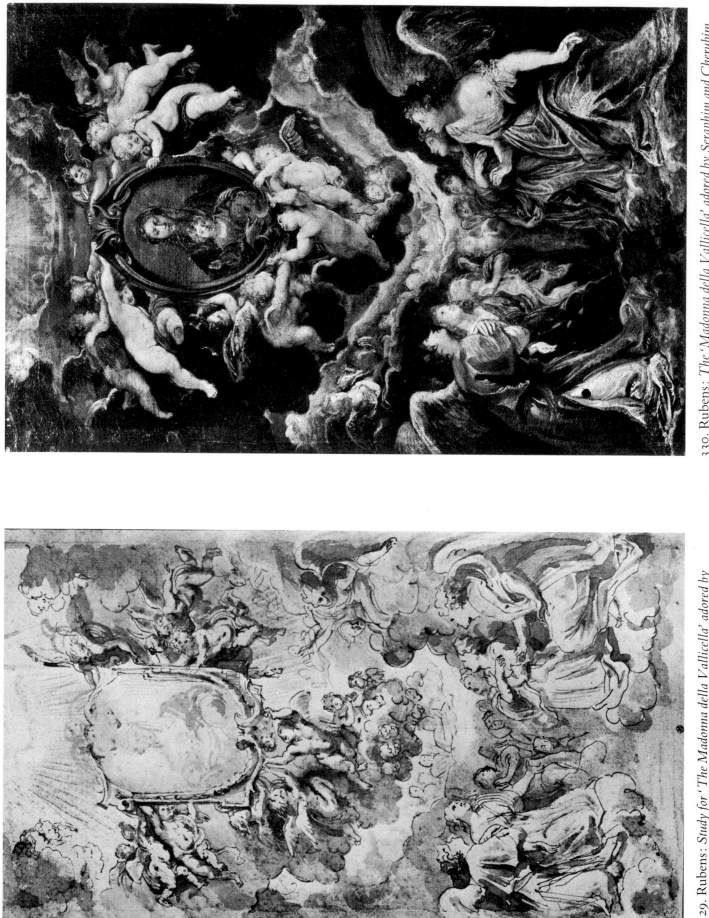

330. Rubens: The 'Madonna della Vallicella' adored by Seraphim and Cherubim (modello for 333). 1608. Oils on canvas. Vienna, Akademie

329. Rubens: Study for 'The Madonna della Vallicella' adored by Seraphim and Cherubim. 1608. Ink on paper. Vienna, Albertina

332. Federico Zuccaro: *The Adoration of the Name of God*
About 1590. Oils on panel. Rome, Gesù

331. Rubens: *Study for Saints Gregory, Maurus and Papianus.* 1608. Ink
on paper. Chantilly, Musée Condé

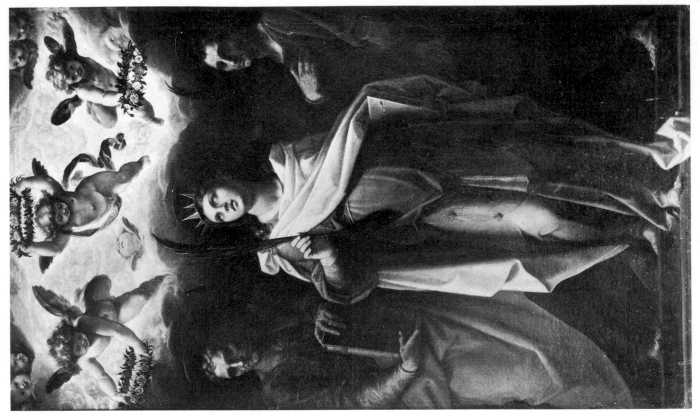

334. Cristofano Roncalli (Pomarancio): *Saints Domitilla, Nereus and Achilleus.* Oils on canvas. Rome, SS. Nereo ed Achilleo

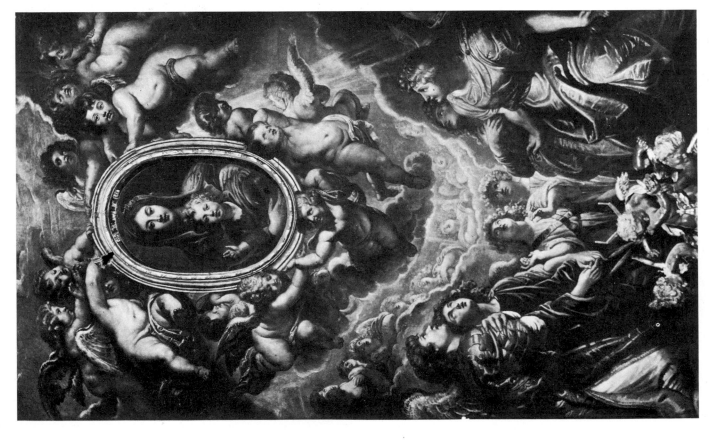

333. Rubens: The 'Madonna della Vallicella' adored by Seraphim and Cherubim. 1608. Oils on slates. Rome, S. Maria della Vallicella

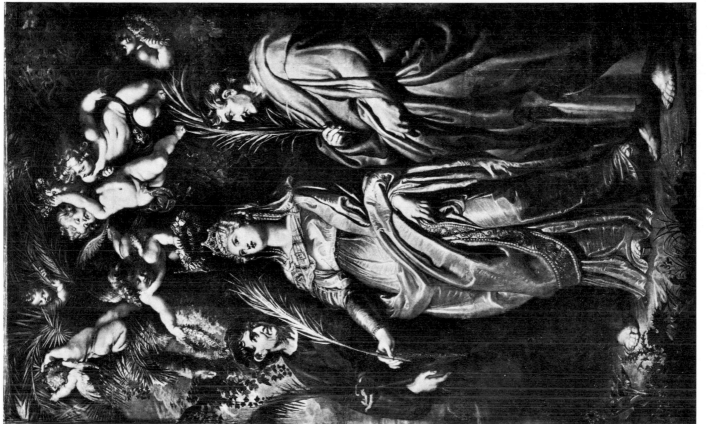

336. Rubens: *Saints Domitilla, Nereus and Achilleus*. 1608. Oils on slates.
Rome, S. Maria in Vallicella

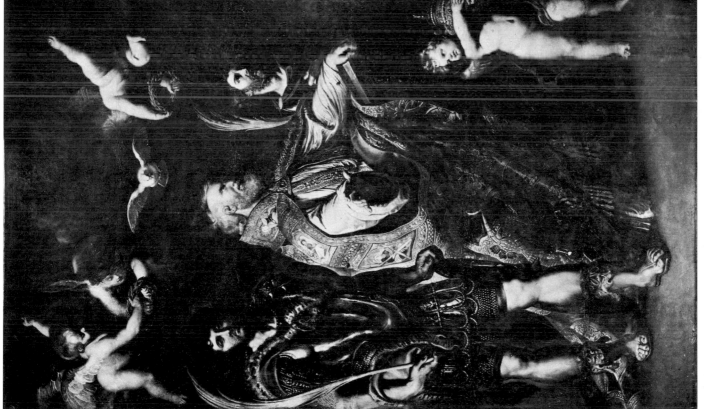

335. Rubens: *Saints Gregory, Maurus and Papianus*. 1608. Oils on
slates. Rome, S. Maria in Vallicella

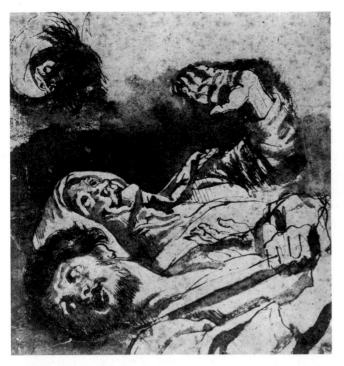

338. Rubens: *Study for the Fermo 'Nativity'* (see 340). 1608.
Ink on paper. Amsterdam, Museum Fodor

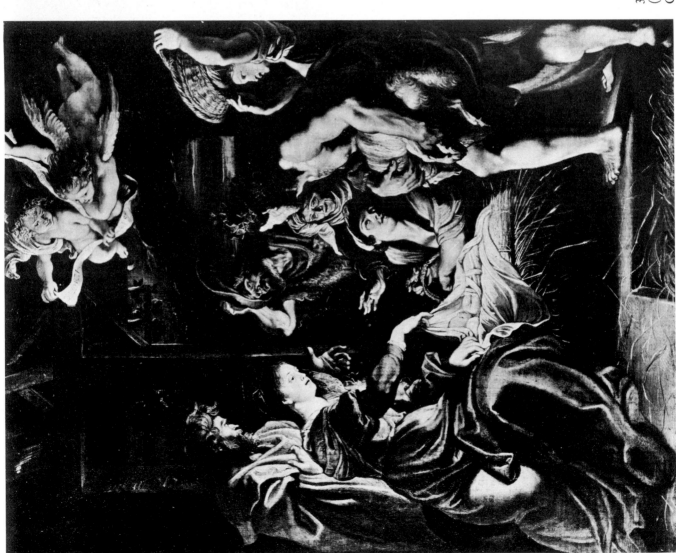

337. Rubens: *The Nativity.* About 1608. Oils on canvas
(formerly panel). Los Angeles, University of Southern
California

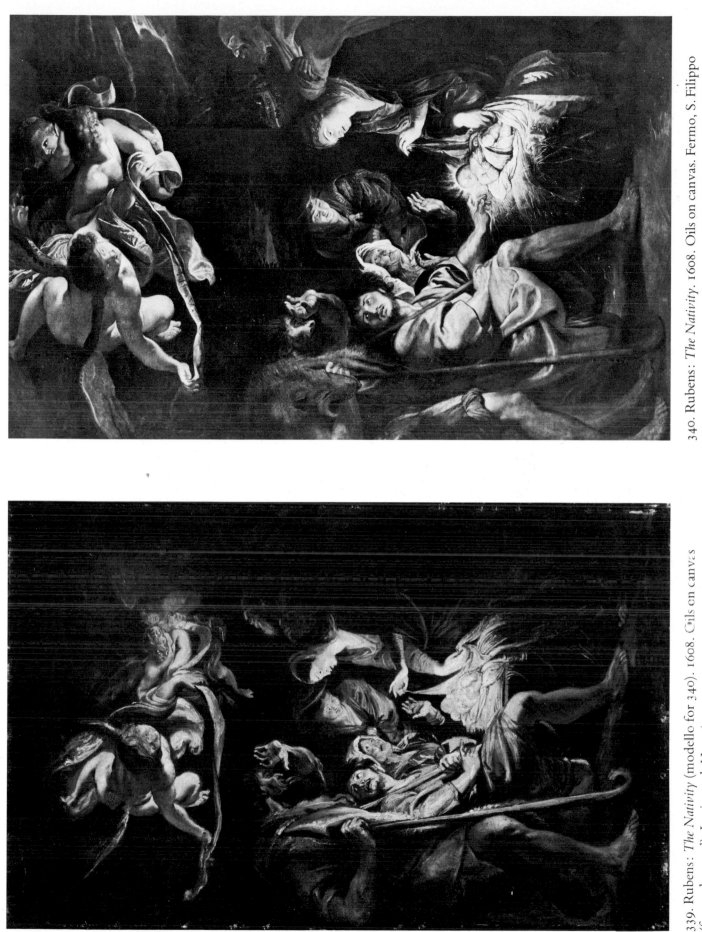

340. Rubens: *The Nativity*. 1608. Oils on canvas. Fermo, S. Filippo

339. Rubens: *The Nativity* (modello for 340). 1608. Oils on canvas (formerly panel). Leningrad, Hermitage

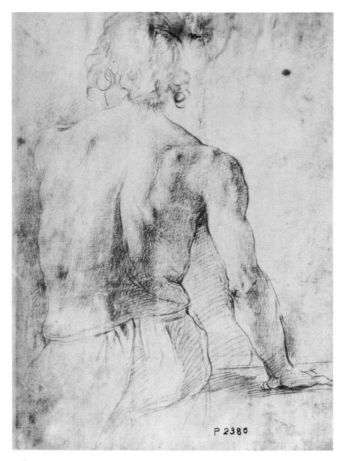

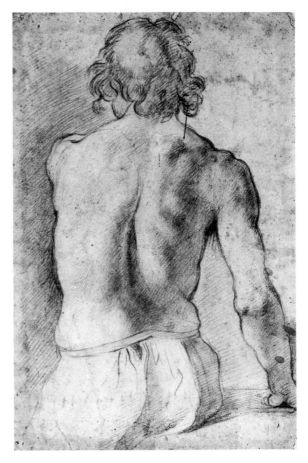

341. Guido Reni: *Study of a seated Youth*. About 1608. Red chalk on paper. Florence, Uffizi

342. Studio of Rubens, after Guido Reni: *Study of a seated Youth*. 1610–40. Red chalk on paper. Copenhagen, Kongel. Kobberstiksamling

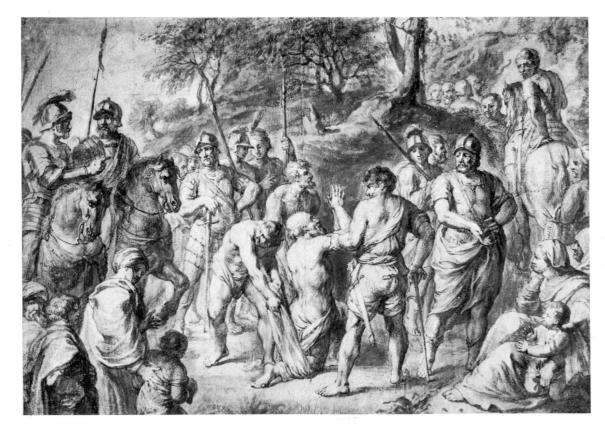

343. Rubens, after Guido Reni: *St. Andrew led to Martyrdom*. 1608. Pen and body-colour on paper. Bakewell (Derbyshire), Trustees of the Chatsworth Settlement

344. Rubens and Assistant: '*Facciata dinanzi il cortile del Palazzo H*' (for '*Palazzi di Genova*', Antwerp 1622). Ink on paper. London, Royal Institute of British Architects

345. Harrewijn: *Rubens's Garden Arch in Antwerp.* Copper engraving

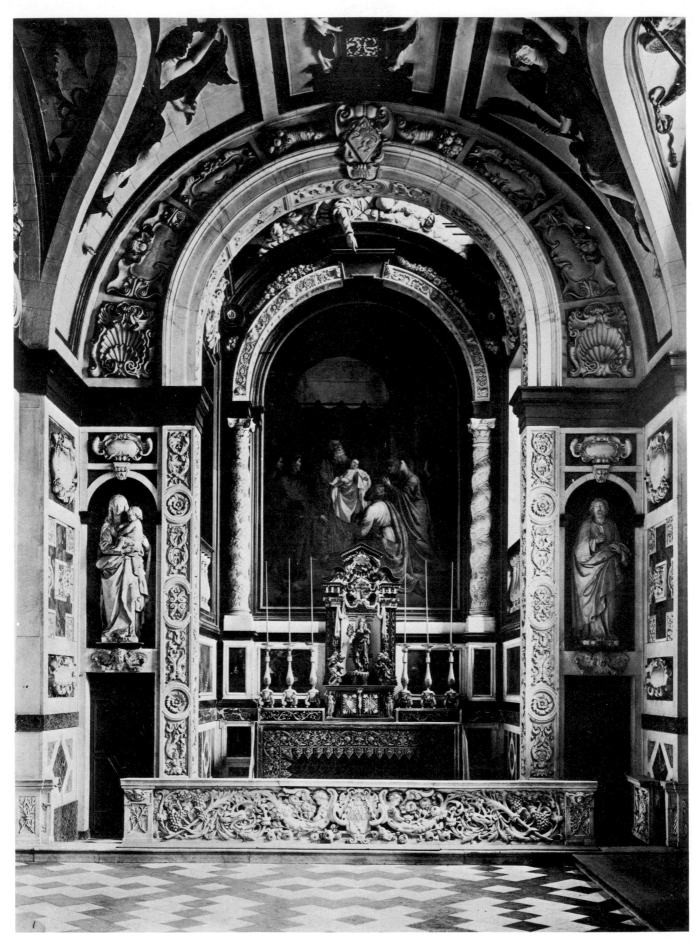

346. Rubens and Assistants: *The Lady Chapel in the Sint Carolus Borromeuskerk, Antwerp.* About 1622